The Ti

SACRED
IRELAND

A Guide to the Sacred Places of Ireland,
Her Legends, Folklore and People

CARY MEEHAN

GOTHIC IMAGE
PUBLICATIONS

ACKNOWLEDGEMENTS

First of all I would like to thank Frances, whose idea this was and who never lost faith in its completion. And Denis too, for his patient fact-finding and proof reading over these last months. So many other people have been involved in the making of this book over the last four years that I couldn't begin to name them but I thank them all. And I would like to acknowledge with gratitude all the people whose doors I have knocked on during my travels for directions and information, as well as permission to visit sites on private land. I was met with unfailing courtesy and kindness by so many people who have cared for the sites on their land for generations and who took pleasure in guiding me and passing on their knowledge.

For Hannah, Oisin and Michael, with love...

First published 2002 by Gothic Image Publications,
PO Box 2568, Glastonbury, Somerset BA6 8XR England.
This edition published 2004.
Copyright © Cary Meehan 2002.
All rights reserved.

The Publisher wishes to thank Linda O'Neall
for her generosity and support.

ISBN 0 906362 43 1
A CIP catalogue record for this book is available from
the British Library.

All photographs in this book are by the author,
Cary Meehan, apart from those credited in the captions.
Cover photograph by Simant Bostock.
(Janus figure, Boa Island, County Fermanagh)
Cover design by Bernard Chandler.
Design, artwork, map origination and monochrome scans by
Bernard Chandler (Graphics), Glastonbury.
Printed in Slovenia by Mladinska knjiga tiskarna, Ljubljana

CONTENTS

A NOTE FROM THE AUTHOR

IT IS AUTUMN AS I AM WRITING THIS and there is a wood nearby where I can walk everyday. There is a special place at the minute where the path is lined with beech trees and the air sparkles with an intense energy which emanates from the leaves as they fall. If I stop for a moment, I can feel it radiate through my body. I go home feeling great - energised, centred and at one with the world. It is as healing as a holy well and as transforming as a splash in the ocean or a climb to the top of a holy mountain.

It reminds me that all places in nature are sacred and powerful and not just those we humans designate. It's a wonderful thing to be surrounded by such places where the natural world is not under threat and can still afford to be generous.

However, our new prosperity has not always been a good friend or even a sensitive master. The Celtic Tiger, as it is called, has exacted a high price. Protection of our fairy or gentle places can no longer be taken for granted. Without our support, the fairies or nature spirits are in retreat. Our ancestors seem to have understood this and lived accordingly. No doubt they felt they had no choice.

Right now we are asking too much of nature to meet the needs of our complex lives. She is showing signs of stress and damage. We need to look a little closer at the price she is paying and make some choices.

HOW TO USE THIS BOOK

THE SITES IN THIS GUIDE are described county by county within each of the four provinces. For ease of reference each province has been given a different colour. The book takes you in a sun-wise (clockwise) spiral from province to province beginning with Ulster. The counties follow a smaller spiral within each province and the sites are also listed in order spiralling from the centre of each county.

There is a map of each province at the beginning of the appropriate section and then maps for each county. These county maps will help you with the general location of a site. Block figures (numbers) in a list on the map pages refer to site locations in the map and entries in the text. Any sites not numbered in the text are

located within the vicinity of the numbered site and do not warrant a number of their own. Detailed directions, where necessary, are in the text. Where map references are used, these have been taken from the Ordnance Survey's 1: 50,000 Discovery Series. This is an excellent map series with all historic monuments including wells and individual standing stones marked in red. They are very useful if you are spending time in a particular area.

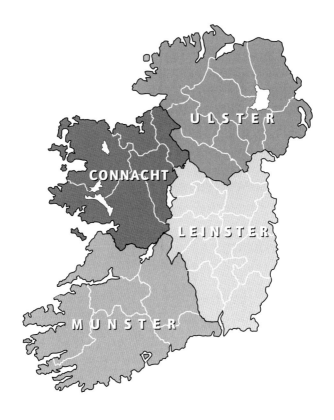

Major cities are not included in this guide, not because there are not sacred places there, but because this information is already easily available. Go to any tourist office or bookshop in Dublin or Belfast and you will find plenty of guidebooks and histories. For the most part, the sacred places of the cities have been created by human endeavour in historical times and their stories are well documented.

IRISH WORDS USED IN PLACE NAMES

This is a selection of Irish words used in place names.
Their most common Anglicised spelling is in brackets.

Abhainn (owen) - *river*

Ard - *height*

Áth - *ford (a shallow place for crossing a stream or river)*

Baile (bally) - *town*

Beag (beg) - *small*

Béal (bel) - *mouth*

Bó (boe) - *cow*

Bóthar - *road*

Bun - *bottom (the foot of a hill, or the end of a road)*

Carraig (carrick) - *rock*

Cill (kill) - *church, churchyard, cell*

Cloch - *stone*

Cluain (clon) - *meadow*

Cnoc (knock) - *hill*

Creagán - *stony*

Cuilinn (cullen) - *holly*

Dearg (derg) - *red*

Díseart - *retreat, deserted place, hermitage*

Domhnach (donagh) - *Sunday, church or place associated with St Patrick*

Droichead (drogheda) - *bridge*

Droim (drum) - *back, ridge of a hill*

Dubh (doo) - *black*

Dún (don) - *fort*

Gall - *foreigner*

Garbh (garva) - *rough*

Gort - *field*

Grian - *sun*

Inis - *island*

Leaba - *bed*

Leitir (letter) - *hillside*

Lios (lis) - *enclosure (a fort)*

Mágh (magh) - *plain*

Maol - *bald, or smooth*

Mór (more) - *big*

Mullach (mullagh) - *summit*

Óg - *young*

Ráth - *ring-fort*

Reilig - *graveyard*

Sabhall (saul) - *barn*

Sagart - *priest*

Sean - *old*

Sliabh (slieve) - *mountain*

Suí (see) - *seat*

Teach, **Tí** or **Tigh** - *house, church*

Teampall (temple) - *church*

Tobar (tober) - *well*

Trá - *beach*

Tulach - *low hill*

HELPFUL DEFINITIONS OF TERMS

Abbey - a monastery governed by an abbot.

Anchorite - a hermit.

Antae - projections of the walls of a church beyond the gables.

Arcade - series of arches.

Augustinian Canons - sometimes called the Canons Regular, these were secular clergy who placed themselves under the rule of St Augustine of Hippo. Their communities were less strict than monasteries.

Aumbry or **ambry** - a small recess in the wall of a church, usually in the chancel and used as a cupboard.

Bailey - an enclosure at the foot of a motte, or castle.

Ban-shee - Bansíog meaning fairy woman. In folklore the wailing of a banshee portends death. Each of the old Gaelic families had their own banshee whose visit meant an imminent death in the family.

Batter - a gradual thickening of walls towards the base of a building, generally for increased stability.

Bawn - a fortified enclosure attached to a house or castle.

Beehive hut - circular stone hut associated with early monasteries. The stones are laid in decreasing circles till they reach the apex, thus forming a roof.

Boreen - A small lane; literally, a small cow track.

Bullaun - a stone with deep cup-shaped depression(s), usually found at sacred sites.

Cairn - a mound of stones often covering a megalithic chamber.

Capital - the head of a column, generally supporting an arch.

Cap-stone - the cover stone of a dolmen or megalithic chamber.

Cashel - circular stone fort, first constructed in the late Bronze Age.

Cathach - a battle reliquary. Colmcille's manuscript of the gospels was called the Cathach. It was carried three times round the army before battle to help ensure victory.

Chancel - the east end of a church where the altar is located.

Chevaux-de-frise - pointed stones placed in the ground at different angles. Used for defence.

Cillín - place where unbaptised children and unsanctified adults (eg. suicides) were buried.

Cist - a small stone-lined box used in the Bronze Age (2000 - 300 BC) to hold human remains.

Clochán - beehive hut.

Cloister - covered passageway around a square courtyard or garden in a monastery.

Clootie - people who come to a holy well for healing sometimes leave a piece of cloth tied to a tree beside the well. This cloth is known as a clootie. As the cloth rots away, the disease should disappear.

Corbel - projecting stone.

Corbelling - a method of roofing where stones are placed in ever decreasing circles until they meet at the top. A self-supporting structure.

Court cairn - neolithic structures (3300 - 2000 BC), so-called because of the round or oval courts giving access to a gallery divided into one or more chambers. They are usually recognised by a curved line of stones forming the court. This structure was then covered by a cairn, an earth or stone mound, supported by a ring of stones around its base, called kerbstones. Most court cairns contain small quantities of cremated human bone, sherds of neolithic pottery, flint tools and sometimes beads. These are generally found in the chambers, though sometimes pits are dug into the ground of the courts and objects placed in them. Court cairns usually open to the east, to the rising sun. There are around 400 identified to date, mostly north of a line between Galway and Dundalk.

Crannog - an artificial island used as a lake-dwelling from the late Bronze Age.

Crossing - the centre of a church, where the nave, chancel and transepts meet.

Cross slab - a stone slab carved with one or more crosses. They are usually associated with early Christian monasteries and often used in modern times to mark prayer 'stations'.

Ditch - long, narrow channel

Dolmen - they are probably contemporary with court cairns (3300 - 2000 BC) and consist of two portals with side and end stones making, usually, a single large chamber. The portals are almost always very pronounced and the chamber is roofed by a cap-stone which is often huge. Dolmens are generally found on hillsides. Like court cairns, they may have originally been covered by a cairn. They generally contain the same kinds of artefacts as court cairns and are also usually facing east towards the rising sun. About 200 have been found in Ireland all over the country though they are more common on the eastern side. They also occur in Wales and Cornwall.

Féis - festival (literally 'spending the night together').

Finial - an ornamental finish at the top of a gable wall.

Fosse - trench.

Fresco - a wall painting using pigmented plaster.

Friary - home of friars, from the French, freres. There were originally four orders of mendicant friars: Franciscans, Dominicans, Carmelites and Augustinians. Mendicants depended on alms for support. In this way they were different from monks.

Fulacht Fiadh, or **Fulacht Fía** - a communal cooking pit usually

associated with Iron Age feasting. It involves a hearth for heating stones which are then placed in a trough of water lined with wood or stone. Food is cooked in the heated water.

Gothic - a style of architecture from the late 12th century.

Henge - a ritual enclosure made of earth, stone or wood with a ditch inside.

Hill-fort - a fort encircling the summit of a hill often enclosing as much as 20 acres. Its shape follows the contours of the hill. Sometimes called a contour fort.

Indulgences - the granting of an indulgence by the Church remits the temporal punishment due to a venial sin.

La Tène - Celtic decorative art style.

Lancet - a tall narrow window.

Lavabo - building for washing in.

Lintel - a flat stone to transfer load either side of a structural opening.

Mesolithic - middle Stone Age, 7500 BC - 3300 BC.

Motte - a circular mound, flat on top, used by the Normans as fortification. It was also adopted by some Gaelic chieftains.

Nave - the main, or western body of a church often flanked by aisles.

Neolithic - late Stone Age, 3300 BC - 2000 BC.

Ogee - a sigma curve used in architecture.

Ogham - Irish script using combinations of lines carved on stone. Used from the 4th century AD.

Passage cairn - neolithic cairns (3300 - 2000 BC) possibly a little later than dolmens and court cairns. There are over 200 of them and many of these occur in a diagonal line from Sligo in the west to the Boyne Valley in the east. The cairns are round, usually on high places and hilltops. They have a stone passage leading into an inner chamber. The passage can be long and narrow as at Newgrange or only a couple of stones long as at Knockmany, Tyrone. The chamber can be a large circular room as at Fourknocks, Meath, or a small cruciform shape with high corbelled ceiling as at Newgrange, or a simple widening of the passage as with the Tramore group, Waterford. The passages of many of these cairns have been found to align to the rising or setting sun.

Pattern - a pilgrimage made by the community on a particular day to a sacred site. This usually involves visiting and praying at different parts of the site in a particular order. Patterns were often followed by dancing and celebration.

Piscina - a basin for washing the sacred vessels in a church.

Priory - usually a house of Dominicans. As their founder, St Dominic adopted the rule of St Augustine and named his houses priories.

Promontory fort - a stone wall or walls built across the neck of a promontory to create a defended area.

Quoin stone - a corner stone of a building.

Romanesque - style of architecture using rounded arches and elaborate carvings from the early 12th century.

Rood - a crucifix.

Round tower - tall slender tower with a conical roof built as part of a monastery. The doorway is reached by a ladder and there were usually up to five wooden floors inside. These are only found in Ireland and were built between the 10th and 12th centuries.

Sacristy - a room in a church where vestments and sacred vessels are kept.

Sedilia - wall seats for clerics in the chancel of a church.

Sheela-na-Gig - a female figure displaying her vagina. The figure was carved from a single block of stone and set into the fabric of a church or castle, usually over a door or window or as a corner stone high in a castle wall. No-one really knows why these figures were carved. Perhaps the portrayal of the entrance to her womb at the doorway of a church echoes the womb-like passage of the great passage cairns or temples of neolithic times. They may subsequently have become a kind of talisman, an unconscious acknowledgement of earlier deities.

Sí - fairy mound or fairy. Plural: **síthe**. Also spelt sídhe. Both are pronounced - she.

Souterrain - underground passage built of stone.

Stations - places (usually numbered in sequence) to stop and pray.

Sweat house - small stone house, heated with fire and then used for sweat baths.

Trabeate - flat-topped, usually referring to a doorway made from two jambs and a lintel.

Transept - one of the two wings of a church perpendicular to the nave.

Transitional - architectural style between Romanesque and Gothic.

Triple-light, Twin-light - terms to describe the number of apertures of a window.

Turas - literally, a journey. Commonly used to describe a sacred journey or pilgrimage.

Tympanum - semi-circular stone panel enclosed in an arch over a doorway.

Vaulting - a series of arches forming a roof.

Voussoir - wedge-shaped stone used to form an arch - often carved with animal or human heads in Romanesque architecture.

Wedge cairn - a gallery of one or more chambers, higher and wider at the front, hence the term wedge. They are usually double-walled with a facade of tall stones at the front which generally face south west. This was covered with a stone cairn. Built around 2000 BC, late neolithic to early Bronze Age, they occur mainly in the west of the country. A quarter of the 400 known wedge cairns in Ireland are in Clare.

INTRODUCTION

THE EARTH GIVES US LIFE and we are all drawn back, at certain times, to this potent source of our beginnings for a sense of nurture and completion. Those places where this sense of connectedness is strongest are the sites we term sacred. And, although our lives have evolved a long way from those of our neolithic ancestors, we are still touched, however unconsciously, by the same earth energies and the same miracle of life. This sense of the divine is reflected in every age, from the ancient cairns of prehistory to the great cathedrals of today.

The places described in this book are just some of these sacred sites and the experience of seeking them out has convinced me that visiting and connecting with these places is vital to the well-being of both ourselves and our planet. It is also a great pleasure.

Some of these sites are of national importance: royal palaces like Tara, sacred mountains like Croagh Patrick and the great passage cairns of the Boyne valley. Others are less well known.

There are spectacular dolmens, massive like Browne's Hill or elegant like Legananny and court cairns with names like Creevykeel, Cohaw and Behy. There are hundreds of stone circles and stone rows, some in complex groups like Beaghmore and others, like Bohonagh, isolated on hillsides. Like the circles, wedge cairns are also from the Bronze Age. Labacallee in Cork is the biggest, its huge dark boulders like the limbs of an eccentric dinosaur.

Myths and stories associated with particular sites continue to illustrate an ancient understanding of the landscape and its energies: the Children of Lir spent 300 years as swans on Lough Derravaragh - itself the shape of a swan in flight. The caves of Kesh Corran in Sligo are seen as an entrance to the Otherworld and the place where the goddess, known as the Morrigan, emerges to do battle. The cairn-topped hills of the south are full of stories of the Fianna and their encounters with the fairy people of the hills. And then there is the Hill of Uisneach, the energetic centre of Ireland and place of many legends.

There are lakes and rivers still identified with pre-Celtic deities and small island sanctuaries which are places of fertility and power. Some of these islands have been Christianised by early saints: Devenish and White Island in Fermanagh, for example, Inchagoil in Galway, and Holy Island in Clare.

The locally venerated sites such as fairy hills, wells, trees and stones, are places which tradition has protected as gentle or fairy places. Fragments of these old traditions are still preserved in their folklore. Some of these were Christianised and became the sites of

early monasteries, oratories, carved crosses, round towers and cross slabs. A number of them, like Glencolmcille, are important pilgrimage sites today. Others are deserted but seem to hold an echo, especially at dusk, of lives spent in contemplation and prayer. Islands with their monastic ruins are often still places of pilgrimage. A few are deserted, though not all. The Aran Islands, Achill and Tory have substantial populations.

Other early Christian sites were built and rebuilt into medieval monasteries with fabulous Romanesque carvings like Cong or Gothic arches, like Kilmallock. Some sites like Ahenny, Moone, Kilfenora, Kells, Clonmacnois and Monasterboice are famous for their beautiful carved crosses.

And there are many cathedrals, each different. St Canice's cathedral in Kilkenny is a treasure house of late medieval figure carving. Killaloe and Tuam have beautiful Romanesque arches. St Brendan's in Loughrea has the best collection of early 20th century stained glass in the country.

It may feel like a great leap in imagination to go from the neolithic passage cairns of 5000 years ago to the great cathedrals of today, but the variety of sites described above seems to link scattered fragments of human experience across time and space, allowing us a glimpse of our own origins. All are, like us, connected.

The flagstone at the centre of the small Bronze Age stone circles in Cork may have served the same purpose as the much earlier cap-stones on the neolithic dolmens in Waterford or County Down. The tiny early Christian oratory with its corbelled roof on the hillside in Kerry is descended from the chambered cairn at Loughcrew in Westmeath. The people who carved symbols on the great megaliths at Newgrange are ancestors of the stone cutter who decorated the high cross at Kilree in Kilkenny with concentric circles and spirals. And the deposits of human bone in a neolithic cairn are part of a tradition of relics as power objects which continued into Christian times. The power of such relics to confer grace and healing is still acknowledged in Ireland. In 2001 the relics of St Thérèse of Lisieux were brought here from France and taken on a tour around the country. Everywhere they went flowers were strewn along the roads and thousands queued to touch them.

MYTH & HISTORY: THE ORIGINS OF THE SACRED LANDSCAPE

OUR MAIN SOURCE OF EARLY HISTORICAL MYTHOLOGY is an 11th century book, called *Leabhar Gabhála Éireann* or, *The Book of Invasions of Ireland*. It begins with the arrival of the first people to Ireland in the time of Noah and is the closest we have to a creation myth.

We also have our most quoted historical text for the early Christian period, *The Annals of the Four Masters*. It was written in the 17th century and begins forty days after the flood in the year of the world 2240. At that time the date for the biblical Creation had been set at 4004 BC by the Bishop of Armagh, Bishop Usher.

Much of it is simply a record of names, dates, battles and disasters with some quotes from ancient sources - a kind of early news bulletin, though less reliable. However, as it gets closer to modern times, more information is available. It is a much-used source of dates for early saints and the founding of their monasteries. Viking raids, accidents and fires are also listed.

Many manuscripts disappeared in the turbulent years of the 8th to 10th centuries, some destroyed in local raids or looted by Vikings. Of those that remain, most are illustrated copies of sacred texts copied by monks with perhaps some historical records about the monastery and stories about its founding saint or local ruler. These give texture and life to these early saints and some, like the *Vita Columbae*, written by Adamnan at the end of the 7th century, provide useful historical data of larger events. Then we have the stories or *cycles*: *The Ulster Cycle*, the *Mythological* and *Fenian* cycles and *The Cycle of The Kings*. For the rest we have archaeology, folklore and our imagination.

THE PALAEOLITHIC 18000 BC - 8000 BC

The Ice Age in Ireland lasted over 1.5 million years, yet during that time temperatures fluctuated and, towards the end of this period, the mountains and much of the south was relatively ice-free. The climate was able to support a tundra-like vegetation - grassland with birch and willow scrub. The great elk, woolly mammoth, arctic fox and brown bear inhabited this landscape. They roamed from the Russian Steppes to the French Pyrenees and were hunted across Europe by early Stone Age or **palaeolithic** people. In Ireland they must have found a haven for no trace of

human presence has been found for this time.

With the last glaciers gone, tundra spread right to the north across the scoured landscape and over the next few thousand years rising temperatures encouraged the spread of woodland: hazel and pine at first, then elm, oak, birch and willow. The large animals of the palaeolithic grasslands were displaced and by about 8000 BC most of the flora and fauna of Europe had spread right to the west.

With them came the first humans. About the same time the island of Ireland was set adrift from mainland Europe as melting glaciers flooded the oceans and covered the last land bridges to the east.

THE MESOLITHIC 8000 BC - 4000 BC

These early mesolithic people settled in this fresh new land on the western fringes of the known world. They lived along river valleys and lakesides where the forest cover was light. They were hunter-gatherers.

For a long time the only tangible signs of their presence were finds of small flint tools, called microliths. The flint was sourced in the calcareous limestone of the north east and this is where the first evidence of these people was found. Later finds were uncovered in the south in Offaly. Here chert was used instead of flint. Since then, other traces of these early people have been found around Dublin Bay and in the south west.

Post-holes at Mountsandel in the north east indicate dwellings made from bending and weaving poles into frames that could be thatched or covered with skins. There were food remains here from different seasons, indicating that they were not as nomadic as we think.

Flint tools in Ireland are significantly different from those found in Britain at this time, yet those found throughout Ireland seem to share a common provenance. This would seem to imply that their owners did not come from Britain at all. Perhaps they came from further south.

However, evidence has been found of a mesolithic presence at Carrowmore in Sligo around 7500 BC. So it is possible that they came from the west. Who knows what truths lie behind the lost civilisation of Atlantis, now buried beneath the ocean?

These people seem to disappear from our sights around 6000 BC. Then comes a later phase which lasted until about 4000 BC. Tools were now significantly larger.

Did the early mesolithic people leave or die out and were they replaced by newcomers?

There are plenty of questions and not many answers. And with no human remains from this time, it is a bit like chasing ghosts.

The authors of *The Book of Invasions* are quite transparent about

giving the Irish Judaeo-Christian roots, but they also draw on knowledge and folk memory of the time. According to this source, the first people to inhabit Ireland were of the family of Noah. Three ships set sail to escape the flood, though only one arrived safely. In it were **Cesair**, grand-daughter of Noah, with fifty of her women and three men: Bith, her father, Ladra, the ship's pilot, and Fionntán.

They came ashore on the Dingle Peninsula in Kerry. The story goes that they divided the women between the three men but Bith and Ladra soon died, leaving Fionntán with responsibility for all the women. He fled and Cesair died soon after of a broken heart and all the women with her. Only Fionntán was left and he is said to have lived on for 5500 years, changing shape over time. He lived as a salmon, then an eagle and a hawk, witnessing the events of history so that they could later be written down by historians of such works as *The Book of Invasions*.

The next people to arrive here fared little better. They were also from central Europe, this time from Greece and led by **Partholán**, a prince who had killed his father, the king. He came with his three sons who each introduced skills previously unknown in Ireland: the first, hospitality; the second, cooking and duelling and the third, brewing. Their father, meanwhile, cleared four plains, having brought with him the first four oxen. However, they only survived for 550 years before being wiped out by plague, except for one, Tuán mac Cairill, who lived on for many years in various animal guises to be a witness to this time.

THE NEOLITHIC 4000 BC - 2000 BC

And so to neolithic times when, according to the archaeological record, human activity began to alter the face of the landscape. These people came with a new energy. They cut down trees, grew crops, grazed animals and erected huge stone structures or megaliths which were central to the new culture.

In recent years in the Ceide Fields in Mayo, in the west of Ireland, a network of dry-stone walls, dating to around 3000 BC, was discovered beneath the bog. These field walls follow the contours of the hills above the north Mayo coast, covering an area of about four square miles, evidence of a highly organised agricultural society and a large one at that. It is estimated that a group of maybe 300 people came here and established this farming community.

Where did these people come from? How did they manage to bring enough animals - cattle, sheep, goats and pigs - to provide genetically viable groups? And why?

We have assumed that successive groups of people came to

Ireland from the east and landed in the east. It was assumed that
they came with difficulty in small perilous boats and would have
needed to see their destination before they set out - a kind of island-
hopping. We have also assumed that the passage cairns of the
Boyne Valley in the east were the earliest in the country. It now
seems that the Sligo cairns, in the west, may be much older. And
as we wake up to the vision and skill of these megalith builders, we
realise that they could have travelled any distance they chose with
the sky to guide them in boats built with great skill from the forests
of Europe and North Africa. And if they settled in the west, it was
probably by choice.

Local tradition and the early writings say that both Cesair and
Partholán arrived in the west. And, of course, we have the Ceide
Fields in Mayo - the biggest neolithic community yet discovered.
Perhaps this is where Partholán set to work with his sons. Nor were
these neolithic people confined by our shores. Stone axes from
Rathlin Island and Antrim have been found from the north of
Scotland to the south of England. And English and Welsh axes
have been found in Ireland.

According to our mythological history, **Nemhedh** arrived
next with his wife Macha and four sons. They cleared twelve plains
and four lakes and he is credited with building a fort in South
Armagh ('Ard Mhacha', meaning 'Macha's height'). And so appears
the first of many of Ireland's deities. Macha has a number of guises
but she is very much a northern goddess.

Nemhedh is also credited with lighting the first fire at Uisneach,
the centre of Ireland. This is the first mention of conflict with
another, already present culture, the Fomoire or **Formorians**. This
may be a conflict between the hunter-gatherer mesolithic people
and the new neolithic farmers with their earth moving, wall-
building activity.

We do not know how long the Formorians had been in Ireland
but they are cast as giants, demonic and malevolent. They have
each only one eye, one arm and one leg. Pushed to the coastal
fringes by Nemhedh, they become cruel pirates, collectors of brutal
taxes, including the children of their victims. They are said to have
cut off the noses of those who could not pay. This tax was collected
each Samhain (Halloween), a time when people are vulnerable to
incursions from a malevolent Otherworld.

Nemhedh defeated them at first, but eventually after his death,
his followers fled, scattered across Europe, some northward, others
to Greece. The Formorians remained on the western fringes and
they continue to be associated with Tory Island, off the Donegal
coast, into modern times.

The next and fourth invasion included three groups, all

descended from the followers of Nemhedh who had spent long years in servitude in Greece after their flight from the Formorians. The best known of these were the **Fir Bolg**.

The Fir Bolg are said to have come to Uisneach, in the centre of Ireland, and from there they divided the country up into its five Cúigedh (fifths) or provinces. The four provinces still radiate out today from that central point at Uisneach, with the fifth division being the land around Westmeath. Each province was ruled by one of five brothers responsible for prosperity, order and justice for all. This formed the basis of sacral kingship, a concept that survives to this day on some of the islands and in certain remote parts of the country.

And so, throughout neolithic times, invasion myths repeat and fall away like incoming waves in a mathematical pattern: the three sons of Parthalón; the four sons of Nemhedh; the five brothers of the Fir Bolg.

The Megaliths

Neolithic people were responsible for the great megaliths, the cairns and temples of prehistory. Archaeologists have called them tombs because they have found cremated bone deposited in them, but they are surely the cathedrals of prehistory. Perhaps people in the future will look at the ruined churches of today and see only the remains of the dead in their special sarcophagi.

It is ironic that they should have come to be associated with the dead when it is much more likely that they were places which ensured the continuity of life. Once you have seen a passage cairn as the belly of the goddess complete with reproductive organs, it is hard to see them in any other light. Small smooth round balls have been found in their recesses, and even decorated phalluses. We can never know the exact nature of their ceremonies, but everything points to an association with rebirth and regeneration, rather than death. It is possible that the bones of their ancestors acted as power objects. Perhaps placing them in the womb of the cairn, where they would be touched by a shaft of sunlight at an especially potent time, ensured the continuing cycle of the year or even the rebirth of that powerful ancestor. Maybe, for some initiates, entering the 'belly of the goddess' was part of a potent initiation rite. It is interesting to note that one of these neolithic groups was called the 'Fir Bolg' which means the 'belly men' or perhaps the 'people of the goddess'.

All the neolithic megaliths: dolmens, court cairns and passage cairns, have certain things in common. There is a chamber with portals which separates it from the outside world. Often these chambers are roofed in dramatic or seemingly extravagant ways like the cap-stone on Browneshill Dolmen in Carlow, or the great mound of cairn material covering the chamber at Newgrange in Meath. This must have served to further separate the inside space

from the outer world. Their astronomical and earth alignments
would have further focused the energy inside the chamber, making
them potent places indeed.

Sometimes, even from this distance in time, that power still lingers.

THE BRONZE AGE 2000 BC - 300 BC

By 2000 BC metal workers had arrived in Ireland and with them a
whole new culture. Most of Ireland's copper came from Munster.
Ross Island in Killarney was the site of the first copper-working
and the copper mines on the slopes of Mount Gabriel in Cork were
a rich source of ore. They would have heated the ore with fires
before shattering it with stone mauls and drawing it to the surface.
Wealth was measured in cattle and the prestige of bronze artefacts.
This would have been a relatively peaceful and prosperous time.
These people built stone circles and rows as well as wedge cairns a
little lower down than the earlier megaliths, for weather conditions
had deteriorated since neolithic times.

Then, between 1159 and 1141 BC, there was a catastrophic
weather change. Tree ring readings show us that there was no
summer growth for 18 years. This was the time of the fall of Troy,
and the beginning of the Dark Ages in Greece. Everything was
cold. Nothing ripened.

Around this time we see sacrificial pools, such as the King's
Stables at Armagh. Bronze and gold objects were deposited, as well
as animal and human sacrifices. Dark times made people more
religious and more warlike. There was a new concern with death
and fertility. Large hill-forts began to appear, and crannogs - both
places of safety in a dangerous time. Hill-fort walls followed the
contours of the hill and were often huge.

By 800 BC society had begun to recover and even grow wealthy.
Fabulous objects of beaten gold appear: discs patterned with more
discs, sun images upon sun images, and neck ornaments shaped
like crescent moons, called 'lunuli'. The best place to see their work
is on the ground floor of the National Museum, Dublin, where a
gold collection is on permanent display. The sun discs from Tedavnet
in Monaghan have double concentric borders surrounding an
equal-armed cross, a universal image which would not be out of
place in a Christian church.

But the landscape was undergoing a change. Increased rainfall
created waterlogged conditions in the once fertile farmland, now
denuded of its forests. Many areas became slowly smothered under
a deep blanket of bog.

Modern turf cutting this century has given us a glimpse of

what lies hidden. In mid-Ulster, in particular, where the stone circles are often low, there have been some extraordinary finds. At Beaghmore, in County Tyrone, turf cutters have revealed a complex of seven stone circles and at least nine stone alignments. One circle is studded with 884 small stones. At nearby Copney, one circle has been uncovered which had been filled with stones set radially and with a hollow centre which may have held a cist. These seem similar to the radial cairns of Cork and would have been constructed around the same time.

In our mythological cycle these metal workers with their Druidic arts and their new, magical technology, were the **Tuatha Dé Danann**. They were the Tribe of the Goddess Danu or Anu. Her male counterpart was the Daghdha, the great father. The Tuatha Dé Danann arrived in a mystic cloud and landed at Lough Corrib, Galway and on the mountain of Sliabh an Iarainn, Leitrim. They brought with them four talismans:

- The Stone of Destiny or Lia Fál which was used at the inauguration of the kings at Tara. It was said to roar when the rightful king was inaugurated.
- The Spear of Lugh which would always ensure victory.
- The Sword of Nuadha from which no-one could escape.
- The Cauldron of the Daghdha from which no-one would go away unsatisfied.

On their arrival, they demanded the kingship of Ireland from the Fir Bolg. When it was not forthcoming, they fought and beat them in the First Battle of Magh Tuiredh and drove them west into Connacht.

However, in the battle, Nuadha, the king of the Tuatha Dé Danann, lost his arm. It was impossible for the king to have any bodily imperfection, so he gave the kingship to Bres the Beautiful instead. Bres's father was a Fomorian, though his mother was of the Tuatha Dé Danann. This turned out badly as Bres did not display any of the kingly virtues besides his physical beauty. He was neither hospitable nor generous, and he humiliated the Daghdha and Oghma by setting them to work building his fort and collecting wood for his fire.

In the meantime, the tribe's healer, Dian Cécht, had made a silver arm for Nuadha. The fingers moved and it was much admired, but one of Dian Cécht's sons, Miach, was a better healer than his father and he decided to try and restore the king's own arm. He took it and brought it to him and set it against his body with incantations. The first day he put it against his side and the second day against his breast, until it was covered with skin. The third day he took bulrushes blackened on the fire to put on it and after that, the king's hand was completely healed. However,

Miach's father, Dian Cécht, was angry with his son for performing a better cure than he could and he killed him. Herbs grew up from his grave, 365 of them over each joint and sinew, according to their usage. Miach's sister spread her cloak and collected the herbs carefully, laying them in order so that she would know their use. But Dian Cécht discovered what she was doing and mixed them up. The knowledge was lost and to this day has not been found.

Meanwhile Nuadha, being whole again, wanted to take back the kingship from Bres as he was proving such an unworthy successor. But Bres was not willing to give up his position and he went to the Formorians, his other kin, for help. This time Nuadha and the Tuatha Dé Danann had to fight the Formorians and Bres. But help was at hand. It was at this moment that **Lugh** appeared at Uisneach, while Nuadha and his household were gathered waiting for the Formorians to come and collect their taxes.

'Lugh' means 'the Shining One', and he saves his people. He is always young and handsome, and associated with wealth and abundance. His festival is Lughnasa, the harvest time of year when young people go berry-picking, dance and make love. His epithet, 'Lámhfhada', means long-armed and, like the Indian god Savitar of the Wide Hand, it means he has great power and generosity.

His grandfather was Balor, the chief of the Formorians, whose stronghold was on Tory Island off the coast of Donegal. Balor had been told that he would die at the hands of his grandson, so he kept his daughter Eithne imprisoned in a tower on the island so that she would not come into contact with any men and so could bear no children. Of course it did not work and she conceived triplets with Cian, another of the sons of Dian Cécht. When Balor discovered his grandchildren, he ordered them to be drowned but Lugh was rescued and fostered by Manannán mac Lir, the Son of the Ocean. Lugh came of age just in time to rescue his father Cian's people from certain defeat at the hands of the Formorians as Nuadha tried to win back the kingdom of Ireland from Bres.

Back at Uisneach Lugh was at first refused entry to the king's palace even though he identified himself in turn as a smith, a wright, a warrior, a musician and more. Each time he was told that the tribe already possessed someone with that skill. It was only when he said that he possessed all these skills together that he was allowed to enter. Nuadha then challenged Lugh to play chess. When Lugh had won every game, he was allowed into the king's household and after proving himself the Oghma's equal in strength, Lugh showed his skill as a harper by moving the company to laughter, tears and finally to sleep. After this, he was given the kingship of Ireland so that he could lead the Tuatha Dé Danann against the Formorians. The battle was called the Second Battle of Magh Tuiredh.

The Tuatha Dé Danann used all their magical arts to help win the battle. And Lugh came face to face with Balor, his grandfather. Balor's eye was so great that it took four men to raise the lid and when it was uncovered, its venomous gaze could kill. Lugh cast a sling-shot straight into the eye which drove it right to the back of his head from where it disabled Balor's own army. Balor died, the prophesy was fulfilled and the Tuatha Dé Danann won the battle. The Formorians were expelled from Ireland forever and Bres escaped with his life in exchange for advice on the best times for ploughing, sowing and reaping.

And so Ireland prospered for many years with Lugh as king, the perfect embodiment of divine authority. In time he seems to have been replaced by the Daghdha and he becomes a shadowy figure, occasionally encountered when some wrong needed to be righted or some wisdom given. This was a time of prosperity when humans and gods were still closely related and both moved easily between the seen and unseen worlds. But then came the next invasion. This time it was the Milesians, or sons of Mil. They came originally from Asia Minor where they had lived for thousands of years.

IRON AGE 300 BC - 500 AD

It is generally accepted that the new wave of Celtic migration reached Ireland around 300 BC and with it the new iron technology. These newcomers are associated with the so-called royal sites or centres of ceremony and administration - Emhain Macha in Armagh, Dún Ailinne in Kildare, Tara in Meath, Rathcroghan in Roscommon and, of course, Uisneach. There are some 30,000 ring-forts or fairy forts in Ireland dating to this time. These were Iron Age farmsteads, some built in stone where it was plentiful or where status or enmity demanded, but most had earth banks, probably topped with a wooden palisade. Many were in use up until medieval times (not to be confused with the Bronze Age hill-forts). They also built long earthworks which have been thought of as boundaries, such as the Dorsey and the Black Pig's Dyke, as well as track-ways across the bog, like the Corlea track-way in Longford. Ornamented ritual stones, like the Turoe and Castlestrange stones, are also of this period as well as many carved stone heads. Ogham (pronounced om) writing evolved around 300 AD. It was based on the Roman alphabet and remained in use till the 7th century.

There is a sense now of kinship groups and families living in separate homesteads, of regional centres of power, boundaries and communication networks. This fits in with the mythological stories of this time.

The sons of Mil, called the **Milesians** or **Gaels**, are said to have landed in the south west of Ireland at the feast of Beltaine. At Sliabh Mis in Kerry they met Banba, a queen of the Tuatha Dé Danann and wife of Mac Cuill, Son of the Hazel, with her **Druids**. Some time later, they met a second queen and she was Fodhla, wife of Mac Cecht, Son of the Plough. And when they came to Uisneach, they met Eriu, wife of Mac Greine, Son of the Sun.

They travelled on to Tara and found these three grandsons of the Daghdha, who shared the kingship of Ireland, quarrelling among themselves. The Milesians were surprised at this as all about them was so rich and prosperous, so they challenged them to give up the kingship or fight for it. The three kings were not ready to fight, so the sons of Mil made an offer. They returned to their ships and sailed out the length of nine waves from the shore. It was agreed that if they could land again, in spite of any enchantments the Tuatha Dé Danann could make against them, then the kingdom would be theirs.

At first the Tuatha Dé Danann raised a storm against their ships. The ship of Donn, one of the sons of Mil, perished, as it was said that he had not given proper respect to **Eriu** when they met earlier at Uisneach. In the end, five of their ships were destroyed and only three were left. Then Amhairghin called out to Eriu, asking that they might come to her again, and the storm abated. He was the first to put foot on the shore this second time and as he did so, he sang to her:

> I am the wind on the sea;
> I am the wave of the sea;
> I am the bull of seven battles;
> I am the eagle on the rock;
> I am a flash from the sun;
> I am the most beautiful of plants;
> I am a strong wild boar;
> I am a salmon in the water;
> I am a lake in the plain;
> I am the word of knowledge;
> I am the head of the spear in battle;
> I am the god that puts fire in the head;
> Who spreads the light in the gathering on the hills?
> Who can tell the ages of the moon?
> Who can tell the place where the sun rests?
> *- Lady Gregory's Complete Irish Mythology*

Then Amhairghin and the Milesians crossed Ireland and, though they had battles to fight, they had won acceptance from the spirit of the land in the form of the three goddesses (queens) and the

number of their dead was slight compared to the Tuatha Dé Danann.

The final defeat of the Tuatha Dé Danann came about at Tailtiu (now Teltown, Meath), home of the great earth goddess of that name. She is said to be the foster-mother of Lugh who instigated the first festival and games there at harvest, later to be known as Lughnasa.

In spite of the Milesian victory, the Tuatha Dé Danann still held power over the land and they withheld her fertility till the Gaels made a settlement with them. The Tuatha Dé Danann took the underworld and the Daghdha, their leader, divided the hills and cairns among them. And so they retreated from the seen world and became the goddesses and gods, or fairy people of later times.

The time of the Milesians or Gaels is the time of the great heroic tales. But above these is the constant presence of the Goddess in her various guises. Maebh is probably the best known and associated with Tara and the high kingship as well as Crúachain in Connacht. There is Macha in Ulster, Boand by the Boyne, Áine in Munster and the Cailleach Bearra, Aoibheall and Clíodna in the south west. Also there are the three great Goddesses of war: Morríghan, Badhbh and Nemhain who personify frenzy and destruction as well as transformation and regeneration.

The Ulster Cycle, also called *The Heroic Cycle*, and first written down in the 7th century, tells of the deeds of Cúchulainn and the Red Branch Knights and the great feud between Connacht and Ulster, called the *Táin Bo Cuailnge*. The stories of Fionn and the Fianna are from this time. The Fianna are a band of heroes in the same Romantic tradition as the Knights of Arthur. They hunt across Ireland righting wrongs and coming up against the magical arts of the beautiful women of the sidhe. Finally Oisín, Fionn's son, and his companion, Caoilte Mac Rónán, live on into Christian times, just long enough to travel with Patrick and tell him all that went before.

The High Kings of Tara

The Gaels or Celts stayed faithful to the goddess through her sacred marriage to the king. The most famous of these ceremonies was the Feis Temhra, the feis at Tara, where for many years the land of Ireland was personified by the goddess Maebh. She was the consort of no less than nine high kings. No one could be high king without her approval.

A Tarbhfheis was also called for in choosing the high king. This involved the killing of a bull. The meat and broth was then eaten by someone who would sleep with Druids chanting over him while he dreamt of the next king. Finally, the Stone of Destiny would cry out when the right king was inaugurated.

Long after the stone ceased to be used, **Brian Boru** used it again in the 10th century to add credence to his claim to the high

kingship. It was said to have cried out then for the last time in Ireland.

Across Ireland every tuath or small territory had its sacred stone, representing the spirit of place, upon which every local chief was brought to power. The power of the inauguration stone lasted right into the 17th century. When Elizabeth I sent Mountjoy against Hugh O'Neill (Ui Néill), the last Gaelic chief of Ireland to hold out against the English crown, Mountjoy went to Tullyhogue in Tyrone and smashed the inauguration stone of the O'Neills. This marked the end of sacral kingship in Ireland and the end of the O'Neills.

But to go back to the Iron Age... Roman power was gradually declining towards the end of the 3rd century and Britain had fallen prey to attacks from those closest to her borders. Irish chieftains were raiding across the water and expanding their territories eastward. The kingdom of Dalriada in the north-east extended into northern Britain and Scotland, creating a route for some of the first Irish missionaries.

Most famous of raiders was **Niall of the Nine Hostages** who is said to have controlled land through hostages taken from the Scots, Saxons, Britons and French, as well as Irish. He is credited with capturing the young Patrick and bringing him back to Ireland as a slave in the middle of the 5th century.

By the 5th century Ireland was divided between the two strongest families, the Ui Néill, sons of Niall, in the north and the Eoghanachta, based at Cashel in the south. For roughly the next five centuries this divide replaced the old five provinces and the Ui Néill ruled at Tara till displaced by Brian Boru in 1002.

Early Christian Ireland 400 AD - 800 AD

We know there were Christians in Ireland early in the 5th century, for Pope Celestine I sent Palladius to be their bishop in 431. These early Christians made converts and built the first churches on land given to them by local rulers.

There are accounts of their adventures and the miraculous feats they performed in most local lore. Sometimes their challenges backfired and they had to flee for their lives. But these events are remembered across the country where Christian faith caused wells to spring up and the imprints of saints' knees or feet to appear in stone. These early converts understood the power of place in peoples' lives so it was natural for them to build churches on sacred sites, blessing the wells and carving symbols of the new religion on the old stones. And so, quite naturally, a new mythology of place began to overlay the old.

Patrick escaped a life of servitude in Ireland and went to Europe where he became a priest. By the time he returned to Ireland, there would already have been many converts to the new

faith with Palladius as their bishop. Small groups of Christians in rural Ireland had naturally evolved into autonomous communities - a monastic system. Patrick took as his mission the spread of Christianity across the country. He founded many churches, each time leaving them in the care of a trusted follower. His name is linked to churches everywhere and, while he probably did not found them all, his influence was certainly widespread.

Patrick also focused his attention on places of power. We see him challenging the High King at Tara when he lit the pascal fire at Slane. Across Ireland at that other great seat of power, he is said to have converted the King at Cashel with his illustration of the Trinity, using a shamrock. He was even said to have fasted against God for forty days and nights on Croagh Patrick in a clever mix of Celtic and Christian tradition which won him responsibility for the souls of the Irish at the Day of Judgement. In exchange, he tried to banish the pagan spirit of Ireland in the form of a great serpent. In this he was less successful. (It was an old Celtic tradition to petition for a change of heart from a more powerful opponent by fasting outside their dwelling till they relented. This accounts, in part, for the power of the hunger-strike in the modern Irish psyche.)

Many Christian concepts must have seemed quite familiar to a 5th century Irish population. At the centre was the Sun King, the Son of God, magician and leader of his tribe. Lugh was just such a figure, personification of the sun, perfect hero and saviour of his people.

The standing stone already had a magical function as a link between worlds. The famous Crom Dubh, covered with gold and silver, and smashed by Patrick as he challenged the old gods, was one of these. It is now in the Cavan County Museum in Ballyjamesduff. In early Christian stonework the Christ figure was represented with outstretched arms joining heaven and earth, bridging the great divide, also forming a link between worlds. He is smiling and relaxed, fully clothed and exhuding love and compassion. The 500 year evolution from this to the monumental stone crosses of the 12th century, with their emphasis on the crucifixion and suffering, illustrates the journey from Celtic to Medieval Christianity.

The Sacred Tree

The Sacred Tree was already familiar. In Celtic myth all trees have special virtues. The hazel by the sacred well at the centre of the world dropped berries into the water. To eat one of these was to gain the wisdom of the goddess. These berries had been eaten by the salmon, hence its spots and hence the **Salmon of Knowledge**.

As the berries dropped in the water, it bubbled. These bubbles were called 'na bolcca immaise' or the 'bubbles of mystic inspiration'. All wells were linked to this one at the centre of the world so that

the magic could happen, or the salmon appear at any of them.

Many stories from the lives of the early saints show a great reverence for trees, following the Celtic tradition. Such was **Colmcille's** respect for the oak trees of Derry that, rather than cut them down, he allowed the first church to be built without an east-west orientation.

There were five sacred trees in Ireland from prehistoric times, each with different virtues. Stories of the lives of Saints Molaise and Moling both tell of the fall of Eó Rossa, the yew tree of Ross in Carlow. The 12th century *Book of Leinster* contains a litany recounting the tree's virtues in metaphor. The saints treated the wood with great respect. Moling used a portion of it to roof his oratory.

The monastery at Lorrha founded by St Ruadhán in the 6th century became one of Munster's most famous monasteries on account of the Tree of St Ruadhán. It was reputed to give enough food to sustain all the monks at the monastery and visitors as well. Its fame continued into medieval times.

The Golden Age

While Europe was experiencing its Dark Age from 600 to 800 AD, it was a golden age in Ireland. Some saints founded hermitages in remote places, on islands in the far west. The monastery on Skellig Michael was founded around 600 AD on a cone of rock, 8 miles off the Kerry coast. Even today it is often inaccessible. The cluster of beehive huts is reached up slate steps 700 feet above sea level. It is a magnificent place, but only people driven by spirit would contemplate living there.

However, most of the early saints chose populated areas on fertile land beside roads and waterways. A typical monastery before 800 AD would have included a small wooden church with an enclosure of domestic buildings to the west. Stone remains from this period would be cross-inscribed pillar stones such as the Reask pillar in Kerry. The abbot or spiritual leader of this monastery might well have been the local chief who ruled over, and was responsible for, all within his domain. His sons would have succeeded him. Some were ordained, some not. Many were married. The chief was patron and the fortunes of the monastery would rise and fall with their chief. In many ways this left the monks free to pursue a spiritual life without having to be responsible for temporal matters.

It was a time of purity of vision, of art and learning. Students in Ireland were studying and preserving what was being lost in Europe. Manuscripts were written, initially in Latin, later in Irish, on spiritual and secular subjects: gospels, nature study, liturgy and legends. Irish monks went abroad as missionaries to places in Europe where Christianity had become weakened and corrupt. As monasteries grew in the **7th century**, the practice of illuminating

manuscripts spread. The 7th century *Book of Durrow* is a copy of St Jerome's *Vulgate* and illuminated in the La Tène style with curvilinear abstracts, tightly coiled spirals, and interlacing. Monks became skilled at metal-work and enamelling.

At this time Pope Gregory was concerned that the Irish church was out of step with Rome. The dating of Easter was a sore point. In 625 AD the Council of Nicaea had decreed that the date of Easter was to be standardised throughout the Christian world. The Celtic church was very reluctant to conform. Eventually the south of England, led by Canterbury, conformed. Ireland and the north of England only followed suit in 664 AD, after it was accepted at the **Council of Whitby**. This marked a triumph for conformity over individuality and a defeat for Celtic Christianity. Ever since then, Easter Day has been celebrated on the Sunday after the first full moon following the Spring Equinox.

In the absence of towns, the monasteries grew in importance and sometimes held the balance of secular power. They became centres of population, trade and politics, as well as learning, craftsmanship and religion. They began to accept gifts of money and land, and rivalry between powerful Celtic families drew them into conflicts. For the first time, a battle over land quarrels is reported in the *Annals*. By the **8th century** there was a slow decline in purity and strength of purpose.

The Céli Dé movement was formed to try to rekindle the spirit of the earlier monasteries. Important sites such as Armagh, Kells and Clonmacnois started building stone churches. This was also the time of the first purpose-built carved stone crosses.

An attempt was made to centralise power again at Armagh and this seems to have involved a revival of interest in the role of St Patrick and his connection with Armagh.

However, towards the end of the 8th century the **Viking raids** began and for the next 50 years their coastal raids overrode all other concerns. By the middle of the 9th century, they had established bases on inland lakes and had begun plundering the heartland. Here is a verse penned at the time:

> Bitter is the wind tonight
> As the sea's hair is tossed white,
> On a night like this I have no fear
> Of fierce sea roving warriors.

There were many atrocities but folk memory still shudders at Ota, whose husband Turgesius led a raid against Clonmacnois. She is said to have desecrated the high altar by using it for pagan oracles. In 867 AD the northern Ui Néill took on the Vikings with

the help of the Bachall Íosa (the Staff of Jesus) and a Relic of the Cross. All settlements north of Dublin were destroyed. Central and southern Ireland now took the brunt of the raiding, but at least the country as a whole was no longer in danger of being conquered. By 880 AD unrest at home in Norway created a lull in the raids.

The last hundred years had taken a heavy toll. The art of illuminating manuscripts did not survive and metalwork and enamelling also suffered a decline. Only stone carving continued to develop. The scriptural crosses were carved towards the end of the 9th and into the 10th centuries.

Another effect of the raids was the huge increase in Irish monks crossing to Europe, often with books and other valuables, to save themselves and their possessions from destruction. Unlike the 7th century missionaries, these monks did not set up their own religious houses, because Europe was in recovery now and had a new diocesan system. The Irish monks had to fit in and some were accused of heresy, but their learning, their manuscripts and their art contributed to the cultural life of Europe and they wrote on a wide range of subjects. By the second half of the 9th century, they were renowned across Europe.

Early in the **10th century** the Norse renewed their attacks. This time the Dál Cais in Clare took them on. The long bitter struggle that followed, lasting until the end of the century, created a folk hero out of one of the Dál Cais brothers, Brian. He went on to take Munster from the Eoghanacht and Tara from the Uí Néill, becoming High King. His full title was Brian Bóromha (pronounced Boru) and he had united the country for the first time in centuries. However, in his last battle, fought at Clontarf to curb Viking dominance in Dublin, he was killed minutes after victory. The year was **1014**.

There followed a time of unrest in Ireland with different families vying for control. Monasteries grew wealthier. Some were ruled by hereditary coarbs. These coarbs were traditionally descended from the original followers or servants of the founding saint. They were often lay, and corruption was rife. The Norse had mostly become Christian but they wanted their own bishops and institutions. By the end of the 11th century, there were calls for reform and the setting up of a diocesan system along European lines.

One of the leaders of this reform was the new Bishop of Armagh, **Malachy**.

Over time a new system was put in place with Armagh, Tuam, Cashel and Dublin as the four diocesan centres. It seems to have been a time of revitalisation as the effects of the reforms were finally felt: round towers were being built and high crosses carved. These new crosses showed newly important bishops carved in stone alongside images of Christ. There was a new interest in pilgrimage

and in relics, and fine metal shrines were produced to house them.

However, Malachy is remembered not for this, but for introducing the first Cistercian monks to Ireland. He had stayed with Bernard of Clairvaux while travelling to Rome and was so impressed that he left some of his monks there. In 1142 Malachy's monks returned home with some of Bernard's Cistercian monks and a French architect to build the first Cistercian abbey at Mellifont. By the time the huge building was consecrated in 1157 with an assembly of kings and bishops, a number of daughter abbeys had already been founded.

Mellifont was built in the new **Romanesque style** and other examples quickly followed. They had round-headed doorways, multiple arches and windows, all carved with designs from a variety of cultures: Celtic, Greek, Roman, Scandinavian and Oriental. Western Europe was being influenced by travel along the trade routes following the crusades. Art and architecture were particularly influenced. Oriental faces began to appear on Romanesque buildings.

Cormac's chapel at Cashel in Tipperary is our finest Romanesque building.

The medieval imagination is brought alive in the stone-carving of the Romanesque period when Sheela-na-Gigs, Mouth-pullers, Mouth-spewers and figures from the medieval bestiaries appeared, incorporated into ecclesiastic architecture.

The Cistercians were soon followed by the other European orders: the Augustinians, Dominicans and Franciscans. Monks flocked to join them, attracted by their strict rule and aesthetic idealism and especially by their freedom from local power and corruption. Celtic eclectic monasticism seemed to have run its course. Some of the old monasteries were absorbed by these new orders. Others became cathedrals ruled by bishops and some became parish churches. Some still flourish in towns and cities throughout the country. Others now lie deserted.

Around the same time as the consecration of Mellifont, Pope Adrian IV granted the overlordship of Ireland to Henry II of England, giving him freedom to send his Norman barons to Ireland. Thus began the **Norman occupation** which was to replace much of Irish tribal society with medieval feudalism. Their architectural legacy was the Norman castle, while their descendants dominated Leinster in the east and the rich lands of Munster in the south.

The move from Romanesque to **Gothic** was later in Ireland than in Europe. Boyle Abbey in Roscommon is a fine example of Transitional style, built in 1161, with both round-headed and blunt pointed arches.

By the late medieval period there were still some monasteries being built, now in the Gothic style. The Franciscan Kilconnell

Abbey, founded in 1400, is a fine example. There followed a period of medieval stone carving and figure sculpture in Ireland which peaked between about 1480 and 1560. The greatest of these carvings are in Kilkenny, with the best single collection at St Canice's Cathedral in Kilkenny city.

In England in 1534, Henry VIII made himself supreme head of the Church, thus removing the ultimate authority of the Pope over spiritual and doctrinal matters. This was soon extended to Ireland where Henry made himself head of the established Church of Ireland. The **Reformation** was sweeping across Europe at this time. There were demands for reform within the church and an end to corrupt practices and the misuse of wealth. Anti-clerical feeling was strong. This meant that, particularly in England, in spite of his opposition to these reformers, and his obvious personal motives, Henry found a certain support for his new role. Monasteries across England and Ireland were 'dissolved' and their wealth transferred to the English crown. The anti-clerical reform movement was not strong in Ireland, however, and the established Church of Ireland with Henry as its head, was really only accepted by those loyal to the English crown. In some places local landowners rented monastic buildings back from the king and the monks continued much as before.

The 16th and 17th centuries were turbulent times. In the middle of the 16th century, between 1563 and 1585, the powerful Norman Geraldine family rebelled against English rule. The rebellion failed and their lands were tranferred to new English Protestant settlers in 1586.

By the end of the century, the last of the Gaelic chiefs were crushed in Ulster. The Nine Years' War ended with their defeat at the Battle of Kinsale and their flight from Ireland in 1603. This was known as the 'Flight of the Earls'. Their land, and that of their followers, was granted to new Protestant, English and Scottish settlers which extended the English feudal system into the heart of Ulster. This resulted, particularly in Ulster, in a polarisation along religious and political lines that would mirror the new religious divide between Protestant and Catholic in 17th century Europe. Cromwellian excesses in the middle of the 17th century remain inprinted on the folk memory in Ireland.

Roman Catholicism remained the religion of the native Irish. It was suppressed until 1829. In spite of this, it has continued as the dominant religion in Ireland and after 1829, new churches were built and continue to be built up to the present time. The Anglican Church in Ireland, called the 'Church of Ireland', generally retained the old churches, many of which were built on early monastic sites which, in turn, were built on even more ancient sacred

sites. In areas where there were significant numbers of Scottish settlers, Presbyterian churches were built from the 17th century.

A small number of these churches are mentioned in this guide. There are hundreds more, far too many to mention here but many that are well worth visiting.

All places where people seek the Divine become sacred places.

GODDESSES, GODS AND
PILGRIMAGE IN IRELAND

THE GREAT CIRCULAR PASSAGE CAIRNS of our neolithic ancestors are the most tangible ancient symbols of spirituality in Ireland. They are a functioning representation of the cosmic force of regeneration in nature, a force which we have come to call 'the Goddess'. They can be seen as a perfect representation of the belly of the goddess into which the penetration of a beam of light generated such power, that it can still inspire us with awe six thousand years later. The midwinter alignment of Newgrange is now televised across the country and is gradually re-emerging in the national psyche, rather like Stonehenge in England.

The court cairns and dolmens of the neolithic period and the later stone circles and rows of the Bronze Age were also carefully oriented to the heavens and to earth energies which are only partly understood today.

The Celtic Festivals

According to tradition, around the year 500 BC, the poet of the Celts, Amhairghin, seduced the three goddesses of Ireland, Banba, Fodhla and Eriu, and the people of the goddess were forced to retreat into the earth, into their cairns, wells and streams. The place of the goddess was taken by the sun god Lugh and new Celtic festivals replaced the old rituals.

Although the Celts were a patriarchal society, the goddess did not disappear entirely, but she became fragmented into a trinity of roles: giver of life, nourisher and harbinger of death or transformation. These aspects are personified in the Celtic pantheon as maiden, mother and hag. The king was her consort and responsible for her well-being. When she was happy, she flourished and so did his kingdom.

Four of the major festivals of the Celtic calendar are still celebrated today, though the form may have altered to some extent. They are known as the fire festivals of Imbolc, Beltaine, Lughnasa and Samhain. Each festival marks a different point in the

cycle of the year and is celebrated in a different way.

The first festival of the Celtic year is **Imbolc**, the first day of February and considered to be the first day of spring. It was traditionally a celebration of the goddess as maiden and the beginning of the new cycle. This is now St Brigid's day and she has taken on the attributes of the goddess as maiden. The word 'Bríd' means 'maiden'. Her festival is associated with new light at the beginning of the spring. She is also associated with food and plenty and in particular dairying. There was a tradition of making a Breedhoge (Brigid doll) from a churn lid and going from house to house in costume on the eve of St Brigid, singing and collecting money.

She has, in fact, many of the attributes of the goddess Boand, who gives her name to the Boyne and is associated with the white cow whose milk is sprinkled across the heavens to form the Milky Way. Brigid's traditional birth-place is north of the Boyne valley in Drogheda, and her famous nunnery is to the south, in the town of Kildare. However, as a national saint, there are sites dedicated to her, especially wells, throughout the country. Her cross has a diamond centre, which symbol appears on the navel of fertility goddesses across Europe.

The second festival of the year is **Beltaine**, on the first of May. The name probably means 'the fires of Bal', and May Eve was a time for bonfires. It was also a time for protecting cattle and crops from the dangers of disease by driving them between two fires. For young people, jumping the May fire would offer the same protection.

At Knockainy in Limerick, men used to bring flaming bunches of hay or straw on poles to the summit of the hill. They would carry them sun-wise round the three barrows which they called 'the Hills of the Three Ancestors'. Then they would take them around the fields and pastures in the area to bring good luck to the animals and crops.

They believed they were emulating the fairies who also performed this rite under the direction of Áine, the sun goddess, as she impregnated the land with her solar energy, once the humans had gone. Sometimes people reported seeing her leading the human procession. Occasionally she was seen on the hill as the 'cailleach' or 'wise woman' and there are many stories of her taking human form. Those who treated her with kindness, prospered. In Ireland the goddess at Beltaine has become the Virgin Mary in the modern psyche and May altars are decorated with flowers in her honour. May parades continue today, perambulations of the locality to echo the fairy blessings.

The third festival is called **Lughnasa** on the first of August. It is associated with berry picking, with harvest time and celebrating the 'first fruits' of the season. It was a time of festivity, sport and play and would usually have involved a journey on foot to a hilltop, lake or riverside. It is dedicated to the god Lugh, the hero of the

ancient Tuatha Dé Danann and sun god of the Celts.

When Ireland became Christian, many of its most important places became associated with St Patrick. He replaced Lugh as a symbol of light, and around the country, most notably at Croagh Patrick, a pilgrimage in his honour has replaced some of the Lughnasa festivals. However, the date remains the same. It is traditionally 1st August, but festivals can be held from 15th July onwards. The pilgrimage up Croagh Patrick is on the last Sunday of July, now called 'Garland Sunday'. It has taken on a penitential character, though Lugh is still remembered as gaiety breaks through after the climb. The present Puck Fair at Killorglin in Kerry may be a more faithful celebration.

And finally we have **Samhain** or All Saints' Day, at the beginning of November. This is the dark festival which marks the end of the cycle, but it is the dark before the new beginning: a time of death but also of rebirth. It was considered the best time to get pregnant and at Crúachain in Roscommon, there is a tradition of the emergence of the New Year maiden from Maebh's cairn at this time. This is also the time when the spirits of the Otherworld pour out of Oweynagat or 'the Cave of the Cats' nearby. In modern times, it is best known as the time of the witch, the goddess as wise woman, symbol of death and transformation.

Of these four festivals Samhain has come to be most associated with the spirit world. This is because its dark aspect is most apparent. Yet all the festivals involved increased contact with the unseen world. The night before any festival is a particularly magical time. Halloween, the night before All Saints' Day, still has many popular customs. There is a tradition at many wells of a vigil throughout this night, and this also came to be the custom before some saints' days. This was a time when supernatural things could happen. At midsummer wells there was often a tradition of the water bubbling up. The well was then especially powerful. It was also a time when a magical eel or fish might be seen.

Fancy dress or disguise were used at these times to trick the spirits and keep them away while fire, music and dance, as well as alcohol, would spin people beyond normal consciousness. In this form, elements of these old practices are still with us, even though they are often performed unconsciously.

Christianity
Many of the old traditions continued as part of the **early Christian** practice of pilgrimage or pattern which is still alive in Ireland today.

Every parish in the country has its **patron saint**. At the very least, the local churches are dedicated to them. Often there are strong folklore traditions crediting them with all kinds of magical

feats, from creating features in the landscape to heroic rescues and miraculous cures. They were usually the founders of the first Christian church or monastery in the locality and therefore responsible for the spiritual well-being of the community. However, in keeping with Celtic tradition, they were also sometimes responsible for the prosperity and physical well-being of the place and those who lived there. St Ciarán of Clonmacnois had a cow that gave enough milk to feed the whole community and all the visitors as well. This was the Dun cow whose hide was later used to provide calf-skin for the famous 7th century manuscript, *The Book of the Dun Cow*. Its magic was still working into modern times, when the book was found again after centuries in the keeping of a farmer who was using it to cure sick animals by dipping it in their drinking water.

Often these saints were said to be of royal blood, choosing to found a monastery, rather than be a chieftain. They became the protector of the 'genius loci'. This 'spirit of place' or goddess, in the old tradition, would usually be associated with a fairy hill, or a well, in the locality. This would be the site of the saint's first church. In some cases, the descendants of those who had a close connection with the saint, still retain responsibility for making this protection available.

For example, Colmcille was born in Gartan in Donegal. Just before the birth, his mother, Eithne, is said to have been directed to a special birth stone by an angel. While she accompanied her kinsmen who were carrying the stone to her home, she sat down to rest by a stream and began to haemorrhage. At this spot today there is a fine clay which can only be lifted by the descendants of Eithne's kinsmen. It offers protection against drowning, burning and sudden death as well as the pains of childbirth and 'every kind of distemper' to anyone who carries it on their person. People take it all over the world and it is even pressed inside perspex key-rings so that people can have it with them at all times.

The landscape around Gartan has many features resulting from the saint's activities. One particularly potent place is Laknacoo or 'Leac na Cumha', meaning 'the flagstone of loneliness'. This stone is said to have been blessed by the saint and used as a cure for heartache and sorrow. He is supposed to have lain here before leaving Ireland and it has traditionally been visited by people before leaving the area, to lift the the pain of homesickness. The cure involves spending a night on the stone. The stone obviously has a much older history. It is a large slab with cup marks cut into its surface. These marks were probably made in the Bronze Age when the stone must have served a ceremonial function. Though that knowledge is lost, the stone's tradition of powerful magical properties continues.

Patterns & Pilgrimage

Colmcille was more than a local saint. He travelled widely and is associated with many places in Ireland and Scotland. **Patterns** are held in these places on St Colmcille's Day, 8th June, every year. The word 'pattern' comes from 'pátrún' or 'Patron Saint'. The dictionary meaning is a festival or gathering with music and dancing. It was only in medieval times that the idea of pilgrimage as hardship and penance was developed.

The church began granting indulgences for pilgrims who made particularly long or arduous trips. Such journeys became hugely popular: the waters of St Mullins in Carlow were black with pilgrims wading in the icy water against the current. And people started going abroad.

Santiago de Compostella was a major pilgrimage site for Western European Christians from the 11th to the 16th century, being by tradition the burial place of St James the Apostle. Many Irish pilgrims travelled to Bordeaux on the ships involved in the wine trade and from there joined the European pilgrims trekking on foot through the Pyrenees.

In Ireland local patterns continued and after the more serious intent of the early part of the day, the gaiety of the old Celtic festivals would break through. There would be music and dancing as well as games and competitions which sometimes degenerated into drunken fighting between groups from different localities.

In 1704 an Act of the Irish parliament forbade the practice of patterns with a penalty of a whipping or a ten shilling fine. The established church disapproved of the practice, both for its pagan associations and for the drunken revelry that followed the 'day out'. At a local level, parish priests would often ban their congregation from attending. Still they continued well into this century and a few have survived till today. Others have been revived, though often in the form of a mass, bringing them more under the control of the church.

Most pattern days involve a journey or 'turas': visiting in turn the various sacred places in the locality. These will usually be centred on an early church site or ruined oratory built, perhaps, on a fairy hill. There is usually a well beside it with a tradition for cures and maybe a fairy tree. There may also be a cairn or standing stone. Many of these stones were carved with crosses in early Christian times.

The old pattern sites are usually powerful places from much earlier times, as many of the early churches were built on sites held sacred by the Celts and those who went before. In this way the stories and traditions continue. These old stories tell how the gods and goddesses of the Tuatha Dé Danann retreated into the hills and cairns in Celtic times, and for many people they are still there. They are the fairies, smaller now, but no less powerful.

The **turas** is a circular journey, sometimes called 'the rounds'. It usually involves walking sun-wise or 'deiseal' around the different parts of a site a prescribed number of times and repeating certain prayers each time. There are places called stations, where people stop to pray and at some of the larger pilgrimage sites, these may be numbered to avoid confusion.

Some turas may involve bathing your feet, taking water from the well or touching or walking over certain stones. In Ballyvourney in Cork, pilgrims scratch the sign of the cross on stone slabs said to cover the saint's grave.

At other sites the prayer stones are turned sun-wise or clockwise for a blessing. If they are turned anti-clockwise, they act equally powerfully as cursing stones. There is a very potent example in Killinagh in Cavan, called St Brigid's Stone. It is a large rounded boulder with a flatish surface and two smaller ones. They all have round or ovoid stones sitting in bullauns or smooth cup-like depressions on their upper surfaces. The stones are turned sun-wise to extend a blessing and reversed to empower a curse. The tradition is that if the curse is unjust, then it will come back on the perpetrator. In some places these stones have been cemented down in recent times by local clerics or built into the fabric of church buildings, like the one in Killala cathedral in Mayo. Some of the cursing stones from Inishmurray, off the Galway coast, are in the National Museum, Dublin, but they are not on display.

Often wells have small cairns beside them, built to emulate the cairns or fairy hills of prehistory. There is a ritual involving taking a stone from the bottom and putting it on top - a kind of symbolic cairn-building. Sometimes these stones are white quartz, a tradition that certainly goes back to the megalithic builders.

At many wells around the country you will find a notice describing the traditional turas for that place. These may be followed by the whole community or by an individual visiting a particular well in time of sickness. Often wells, known to have special cures, have trees beside them, where people can tie a small piece of cloth to leave the illness behind. As the rag fades and disintegrates, so does the sickness. These are known as 'clooties'. Some trees are stuck with pins or coins to effect a cure and often people leave a token of themselves at the well, or a token of their illness. Modern inhalers and prescriptions are commonly left, and at Doon well in Donegal there are crutches pushed into the ground, strong testament to miraculous cures.

Province of
ULSTER

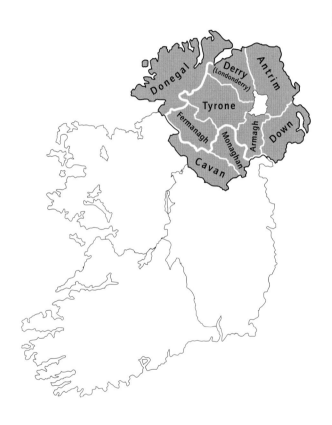

PROVINCE OF ULSTER

ULSTER IS THE NORTHERN PROVINCE. There are nine counties, three more than the political entity of Northern Ireland. To the north, east, and west, Ulster is bounded by the sea. Its southern border is less obvious. Here natural boundaries, like the Erne Lakes in Fermanagh, have been largely ignored and the border seems to weave at random through hills and lakes with little regard for these natural features.

The landscape from east to west could not be more different. The west coast of Donegal is pounded by the Atlantic Ocean and by the wild wet wind coming off the sea, while in the east the harbours are deep and gentle. In the north the Sperrin uplands are covered in blanket bog and in the south the land is dotted with small drumlin hills and lakes. Between these, the land is fertile and green.

In the middle we find the largest lake in the British Isles, Lough Neagh. Five of Ulster's eastern counties touch its shores. Its name, 'Loch nEachach', means 'the lake of the god Eochaid'. 'Eochaid' means 'horseman', and one version tells us that this lake was formed from the urine of a great horse on which the warrior-god Eochaid had abducted his father's wife. (*The Sacred Isle*)

The horse symbolism continues at the royal site of Emhain Macha in Armagh which is associated with the goddess Macha, the principle sovereignty goddess of Ulster. Epona was the great horse goddess of the European Celts and Macha can be seen as her Irish counterpart. In one of the stories of *the Ulster Cycle* (*A Collection of Stories from Iron Age Ulster*) she curses the men of Ulster because the king has forced her to race against his horses while she is pregnant. Her husband has seen her running across the hills, with her red hair streaming out behind her like a horse's mane, so he boasts about her to the king, saying she can run faster than his horses. She wins the race, but curses the men of Ulster as she falls to the ground and gives birth to twins. From then on, in times of danger, the Ulster warriors will experience the pains of a woman in labour and be overcome by weakness.

Provincial identities seem to appear with the development of the new Celtic culture and the beginning of the Iron Age. In Ulster this was the time of the linear earthworks, the Dorsey and the Black Pig's Dyke, which seem to separate Ulster from the other provinces. *The Ulster Cycle* depicts this as a great golden age with King Conchobhar as an Arthur figure at Emhain Macha, and his Red Branch Knights as the Knights of the Round Table. The fantastic exploits of the heroic Cúchulainn culminate in the great

epic, the *Táin Bó Cúailnge, The Cattle Raid of Cooley*.

This elevates to mythic proportions the great enmity between Connacht and Ulster. Ulster, weakened by Macha's curse, is saved by the young Cúchulainn.

This golden age came to an end by about the 5th century AD. The Uí Neill clan moved north and established their power base at the Grianán, in Donegal, and their kinsmen, the Three Collas, destroyed Emhain Macha and pushed the Ulaid, who were the people of Ulster, right to the east of the country. The Ulaid expanded east across the sea into the north of England and Scotland and their new kingdom, Dalriada, straddled the Sea of Moyle just as the Byzantine Empire surrounded the Mediterranean.

For centuries the two branches of the Uí Neill clan, with their common ancestor, Niall of the Nine Hostages, were to remain the most consistently powerful dynasty in Ireland. Between them they controlled the high kingship at Tara from the fifth until the 11th century.

For many centuries contact between Ulster and Scotland was easier than contact between Ulster and the rest of Ireland. This is reflected in mythology. In the story of Deirdre and the sons of Uisneach, (see WESTMEATH) Deirdre and her lover flee to Scotland to escape the vengeance of Conchobhar. In historical times Colmcille chooses, as his place of exile, the Scottish island of Iona. In their need for new territory, the Ulaid pushed the Picts up further into Scotland as far as Inverness. We hear of Colmcille travelling to Inverness to visit King Brude, the King of the Picts, to try and convert him to Christianity. The king of neighbouring Dalriada was Colmcille's cousin.

Around Ireland's coast different influences were being felt. While trade and ideas flowed to the south and west of the country from the Mediterranean, Leinster was raiding and trading with Wales and the west coast of England. In the north the people of Dalriada were converting the Picts of Scotland to Christianity and trying to hold onto their power base there.

Of all of Ireland, Ulster remained the least affected by the coming of the Normans in the 12th century. The Norman barons had been invited into Ireland by the deposed King of Leinster, Diarmuid Mac Murrough, and promised vast estates across the fertile lands of Leinster, in exchange for helping Diarmuid to regain his kingdom. (see **Ferns**, WEXFORD) Norman power and influence spread across much of Ireland though they were still, in theory, under the overlordship of Henry II. Worried by the increase in Norman power on his doorstep, Henry followed them to Ireland with his own army and established an English power base on the east coast.

PROVINCE OF Ulster

The heart of Ulster was little affected by all this, though the Anglo-Norman presence was strong in the eastern counties of Down and Antrim. During the centuries that followed the Gaelic chiefs in Ulster managed to stay just beyond the control of the English Crown. Elizabeth I changed that. By the time she died, the last of the Gaelic chiefs, Hugh O'Neill of the great Uí Neill clan, was only six days away from surrender.

The Plantation of Ulster followed. This was an attempt by the Protestant English Crown to control the last stronghold of Catholic opposition in Ireland by introducing Protestant settlers from England and Scotland into Ulster. Ironically, many of these Scottish settlers were undoubtedly descended from the Ulaid who had crossed into Scotland a millennium earlier.

This rather complex history goes a little way to explaining the current political situation in Ulster. When most of Ireland became independent in 1921, a majority in these planted areas wanted to remain part of Britain. A line was drawn around what is now Northern Ireland.

Ulster is also closely associated with two of Ireland's best loved saints, Patrick and Colmcille. Patrick was brought here as a slave from Britain, captured by an Irish raiding party. Colmcille was a prince of one of the most powerful clans in Ireland, the Uí Neill. Between them they changed the face of Irish spirituality. Patrick is said to have confronted the Corra, or serpent goddess, the symbol of pagan power, at Lough Derg in Donegal. She swallowed him, but after two days in her belly, he killed her and freed himself. This story is the basis of a pilgrimage which continues today.

Ulster is also a province of stone circles and dolmens, court cairns and holy mountains and some of the best and most powerful prehistoric figure-carving in the country.

ULSTER **Armagh**

County
ARMAGH
PRINCIPAL SITES

1 **Emhain Macha**

2 **Armagh City**

3 **Annaghmare** court cairn

4 **Ballykeel** dolmen

5 **Ballymacdermot** court cairn

6 **Clontygorra**

7 **Killevy** monastic church and well

8 **Kilnasaggart** pillar stone and monastic site

9 **Slieve Gullion**

10 **Tynan Cross**

Block figures in list refer to site locations in map and entries in text.

ARMAGH

ARMAGH IS A COUNTY OF GENTLE HILLS in the heart of Ulster. Its southern border just reaches Carlingford Lough in the east, an area rich in early prehistoric culture. Just west of the lough is Armagh's highest mountain, Slieve Gullion, an ancient craggy volcanic plug encircled by twelve small granite hills, the fall-out from its last eruption 60 million years ago. Its passage cairn, which is known locally as 'the Cailleach Birra's House', looks south and west over forty miles as the crow flies to that other hill dedicated to the Cailleach, or Wise Woman, Sliabh na Caillí, in Meath.

The great mound of Emhain Macha, the royal site of Iron Age Ulster, is in the north of the county. It is one of the few places named in Ptolemy's early map of Ireland from the second century AD. He calls it 'Isamnion', which is generally agreed to mean 'Emhain'. The other Ulster site mentioned by Ptolemy is 'Regia', which seems to correspond geographically to Clogher in Tyrone. He apparently used a map of the world which had been drawn a hundred years earlier by Marinos of Tyre, as well as information from what was then the greatest library of the ancient world, the library at Alexandria. This serves to remind us of the links that existed across the ancient world so that when archaeologists come upon, for example, the skull of a barbary ape, at the site of the royal palace of Emhain Macha, we should not be too surprised.

The goddess here is Macha. In one of her stories she is a fairy woman, forced to race against the king's horses. In this story she takes the role of the sun goddess running with the horses across the heavens to take the world from night to day and back to night again. The story ends with her curse. (see below)

Right in the south of the county is a large enclosure, called 'the Dorsey'. It is 6 miles south of Newtownhamilton. It appears to be a huge elongated enclosure running for about a mile from east to west. When it was dated, using tree ring dating from oak used in its construction, the north side dated to 150 BC and the south side to 95 BC. Perhaps these are more Iron Age defences and the two banks represent destruction and rebuilding further south.

In keeping with this theory, the best preserved bits of the Dorsey are on the south rampart one mile north west of Silverbridge, and west of Drummill Bridge on the Dorsey river. The ramparts here are over 20 feet high. Emhain Macha is 17 miles north north west of here. Perhaps this forms the southern limit of her territory.

1 Emhain Macha

On the summit of a low hill just over a mile west of Armagh City.
Signed on the A28.

Emhain Macha first appears as a gentle rounded hill encircled
by a bank of mature trees. This bank encloses an area of about
18 acres and just inside it a deep ditch falls away before the ground
rises again towards the summit of the hill.

The hill was for many years considered to be a fort. However,
in recent years it has been realised that defensive sites such as forts
have a ditch on the outside of the bank, not on the inside. A ditch
on the inside would in fact make defence more difficult and
therefore it must serve a different purpose. There is no clear
answer as to why internal ditches were dug, but they are a feature
of most ritual or sacred sites.

At the top of the hill is a large mound about 18 feet high and
150 feet across. To the south east is a smaller circle, an almost
flattened ring from the late Bronze, or early Iron Age. From the
top of the mound you can see for miles. To the east the pinnacles
of Armagh City's two cathedrals are visible.

The Mythology

The goddess Macha was sovereign here. She has three aspects and
three stories. In the first story she was the wife of Nemhedh who
arrived in Ireland with her, their four sons and their wives, and a
small band of followers. Nemhedh set about preparing the land.
He formed four lakes and twelve plains, but Macha saw in a vision
the terrible suffering that would come about as a result of the Táin
Bó Cúailnge (see LOUTH) and died of a broken heart.

The next Macha was the only daughter of one of the kings of
Ulster. He had two brothers and they ruled each in turn for seven
years. When her father died, Macha insisted that his sovereignty
fell to her. Her uncles, Dihorba and Cimbaeth, disagreed, saying
that she could not rule because she was a woman. So she challenged
them to fight her for it. Dihorba was killed and Cimbaeth
displaced, so Macha ruled for the next seven years. All agreed that
she ruled wisely and well and eventually she took Cimbaeth in
marriage. She sought out Dihorba's sons and tricked them into
following her one by one into the woods where she tied them up
and brought them to the site of Emhain Macha. She kept them in
bondage until they had built her royal palace.

The third Macha appeared in the house of Crunnchu, a
wealthy nobleman of Ulster who was widowed. She lived with him
doing all that a wife should. Crunnchu could not believe his good
fortune but he could see that she was not like other women.

Each night before she got into bed, she made a right-hand turn to ensure good fortune. Sometimes she would lift her heels and run through the hills, her red hair flying behind her. She seemed to run faster than the wind.

She soon became pregnant. Some time later, Crunnchu was preparing to go to the great assembly. She warned him not to speak of her there, but when he saw the king's horses racing and heard them being praised, he could not stop himself boasting that his wife could run even faster. The king was angry and threatened to cut off Crunnchu's head if he did not produce his wife and have her race the horses. Macha was angry and begged the king to wait as it was near the time for her baby to be born. The king would not listen and so she raced. She finished before them but fell down, immediately uttering a great cry as she gave birth to her twins. (Emhain Mhacha means 'the twins of Macha')

But the race had exhausted her and, full of anger, she cursed the men of Ulster and died. The curse was this: for nine generations in times of great danger the men of Ulster would become as weak as a woman in labour. It was because of this curse that when Maebh attacked Ulster in the *Táin Bó Cúailnge*, only Cúchulainn was able to stand against her army. These three Machas form a triple goddess: visionary, warrior, and mother.

The Ulster Cycle is a group of sagas and romantic tales from Iron Age Ulster. They date from the 12th to the 15th century, though some of these are transcribed from originals dating back as far as the 8th century. According to this tradition, Emhain Macha's most powerful ruler was King Conchobhar Mac Nessa.

Conchobhar became king through the machinations of his mother, Nessa. She conceived him with the Druid Cathbad at an astrologically auspicious moment and when he was a boy, she made a pact with the king that she would marry him only if he allowed her son to become king for a year. The king agreed but of course Conchobhar did not stand down at the end of the year. He had ruled well and his people did not want the old king back, as he had given up his kingdom so lightly.

Like Fionn mac Cumhaill, Conchobhar was surrounded by a special band of warriors of mythical abilities. Fionn had the Fianna, Conchobhar had the powerful Red Branch Knights and their most famous member, Cúchulainn. Ulster's traditional enemy was Connacht which was ruled by the powerful Queen Maebh and her husband Ailill. The *Táin Bó Cúailnge* is a kind of allegory of their enmity. It ends with the destruction of Ulster's greatest hero, Cúchulainn.

Cúchulainn was Conchobhar's nephew. His mother was Conchobhar's sister, Deichtine, and his father was the mythical sun

god, Lugh. Because he was born in Leinster and because he was part god, he was not subjected to Macha's curse on the men of Ulster. His name was originally Setanta and, at the age of seven, he came to live with Conchobhar as his foster-son. One evening when Conchobhar and his men were preparing to attend a feast at the house of the king's blacksmith, Culann, Setanta was finishing a game and promised to follow soon, but night was falling by the time he set out on the long journey to Slieve Gullion where Culann lived. Meanwhile, the feasting had begun and Culann told his servants to close up the fort. The servants let loose Culann's best guard dog. He was unsurpassed in strength and in the dark night he was silent and his eyes glowed like coals.

When Setanta arrived, all was dark and the gate shut. Unaware of the danger inside, he climbed over the wall. Culann's hound sprung out of the darkness and in the struggle which followed, the hound was killed. By the time the revellers rushed out, the dog was dead. Conchobhar was relieved to see his foster-son safe but Culann was angry about the loss of his best hound. Setanta offered to guard Culann's fort until another dog could be trained to take his place. That is how he got the name Cúchulainn, which means 'the hound of Culann'.

Conchobhar's fate parallels that of Fionn in that both are rejected by a young woman to whom they consider themselves to be betrothed. Fionn is rejected by Gráinne, Conchobhar is rejected by Deirdre. (see WESTMEATH) The treacherous nature of Conchobhar's revenge sets the people of Ulster against each other and the prosperity and harmony of his kingdom are lost. His close friend Fergus goes into exile in Connacht with 2000 Ulstermen. And when they meet again on the battlefield at the end of the Táin, Fergus almost kills Conchobhar.

Conchobhar, however, did not die then. He was wounded when he was hit by a ball which was made from the calcified brain of the King of Leinster. This ball lodged in his brain and, on the advice of his surgeon, the wound was sewn up with the brain ball inside. The wound only proved fatal when Conchobhar was in shock after hearing of the death of Christ. The ball shook loose and he died. The year was 33 AD.

The Archaeology

The site was excavated between 1963 and 1971. While there was some evidence of a mesolithic and neolithic presence on the hill, it is only really around 300 BC that there is much sign of activity on the site. A round house was built and later rebuilt on the site of the low earthwork to the south east of the mound.

Where the mound now stands a sequence of houses were built and rebuilt many times over several hundred years. This may have

been the great palace of Macha and Conchobhar. One of the most interesting finds from these buildings was the skull of a Barbary ape (now in the British Museum). It has been suggested that there were North African mercenaries fighting in Conchobhar's army. Who knows? What happened next is even stranger.

The buildings were cleared away around 94 BC and a great wooden structure 125 feet across was erected. It was made of five concentric rings of wooden posts evenly spaced throughout the whole area, with a passage leading from the east into the middle. A large post of oak was then erected at the centre. This must have been something like an artificial forest with a great totem pole in the middle. It is not clear how long this 'temple' remained, or even whether it was roofed, but sometime in the first century BC, while the posts were still standing, the structure was filled with limestone cobbles and set alight. The upper parts of the posts were burned away and afterwards the cobbles were covered over with earth, forming the mound as it is today.

Later excavations in 1998 on the north west side of the ditch encircling the hill, uncovered a large oak timber dated to around 95 BC. This means that the ditch was not dug until the time of the huge 'temple' - the oak timber may even have come from the 'temple' building.

This is a very dramatic story and yet there are similarities with earlier rituals. We know that neolithic people filled in the courts of their court cairns with stones blocking the entrance before covering them over. We also know that door slabs were placed across the entrances of passage cairns. The burning of a ritual site is different, but not so different from other ritual burnings. The most recent example of this might be the traveller tradition of burning the caravan of someone who has died.

North east of Emhain Macha, on the other side of the quarry, lies a small natural lake called Loughnashade. Its name means 'Lake of the Treasures'. In 1798 workmen found four bronze ceremonial horns in the lake, probably a Bronze Age ceremonial offering. Three have been lost but one survives in the National Museum, Dublin. It is just over 6 feet long and curved, made of sheets of bronze riveted together. Its mouth is a finely ornamented disc.

About half a mile west of Emhain Macha there is a hill-fort called Haughey's Fort (Dún Eochaidh). There is little to see on the ground here, but interestingly, to the north east of this site at the same distance and in the same direction as Loughnashade is to Emhain Macha, an artificial pool was dug where ritual deposits were also made. Pottery and worked bone were found here as well as red deer antlers. The facial, or front part of a human skull was also found.

The History

It seems that Emhain Macha remained a royal palace for another 300 years. The annals tell us that around 331 AD the Ulaid, the people of Ulster, were pushed eastwards away from their seat of power by the Three Collas. These were three brothers, 'colla' meaning 'a chief or leader'. They burned the royal palace of Emhain Macha and established the new kingdom of Airgialla or Oriel.

Although its temporal power had gone, Emhain Macha remained an important place in the psyche of its people. In the Middle Ages it was a regular place of fairs and assembly. The High King, by law, expected to be received and feasted here when he made his circuit of the country. A 12th century text tells how an Ulsterman who did not visit the mound at Samhain Eve, would be sure to go mad and die.

2 Armagh city

The twin hills and two cathedrals seem to echo the story of the twins of Macha. The Church of Ireland Cathedral is square and medieval with the old town spiralling out from it. The Catholic Cathedral with its twin spires is a celebration of 19th century Gothic. Both are dedicated to St Patrick. The Book of Armagh tells how he established the first church there.

The Book of Armagh

Written in the 9th century, *The Book of Armagh* contains accounts of St Patrick's life, a copy of St Patrick's own *Confessio*, as well as a complete New Testament. It was written by the monk, Ferdomnach, who died in 846. The abbot of the time, from 807-808 AD, was Torbach. A number of other books have been ascribed to the scriptoria of Armagh around this period. Both Ferdomnach and Torbach are commemorated in stained glass in the present Church of Ireland Cathedral.

According to this book, St Patrick asked the local chieftain for a site on which to build his church. The chieftain, Dáire, refused Patrick the site he wanted, but gave him instead the place now called 'St Patrick's Fold' or 'Ferta Martyrum', in the present Scotch Street. A circular enclosure was excavated here and thought to date to this time. Some time later Dáire gave Patrick the site he had wanted. According to this 9th century manuscript, it happened like this:

Patrick and his followers had established themselves at Ferta Martyrum when one of Dáire's servants left a horse there to graze. This intrusion angered Patrick and he had the horse killed. Of

course, Dáire was furious and sent two of his servants to kill Patrick but, after he had given the order, he fell down ill. His wife, realising that the order must be stopped, sent for the servants and also to Patrick to save her husband. Patrick gave her messengers some holy water, telling them to sprinkle it on the horse as well as Dáire. The horse came back to life and they took it home.

When Dáire was similarly revived, he went to thank Patrick and took with him a marvellous cauldron which was three times bigger than any other. Patrick thanked him simply and Dáire left. However, he was upset that Patrick had not shown more enthusiasm for his gift and so he went and took it back. As he took it, Patrick merely thanked him in the same simple fashion. A short while later, Dáire took the cauldron back and gave it to him, as well as the land called Drumsaillech, or the Hill of Sallows.

When they went to the site to inspect Dáire's gift, a doe with its fawn were lying on the hillside. His followers wanted to kill it but Patrick took the fawn on his shoulders and carried it to another hill to the north.

St Patrick's *Confessio*

From reading Patrick's own writings, it would seem that he was actually something of a rebel. His *Confessio* is a plea for understanding in the face of criticism by the Church of the time and is a breath of fresh air compared to the propaganda written about his life by other writers. He is defending his actions in taking Christianity to the heathen, saying that he was following direct guidance from God. He was being criticised for his unauthorised missionary work, his neglect of his Christian flock, and his motives were being questioned. His critics were accusing him of being motivated by personal gain.

This is a very different Patrick than the one written about between the 7th and 9th centuries. By this time his life and affiliations with particular churches had become a propaganda tool as the church struggled to become more centralised. The balance of secular power had shifted in the north and Armagh was struggling to become the spiritual head of the Christian Church in Ireland. Patrick was promoted as the centre figure of an increasingly centralised Roman Irish Christianity.

Much later, in 1142, St Malachy was made Bishop of Armagh. He was one of the principle 12th century reformers of the Church in Ireland. He helped introduce the European episcopal and parochial system into Ireland, to bring it more in line with Rome. He also introduced the first of the European monastic orders to Ireland. He brought the Cistercians to Mellifont in Louth.

The Church of Ireland Cathedral

On a hill in the centre of the city.

This is the Hill of Sallows. The first Great Church was probably built in 458 AD and was on the site of the present medieval cathedral. The first stone church is mentioned in Armagh in 788.

The settlement of Armagh was raided many times by Vikings. Towards the end of the 9th century, the northern branch of the Uí Néill pushed them out of the northern half of the country. Their final defeat came at the Battle of Clontarf when the High King, Brian Boru, defeated the Vikings of Dublin and their allies. Unfortunately, he was fatally wounded. His body was brought north for burial here at Armagh. He is buried on the north side of the current cathedral with a plaque on the wall noting the spot. 'Near this spot on the north side of the great church was laid the body of **BRIAN BOROIMHE** slain at Clontarf AD MXIV'.

The core of the building dates back to the 13th century, though the outside has been coated with a 19th century sandstone plaster. Apparently, Thackery is said to have remarked, "It is as neat and trim as a lady's dressing room".

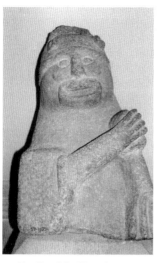

Nuadha of the Silver Arm, also known as the Tandragee Idol, Armagh cathedral

Inside the west doorway are some fragments of a tall 10th century high cross. It is sandstone and carved with scriptural scenes. The east side from the bottom shows Adam and Eve, Noah's Ark, and the Sacrifice of Isaac. The west face has Angels appearing to the Shepherds, the Adoration of the Magi, and the Baptism of Christ. The head of the cross has the Crucifixion and Christ in Glory.

If you stand at the back of the nave, you will notice that the central aisle does not run straight up to the altar. It tilts at the chancel. This was a medieval building practice in deference to the tilt of Christ's head on the cross. High up on the inside of the walls are carved medieval heads, both human and animal.

Against the south wall of the nave there is a stone carving, thought to be Iron Age, of a helmeted figure with his right arm clutching his left one. Called 'the Tandragee Idol', it is probably a

carving of Nuadha, king of the Tuatha Dé Danann, who lost his arm in the first battle of Magh Tuiredh when they fought the Fir Bolg for the kingship of Ireland. They won but Nuadha lost an arm. He was then physically imperfect and could no longer be king. His physician, Dian Cécht, made him a silver arm and he became known as 'Nuadha of the Silver Arm'.

A figure from Boblingen in Germany has the right arm clutching the left arm, as if illustrating the same figure, though the style is very different.

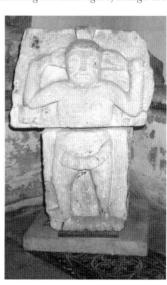

The chapter house in the cathedral houses a number of other interesting carvings, probably also from this period. One is a human figure in two parts with what appear to be huge ears. This is possibly Labhraidh Loingseach who was the King Midas of the Celtic world. He hid his ears, big like those of an ass, inside a turban and had his barbers put to death so that no one would talk about his ears. Eventually he took pity on a mother's only son and let him live. The young barber relieved himself of the secret

Labhraidh Loingseach carving,
Armagh Cathedral

by whispering it in the woods. Unfortunately, a tree was cut down in the woods to make a new harp for the King's court and it knew his secret. As soon as it was played, it sang out, "Labhraidh Loingseach has the ears of an ass".

The Robinson Library

On the corner of Abbey Street, just down from the cathedral on the left.

This building housed the first public library outside Dublin. It was founded by Archbishop Robinson in 1771 and includes many books donated by him. There are over 25000 books and manuscripts, from ancient and valuable first editions to current titles. There is even an ogham stone in the hallway on the ground floor. The Greek inscription below the pediment on the front of the building translates as, 'The Healing Place of the Soul'. (Phone: 028 375 2314)

ULSTER Armagh

St Patrick's Roman Catholic Cathedral
Its twin spires are visible from all points.

The building of this cathedral was begun in 1840. Work stopped during the famine and it was finally consecrated in 1873. Its style is Gothic Revival. Two tall slender spires rise from the front of the building which is accessed up wide flights of steps.

Inside, the pale blue ceiling depicts many Irish saints in the company of a multitude of angels. Everywhere are colourful mosaics and carvings, giving an overall effect of lightness and celebration. In the Lady Chapel the ceremonial hats of former cardinals dangle from the roof.

3 Annaghmare Court Cairn
Take the B135 north from Crossmaglen. Just under a mile turn left onto Annaghmare Road. Signed after a mile. The site is down a long tarred lane to the right.

This monument is known locally as 'the Black Castle'. It was excavated in 1963/4. Its entrance faces south and it has a long wedge-shaped cairn tapering to the north. The gallery is 23 feet long and separated by jambs into three chambers. The court is deep and asymmetrical. The spaces between the outer kerbstones are filled with dry-stone walling, the orthostats and walling alternating right around the court. Two more chambers, sitting back to back, open onto the sides of the cairn which appear to have been extended an extra 12 feet to accommodate them. Both were looted before the excavation. The court had been blocked to a height of two feet with only a small access path to the left. Later the whole court was filled with cairn stones and closed.

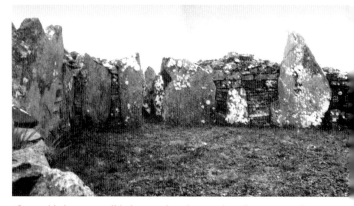

Court with dry-stone wall in between the orthostats, Annaghmare court cairn

Cremated bones of at least two individuals, parts of two inhumations, animal teeth including bear's, and flint tools and pottery were found in the chambers. The pottery was late neolithic, both plain and patterned.

This cairn sits in an unusually sheltered location and this, and the fact that the stones were in the cairn until excavation, means that there is very little wear on the surface of the stones. This gives it a strangely fresh feel, even though it is about 5000 years old.

4 Ballykeel Dolmen

Take the B134 north of Forkhill. Ignore the first sign to the monument. The second sign about a mile later brings you straight to it. It is about a mile north of Mullaghbane and 6 miles south west of Newry off the B30.

This beautiful dolmen is unusual in that its surrounding cairn is still present. The cairn is huge, 90 feet long and about 30 feet wide. The dolmen sits at the south end and faces south. The portals are tall, about 7 feet high, and support a large cap-stone. The endstone had fallen but has been replaced, and the huge granite slab sits poised on the tips of these three stones. The balance is breathtaking. Like Annaghmare, the stones look barely worn and the edges are quite sharp. Maybe it is the hardness of the granite, though this monument is also in a fairly sheltered location. There is a good example of a door slab, also restored to its original place.

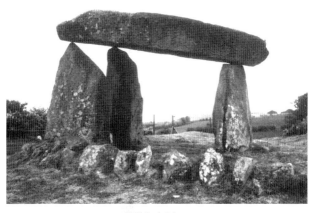

Ballykeel dolmen

The site was excavated in 1963 and a variety of early neolithic pottery was found, plain and decorated. A cist burial was also found at the north end of the cairn.

5 Ballymacdermot Court Cairn
2 miles south south west of Newry, it is signed west of the A1.

This is a magical place. The cairn is 600 feet up the southern slope of Ballymacdermot Mountain, with the Mourne Mountains in the east, Slieve Gullion in the west, and the meandering waters of Dundalk Harbour and Carlingford Lough ahead.

A long cairn survives with the court entrance in the north facing uphill. The thin soil on the site contained charcoal, indicating that the area had been cleared by fire before the monument was built. Presumably this hillside was once covered with forest.

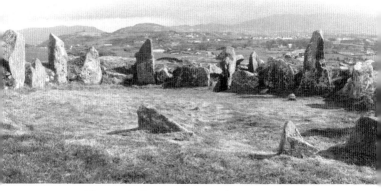

The court, Ballymacdermot court cairn, looking south to the Mourne mountains.

The court is almost circular and a little asymmetrical. Small hollows were found here with bits of flat-bottomed pottery. Some of the largest orthostats are placed near the entrance to the court, rather than more usually, at the entrance to the chamber.

Inside are three substantial chambers with portals and door slabs between. The roofing has almost gone but some of the corbelling can still be seen on one side. When the site was excavated, the first and second chambers were empty, but in the third chamber cremated bones and pottery sherds were found.

6 Clontygorra Court Cairn
4 miles south of Newry in the very south east of the county. Turn left just as the railway line crosses the road. Go past 2 crossroads and fork left after about a mile. Roughly a mile later at the next crossroads, turn left and the cairn is signed on the right.

Its local name is 'the King's Ring'. This may refer to a now lost ring of kerbstones, or it may describe the unusually deep court

which nearly forms a full circle. When the site was excavated in 1937, the court was found to be roughly paved with some sherds of neolithic pottery on it.

Some of the orthostats are really huge. The portals at the entrance to the first chamber are about 5 feet high with 9 foot portals guarding the entrance - still awe-inspiring after thousands of years. The first chamber has a large cap-stone supported by stone corbels. Some of these are still in place though the lintel has slipped. Some plain neolithic pot sherds, hollow scrapers, a polished axe, some charcoal and the cremated remains of one person were found in this chamber, as well as evidence of a later Bronze Age burial.

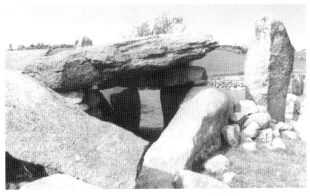

Looking into the gallery and out through the portals, Clontygorra court cairn. The tall orthostat on the right is part of the court

The other chambers were badly destroyed but also contained pottery, cremated bones and three leaf-shaped arrowheads. The huge stones that once formed the chambers look oddly naked on the grass. This is a very powerful place.

200 yards to the south, in a clump of fairy thorns, is another, smaller court cairn. One chamber remains of a two-chambered gallery. Cremated bones, neolithic pottery and a lozenge-shaped arrowhead were found in this chamber. It is on private land behind a house.

7 Killevy Monastic Site

4 miles south west of Newry under the eastern slope of Slieve Gullion. It is by the roadside between Meigh and Camlough.

This is the site of an early convent founded by St Modwena. In spite of repeated raiding by the Vikings from Carlingford Lough, it survived until the 12th century. There was once a round tower here, but that has disappeared. On the site there are two

small ruined churches. The smaller one has a lovely trabeate west doorway with huge well-fitted stone blocks as jambs.

Up a lane by the side of the church is a holy well, also dedicated to St Modwena. This is a gentle place on sloping hillside surrounded with gorse and thorn bushes, the grass dotted with spring flowers. The slope is gentle but high enough up to give a feeling of being 'above' the everyday world. The area is beautifully kept with a small, freshly whitewashed altar.

St Modwena is portrayed as a pure spirited and generous young woman who talked with angels and followed a life of strict chastity and poverty. There are many stories about her, some of them rather bland moral tales, yet her light spirit seems to shine through. She spent time with Patrick who was very taken with her clear purpose, and she also spent time with St Brigid whose gift of a silver dish to Modwena, when they parted, is recorded in the annals. Modwena, apparently, did not feel comfortable accepting

St Modwena's well, Killevy

such a dish and hid it. Of course, it was later found by Brigid who could not give it away again and so threw it in the river. Eventually the water brought it to Modwena again. She was also a practical person and not above turning water into wine or beer, should the need arise. A poor man who gave her his last food and drink, was rewarded with a beer barrel that never ran dry.

When she was dying, followers pleaded with her to stay with them longer, but she said that SS Peter and Paul had come and were waiting for her, so she had to go. However, she left them her rake and spade and her badger skin garment - all of which she said would protect them against anyone who came to harm them.

Without the prefix Mo, her name was Edana. Skene (*Celtic Scotland*) identifies the name Edinburgh with Edana, saying it was Edana's sanctuary and place of pilgrimage long before King Edwin is supposed to have built a fort there.

8 Kilnasaggart Pillar Stone and Monastic Site

About a mile south of Jonesboro near the Kilnasaggart railway bridge.

Kilnasaggart means 'the church of the priest'.

This slim 7 foot granite pillar has no less than thirteen crosses inscribed on it. Some are encircled, some have spiralled or wedged terminals. On one side the inscription in Irish reads: 'this place did Ternóc son of Ciaran the Little bequeath under the protection of Peter the Apostle'. Ternóc's death is recorded in 714 or 716, so this dates the stone to around 700 AD and makes it one of the only dateable early Christian monuments in Ireland. There are two crosses, one above and one below the inscription. The others are all on the other side.

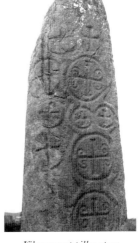

Kilnasaggart pillar stone

The stone stands at the north end of an enclosed area some 50 feet in diameter. The enclosure is not old but serves to protect the site. The pillar stands at the edge of an old graveyard. Before excavation in the 1960s, it was said that the graves were placed radially in two concentric circles. This was found to be untrue, but many graves were uncovered, some in long stone cists and some in earth graves.

Some of the smaller stones lying in the enclosure have cross inscriptions on them and were probably originally grave slabs.

9 Slieve Gullion

5 miles south west of Newry. Take the A1 south of the town and branch off to the right onto the B113 signed Meigh. Follow signs to the Slieve Gullion Forest Park. A road which circles the mountain about halfway up is signed 'Scenic Drive'. Access to the south cairn is easiest from this road. The climb to the top is about a mile. There is a rough path with red and white markers.

This is Armagh's highest mountain, 1894 feet high, and sits to one side of the Gap of the North. Slieve Gullion itself is a steep volcanic mass surrounded by a rocky ridge about 8 miles across, known as 'the Ring of Gullion'. This ring marks the edge of a massive explosion some 60 million years ago. From the top of Slieve Gullion this 'ring'

can be seen as a circle of twelve small granite hills.

The south cairn is a passage cairn dating to about 3000 BC and called locally 'Cailleach Birra's house'. The Cailleach is an aspect of the triple goddess - the wise woman or hag. Stories describe her as an old woman who lives under or inside the cairn.

One local story tells how the leader of the Fianna, Fionn mac Cumhaill, was enticed into her house and taken deep into the earth. When he emerged, he was an old man and it took a long time for him to return to his former strength.

Within each aspect of the goddess lie the other two aspects and many stories tell of changes from one to another. Sometimes the goddess appears as an old woman and when she is accepted by a human lover, she changes into a beautiful young woman. There are elements of the union of the mortal king and the sovereign goddess in this story, but the outcome reflects the uneasy relationship between Fionn and his warriors and the older goddesses across whose lands they hunted and played.

Just as the young maiden is symbolised by the 'first fruits', the Cailleach is symbolised in harvest rituals by the last handful of oats. These were traditionally left growing in the ground and plaited before being cut. This plait was given to the woman of the house and it was hung above the table at the harvest supper.

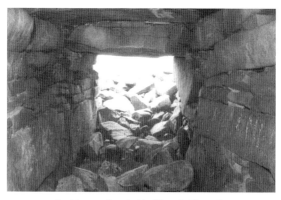

Looking out from inside Slieve Gullion cairn

The south cairn is one of the largest passage cairns in Ulster and in the highest place. It is now a massive stone pile, over 80 feet in diameter, originally about 20 feet tall and with a 15 foot passage. This passage has dry-stone walls and is roofed with lintels. The entrance is clear and faces south towards Sliabh na Cailleach or Cailí at Loughcrew in Meath. It is easy to crawl inside and possible to stand up in the 10 foot tall corbelled chamber. The chamber is octagonal with a recess opposite the entrance.

The cairn had been robbed before excavation but cremated

bone, some stone basins and a flint arrowhead were found.

The north cairn, some 140 feet lower down, was found to contain two stone cists. Pottery from this cairn was dated to the early Bronze Age, around 2000 BC. The new metal technology was spreading across the country but the weather had not yet deteriorated. By about 1000 BC the weather was colder and wetter. While neolithic cairns often crowned the highest hills, the cist and wedge cairns of the Bronze Age are usually found on lower ground.

10 Tynan Cross

About 7 miles west of Armagh, the village of Tynan is signed on the left off the A28. The cross is in the village, almost opposite the entrance to the church.

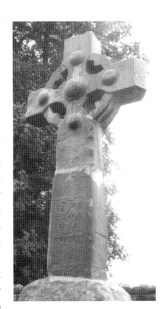

Tynan cross

The church sits on raised ground in the centre of this small village on or near the site of an early Christian foundation dedicated to St Vindic. His saint's day is 29th August. By 1306 it was a parish church.

The cross is almost all that is left of the original monastery and is actually parts of two different crosses. The east face shows *Adam and Eve* and there is an unidentified figure on the west face. A cross base and another fragment have been built

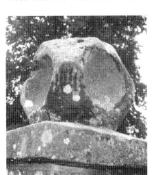

Medieval sundial, Tynan

into the nearby churchyard wall. Another cross, similar to the Tynan cross, was re-erected on private property in the nearby Abbey demesne where there are also two other crosses taken from the Glenarb monastic site, near Caledon.

On top of the church gatepost sits a 17th century dice-shaped sundial, similar to one in Monaghan town.

County
M O N A G H A N
P R I N C I P A L S I T E S

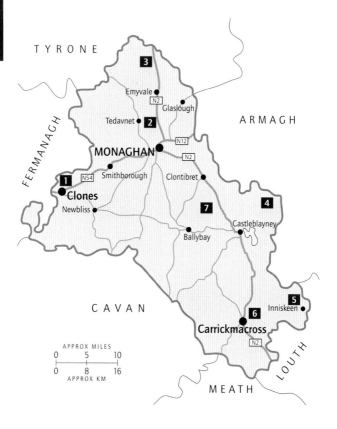

1 **Clones**
2 **Tedavnet**
3 **Errigal** old church
4 **Mullyash Hill**
5 **Inniskeen**
6 **Carrickmacross** St Joseph's Church
7 **Lennan** dolmen
 Corlealackagh giant's grave

Block figures in list refer to site locations in map and entries in text.

MONAGHAN

MONAGHAN IS RIGHT IN THE HEART of the Drumlin Belt but with fewer lakes and rivers than its neighbours, Cavan and Fermanagh, where water has provided a fluid communication network. Nevertheless, a small ribbon of lakes in the south east of the county links the east coast in Louth, through Castleblaney and Monaghan town, north west to the Clogher Valley. This is still the main route today from Dublin in the south east to Derry in the north west.

There are a number of court cairns, dolmens and wedge cairns across the county. The intricate network of winding roads make them quite difficult to find, but a few of the best are described below. Part of the Black Pig's Dyke, the Iron Age earthwork which runs along much of the south Ulster border, is visible in the townland of Aghareagh West, near Scotshouse. There are six miles of it in Monaghan, with a double ditch and bank. Some oak from the Dyke was carbon-dated to between 500 and 25 BC.

The Plantation of Ulster (see ULSTER) saw Monaghan settled by Scottish farmers in the early part of the 17th century. One notable legacy can be seen in the county's graveyards, where low circular gravestones with short cross arms display mortality and other symbols of Masonic origin finely carved in high relief.

The county museum in Monaghan town is excellent. It is open from Tuesday to Saturday from 11am to 5pm. Closed from 1 to 2pm. Phone: 047 82928.

1 Clones
On the N54 south west of Monaghan town.

Cluain Eois means 'the meadow on the height'. The elegant layout of Clones dates from 1601. It has fine Georgian town houses and some interesting ecclesiastical remains. The town sits on a hill with its central diamond sloping down from St Tighernach's Church of Ireland church. The top of the hill is up behind the church and accessed from a lane in a side street.

It is called Clones Fort and sits now, fringed with thorn trees, above the town with wide views of the surrounding countryside. At the time of writing, a fallen tree blocks the entrance and the sign has been taken down. It has the feel of a sacred hill and was probably the focus of the early monastery founded here by St Tighernach in the first half of the 6th century. He died here about 550.

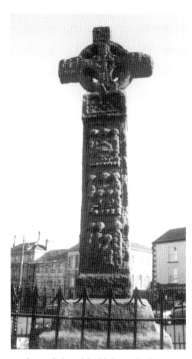
Stone shrine of St Tighernach, Clones

In the diamond there is a 10th century sandstone cross, which is actually the shaft of one cross and the head of another mounted together. It is very tall, almost 15 feet and quite worn, although most of the scripture panels can still be identified. The sides are finely ornamented with intricate interlacing and there is an angel at each end of the cross arms.

On the north face are New Testament stories. From the bottom: *The Adoration of the Magi*, *The Miracle at Cana*, *The Miracle of the Loaves and Fishes*, and in the centre of the cross, *The Crucifixion*.

The south side begins from the bottom with scenes from the Old Testament: *Adam and Eve*, *Abraham and Isaac*, and *Daniel in the Lions' Den*. The centre of the cross here is remarkably similar to the other side which is very unusual. It looks a little like the Crucifixion but could also be an Old Testament figure with animals.

Down past the Georgian houses in Abbey Street at the bottom of the diamond, is a tiny graveyard on the right with the remains of a simple rectangular 12th century church called locally, 'the Wee Abbey'. It has a small round-topped window, its lintel carved from one block of stone. This may be the remains of a small Augustinian foundation. The graveyard has some lovely 18th century gravestones, quaintly worded and beautifully carved. It also has a number of circular slabs heavily incised, with moulding round the edges. In the centre are symbols of mortality: the skull and crossbones, bell, book, hourglass and coffin, a relic of the Scottish immigrants who came here in the 17th century. (See also **Kilwirra** in LOUTH, and **Aghalurcher** and **Galloon** in FERMANAGH.)

Nearby, through a stone archway, are the remains of a fine round tower and a stone house-shaped shrine dating possibly from the 9th century. It is smaller than others in Bovevagh and

Banagher in Derry and it is solid. In front, a modern slab reads: "Here lie the remains of St Tiernach of the Royal House of Oriel. First Abbot of Clones Monastry. Bishop of Clogher 500 AD to 4th April 548".

2 Tedavnet

4.5 miles north west of Monaghan town. Signed on the left off the N2.

Tigh Dhamhnat means 'Damhnat's house'. In the 6th century St Damhnat founded a nunnery here for women. Her name is Latinized as 'Dympna', though she is not the same St Dympna, celebrated at Gheel in Flanders, as patron saint of the insane. Her bachall, or staff, is now in the National Museum, Dublin.

The old graveyard is up steps and through a gateway in the village and is all that is left of her nunnery. It is on a gentle hill, one of the county's many drumlins. Here you can see some beautifully ornate 18th century gravestones. They are carved with angels and humans in the act of praying, sometimes with hands held high and illustrations of the *Tree of Life*. Some have figures carved even on the narrow edges of the stones.

The subjects and style of carving here are repeated in Errigal churchyard nearby, with a number of different stone carvers using the same motifs.

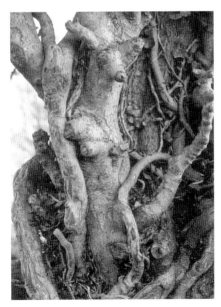

Tree spirit

3 Errigal Old Church

3 miles north of Emyvale,
signed on the left off the
N2 going north.

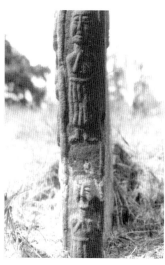

This is an ancient sacred
hill with a special atmos-
phere and a very interesting
collection of 18th century
gravestones with similar
carvings to Tedavnet. There
are also many heraldic images
here. Some of the edges of the
gravestones are carved with
monks, one above the other,
up the edges of the stone.

Monks on grave slab, Errigal old church

4 Mullyash Hill

About 5 miles north east of Castleblaney, north of the R182.
On the Armagh border.

Mullyash is also called Carn Hill because of the cairn on its summit.

Local people used to climb this hill at the beginning of harvest
every year on the first Sunday in August, which they called
Blaeberry Sunday. This ancient Lughnasa assembly is remembered
as late as the 1940s and involved taking a stone up to put on the
cairn and throwing a stone down off it as well.

A large rock, called 'the Long Stone', was also visited on the
hill. It had the marks of a giant's foot, hand, and knee, and was said
to have been thrown from Slieve Gullion in Armagh. There are
two cairns on Slieve Gullion which is clearly visible about 10 miles
away to the east.

The assembly was associated with tasting the first potatoes,
one of the first harvest rituals, as well as dancing, sporting contests,
blaeberry-picking and courtship.

5 Inniskeen

Signed south from the N53 about 8 miles west of Dundalk.

The name 'Inis Caoin' means 'gentle island', and it retains some of
this quality still. An island monastery was founded here in a deep
bend in the Fane river by St Daig MacCarell, sometime between the
6th and 7th centuries. He was a nephew of St Molaise of Devenish

Island in Fermanagh, and was taken there by him and trained as a smith. He spent time at Clonmacnois in Offaly as Chief Artificer of St Ciarán, and also studied at Bangor in Down. He is credited with making 300 bells, 300 croziers and 300 gospels, or metal manuscript covers, but no trace of any have been found here.

Now only the broken tower remains, 42 feet high. It is said that the tower was built in a night by a woman with three aprons of stone, one apron for each storey. Next morning a passer-by criticised her work and she leaped from the top into a pond in the river, called the Church Pool, and was drowned. This story echoes a much older one which describes the origins of the passage cairns at Loughcrew in Meath, and the mounds at Crúachain in Roscommon. These are also said to have been generated from the apron of an old woman. In the case of Crúachain, she was the sun goddess.

A few pieces of masonry from the old church have been built into its successor, the Church of Ireland church in the middle of the village. It is now a small museum, unfortunately closed at present, awaiting funds to repair the roof. (Phone: 042 78102). The graveyard around the church is full of gravestones so ancient that they have taken on the character of standing stones.

In 1014 Brian Boru's body was brought through Inniskeen on its way to be buried in Armagh after the Battle of Clontarf. It would have been carried along the north side of the river, along the old road which remains today as a footpath by the river.

On the south side of the village is a Norman motte. Beside it are the remains of an Augustinian Priory built in the 12th century. This would have had close associations with St Mary's Augustinian Priory at Louth, just 4.5 miles to the south.

Iniskeen is the birthplace of Patrick Kavanagh, the poet. His grave is near here, in the graveyard of St Mary's church - just past the motte on the edge of the village. This church is now the Patrick Kavanagh Rural and Literary Resource Centre which has information about his life and work, as well as local history.

6 St Joseph's Church, Carrickmacross

St Joseph's Roman Catholic parish church is a late 19th century Gothic Revival building. It has eight windows by Harry Clarke which date to the 1920s. He has included a portrait of Stalin, at the time considered an anti-Christ, at the tenth Station of the Cross.

Harry Clarke's windows can be found all over the country and are famous for their vibrant form and colour. He was one of the most famous Irish stained-glass artists of the early 20th century.

ULSTER Monaghan

7 Lennan Dolmen

745 232

4 miles north east of Ballybay. Just outside Castleblaney on the Monaghan road, turn left onto the R183 for Ballybay. After 3.3 miles, turn right at the crossroads in Doohamlat, then left at McNally's crossroads after a further 2.3 miles. Take the first right (0.6 miles) and after another 0.6 miles, the stones are just visible from a bend in the road up on the hill to the right in good pasture. Pull in near the double field gate.

This dolmen opens to the north west with two side stones and a large split cap-stone resting on small stones at the back. There are markings on one upright.

Corlealackagh Giant's Grave is nearby.

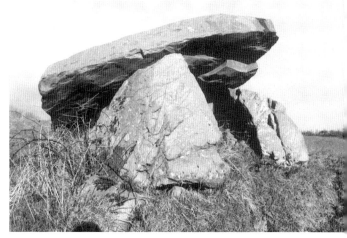

Lennan dolmen

Corlealackagh giant's grave

Go back to McNally's crossroads and go straight over. After 1.5 miles, turn right at the crossroads and continue for another 1.5 miles. There is a lane on the right leading to a bungalow and farmhouse. Ask at the farmhouse.

Across the fields in a small wood is a raised cairn covered in thorn bushes. The gallery is aligned north west to south east, with the court at the south east end formed now by just 2 stones and the gallery portals. There are 2, possibly 3 stone chambers, now open to the elements and carpeted with moss. This is a lovely gentle spot.

Corlealackagh giant's grave

ULSTER **Cavan**

County
CAVAN
PRINCIPAL SITES

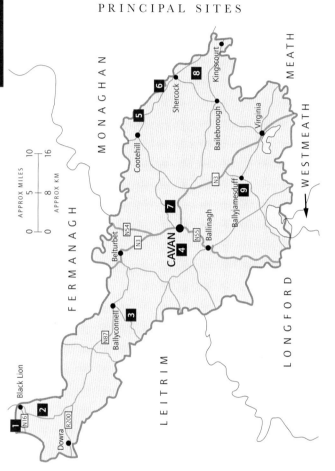

1 **St Brigid's Stone**
 The Burren
2 **Dolmen**
 The Giant's Grave
 Moneygashel sweat house
 Shannon Pot
3 **The Killycluggin Stone**
4 **Kilmore Cathedral**
5 **Cohaw** giant's grave
6 **Labbyfirmore**
7 **Fionn MaCumhail's Fingers**

CAVAN

Like Monaghan, the landscape of Cavan is dotted with drumlin hills, but here in Cavan there are also many lakes and the drumlins form wooded islands creating areas of half water, half land - marshy, boggy terrain which is not easy to cross. Perhaps because of this, Cavan has more secrets than most counties and some very interesting places.

One of these is the ancient University of **Tuaim Drecuin**. Its name is thought to survive in the parish of Tomregan which includes the town of Ballyconnell within its boundaries. There is no definite site identified, but in the grounds of the Church of Ireland church in Ballyconnell there is a stone, called 'the Tomregan stone', which is said to depict St Bricin, founder of the university, performing an operation. St Bricin is referred to as a saintly physician of extraordinary skill. He is also mentioned as working abroad as a missionary.

One of Tuaim Drecuin's most famous scholars was Cenn Faelad who was born around 618. He was a king's son, eligible by birth for the kingship of Aileach in Donegal, and even the High Kingship of Ireland. Experience and training in battle would have been an important part of his training for kingship and it was during the battle of Magh Rath (**Moira** in COUNTY DOWN), that he was badly wounded in the head and taken to the hospital at Tuaim Drecuin with part of his brain protruding. A medieval account of the event says:

> "his brain of oblivion was dashed out of Cenn
> Faelad's head in the battle of Math Rath".

Losing his 'brain of oblivion' sounds like a reference to the practice of trepanning, whereby a hole is bored through the skull to relieve pressure on the brain and possibly facilitate special mental abilities. Whether this is so, St Bricin performed an operation which saved his life and he stayed for three years to recuperate at the university. This was the custom and during that time he studied

at all three schools in the university: Classics, Law and Learning.

The university was a flourishing centre of learning at this time with a European reputation and roots going back into the Druidic mysteries and Bardic tradition. When Cenn Faelad was there, it was beginning to embrace the modern Christian teachings as well. He became a kind of transition figure between the two cultures. It is said that he absorbed the oral teachings in the old tradition during the day, committed them to memory, and then copied them down in the evening in poetic form. He later wrote the first book of Irish grammar, one of the first books to be written in the Irish language, in which he compared grammatical principles of Irish and Latin, showing Irish to be the more comprehensive language. In his book he makes reference to Greek and Hebrew as well. He also had a career as a dispenser of justice and wrote several books on law.

When he left the university after his period of recuperation and study, he went to Daire Luráin (**Derryloran** in TYRONE) where much of his writing was done. Some of his writings are still extant.

The university closed down some time in the 8th century, replaced, no doubt, by the growing monastic centres of learning and culture. Some of Cavan's greatest treasures are now in the County Museum in Ballyjamesduff which is one of the most interesting museums in the country outside Dublin.

THE NORTH WEST

This part of the book is dedicated to Harold Johnston in Blacklion who, on hearing that I wanted to visit the Burren, took down some brand new work-boots with bright yellow laces from a shelf in his drapery shop, and took me out for the day. It was an unforgettable experience.

(The Burren is about 2 miles south of **Blacklion** in CAVAN and not to be confused with the better known Burren in Clare. Burren means 'a rocky place'.)

Harold Johnston at St Brigid's stone

1 St Brigid's Stone

Take the Sligo road out of Blacklion for 1.5 miles. You can see the ruins of Killinagh church across a field to the right. From the far side of the church, cross over into the next field on the right and the stones are visible at the far side of the field. They are on a slight promontory overlooking Lough Macnean from the south.

There is one large drum-shaped boulder here with two smaller, more irregular ones beside it. All three stones have bullauns, or deep, smooth, circular depressions in them. These bullauns all have round or ovoid quartzite stones sitting in the depressions.

They are called 'cursing stones' and are turned traditionally sun-wise to extend a blessing towards someone and reversed to empower a curse. The tradition is that if the curse is unjust, then it will come back on the perpetrator.

Bullauns are found at most ancient sacred sites but rarely are the stones inside them still in place. Archaeologists and historians have suggested various functions for them, usually associating them with early Christian sites, although they are probably much older. They have been called 'grinding stones' or 'fonts', but wherever they are found today, they are always considered to be sacred. Often they are called holy wells and the water that gathers in them is used to cure warts or other ailments. This is a very special place.

The nearby church dates from the medieval period but low down in the north wall are two triangular stones which may have been the gable tops of an earlier building. They could also have been the gable ends of a slab shrine which held the remains of the founding saint.

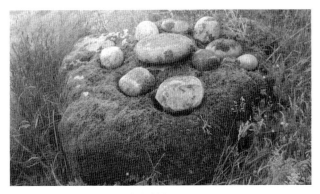

St Brigid's stone

The Burren

Take the Sligo road out of Blacklion and fork left. Take a left turn up the hill (signed Cornagee) for about 2 miles and pull in by green forestry gates on the left.

This rocky landscape is remarkable for the variety of its megalithic remains. Much of the area is now covered with conifers planted some 50 years ago when this was still done by hand. This gives a slightly more natural feel to the forest and in places where the planted trees have not grown, other indigenous shrubs and plants have returned.

Here are just a few examples of sites in the area:

2 Dolmen

Follow the path through the woods till you come to a small ruined house. The dolmen is behind it.

It sits in the wall of a small enclosure which once surrounded the house and has been modified at some time in its past and used as a calf shed. The whole has now been covered with moss so that you have to look quite closely to see which bits are original. The capstone is a massive limestone slab 16 feet long which appears to rest on one of the uprights, but in fact it does not quite touch it. It extends from the ground, supported only by a very low stone near the ground.

This is a magical place deep in the woods - a place of moss and toadstools. In an odd way the dolmen is enhanced by its inclusion in this woodland garden. This is a place to see fairies.

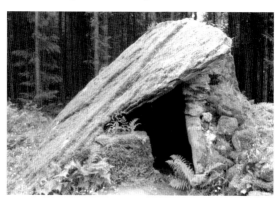

The dolmen

The Giant's Grave

Continue on the path till you come to a wooden marker by a track through the trees on the right. Follow the track to another marker and another track, again on the right. The Giant's Grave is on high ground in a small clearing.

It is a wedge cairn with 3 chambers opening towards the south west. The main chamber is 17 feet long and narrowing from 4 feet

to 3 feet in width. It is divided from a small antechamber in the front and an end chamber at the back by cross slabs. The cross slab between it and the front chamber has been cut away at the base to create an aperture. (See **Corracloona** in LEITRIM) The front portals are in the south west and converge to form a triangular entrance.

The most westerly of the five cap-stones is covered with ring and cup marks: circular hollows or cups and incised circles. Some kerbstones are still in place, running in line with the chamber at a distance of about 4 feet.

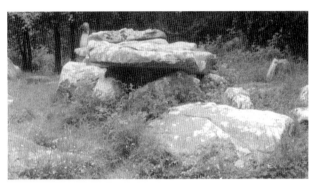

The giant's grave

Behind this cairn to the north east is a fault in the limestone, forming a deep gully, known as the Giant's Leap. There are some stones at the bottom where he is said to have met his death and where he lay before his subsequent interment in the Giant's Grave above. You can follow this gully north west till it crosses a small track through the trees, and turn left to get back to the main path.

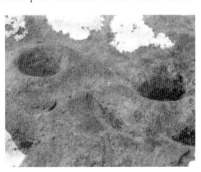

Cup marks, the giant's grave

There are a number of other cairns extending east towards Marble Arch Caves in Fermanagh and north to Lough Macnean.

Moneygashel Sweat House

From the forestry gates (see The Burren above) go back on the road and downhill to Legeelan crossroads and post-box.
Turn right and go about 100 yards to some stone sheds up on the right. Behind them is a small sweat house.

It was last used in 1923. Its stone walls would be heated through with a turf fire inside. Six hours later, the fire would be raked out and the floor lined with rushes which would be sprinkled with water to create steam. Two people would crawl in and the entrance blocked so the cleansing could begin.

This sweating is mentioned in different places as having a variety of purposes, from clearing the skin to curing diseases of the joints and lungs.

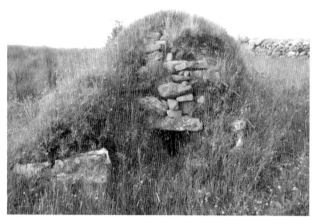

Moneygashel sweat house

Shannon Pot

This 50 foot wide pool shaded by overhanging trees is the traditional source of the river Shannon, although the Shannon is now known to come from several sources. The river is named after Sionnán, who was the grand-daughter of Manannán mac Lir, god of the sea.

She came here to eat the fruit of the forbidden 'Tree of Knowledge' which had been planted in the time of the Druids. Others say it was the salmon of knowledge she was trying to catch and that the fish was so enraged when she caught it, that it lashed its tail at her. Either way, as she began to eat, the waters of the pool sprang up and overwhelmed her, drawing her down into it to flow out later across the land as the river Shannon.

3 The Killycluggin Stone

Take the R205 south west from Ballyconnell. After 3 miles there is a replica of the Killycluggin stone by a right turn to Bawnboy.

This replica is no more than a marker as it gives no sense of the original either visually or energetically. The original is in Cavan

County Museum in Ballyjamesduff and is an Iron Age ritual stone, similar to the Turoe Stone in Galway, and the Castlestrange Stone in Roscommon. It is a rounded boulder, probably originally about 5 feet tall, elaborately decorated with closely coiled spirals interconnected with La Tène style patterns. It seems to be slightly waisted near the base. The top has been damaged by St Patrick, if accounts of his confrontation with Crom Dubh at Killycluggin can be believed. However, he was not successful in destroying it as it still exudes a very powerful earthy presence from its corner in the museum.

This stone stood at one time outside the stone circle in Killycluggin and was decorated all over with gold. It represented the god Crom Cruach, or Crom Dubh who is the dark god, the 'bent one' who receives the 'first fruits' at Lughnasa or harvest in the form of the corn maiden, and carries her on his back down into his underground kingdom. This ritual or 'sacrifice' ensured the continuing fertility of the earth. The 11 stones of the nearby circle formed his court.

When St Patrick travelled this way, he smashed the pillar stone and overturned the stones of the circle in an attempt to destroy the powerful hold of this dark pagan god on the people.

"Since the kingship of Héremón, bounteous chief, worship was paid to stones till the coming of noble Patrick to Ard Macha. He plied upon Cromm a sledge from top to toe; with no paltry prowess he ousted the strengthless goblin that stood there." (E Gwynn XI 19ff *The Metrical Dindshenchas)*

The circle is over in the trees, almost behind the school, and is accessed through the field across the road from the replica. The landowner lives by the turn to Bawnboy.

Some of the stones have indeed fallen and they are crossed by a field boundary. However, some are still standing and are well spaced with oak, thorn and elder trees growing among them. Some sources say that they are the kerbstones of a cairn.

Continue this road round to Kilnavert past a right turn to Templeport. The road curves round a hill on the left, called Crom Cruach, which is just 1.5 miles from the stone circle.

The three townlands in this area, Killycluggin, Kilnavert and Lissanover have a number of prehistoric remains, many of them Bronze Age. There are scattered standing stones and the remains of boulder circles on hilltops. These circles may originally have formed kerbs around cairns.

Crom is locally associated with the hills and his feast day is 1st August, the same as Lughnasa. He is the dark side of Lughnasa, the festival of Lugh, or harvest. The name Garland Sunday has replaced Lughnasa, or Crom Dubh's Day, in many parts of Ireland, and there are many Garland Sunday gatherings in this area.

There are also many St Patrick's Well pilgrimages here. The route that St Patrick is supposed to have taken to get to Killycluggin to destroy Crom Cruach has many wells dedicated to him. Areas that maintained strong pagan traditions were usually flooded with dedications to St Patrick to help counter the pagan gods.

4 Kilmore Cathedral

3.5 miles south west of Cavan on the way to Crossdoney.

'Cell Mór' in Irish means the 'great church'. It was founded originally by St Feidhlimidh. Today the small modern Gothic cathedral sits up on the right with a holy well dedicated to St Feidhlimidh in front.

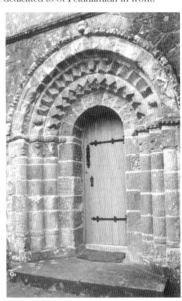

Kilmore Cathedral

Built into the vestry on the north side of the building is an ornamented Romanesque doorway taken from the abbey on Trinity Island in Lough Oughter. It has four orders beautifully carved with chevrons and animal and human heads. The faces are mongoloid, influenced, it is said, by the experience of the Crusades.

The doorway has a particularly luminous quality, partly because of the soft yellow sandstone but also on account of the variety and beauty of the carvings. It has not been perfectly reassembled, but this seems to give the individual figures more impact than if they blended together more harmoniously.

This is the same period, the 12th century, as the arch on White Island in Lough Erne, Fermanagh, the only other Romanesque doorway in Ulster. It certainly makes sense of the Romanesque passion for ornamented doorways as a powerful symbol and magical device.

William Bedell, once bishop of Kilmore, is buried here. He compiled an Irish grammar but, more famously, he was one of four translators who made the first translation of the Old Testament into Irish in the 17th century.

5 Cohaw Giant's Grave

From Cootehill take the R190 east and turn right onto the R192
to Shercock. It is signed and visible on the left after 1.8 miles.

This is a lovely dual court cairn with 5 chambers aligned north south. It has an 85 foot long rectangular cairn. A court at each end gives onto a two-chambered gallery with sills at the entrance and between the chambers. The fifth chamber sits between the two galleries. There are modern stone pegs across the entrances to the forecourts to mark the positions of post-holes. These posts closed the mouths of both courts. Just inside the north court are two socket holes which held tall thin pillar stones, now broken.

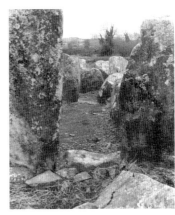

Looking through the portals from the north, Cohaw giant's grave

The site was excavated in 1949 and in the most southerly chamber a crushed neolithic pot, the cremated bones of a child, and the skull of a young person, were found. This cairn overlooks the Annalee river which flows west into Lough Oughter. There are a number of other cairns in the area, also near the river, but Cohaw is the finest.

6 Labbyfirmore

699 083

3 miles north north west of Shercock in Corgreagh townland.
Going south towards Shercock, it is on the left of the R181,
close to the Monaghan border.

Its name, Labbyfirmore, means 'the giant's bed'. It is a long cairn with a chamber and displaced roof-stone.

7 Fionn MaCumhail's Fingers

Just over 3 miles north east of Cavan on the east shoulder of
a high ridge on Shantemon Hill.

This hill is said to have been the inauguration place of the O'Reillys, one of the chief families of Cavan. This would certainly

mark it as a sacred place and the five stone alignment, called Fionn mac Cumhaill's Fingers, would confirm this. These five standing stones, one of which has fallen, run in an alignment from north west to south east. They are in a clearing among the trees. Their height decreases from north to south.

Young people in the area still climbed the hill on Bilberry Sunday in an event, called 'the Pattern of Shantemon', at least until the 1940s. This would have been a remnant of a Lughnasa assembly and Shantemon Hill must have been a Lughnasa Site. (*The Festival of Lughnasa*)

8 Lughnasa Assemblies in the South East

*The road from Shercock to Kingscourt runs along the border between Cavan and Monaghan. South of Shercock, in a triangle formed with Kingscourt and Bailieborough in the west, Máire MacNeill has noted four more hills which were all assembly sites at Lughnasa. (*The Festival of Lughnasa*)

Lughnasa was traditionally celebrated on the 1st August. In Christian times it was often celebrated on the nearest Sunday, called Bilberry or Garland Sunday. Outings to pick berries were still enjoyed at these sites into the middle of the 20th century and sometimes other vestiges of the earlier assemblies lingered as games or contests.

Loughanleagh Hill

Between Bailieborough and Kingscourt.

There is a cairn on top of this hill which was climbed every year on the Sunday before the nearby Muff Horse Fair on the 12th August. People camped here and passed the time with dancing, singing and athletic contests. Mud from a dried-up lake on the hilltop was used to cure a variety of ailments.

Taghart Hill

This hill is about 3 miles from Kingscourt and the same distance from Bailieborough. It is 2 miles north of Loughanleagh.

Taghart Mountain is 982 feet high. According to one local person, the fair here in 'olden times' lasted for a week. There were races where people ran across the field at the foot of the mountain and also swam across part of a lake. This was remembered as more than 200 years ago. However, more recently in the 1940s, young

people were still climbing the mountain on Bilberry Sunday.

The Ralaghan Figure in the National Museum, Dublin is from Ralaghan Bog at the foot of the mountain. It is a tall thin angular wooden figure with a hole for a phallus. This hole was found to contain quartz crystals fragments, possibly the remains of a quartz phallus.

Corleck Hill

This is 5 miles west of Taghart Hill in the parish of Knockbride.

People came here on Bilberry Sunday and there is mention of 3 monuments and a well at one time. It is famous today because of a carved stone head which was found here in 1855.

It is a tricephalos - a head with three faces. This powerful stone is now in the National Museum, Dublin. However, an excellent replica is on display in the County Museum in Ballyjamesduff. The faces are very simply carved, all the same, except that one seems to look up, one down, and one straight ahead. There is a hole in the base to mount it. There are plenty of examples of the Celtic Trinity or triple deity in literature, but very few in stone.

Local people tell of 2 jani-form heads (with two faces) found at the same place but there is no trace of them now.

The fourth hill in the area is **Teevurcher Hill,** which is just over the county border in Meath. There are folk memories here of a great fair. Outings for bilberry-picking continued here until recently.

9 The County Museum

Virginia Road, Ballyjamesduff.

The Corleck Head and the Killycluggin Stone have already been mentioned, but there are a number of other reasons to visit this museum.

There is another stone head here from Coravilla, also probably Iron Age, though the style is very different. It has deeply cut almond eyes and a wide mouth. The face is quite impassive and gentle and has the look of a young boy. Here also some excellent Sheela-na-Gigs can be seen.

ULSTER Fermanagh

<div align="center">

C o u n t y

FERMANAGH

P R I N C I P A L S I T E S

</div>

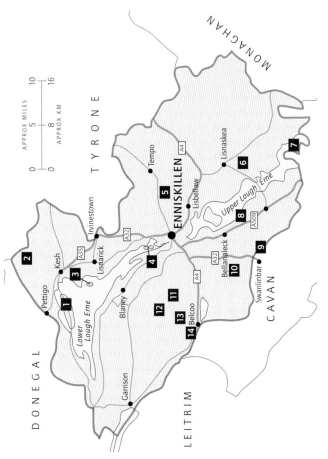

1 *Boa Island* Janus Figure

2 **Drumskinny** stone circle
 Montiaghroe circles and alignments

3 *White Island*

4 *Devenish Island*
 Killadeas Bishop's Stone

5 **Topped Mountain** multiple cist cairn

6 **Aghalurcher** church

7 *Galloon Island*

8 St Ninnidh's Well

9 Drumbrochas Spa

10 **Doohatty Glebe** court cairn
11 **Belmore Mountain** passage cairn, also called Moylehid
12 **Boho** cross shaft
 Ryfad rock art
13 **Aghanaglack** dual court cairn
14 **Belcoo**
 St Patrick's Well
 Crom Cruach
 Templenaffrin

Block figures in list refer to site locations in map and entries in text.

FERMANAGH

A THIRD OF THE COUNTY OF FERMANAGH IS WATER and most of that is in the two lakes of the Erne river. The northern lake is the lower lough and the southern lake, the upper. To the north of the county sttone circles still lie hidden beneath blanket bog. To the south the limestone hills, with their caves and cairns, stretch towards the border with Leitrim.

In the middle lie the lakes, quiet, reed-fringed, and deep. They are named after the goddess Erne who was a young priestess of Maebh, living with her at Crúachan in Roscommon. Erne had been entrusted with Maebh's comb and casket which were the divine symbols of her sexuality. However, frightened by a creature which had emerged from the dark cave at Crúachain, she fled north with some of her maidens. Here she was further terrorised by a fierce giant and she and her maidens were drowned in the lake. The casket and comb were also lost and the lake was renamed Erne.

So, the symbols of Maebh's sexuality lie hidden in the depths of the lake while the surface is dotted with island sanctuaries. The dark inner world and the outer world are in perfect balance. This is reflected in its long history.

On its southern shore the limestone ridges are topped with neolithic cairns while later Bronze Age circles lie beneath the bogland to the north. On Boa Island, which means 'the island of the warrior goddess', a powerful two-headed stone figure still sits in its wooded sanctuary. And into Christian times the island of Devenish still rings with the sounds of 1500 scholars living within its shores.

1 Boa Island - Janus Figure

It stands in the south west of Boa island, which is near the northern shore of Lower Lough Erne. The A47 crosses the island connecting it at either end to the mainland. The graveyard, called Caldragh, is signed to the south, at the west end of the island.

Boa is not so much an island as a part of the intricate lacework of the coastline of Lower Lough Erne. Still, there is a strong sense of being surrounded by water. Within these watery surroundings the ancient graveyard of Caldragh has been encircled by hazel woods. This combination of trees and water give a real sense of entering a sanctuary.

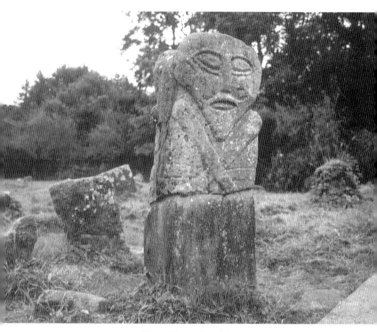

Janus Figure, Boa Island

Boa Island, written in Irish, 'Badhbha', is usually taken to mean 'Cattle Island'. However, the word 'badhbh' actually means 'war goddess' and 'badhbha' means 'warlike'. This revelation made me look long and hard at both faces on the extraordinary stone figure in the graveyard here, and wonder why I had assumed, along with everyone else, that it was male.

This 'Janus figure' stands about 3 feet high among the old gravestones, two faces and bodies, back to back. They are similar but not identical and seem, the longer you look at them, to have very different qualities. Both have large flatish heads with wide foreheads and pointed chins. They have wide almond-shaped eyes,

straight noses and strong, deeply cut mouths, suggestive of an oracular authority. Their hair appears to be intertwined at the sides and on top, between the two heads, a recess is filled with coins. Perhaps this was originally meant for another carved stone or head-dress.

Each torso has two limbs crossing it, thought to be arms, though on closer inspection, it could be an arm and a leg. A double incised line runs around both figures about waist height. The carving sits up on a concrete plinth to compensate for its broken base.

One figure seems more impassive, the pupils less pronounced, and the mouth closed. The other is alert, eyes watching and mouth open in the middle of speech.

From every point in the graveyard the statue watches. Its presence is still strong after all this time, still lingering in the fabric of the stone. Whether male or female or both, this was a powerful deity in its time. It may have been at the centre of a ceremonial arena where its presence could be felt, even at a distance.

Nearby sits a smaller carved figure brought here from Lusty Beg Island. In contrast, it has a much more benign or gentle presence, the kind of stone one might touch for healing. Its presence isn't so strongly felt from a distance. Locally it is known as 'the Lusty Man'.

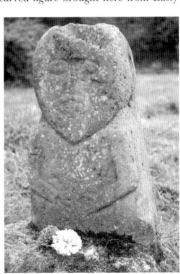

I came here last with friends, one of whom had a pendulum. Interestingly, the Janus figure caused the pendulum to swing widely anti-clockwise while the Lusty Man moved it clockwise.

The Lusty Man, Boa Island

2 Drumskinny stone circle

About 6 miles north east of Pettigo. It is signed on the left off the A35 from Pettigo to Irvinestown. There is a small car-park by the roadside.

There are many circles and stone rows in this upland area of north Fermanagh. This circle was discovered peeping from the bog in 1934, but it was only excavated in 1962. It is 43 feet in diameter

ULSTER Fermanagh

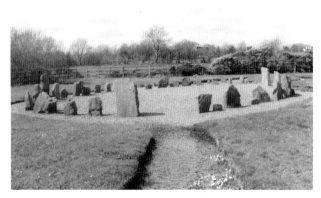

Drumskinny stone circle

and the finest of the circles in this area and very similar to the
Beaghmore complex in Tyrone.

The circle originally had thirty-nine stones. Seven have disappeared
and been replaced by small stones, marked MOF, for Ministry of
Finance. There are a number of possible entrances, though the one
in the east seems the most probable. The stones vary hugely in size
and shape with lozenges and pillars, fat and thin. The tallest are
about 5 feet.

A small cairn 13 feet in diameter and surrounded with
kerbstones was found just outside the circle to the north west.
Aligned with the centre of the cairn, a row of 24 small stones was
uncovered, running just east of south at a tangent to the circle.
Only a few worked flints and a rough hollow scraper were found
around the cairn. A single sherd of neolithic pottery was found
near one of the stones on what would originally have been the
ground surface.

Montiaghroe Circles and Alignments

*The remains of at least five circles and more alignments are visible
here and there in the townland of Montiaghroe about a mile south
of Drumskinny.*

Go back from Drumskinny to the nearby crossroads, and
turning south, there is a church on the right after about a mile.
Opposite the church on the left is an alignment of three tall stones
running south east to north west. The area around these stones is
fairly impenetrable but a little further on, if you turn left at the
crossroads and go 0.3 miles, a further three stones are visible across
a field. They seem to be part of the same alignment and are also
over 6 feet tall.

Go back to the crossroads and go straight over it. After about 2 miles, you pass a hill on your right in the townland of Formil. There are a number of stones here, the remains of three circles, two with alignments.

3 White Island

The island is accessed by ferry from Castle Archdale Marina, which is on the north shore of Lower Lough Erne. It is a 15 minute trip each way and the ferry runs hourly in the summer and at weekends and bank holidays between Easter and Halloween.

The boat trip is exquisite. It takes you across the lake through densely wooded islands to the small landing strip on the east tip of this tiny island. The first thing you notice as you step onto the island is the gentle sense of calm.

In a field next to the jetty is a small ruined Romanesque church with a round-headed doorway enclosed by a dry-stone wall which has been recently restored. The remains of an earlier wooden building were found during excavations in 1959. Between the jetty and the church are earthworks which may have been the original boundary. This boundary runs north south to a solitary thorn tree on high ground to the south. This tree marks a particularly gentle spot on the island. The ferryman said he felt rejuvenated there. The tree seems to mark the southern boundary of the enclosure.

Inside the small church there is a row of remarkable stone figures now built into the north wall. There are two small figures to the west, then five large full-length ones. At the east end there is a head with down-turned mouth. This head has a flat, drum-shaped hat and two lines marking high cheekbones which give him the oriental

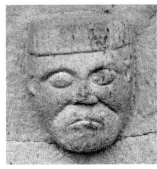

White Island figure - Oriental head

appearance of many Romanesque heads of the 12th century.

The first small figure seems to be a Sheela-na-Gig, wearing a short cape, with deep round eyes, wide puffy cheeks, a grinning mouth and knees bent with legs apart. Her arms are on her thighs as if to display her genitals. Beside her is a contemplative figure with strongly delineated cheekbones. He is sitting holding a rectangular object and is wearing a long robe with a border

around the hem. He may also have a drum-shaped hat like the Romanesque head.

The first of the taller figures is hooded and holds a bell and crosier. His hair, beneath the hood, is parted in the middle. He wears a robe, like the seated figure, also with a border around the hem. He may be a bishop. The next figure carries a stick and has a pouch at his waist. He has one hand raised to his mouth. Some suggest that he is David who sang and wrote the psalms. The next figure has tightly coifed hair and holds two exotic creatures by their necks, and beside him is a warrior with brooch, sword and shield. The next one is unfinished.

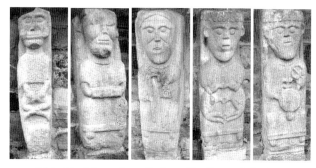

White Island figures, l-r: - Sheela-na-Gig; Contemplative figure;
Cleric; Figure holding two exotic beasts; Warrior.

Some of these figures have Romanesque characteristics. They have almost certainly been taken from the earlier church which has a Romanesque door, so it is probable that they were part of that building. However, they are quite unlike anything in situ in a Romanesque building anywhere else in Ireland. Perhaps they are caryatids: stone figures used as pillar supports for a stone sill or table. Whatever their origin, they are a magnificent sight.

Killadeas Bishop's Stone

205 540
6.5 miles north west of Enniskillen
on the B82. The Priory Church of
Ireland is on the left hand side
of the road. The stone is in the
graveyard.

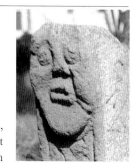

The Bishop's Stone, as it is known, is reached by a little path to the right of the graveyard. It stands 3.5 feet high and its wide face is carved in half relief

Killadeas stone

with the profile of a figure carrying a bell and crosier. The stone curves asymmetrically at the top and this figure is bent to fit the contours of the stone. His face is carved in full relief on the edge of the stone in the same style as the White Island figures. Below his face his body is represented by an interlace panel, though there are hints of a body which may have been chipped away.

This is a delightful stone and very hard to date. There are also two cross slabs in the graveyard.

4 Devenish Island

Ferries cross to the island from Tuesday to Saturday between 10am and 1pm and between 3 and 5pm. The trip takes about ten minutes. The tiny road to the jetty is about 2 miles north of Enniskillen on the A32 signed on the left just as the main road forks. It is not suitable for coaches.

Across the centre of the island lie ruined monastic buildings, all medieval, although the island's fame as a holy place and centre of spiritual and scholastic learning, belongs to a much earlier period. Devenish or 'Daimhinis' can mean 'ox island', but 'damh' (pronounced dav) also means a 'stone church'.

The earliest monastery here was founded by St Molaise who died late in the 6th century so the buildings from his time would

Head above the west door of St Mary's Abbey, Devenish Island

have been of wood, not stone. However, it is thought that St Molaise's house, built in the 12th century just east of the round tower, may have been modelled on an earlier and much revered wooden church or shrine which burned down in the fire of 1157. It is well built with thick walls of very large stones and it has narrow antae with delicately carved bases. The style is similar to **St Kevin's Kitchen** at Glendalough, though much finer. Unfortunately, it is not so well preserved. In the 19th century, stone from St Molaise's house was taken for other buildings. Inside is a stone coffin, called 'St Molaise's bed', which is said to cure back pain if you lie in it all night.

The site suffered an earlier burning, this time at the hands of

the Vikings, in 837. At this time the monastery was a busy and prosperous place of learning, described in an early 8th century text as 'multitudinous'. Extraordinarily for this small island, there were at one time up to 1500 scholars here. Strange also to realise that this 'heyday' was passing even before many of the current stone buildings were here.

The round tower is one of the latest in Ireland and possibly the most ornate, having details in the 12th century Romanesque style. It stands 81 feet high with five storeys and has four small windows at the top facing the four cardinal points. Above each is a finely carved head with stylised hair and beard flowing into a patterned cornice which runs around the top of the building. The rounded arch of the doorway is also Irish Romanesque.

Its story is not so lovely. Domnall, son of Amhlaoibh O'Maoil Ruanaidh, King of Fir Mhanach (Fermanagh), was burned in the tower by his own kinsmen.

The Teampull Mor or big church further down the hill, has a fine 13th century window in the south wall but much of the rest of the building is later. Inside it is the bullaun stone credited with carrying St Molaise across the water to the island.

Further up the hill is St Mary's Abbey or Priory founded by the Augustinians in the 12th century. They seem to have come into existence and functioned alongside the older foundation for some time, perhaps when the other was already in decline.

Midsummer brazier, Topped Mountain

The buildings remaining today are mainly 15th century and built of grey carboniferous limestone, much used in the late Middle Ages. There is a reproduction of a carving of a female head over the

west door of the church. It is probably St Mary (the original is in the little museum). The domestic buildings are to the north. Excavations in the early 1970s showed burning, which was probably the fire of 1360, but the fabric of earlier buildings proved hard to date.

The museum has a number of carved stones through which it attempts to show what the earlier buildings would have looked like. St Mary's was ruined by the 17th century but was still used as a burial ground for another 200 years.

South of the abbey stands an unusual 15th century high cross with intricate patterning. It looks out across this tranquil place surrounded by water which would at one time have made it so accessible. The foot falls of 1500 monks are only an imagined echo now in the silence and its dynamic past is something more sensed than seen.

5 Topped Mountain Multiple Cist Cairn

311 457

5 miles east north east of Enniskillen. From Lisbellaw drive under the main A4 and turn left opposite the telephone box. After just over a mile, turn right (signed Garvary Crossroads). Topped Mountain is signed left off this road.

There is a small car-park at the foot of the mountain, though this is not so much a mountain as a wide expansive hill with a small stony path winding its way to the top. To the north are the dark distant Sperrins; to the east the wide fertile Clogher Valley; south are the massive escarpments of the Cuilcagh Mountains, Slieve Rushen, Slieve Beagh. Below lie the lakes and islands of the two Lough Ernes.

The hill is capped by a cairn, 90 foot across and 12 foot high. A cist of small stones was found in the east side of it. It contained a burial with a bronze dagger, a gold pommel on its handle. There was also a vase-shaped pot and a cremation in the floor. Other cremated bone accompanied by pottery or, in one case, accompanied by a polished stone axe, was found in the cairn indicating that it had been used over a long period of time.

Today, the day after midsummer, there is a gas bottle and brazier from yesterday's midsummer celebration. Traditionally it was also visited by bilberry gatherers on the 3rd Sunday in July, an old Lughnasa assembly. They came to the cairn to pick bilberries and to enjoy the view (*The Festival of Lughnasa*). Right now tiny underground streams noisy with recent rain provide the most persistent sound with the meadow pipit and a distant tractor joining in from a distance.

ULSTER Fermanagh

6 Aghalurcher Church
It is signed off the A34 about 2 miles south east of Lisnaskea.

This quiet secluded spot lies among the tiny lakes around the fringes of Upper Lough Erne. It was the site of an early Christian foundation, probably 7th century, associated with St Ronan whose festival day is the 23rd December. Little is known of this early church but it became important in medieval times and the church was remodelled in 1447 by Thomas Maguire, 'King of Fir Manach in honour of God, Tigernach and Ronan'. The 6th century saint, Tighernach, is associated with this area and considered to be the patron saint of the Maguires.

They were the ruling Gaelic family in Fermanagh until the 17th century and this was their main burial place. Some of their grave slabs can be seen in the stone vault on the north side of the church. It is said that a Maguire killed one of his kinsmen here on the altar of the church.

Many interesting gravestones from the 17th and 18th centuries can be seen in the graveyard, including some low circular stones with the symbols of mortality in high relief on the back. These were the skull and crossbones, a bell, book and hourglass. It is thought this tradition came over from Scotland with the new Scottish settlers in the 17th century. They are also found at Galloon, as well as at Clones in Monaghan, and at Carndonagh in Donegal. Mortality in art and literature became popular following the Black Death in the 14th century

The ruined church, with its heraldic Maguire carving and its sombre images of death, is guarded by an ancient yew tree inside the graveyard, while a carved stone head watches over the entrance from the centre of the stone arch over the gateway.

Two carved stones from here are on display in the County Museum, Enniskillen, and the Acrobatic Figure, or Sheela-na-Gig, is in the Department of the Environment in Belfast. This latter figure was probably part of the earlier church along with the stone head above the gateway.

7 Galloon Island
Take the main road south from Newtownbutler to Wattlebridge and there is a sign on the right after 2.5 miles.

This southern part of Upper Lough Erne has fragmented into a maze of tiny islands. Galloon is one of them and access is possible across a low bridge. Cross the bridge and keep to the right. The graveyard is on the left.

It is extraordinary how different it feels to be on an island, even one as tiny as Galloon and as accessible. The water laps gently at the shore by the road-side. Being surrounded by water makes the land feel more solid.

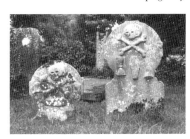

The graveyard marks the site of a 6th century monastery founded by Tighernach, who is linked with Aghalurcher, and who also founded the monastery at Clones in Cavan.

Symbols of mortality, Galloon Island

In the graveyard there are two cross shafts with scriptural panels. Both crosses are worn but some familiar scenes can still be recognised, especially on the east cross. *The Sacrifice of Isaac* is on the east face. The west face has the *Adoration of the Magi, The Baptism of Christ* and *SS Paul and Anthony receiving Bread from the Raven in the Desert.* Both have deeply recessed tops where the upper portion of the cross was joined.

There are also a number of circular 18th century grave slabs here with high relief skull and crossbones, bell, book and hourglass on the back. These also occur at Aghalurcher and Clones and provide another, much later link between these three sites.

8 St Ninnidh's Well

Derrylin is a small village on the south west side of Upper Lough Erne. Take the B127 south from Lisnaskea. Go through the village. About a mile further north, on the A509 to Enniskillen, Knockninny Pier is signed. The road goes behind Knockninny or Ninnidh's Hill.

The well is to the right of the pier, near the lakeshore. The water is clean and clear with a wall surround which has a tiny recess on the inside containing bottles of holy water and earth from the Holy Land.

St Ninnidh was a 6th century saint also associated with the island of Inishmacsaint on Lower Lough Erne.

Nearby **Knockninny** is a lovely conical hill some 630 feet high and sacred in prehistoric times. There are the remains of three court cairns on its lower slopes. On the south west slope, in **Shehinny,** is a natural cave inhabited in prehistory and used later as a burial place.

There is no direct access. At the minute the easiest way to climb

the hill is along the side of the quarry, but you need to check with the quarry first. The views across the lake and its islands are superb.

9 Drumbrochas Spa

Go south through Swanlinbar and turn left (signed to graveyard). Continue out of town, over the bridge and turn right. Go past a food packaging business, a sharp left turn, and the spa is over a low wall on the left hand side.

Sulphur well, Drumbrochas Spa

Swanlinbar was a prosperous spa town in the 18th century when gentlemen and ladies would come to partake of the water here between the months of May and November. It was said to cure many things from ulcers to colic. There were five or six active spas in the area. Drumbrochas is the only well that remains easily accessible.

This spring fills into a circular stone enclosure and overflows into a nearby ditch, leaving a white sulphur deposit on the stone. The path to the well is on the side of a meadow full of ragged robin and buttercups. The water contains sulphur and it is still used by many people who swear by its healing powers.

10 Doohatty Glebe Court Cairn

185 312

On the east slope of Benaughlin 2.5 miles north of Swanlinbar. Take the A32 north to Enniskillen. Doohatty Glebe is on the left up the forestry track. Go up this track and take the second turn off on the left. The cairn is on the left.

This cairn sits under the eastern scarp of Benaughlin. The court has gone but the long segmented chamber of this court cairn is still here. In some places there seems to be a kerb nearly parallel to the chamber which would have formed the outer boundary of the cairn. In excavations carried out in 1882, about 15 small cists were found in the cairn material containing burnt earth and fragments of bone.

Benaughlin, known locally as Bin, was traditionally visited on the last Sunday of July, known as Bin Sunday. People used to

collect bilberries, admire the view and explore the caves on the hill. Earlier gatherings involved singing and dancing, wrestling and fighting contests.

It is known as a fairy hill and there was a tradition that Donn Maguire, the first of the ruling Maguire clan, lived on the hill. He was king of all the fairies of Fermanagh and was said to come to the aid of the Maguires in battle. (*The Festival of Lughnasa*)

11 Belmore Mountain Passage Cairn also called Moylehid
150 417
Belmore Mountain is the next peak east of Aghanaglack. The passage cairn is on the summit overlooking a high escarpment to the south east. Belmore mountain is 5.5 miles west south west of Enniskillen. Several lanes lead up onto the hill from the Boho Belcoo road. 0.5 miles from Boho, you can follow the lane up to the quarry and walk from there.

This cairn, 40 feet across and 10 feet high, was opened in 1894 to reveal a small passage and cruciform chamber some 13 feet long. Sills marked off the three recesses in the chamber and another three sills divided the passage. The orthostats were only 2 or 3 feet high and the chamber and passage unroofed.

The cairn material had been piled directly on to the depositions of cremated bone, pendants and stone beads. These had been placed in the passage as well as the end chamber and the right hand chamber. The chamber on the left was two-storeyed, with inhumed remains, animal bones, boars' tusks and sea-shells. The upper half contained cremated bones and a bowl-shaped food vessel. The cairn had been used much later to hold three cists.

There are segmented passages in the passage cairn at Dowth in Meath and at Carrowkeel in Sligo, but the height of the sills here seems more like the divisions between the chambers of a court cairn and may have been influenced by them. However, this might be a late passage cairn: early Bronze Age perhaps. In the National Museum, Dublin, there are eight pendants and two beads from here and they are typical passage cairn goods.

In ancient times this was the site of a Lughnasa assembly and people were still climbing to the cairn in the middle of the 20th century on Bilberry Sunday to pick berries and have a day out. Large gatherings were held here, with food and drink stands, and dancing at the cairn. (*The Festival of Lughnasa*)

12 Boho Cross Shaft

Take the A46 from Enniskillen to Belleek and then left onto the B81.
Boho is signed on the left. It is a tiny village high up in the hills.
The cross shaft is in the graveyard of Toneel Roman Catholic Church.

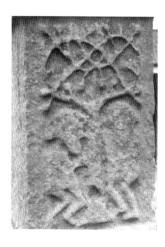

Although it is quite weathered, you can still see a very lively *Adam and Eve* on one side of the shaft. They seem to be dancing round *The Tree of Knowledge*. The other side shows *The Baptism of Christ*. Recesses in the sides of the shaft may have held supports, like the cross on the Rock of Cashel.

In the church porch is a cross head, part of a different cross.

Adam and Eve either side of the Tree of Knowledge, Boho cross shaft

Ryfad Rock Art

Continue past the church up the hill on the concrete road until the
path divides. Keep left up the hill, with fields to the left and a
steep mossy bank on your right.

This climb takes you up into the limestone hills of south Fermanagh and you can hear the water trickling through the rocks on your right. The arched stalks and pink heads of water avens protrude from the damp ditch. The stones are in a field on the left, just below the house at the top of the hill.

There are six large stones in one area, five of which have cup and ring marks and groups of concentric circles. In some places the circles appear to join others, some appear to spiral out into other forms, and several have lines going into the centre as though forming a sort of labyrinth. No one knows the history of these stones but they are magnificent and the location spectacular. Other similar stones are Clonfinlough in Offaly and Boheh in Galway.

Ryfad rock art

13 Aghanaglack Dual Court Cairn

*1 mile north east of 'the Devil's S', a bend on the road from
Belcoo to Boho. Signed on the left. You can drive some of the
way on a forestry track. The cairn is signed down a short wooded
path which leads to a delightful small glade surrounded by
deciduous trees. Through a gap in the trees you can see across
south Fermanagh to the Cuilcagh Mountains and Leitrim.
Far from houses and roads, the only sounds here are bird song
and whispering trees.*

The cairn has two double-chambered galleries back-to-back,
running south west to north east and separated by a shared
endstone. There is a court at each end. The court in the north east
is at an angle to its gallery and opens to the east. The stone slabs

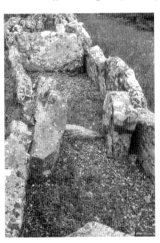

used in the building of these
chambers are quite symmetrical,
giving the impression of stones
cut for this purpose.

The outer chambers at
each end contained cremated
remains: in the north east
were the remains of a child
and in the south west, the
cremated bones of a youth
and the teeth of pig and red
deer. The inner chamber at
this end contained neolithic
pottery and bowls with simple
cord impressions, flint tools
and weapons.

*Two galleries separated by a
shared endstone, Aghanaglack
Dual court cairn*

The ash charcoal indicates
a date in the late neolithic
period, as ash was very rare in the locality before 2500 BC.
(*Living Places*)

14 Belcoo

*14 miles south west of Enniskillen on the A4. A border town. From
the north side of the bridge, turn west out of town. At the
crossroads in Holywell on the edge of town there is a small
medieval church, called Templerushin. In the graveyard there is
a large bullaun. There is also an old stone cross by the roadside
near the crossroads.*

St Patrick's Well

Across the road from the old church and down a flight of steps.

The well is a wide pool of water bubbling up from beneath and flowing away at both ends. This is an old Lughnasa site and the well is still visited from the last Sunday in July until the 15th August. This is the time usually associated with harvest time and the god Lugh. The well was said to cure nervous and paralytic disorders. It was transparent and very cold in the spring. After April it changed to the colour of milk for seven weeks.

The Lughnasa festival has been overlaid with a local tradition that St Patrick brought Christianity here. He blessed this well and since then the old fair has a Christian focus. It still involved visiting the well and two bullauns in the graveyard across the road, as well as the stone cross by the road side. Prayers were said at each of these stations. After that, everyone enjoyed the fair.

The well was also called 'Davagh Patrick' in an extraordinary mix of symbols. Davagh means 'a vat' which is a very old symbol for the power of the goddess. The vat, or cauldron that never fails, means fertility and plenty for her people. And indeed, this is still a very potent place where the water bubbling out of the ground is more than just a symbol of the living earth.

Bullaun, Templerushin, Belcoo

Crom Cruach

A few fields away, in the townland of Drumco, is a large standing stone, known as 'the Pagan Stone God' or 'Crom Cruach'.
Take the road signed to Boho from Holywell crossroads, go just past a hump-backed bridge and take the lane in on the right past a derelict farmhouse. Continue across three fields after the lane stops and the stone is there, about 7 feet high, and still gently potent in spite of being displaced to this remote field.

ULSTER **Fermanagh**

The god, Crom Cruach, is sometimes represented as the last sheaf of corn cut at harvest. He is responsible for the underworld where seeds germinate to start the cycle of growth. He appears at harvest time, or Lughnasa, to claim the 'first fruits' to take back to the underworld. This was the corn maiden who had to go with him to the underworld to ensure the beginning of the new cycle. In Christian times he was seen as the dark side of paganism and treated as the devil. The 'first fruits' are still taken into Christian churches to be given back to God. There was a tradition in Ulster of taking the last sheaf of corn to be cut and hanging it up in the house to represent Crom Cruach. It would hang over the table where the harvest supper was being eaten. In earlier times the Crom Cruach would have been resorted to as a kind of oracle.

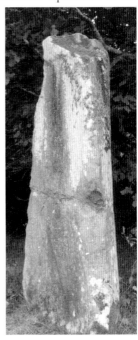

Crom Cruach

Templenaffrin

Continue on the Boho road past the first left turn signed Boho. Pull in at the 2nd left turn and follow a track just opposite it on the right. The church is visible across a meadow on the ridge of the hill to the left.

This is a fine old red sandstone building contained within a circular walled graveyard. It has battered walls and a small round arched window in the west gable, where there is also a simple carved head. It sits in a beautiful meadow absorbing the evening sunlight into its warm pink walls. The meadow is exquisite at midsummer, knee-high with a mixture of the kind of wild flowers we have all forgotten. The church sits alone now. The life of the local community has shifted and left it up on this wooded ridge, invisible to everyday life, gradually being re-absorbed by the natural world around it.

About 275 yards south west of the building is a double bullaun, easier to find before the summer growth. It was used in the church as a baptismal font.

ULSTER **Donegal**

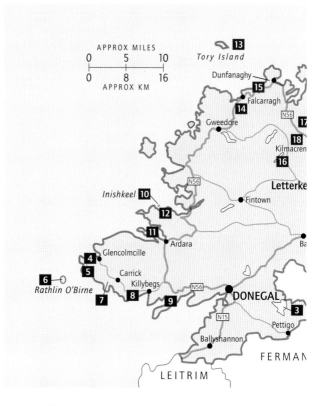

1 Grianán of Aileach

2 Beltany stone circle

3 Lough Derg

4 Glencolmcille
 Farranmacbride court cairn

5 Cloghacorra
 Cloghanmore court cairn
 Malinmore dolmens

6 *Rathlin O'Birne*

7 Slieve League (Sliabh Liagh)
 Tobar na mBan Naoimh

8 Shalwy and Croagh Beg court cairns

9 Killaghtee ringed cross

10 *Inishkeel*

11 Kilcashel cross slab

12 Kilclooney dolmen
 Doon Fort

13 *Tory Island*

14 Tullaghobegley church and graveyard
 Beaglaoch's Stone

15 Ray church

16 Churchill
 Laknacoo or Leac na Cumha (flagstone of loneliness)
 Colmcille's Abbey

17 Eithne's Well
 Barnes lower standing stones

18 The Rock of Doon
 Doon Well

19 Gortavern dolmen

20 Drumhallagh cross

21 Fahan cross

22 Carndonagh St Patrick's Cross and pillar stones

23 Malin Wee House

24 Glacknadrummond or Bocan Stone Circle
 St Buadan's Cross
 Carrowmore crosses

Block figures in list refer to site locations in map and entries in text.

DONEGAL

DONEGAL EXTENDS FROM THE RIVER FOYLE IN THE EAST, with its rich arable land, across the ancient granite mountains of Derryveagh, and to the west where the rocky edges of the county dip and slide into the wild Atlantic. The mountains run either side of a great rift, called 'the Gweebarra Fault', which is a continuation of the great rift valley which crosses Scotland. Along the north, fractures run deep into the landscape forming peninsulas with broad open headlands. One of these, Malin Head, is the most northerly point in the country and a key location in the shipping forecast.

Further west, Tory Island lies seven miles out to sea. Its broad black rocks made a fitting stronghold for the one-eyed Balor, king of the Formorians. His grandson, Lugh, was born here and fostered by the sea god Manannán mac Lir. Lugh became a hero, a king and a god amongst the Tuatha Dé Danann and the Celts; the remnants of his festival, Lughnasa, are still with us today.

Some say that Lugh slew his grandfather on the slopes of Bloody Foreland and the blood that came out of his eye gave the headland its name.

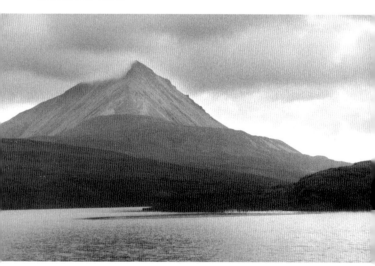

Errigal Mountain. (photo: Ewan Berry)

Gartan, in the heart of the Derryveagh mountains, was the birthplace of one of Ireland's best loved saints, Colmcille. He founded many churches in the county but Glencolmcille is the place where he is most in evidence. Carved pillar stones cross and re-cross the valley to map a sacred journey still made by thousands of pilgrims today. Tradition tells how he brought Christianity to

Tory. (see below)

There are three pointed rocks off the west coast of Donegal near Gola Island. They are called 'Trí Mhic 'a gCorra', which means 'the three sons of the serpent'. They are supposed to be three islanders fleeing Tory to evade Colmcille and his Christian teachings. Tradition says that every seven years on the 1st May they turn back into humans and try to return to Tory, but must change back if anyone sees them. A couple of years ago one of them mysteriously disappeared...

Finally, Errigal, in north west Donegal, is one of Ireland's most beautiful mountains. Its white crystal cone overlights the landscape around the north west coast with its gentle benevolent presence.

1 Grianán of Aileach

High above the south side of the N13, just a few miles west of Derry and right in the middle of the narrow neck of the Inishowen Peninsula. Signed from the main road.

The circular drum shape of the Grianán sits snugly on top of the hill. It is visible for miles and from the top of its reconstructed walls, you can gaze out across the land in every direction. The distant hills give a sense of being at the centre of this vast and wonderful

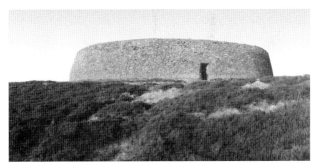

Grianán of Aileach

landscape. It is visually and energetically exhilarating.

From the stone walls you can see the remains of three concentric rings of earthworks which is all that is left of the original structure. Tradition holds that it was built around 1700 BC by the Daghdha, the father king of the Tuatha Dé Danann. It is known as 'the Sun Temple'. Its name, 'Grianán', means a 'sun room' or 'temple', but it also means 'a person of loving and sunny disposition'. This, of course, is Gráinne, the sun goddess.

The circular stone walls of the Grianán are about 17 feet high. Inside, a number of steps lead to terraces in the inner wall. It is possible for several hundred people to mass here on the walls to watch a ceremony in the circular enclosure below. It is not a fort but a perfect amphitheatre and was one of the inauguration sites of the Uí Neills, who dominated Ireland for at least six centuries from here and from Tara. The Grianán of Aileach was second only to the royal site at Tara and they were linked by an ancient road.

Marko's Stones (see DERRY page 160)

As befits the sun, the Grianán is at the centre of a number of energy lines feeding into, and out from, this point in the landscape. According to Marko Pogacnik's perception, an energy line runs from the cosmic 'inbreath' point at Bocan Circle (see below) in the north, through the sun temple at the Grianán to Beltany Stone Circle further south. Other energies radiate into the centre from Cashel Hill, Holywell Hill, Castle Hill and Inch Island. He has placed lithopuncture stones at these points. One of them, a tall pillar, stands by the road as it spirals to the top of the hill at the Grianán.

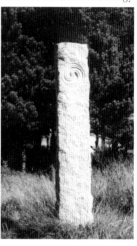

Marko's stone, Inch fort

The other stones are on private land, so permission is needed to visit them. There are two on Inch Island. From Derry or Letterkenny, follow signs for Buncrana. The island is accessed by a causeway from the R239 just past Burnfoot village. The north stone is near Inch Fort, in the grounds of the Meitheal Trust. The second stone is near Inch Castle, on the south side of the island.

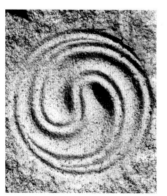

Detail, Marko's stone, Inch fort

Cashel Hill is up behind the village of Burnfoot, just before the causeway onto the island. Castle Hill is visible as the square tower house, called Burt Castle, to the north of the N13 opposite the Grianán.

2 Beltany Stone Circle

On the summit of Tops Hill, about two miles south of the village of Raphoe and signed from there.

This is one of only two stone circles extant in the county. Like the Grianán, this is a highly exhilarating site. It is associated with Bealtaine, the beginning of summer, a time of ritual fires reflecting the power of the sun and celebrating this time of abundant growth.

This huge circle, about 145 feet across, is made up of 64 stones, though there would originally have been at least 80. They are big, some more than 6 feet and all shapes and sizes; they jut and gape like a mouthful of old teeth. They enclose a platform 2 or 3 feet high. When the site was described in 1909, the stones enclosed 'a flat circular space', but the centre was 'excavated' in the 1930s and left in the disturbed state which still remains today. It is possible that the centre held chambers and a cairn like the circles at Carrowmore. The circle itself, with its closely placed stones, may be the kerbing of an enormous passage cairn.

It is certainly very different from the more common Ulster circles of Tyrone and Fermanagh, with their much smaller stones. It is more like the large circle right at the other side of Ulster in Ballynoe, County Down.

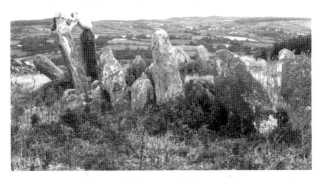

Beltany stone circle

The tallest pillar in the circle is in the west south west. It faces a triangular slab, east north east, which is 4.5 feet high and decorated with cup marks on its inner side. A line from the tall pillar over the top of the decorated stone runs 5 miles towards Tullyrap hill and the position of sunrise at Bealtaine. The circular cup marks perhaps symbolise this moment when the sun rises on what, for this circle, is the most significant day of the year.

There are a number of other possible alignments. A line from the tallest stone in the south western part of the circle, taken through the outlier, goes 28 miles south east to Bessy Bell Hill in Tyrone.

Another line could run through the circle to Croaghan Hill, 4 miles east south east. This hill has a cairn on top and overlooks, from the east, the ruined passage cairns of Kilmonaster. Kilmonaster is only 2 miles south east of Beltany. (*A Guide to the Stone Circles of Britain, Ireland and Brittany*)

Carved Heads

Three carved heads, dating probably to the Iron Age, have been found in the Raphoe area. A round face carved with strong features on a thin slab of stone was found at Beltany. It has heavy protruding almond-shaped eyes and pronounced lips, with a possible protruding tongue. It is now in the National Museum, Dublin.

Another head, much flatter but with the same strong almond-shaped lips and eyes, was found in the Ballybofey area. It is in Donegal County Museum in Letterkenny.

A third head from Creaghadoos is now in a private collection. It is very different in style with slight, understated features carved on what seems to be a naturally rounded stone. It is similar in style to the Corleck Head which is in the County Museum in Cavan.

These figures are thought to be Iron Age. The Beltany figure implies that this hill continued as a spiritual centre into Iron Age times and the historic period.

3 Lough Derg

5 miles north of Pettigo on the north shore of Lower Lough Erne in Fermanagh. Take the R233 north till the road runs out on the bleak shores of Lough Derg. You pass beneath a wide metal archway with the words "St Patrick's Purgatory" written in huge metal letters overhead.

Pilgrims have been coming here since at least the 12th century. At one time it was so well known that it was the sole landmark on several Irish maps of the Renaissance period. On Betelius' map of Ireland of 1560, St Patrick's Purgatory is marked larger than any towns.

Legend links this bleak stretch of water with the holy mountain, Croagh Patrick, in Mayo. It is said that the Corra, a warrior aspect of the triple goddess, drew Patrick here. When he looked down, she had taken the form of a serpent and lay coiled in the water. He approached her and she opened her jaws and swallowed him whole. It took two days and nights for him to cut himself free, killing her in the process. The water around turned red with her blood and her body turned to stone. These stones can be seen there to this day jutting out of the lake.

Some local stories say the serpent was always there until Patrick slew her. She ate their cattle and demanded more, so that they had to raid the whole of Ireland to keep her satisfied. Others say it was Fionn mac Cumhaill's son, Conan, or even Fionn himself who killed the serpent. Whatever his name, the hero is swallowed by the Great Swallower, Corra or Caoranach, and returns to the womb or underworld from where he is reborn. The experience cannot have been all bad, for pilgrims began coming to a cave on Saint's Island to emulate Patrick's experience inside the serpent, and undergo their own form of rebirth. And they are still coming today.

St Patrick is credited with the first Christian settlement here on Saint's Island. He is supposed to have left it in the care of St Daveog. Dabhach, pronounced 'Dava' in English, means 'a vat' or 'a tub', a cauldron perhaps. Nothing really is known about this Daveog, yet the name provides a perfect symbol for the place: the belly of the serpent being synonymous with the womb of the goddess for which the cauldron is a symbol.

This particular pilgrimage became very popular, attracting pilgrims from all over Europe, including Alfred of Northumbria, and Harold, who was later to fight the Normans as King of England in 1066. One pilgrim became particularly famous. He is called the Knight Owein, and his experiences were written down at the end of the 12th century by a brother of Saltery Abbey, near Lincoln. This story became so popular in medieval times that there are still many extant copies today. Owein followed the customary preparation of fasting and praying and then entered the cave where he experienced torments by hideous demons and witnessed the torment of other souls in vivid medieval detail.

Pilgrimages here became even more popular, often with as many as 1500 pilgrims on the island at once. The cave became notorious and strangely fascinating: pilgrims went insane from their experiences; others were said to disappear altogether.

The cave was closed by Papal Decree in 1497, but the pilgrimage just moved to Station Island, using a cave there, and the remains of penitential cells built by the Saint's Island monks nearly a thousand years earlier. In 1632 it was suppressed by the Privy Council of Ireland and the buildings destroyed; in 1701 an Act of Parliament laid down punishments to be incurred for taking part.

Attitudes changed in the 18th century. In 1780 the cave was replaced by a chapel which was replaced earlier this century by the Basilica: a huge octagonal church and central venue for much of the three-day pilgrimage. The island is just visible today, almost submerged beneath a cluster of ecclesiastical buildings, which provide some shelter for the thousands of pilgrims who visit the island each year. And so it continues today, a little less dramatic

perhaps, but still with the power to help people turn their lives around.

If you want to experience Lough Derg without being an official pilgrim, turn left just before the Gates of Purgatory and follow the road round the lakeside. The next townland is Seadavog, meaning 'Daveog's chair'. Here, by the lakeside, you will find Daveog's huge stone chair from which you can contemplate the whole thing.

There are pilgrimages from June 1st to August 15th and they last for 3 days. It's not really appropriate to visit the island unless you want to participate. For details, phone 072 9861518. Email: lochderg@iol.ie

4 Glencolmcille

This remote and beautiful valley is bounded on three sides by hills carpeted with bog while the Atlantic Ocean lies to the west.

It is most famous as the sanctuary and pilgrimage site of Colmcille, but its history is much older than that. Ancient field walls and megaliths remain from a time when the hills of west Donegal were farmed by neolithic peoples and probably more populated than they are today. Sometimes faint traces of their huts leave a ghostly presence in the landscape, but mostly we are aware of them only at such sites as the great court cairn at Farranmacbride, or the equally impressive Cloghanmore Court in the next valley to the south.

(Michael Herity has a small, but excellent and beautifully illustrated guidebook to this area.)

The Story of Colmcille and the Demons as described by Manus O'Donnell in his *Life of Colmcille*

When Patrick banished the demons from Croagh Patrick in Mayo, they fled to Glencolmcille and stayed there until the time of Colmcille. There was a great mist around them so they could not be seen, and the river before them became a fiery stream so that no one dared cross it.

Colmcille was told of their presence by the angels and he went to that place accompanied by a number of other holy men. As they approached, the devil hurled a holly stick at them which struck and killed An Cerc, Colmcille's servant. Colmcille seized it and flung it back. While it was in flight, he could see through the mist and he blessed the river which at once cooled, so that they were able to cross it. The holly branch meanwhile fell to earth and began to grow.

Colmcille was given a green stone by an angel and told to throw it along with his bell at the demons. He obeyed and they fled to a rocky outcrop in the west, by the sea. He followed them,

commanding them to go into the ocean where they were changed into fish, red fish and blind in one eye, so that no fishermen would unknowingly catch and eat them.

God returned the stone and bell to the saint and Colmcille left the stone there endowed with magical qualities. He declared the place a sanctuary and it has been one to this day.

Farranmacbride Court Cairn

Follow the road east from the Church of Ireland church in Glencolmcille and turn up the first small road on the left. Go past Station 9 (see below), and continue till the road curves round to the right. The site is down a lane on the left.

The enormous cairn surrounding this court is nearly 200 feet long. Much of it is destroyed but its huge oval centre court is 67 feet long and the largest of its kind in Ireland. There are two galleries, one at each end of the court, each 16 feet long and each divided into two chambers. There are three, possibly four, other smaller chambers set around the court.

This cairn is in a rather ruined state, with an old track running through it, yet it is still an impressive site in a beautiful place.

The Turas

A 'turas' is a sacred journey. Today Glencolmcille is still a place of sanctuary and pilgrimage where people come to follow the turas around the valley.

The journey is circular or sun-wise. The Irish for sun-wise is 'deiseal', which also means 'propitious' or 'lucky', and the tradition of moving sun-wise both for ceremonies and in everyday life, is a very old one.

The modern turas, with its 15 stations, covers 3 miles and can be made anytime, though the traditional day is the 9th June, St Colmcille's Day. It takes about 3.5 hours.

Michael Herity suggests that stations 3 to 8 formed the original turas, which is marked with simple 6th century cross slabs (see **Glencolmcille**). This route is centred on Teampall Cholmcille, 'the old church', Leaba Cholmcille, 'the saint's bed', and the holy well with its great stone cairn at station 7. These cross slabs are generally small and simply inscribed, though the crosses themselves differ from stone to stone.

The first two stations and those from station 9 to station 15 are 'new', added around 700, and much more elaborately carved, reflecting perhaps the new artistic style of jewelled metalwork and manuscript art of the period. The symbol of the cross has been elaborated as an artistic expression, whereas the earlier stones are

simply marked with a cross as an act or symbol of power. The longer turas begins and ends with key pattern cross slabs.

Station 1 is at the Church of Ireland parish church of St Columba, with a ruined court cairn beside it. This 19th century church is probably on the site of the first foundation established by Colmcille around the middle of the 6th century. The last church stood here till 1828 in the centre of the graveyard above a souterrain which runs east west under the enclosure. There are a number of early cross slabs incorporated into the souterrain, their presence probably a sign that this is an early Christian site.

From here, follow the road west to the second station - **Station 2** - a tall pillar set on a small rocky rise, and finely carved on each side.

Follow the road north west with the inlet on your left, across the stream. Take the lane on the right till you reach a cairn by the roadside. On a flat stone on the north east side of the cairn is a round stone (there used to be three). This is **Station 3**. After 3 rounds of the cairn, the stone is passed around the body for healing.

This is a very ancient practice. In pre-Christian times a stone, especially a rounded one, was a symbol of the goddess. Sometimes at holy wells they are considered to be eggs, even serpent's eggs. These often have the tradition of encouraging fertility. The symbolic placing of stones is still important in modern pilgrimages in Ireland, the most common practice being to place one on a cairn.

A little further on the right is a circular stone enclosure with a cairn inside. This is **Station 4.** The enclosure has an opening in the east and a cross inscribed on one of its foundation stones. A stone slab on the cairn has a Latin cross inscribed on its west face.

Station 5 is the remains of a small rectangular building, called Colmcille's chapel. Inside there is a rectangular stone box, known as 'Colmcille's bed' ('leaba'), or 'tomb shrine'. Around the chapel are three cairns enclosed in a circular dry-walled enclosure. This station is called 'Mullagh na Croise', or the 'Eminence of the Cross', and here the pilgrim encircles the church three times before going in and lying on the bed and turning round on it three times. Then each of the cairns are circled in turn while praying. Inside the church in a niche were three small stones used for healing and sometimes taken as far as America when a cure was needed. Clay from beneath Colmcille's bed was taken to protect against fire in the home. This church is probably an early hermitage site.

Just to the south east is a large erratic boulder with an equal-armed ringed cross carved on its upper surface. It is barely visible now but can be felt quite clearly. This is **Station 6** and it

was traditional to stand on this stone and face west while making three wishes.

Go north now on to the lane, past a farm where the road turns west. Turn north again onto the track up the hillside until you come to a huge cairn which arcs around three sides of a small holy well. This is Colmcille's Well and **Station 7.** The pilgrim carries three stones up to this station and places them one at a time after each circuit of the cairn and completion of the prayers. Then comes a drink from the well with three drops spilt on the ground for the three aspects of the Trinity. Over the well is a cross, about 3 feet high, with an unusual Latin cross incised on its west face. The arms have long tapering lines dropping vertically from their terminals, giving the appearance of a fork.

Below the well is Colmcille's Chair, said to revive the pilgrim exhausted from the long climb to the well. Whether it is the chair itself or the wild beauty of the glen below as it dips into the Atlantic breakers, it works. West of the well is the Demons' Rock, their last refuge after being chased here by St Patrick. From here they were banished forever from Ireland by Colmcille. (see above)

Turn south east and follow the side of the hill down past the farm on your right and past some old ruined outhouses, to three small cairns, lined roughly east west and inside a dry-stone enclosure with an opening to the west. This is **Station 8** and each cairn, topped by a cross incised slab, is circled three times while praying.

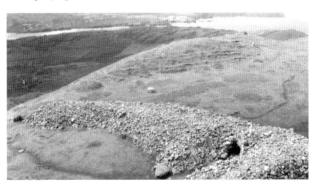

Station 7, cairn and holy well, Glencolmcille

According to Michael Herity, this completes the original 6th century turas. We will, however, continue in brief:

Continue from Station 8 south east for less than a mile. On the way there is a stone basin, called 'Umar na Ghlinne', where it is traditional to wash your feet in the water collected in the stone. **Station 9** is a low cairn with a tall cross pillar facing as you approach. The pillar stone has three circular patterns placed

equidistant along a vertical line. The lowest is quite worn but appears to be a marigold design; in the middle is a simple circle with a small central depression and at the top is an equal-armed cross of a kind of block design inside a circle. A small hole has been bored through the centre of the cross through which the pilgrim can look to get a glimpse of 'heaven'. It is also thought to bring luck in fertility.

Continue south east to the road and **Station 10**, a small cairn topped by an undecorated slab. **Station 11** is a short way along the road going east and is also a cairn with an unmarked slab. Here it is time to turn and head back west.

Having turned back along the road, **Station 12** is on the left. The tall cross pillar is decorated on both sides with elaborate cross motifs and sits inside a circular enclosure with an opening in the west. The townland here is called 'Baile Na nDeamhan', or the 'Townland of the Demons'. This is reputedly the place where the demons attacked Colmcille.

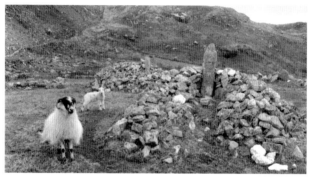

Station 8, three cairns in a row, Glencolmcille

Station 13 is also on the left hand side of the road, near the Garda station. It is over 5 feet tall with three circular motifs one above the other. Like Station 9, the top motif is based on an equal-armed cross inside a circle.

Turn left here before Station 13 and follow the road to the river, crossing on the stepping stones. Follow the path round to the right to **Station 14,** another slender cross slab, 3.6 feet high, set on a small cairn on a rocky outcrop and decorated on its north east face. Here two circular panels are linked by a vertical line.

Go back to Station 13 and turn right. At the church again the circle is complete with **Station 15**, a pillar slab, now broken but having a vertical line with 3 motifs. The lower pattern is a kind of encircled swastika and the upper pattern an inverted triangle with a line bisecting each side, thus dividing the space into 6 segments. These are encircled, giving a six-petalled effect. The vertical line

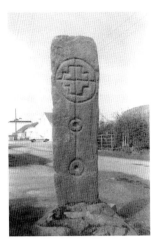

Station 13, Glencolmcille

from these two motifs divides into two at the middle of the slab and each terminal loops back around the other in a continuous knot pattern. The two-lobed terminals are very like those on the marigold stone at Carndonagh. The circle is complete.

Despite many changes, Glencolmcille has managed to retain its sanctuary quality and, over the centuries, the neolithic has merged with the Celtic, and the early Christian with the medieval, so that today Christian pilgrims come to pray in the ruins of a court cairn and walk around stones held sacred long before Christianity was heard of in this valley.

5 Cloghacorra

The next valley, Malinmore, south of Glencolmcille, is rich in megalithic remains. Follow the R263 from Glencolmcille west and south to the crossroads at Malin More. Turn left here. About a mile along on the left, just before a knitwear shop, are two standing stones amidst a pile of fallen stones. One is tall and slender and the other triangular and squat. They are called 'Cloghacorra', or the 'stone of the Corra'.

They are said to mark either end of a giant's grave. This is probably a much collapsed portal dolmen.

The Corra is traditionally said to be the name of the great Goddess as serpent or swallower and it is interesting that it is to Glencolmcille, just a few miles up the road, that St Patrick is said to have banished the demons of Ireland. Other versions of this story have him chasing the Corra, and in one version he chases her further north to Lough Derg, also in Donegal.

Cloghanmore Court Cairn

A little further along the Carrick road on the right, pull in at the small car-park. The site is signed across a small footbridge.

Cloghanmore means 'the great stone heap'. This massive cairn is over 150 feet long and encloses a court and six chambers.

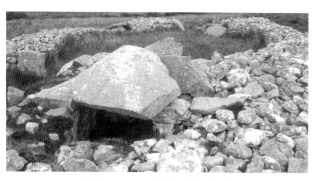

Cloghanmore court cairn, Glencolmcille

A short passageway in the east leads into a large oval court, 46 feet by 36 feet, with a single chamber at each side. Both chambers have a decorated orthostat on the right of their entrances - the only known example of decorated stones in court cairns in Ireland. At the far end of the court in the west are two parallel galleries, each divided into two chambers. This impressive site was partially reconstructed at the end of the last century.

Malinmore Dolmens

Go back west to the crossroads and turn left. The first lane on the left leads to the Malinmore dolmens. Walk up the lane and past a couple of farmhouses and in a field on your right begins a line of six portal dolmens.

The two largest dolmens stand nearly 300 feet apart, forming a line running east west, with the four smaller ones between them, a little to the north of the line.

The first one, just inside the gate, is the most impressive with a huge stone nearly 8 feet high, set in front of the south portal. One of the two massive roof stones rests on two tiny corbels - an extraordinary feat of engineering. The largest cap-stone, fallen from its original position, is estimated to weigh about 40 tons.

Both of the end dolmens and one of the middle ones open east. Another faces north but with the other two, it is impossible to say. They have not been excavated.

Taken as a group, these structures are incredible. Each one is completely different in character and size and they seem to bear no relation to each other yet they stand in line, probably at one time encased in a single cairn of stones at the west of this remote valley. They have stood here for upward of 4000 years.

6 Rathlin O'Birne

South of Malinmore is the tiny village of Malin Beg and off that the island of Rathlin O'Birne.

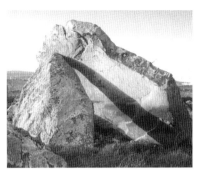

Malinmore dolmen

The only buildings on the island, other than the lighthouse complex, are the ruins of the hermitage of St Assicus (also known as St Tassach), favoured disciple and goldsmith of St Patrick and Bishop of Elphin, who spent the last seven years of his life on the island. He is said to have retreated here from the monastery in Elphin, in Roscommon, where he had been left in charge by St Patrick. After seven years, he was discovered and persuaded to return to his duties. He died on the journey.

There are a number of ruined buildings, a well-house and cross-inscribed slabs within the remains of an enclosure on the island. One cross slab, just north east of the well-house, is particularly elaborate and may even be the work of Assicus himself (see **Glencolmcille**). This would make it early 6th century.

There is no regular access to the island, though the well-house and early Christian foundation were, for a long time, the site of a turas or pilgrimage.

7 Slieve League (Sliabh Liagh)

Turn towards the coast in Carrig (Carrick) which is on the R263 south east of Glencolmcille. Follow signs for Bunglas. Park in the first car-park just inside the sheep gate because, although you can drive further up, you miss so much.

You need your feet firmly on the ground as the cliffs come into view. These cliffs are 1972 feet high and said to be the highest in Europe. However, it is not just their height that inspires. After the second car-park, you can take a narrow path up the side of the cliffs and follow a track along the top. This is called, appropriately, One Man's Pass, as there is a drop of 1800 feet on the cliff side and it is strictly single file. You can follow this for several miles west along the coast, with the cliffs on your left, and the more gentle sloping scrubland dropping away to Teelin on your right.

On a clear day, with the sun shining, you find yourself surrounded by all four elements: the earth, though not much of it,

beneath your feet, the wind in your hair, the fire of the sun in your face and a steep drop to the sea water churning below you. The colour of the cliffs changes with the light and the seasons - orange, silver, green and gold. To the south on a clear day, you can see Ben Bulben in Sligo and even further south, the strong peak of Croagh Patrick in Mayo. Five counties are visible from here.

This walk can be followed all the way west to Malinmore, or you can follow a spur which runs north east after about 1.5 miles. This takes you past a small ruined oratory and down into the village of Bunglas.

Around the tiny rectangular church, there is also a ruined beehive hut and a tall pillar stone with a cross inscribed on it. It is in one of the most remote and beautiful locations in the country and is associated with St Aedh mac Bric. St Aedh mac Bric was a prince of the Ulster Uí Neill clan. He was also a master physician. He is associated with foundations in Killare in Westmeath, Rahugh in Offaly, and Rathlin O'Birne, off the coast at Malin Beg to the west. He was such a powerful healer that his reputation grew after his death and he became associated with aspects of the god Lugh.

Tobar na mBan Naoimh

'The Well of the Holy Women' is above the harbour at Teelin. A small gate leads into a field and the well is a little way up the hill.

The traditional pilgrimage to the well was an overnight midsummer vigil. This, and the association with three women, are a strong link to pre-Christian traditions.

In modern times, the names of the women are Ciall (sense), Tuigse (understanding) and Naire (modesty). They are said to have grown up beside the well and becoming nuns, blessed it.

Tobar na mBan Naoimh, Teelin holy well

Fishermen salute the well and the women when passing at sea.

8 Shalwy and Croagh Beg Court Cairns

Between Killybegs and Kilcar on the sea side of the R263.
There are at least six court cairns in the Killybegs area. These two are probably the most impressive. They are in the steep rocky valley running down to Shalwy Strand. 5.6 miles from the centre

*of Killybegs. turn left down a narrow road towards the sea. The
stones are visible in the valley on the left just 0.6 miles from the
main road. Shalwy lies about 250 yards north east of Croagh Beg.*

Shalwy Court Cairn

This is a long cairn, about 130 feet, with a crescent facade in
the north east set in front of an oval court. The 20 foot gallery is
divided into two chambers by jambs and a lintel. The back
chamber is roofed with a large slab resting on several tiers of
corbelling. There is a massive double lintel at the entrance to the
gallery. The top lintel is gable-shaped. When this site was
excavated, finds included worked flint tools and arrowheads,
fragments of a shale bracelet and sherds of neolithic pottery.

This structure and nearby Croagh Beg, perhaps because of
their size and the gabled lintel, have more the feeling and
appearance of temples than many of the smaller court cairns. They
are quite extraordinary. A further, more ruined cairn, lies near the
main road. These three sites, so close together and so monumental,
would seem to suggest that this was once, perhaps 4000 years ago,
home to a strong and prosperous neolithic community.

Croagh Beg Court Cairn

Croagh Beg is about 330 yards from the strand.

The cairn is about 120 feet by 50 feet with a full court at the
north east end built of large blocks laid in two courses. The gallery
has two monumental chambers built with huge side and end stones
and divided by jambs and a lintel. The entrance has an enormous
lintel and the gallery itself still has some high pitched corbelling. It
also has a single secondary chamber opening directly onto the court
at the north east side by the entrance. Flint tools have been found at
this site.

9 Killaghtee Ringed Cross

*0.5 miles south west of Dunkineely. Take the second turn on the
left (travelling west) from Dunkineely to Killybegs. The entrance to
the graveyard is 0.5 miles down this road on the right, just by the
stumps of the old railway bridge. There are two gates side by side,
a farm gate and a rusted iron one which leads down a grassy lane
to the churchyard. There is some information about the area at the
gallery and museum at the top of the road.*

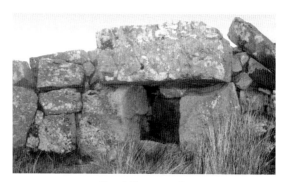

Croagh Beg court cairn

This stone stands in the old graveyard to the south west of the late medieval church and measures about 6 by 2.5 feet. The carving is on the west side. A Maltese cross has been carved in relief and encircled on the top portion of the slab. The slab itself is cut at the top to the shape of the circular surround. There are two small concentric circles at the centre of the cross. Below this and to the right, is a simple threefold knot, or triquetra, which probably symbolises the trinity. Some people see these Donegal crosses as the transition between slab and high cross, but they may be an independent tradition entirely.

It is thought to date from about 650 AD and may mark the resting place of the anchorite and monk Aedh. (see **Slieve League**)

10 Inishkeel

The island of Inishkeel is connected by a low sandbar to the southern side of Gweebarra Bay at the village of Naran. It can be accessed on foot at low tide. The best time to cross over is around the new or full moon on the ebb tide. This allows you two or three hours on the island before it gets cut off again.

Inishkeel was the site of an early Christian monastery founded by St Connell or Conall Caol, a relative of Colmcille, in the 6th century. His feast day is celebrated on the 2nd May. It has been uninhabited since 1904.

It is said that as a young man he was very hot tempered, and one day, as he was working with his father who was a builder, he flew into a rage and killed him. As a penance, he was banished to the offshore island of Inishkeel to remain there until he had so overcome his wild temper that birds would nest in the palm of his hand. After seven years, he lay down on the ground one day with arms outstretched and fell into a deep sleep. He awoke some time later to find that some birds had built a nest in his hand.

The two surviving churches of St Mary and St Connell are enclosed in a walled graveyard at the east end of the island, clearly visible from the mainland. St Mary's consists of an early 13th century chancel and late medieval nave. The south wall of the chancel has a narrow window with a semi-circular head. A partially collapsed buttress supports the wall. The nave walls include many pieces of dressed stone from the original chancel.

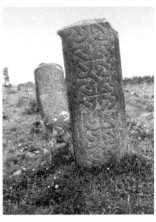
Cross shaft and cross slab, Inishkeel island

A broken grave slab, with a Maltese cross and circle, lies inside the church. Just south of the building is another grave slab with a simple cross and an interesting, asymmetrical, almost labyrinthine, circular pattern around the intersection.

The east wall of St Connell's church is almost at full height and has a distinctive base batter. The narrow east window, splayed on the inside, is finely moulded, though the lintel is a simple flag. The three windows in the south wall are all different and show signs of alteration. They are probably 14th century. Some moulded fragments and a sill from St Mary's church form a simple altar below the east window. A small cross slab sits on the altar. There is also a large flag with a hole in it which has been used for generations as a healing stone.

Outside in the graveyard is a large concave boulder, known as 'St Joseph's bed'. A rest on this stone is considered a good cure for a bad back. South of St Connell's church is a broken grave slab, showing Christ with outstretched arms. There is an angel and a human figure beneath each arm.

To the north east stands a tall slab with a broad band interlace in relief on its east side, and on its west side, a narrow interlace border. It stands over a metre high but appears to have been broken off, and a slight protrusion on one side gives the impression that it might be the shaft of a tall cross.

Inishkeel Cross (known as the 'swan cross')

Just west of this 'cross shaft' is another slab, about 4 feet tall, and rounded at the top. It is carved on both sides. Both faces have Latin crosses made of interlacing with expanded terminals. On one side, two stylised hooded figures in profile stand under the arms of the cross, while beneath the cross two figures stand facing each other

and seem to bow low to an altar, or shrine, between them.

On the other side of the slab, there are two robed figures with two birds (swans?) above the cross, and below it, a horse and wheel, probably a wheeled cart or chariot. There is a similar horse and wheel on the east face of the pedestal of the *Cross of the Scriptures* at **Clonmacnois**.

This use of braiding to form the cross is a feature of two other crosses in Donegal, one called *St Mura's cross* in **Fahan** old graveyard, and the other in a field in **Drumhallagh**, on the west shore of Lough Swilly.

On the north side of the island are two holy wells. One is now dedicated to St Mary, and the other to St Connell. At St Connell's well, it is traditional to drink the water from a shell. When you have made your request, it is also customary to take a stone from the bottom of the small cairn nearby and throw it on the top.

11 Kilcashel Cross Slab

Going west from Ardara, take the road to Loughros Point. About 2 miles along this road, turn right. The cross slab is less than a mile along this road on the left, in Kilcashel graveyard, just beyond Lough Aleen.

The stone is over 5 feet tall with short arms. It is incised with a simple cross with arms reaching some way into these extensions. The arms and shaft are cut across with a short line near their tip. The centre of the cross is encircled. The carved side of the cross is facing south, possibly to face pilgrims as they travel towards Inishkeel. Crosses associated with a monastery would usually face east and west.

There is a similarity to Reenconnell cross (see KERRY). The centre of this cross is also encircled, though this time with a double circle. It is interesting that both are associated with St Connell, and the siting of both on the west coast might imply that the connection lies by sea (*Donegal: History and Society*, Chapter 2. Michael Herity).

Loughros peninsula lies between Inishkeel in the north and Glencolmcille further south. There is a concentration of early Christian cross slabs and cross engravings on boulders and rock on the peninsula, and there is an old tradition of a linear turas between Glencolmcille and Inishkeel. It is called 'Turas Chonaill', or 'St Connell's Pilgrimage', and is said to follow a route taken by St Connell, or Conall Caol, the 6th century founder of the monastery on Inishkeel. The 6th century is certainly a possible date for these carved crosses.

Most turas follow a circular route so that the pilgrim finishes up at the place where they began - only the person is transformed.

Another example of a linear turas would be the journey from Ballintuber to Croagh Patrick. (see GALWAY)

Access from the starting point at Inishkeel, across to the mainland, is only possible at low tide and the turas continues onto and off the Loughros peninsula, across sands also only accessible at low tide. It is said, of course, that St Connell managed all three crossings on the same tide!

12 Kilclooney Dolmen

Travel 4 miles north from Ardara to Kilclooney and park by the church. Take the path to the left of the graveyard outside the wall. It crosses in front of a house where you can knock for permission to continue. Then follow the track until one of Ireland's most beautiful megaliths comes into view. Like all good dolmens, it just appears suddenly out of the landscape.

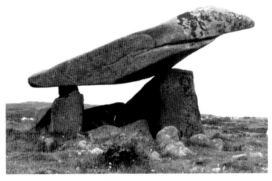

Kilclooney dolmen

The portals are 6 feet tall with a massive 20 foot cap-stone angled like a giant bird poised for flight. Fragments of undecorated neolithic pottery were found inside the chamber. To the west is a tiny second dolmen, partially collapsed, but with a well-preserved chamber. Both chambers face east and both have low entrance sills. Both are thought to have been within the same east-facing cairn, though they are now separated by a modern field wall.

To make a wish, you must kiss the cap-stone. It works.

Doon Fort

Going west from the small coastal village of Portnoo, turn left after Pond Lough. Access to Doon Lough is marked up a lane on the right. You hire a rowing boat at the house. The land here is hilly and although the lake is small, the fort is not visible from the shore. Row out into the lake until you pass the headland to your left.

Suddenly the fort is there like a giant barnacle almost covering the tiny island that supports it. Its walls, hoary with lichen and up to 13 feet thick, present an impenetrable front, except in the south south east where a single break in the wall, 6 feet wide, gives access to the interior. However, for the amateur sailor, negotiating disembarkation is the first challenge.

The fort is slightly oval and appears to have been built to the exact shape of the island. The walls are 16 feet high on the outside and inside access to the parapet is by four sets of four short flights of steps. There is a passage inside the walls at the entrance.

This fort does not protect inland waterways or rise above tribal lands. It nestles, out of sight, in a lake which is itself almost invisible. This gives the place a very magical quality, and the approach, accompanied only by the sound of lapping oars echoing across the water, allows the atmosphere to remain undisturbed.

It is associated with the O'Boyle family and probably dates to the late Bronze Age.

13 Tory Island

The island is 7 miles north of Bloody Foreland, the north west tip of Ireland. Ferries run from Bunbeg or Maheraroarty.

The word Tory, or 'tóraí', means 'outlaw'. This name has also come into the English language as the Tory party in Westminster. It was the name given to the renegade supporters of the succession of James II to the throne of England.

Tory Island has long been held to be the last outpost of that mythological race, the Formorians, perhaps the earliest people in Ireland. They seem to be an indigenous people whose very different aboriginal culture came into conflict with the new farming followers of Nemhedh. The Nemhedhians defeated them at first and destroyed the great mythical glass tower of Conand on Tory. Conand, leader of the Formorians, was killed, but later, when Nemhedh too was killed, the tables were turned and his followers fled, scattered across Europe, some northward, others to Greece.

The Formorians are generally cast as giants, demonic and malevolent. They have each only one eye, one arm and one leg. Pushed to the coastal fringes by Nemhedh, they became cruel pirates, collectors of brutal taxes, including the children of their victims. This tax was collected each Samhain (Halloween), a time when people are vulnerable to incursions from a malevolent Otherworld. The Formorians became the dark Otherworld gods living on the western fringes of the world.

They remained a powerful force and held the recently

returned Nemhedhians, now called the Tuatha Dé Danann, in thrall, until the arrival of Lugh. Lugh was half Formorian, but he became the champion of the Tuatha Dé Danann, driving the Formorians once more to the very edges of the country, and killing his grandfather, Balor, in the process.

The leader of the Formorians, Balor of the Baleful Eye, had as his stronghold the promontory fort at the east end of the island. He had only one eye. Balor was under a curse that he would die at the hands of his grandson. To pre-empt this terrible fate, he kept his daughter Eithne imprisoned in a tower on the island so that she would never bear children. However, Cian, son of Dian Cécht, the healing god of the Tuatha Dé Danann, seduced her and she bore triplets. When Balor discovered his grandchildren, he ordered them to be drowned, but Lugh was rescued and fostered by Manannán mac Lir, the Son of the Ocean. He came of age just in time to rescue his father Cian's people from certain defeat at the hands of the Formorians. (see the **Battle of Moytura**, SLIGO)

The Formorians remained on the western fringes of the world and they continue to be associated with Tory Island, off the Donegal coast, into modern times.

In Celtic times, Tory became a strong Druidical centre. When they wished, the Druids could apparently control the weather there, and make the island disappear at will. In time it became a great challenge to Colmcille, whose birthplace, Gartan, was only about 40 miles away. He decided that the time had come to break their power.

The story goes that Colmcille and three other saints, Beaglaoch, Fionnán and Dubhthach, gathered on the top of

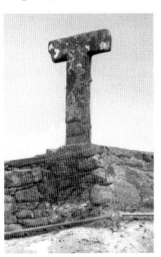

The Tau cross, Tory Island. (Temporary scaffolding during pier extension.)

Cnoc na Naomh, 'the hill of the saints'. It was a sunny day, with Tory clearly visible across the 7 miles of sea. Colmcille suggested that each of his friends throw their staff across the water and whichever one of them succeeded in throwing it onto the island, should be the one chosen by God to take Christianity there.

Beaglaoch threw first, invoking his own strength and that of God. His staff fell on the mound, now called Tullagho-begley, 'Begley's mound'. He founded a church there. Fionán and Dubhthach each threw

theirs with a similar invocation. Fionnán's fell near the water's edge at the place now called Ray. His staff hit a rock and a spring appeared. He chose this place to build his church. Dubhthach's staff fell on one of the islands just offshore. It is now called Inishdooey, and the ruins of his church can be found there.

Colmcille then threw his staff, calling first, "with the help of God and by my own strength this staff will go to Tory". It did. And this is how Colmcille is said to have come to convert the islanders of Tory to Christianity.

It was not easy. The king, Oillil, would not allow him to build a church so he asked for just as much land as his cloak could cover. Oillil agreed to this modest request and watched as Colmcille's cloak grew and spread over the entire island. There was no looking back. Colmcille won the islanders to the new religion and his monastery flourished here until it was sacked in 1595 by the then Governor of Connacht, George Bingham.

There are a number of relics of the Columban foundation still on the island. Most of these are clustered near the stump of a round tower which is now about 50 feet high. There is a stone slab, called 'Colmcille's pillow', which is said to hold the imprints of his fingers. Water collecting in these depressions is believed to ease the pain of childbirth. There is an altar nearby, called 'St John the Baptist's Altar'. Prayers would have been said here by the islanders when there was no priest.

The Tau cross near the pier is very unusual. It is T-shaped and 6 feet high, with arms nearly 4 feet across. The only other one in Ireland is in the Burren Centre in Clare (originally at **Killinaboy**). The Tory cross is made from a single block of slate. It is undecorated. There are two cuts on it, said to have been made by someone trying to destroy it. They were given permission to strike it twice with a sword, but the cross remained intact. The Tau cross follows the shape of a Coptic crosier. (see CLARE) It possibly indicates a link between the early Celtic church and the Copts in Egypt. Most of these links are found down the west coast of Ireland in places now considered remote, but which once had much closer contacts with central European culture. The following story at the very least implies a tradition of such faraway contacts.

The king of India is supposed to have heard of Colmcille and sent his six sons and one daughter all the way from India to hear him preach. However, the journey was so arduous that they died shortly after arriving, and were buried together in one grave. The next morning the body of the sister had come to the surface. It was reburied, but surfaced again, and eventually it was decided that she should be buried separately. It is from her grave that the Tory Clay is dug. It is believed to have magical properties to ward off disease,

prevent sea-sickness and keep boats and ships safe at sea. It is also said to banish rats. However, it can only be dug by the head of one family on the island, in this case, the Duggan family.

Tory was bought by a Manchester businessman in 1861. However, he joined the tradition of absentee landlords and gradually the islanders stopped paying rent. In 1884 the gunboat HMS Wasp was sent out from Mayo to collect the arrears. It is said that Paddy Heggerty, then King of Tory, collected the islanders and assembled them at the cursing stone on the cliff. They turned it on the ship which went down with the loss of fifty lives. There were six survivors who were cared for by the lighthouse personnel. A number of graveyards along the mainland coast have graves of crew members washed ashore in their area.

Today the island is known for its artists, most of whom paint island and seascapes in a naive style. They have been dubbed 'The Tory School'.

Colmcille is supposed to have decreed that, with the coming of Christianity to Tory, it would always remain visible from then on. However, the island often disappears from view when the sea mists roll in. Some of the old magic still hangs around.

14 Tullaghobegley Church and Graveyard

In Ballintemple townland, less than a mile south of Falcarragh. Turn inland at the crossroads. Signed.

This is a gentle mound in the river valley with the high mountains of Cloghaneely behind. It is the site of St Beaglaoch's (Begley's) early church. He is said to have visited here in the 6th century with St Colmcille, St Fionnán and St Dubhthach. (see **Tory** above) Beaglaoch's father was Tighernach, great grandson of Conal Gulban and close relative of Colmcille. Fionán and Dubhthach were also related. Each founded churches in the area.

The present ruined church at Tullaghobegley is 13th century. There are many inscribed gravestones from the early 18th century, as well as many earlier unmarked stones.

Beaglaoch's Stone

Take the road south from Falcarragh crossroads. Turn right at the next crossroads. About a mile along, there is a lane up to the stone, accessed through a farmyard with a new shed on the right.

In his enthusiasm to convert the local king to Christianity, St Beaglaoch apparently antagonised him so much, that he came

after him with some of his men, determined to kill him on the hills behind Gortahork. Beaglaoch took to his heels and ran and ran till he could run no more and still he could hear them not far behind him with their hounds preparing to tear him limb from limb. Realising he could run no further, he threw himself down on his knees on a small stone, wound his black cloak three times round himself and prayed. A blackness descended on the hill, leaving the hunters lost and afraid, allowing Beaglaoch to escape.

From that day on, the chief became a Christian and the rock on which the saint knelt is still there on the hillside with the two impressions of his knees in it. This is Beaglaoch's Stone. It has a reputation for healing warts which works by taking some water to bathe the wart and leaving some silver behind. The water also is said to protect against violent death.

Beaglaoch's Stone

15 Ray church

A couple of miles from Falcarragh on the N56 to Dunfanaghy, you pass a small Church of Ireland church on the left. The old Ray church is down a small road about a half a mile later. You can see it across fields from the road.

This church was destroyed by Cromwellian soldiers in the 17th century and the congregation massacred. It was in use as a Church of Ireland church until the 19th century.

Ray church and cross

Inside there is a huge plain stone cross said to have been carved from a single slab taken from nearby Muckish Mountain. It was said to have been made for Colmcille's church on Tory, but was given by him to St Fionnán for the church at Ray. Some say it was to thank him for retrieving a lost manuscript, but others say that perhaps he realised it was too big to take across to Tory!

16 Churchill

From Letterkenny take the R250 to Glenties and fork right to Churchill and Gartan Lough.

The lake is fringed with green fields and woodland, a small fertile pocket of land surrounded by granite hills and silent blanket bog. This is the birthplace of Colmcille (pronounced 'colmkill' and referred to as 'Columba' in Scotland and England), Prince of Tirconnell, and tireless emissary of Christianity who leapt from mountain tops and performed daring feats of magic to win the hearts of a people accustomed to the mythic heroes of the past. (Much of the detail contained in these next pages comes from an excellent book, written by a local school teacher, Christy Gillespie, called *St Colmcille, Gartan to Iona: A life's Journey*).

Colmcille was born here around 521 AD, son of Feidlmith and Eithne and great, great grandson of Niall of the Nine Hostages, one of Ireland's most powerful leaders. Conall Gulban, his great grandfather, was Niall's son by his second wife. Her descendants were called the Northern Uí Neill, while the descendants of Niall's first wife became the Southern Uí Neill. There was great rivalry between the two branches of this powerful clan and for centuries the high kingship passed back and forth between them. Colmcille was a descendant of Conall Gulban and therefore of the Northern Uí Neill.

Conall Gulban created the kingdom of Tirconnell, now Donegal. He is said to have become a Christian when St Patrick inscribed the sign of the cross on his battle shield.

Shortly before Colmcille's birth, his mother Eithne had a dream in which an angel showed her a beautiful cloak of many colours. Eithne touched it but the angel took it away and she watched with disappointment as it floated from her. Then, as she watched, it grew in size and spread out to cover all the surrounding land. The angel explained that this cloak symbolised her child who would not remain long with her but was destined to be a great spiritual leader who would touch many people.

Just before the birth Eithne is said to have been directed to a special birth stone by another angel. While she accompanied her kinsmen who were carrying the stone to her home, she began to haemorrhage, her blood seeping into the bare ground. At this spot today there is a fine clay which can only be lifted by the descendants of Eithne's kinsmen, the Friels. The clay offers protection against drowning, burning and sudden death as well as the pains of childbirth and 'every kind of distemper', to anyone who carries it on their person.

Colmcille was baptised and cared for by his foster father who was a priest and he seems to have been trained from an early age

for a spiritual life. He went to Movilla, in County Down, to the monastery of St Finnian, where he was made a deacon. He also went to Clonard in Meath, where he was ordained a priest, and he spent time in his mother's country, Leinster, studying under the Christian Bard, Gemman. He finally returned to Derry where he was given land by his people, the descendants of Conall Gulban, and he founded his first monastery here at Daire, probably around 556 AD. (see DERRY) He went on to found 37 other monasteries over the next few years.

The Annals of the Four Masters records that there was a battle at Cúl Dréimhne in Sligo, in 561. It was a terrible battle in which 3,000 people were killed. The most commonly given reason for the battle was this: while visiting the monastery at Movilla, Colmcille, now an abbot, had borrowed a manuscript. St Finnian, suspecting foul play, sent a young monk to find him and the monk, peering through a crack in the church door, saw Colmcille alone, except for his pet crane, busy copying the manuscript while the pages appeared to be illuminated by a miraculous light which emanated from his fingers. Colmcille, aware of the monk, sent his crane who pecked at his eye through the crack in the door. The monk ran to St Finnian who healed his eye and eventually took his grievance over the copying of the manuscript, without permission, to the high king for judgement. The high king was Diarmuid Mac Cerbhaill, of the southern Uí Neills, and he judged in favour of Finnian with the words: "To every cow its calf, to every book its copy." This was the first recorded copyright law case.

Other accounts say that the king had killed one of his young hostages who was under Colmcille's protection. There is some suggestion that the boy had killed Diarmuit's son in a hurling accident, but even so, the killing of a hostage was a serious thing and Colmcille may have felt it was his place to avenge it. The high king's ruling against him may have further soured relations between the two Uí Neill families. The people of Connacht sided with Colmcille and the northern Uí Neills, and Diarmuit and the southern Uí Neills invaded Connacht. The northern Christians rallied. They used the copied Psalter as their 'Cathach', or 'battle standard', carrying it three times around their soldiers before the battle. Diarmuit's Druids drew a magic line of defence around his soldiers, but a great fog came down enveloping the battlefield, and when it lifted, 3000 of his men were dead. Colmcille and the northern Uí Neill had won.

A church synod was held to determine the extent of Colmcille's responsibility for the bloodshed. Whether his subsequent exile was self imposed or a judgement of the synod, Colmcille took council with Molaise on the island of Inishmurray,

and left Ireland. He sailed till he could no longer see any of his beloved Ireland. It is said that he vowed not to return until he had converted as many souls to Christianity as had been lost on the battlefield. He reached Iona and the second phase of his career.

Laknacoo, 'the flagstone of loneliness', Gartan

Laknacoo or Leac na Cumha (flagstone of loneliness)
Sign from Gartan Lake.

This stone is said to have been blessed by the saint and used as a cure for heartache and sorrow. A large slab with many cup marks, it sits beside a small semi-circle of upright stones and looks as though it may have been the cap-stone of this small prehistoric cairn. Colmcille is supposed to have lain here before leaving Ireland, and it has traditionally been visited by people before leaving the area, to lift the pain of homesickness. The cure involves spending the night on the stone. In the past people also drank water from a bullaun stone nearby. Unfortunately this has disappeared.

It was the scene of much anguish after the Derryveagh evictions in 1861, when 47 families were made destitute. 143 young men and women left from here in January of 1862 to settle in Australia. Ironically, just beside the stone, is a large cross erected in memory of Colmcille by Cornelia Adair. It was her husband, John George Adair, who was the landlord of the area at the time of the evictions.

Colmcille's Abbey

Past Laknacoo, the site is visible up on the left, with Lough Akibbon on the right.

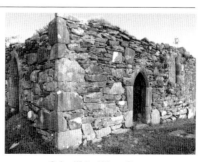

Colmcille's Abbey, Gartan

The old name for this site is 'Ráth Cnó', 'the fort of the nuts', and there would originally have been a circular enclosure surrounding the home where Colmcille was born. If you climb to the height behind the graveyard, you can see the

probable extent of the enclosure, as well as one of the worn stone crosses that marked the later monastic site. The other cross is lower down, near the entrance.

In the graveyard are the scant ruins of a small church, known as 'the abbey' although there is no record of an abbey here. In front is a tiny church, or oratory, measuring about 15 by 20 feet. There is no roof, but the altar is covered with small offerings. This church was built in the 16th century by Manus O'Donnell, a descendant of Colmcille. There is an enclosed well on the way up to the site.

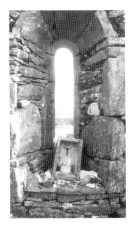

Altar, Colmcille's Abbey, Gartan

The best part of this site is the view. It looks out across the valley and the three lakes: Lough Akibbon below; little Lough Galliagh, meaning the 'lake of the nuns', and Gartan Lake.

A turas is still made at this site and new stone markers number the stations.

17 Eithne's Well

From Kilmacrenan to Creeslough on the N56, turn right at the sign for Barnes Quarry. Less than 0.5 miles up this road, it bends to the left while a lane goes straight ahead. Take the lane on foot.

A little way up on the right, is a piece of raised ground, a cillín, or children's burial ground. This was the place where unbaptised children and adults were buried as they were not allowed within the consecrated ground of the church graveyard. Older sacred sites were often chosen for cillins. A little further on, there's a slim standing stone, just over 4 feet high, on the left. It has a number of horizontal lines on it which may be ogham letters.

Cairn, Eithne's well.

Continue up the lane through several gates to a deserted house. To the right of the house is Eithne's Well. A thorn tree stands beside the well and to the left a raised altar.

Behind and to the right are three stone cairns, two with standing stones at their centre. These are part of a turas still performed here from the 9th June.

It begins on a stone between the altar and the well, which is thought to be where Colmcille knelt. Each cairn is circulated three times with prayers each time and each time a stone is taken from the bottom and put on top of the cairn. You must then wash your feet in the well below the stream before taking some water from the well.

This was at one time called 'Turas na Rí', meaning 'the pilgrimage of the king'. Perhaps this place was visited by the new king as part of his inauguration ceremony at Doon. It has all the necessary components of a Celtic sacred site: a mound, a well, a stone and a tree.

Barnes Lower Standing Stones

Take the lane back to the road and turn right. After about 0.25 mile, just past the turn to the quarry, the stones are in a field by the roadside on the right.

The bigger of the two is 7.25 feet high and nearly 7 feet wide with about 48 cup marks. Some have concentric circles around them and short radial lines. The east face of the smaller stone has eight cup marks and a small cross.

18 The Rock of Doon

Well signed from Kilmacrenan on the N56 going north towards Creeslough. The rock is on the right as you approach the car-park.

This is the inauguration place of the O'Donnell chieftains and used up until 1603, when Niall Garbh was the last to be inaugurated. The old inauguration ceremony involved a winning of the sovereignty goddess by the incoming chief, so that together they could ensure a prosperous and fertile kingdom. In Christian times there was a ceremony in the nearby abbey at Kilmacrenan, followed by a ceremony here. The incoming chief stood on the inauguration stone and took an oath, receiving the 'Slat Bán', a straight white rod symbolising purity and uprightness. A member of the O'Friel family was present as inaugurator, as well as the Bishop of Derry, as successor of Colmcille.

Twenty five chieftains were inaugurated here, beginning with Eigneachan in 1200 AD and ending with Niall Garbh, in 1603.

Although it is only a rock, albeit a big one, the view is wide.

After the ceremony, the new chief would turn, so his people could see him, and also so that he could view his territories.

Doon Well

The well is just beyond the car-park.

This well is not associated with any church or saint. Most pagan wells associated with places of power were adopted by Christian saints who blessed them and built their churches there. This did not happen at Doon. It has always been a pagan well.

About 300 years ago there was a healer in the area, a member of the O'Friel family, called Lector O'Friel. As he became old and frail the people asked him what they were going to do without him, and so before he died, he blessed the well at Doon, saying that it would never run dry and would always be there to go to in times of need.

It is the most visited well in Donegal especially at New Year's Eve and May Eve when there is a night vigil. By the well are some small birch trees which are always heavily laden with personal items that have been left there to effect a cure.

19 Gortavern Dolmen

About 3.5 miles from Milford. From Kilmacrenan take the road past Lough Fern to Milford and on to Carrowkeel on the R246. Turn right in Carrowkeel onto the R247 towards Rathmullen. The dolmen is signed on the right after less than a mile. The last small sign takes you up into a farmyard. Continue up the lane on foot and turn in a gate on the right with a home-made sign. The dolmen is visible from the gate. Cross the field and through a thorn thicket and across a small but tricky gorge and you are there.

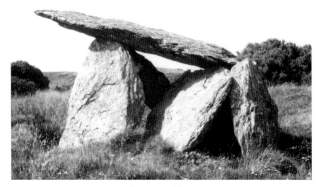

Gortavern dolmen

This is a very elegant dolmen in a wonderful setting. It is in a sheltered valley surrounded by yellow gorse bushes with a view west out into the Broad Water in Mulroy Bay. But it is definitely one for a sunny day!

20 Drumhallagh Cross

Take the R247 north from Rathmullan for about 3.5 miles. Cross Drumhallagh bridge and turn left down a narrow road. Stop at the first right hand bend with a house on either side. Access to the stone is through a gate by the cottage on the left. Permission needed.

This cross slab is about 4 feet tall. The style and shape of its patterned cross is very similar to the crosses at Carndonagh and Inishkeel. It is a little smaller than the other two and considerably more weathered, yet well worth a visit. It seems to be known locally as the 'angel stone'.

On the east face a double band fills the cross with a loose interlace pattern with pointed knots at the arms and shaft. The pattern in the right arm seems confused. Above the cross on each side is an angel with one arm raised. There are two cloaked figures either side of the cross shaft, one holding a short crook and the other, a Tau crosier. There is a Tau cross on Tory Island, one of only two in the country. The Doorty Cross in Clare is the only other image of a Tau crosier. Both are indications of a possible link from the west coast of Ireland to the Coptic monks of Egypt.

On the other side is a Latin cross with a carved boss at the centre and limbs filled with bosses. Each of the four angles contains a carved circular boss.

21 Fahan Cross

Approaching Fahan village travelling south from Buncrana, the old graveyard is on your right just before leaving the village.

The site is signed. There is a carved wheel cross built into the graveyard wall and also a hole stone into which you can place your clenched fist as you make a wish.

The abbey here was established in the 6th century by Colmcille as an outpost of the Columban monastery in Derry and St Mura was his disciple. It fell into disuse in the 13th century and a later building on the site was destroyed in the 16th century. An ivy choked east wall with an elegant three-light window is almost all that remains of a parish church used until 1820.

Just south east of this wall is St Mura's cross, said by some to mark the grave of the saint. It most likely dates to the 8th century. The slab stands over 6 feet tall with small extensions on either side

to suggest arms.The west face has a beautifully complex cross in triple-banded interlaced relief. One strand forms an equal-armed cross with expanded terminals in the upper half of the slab, and a second strand is interwoven through the first and continues to form a long shaft for the cross with a wide plinth at the bottom. Standing on this plinth at either side of the cross are two figures in robes facing each other. Earlier photographs show that each had an inscription on their cloaks though you can't actually see them anymore.

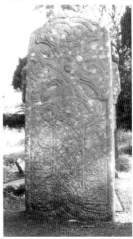

Fahan cross

The east face is carved with a less complex cross, though again there is an equal-armed cross with expanded terminals and a second band of interlacing forming a shaft. A pair of birds with curved beaks sit above the cross and four sets of three concentric circles sit, one between each arm. Both crosses have a small boss in their centre.

On the north side of the slab is a Greek inscription which translates as: 'Glory to the Father, the Son and the Holy Spirit' (*RSAI, 1920*. RAS Macalister).

This broad ribbon interlacing on this cross at Fahan is also a feature of the Carndonagh cross below and the crosses at Inishkeel and Drumhallagh (above). It is also found on the Domnach Airgid (silver book shrine - see **Clogher**, TYRONE). It is also a feature of *The Book of Durrow*, which is dated to around 664 AD. This gives us a possible date in the 7th century for these Donegal crosses.

In the nearby St Mura's church is a beautiful stained glass window by Evie Hone, depicting St Elizabeth of Hungary. In the graveyard are some grave slabs with skull and crossbones, images brought to Ireland by the Scottish settlers in the 17th century.

St Mura's bacall, or crosier, is in the National Museum, Dublin. His bell shrine is in the Wallace Collection, London.

22 **St Patrick's Cross and Pillar Stones, Carndonagh**

Travelling north from Buncrana to Carndonagh, the present Church of Ireland church sits at a crossroads on the outskirts of the town. East of the church, just outside the graveyard, is a stone platform where St Patrick's Cross, also called the Donagh Cross, sits flanked on either side by much smaller pillar stones.

Sacred Ireland *PROVINCE OF ULSTER* 133

ULSTER **Donegal**

The cross is 8 feet high and beautifully proportioned, its shape a little reminiscent of the interlaced crosses on the Inishkeel and Drumhallagh cross slabs. The arms are short and gently curved, with the top half of the cross filled with a finely indented single band of interlacing, forming a cross with equal arms. Beneath it, Christ stands smiling with arms

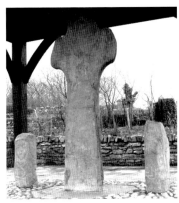

St Patrick's Cross and pillar stones, Carndonagh

outstretched in blessing, rather than crucifixion. There are other figures in profile open to interpretation and also some entwined bird motifs beneath the arms of the cross.

This is a delightful carving, which seems to convey a simple message of beneficence and harmony, placing this stone among the magical, rather than the monumental crosses. It is carved from red sandstone.

The North Pillar

This low stone pillar stands on the north side of the Carndonagh Cross. It has a carving of a seated harpist on its west face. The east face has the outline of a warrior, marked in pocking, as if the carving

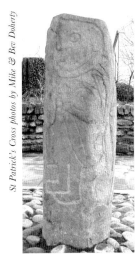

Warrior: East face of the north pillar

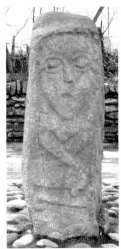

Bell & Book: South face of the south pillar

St Patrick's Cross photos by Mike & Bev Doherty

is not complete. Some sources interpret these two figures to be *David as warrior and harpist.*

The north side has a fish with a bird on its head and there are spirals on the south side.

The South Pillar

On the south side of the cross, this pillar has a figure on its west side very like the Boa Island Janus figure, with pointed chin and crossed arms. However, he carries a bell and a book and has a crosier beneath his feet, which is reminiscent of the much later White Island figures. On the south side is a clear Labhraidh Loingseach figure with big ears. (see **Armagh Cathedral**)

The east side shows a face and, on the north side, a profiled head seeming to disappear into a fish's body - perhaps *Jonah being swallowed by the whale.*

These stones have an interesting mixture of images, mythological and Christian. The style is often naive and quite similar to the Fermanagh carvings. The harpist is very similar in style to the Bishop's Stone at Killadeas.

The Marigold Stone

It stands in the graveyard to the south east of the church and is 5.5 feet high and 1.4 feet wide.It is thought to date to about 600 AD, a little earlier than the three crosses of Fahan, Drumhallagh and Inishkeel, but there are a number of similarities.

It gets its name from the seven-petalled flower on the west face. It is enclosed in a circular border with an ornate key-patterned handle, ending in two large loops. This is thought to be a flabellum, or liturgical fan, carried in churches on ceremonial occasions. Two figures stand facing each other, one on either side of the handle. They are similar in style to those on the crosses except that these wear only knee-length garments. The space beneath them is filled with interlacing and key patterns.

The east side shows the Christ figure with arms outstretched on an equal-armed cross extended with interlacing and a tripartite knot at its base. Christ's head is enlarged

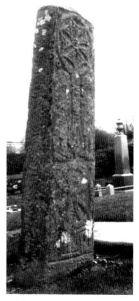

Marigold stone, Carndonagh

and fills the raised protuberance at the top of the slab. Two figures, again with knee-length garments, stand at either side of the cross and again the space below is filled with interlacing and key patterns. As with the Donagh cross, although interpreted as a crucifixion, the feeling here is much more of blessing. The sides of the slab are closely patterned with double-laced knotwork.

A very weathered carved lintel from a pre-Romanesque building, sits on the ground by the west door of the church. You can just make out a wheeled cross and some figures.

Other carved lintels still exist at Raphoe and at Clonca, both in Donegal.

23 Wee House at Malin

12 miles north of Carndonagh. Take the R238 and follow signs for Malin Head.

The Wee House is a small rounded cave in the cliff face up behind the ruins of St Machar's church. There are stone seats around the interior and it is said that, no matter how many people come into it, there is always room for more.

Below the house and church lie the remains of an old fort,

Wee House at Malin

just visible. The rocky promontory has a natural tunnel going through it into the sea. There is a smooth rock in the middle of the tunnel, said to be the saint's chair, and the red rock overhead is said to be his blood where he was killed. There is some confusion as to which saint is being alluded to. The church is dedicated to St Machar, but some say 'the wee house' was the home of St Muirdhealach. St Marue is also connected with this area.

The greatest reason for visiting this place is none of these things, but rather the small beach of semi-precious pebbles smoothed and graded perpetually by the rolling waves. It's a place of contemplation and metaphor guaranteed to change your mood.

24 Glacknadrummond or Bocan Stone Circle

A mile south east of Culdaff village on the R238.
On Mass Hill just behind the parochial house.

The site is called 'Banchan', which means 'pasture'. This wonderful location is the site of a stone circle. Only eight stones are still standing but they seem each to have a different character and shape, and to carry a different energy. There were probably originally thirty stones and there is a local tradition that the rest were taken from here to make the inner circle at Stonehenge.

Across the road, on a low hill, known as Black Hill, is the Temple of Deen, which is probably a court cairn with twenty large stones forming court and chamber.

Marko's Stones

This is the point of cosmic inbreath according to Marko Pogaknic's reading of the energy in this landscape area (see **Marko's Stones**, DERRY). This energy runs from here to Inch Island in Lough Swilly. The energy encircles and one stream returns to Bocan. The other flows to the Grianán. (see below)

There is also an energy line from here which goes through Red Castle on the banks of the Foyle river and continues on to Dungiven in Derry. Marko has placed a stone at Red Castle. It is down a wooded drive to the Red Castle Country Hotel on the shores of the lough.

St Buadan's Cross, Clonca

A mile south of Culdaff. Take the second road on the right about a mile south of Culdaff on the R238. Or go north from Bocan Circle and take the first left opposite the church.
The site is less than a mile down this road, visible on the left.
A small path leads from the road.

This was the site of a 6th century foundation associated with St Buadan. The ruined church was rebuilt in the 17th century and in use until 1827. A very worn carved lintel has been re-used over the west doorway. It is possible to see some figures but not to identify them. This lintel, like the ones at Carndonagh and Raphoe would have come from early stone churches built some time before the beginning of the 12th century.

A very tall cross with short arms stands nearby. Apart from three figure panels, this cross is covered in fine interlace and fret panels, each different. One panel has two large spirals opening towards each other and looking like the coiled heads of two crosiers. It is particularly strange in that it lacks the perfection of the other panels, looking like the work of an amateur by comparison.

On the west side there is a panel with two figures side by side with crossed arms. They are similar in this respect to the west face of the south pillar at Carndonagh and the Janus figure from Boa

Island in Fermanagh. Here they could be two clerics or, as on many other crosses, they may represent St Paul and St Anthony in the desert. Above them two animals sit with their very human-looking heads close together, a mirror image in the animal world of the figures below. On either side, the head of a crosier fills the space above their backs.

On the east side is a very characterful profile of Jesus sitting on a chair and holding up a circular platter with five loaves. Beneath him are two small fishes. This represents the miracle of the *Feeding of the Five Thousand.*

On one of the arms of the cross there is a small figure with hands upstretched in an attitude of prayer.

Inside the shell of the church, a 15th century grave slab commemorates a Scottish gallowglass from Iona (A gallowglass is a professional soldier). It has a finely made narrow curved stick, as used in the Scottish form of hurling, called 'shinty'.

The grave slab was made by Fearghas mac Allain to the memory of Mánas mac Mhoireasdain of Iona.

Carrowmore crosses

Continue south past Clonca to the first crossroads. Turn left and then, almost immediately, right. The Carrowmore crosses are here, one either side of this small road.

These two crosses here on the side of the hill mark the site of an early Christian foundation. The short one is plain and the tall one has a badly weathered carving which some say is Christ in Majesty accompanied by two angels.

Carrowmore cross

Outlines of buildings and an enclosure can be traced in the fields around the crosses. They are especially pronounced around the tall cross. Viking silver was found here: five arm rings were linked together and buried under a stone with carvings on it, by the enclosure.

C o u n t y
TYRONE
P R I N C I P A L S I T E S

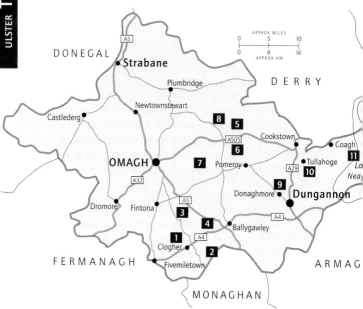

CLOGHER VALLEY

1 Rathmore

 Clogher Cathedral

2 St Patrick's Chair and well
 Ballywholan dual court cairn: Carnagat
 Ballywholan chambered cairn: Carnfadrig

3 Knockmany passage cairn

4 Errigal Kerrogue old church and well
 Sess Kilgreen passage cairn

5 Beaghmore stone circles

6 Cregganconroe court cairn
 Creggandevesky court cairn

7 Loughmacrory wedge cairn
 Altdrumman portal dolmen

8 Dun Ruadh
 Aghascrebagh ogham stone

9 Donaghmore high cross

10 Tullahogue Fort

11 Ardboe cross and abbey

Block figures in list refer to site locations in map and entries in text.

TYRONE

Much of Tyrone is hilly and wild. In the west, the Sperrin Mountains reach north towards Derry. Their foothills stretch across the centre of the county. This area was farmed by neolithic people from about 3500 BC, before over-use and deteriorating climate forced them down to the lower land. The exposed hills became saturated with rain water and eventually the area became smothered in the blanket bog that is still there today.

The centre of Tyrone is littered with ruined cairns and standing stones of all kinds from neolithic and later Bronze Age communities. Stand on any raised ground and, if you know what to look for, you will see them. Here and there, protected for millennia by bog cover, sites have been found undisturbed since they were abandoned by the people who used them. One of the most interesting group of circles in Ulster, the Beaghmore Circles, were discovered in this way.

Another more recently discovered site at Copney is not open to the public yet. Here a number of circles, one slightly ovoid, have been exposed in the bog. They are made of small stones and studded with even smaller ones. In their newly exposed state, the stones are bleached white and from the air they look like ornate jewellery lying against the earthy colours of the bog. In two of the circles the stones are arranged in tight concentric rings and in the other, they are arranged radially. They have small cairns in the middle and stone rows associated with them.

Between Sixmilecross and Omagh, is a small ruined church called Donaghanie. This means 'the church of the horse'. There is a small lake nearby, called Lough Patrick, where an assembly was held in the past. It was said that a tide came on the water at this time and when the water rose up, it could cure any ailment. There is a small cairn of stones near the lake where an angel had been seen with yellow hair and wings that reached right down to her feet. It was also said that a horse rose up out of the lake every seven years. This association between water and horses is a very ancient tradition which is also found in Ulster's biggest lake, Lough Neagh. (see ULSTER)

Running along the south of the Sperrins is the Clogher Valley, linking Lough Neagh in the east to the Fermanagh Lakes in the south west. On its southern slopes stands the wide expansive Slieve Beagh, whose cairn-capped summit rises out of the forests of the Fermanagh/Tyrone border. Its slopes are peppered with prehistoric megaliths. The small town of Clogher is marked on Ptolemy's second century map of Ireland. It has been the site of a great pagan Oracle, the Cloch Óir, as well as a royal seat in the Iron Age, and an ecclesiastical see today.

ULSTER Tyrone

CLOGHER VALLEY

This deep wooded valley in the south of the county runs from mid-Ulster south west to the Fermanagh lakes. It has been an important route linking east with west since early times.

The small town of Clogher sits on a small rise in the middle of the valley. Its name, Cloch Óir, means 'the Golden Stone'. This stone was an ancient oracle, said to be one of the three magical stones of Éireann, the others being the Lia Fail at Tara in Meath and the Crom Cruach at Killycluggan in Cavan. Its voice was called Cermand Cestach, 'the Chief Idol of the North', and the places where the gold and silver were joined to the stone, could apparently still be seen in the 15th century. According to Wakeman, in prehistoric

The golden stone (Cloch Óir), Clogher

times: "the Devil used to pronounce Juggling Answers like the Oracles of Apollo Pythius".

It is possible that, like the Lia Fail, it was also an inauguration stone and used by the kings of Oriel as a symbol of their right to rule here.

Since 1929 the stone has sat in the porch of the Church of Ireland cathedral, no longer covered in gold, but a presence none the less. It must be said that there is some question as to whether this is the original stone. It looks a little like an early stone lintel, but who is to say?

The hills around the town are rich in ancient sites. Slieve Beagh is the great grandfather mountain on the south side of the valley. It has a cairn on its summit, a neolithic passage cairn probably 5000 years old, and is said to be the final resting place of Bith, Noah's son. (see **Knockmaa**, GALWAY) There are a number of court cairns on its lower slopes. Its powerful presence was also acknowledged by St Patrick. This is held to be one of the seven places where he left a perpetual guardian to watch over the people of Ireland until the end of time. (see **Slieve Donard**, DOWN)

On the north side of the valley is Knockmany passage cairn

with its decorated sandstone chamber, as well as the Sess Kilgreen cairns further east.

Rathmore, in Clogher town, is only one of over thirty raths or ring-forts in this part of the valley, taking the history of the area into more modern times. And finally Clogher's medieval cathedral, St Macartan's, takes us into the present.

The town of Clogher is now scarcely more than a village. It has a quiet ancient feel about it, surrounded as it is by sacred sites where people have, in their different ways, reached out beyond everyday consciousness for over 5000 years.

1 Rathmore

Visible on high ground just behind the cathedral. The access path is beside the primary school.

The name Rathmore means 'the great fort'. The earliest part of this site is the hill-fort which probably dates to sometime between 100 BC and 100 AD. Some Roman jewellery and some sherds of an amphora (a pottery wine jug from the Mediterranean) were found during excavations in the 1970s, implying that the people of Clogher had trading links at least with southern Britain, if not further. Rathmore at Clogher is marked 'Regia' on Ptolemy's map of Ireland, which was drawn in the 2nd century AD.

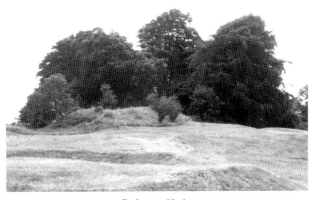

Rathmore, Clogher

From the 4th and 5th centuries this site was the seat of the kings of Oriel or Airghialla. Tradition has it that sometime around the end of the 4th century, the last Ulster king of Emhain Macha (see ARMAGH) was killed by three warriors, known as the Three Collas. They are said to have burnt Emhain Macha and driven the Ulaid or Ulstermen eastwards. The Three Collas established the kingdom of Airghialla here in the middle of Ulster, with Rathmore as their seat.

Some time later a ring-fort was built inside the greater hill-fort and excavations in the 1970s identified a small barrow, now visible on the south side.

The fort is now a high grassy mound with a bank and ditch. It is lightly wooded with mature beech, sycamore and lime.

Clogher Cathedral

Below Rathmore, beside the road.

St Patrick is said to have passed this way and founded the first church here, which he left in the capable hands of his friend and champion, St Macartan. Apparently, as they were travelling from Clogher to Armagh one day, Macartan was carrying Patrick across the ford at Augher. He groaned and told Patrick that he was too old to be still travelling from place to place. Patrick took pity on him and made him bishop of Clogher. He also gave him the 'Domnach Airgid', the 'Silver Shrine', which was kept here for centuries. It contained a copy of the Gospels in Latin. Since 1847 it has been in the Royal Irish Academy in Dublin.

Clogher developed into a monastic community. Little, of course, is left of the early monastery, though the remains of two high crosses, decorated with knotwork and bosses, stand to the west of the building. They are thought to date to the 9th and 10th centuries.

Another remnant of earlier times (probably 7th to 8th century) is a sundial about 5 feet high. It is now standing inside the cathedral. It is sometimes referred to as a cross slab, as the shaft widens slightly to hold the dial and becomes narrow again at the top, giving the impression of short arms. The dial face sits above ribbon interlacing which broadens to support it from below. There is a small inter-laced panel above the dial as well. It is very similar to the cross at Carndonagh, in Donegal. Interestingly, there is a connec-tion between the two places, as St Patrick is said to have stayed for forty days at Domnach Mór Maige Tochair (**Carndonagh**), and left behind him MacCairthinn, a brother of St Macartan.

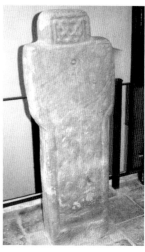

Sundial, Clogher Cathedral

(*Tripartite Life of St Patrick*)

At the base of the sundial shaft is a fish: symbol of mystic knowledge in Celtic Ireland and later symbol of Christian discipleship. The sundial was an important part of most early monasteries as they divided their day between work and prayer.

The other side of the stone has a plain border around the centre and shaft, with ribbon knotwork in the centre and a badly worn head at the top. The head appears to have strongly incised curls or ears. This is one of only four sundials in Ulster, the others being at Bangor, Nendrum and Saul (now lost).

The cathedral itself is a small classical building dating to 1744, broad and simple and very pleasing to the eye. It has some fine stained glass.

If the church is locked, phone: 028 855 48235 for the Deanery or 028 855 48288.

2 St Patrick's Chair and Well

Signed on the left about 5 miles out of Aughnacloy on the A28 to Augher. The site is about 3 miles from here, well signed with a small car-park.

This is Altadaven on the north eastern flank of Slieve Beagh. Its name means 'the cliff of the demons'. Follow the arrows through the woods. When the path forks, either way will get you there, as it is a circular path. St Patrick's chair is a massive and well worn stone in the

St Patrick's chair

shape of a seat with back rest, a seat of dimensions more suited to a giant than a saint. It sits on a high ridge surrounded by other enormous boulder stones, like the ruins of some giant temple. There are a number of cup marks on these stones.

Below the ridge, visible from the chair, is the well. It is a bullaun: a deep, smooth, circular depression cut in a huge stone. Clooties (rags) flutter from branches above the well stone and all around are mossy crevices and ferns.

On the Sunday after the 26th July, which was called locally 'the Big Sunday of the Heather', a gathering was held here well into the 20th century. Everyone

climbed the rock and sat in the chair to make a wish. Pins and pennies were left at the 'well' which magically remained at the same level. It filled up again miraculously within half an hour of being emptied. Blaeberries (bilberries) were picked and dancing and sports took place on the grass below the chair.

According to local tradition, Patrick was passing this way as he journeyed from Clogher to Armagh, when he came upon a pagan rite being performed at this site. Instead of destroying the rock as he did at Killycluggin, he merely banished the pagan spirits to a nearby lake. He then preached from the chair and, needing water to baptise the people, he ordered water to come from a rock. This was the origin of the well. (*The Festival of Lughnasa*)

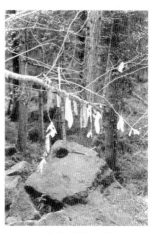
St Patrick's well

The Big Sunday of the Heather seems to be an ancient Lughnasa assembly which has been brought into Christian times and the stone at which people meet has been Christianised by its renaming and by the story of Patrick's visit. In spite of this, the wooded hill, stone seat, and well provide all the elements of an ancient sacred place. There are a number of cairns to the south of here. Two are described below.

Ballywholan Dual Court Cairn: Carnagat

Continue south past the Favor Royal Estate for about 2 miles and the hill of Cullamore (see The Legend of Knockmany, *below) is on the right. About a mile further on, the road turns sharply to the right. Pass 2 lanes and fork right, which takes you round the hill to this well-preserved monument.*

This site overlooks the valley of the Fury river. There are semi-circular forecourts at each end leading to two chambered galleries which share a common endstone. It was partially excavated in 1899.

Ballywholan Chambered Cairn: Carnfadrig

Go back to the fork and turn left. Just over a mile later, turn left again and the site is about 0.5 miles along on the right above the road.

Carnadrig or Carn Patrick is so named, like St Patrick's Chair and Well, from the association of this area with the saint as he passed from Armagh to Clogher. There is a local story that the saint lost a wheel from his chariot in this place.

This is a long narrow cairn with a large chamber at the east end reached through portals and over a sill. There are two side chambers at the west end.

This site was excavated in 1897 and human bones and flint were discovered and some sherds of undecorated pottery. (*Monuments of Ireland*)

3 Knockmany Passage Cairn

A key can be obtained from the local forester phoning the central office in Enniskillen and making an advance arrangement. Phone 028 6634 3140. Turn north onto the B83 in Clogher's main street by the police station. It is signed after about 1.5 miles. The narrow hilly road is called locally 'Mad Woman's Leap', and Lumford's Glen is signed off on the left. The road stops at a small parking space and a lane through the woods takes you on a spiral path to the top of Knockmany Hill where the view opens out across the Clogher Valley to the south.

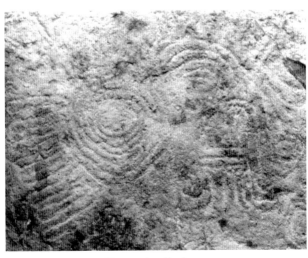

Stone carving, Knockmany

The stones have been enclosed in a modern cairn-like shelter erected in 1959 to protect them, hence the need for keys, though the stones can be seen through the locked gate. Inside the shelter there are some 13 sandstone slabs forming a large chamber with almost no passage. Originally it was covered by a stone cairn

earthed over and with stone kerbing. Some of this has been re-created by the modern shelter.

The carvings on the warm sandstone slabs are magnificent. They are complex and extensive, yet they have a great fluidity about them. Excavations revealed cremated bone, some flints and a single pottery sherd.

This cairn is aligned due south and faces directly towards Loughcrew, some 50 miles away. From its elevation, it is aligned to the midday sun and could be used to map the year by the angle of the sun at midday which is at its highest in midsummer. The stone to the left of the endstone and at right angles to the chamber has a series of horizontal lines which might mark some of these positions. The cairn, called W, at Loughcrew, has its floor sunken so that it can also mark the midday sun. Its endstone also has parallel lines. (*The Stars and the Stones*)

The cairn with its doorway into the hill is a fairy mound and very evocative. In local tradition this was the home of Fionn mac Cumhaill who, in local lore, was a giant. The Knockmany legend tells how he returned home to his wife one day from his work on the Giant's Causeway, fearful because another giant, Cúchulainn, had sworn to find him out and fight him. Cúchulainn was so strong, he was known to have a tame thunderbolt in his pocket. Fionn was shaking with fear. He sucked his thumb, which allowed him to see into the future, and he saw Cúchulainn on his way.

Úna, his wife, thought up a plan. She had her sister, who lived across the valley at Cullamore, throw her over some butter. The first throw didn't reach, as she forgot to say the appropriate spell, and in anger she turned the butter into a grey stone which lies there to this day with a curse on anyone who tries to take it. Undaunted, Úna borrowed 21 iron griddles and baked them inside twenty-one loaves of bread, and made a large pot of curds. She made Fionn dress in baby clothes and lie in the cradle before Cúchulainn arrived.

When he came in the house, the whole hill shook beneath his feet, and Fionn trembled in the cradle. Úna offered him the bread and feigned surprise when he howled with pain and several teeth fell out. She gave a loaf without iron to Fionn, and when Cúchulainn saw how Fionn's baby could handle the bread that had taken out his teeth, he was afraid. She gave Fionn some curds to squeeze juice from and she gave Cúchullain a white stone, which of course yielded no liquid, and again it appeared that the child could do what the giant could not. Úna made him rip up a great stone to create a well, claiming that Fionn had meant to do it himself. The hollow supposed to have been created by this is now called Lumford's Glen. It is about 0.25 mile long and 400 feet deep. Eventually

Cúchulainn fled, vowing to keep out of Fionn's way in future.

The Grey Stone, said to have been the piece of butter tossed by Fionn's sister-in-law, lies at the edge of the Broad Bog near Augher. It was broken up by two workmen, but true to the curse, one was killed and the now broken stone was left alone. It is possible the butter being tossed across the valley represents the yellow sun which needs to shine exactly into the cairn.

4 Errigal Kerrogue Old Church and Well

On the A5 between Ballygawley and Omagh, turn left just before the sign for Omagh District.

This is a gentle spot overlooking the Clogher Valley and probably a sacred site before St Ciarán chose it as the site of his monastery. Today the remains of a medieval church stand among ancient gravestones, with an unfinished cross to the west of the building.

Some fragments of stone querns have been built into the north wall of the church as part of a restoration scheme. Beside them, also now attached to the wall, is a large and very worn Sheela-na-Gig.

Sheela-na-Gig,
Errigal Kerrogue old church

It is said that when the monastery church was being built, a bullock helped draw cartloads of stone. Each evening it was killed by the builders, eaten, and its bones placed in the nearby well. Each morning it was alive and ready for work again. However, someone called MacMahon damaged one of the leg bones and the next day the bullock was lame. St Ciarán was very angry and said that before the church was finished, the top would fall on a MacMahon. No one knows if his prophesy came true.

St Ciarán's well is across the road to the north east.

Sess Kilgreen Passage Cairn

4.2 miles from Aughnacloy. Going north on the A5, take the Omagh turn on the Ballygawley roundabout. 2 miles from the roundabout is a bridge, shop and school. Ask here for directions.

ULSTER Tyrone

There is an oval chamber here about 11 foot long. The endstone is patterned with a double concentric ring motif with another smaller concentric circle in the centre.

Carved stone, Sess Kilgreen

Martin Brennan points out that when the summer solstice sun is illuminating this endstone, a similar pattern on the endstone at Cairn U at Loughcrew in Meath, is also being illuminated. (*The Stars and the Stones*)

Carvings were noted on several of the other stones when it was excavated in the 19th century, but little survives. Some cremated bone and a perforated axe-head were found in the chamber. (*Prehistoric & Early Christian Ireland*)

In the next field there is a remarkable stone, a single upright. It is about 5 by 4 feet and is thought to have been taken from a cairn. It is highly ornamented with a diagonal line of cup marks right across the stone. The rest of the face is covered with concentric and rayed circles, series of arcs and a spiral near the top.

The word 'green' comes from the goddess Gráinne, appropriately the sun goddess.

5 Beaghmore Stone Circles

10.8 miles north west of Cookstown. From Cookstown, take the A505 west towards Omagh. Turn right to Dunnamore and follow signs to the stone circles. This route takes you quickly from the busy main road to the wild blanket bog on the southern fringes of the Sperrin Mountains. There is a small car-park by the road.

This complex of circles, alignments, and cairns, dated to the early Bronze Age, appears to have been erected on top of much earlier

neolithic field systems. The stones were revealed by turf cutting and partially excavated in the 1940s and again in the 1960s. There is probably much more still hidden beneath the bog.

These wild boggy uplands would originally have been wooded with birch, alder, hazel and oak. The land was then farmed from about 3500 BC by neolithic people. Loss of woodland through farming, combined with a wetter climate, saturated these exposed hills and led, around 1000 BC, to the area gradually being enveloped in blanket bog. Between the neolithic farmers and the growth of the bog, this place became a great Bronze Age ceremonial site. Their stones have been dated to between 1500 and 800 BC.

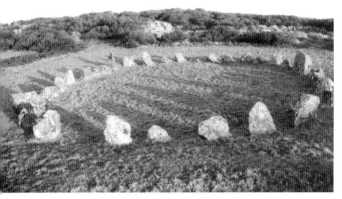

Stone circle, Beaghmore

There are three pairs of stone circles, each with a cairn between or near them. They all vary in size. From these cairns, stone rows run towards the north east. This gives the circles and cairns the appearance of exotic insects with long trailing tails. Some of the rows are made with low stones not over 2 feet high. In some places rows of much bigger stones run parallel to them. At the eastern pair of circles, four stone rows converge on the central cairn from different angles between east and north east. This cairn contained a Tievebulliagh, a polished porcellanite stone axe. (see ANTRIM)

The seventh circle stands alone. It has 884 small stones bristling across its surface, known as 'the Dragon's Teeth'. There is a small cairn on its south west perimeter from which two lines of stones run north east. Altogether, there are twelve cairns. Five of them contained cists with cremated bone inside. Perhaps the others had already been disturbed. Two more circles were recorded on the other side of the road, but are now no longer visible. (*Ulster Journal of Archaeology*. 32. 1969)

Four of the stone rows, or pairs of rows, point to the position

ULSTER **Tyrone**

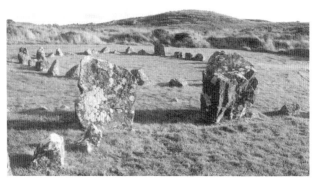

Beaghmore stone circles, with portals in the foreground

of the summer solstice sunrise on the horizon 3000 years ago. One pair of rows from the eastern circles is on this alignment, the other two rows fan out further east. It would be interesting to know the time sequence of these structures, as the dates usually quoted for the whole site come just from one of the cairns, not directly connected to a circle.

This is a wonderfully atmospheric site. It has a bleak beauty about it, a wild sky and sodden landscape which seems to glow anytime the sun appears.

There is a large wedge cairn in Dunnamore village. Go into the village from the A505 and turn left towards the school, instead of straight on to Beaghmore. It is on the right opposite the school.

6 Cregganconroe Court Cairn
12 miles west of Cookstown. It is signed from the A505 Cookstown to Omagh road 5.8 miles from Cookstown.

This court cairn is almost at the end of a long lane on raised ground to the right of the lane. It has never been excavated.

There is a shallow forecourt at the east end with huge portals leading to two chambers with a massive displaced cap-stone. There are two small side chambers to the west or back of the cairn, which would have been accessed directly from the sides.

The sheer size of these stones make this a wonderful site in spite of its dilapidated appearance.

Creggandevesky Court Cairn
From Cregganconroe, go north to the first T junction and turn left at the crossroads. The site is signed on the right just by Lough Mallon. There is a farm gate by the lake and muddy track around

*to the far side where the cairn sits on a small glacial hill west
of the lake.*

The cairn is long and wedge-shaped, diminishing in size from
its wide front. This front faces nearby Lough Mallon to the south
east. There is a deep semi-circular court in front of the entrance
which leads into a gallery divided into three chambers. The
chambers are ovoid, their sides
shaped by large upright stones.
They are separated by jambs
which form narrow doorways
between them. The entrance portals
have a lintel in place and there
are traces of corbelling at the
edges of the chambers. The sides
are kerbed with dry-stone walls.

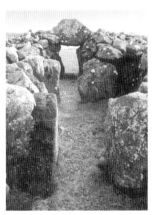

The site was excavated
between 1979 and 1982, when it
was under threat from land
reclamation. Only a few large
stones were visible at the time.
One of these was the lintel which

Creggandevesky court cairn

is still in place. Its long burial beneath the peat has meant that this
is an exceptionally well-preserved cairn. The collapsed cairn material
found at excavation suggests that the cairn was up to 10 feet high.

Cremated bone was found at the front of the court and in front
of the chambers. The remains of five males, seven females, one
adolescent and eight other individuals were found. This makes
twenty-one individuals, which is very unusual, as most court cairns
average two or three individual burials. Pottery sherds, flint tools
and a necklace of 112 stone beads were also found.

Some of the cremated bone was dated to around 3500 BC.
There are at least eleven other court cairns within a 10 mile radius
of this site, which probably means a substantial neolithic
population. However, the area would have been abandoned as
weather and soil conditions deteriorated. Gradually this once
populated area on the lower fringes of the Sperrins would have
become deserted, and nature left to reclaim the landscape. It did
this by smothering the area in blanket bog at the rate of about 3
feet every thousand years. This gives sites like Creggandevesky and
Beaghmore a special quality, as if they have been reclaimed from
the 'Otherworld'.

There are wide views across the bog from this exposed site,
with a small hill called Skelp behind. This hill was formerly
climbed by local people at Lughnasa on the 1st August. They

picked bilberries on the hill and held sporting events on the low ground below. It was known as Skelp Sunday.

7 Loughmacrory Wedge Cairn

From the A505 turn south onto the Loughmacrory Road. The site is about a mile along on the left hand side of the road.

This is a very well preserved wedge cairn with three roof stones still in place. It is on the west side of Loughmacrory Hill which includes on its eastern flank the stone circles at Copney. The entrance faces south west, directly towards the dolmen at Altdrumman about a mile away. The cairn is enhanced by the delightful presence of a fairy thorn growing amongst the stones.

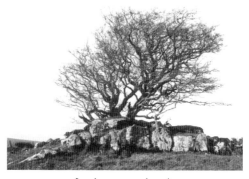

Loughmacrory wedge cairn

To the west is Lough Fingrean with its submerged crannog. A log boat found at the lake is now on display in the nearby An Creagan Visitor Centre. Between the lake and Loughmacrory Wedge Cairn, is a cairn of stones overlooking the lake which may once have contained a passage. Some depressions in the sides look like they may have contained cists from a later period.

This area is peppered with standing stones and ruined cairns. A little further south along this road, there is a possible court cairn beside the road on the right. A mile further on, on the right, are an unexcavated court tomb and a standing stone.

Altdrumman Portal Dolmen

Turn right about a mile south of Loughmacrory wedge and continue into the village, called either Loughmacrory, or Milltown. Turn right in the village and continue north north west down a cul de sac skirting the west side of Lough Macrory. The dolmen is visible through a field gate on the left near the end of the road.

It sits by a stony outcrop on low ground between two small lakes north and south, and hills east and west. Its chunky cap-stone is poised on low pointed portals and an endstone now tilted into the chamber. There is one side stone still in place. The portals face north east, directly towards Loughmacrory wedge.

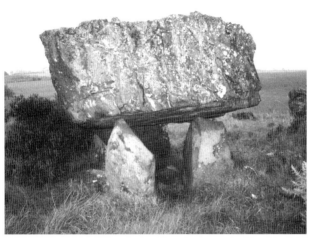

Altdrumman portal dolmen

The Murrins, in Altdrumman townland just north west of the dolmen, was the site of a Lughnasa assembly, called in more recent times, Morrians Sunday. It was a day of sport and berry-picking.

8 Dun Ruadh

This site lies 3 miles due west of Beaghmore and can be approached by returning towards Dunnamore and turning west before the village. Continue for about 3 miles, crossing Crouck Bridge, and stop by the disused school. A lane runs up the side of the school and the site is accessed through a farmyard and two fields at the top of this lane. Permission needed from the farm.

This is an extraordinary site on the gently sloping north east side of the Owenkillew river valley. There is a small clearing at the centre of the site where two fairy thorns now grow together. A little circle of standing stones encircles the trees. This is surrounded by the remains of a large stone cairn up to 7 feet high with some dry-stone wall as kerb to keep the cairn material from encroaching on the central clearing. The cairn opens in the south west to make an entrance into the centre, which was at one time cobbled. Around the outside of the cairn there is a henge, a wide earth bank, which is thought to be the oldest part of the site.

Archaeologists found a number of pits under the cairn with stones, charcoal, flint and neolithic pottery. There were similar remains found under the henge. The cairn itself contained 13 cists which held cremated bone and Bronze Age pottery. This has led people to think of this as a Bronze Age site, although the stone cairn with its central clearing looks very like a passage cairn which has been almost denuded of its stones. It seems that the disused school near the road, which was built in 1877, used stones pillaged from the cairn.

Dun Ruadh

Whatever its origins, it is a magical place. The henge forms a barrier with the outside world and the passage into the clearing gives a strong sense of entering a sacred place.

Aghascrebagh Ogham Stone

Back by the old school, continue north west for about 0.5 miles to the first staggered crossroads. Turn left here and take the next left (straight ahead is Greencastle, 1.3 miles and Gortin, 7 miles). The fields here slope away on the left down to the Owenkillew river just across from Dun Ruadh. The stone is signed on the left less than a mile down this road. There is a small parking place and picnic bench.

Ogham stones are rare in Ulster and this is the only known example in Tyrone. The inscription reads DOTETTO MAQI MAGANI. Aghascrebagh means 'the field of writing'.

9 Donaghmore

At the top of the village which is on the B43 between Dungannon and Pomeroy.

This massive sandstone cross stands sentinel below the old graveyard at the top of the main street. It is made from two different crosses and stands over 15 feet high. The two pieces can be distinguished by their slightly different mouldings, but the similarities between the two parts suggest that they both came from the same monastery. The carvings are weathered now, though many of the scriptural scenes are still quite clear.

The base is rectangular and stepped with slightly inclining sides. There is a figure of a horse and rider on the west side.

The west face has Old Testament scenes, including Adam and Eve, Cain and Abel, the Sacrifice of Isaac, and Daniel in the Lions' Den. At the centre of the cross is a multiple boss pattern.

The east face has a crucifixion scene at the centre and New Testament scenes on the shaft. These include the Angels Appearing to the Shepherds, the Three Wise Men, and the Baptism of Christ.

The sides of the cross have circular and lozenge-shaped panels with ornamentation, and a lizard-like figure at the end of the cross-arm on the south side.

A replica of this cross has just been erected in the graveyard behind the original. There are also some interesting 18th century grave slabs here and a bullaun stone beside a fairy thorn.

10 Tullahogue Fort

Probably originally an Iron Age site, this earthwork sits high on a rounded hill, 2 miles south south east of Cookstown, to the east of B162. There is a small car-park and concrete path up the hill.

Tullahogue means 'the mound of the young men'. The banks of this earthwork are planted with mature trees, making it clearly visible for miles around and helping to contain a quiet sense of place inside. The entrance is in the north, through the outer bank, opening onto a clear circular space which runs right around the site between the outer and inner banks. A causeway leads from this ring to a gap in the inner bank and into the centre. Its inside diameter is 100 feet.

Unlike a two-banked or bivallate rath, this earthwork has no ditch outside either bank to impede entry and so make it a defensive site. The space between the banks is too wide for that

purpose. It seems more like an elegant walkway.

Perhaps it was just that. We know that from the 11th century, this was the inauguration place of the Cenél nEógain (the O'Neills) of Tyrone. The O'Hagans were their stewards. They would have lived nearby and been part of, or performed the ceremony.

Hugh O'Neill was the last chief to be inaugurated here in this seat of power in 1593. Richard Bartlett's pictorial map of 1601 shows the site with two gateways, two thatched buildings and the inauguration seat outside the enclosure on the hillside to the south east. The stone or 'seat' used for the inauguration was said to have been blessed by St Patrick. Perhaps before this, it had similar oracular powers to the Cloch Óir at Clogher. It must certainly have had a powerful ceremonial presence.

Between the banks, Tullahogue Fort

Another pictorial map shows the inauguration ceremony. The O'Neill chief sits in his chair with seven people assembled around him. Their fur collars and knee-length cloaks give them an air of affluence. One man has his hand on the seat and another holds an object above the chief.

The stone was smashed by Lord Mountjoy in 1602, while he was advancing against the O'Neills in Ulster. This was part of Queen Elizabeth I's campaign to destroy the last strongholds of Gaelic sovereignty and consolidate English authority in Ulster. It succeeded and Hugh O'Neill surrendered. Conditions under English rule proved intolerable, however, and the Flight of the Earls took place a few years later, when the last two great Gaelic chiefs fled to Rome with their followers, hoping to raise an army for their cause. Neither was to return. Hugh O'Donnell died a year later of malaria, aged 33, and Hugh O'Neill died 9 years later, aged 76. Ironically, Queen Elizabeth also died. She died on the 24th March, six days before Hugh O'Neill's surrender.

ULSTER Tyrone

11 Ardboe Cross and Abbey

Take the B73 east from Cookstown to Coagh. Go 5 miles east of Coagh towards The Battery. Turn left just before Lough Neagh.

The present ruin is a modest 17th century church built on a small eminence overlooking Lough Neagh. This slight rise gives the place its name, for Ardboe means 'the high place of the cow'. The church was built on the site of a 6th century monastery associated with St Colman. His relics were preserved at this abbey for centuries and pilgrimages made here on his day: the 21st February. The monastery was destroyed by fire in 1166.

At the entrance to the present churchyard stands a massive 18 foot sandstone cross, thought to have been carved in the 10th century. It is finely carved with biblical scenes. The east side has illustrations from the Old Testament. From the lowest panel are: *Adam and Eve, The Sacrifice of Isaac, Daniel in the Lions' Den* and *The Three Young Men in the Fiery Furnace*. There is also an ecclesiastical figure and *Christ in Glory*. The west side has New Testament scenes including the *Three Wise Men, The Marriage at Cana, The Miracle of the Loaves and Fishes*, and scenes before and including the Crucifixion. The south side shows *Cain and Abel, David and Goliath*, and *Paul and Anthony in the Desert*. The north side is too worn to interpret accurately, but possibly shows *The Baptism of Christ*.

The area was also famous for its sacred tree impregnated with coins and pins. Unfortunately this was recently struck by lightning and nothing of it remains.

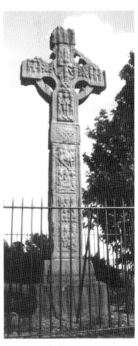

Ardboe cross

There was a pilgrimage to Ardboe Cross on the first Sunday in August until recent times. Apparently, people gathered from both sides of the lake. The rosary was recited at the cross and then everyone washed their hands, feet, heads and faces at the lakeshore. This was followed by another recitation of the rosary at the cross. Individuals could make this pilgrimage any time between the 23rd July and the 2nd August.

ULSTER **Derry**

County
DERRY
PRINCIPAL SITES

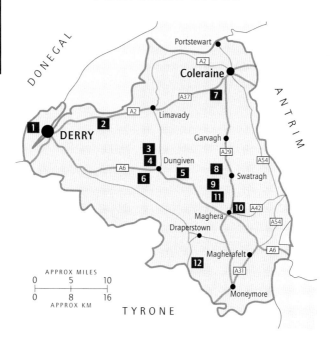

1 **St Columb's Stone**
 Marko's Stones

2 **Eglinton** holy well

3 **Bovevagh** old church and mortuary

4 **Dungiven** priory

5 **Boviel** wedge cairn

6 **Banagher** old church

7 **Dunalis** souterrain and ogham stone

8 **Tamnyrankin** single court cairn
 Knockoneill single court cairn

9 **Slaghtaverty** dolmen

10 **Maghera** St Lurach's Church

11 **Tirnony** dolmen
 Tirkane sweat house

12 **Ballybriest** dual court cairn

Block figures in list refer to site locations in map and entries in text

DERRY

COUNTY DERRY TOOK ITS NAME FROM THE CITY OF DERRY which had its beginnings on a small island inside the deep inlet of the river Foyle. This was an ancient sanctuary, a sacred grove of oak trees on a small island in the north coast of the county. It was called Doire.

The land belonged to the powerful Uí Neill clan who numbered Niall of the Nine Hostages among their lineage. It was into this family that the young Colmcille was born. His calling was apparent from an early age and he chose the life of a Christian priest over that of a clan chief. After years of spiritual discipline and study, he was living in seclusion in Glasnevin, which is now part of Dublin, when an epidemic of the Black Plague broke out. He returned to the north and founded his first monastery in 546 on the island of Doire.

The oak, symbol of Derry

There is a tradition that Colmcille built his first church aligned north south rather than facing east, in order to minimise damage to the oak trees. Later records follow Colmcille's example in their respect for the sacred trees. For example, we know that in 1146 sixty oaks blew down in the gales. This was recorded in *The Annals of Ulster* and again when a hundred and twenty trees blew down in 1178. There were strict regulations concerning their use. They had to be left lying for nine days and then be distributed to people equally, without paying attention to individual merit. (*Celtic Christianity and Nature*)

In time, the water west of the island silted up and Doire was no longer an island. (This area of the city of Derry is now called the Bogside.) The present walled city was built in the 17th century by the City of London Companies' Irish Society. They founded a fortified city here as a commercial and industrial centre for the new Scottish settlers brought over by James I.

Inland the vast expanse of the Sperrin mountains stretches south into Tyrone. These mountains were once the fertile farmland of neolithic settlers. Their cairns and dolmens still stand up in the hills. Their lower slopes have sheltered the first Bronze Age people and their stone circles and cairns are spread out across the lower slopes. For thousands of years these sites have been smothered by an ever thickening layer of blanket bog.

MARKO'S STONES - THE DERRY/DONEGAL LITHOPUNCTURE PROJECT

This piece of landscape sculpture is the work of Slovenian artist Marko Pogacnik. His wife, Mareka, and his daughters, Ana and Ajra, also worked with him on the project. It was completed in 1992.

Marko lives and works in Slovenia where he has, for many years, been using his art as a tool for healing the earth. In this project he has attempted to map the flow of different energies within the body of the landscape. Where these energy lines have been blocked or disturbed, his stones act like acupuncture needles to allow the energy to flow freely again.

This project covers a triangular area of the landscape from Bocan stone circle in Inishowen in north Donegal, to Dungiven in

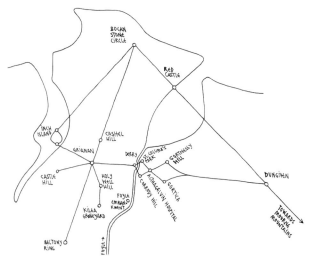

The lithopuncture plan for the Derry-Donegal landscape.

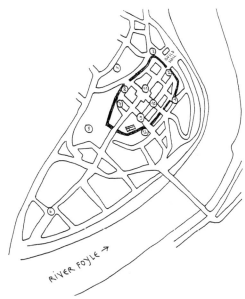

The acupuncture points of the Derry Hill are marked by bronze plates in the pavement of the city.

the centre of County Derry. The other side of this triangle runs from Bocan circle south west to Beltany Stone Circle near Raphoe, also in Donegal. Marko has identified the apex of this triangle as a point of 'cosmic inbreath' at Bocan. Energy flows south west to Beltany circle which is the main point of 'outbreath'. It also runs south east to Dungiven and continues to the Mourne Mountains in Down.

He perceives two other forms of energy lines, those created by water and those he calls 'aquastats', which are created by constant interaction, such as people moving along a particular line.

There is also the soul dimension of the landscape which could be called its inner identity, often recognised here as the sovereignty goddess. In the centre of this particular triangle, she is present as the sun goddess, Gráinne, in the sun temple known as the Grianán of Aileach.

The cosmic energy has three aspects which we can understand as the three aspects of the goddess. The virgin aspect is present in the Donegal landscape at Inch Island in Lough Swilly, the mother aspect is present at the Grianán of Aileach, and the hag or transformation aspect is present at Derry. Energy lines run between and around these points, sometimes dividing into male and female and it is their dance that ensures the well-being of the landscape. The Celts understood this and worked with this energy in their ceremonial marriage or 'Bán Fheis' between an incoming

chief and the landscape goddess. In earlier times this work was less symbolic. The builders of the megaliths were co-operating directly with this energy.

Today there are many things which interfere with the healthy flow of these energies across the earth. In this particular area Marko identified several: the border between Northern Ireland and the Republic; the city walls around the ancient sanctuary of Derry; the destruction of many of the old megalithic structures; military forts and television masts.

During the project a number of granite pillar stones were erected across the landscape, like acupuncture needles to stimulate the energy lines and help in the healing of this particular landscape. Each stone was carved with a different

Princess Macha,
Altnagelvin Hospital, Derry

'cosmogramme', an energy pattern designed to reflect and strengthen the energy in that particular place. In the centre of Derry city, where pillars would be impractical, bronze plates have been set into the flag-stones.

This healing is an ongoing process and these stones are meant to be visited. They are physically beautiful and each has absorbed something of the energy which it is there to stimulate. They have become an integral part of the landscape. And just by acknowledging and appreciating, them we can contribute our energy and become part of the healing process that they have begun.

1 St Columb's Stone

The Long Tower Church is off Bishop's Street, through the city walls from Bishop's Gate.

This 18th century church is on the site of the 'Great Church', built in the 12th century for the town which had grown up around the old monastery. Outside the church, built into a 19th century Calvary tableau, is St Columb's stone.

This bullaun is all that remains of the ancient island sanctuary of Doire. It has three depressions, each emanating a different

energy. This stone was at the centre of Marko's vision of Derry. It came originally from a place called 'the Three Holy Wells', which is down below the city walls, at the foot of the hill on the north west side, now the edge of the Bogside. This would at one time have been the edge of the island.

Marko's Stones

The Three Holy Wells

Three stones stand here marking the original site of the bullaun stone. Marko considered this point to be the key to the Derry/Donegal landscape, in anthropomorphic terms equivalent to the first chakra. According to this model, the Grianán is the belly and Inch Island the head.

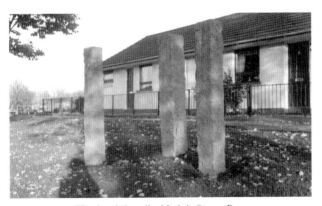

The three holy wells, Marko's Stones, Derry

Corrody Hill

Continue anti-clockwise round the city walls, down the Abercorn Road and over the bridge. On the east side of the river, go up through the Waterside and Gobnascale Estate and continue up Corrody Hill. The stone sits in front of some industrial buildings and a galvanised fence.

Not a very prepossessing situation, but the view from the stone right down across the city is beautiful.

Altnagelvin

From Corrody, go back through Gobnascale and then round to the right, instead of back down the hill. Follow Irish Street around to the Tesco's roundabout and turn right for the hospital. In the main entrance there is a grass traffic island in front of the main entrance. The stone was moved here from its original position when work was

done on the buildings a few years ago.

The island also contains a statue of the goddess Macha, called 'the Princess Macha', commissioned when the new hospital was built. The original foundation stone from the old hospital is also here. The area has a lovely energy with all three structures dedicated in one way or another to healing.

Gortica

Take the A6 from the hospital away from the city (Belfast road). In Drumahoe, the first village, (after 1.7 miles), turn left onto the Lettershindoney Road. The stone sits high on the left, just inside the hedge, almost a mile up this road. The carved front of the stone faces into the morning sun. In the next field is an impressive ancient standing stone leaning at an angle.

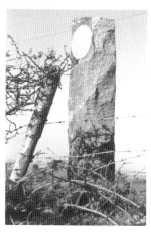

The Gortica stone

Gortnessey

Continue on this road. The next stone is on the top of the hill by the roadside.

St Columb's Park

From Altnagelvin, again follow the main road towards the town centre. After 1 mile turn right at the traffic lights and after 0.4 miles turn left into the park. Park and get directions from the sports centre. Failing that, go past the centre on the left and follow the path to the gates of St Columb's House. Do not go through the gates but take the path to the left and the stone is on your right in a grove of very elegant tall trees.

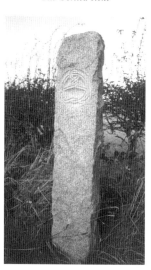

The Gortnessey stone

A beautiful setting, especially in autumn, and the stone sits high on a ridge overlooking the city. It seemed particularly alert and active in a more dynamic way than the more rural stones, perhaps because of the kind of energy it was responding to.

For details of the Donegal Stones, see the Grianán of Aileach and Bocan Circle in Donegal.

2 Eglinton Holy Well
Take the A2 east of Derry for 6 miles to Eglinton. Turn right just after the church on the left and stop at a farm a quarter of a mile up on the left. The well is down a lane and across 2 fields behind the farm buildings. Ask.

This well sits in the middle of a field beneath the roots of an ancient twisted thorn tree. It is built around with stones and is well cared for with clean clear water. Beside it is a large gorse bush exuding scent and colour, adding to the magic of this lovely secluded place.

Eglinton holy well

3 Bovevagh Old Church and Mortuary
About 3 miles north of Dungiven on the B192. It is signed on the left.

The present ruined medieval church sits high up on a bend in the Bovevagh river. A leafy lane leads to the church and graveyard which was used until the 19th century. Before the current building, there was a timber church here since early times.

The small mortuary house, or saint's grave, is at the south west corner of the church. It has stone and rubble walls and a stone slab roof and in one of the gable walls is a small hole through which pilgrims could touch the saint's remains inside. (see **Banagher**)

Peephole, Bovevagh mortuary house

4 **Dungiven Priory**

Just east of Dungiven on the A6, the priory is signed as you leave the town. There is access on foot down a long lane on the right.

The graveyard and church overlook the river Roe. This was the site of an early Christian monastery thought to have been founded by St Nechtan. In the 12th century it became an Augustinian Friary closely associated with the O'Cahans who built a castle on the site.

After the Reformation, it became a large house with a bawn, or defensive wall, and the church was rebuilt. The oldest visible building is the nave with its south window which dates from the 12th century.

There is an ornate 15th century tomb, traditionally that of Cooey-na-Gall O'Cahan. His effigy is in Irish costume on an arcaded plinth on which are carved six gallowglasses. These were professional Scottish soldiers hired by Irish chiefs to fight for them. The carving is thought to be the work of a Scottish craftsman.

To the right of the path approaching the buildings is a bullaun stone filled with water. The trees around are tied with rags which have been left there as part of a cure for warts. As the cloth disappears, so does the wart.

5 **Boviel Wedge Cairn**

Two miles east on the A6 from Dungiven, turn left up Boviel Lane. The cairn is visible on the right from the lane.

This cairn is about 0.5 miles up on the hillside overlooking the upper valley of the river Roe. It is known locally as 'Cloghnagalla', or the 'Hag's Stone'. The gallery has a small antechamber in front which is divided from the main chamber by jambs and a lintel. A loose boulder with a cup mark on it was found at the end of the gallery. The entrance faces west south west. The walls of the gallery are thick and formed, like most wedge cairns, by a double row of uprights. There are some kerbstones marking a possible edge to the covering cairn, though none of the actual cairn remains.

Excavations in 1938 uncovered the cremated bones of an adult female, which is interesting, given that the local name for the site means the 'Hag's Stone'. This phenomenon of a local name reflecting an ancient 'memory' of a site also happens at Labacallee in Cork, which means the 'Bed of the Hag'. This cairn also contained the remains of an adult female.

Neolithic pottery sherds, scrapers, an arrowhead and a polished stone axe were also found, associated with Cloghnagalla. This is unusual as most wedge cairns are associated with the early Bronze Age. This is a very early wedge cairn. (*The Archaeology of Ulster*)

6 Banagher Old Church and Mortuary House

Take the minor road south from the centre of Dungiven town. 1.5 miles later, turn right and the site is on high ground on the right just before a farmhouse. Signed.

The church here is said to have been founded by St Muiredach O'Heney in the 11th or early 12th century. The nave is original and has a very fine doorway in the west in the much earlier style of huge lintel and converging jambs. However, on the inside, the doorway has a more modern Romanesque arch. The chancel was probably added in the early 13th century and has a lovely window in the south wall with multiple roll mouldings. The east end of the chancel was remodelled in the 15th century.

South west of the chancel is a mortuary house, 7 feet high, said to contain the remains of the founder St Muiredach. The figure,

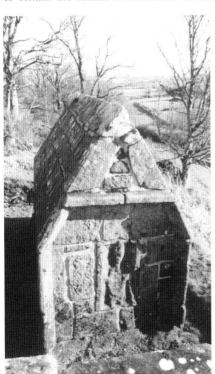

Banagher old church mortuary house

carved in false relief on the west gable, is probably the saint himself. It is usual for such shrines to have an opening for access to the relic within, but this is not the case here. Instead, the beneficence of St Muiredach is said to emanate around the shrine and is contained in the sandy earth on which it sits. This famous sand is very potent and will, among other things, bring luck in racing to the horse it is thrown over.

East of the church is a simple stone cross and bullaun stone just outside the graveyard wall. A second cross stands across the road to the south west. This marks the townland boundary.

There are three holy wells nearby where stations were performed.

ULSTER Derry

7 Dunalis Souterrain and Ogham Stone

Take the B201 west out of Coleraine. Stop at the reservoir on the left. Follow the lane on foot to the reservoir and continue round the right side of the water till you come to some metal steps leading up to a small fenced area.

This site was excavated in 1934 and the entrance reconstructed so that it is now accessed down some steep stone steps. There are three narrow chambers running from east to west, though on slightly different levels. They are connected by narrow creep holes which means one can only get from chamber to chamber by creeping. The lintel at the east end of the second chamber has an ogham inscription on it. It is most likely to have been taken from its original site for use in the souterrain and this dates the site to sometime after 500 AD. There was a long transverse chamber beyond the three main chambers. This is now filled in.

At the time of writing the site was closed by a manhole cover.

8 Tamnyrankin Single Court Cairn

Go north of Swatragh on the A29 and take the Tamnyrankin Road. About a mile along, over a hill and down again, there is a green lane on the right. Half a mile up the lane and past a disused cottage, keep straight on through two gates and there is a sign.

Tamnyrankin court cairn from the outside

This is a beautiful site. By the time you reach the cairn you have gone over the summit of this gentle hill and the view opens out into the next valley. The cairn is secluded with tall hedges and trees nearby.

The long cairn has a wide forecourt in the south east end with portals leading into a two-chambered gallery dark with undergrowth. Another more open double-chambered gallery runs across the cairn

Tamnyrankin court cairn from the inside

north east to south west. Much of the cairn mound is still in place so that the passages appear to lead into the mound, like a true fairy hill. Excavations in the early 1940s produced a range of pottery as well as hollow scrapers and a leaf-shaped arrowhead.

Knockoneill Single Court Cairn

*Back on the Tamnyrankin Road turn right. Turn right again at the
T junction and then left onto Knockoneill Road. The site is signed
on the right by a farmhouse.*

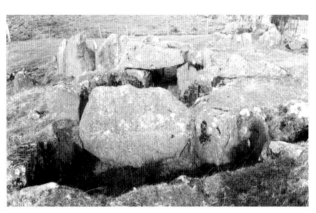

Knockoneill court cairn

This monument has an elegant court 24 feet across with
double jamb entrance and lintel leading into a gallery some 14 feet
by 7 feet. This entrance faces north west. From the south east kerb,
a side passage runs across the cairn to another chamber. The back
stone of the main chamber forms the side wall of this secondary
chamber. Ornamented bowls and a pot were found here and in the
main chamber, bowls and food vessels were found.

Under the forecourt there were two ceremonial pits. One had
an inverted pot with a cremation and an incense cup.

There is a line of stones across the forecourt which excavation
has shown to be later than the original court. The pits are thought
to come from that time as well. (*Prehistoric & Early Christian Ireland*)

9 Slaghtaverty Dolmen

*About 3 miles south of Garvagh. From the Knockoneill Road turn
left, then right and right again. Turn right again at the crossroads,
then right again and follow this road about 2 miles south into
the hills.*

This is known as 'Leacht Abhartaigh', or 'Abhartaigh's Stone'.
According to tradition, he was a dwarf who terrorised local people,
enchanting the women with his magical powers and the music he
played on his harp. He is supposed to have been killed by Fionn
mac Cumhaill and buried upside down so his music could no
longer be heard.

10 St Lurach's Church Maghera

The key for the graveyard and church tower can be borrowed from the nearby Recreation Centre.

St Lurach founded a monastery here in the 6th century and the site has had a turbulent history, being plundered by Vikings in 832 and burned in 1135. What remains today is a nave built of large uneven-sized stones and showing traces of antae, both characteristics of early stone building, probably 10th century. Domestic buildings associated with this church would almost certainly have been built of wood.

The famous west door is probably 12th century, with a lintel outside and arch within. A tower added in the 17th century has served to protect the elaborate carvings around the door. The lintel

Font, St Lurach's old church, Maghera

is carved with an elaborate crucifixion scene which includes the two thieves on either side of Jesus. There are eleven other figures. Above Christ's head is the hand of God and above the cross, two angels. The door jambs are also ornately carved in the Romanesque style. These decorations were probably a response to the church being made a cathedral in the mid-12th century. The cathedral was later moved to Derry. It is interesting to note that the figure of Christ is larger and cut deeper than the others, a kind of spiritual perspective, rather than the more usual artistic one. Far from being alone at the crucifixion, Christ is pictured surrounded by his disciples, the thieves, the angels and the hand of God, symbolising the Christian church which had yet to be formed.

Inside the ruined church, a stone seat, said to be the bishop's seat, is carved in the east wall. To the west of the church, in the graveyard, is the saint's grave, marked by a pillar stone carved with a ringed cross, now very worn.

St Lurach, like many of the early saints, was a member of a royal family, the old name for Maghera being 'Rath Luraig' - 'Lurach's rath or fort'. Maghera (Machaire Ratha) means 'the plain of the fort'. Local tradition holds that St Patrick baptised Lurach. Slemish Mountain, associated with Patrick's early captivity in Ireland, is only 30 miles to the east. It is believed locally that, on

returning to Ireland, he first visited the area where he had lived as a slave and goat-herd many years before.

11 Tirnony dolmen

Leave Maghera on the Tirkane Road travelling north west for one mile. Turn right (the dolmen is signed here but only from the other direction), and you come across it on the right hand side of the road.

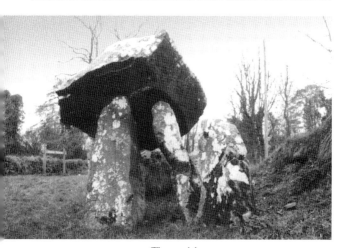

Tirnony dolmen

The pillar stone on the right of the portals gives an impression of a possible court around the entrance to this dolmen. The portals are 5 feet high and face east. The small chamber (6 feet by 5 feet) has two orthostats on each side and a well-fitting endstone. There is a wonderful light energy about this site.

Killelagh church nearby shows that this has continued as a sacred site into modern times.

Tirkane Sweat House

Back on the Tirkane Road continue north west for just over a mile and then turn left onto the Urbalshinny Road. The sweat house is signed half a mile along on the right hand side. A well-kept path leads down to the sweat house situated beside a spring which feeds into a small stream.

Although probably not ancient, the house has an ancient fairy quality about it and certainly represents an ancient tradition more commonly associated with Native Americans. The stone

interior is about 9 feet by 6 feet with a central chimney. It sits now covered by a grassy mound, the nearby spring encircled by a mossy stone wall.

The stream would have been dammed to provide a bathing pool. The hill in front of the sweat house is called 'Seefinn', or 'Sidhe Fionn', meaning the 'fairy mound of Fionn'.

12 Ballybriest Dual Court Cairn

Take the B41 south west from Draperstown and then left onto the B162 to Cookstown. About 3 miles along at the Black Water Bridge, take the left fork up over the hill. The site is half a mile up this road, visible on the right hand side. There is a stile for public access and an information panel.

This cairn sits on the lower slopes of Slieve Gallion which is a high peak on the eastern edge of the Sperrin foothills. The cairn overlooks Lough Fea to the south west. The Beaghmore complex is 8 miles away beyond the lough. This is an area rich in megaliths and, no doubt, much is still hidden by blanket bog.

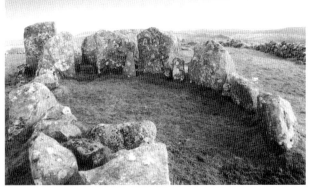

Ballybriest court cairn

There are two galleries, each with two chambers. The west gallery is still intact as are the north sides of both courts. Excavations in 1937 revealed that the cairn was built directly on top of the ashes of a huge fire. Underneath the east gallery and court was a layer of charcoal, flints, pottery sherds and lumps of potter's clay. Beneath this layer were ritual deposit pits containing more charcoal and neolithic pottery sherds. No bones were found, possibly because the site had already been disturbed, though some cremated bone and a small pot were found on the south side of the cairn.(*Prehistoric & Early Christian Ireland*)

About 325 feet south, a small wedge cairn has been reclaimed by turf digging, while some 350 yards west south west lie the remains of a small stone circle. To the east, across the road beside a large quarry, is a cairn with a small chamber or cist at the centre.

There are two cairns on top of Slieve Gallion. Until the middle of the 20th century, there was an excursion at the end of July to pick bilberries. This is the remnant of an old Lughnasa assembly.

An account in *the Dindshenchas* tells how Slieve Gallion (Sliabh Callainn) got its name. There was a hound, called Callann, who was killed here by the Donn Cúailnge, the Ulster bull from the Táin Bó Cúailnge (see LOUTH). He was buried on the hillside.

There is another local story about the giant, Callan Mór, who lived in the cairn on top of the hill. His sister was the river goddess, Bann, to the east and she wanted his mountain removed so that she could have a clear view over to her friend in Tyrone. She sent some of her workmen over and they began to dig at the mountain, but their hands became all covered with red sores. Even to this day, anyone who tries digging away the mountain, will get red sores all over their hands. (*The Festival of Lughnasa*)

County
ANTRIM
PRINCIPAL SITES

APPROX MILES
APPROX KM

Rathlin Island

Portrush

Ballycastle

Cushendun

Ballymoney

Cushendall

Ballymena

Larne

Whitehead

Antrim

Ballyclare

Carrickfergus

Lough Neagh

BELFAST

DERRY

TYRONE

Lisburn

DOWN

ARMAGH

1 **The Giant's Causeway**
2 **Lissanduff** circles
3 **Castlelea**
4 **Coshkib Rath Pair**
5 **Dunseverick** castle and well
 Templastragh church
6 **White Park Bay**
 The Druid's Stone
 Clegnagh passage cairn
 Lemnagh Beg passage cairn
7 **Carn-na-Truagh** round cairn

8 **Carnanmore** passage cairn
9 **Bunamargy** friary
 Broughanlea cross
 Culfeightrin Church - standing stones
10 **Drumnakill** church and bullaun
11 **Atlagore Cashel**
12 **Ossian's Grave**
 Layd church and St Ciarán's Well
13 **Cloghastucan**
14 **Ticloy** dolmen
15 **Cave Hill**
16 **Ballymacaldrack** single court cairn
 Broad Stone court
 Craig's Dolmen
17 **Doagh** hole stone
18 **Browndod** single court cairn
19 **Cranfield** holy well
20 **Slemish Mountain**

Block figures in list refer to site locations in map and entries in text.

ANTRIM

THE NORTH EAST COAST OF IRELAND from Derry to Belfast
is a dramatic mix of long white beaches interspersed by rugged
cliffs with grassy headlands cropped close by grazing sheep. The
coastline is spectacular. As you move further east, the drama
lies, not with the sea, but in the mobility of the landscape. And,
according to the road subsidence and landslide warnings, it is still
moving.

The dominant surface rock is oily black basalt. Successive lava
flows some 60 million years ago covered the softer layers and
created the high Antrim plateau which has been cut into glens by
its rivers. Today these glens are spectacular folds of green fertile
grassland dipping dramatically to the shore, with small towns
perched at sea level around the river mouths.

Slow cooling basalt also created one of Ireland's most famous
areas of coastline, the giant honeycomb of crystals, known as 'the
Giant's Causeway'. Beneath this basalt is the soft grey lias clay
which, saturated with ground water, has been responsible for many

ULSTER Antrim

spectacular landslides around Antrim's coast.

Also beneath the basalt, chalk layers surface occasionally as white cliffs. This chalk contains flint nodules created over millions of years from the depths of the ocean, evidence of a turbulent geological history and more precious than gold to the earliest inhabitants of this island. At Mountsandel, along the east side of the river Bann, on the Antrim/Derry border, amateur enthusiasts have been collecting worked flint for years. In 1959 the site was officially discovered as the earliest known human habitation site in Ireland, with hearths and hut sites dating to around 7000 BC. Since then, other early mesolithic sites have been found.

1 The Giant's Causeway
North of the small town of Bushmills which is on the A2 coast road. Well signed from every direction.

'Clochan na bhFómharach', its Irish name, means 'the stones of the Formorians'. The Formorians were one of the earliest mythical inhabitants of Ireland. They were defeated by the Tuatha Dé Danann after which they retreated to the coastal fringes and islands of the north west.

The giant's boot, Giant's Causeway

The Giant's Causeway was declared a World Heritage Site in 1987. An interpretative centre has been set up there to explain the geological history of the Causeway and its mythical associations as well as the treasure of the Girona. (see below) It is possible to visit the site without going through the centre.

The Causeway is formed by basalt columns packed together, whose tops make 'stepping stones' leading from the cliff face and disappearing under the sea. They reappear again on the island of Staffa, off the west coast of Scotland. Over the causeway as a whole, there are about 40,000 of these black crystal pillars. Most are hexagonal, but they can have anything from four to eight sides. They were formed about 60 million years ago by the cooling and shrinking of molten lava from a vast volcanic eruption that formed the Antrim plateau. Fossilised plant from the time of the eruption 60 million years ago shows that the climate of Ireland was semi-tropical then.

The tallest columns, in the Giant's Organ, are 40 feet high and the solidified lava in the cliffs is 80 feet thick in places. Light-coloured patches in the cliffs are the residue of gaseous bubbles in the boiling lava. These have been called 'giant's eyes'. By the shore is a large curved boulder, known as the 'Giant's Boot'. The Causeway itself is said to have been built by Fionn mac Cumhaill, a giant in folklore, so that he could visit his girlfriend in Scotland.

The Causeway's fame has been increased by the discovery, and recovery, at Port na Spaniagh in 1967 and 1968, of the most valuable treasures ever found in a Spanish Armada wreck. The Girona, the biggest ship in the Armada, was wrecked off these shores in a storm on the night of October 26th, 1588. There were only five survivors out of 1,300 men aboard. The Girona carried not only her own treasure, but also what the sailors had been able to save from two other Armada ships wrecked earlier off the west coast of Ireland. Nearly 10,000 objects were brought to shore rivalling the contents of any storybook treasure chest. It included 400 gold and 750 silver coins, gold jewellery inset with rubies and pearls, solid gold chains, silver forks and spoons.

Many of these items are now on permanent display in the Ulster Museum, Belfast.

2 Lissanduff Circles

In Portballintrae which is signed from Bushmills. From Portballintrae car-park, follow the path to the sea and the circles are signed from there.

Between the river Bush to the west, and the sea to the north and east, sit two sets of two concentric earthen banks, originally thought to be two ring-forts. The lower pair encircle a spring and are clay-lined to retain the spring water and create an artificial pool. Ritual offerings were found and dated to the Bronze Age,

leaving no doubt that it was built as a water ritual site. Both earthworks around this lower 'pool' are oval and are more substantial than the circles higher up. Today the inner space is marshy and full of rushes.

Fairy thorns, Lissanduff Circles

The upper circles may be a two-banked fort, but the floor inside the inner ring is at ground level. Raths usually have raised floors. It is possible that these circles were used as part of a ritual site involving the lower pool.

Part of an ancient road was found near the upper circles and it is possible that it once went south from Lissanduff all the way to Tara.

Below are two other sites in the area which seem to have been artificial ritual pools. Neither are as clear as the site at Lissanduff and both are on private land.

3 Castlelea

006.432

On the A2 travelling east, turn right onto Moycraig Road opposite the road down to White Park Bay. The site is across a field on the right, on the edge of a slope about a half a mile up this road.

Here there are two single ringed circles of earth and stone, one wet, as at Lissanduff.

4 Coshkib Rath Pair

234. 292

One mile north of Cushendall which is further round the coast to the east. It is at a height of over 500 feet, overlooking the sea and the glens.

Again here there are two circular embanked enclosures close together, one with a waterlogged interior.

5 Dunseverick Castle and Well

3 miles north east of Portballintrae at a signed lay-by on the B146. Park in the lay-by and follow the grassy track, visible from the road.

Thought to have been the capital of the ancient kingdom of Dalriada (see ULSTER), this is now a dramatic fragment of a 16th century castle on a basalt stack surrounded on three sides by sea. Built of basalt, it blends well with the cliffs and looks as old as them, although it is actually the last phase of occupation of a very ancient site.

Some foundations and traces of the wall which made up the promontory fort in the Iron Age can be seen on the ground. This was traditionally considered to be the northern point of one of the five ancient roads of Ireland, though it is possible that Lissanduff marks the end of the road. (see above)

In Irish it is called 'Dún Sobhairce', and is mentioned in the early historical annals in connection with St Patrick and St Olcan. At the tip of the rocky promontory, with sea on three sides, is a well, a water-filled hollow with a miraculous stone said to have been thrown there by St Patrick. Places blessed by St Patrick were invariably important pagan sites.

It is also said to be the place to which Deirdre and the sons of Uisneach returned from their exile in Scotland, having been tricked by the king into believing he had forgiven them. They were ambushed and killed in an act of treachery that divided all Ulster and left not a family in the province untouched. (see **Uisneach** in WESTMEATH)

Templastragh Church

Turn left off the A2, 4 miles east of Bushmills towards Portbradden. The site is visible across a field on the left and there is public access from a farm lane by a bend in the road. It can also be accessed by the National Trust coastal path between Dunseverick and Portbradden.

The walls of this ruined church are made primarily of large basalt sections infilled with smaller stones. The oldest part of the building is a cross slab attached to the west gable. The cross inscribed on this slab is circled and has 4 small circles, one in each angle of the cross. Both the upright and the arms seem each to be made of up to 4 lines.

The original Templastragh church, of which this cross was a part, was built to the north of this site in an enclosure which is still visible. The cross slab is all that now remains.

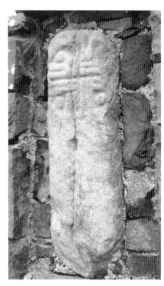

Cross slab, Templastragh Church

It is said that St Lasair was working at another place, building his new church, when late one night he saw a flame at this spot. He took this as a sign to move to this site and the place was named Templastragh, which means the Church of the Flame.

6 White Park Bay

Half way between Bushmills and Ballycastle, this beautiful white sandy beach is now in the care of the National Trust.

From here it is possible to look inland at a sacred landscape which begins with a passage cairn here in the bay. Just inland, and overlooking the bay, are the remains of three more passage cairns, stone chambers each now denuded of their cairns. Beyond these again, further south and high on the top of Knocklayd and on Carnanmore to the east sit two more, forming a possible group of six sites. Maybe this is part of a wider sacred landscape that reaches across to Scotland as the Giant's Causeway does in geology and myth.

Flint tools and pottery sherds from neolithic times have been found in 'blow outs' in the dunes surrounding the bay, and on either side, at Portbradden to the west and Ballintoy to the east, are basalt caves inhabited over long periods in later medieval times.

Stone axes cut from porcellanite at Tievebulliagh, here in Antrim, and Brockley on Rathlin Island, were polished here in the small streams around the bay using the abundant sand and water.

Many of these dark polished stone pieces were tools but some were made as sacred or ritual objects. They were elegant, beautiful and very precious. A quantity have been found in the area. The Ulster Museum, Belfast has a collection on display, known as 'the Malone Hoard', which were probably ritual objects.

A grassy cairn or mound, with a stone kerb 36 feet in diameter, sits on a hillock in the middle of the bay. This passage cairn was opened in the late 19th century and a skeleton found on a raised stone surface in the centre of the cairn. This is thought to have been a later deposition on top of the passage and chamber, which probably still remain untouched within the cairn.

The Druid's Stone

From the layby above White Park Bay, go 0.8 miles east. Turn up a lane leading to a large farmhouse to the left and the Church of Ireland rectory to the right. The site is best approached with permission on foot up a lane behind the farm. At the top of the hill, turn west and follow the stone wall south to a small gate. The Druid's Stone is just through the gate.

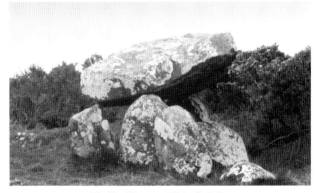

The Druid's stone, White Park Bay

This beautiful dolmen sits just behind the summit of the hill overlooking White Park Bay. A large cap-stone balances delicately on 2 portals and an endstone, with two other stones forming the chamber. Though it looks like a dolmen, it is in fact a passage cairn, with some of the kerbstones which would have edged the cairn, still forming an outer ring about 35 feet in diameter.

The cairn was excavated in 1939 and found to have been built on a burnt layer in which fragments of worked flint, cremated bone and fine neolithic shouldered bowls were found. There were also several pits in the ground, a feature more common in court cairns. This could mean that the passage cairn was built on the site of an

earlier court cairn. The chamber was empty, possibly having been robbed earlier. It faces north west which means it is aligned to the setting summer sun. This may be an indication of the most important ritual times. The chambers at Clegnagh and Lemnagh (below) also face north west.

Clegnagh Passage Cairn

Back on the main road, this site is accessed up another farm lane 0.6 miles west. It is actually visible from the layby as it sits on the edge of an old quarry overlooking the bay.

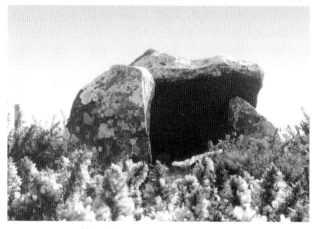

Clegnagh passage cairn, White Park Bay

What remains here is the back of the chamber, the front and the passage having disappeared with the quarry. It sits like a tiny dolmen high on a rocky outcrop surrounded by gorse. Some kerbstones still lie to the south east and the chamber entrance must have faced north west into the evening sun in summer, as at the Druid's Stone. A lovely site.

Lemnagh Beg Passage Cairn

Back on the main road, Lemnagh Beg is accessed up yet another farm lane 0.2 miles further west. The advantage of needing permission to reach these sites is that you can also get directions. The site is on top of the hill across two fields from the farmyard.

This chamber sits on top of the hill with a full view of the bay, though it is now too small to be seen from below. It looks like a tiny squat dolmen with a large cap-stone and is surrounded by gorse. A few kerbstones can be picked out among the bushes.

At all four of these sites the dominant feature, apart from the sunset, is the wide sea-scape reaching all the way to the horizon.

7 Carn-na-Truagh Round Cairn

3 miles south of Ballycastle. Take a minor road to the right off Glenshesk Road east of Ballycastle. The cairn can be accessed by a steep climb up Knocklayd Mountain from various points in Knocklayd Wood.

This massive cairn is about 50 feet across and 16 feet high and sits in isolation on top of the dome of Knocklayd, at a height of 1695 feet. It is possible that it sits above the cairns of White Park Bay as part of that complex, though it remains something of an enigma and has never been excavated. There is no visible entrance, but there are many white quartz stones, usually associated with passage cairns, in the cairn material. From here the cairn on Caranmore can be clearly seen, a mere 6.5 miles away as the crow flies.

The name 'Carn na Truagh', means 'Carn of Compassion', or 'Carn of Woe', and local legend tells of three bronze swords being found at the site, buried vertically in the ground. Like Caranmore, it is an impressive site in a stunning location, from which you can see for miles. From up here Scotland comes closer than Donegal and one can understand the identity of the watery kingdom of Dalriada, which stretched from here to south west Scotland.

8 Carnanmore Passage Cairn

4 miles north north west of Cushendun and 1.5 miles south west of Torr Head on the coast road going north from Cushendun. Access is through a farmyard on the left just after the first turn for Torr Head. Permission is needed from the farmer before setting off on the steep climb.

The cairn sits on the hilltop at a height of 1253 feet. It is 75 feet across and is clearly visible for miles and well-preserved, but not excavated. A passage, 4 feet wide with dry-stone wall sides, runs south west for over 10 feet to a chamber. The chamber is lined with orthostats and has a corbelled roof now open at the front and capped by a massive stone slab. Two corbel stones are decorated with lozenges and spirals. Unlike the three cairns near White Park Bay, this cairn faces north east towards Scotland.

Well worth the long climb, some of this site's atmosphere must be attributed to its position, wild, windswept and on top of the world. It is a good position from which to look across at

Caran Na Truagh, 6.5 miles west south west, and contemplate the world from a neolithic perspective.

9 Bunamargy Friary

Beside the A2 just east of Ballycastle. Well signed by the roadside.

This is a Franciscan Friary founded by Rory MacQuillan around 1500. It was closed in the 1540s at the Dissolution and used as a billet for English soldiers in 1584, when it was burned down.

The approach to the friary buildings is along a path fringed with thorn trees and through a gatehouse set in an earthen bank. This bank formed the enclosure of the original monastic foundation of the early Christian period. It seems to continue to create a barrier between the outer world and this place of quiet contemplation. Within the enclosure are the remains of a large rectangular church and beside it a workroom and store, with a stairway leading up to a dormitory on the first floor. The buildings are of granite and warm red sandstone infilled with small basalt blocks. Simplicity of design and the glow of the sandstone create a gentle atmosphere.

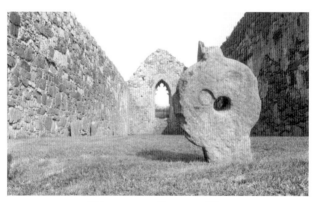

Hole stone cross, Bunamargy Friary

At the west doorway of the church is a holed cross set low on the ground. It is said to mark the grave of Julia Quillan, a recluse and a mystic who was known as the black nun. She is supposed to have lived here around 1650. Apparently she had a sister who, unlike her, lived a wild and exciting life. Her sister came to her in her cell one night and asked her to pray for her as she did not have long to live and was repenting of her wild ways. Julia is supposed to have fled from her in disgust (whether at her diseased body or her sinfulness, we don't know), but looking back towards her cell, she saw light streaming from it and a

voice saying, "Come unto me..."

She felt so ashamed at her rejection of her sister, that she spent the rest of her life looking after the sick and when she was dying, as a token of humility, she asked to be buried by the doorway of the church so that all who entered, would walk on her. She also asked that her coffin be kept back and used by the next poor person who had need of it.

Broughanlea Cross

A half a mile further east on the A2, this cross sits on a wall by the roadside opposite Colliers Hall.

This cross was brought here from Magherintemple old church about a mile to the south. It appears to have a crosier and a Tau cross inscribed on it and has been the subject of much speculation. Perhaps it was the grave marker of a Coptic cleric.

There is a Tau cross on Tory Island in Donegal and another in Clare. One is also carved on the Doorty cross in Kilfenora, in Clare. It is a Coptic or Egyptian symbol and echoes the shape of the staff used by the Coptic monks for support as they stood during their long hours of prayer.

The presence of the Tau in Ireland would seem to imply a familiarity with the Copts. There has been speculation that some of them may have fled persecution from the Mediterranean to the west coast of Ireland, but it is very unusual to find such a symbol in the north east of the country.

Culfeightrin Church - Standing Stones

In the Church of Ireland churchyard near Ballyvoy, about half a mile east of Broughlea Cross on the A2.

A tall pillar stone stands near the west door of Culfeightrin Church on the south side and a smaller lozenge-shaped stone stands at the south east corner. At one time there was a third stone at the base of which were found two Bronze Age cist burials.

Across the road is a slight mound, all that is left of an ancient fort, called in local tradition, 'Cahir Rí Ulaid', or 'the Castle of the King of Ulster'. A stone building existed there until the early 1800s when the stones were removed. The boggy area at the bottom of the hill was known as 'the Bog of the Spears', because so many weapons were found there during peat cutting. They were thought to have been lost in battles, but it is possible that this was a water site where bronze objects were ritually deposited as offerings.

ULSTER Antrim

10 Drumnakill - Church and Bullaun

Murlough Bay lies to the east of Fair Head and is well signed from the A2. The remains of Drumnakill church lie down in the bay in a sheltered spot below a rocky outcrop. At the first car-park on the narrow National Trust road, there is a plan of the area.

This church is said to be dedicated to St James and St John but also, and perhaps earlier, to St Mologe, who gives his name to the bay. Much of the stonework has been removed, probably to build the small row of deserted miners' cottages which sit near the water to the east. Fragments of dressed sandstone can be seen in their walls. A bullaun stone sits at a short distance from the second last car-park on the way down.

The approach to the bay is stunning. The road rises steeply over the bare headland which falls away so sharply that all you can see ahead is the sea. Then comes the descent through hairpin bends down to sea level and the shelter of the bay. It feels like being on the edge of the world and in many ways it is very fitting that the church has almost become re-absorbed by the landscape. St Mologe, I hope, would have approved. This is a wonderful place.

11 Altagore Cashel

Just over a mile north of Cushendun and dramatically visible from the coast road going south towards Cushendun.

The cashel comes into view about a mile north of Cushendun on the west side of the road. It is halfway up the glen, to the side of a walled track. A small pathway leads from the track to a single narrow entrance in the cashel wall. Beside the entrance, which faces north, are stones protruding from the wall, forming steps to the top. Enormously thick walls, measuring some 10 feet across, enclose a space 50 feet in diameter. In places they are 10 feet high. There is a fairy tree growing inside it. A small doorway into a passage in the wall is now blocked with stone.

This cashel provides a place apart, yet in harmony with the landscape around it.

12 Ossian's Grave

1.7 miles west north west of Cushendall.
Take the Ballymoney Road and follow signs.

This is a neolithic court cairn, possibly 5000 years old and therefore much older than the famous Ossian, poet and warrior of the Celtic

Iron Age, in the first centuries AD.

The semi-circular court is about 16 feet across and opens into a gallery divided into two chambers. The chambers are about 6 feet by 3 feet. The court opens to the south east. The stones are modest in size and it is hard to say what it is that makes this such a magical place. The views across to Glendun, Glenaan, and on a clear day, Scotland, are magnificent, but the quality of the place does not owe everything to its views.

Dusk was falling the last time I went there, so there was no view. Instead, I felt a quality I can only describe as heart strength, as if the place was strengthening and opening my heart. I experienced a similar quality at Ballymacdermot, in Armagh. Maybe this explains the association with Ossian, whose story is very much bound up with affairs of the heart.

Ossian's father was Fionn mac Cumhaill, leader of the Fianna. Fionn first met Ossian's mother when she was in the form of a deer, having fallen under the enchantment of a wicked spirit. Fionn brought her to his home which broke the spell, and they fell in love and married. Some time later, while he was away from home, the wicked spirit returned, and when Fionn came back, she was gone. He searched everywhere but could never find her.

Some years later, while out hunting, Fionn came upon his two hounds standing protecting a young child from the other dogs. The child was naked, with long blond hair, and very beautiful. Fionn took him home and after the boy had learned to speak, he told Fionn how he had lived till then in a valley with no one else around, only his mother who was a deer. Sometimes a man would come and try to persuade her to leave with him, but she always refused till one day the man cast a spell on her, and she had to follow him. The child was left behind.

Shortly after this he had been found by Fionn's dogs. Fionn, of course, realised that Oisín was his son. (Oisín means little deer) Oisín grew to manhood: brave, handsome, and a poet. One day a beautiful woman appeared. She was none other than Niamh of the Golden Head, the Princess of Tír na nOg. She had fallen in love with Oisín and he naturally enough was enchanted by her so that her promises of fabulous wealth and wonders beyond imagination seemed hardly necessary. He willingly agreed to go with her to her land where he would never grow old.

Many lifetimes later, he was moved to return to the world of humans. Niamh warned him not to touch the earth there. As he galloped across the plain, he saw some old men struggling to move a large stone and he leaned from his horse to help them. His saddle broke and he fell to the ground. He immediately became very, very old. He had time only to talk with St Patrick before his age caught

up with him and he died.

(For more about Oisín, see WATERFORD)

There is a small stone cairn erected nearby in memory of John Hewitt, the Ulster poet and writer, who died in 1987.

Layd Church and St Ciarán's Well

From Cushendall go north on the Shore Road. Very soon Layd Old Church is signed on the left. There is a car-park on the right after 0.8 miles.

This is a lovely site tucked low into a gully beside a stream which runs down to the sea at Port Obe. St Ciarán of Clonmacnois is said to have founded a monastery here in the 6th century. It later became a Franciscan foundation, but it is first mentioned in writing in the 1306 Taxation Roll, when it was in use as a parish church. The present church dates from 1100 and was used till the beginning of the 17th century. It is built mainly of soft red sandstone which has a warm and gentle quality about it, perhaps because it absorbs the sun so easily.

Cross na Naghan, Layd Church

The original entrance was probably from the west through the tower before another door was made in the south wall. The square tower at the west end of the church has a vaulted ceiling on the ground floor which still shows the marks of wicker-work used to hold it centred as it dried. The tower has an upper room only accessible by ladder. It is thought to have been a small hospital and has a window through which patients could look down into the body of the church while services were held.

At the entrance to the site is a slender holed stone, Christianised by the addition of 4 cuts in the shape of a cross with the hole at its centre. It has also been re-used as a grave marker. It is called locally, Cross Na Naghan. Naghan was king of the Picts

between 599 and 621 AD.

Like Bonamargy, this was an important burial site for members of the MacDonnell clan. An 18th century cross is inscribed to Dr James MacDonnell, patron of harpers and one of the first surgeons to operate with the aid of chloroform.

St Ciarán's well is nearby.

Just before the sign for Layd church, there is a mound on the right, called **Tiveragh**. This is an old sacred site with a local tradition as a fairy place.

13 Cloghastucan
Beside the A2,
5.6 miles north
of Carnlough.

The White Lady is a bizarre limestone pillar in the shape of a woman gazing out to sea. She appears suddenly on a dramatic stretch of road where the road signs warn of falling rocks on your left and the sea breaks against the wall on your right in stormy weather.

The rock has been deified since Celtic times and is now called locally, 'the White Lady'.

Cloghastucan

14 Ticloy Dolmen
232118
Take the A42 inland from Carnlough. After 6.8 miles
turn right onto the Killycarn Road. Continue for 1.6 miles.
The dolmen is reached up a farm lane on the left and through
a gate on the right.

The surrounding townland is called 'Ticloy', which means 'stone house', after the dolmen. It sits in an area of modest fields enclosed with tall, well-maintained dry-stone walls.

This is a lovely granite dolmen with a large cap-stone covering a small central chamber about 4 feet square. There is a small secondary

ULSTER Antrim

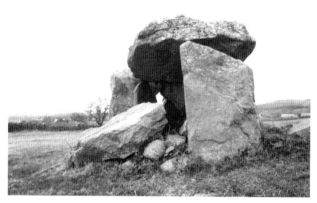

Ticloy dolmen

cap-stone behind it. Originally there were two chambers here, but the smaller westerly one has now disappeared. The portals of the surviving chamber open east and part of a court can be seen around it. Traces of a cairn are also visible, making this lovely site most probably the denuded remains of a court cairn or possibly a transition monument, part court cairn, and part dolmen.

15 Cave Hill

Cave Hill stands some 1182 feet above sea level, to the north of Belfast City, overlooking Belfast Lough.

There are five caves in its east-facing limestone escarpment and at its highest point, a promontory fort, known as McArt's Fort. The fort is accessed by paths from the grounds of Belfast Castle below, a steep climb, but well worth it. This mountain habitat, still within the city limits, is home to skylarks, kestrels, peregrines and ravens. The fort is now a well-defined earthwork, much visited in spite of the long climb. At the top, a track leads to the neolithic ruins of Ballyaghagan cairn.

16 Ballymacaldrack Single Court Cairn

Just under a mile south south east of Dunloy village on the B93, on the east side of Long mountain. Signed on the right. It is also called Dooey's Cairn, after the landowner who gave the site to the state.

This is an oval cairn with a lovely deep court facing south west. There are five stones forming the north side of this court and seven on the south side, with one fallen. The court leads into a single chamber where artefacts, but no bones were found.

Beyond this, through the second pair of portals, there is a passage with boulder walls where cremations took place. This passage was paved with stone. On top of this, three inches of charcoal were laid, and earth and heat-fractured boulders were placed on top of that. Three pits cut through this were lined with small boulders. Two contained black earth, charcoal, burnt stones and sherds of Lytes Hill ware. There were indentations on a piece of pottery made by 13 spikelets of wheat. This provides some rare first-hand evidence of what crops were being cultivated at the time the bowl was being fired.

The third chamber contained charcoal and the intensely cremated bones of at least five adults, male and female.

When the site was closed, the entrance to the chambers was sealed with dry-stone walling, in which two Tievebulliagh polished

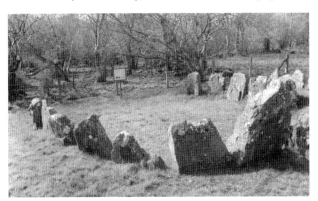

Circular court, Ballymacaldrack court cairn

axes had been placed. The court was then packed with cairn material.

This site was first excavated in 1935. It was re-excavated in 1975 by Pat Collins, of *The Archaeological Survey*, when it passed into state ownership. He decided that the passage or cremation trench had been fired around 3800 BC and that the three pits were post-holes for a wooden structure associated with the cremation, either a cover or a platform. There were probably two cremation episodes and they are likely to have taken place up to 500 years before the court cairn itself was built. (*UJA.39.1976.1-7*)

Broad Stone Court

978175

About 2 miles south east of Finvoy and 600 feet up on the west side of Long mountain. Go east off the B62 at Finvoy (signed Dunloy) and right at the first crossroads. It is just under a mile along this road on the left up on the hill north of Craigs wood.

There is a huge cap-stone over the entrance and first chamber which gives the court its name. The gallery has three 6 foot chambers, the first a little narrower than the other two. A shallow court faces south east. The kerbstones are clearly visible along one side.

It has been a popular place of assembly and it remains unexcavated.

Craig's Dolmen

973172

Back on the road from Broad Stone Court, go a little further south. Craig's Dolmen is on the right just past some farm buildings and visible from the road. A small stile gives access to the field.

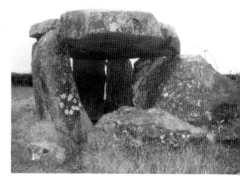

Its cap-stone is supported by three uprights. One of these, and the cap-stone, were erected in the 19th century to make it look like a dolmen. However, the monument itself is genuinely neolithic, as a 1985 excavation showed that it was the chamber of a

Craig's dolmen

passage cairn. There are also remnants of an earthen mound around it. This would date it to about 3000 BC. It was used later during the Bronze Age.

The chamber faces north west out across the wide expanse of Mid-Ulster. It is part of a possible 22 passage cairns in Antrim and just south of the main complex between White Park Bay and Torr Head. It also faces across the river Bann to Moneydig in the west just 3 miles away.

17 Doagh Hole Stone

Take the B59 from Doagh to Ballymena. After 2.4 miles, turn right into Holestone road. Continue up to the brow of the hill and the stone is just visible through the field gate on the right.

Referred to in Doagh as 'the Pagan Stone', everyone I spoke to knew about it, but had widely differing opinions as to where exactly it was. Some people thought it would be covered by whins (gorse)

but it is actually visible from the field gate, sitting high on the crest of a hill on a rocky platform with steep sides and easily accessed by rough steps in the rock. The top of the platform is ringed by gorse and the stone itself is in the centre of the grassy arena inside. The grass is kept cropped by animals. The stone is a tapered dolerite slab, slim and 5 feet tall. The hole is circular, 4 inches across and bored from both sides. It is about 3 feet from the ground. It has been dated to the Bronze Age and was mentioned in the *Dublin Penny Journal* with a wood-cut illustration in 1832.

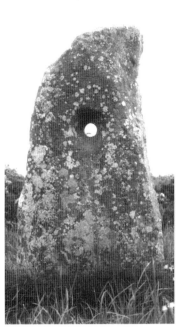

It was traditional for couples to pledge themselves by clasping hands through the hole. Similar rites, perhaps a remnant of a fertility rite, are performed around the country.

There are many souterrains in this area and it appears to have been heavily populated in early Christian times.

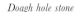
Doagh hole stone

18 Browndod Single Court Cairn

From the Holestone go back down the hill to the B59 and turn right towards Ballymena. After 2.6 miles, turn left at the crossroads onto Browndod Road. Go up the hill 0.7 miles and turn right onto a narrow concrete lane. Keep left at the fork and continue uphill for 0.4 miles, stopping at a passing place with gates on both sides. Through the gate on the left, follow a rough path through several fields until you see the stones on your left.

This site does not get many visitors as it is not signed and it is quite a distance from the road. However, it is well worth the effort and the view is tremendous as it is almost at the top of Browndod Hill. The hill is part of the Antrim plateau and made of black basalt, as are the stones of this megalith.

Before building this cairn here, a layer of red clay was laid down covering an area about 100 feet across and 55 feet at its

widest point. It still reaches a depth of 5 inches. It is possible the clay came from an area further down the hillside. The cairn was built on top of this red layer.

The court entrance faces east. It is very deep and has a broken standing stone near its centre. Three ritual pits were found here, each about one foot across and a foot deep, containing neolithic pottery sherds. They had been dug down through the red clay and into the subsoil. One pit had even been hewn 3 inches down into rock to achieve the required depth.

Browndod court cairn

The gallery is not in line with the court entrance but opens to the south east. It is divided into four large chambers clearly separated by sills and jambs, except that there is no sill between the first two chambers, giving the impression that this might have been a long passage rather than two chambers. The same pottery was found in the chambers and in the cairn material which covered the whole structure in a trapezoidal mound, 100 feet in length and 50 feet at its greatest width. The chambers were infilled with red and black soil which also extended into the court.

19 Cranfield Holy Well

Signed just west of
Toombridge off the A6. It is
3.6 miles down to the lakeside.

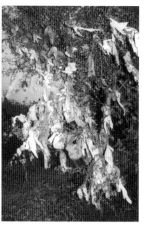

Inside the graveyard are two wooden crosses. One is a copy of a medieval termon cross which stood some distance north of the church. From the lower end of the graveyard some wooden steps lead down to the lakeshore and the well is close by to the left. It is a deep wide well inside a low circular wall. Around it are

Clootie tree, Cranfield holy well

growing hazel, ivy and thorn trees, many of which are tied with rags to facilitate a cure. The well is still much visited.

20 Slemish Mountain

It is signed from the A36 just east of Ballymena and looks quite close at this point. In fact it's a further 7.7 miles.

Slemish is one of the holy mountains of Ulster. Its presence is felt from right across the great expanse of water that is Lough Neagh, over in Tyrone, and from Derry County down to Belfast. Its profile is similar to Knocknarea, in Sligo, and it gets more powerful the closer you get.

It is actually a volcanic plug formed some 50 to 60 million years ago, around the time when the Giant's Causeway was formed. It is about 1437 feet high with a narrow road that takes you about halfway up. From here, a circular path about a mile long leads around the top of the mountain.

Muirchú's 7th century *Life of St Patrick* describes Slemish as the mountain where St Patrick spent time as a slave caring for his master's pigs and sheep. He tells us that his master was a farmer called Miolchu and that it was here that Patrick heard the voice of an angel telling him it was time to return to Britain. He was directed to the coast where he found a ship transporting dogs to Gaul.

Muirchú's account of the life of St Patrick contains many associations with particular places. St Patrick's own writings, his *Confessio*, mentions only one place: the wood of Foclut, which is by the western sea. He implies that this is where he spent his early years. This has now been identified with the western shore of Killala Bay, probably around the headland, now called Downpatrick, in Mayo.

This in no way diminishes the power of Slemish. It is likely that it was chosen as a fitting place for the story of Patrick's captivity because of its already powerful presence. This mountain has a strong fiery charisma.

ULSTER **Down**

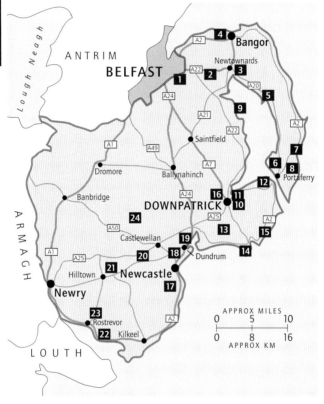

County

DOWN

PRINCIPAL SITES

1 The Giant's Ring

2 Kempe Stones

3 Movilla abbey

4 Bangor sundial

5 Grey abbey

6 Cooey's Wells

7 Millin cairn

8 Derry churches

9 Nendrum monastic site

10 Downpatrick Cathedral
 The Hill of Down
 Gaol Museum
 Struel Wells

11 **Saul** church
 Mearne well
 Slieve Patrick

12 **Audleystown** court cairn

13 **Ballynoe** stone circle

14 **St John's Point** church and holy well

15 **Ardtole** church

16 **Inch Abbey**

17 **Slieve Donard**

18 **Maghera** old church

19 **Dundrum Castle**

20 **Drumena** cashel and souterrain

21 **Goward** dolmen

22 **Kilfeaghan** dolmen

23 **Kilbroney** cross and medieval church

24 **Legananny** dolmen

Block figures in list refer to site locations in map and entries in text.

DOWN

COUNTY DOWN IS IN THE SOUTH EAST OF ULSTER. Three deep inlets shape its east coast: Belfast Lough which it shares with Antrim in the north; Strangford Lough in the middle; and Carlingford Lough which it shares with Louth to the south.

Since prehistoric times these deep natural harbours have drawn people from across the water. The areas around these loughs are rich in prehistoric culture. Some of these sites appear to have closer links with the west coast of Britain than with Ireland. Estyn Evans saw close parallels between the cairn at Audleystown (see below) and similar cairns in the Severn-Cotswold area of England. Aubrey Burl suggests that Ballynoe stone circle has more in common with the stone circles of Cumbria than it does with the rest of Ulster. The Giant's Ring, near Belfast Lough, seems to be unlike any other site in Ireland or Britain.

The south of the county is dominated by the Mourne Mountains. Their velvet peaks sit layer behind layer against the horizon. They can be seen from almost anywhere in the county and must have been a powerful presence in the lives of the prehistoric peoples who lived within their aura. For those living nearest to them, their dramatically steep rise from the lowlands and

the sea, must have added to their power. There are two cairns on top of Slieve Donard, the highest peak, one on the summit and another 800 feet to the north east. A *Dindshenchas* poem (*Dindshenchas* were early stories explaining the topography of Ireland) tells how Partholón, father of one of the early races of Ireland, buried his son Slánga beneath the cairn on the summit. Slánga was the old name for this peak.

According to local tradition, the next significant arrival on the coast of Down was a young slave named Patrick, taken from the coast of Britain and put to work minding animals on the slopes of Slemish in Antrim. When he returned many years later as a Christian priest, he was on a mission to spread Christianity across the country. We will never be able to separate history from myth and 'spin' but, almost without fail, sites associated with this father saint of Ireland were powerful or important places before the arrival of Christianity. In Down his early work is particularly associated with the centre of the county around Downpatrick.

In later years the Vikings came to control Strangford Lough. Both names, Strangford and Carlingford, are Viking names. 'Ford' comes from the Scandinavian 'fjord'. Somehow the monasteries continued, maintaining their historic links with the north of England.

A few centuries later the Normans came and Down came under the control of John de Courcy. Tower houses were built and defended, and campaigns were fought over the centuries. English Cistercian monks came to Inch and Grey Abbey and flourished in the mild climate.

Today the landscape of north Down is still fertile and the farms prosperous. The legacy of St Patrick dominates, yet many of the county's older sacred places are there too, just tucked away, forming a deeper level of the county's psyche. Over all towers the presence of the sacred mountain, Slieve Donard.

1 The Giant's Ring

From Belfast take the Malone Road west to Shaws Bridge on the outskirts of the city. The Giant's Ring is about a mile away to the south west. Follow the brown signs.

The ring is a huge earth bank, about 12 feet high and up to 80 feet wide, enclosing a circular area 600 feet across. It lies in a bend in the river Lagan near an ancient crossing, and from its bank, you can see right across the river valley to Belfast and the distant hills to the north.

It has been called a ceremonial site and classified as a henge

but there are no ditches either inside or outside of the bank. Ring-forts have a defensive ditch outside their banks while other, more enigmatic circles generally have a ditch inside the bank. Archaeologists call the latter 'ritual sites' because they can see no practical purpose for an inner ditch. If a circular bank is not surrounded by a ditch to keep enemies out, then it must be there to enclose a special area and set it apart, hence it is a place of assembly or ceremony. Usually the material from digging the ditch provided the earth for the bank.

The Giant's Ring is the largest ritual enclosure anywhere in the country. Excavations revealed that the bank was made from gravel, boulders and clay taken from shallow scooping of the inner area. There are a number of openings in the bank but it is not known if any are original.

Inside, just off-centre to the east, there is a dolmen with a large sloping black basalt cap-stone supported by five uprights. A possible second cap-stone lies nearby. The chamber formed by the uprights contained cremated bone which has been tentatively dated late neolithic. There are 18th century accounts of a small circle of stones surrounding the dolmen. These may have been the kerbstones which would have surrounded an earth mound covering the dolmen or stone chamber.

Like most important sites, the Giant's Ring was at one time surrounded by many smaller structures. A number were recorded in the 19th century to the north of the Ring. These have mostly disappeared, visible only as crop marks in very dry conditions although one large standing stone survives to the north west.

In recent years, Barrie Hartwell of Queens University in Belfast, has been carrying out excavations in the locality. North of the henge is an oval enclosure nearly 300 feet long with a circular inner enclosure about 50 feet in diameter. Both shapes were delineated with double rows of massive stakes sunk 6 feet deep in the ground. A planked walkway led in to a platform in the inner enclosure. It has been suggested that this platform might have been for the defleshing of human remains. The inner area was at some point dismantled, burned and buried.

The area has no history, oral or written, and remains an enigma, perhaps in part because the Plantations of the 17th century and later emigration displaced the indigenous population. However, this would have been true all over Ulster, and there is no shortage of stories and legends in other parts of the province.

More recently, in the 19th century, the ring was used for horse racing. Perhaps this is an echo of the games and contests that are such a strong and ancient tradition at other ceremonial sites around the country. Horse racing is particularly appropriate to an

Ulster tradition where the principal sovereign goddess was Macha. (see ARMAGH)

Today the sheer size of the site is quite awe-inspiring, the banks and interior grassy and smooth and its secrets safely hidden from the casual visitor. It has been in state care for nearly a century and the area around it has remained lush and fertile, well protected from the encroaching city. Belfast is only a shout away, but silent from inside the Ring's deep banks.

2 Kempe Stones

Just east of Dundonald which is east of Belfast. From the A20 to Newtownards, turn north on the Greengraves Road just before the Orchard.

The townland name is Ballycloghtogall, meaning 'the town of the raised stone'.

The stones are known as the Kempe Stones possibly from the Old English word 'cempa', which means a 'warrior'. Local tradition says that a giant or warrior was killed and buried here. While this is a common folklore response to megalithic sites, the Old English is unusual.

The stones of this dolmen are basalt: two large portals, two side stones and an end stone roofed by two overlapping cap-stones, a large front one and much smaller one behind. It was excavated around 1830, about the same time as Goward dolmen in the south of the county (see below), and human bones were found. A bowl-shaped food vessel was found in the area and is now in the Armagh County Museum in Armagh.

3 Movilla Abbey

Newtownards, east of Belfast. From the centre of the town take the A48, then the B172 to Millisle. The abbey ruins are on the right inside the town cemetery.

The name Magh Bhile (pronounced Mavilla), means 'the plain of the sacred tree'. The bile or sacred tree was an important part of the sacred landscape in pagan Ireland and its name marks this as a special place before the arrival of St Finnian. He came here in the 6th century after studying at the Scottish monastery of Candida Casa. It is said that he brought with him a copy of the Latin translation of the Bible, which was known as *The Vulgate*. As Movilla grew in importance as a teaching monastery, the Vulgate gradually displaced other Latin translations in Ireland. This is the manuscript that Colmcille was accused of copying on a visit to

Movilla and which resulted in his eventual exile to Iona. (see DONEGAL) The early wooden buildings of St Finnian's monastery were burned by Vikings in 825.

In 1135 St Malachy of Armagh introduced the Augustinian Canons to Movilla. They built an abbey here in the new European style. A small round-headed window within the 15th century east window is probably all that remains from that period.

The rest of the scant ruins are 15th century and not in themselves of great interest. However, built into the north wall are seven carved 13th century coffin lids of a type which are only found here in the north east of Ireland.

Some are carved with a cross with four deep semi-circles, their curved sides touching at each arm of the cross, forming four fleur de lys. This pattern seems to have a parallel in the north of England and may have been brought here by an English stone mason. Others have a diagonal cross overlaid on the basic cross. Most have a small cross-bar further down the shaft, and some have leaves growing from the shaft, creating an image that includes the Tree of Life or the Sacred Tree (bile), as well as the wooden cross. Most of the lids also have a heavy medieval sword carved on them and one has shears. It has been suggested that the sword represents a male burial and the shears a female, but it is possible the sword represents a knight and the shears a wool merchant or landowner.

Beside these is an early Christian cross slab with a simply incised cross and the words: OR DO DERTREND, meaning 'Pray for Dertrend'.

Similarly carved stone coffin lids can be seen at different churches in the area, but this is the most splendid collection.

4 Bangor Sundial
North of Newtownards

In the rose garden on the terrace in front of Bangor Castle is a sundial, probably contemporary with those at Clogher in Tyrone and Nendrum (see below). It has, however, suffered more damage than its contemporaries. It has probably come from the site of the old abbey which is now occupied by a parish church.

It is made of grey Silurian limestone and stands now almost 5 feet high, though its original height was recorded as 6 feet. The front face goes from 10 inches at the bottom to 12 at the top, while the sides are slightly wider at the bottom, decreasing gradually towards the top. The dial is marked by two concentric lines and the gnomon hole goes right through the stone. Parts of five rays are visible, emerging from the gnomon hole. (*Figures from the Past*)

5 Grey Abbey

From Newtownards the A20 goes down the west side of the Ards Peninsula and through the little village of Grey Abbey. There is a small entrance charge to the abbey which is closed on Mondays.

From the car-park you can see the abbey church sitting amidst tightly packed gravestones against a backdrop of mature trees. Entrance to the site leads past a small visitor centre on the right which has illustrations of what the abbey would have been like before its dissolution in 1541, as well as information about the plants in the beautifully laid out physic or medicinal garden to the left. The garden is based on what is known of medieval herbal lore generally, rather than on evidence from Grey Abbey itself.

Grey Abbey was founded in 1193 by Affreca, daughter of Godred, King of the Isle of Man. She was the wife of John de Courcy, a strong Anglo-Norman figure in this part of Ulster (see **Downpatrick**). The tradition is that she founded the abbey in thanksgiving for her safe delivery from a storm at sea. It is generally accepted that the 13th century effigy in the chancel represents her and marks her place of burial. Grey Abbey was unique among Cistercian foundations in having a female patron and it was unusual for a patron to be buried within the church in the 13th century, but her relationship with the abbey was probably quite unusual. Her husband was chased out of Ulster in 1205, never to return but she applied for dowager lands here in 1219 after his death.

The mother house of Grey Abbey was Holm Cultram in Cumbria where the de Courcy had family connections. They brought with them the new Gothic building style already established in the north of England and Grey Abbey was the first fully Gothic building in Ireland. The gently pointed west door with its four carved arches is one of the abbey's finest features. However, the beauty of Grey Abbey lies generally in the simplicity and grace of its buildings, so characteristic of the Cistercian Order and the warm red local sandstone from which it was built.

The Abbey and its lands, the Rosemount Estate, were given to Sir Hugh Montgomery in 1607, after the final defeat of the Gaelic chiefs in Ulster. The Montgomery family have lived here ever since and the abbey buildings have been, for 300 years, a feature in their garden, as well as being used as a parish church until 1778. Its continued use as a parish church has meant that part at least of the abbey buildings has been well maintained, and its place within the Rosemount Estate means that it sits today in beautiful parkland shaded by mature trees.

In 1907 the abbey was given to the nation and some rescue

work was undertaken on the buildings, including the controversial flying buttresses which now support the south wall.

The remains of the abbey show a typically Cistercian plan. It is an aisleless, cruciform church, with two chapels in each transept and a tower over the crossing. The chancel is east of the crossing and the nave, west. There is a row of square beam holes on the outside of the north wall of the nave where a pentice, or covered walkway, would have been attached. It runs to a door at the east end of the nave so that the monks could arrive in the chancel without having to pass through the ranks of lay brothers worshipping in the lesser sanctity of the nave. They could also get to the chancel down the night stairs which went up to their dormitory. They would have used these stairs when they woke in the early hours of the morning to fulfil their strict pattern of prayer.

The abbey buildings surrounded cloisters with the church on the north side. The monks' quarters were on the east side. This included the vaulted chapter house where they would have met daily to hear a chapter from their rule and discuss important abbey business. The lay brothers would have worshipped in the nave at the west end of the church, and come in through a door, now blocked, in the west end of the south wall. They would have lived at the west side of the cloisters, which linked with the refectory and kitchens in the south, where their labours would have been needed. In this way the sacred aspects of the abbey were located towards the east and the mundane remained separated in the west and south.

The base of the monks' day stairs and the pulpit in the refectory can still be seen. There are also traces of a collation seat on the outside of the south wall of the church, where the abbot would have sat in the cloisters to listen to and discuss readings by his monks.

Today, in the evening sunshine, the red sandstone walls seem saturated with the contemplative quality of its monks, while the trees, lawns and nearby river offer seclusion and provide a buffer against the outside world.

6 Cooey's Wells

Cooey's Wells are signed from the A2 on the right about a mile north of Portaferry, near the southern tip of the Ards Peninsula. They are about 3 miles from the town.

Templecooey was a small monastic foundation attributed to St Cooey who later became Abbot of Movilla and died there in 731. Today the remains of a small 12th century church, surrounded by

tiny worn and unmarked gravestones, slope down to the salt
marshes at Tara Bay. Within the church ruins there is a modern
altar with 3 sacred stones on top, relics from the old church or
maybe even older.

Below the church are the three wells. One is for washing,
another for drinking and the third for bathing the eyes. They are
clearly marked and the place well cared for. A sign commemorates
the gifts of land and labour which allowed the site to be done up
and made accessible in 1977.

A narrow concrete path disappears into the tall jungle-like
undergrowth with buttercups and meadow sweet growing 6 feet tall
and ragged robin waist-high. The path emerges on the salt marsh
and goes to St Cooey's stone, a flat rock in which a number of
white pebbles are embedded. The pebbles and some indentations
are supposed to mark where the saint placed his hands, knees and
feet as he prayed. This is called the penance stone.

St Cooey's name has been Anglicised into Quinton, which
occurs in local place names.

7 Millin Cairn

*The cairn is 1.6 miles north of Cooey's Wells. Follow the A2 north,
turning right onto Quintin Bay Road. The road goes round Tara
Hill to the west. There is a fort on top of this hill where Cúchulainn
is supposed to have stayed to learn the art of hospitality from his
kinsmen. 'Tara', or 'Teamhair', means an elevated place. Just where
the road reaches the sea at Millin Bay, the cairn is signed on the
left. A narrow path runs along the side of a field.*

This site now looks like an oval mound, some 75 feet by 50 feet,
lying north/south and outlined by eleven standing stones.

It was excavated in 1953 and some remarkable discoveries
were made. The chosen site already had a dry-stone wall running
from north to south through the middle of it. This wall was left in
place and accommodated within the structure. Presumably the
exact location was important enough to accommodate the wall
rather than move to one side of it.

A long stone-lined cist runs north south to the side of the wall.
At the southern end of this cist, selected bones from at least fifteen
bodies were neatly sorted and stacked, though some of the teeth
were apparently replaced in the wrong skulls. The cremated
remains of another individual were scattered through the bones.
The cist was then covered by a low mound of shingle sealed with
clay, and this was surrounded by a kerb of thin slabs, except where
the stone wall cut through. Many of these kerbstones were

decorated on the inside as were some of the stones lining the cist.

The partial remains of an outer kerb were also found, and at the north end there was a strange construction on the wall which the excavators nicknamed 'the Pulpit'.

Eight cists and a number of cremated remains were found outside this inner mound as well as several rows of large smooth pebbles or baetyls. The standing stones were outside this again. The mound was then covered with sand, some at least probably wind-blown.

There were, in all, some 64 decorated stones, with lots of circles but no spirals. The marks were made using both pecking and incision.

This is a unique site. Although this detail has been covered again by a mound and only the outer stones remain visible, it is still worth a visit. On a clear day, from the top of the cairn, you can see all the way to Scotland - an impressive view and perhaps an intentional one on the part of the cairn builders, who may have come from across the water to this site.

8 Derry Churches

From Cloghy take the A2 to Portaferry. The Derry Churches are signed on the right about 1 mile north east of Portaferry.

These churches sit on raised ground in the middle of what would have been bog-land before recent agricultural reclamation. The smaller church to the south is the oldest, probably 10th or 11th century, and built of small pieces of undressed stone packed with yellow clay rather than mortar. There is an unusual beam slot in the east gable, a kind of early scaffolding. There are also the remains of substantial antae at the corners. These were a typical feature of early Irish stone churches and probably an important structural feature of the wooden buildings that preceded them.

Evidence of an earlier timber structure was found beneath the present building during excavations in 1960. This had been covered with a layer of clay and the stone building placed on top. It may be part of the 7th century foundation of St Cumain. His festival was at one time preserved in this small church. The excavations also revealed a domestic site, as well as an early Christian graveyard. These were dated at not later than the 8th century, so it is likely that this is indeed St Cumain's site.

The north church is larger, probably 12th century. There is a small decorated cross slab inside, the cross made of a number of incised parallel lines. There is a narrow east window about 2 feet high and a pronounced batter at the base of the east gable. It was

beneath this church that the remains of the habitation or domestic site were found.

9 Nendrum Monastic Site

Well signed from the A22 south of Comber and south west of Belfast. The site is on Mahee Island which lies at the end of a string of islands linked by causeways. Seemingly remote today, the site would have been close to the waterways of Strangford Lough and easily accessible from its busy medieval ports.

The earliest foundation here is attributed to St Machaoi who died towards the end of the 5th century. We know nothing more about Nendrum until the 7th century when it is mentioned in later written records.

According to records, the site was badly damaged by fire in 976. This may have been a Viking raid as Strangford Lough would by this time have been one of their main bases. The abbot was burned in his house. The settlement must have recovered because it was still functioning in the late 12th century when John de Courcy established a small Benedictine cell here.

By 1306 it had become a parish church. This was abandoned for a site on the mainland in the 15th century, and Nendrum lay undisturbed until it was rediscovered in 1884. A local priest, interested in antiquities, thought he had found an old limestone kiln. After further investigation, it was found to be the stump of a round tower and the site was then identified as the old monastery of Nendrum.

It was excavated in the 1920s and some restoration work carried

Nendrum Monastic Site

out on the mainly post-9th century stonework. Unfortunately, inadequacies in the excavation technique meant that early wooden structures, which would have existed before the present stone buildings, are now lost. This is particularly regrettable as this is one

of the few monastic sites in Ireland that was not in continued use as a burial ground. Because of this, earlier occupation layers would have been left mainly undisturbed.

Today there is an enclosure with three roughly concentric stone walls or cashels around it. The inner area contains the church and graveyard and the remains of a round tower, added probably in the 10th century. The east end of the church, the chancel, with its tiny annex on the north side, is probably from the Benedictine period. The west wall and fine lintelled doorway are earlier and were reconstructed in the 1920s when some cross slabs were built into the fabric of the wall. The sundial by the church door was also reconstructed at this time. The triple moulding is quite ornate and probably incorrectly reconstructed, though it gives a good sense of the original.

The middle cashel shows the remains of stone huts to the south west, perhaps where the monks lived or worked, and a rectangular building, known as the schoolhouse, on account of some thirty slate pieces found there which had been used for practising knotwork designs. The slate tablets were found in a wall crevice with the monastery bell, where they had been hidden for safe-keeping. It is assumed that the outer cashel was used at least in part for growing food and on the north side, the remains of a grain drying kiln has been identified. Recently a possible stone fish-trap has been found in the bay.

Now the site is remote, beautiful, and a rare glimpse of monastic life in pre-Norman Ireland. It must have been a thriving community as no small struggling monastery would have had the resources or inclination to build a round tower. Round towers are often described as places of refuge built in the time of Viking raids. This tower which, even in its ruined state, allowed the site to be found in the 19th century, must have been a very prominent landmark from the 10th century onwards. Strangford Lough would, by this time, have been a strong Viking base. As the tower would have made the monastery very visible from the lough, it seems unlikely that it was built as a refuge from Viking raiders. The function of round towers is not really known, but their visibility in the landscape must have been important to their builders, as it would have advertised their presence to friend and foe alike.

A small visitor centre on the site has additional information and makes a small admission charge. Admission to the site itself is free.

10 Downpatrick Cathedral and The Hill of Down
Downpatrick lies 21 miles south of Belfast.

There are two hills here at Downpatrick. One, the Hill of Down, is the site of the present Church of Ireland Cathedral on the west side of the town. The other is called the Mound of Down, and lies to the north of the town on the edge of the Quoile Marshes. It is signed down a path to the north of the museum, which is housed in the old gaol, near the cathedral. Beyond the mound, across the marshes, lie the massive ruins of Inch Abbey. (see below)

The Mound of Down is a large oval site enclosed by a steep bank and wide outer ditch. Inside is a tall U-shaped mound in the south east. This was the seat of power of the Dál Fiatach, the ruling family of east Ulster in the 11th and 12th centuries. In 1137, when the Norman John de Courcy took control of Down, he made it his principal seat of power, recognising its strong strategic position. With the taking of the mound, he also took over from the Dál Fiatach the patronage of the monastic settlement on the Hill of Down to the south, as well as Inch Abbey and Nendrum to the north. Both were flourishing at the time. Both had built fine round towers.

The monastery on the Hill of Down was said to have been one of the first churches to be founded by St Patrick. The hill had been known until then as 'Rath Celtchair', 'Celtchair's Fort'. Celtchair was one of the Red Branch Knights of Emhain Macha, and a friend and contemporary of the great Iron Age King of the Ulster Cycle, Conchobar Mac Nessa himself. (see ARMAGH) This must already have been a sacred hill to have been chosen for one of St Patrick's first churches.

In 1137 St Malachy, then Bishop of Down and Dromore, according to the newly reformed system, introduced the Canons Regular of St Augustine to the foundation at Rath Celtchair. It was part of his campaign to reform monastic life in Ireland and bring it more in line with the European system.

It is probable that this marked the beginning of the present cathedral building.

However, when John de Courcy took Down later in the same year, he removed the Irish Augustinians and replaced them with Benedictine monks from Chester in England. They continued building. They rebuilt the church and there is evidence that they built several other large stone buildings nearby, though no cloister typical of their order has been found.

Later, war and destruction have ensured that little remains of the old buildings today, though some would say that 19th century restoration did more to obliterate the past than either Edward the

Bruce or the Tudor conquest. In 1826 restoration was completed when the round tower was taken down and used to build the present cathedral tower! There are just two fragments of early Christian crosses set into the east wall, though the aisled choir and chancel of the Benedictine cathedral remain, and the capitals and responds of the arcades survive from the medieval period.

In fact much of the cathedral's charm lies in its more modern furniture - Regency box-pews, choir stalls, and a fine organ. John Betjeman called it "the prettiest small cathedral in these islands".

The Hill of Down and its cathedral seem to owe their importance as a religious site to the activities, sometimes rather suspect, of those in power on the next hill. Its importance as the final resting place of Ireland's three great saints, Brigid, Patrick and Colmcille, is now seen as potent 12th century propaganda - certainly good for business. John de Courcy's seal of approval says more for his experience in political expediency than it does for the veracity of the rumour.

Colmcille died on Iona in 597 and his body was buried on the island. In 807 the monks of Iona fled to the Columban monastery

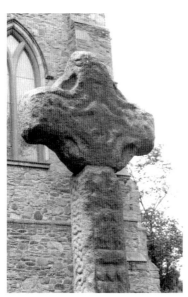

High cross, Downpatrick Cathedral

at Kells, in Meath, and seventy years later the relics of their founding saint were brought to Kells too. Strange as it may seem, during one of their frequent raids on the monastery, the Vikings from Dublin stole these relics and took them with them across the sea. This was not the end of the story, however, for a great storm blew up and the relics were washed overboard and came ashore near Downpatrick. Thus they made their way to join the bones of St Patrick. This story is beautiful in its way and after all, it is the power of myth which has maintained Downpatrick as a place of pilgrimage as potent today as ever.

A large stone inscribed with a cross and the word 'Patric', sits to the south of the cathedral. It was commissioned in 1900 to mark the site of St Patrick's grave. As you approach the cathedral at the

east end, there is a rather worn high cross dating from the 9th or 10th century. It was taken from the town in 1897 and placed here.

The Gaol Museum

The museum is housed in the old 18th century gaol and governor's residence on the Mall on Cathedral Hill.

The gaol, completed in 1796, was a model for its time with bathing facilities and heating. It held up to 130 prisoners. It was replaced in 1835 by a new gaol and used as an infantry barracks.

It displays artefacts from prehistory to more modern times, with the history of the gaol itself and its most famous prisoner, the United Irishman, Thomas Russell. There are also several rooms telling the story of St Patrick.

It is open on weekdays and weekend afternoons in summer. In winter it is closed all day on Sunday and Monday. Admission free. Phone: 028 44615218

Struel Wells

Under 2 miles east of Downpatrick. From the town, take the Ardglass Road turning left just past the hospital. The wells are signed from here.

These are said to be the wells where St Patrick came to bathe from nearby Saul. It was probably a sacred place for a long time before that. Until the 19th century there were patterns here at midsummer and on the Friday before Lammas (Lughnasa), and although the tradition of the pattern is a Christian one, these Celtic festival dates indicate a much older tradition.

The site itself is a tranquil rocky valley with a wide base. A stream flows through it (strúill means 'a stream' or 'flow'), sometimes passing through underground culverts but accessed at four points which are known as the four wells. Each well has a stone building and they are all contained in a spacious grassy enclosure.

There are small stone huts over the water at the drinking well and the eye well. The bathing well has large separate bathing houses for men and women for bathing more extensively. The men's house still has its stone roof. Steps lead up to a dressing room and then to the bath room with a huge sunken stone basin and stone steps to climb down into it. Water pours in from the side. The women's house is less dramatic. Their dressing room lies at the back of the men's building and their bath house contains a shallow

channel in the floor into which water runs from a spout halfway up the wall - more of a shower than a bath. Jonathan Binns, writing in the early 19th century, says that those who could afford to pay a few pennies admission, went into the big bath house where they could immerse their whole bodies in private. The smaller bathing house was called the 'limb well'. There was no charge but its shallow channel and high spout were meant to be used for the discreet dipping of limbs. He was shocked to find that some people abandoned all modesty and bathed naked here in public. (*The Miseries and Beauties of Ireland*)

Struel wells

The wells are first mentioned in writing in 1306 when a chapel was recorded on the site. Some pieces of decorated stone from this period are built into the outer wall near the drinking well. The current church building, dating to the middle of the 18th century, appears never to have been completed.

The midsummer pattern involved mass in Downpatrick. Clay was collected from his grave site and then the well was visited. Some people brought a stone to the cairn. Some went on their knees. At midnight between the 23rd and 24th of June the water here was said to rise up. The eye well overflowed, filling the green for half an hour before it subsided. Its powers were considered greatest then. This tradition of the waters boiling at midsummer's eve is widespread and often associated with St John, whose day is the 24th June.

However, by the 19th century, the church had banned the patterns here on the grounds that they had become too rowdy. This seems to have happened all over Ireland. The celebratory side of the old festivals was not in line with 19th century Christian values and behaviour.

The wells are still visited for their healing properties and the area round them provides a tranquil setting which in itself contributes to a healing sense of peace and ease.

11 Saul Church

Saul is 2 miles north east of Downpatrick and is well signed from there.

The story goes that Patrick, on his return to Ireland in the 5th century, pulled up his boat at the mouth of the Slaney river just north of here. He was spotted and the local chieftain was called. The chieftain's name was Dichu, and he promptly set his dogs on the new arrivals. Patrick is supposed to have declared that no dogs should attack those who proclaim the new faith, whereupon the dogs became quiet. Dichu was impressed and later converted to Christianity, offering Patrick his barn for his first church. Sabhall (pronounced Saul), means barn.

A monastic foundation grew up here, though little remains of it except a small stone mortuary house north of the new church. Another small structure has been incorporated into an elaborate vault. There are a number of cross slabs in the churchyard and to the west the well, blessed by the saint.

The new church here was built in 1932 on the site of that first church. It is a simple building in the style of the early Celtic churches complete with small round tower. St Patrick's life is commemorated in the stained glass windows.

Mearne Well

To find the well, go down the hill from the main gates of the church and turn left onto Mearne road. It is in the front garden of a house on the left hand side of the road and they have created an access path for visitors. The water is clean and clear and the well cared for, but it feels a little strange being in someone's front garden just under their sitting-room window.

Slieve Patrick

Turn round at the well and travel east along Mearne road. Slieve Patrick rises ahead, easily marked out by the enormous granite statue of the saint which stands near the top of the hill. There is a large car-park and gates on the right.

The hill has become known as St Patrick's Shrine, and the path to the top is punctuated by the Stations of the Cross. From below the man-made monuments tend to dominate, but once you've climbed the hill, nature reclaims its power. The other sacred mountain associated with St Patrick is Slemish in Antrim.

12 Audleystown Court Cairn

*It sits above the southern shore of Strangford Lough in lush
farmland, 5.7 miles east of Downpatrick on the road to Strangford.*

This site was excavated in 1952 and partially restored. The cairn is
wedge-shaped and the kerbs are made of dry-stone walling rather
than the more usual large stones. A shallow court at each end
leads to a gallery with four paved chambers each. The stones
forming the court are mainly triangular in shape, as are the
endstones at the innermost chamber on each side. Some of the roof
corbelling is still in place.

In some of the chambers, a layer of stones and black earth
several inches thick was found, scattered with human bones, some
burnt and some not. There were also pottery sherds and flint tools.

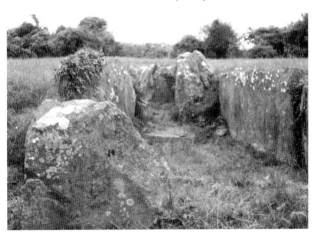

The gallery, Audleystown court cairn

The remains of seventeen individuals were identified in each
gallery. Most court tombs contain the remains of only two or three
bodies. It appeared, on excavation, that the contents of each
gallery was the result of a single burial of many bones, rather than
a series of burials. Two thirds of the bones were defleshed and
unburned. This is also very unusual.

According to Estyn Evans, the wedge-shaped cairn, the
method of burial and the dry-stone walling round the cairn point
to a close connection with the megalithic culture in the Severn-
Cotswold area of England (*Prehistoric & Early Christian Ireland*). This
is quite possible, being near the shore and a sheltered harbour.

Toberdoney Holy Well is 100 yards north west of the cairn by
the lough shore.

13 Ballynoe Stone Circle

Signed just south of Downpatrick off the B176 to Killough.

The site is accessed up a long lane fringed with wild flowers and arched in places by thorn trees.

This is a very gentle place and an unusual site. Most of Ulster's 100 circles are small, both in diameter and in the stones used to make them. They are also mostly in the middle of the province.

You can see for miles from this circle, even though it is on the gentlest of slopes. At first it seems like only a circle of stones, closely spaced and about 108 feet across, but as you get closer, you can see an oval cairn in the middle, with kerbing at one end and an arc of standing stones set out from the other. There are many outliers around the field, some possibly erratics.

The circle comprised about 70 stones, standing close and 3 to 7 feet high. They are largest in the north and south. There is a gap in the south west. The entrance is between two portals just south of west: two more stones form outer portals just outside the arc of the circle and two more just inside it. This makes a kind of passage with three stones on each side.

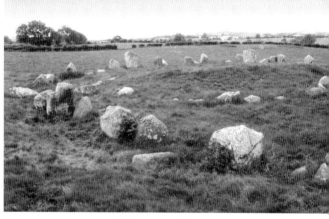

Ballynoe stone circle

According to Aubrey Burl, in *A Guide to the Stone Circles of Britain, Ireland and Brittany*, this circle is oriented to two peaks in the Mourne Mountains, visible 14 miles to the south west. The sun at midwinter would appear to set behind Slieve Donard a little south of west as the skyline is so high there. Slieve Donard is 2700 feet high. This would align exactly with the entrance to the circle.

The site was excavated in the 1930s and a cist with cremated bones found at each end of the cairn. Seven individuals were identified. Also buried in the cairn were a number of water-

smoothed stones, or baetyls, and a sherd of Carrowkeel pottery which would date it to the neolithic. A ditch was found around the circle. However, the excavations did not give any insights into the sequence of the different parts of this site. It was obviously used in different ways over a long period, from neolithic times well into the Bronze Age.

Aubrey Burl suggests that the cairn and stones inside the circle must have been constructed after the circle. He sees similarities between Ballynoe and the circles of Cumbria. It is only 5 miles to Dundrum Bay and he suggests that neolithic traders perhaps coming across from Cumbria for some fine porcellanite axe heads at Tievebulliagh in Antrim, might have decided to stay.

14 St John's Point Church and Holy Well

1.5 miles south south west of Killough on the road to the lighthouse.

This is a delightful small early church dating to the 10th or 11th century. It has a lintelled doorway with sloping jambs and antae to the east and west. There is a small south window.

A small scale excavation in 1978 showed burials under the north wall. Local people apparently believed that the burials around the church were placed radially. This was found not to be the case. The same local belief held for the area around the Kilnasaggart Stone in Armagh.

By the road, near the entrance to the church, is a holy well and bullaun stone.

15 Ardtole Church

0.75 miles north east of Ardglass, to the east of the A2 on a hilltop overlooking the sea.

This is probably a pre-Christian sacred site. To the north and west are traces of an old stone enclosure and all the components of a sacred place: a hill, a well and a special stone.

The present remains are 15th century. There is a long, narrow church with large east window and north and south doors, one with a draw-bar hole. This was the parish church of Ardglass, dedicated to St Nicholas, the patron saint of sailors.

Sometime around the late 15th or early 16th century it was burned down, with its congregation inside, by the MacCartan family, to avenge a great insult. Apparently, the townspeople of Ardglass had found the chief of the MacCartans lying on the hillside in a drunken stupor. They played a trick on him by

fastening his considerable hair to nearby briars so that when he woke up, he couldn't move. This is said to be the story that gave Jonathan Swift his idea for a similar adventure in *Gulliver's Travels*.

At the edge of the altar is a carved hand. This may be another example of the Right Hand of God with its connection both to a Judaic blessing of God to his people, and a pagan fertility blessing on the land. (At Quin Abbey the hand is a mason's mark showing the work to be complete.)

An early cross slab from here has been built into the porch gable of the church at Chapeltown, where it was taken in 1791.

16 Inch Abbey

The abbey is signed off the A7 on the right as you approach Downpatrick from the north. You then take the first turn on the left.

This site would have originally been an island in the Quoile Marshes, accessed by a causeway to the north, hence the name Inch, meaning island. This would have given it the isolation sought by the Cistercians following their ideal of a wild and deserted place. At the same time it would have been easily accessible by river from the nearby secular and monastic settlements that were later to become Downpatrick.

Today tree-lined ditches to the east and west of the present site mark some of the boundary of the early foundation. There was a monastery here by 800 AD. It was called Inis Cúscraidh. As is often the case, little is known about this early site, except that it was burned down twice and presumably rebuilt.

When John de Courcy took Ulster in 1177, he brought over a group of Cistercian monks from Furness in Lancashire, and installed them here within sight of Downpatrick, sometime between 1180 and 1187. So Inch became a daughter house of the English abbey in Furness. Some say it was to atone for his destruction of the abbey at Erenagh and part of his own personal contract with God. It also sat well with the new reforming wave within the church in Ireland, and furthered his mission to subdue Ulster.

The visible remains today are typical of the Cistercian Order. There was a cruciform church with transepts and a crossing tower. South of the church are the outlines of cloisters with some remains of the monks quarters to the east, and kitchen and refectory to the south. A well and bake-house lie to the west of the main building and a probable infirmary to the south east.

The style is Gothic, indicating a building date after 1200. One

Romanesque carved stone of 12th century date is the only hint of what was here before. An exterior wall in the north transept holds the masons' marks left by individuals working on the building. The east wall of the church still stands, with its triple lancet windows which play dramatically with the strong evening sunlight, giving some idea of the splendour of the original building and the awe it must have been held in at the time. The east end of the church would have been accessible only to the brothers themselves, of course. The lay brothers would have been confined to the nave and separated from the chancel, probably by a wooden screen. In the south wall of the chancel are the remains of a triple cedilla and a piscina.

Inch Abbey does not seem to have flourished and by the 15th century the community was much reduced and internal walls erected in the church to make it smaller. In 1541 the abbey was dissolved and the lands granted to Gerald, Earl of Kildare.

Just before the Abbey entrance are the grounds of the parish church. It was not uncommon to have a public church near Cistercian foundations as lay people were not allowed to worship in the abbey itself. This church was used as a parish church until 1730 and the graveyard continues to be used to this day. There is a stone with a finely carved crucifixion scene in the graveyard.

17 Slieve Donard

Just south of Newcastle on the coast road. Stop at Bloody Bridge at the foot of the mountain.

The Mourne Mountains rise steeply from the sea and from the lowlands to the north. Their highest peak, Slieve Donard, is 2798 feet high, and one of the sacred mountains of the east. Its most ancient associations are with Partholón, father of one of the early races of Ireland, who is said to have buried his son, Slánga, beneath the cairn on the summit.

More recently its power is associated with Donairt, who was the youngest son of the last pagan king in the area. His father was called Echu or Eochaid and was accused by Patrick of abusing two young women of his household who had become Christians. Patrick is said to have cursed Echu and his descendants saying the kingship would pass to his brother, Cairell, and his brother's children. Echu's wife, pregnant with Donairt at the time, fell at Patrick's feet and he blessed the child in her womb. Donairt was eventually left by Patrick as the perpetual guardian of the holy mountain.

Thereafter he blessed the men of Ireland from the Rick, and he
orders seven of his household (who are still alive) to guard the men
of Ireland, to wit, a man at Cruachan Aigle, and a man at Benn
Gulbain, a man in Sliab Bethad, and a man in Sliab Cua, and the
married pair at Cluain Iraird, and Domangort of Sliab Slangia.
— *Tripartite Life of St Patrick*, translated in *The Festival of Lughnasa*
(The Rick is Croagh Patrick.)

In an interesting detail, Donairt's mother was said to have four
breasts. Maybe these are the four hills surrounding the highest
peak of Donairt. His pattern day is the 25th July and a pilgrimage
or pattern up the mountain took place on this day until the
19th century.

In a way St Donairt 's presence on the mountain is a way of
relating to the spirit of the mountain. Echu's rath, or fort, is
thought to have been the enclosure around the present church of
Maghera. (see below)

An extraordinary wall, called 'the Mourne Wall', was built
between 1904 and 1944 to enclose the catchment area of the
Belfast Water Commissioners. It begins at Slieve Binnian and
circles part of the mountains, with 22 miles of broad wall built from
two layers of dressed stone. It runs up the side of Slieve Donard,
from the Bloody Bridge right to the main cairn, and is a good place
from which to climb the mountain.

According to Estyn Evans, in *Prehistoric & Early Christian Ireland*,
this cairn right on the summit is a passage cairn, though it remains
unexcavated. It is just outside the Mourne Wall as it turns sharply
to the west. Below to the north east is the lesser cairn.

This is a well-defined mountain top, a peak with views, on a
clear day, that make you feel closer to other peaks, like Snowdonia
in Wales, than to the lowlands of Down.

18 Maghera Old Church

*3 miles south east of Castlewellan. Signed. The last sign for the
church has gone, but it is the first gate after the left turn out of
the village of Maghera.*

This small 13th century church is on the site of a 6th century
monastery associated with St Donairt. It is in a sheltered spot,
surrounded by lush fields and high hedges. The circular enclosure
around the church marks the rath or cashel of Murbhuilg, home of
the chieftain, Echu, who was Donairt 's father. (see Slieve Donard)
Burials around the church have raised the ground level to the top
of the cashel walls, which are about 10 feet thick. Inside the walls

there are two early cross slabs. In the field nearby there is a ruined round tower with walls of beautifully rounded stone. This is a gentle, sheltered site.

There was a tradition at Easter, of bringing a meal of mutton and beer to Rath Murbhuilg for St Donairt who was made immortal by Patrick and left as the perpetual guardian of the mountain. This developed into the tradition of a feast of mutton on Easter Monday for everyone.

19 Dundrum Castle
On high ground inland above the town of Dundrum and signed from the A2. Environment and Heritage Service. Small admission charged.

This is a magnificent site, no doubt developed for its strategic

Dundrum Castle

importance. You can climb to the top of the old cylindrical keep and look out across Dundrum Inner Bay to the 3 mile-long gravel spit that extends up from Newcastle to the south. The dunes beyond the golf course on the sea side of this spit, have turned up plenty of evidence of prehistoric settlement from Bronze Age times, and the hills themselves have given the name to Sandhills Ware, which is a type of decorated neolithic bowl. To the south west are the Mourne Mountains.

This is definitely a fairy hill and as time erodes the military excesses of the last 2000 years here, the hill has been reclaimed by nature. Today the 13th century keep, an innovation in its time, takes you high above the bay below and the later defensive additions provide landscaping for the semi-wild profusion of

valerian and wall flowers.

In the 13th century this would have been one of a string of Anglo-Norman castles, held to maintain control of the country or at least its coastline. Since then it has had a turbulent history, taken and retaken and then finally abandoned as it became strategically irrelevant.

The Bay below, now Dundrum Bay, was previously known as Loch Rudhraighe, after the second son of Partholón (see **Slieve Donard**). He was said to have drowned here when the waters rose up in fury against him. Another local story tells of a king, called Fearghus mac Léide, who lived here. His mouth was twisted with horror when he saw a monster in the bay. Though kings had to be without blemish, he remained king by hiding his twisted mouth until a slave woman noticed it. After that he had no choice but to give up the kingship. He went out into the bay and fought the monster, but was himself killed. (*The Sacred Isle*)

Slidderyford Dolmen

Leaving Dundrum on the A2 going south, take the B180 on the right and then keep left on the old road which runs parallel to the A2. Just before you rejoin the main road, there is a farmhouse on the right, called Dolmen House. The dolmen is in the next field beside the house.

The field slopes gently up from the road and the dolmen looks very dramatic, about 100 feet away on the skyline. It is a single chamber with a huge granite cap-stone resting on two portals which face north west. A third slab at the back forms the end stone. The north portal is also granite, 6 feet high, with its shoulder cut to fit perfectly the rounded base of the cap-stone. The other portal and the end stone are shale and both about 4 feet high.

20 Drumena Cashel and Souterrain

2.5 miles south west of Castlewellan on the A25 to Newry. Turn left at the crossroads before the reservoir on the right. The cashel is visible on the right.

There is access up a pathway and through a narrow opening in the wide dry-stone walls. These are made from local boulder clay, up to 12 feet thick and waist-high. The original entrance is thought to be a gap in the east. The walls were extensively rebuilt in the 1920s.

It is very still inside, with that strange sense of separation you get behind thick stone walls, even when you can see over them.

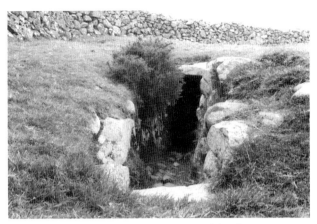

Drumena souterrain within the cashel walls

The cashel sits on a stony ridge on the northern foothills of the Mournes and you can look south right across a valley which would have once been an important route from the north east, down through the Gap of the North beyond Newry.

The walls enclose an oval area. There are some dry-stone foundations which are probably house sites and a well-restored souterrain shaped like a pickaxe with a wide 'blade'. The main passage is about 7 feet high with dry-stone walls and a lintelled roof. The entrance is now down steps in the 'handle', but would once have been via the 'blade'.

21 **Goward Dolmen** (also called Cloghmore Cromlech)
Signed on the right off the B8 about a mile north east of Hilltown. It is just under a mile off the main road. The lane degenerates towards the end, but once you get there, there is space to park and turn.

This is one of those dolmens that takes you by surprise even when you are expecting it. It is dramatic and huge yet tucked away in a slight drop to the north side of the lane. Equally unexpected are the views to the north - 180 degrees from east to west.

It has a mighty granite cap-stone about 5 feet thick and 13 feet by 10 feet, supported in the east by pillar stones nearly 6 feet tall. Beside these pillar stones are some more uprights which may have formed an impressive court at the front of the chamber. At the back of the chamber, which is 9 feet long, is a thin slab which may have been an end stone or else a second cap. Some traces of a cairn can be seen and excavations around the 1830s revealed a cremation urn and a flint arrowhead in the chamber.

The dolmen is also called 'Finn's Fingerstones', and 'Pat Kearney's Big Stone', though the 'Fingers' may actually be a group of large stone uprights at the southern angle of an enclosing wall, just 300 feet north west of the dolmen.

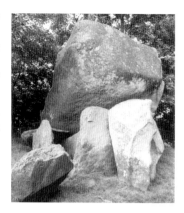

Goward dolmen

22 Kilfeaghan Dolmen

232154
South east of Rostrevor and just north of the A2. Signed inland and uphill.

The granite pillar stones of this dolmen are about 8 feet tall, but partially hidden by an infill of small stones. They support a massive cap-stone, also granite, and are estimated to weigh around 35 tons. Excavations in the 1950s showed that it once sat at the north of a

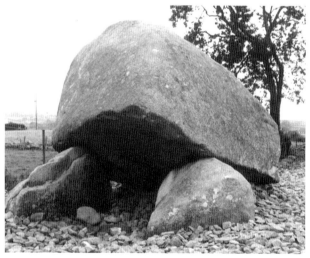

Kilfeaghan dolmen

long tapered cairn which was aligned north south, and its pillar stones may have opened onto a court. Local memory of earlier excavations mention bones and pottery being found.

These are the southern slopes of the Mourne Mountains and

the views are wide and wonderful out over Carlingford Lough and on to the Cooley Mountains in Louth.

23 Kilbroney Cross and Medieval Church
1 mile north east of Rostrevor on the Hilltown Road.

This is the site of a monastery founded by the Virgin Brónach, patron of seafarers. The ruined church is a much later medieval parish church, but south east of it stands a large cross, patterned on its west face. Nearby is St Brónach's Well and between the well and cross, is a small granite cross about 3 feet high with a crude crucifixion on its east face. This small cross is referred to as the 'face-cross'.

The bell from St Brónach's nunnery is now in the Catholic Church in Rostrevor and St Brónach's enshrined staff, a much venerated object, is now in the National Museum in Dublin.

24 Legananny Dolmen
7.5 miles north north west of Castlewellan. Signed off the Castlewellan to Banbridge road.

This is a beautiful dolmen, perhaps the most poised and graceful one in the whole country. A tapering granite slab some 10.5 feet long rests effortlessly on two slender 6 foot pillar stones and an elegant pointed end stone. It retains a remarkable presence in spite of the small space allotted to it on the side of a farm lane. No side stones or sill remain. The distant horizons provide its wider setting on the south west slope of Cratlieve, with Slieve Croob in the distance. There are stories of urns being found in the chamber, but if this is true, they have since been lost and the site has never been excavated.

Slieve Croob was formerly a Lughnasa Assembly site. Unfortunately, there are now three radio masts on top of the hill.

There are a number of standing stones in the area. Turn left as you leave the farm lane and follow the road round, bearing right down to the T junction. There is a stone in the field to the right which has been inscribed with a cross.

From the stone turn right, then right at the crossroads and then right again at the T junction. From here the road winds uphill and through the Windy Gap with views in all directions. Nearby is a tiny circular mass garden, surrounded by a neatly trimmed hedge, sheltering a flower-filled garden with benches and a rock altar. A sign advertises mass here every Sunday at 2.30pm.

ULSTER **Down**

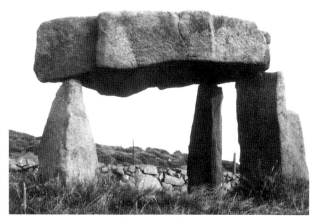

Legananny dolmen

Province of
LEINSTER

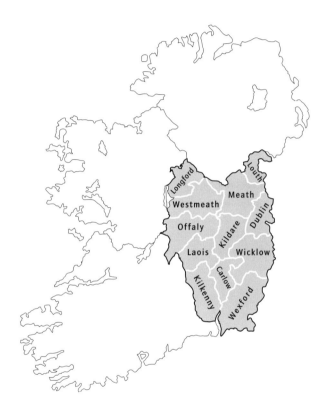

Longford

Louth

Meath

Westmeath

Offaly

Kildare

Dublin

Laois

Wicklow

Kilkenny

Carlow

Wexford

PROVINCE OF LEINSTER

LEINSTER COVERS THE SOUTH EAST OF IRELAND, more east than south, but it also includes within it the mythical fifth province or middle kingdom of Midhe. This fifth province is now known as Meath and Westmeath, and it is here that the Hill of Uisneach, the symbolic centre of Ireland, is found. Uisneach is called the navel of Ireland. Geoffrey of Monmouth tells how there was a sacred circle of stones here, so powerful and magnificent that they were coveted by the king of England and spirited away by the Druid Merlin just before the time of King Arthur. (see WESTMEATH)

The navel is the point through which we are connected to our source. At birth it connects us to our mother. Uisneach is, for Ireland, the belly of the earth goddess. The land around the centre is prosperous and rich, the most powerful and vital part, the place of new beginnings. It is also the only province where the soft fertile centre of the country reaches right to the coast, leaving it vulnerable and open to outside influences.

The sea between Ireland's east coast and the rest of Britain allowed for constant movement and exchange across the water. The Irish Sea was more easily crossed than most of inland Ireland in prehistoric times. Even after the Romans came, there were colonies of Irish invaders living in south west England, Wales and Scotland, on the edge of the Roman Empire. 'Scoti' is the Roman name for 'the Irish' because Scotland was seen as the land of the Irish. When Patrick came to Ireland, he had been kidnapped by an Irish raiding party. The famous High King, Niall of the Nine Hostages, in the 5th century, was said to have taken one hostage from each of the provinces of Ireland and one each from the Scots, the Saxons, the Britons and the French.

But sometimes the raiding came the other way. Leinster's vulnerable coast was the first to be attacked by Vikings towards the end of the 8th century. Fifty years later, in 841, the Vikings had established a base at the mouth of the river Liffey. They built their first settlement nearby, the first town in Ireland and now its capital city, Dublin. The power of the Vikings was crushed in 1014 at the Battle of Clontarf near Dublin, but the introduction of towns and the legacy of trading using coins and weights spread from here to other parts of the country.

And, of course, it was at Leinster that the first Normans landed towards the end of the 12th century. Their power-base, the Pale, was along the Leinster coast. They were invited here by the Irish king, Diarmuid MacMurrough, who had been deposed as king of Leinster. He needed help to regain his kingdom. However, Henry

II of England followed soon after his Norman barons to safeguard his authority which had now technically spread to include Ireland. The Irish were used to Gaelic chiefs who allowed the ruling families autonomy over the land. They didn't expect Henry's overlordship to make much difference. But Henry took their land and gave it to the Norman barons. He granted Leinster to Strongbow and Meath to Hugh De Lacy. The impact of these events changed the relationship for ever between Ireland and her neighbours.

While Leinster may have been vulnerable politically, it has a rich spiritual heritage. The Boyne Valley is the apex of the neolithic passage cairn culture and the royal site at Tara held the tradition of ritual marriage between king and earth goddess for over a thousand years. Leinster is the home of the *Book of Kells* and the scriptoral high crosses. And it was here that the first of the European monastic orders came. Mellifont in Louth was the site of the first Cistercian abbey in Ireland.

Overall, Leinster's geographical vulnerability has made it culturally diverse, which gives it a special vitality.

PROVINCE OF **Leinster**

LEINSTER **Westmeath**

County

WESTMEATH

PRINCIPAL SITES

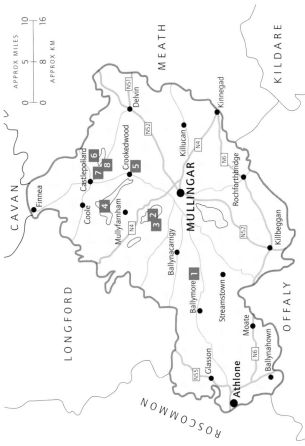

1 The Hill of Uisneach
2 Lough Owel
3 Frewin Hill
 Portloman Abbey
4 Lough Derravaragh
5 St Munna's Church
6 Fore Abbey
7 Gallagher's Moteens
8 Rindoon Hill - Turgesius' Fort

Block figures in list refer to site locations in map and entries in text.

WESTMEATH

WESTMEATH IS AT THE CENTRE OF IRELAND and has within its borders the Hill of Uisneach, place of legends and myths, expressing in so many different ways its role as the centre of the Irish landscape. This hill seems unremarkable when you pass by, but on closer inspection, I found it to be one of the most magical places in the country. In an increasingly fragmented world, it is a valuble thing to be able to spend some time at the centre.

Westmeath is also a county of lakes and beautiful flooded limestone valleys that inspire legends and stories. The heart of Ireland is often overlooked and probably that is not a bad thing. Often it is the undramatic gentle places at the heart of the country that still hold a strong connection to the Otherworld - only entered now through the imagination.

LEINSTER Westmeath

1 ## The Hill of Uisneach
It lies about 15 miles west of Mullingar on the R390 to Athlone. It is 5 miles east of Ballymore in the centre of Westmeath and it is signed.

The hill of Uisneach is a low, undulating limestone outcrop about 600 feet high rising out of the flat plains of the midlands. There are many claims about how far you can see on a clear day. Some say you can see twenty of the thirty-two counties. It is also said that a bonfire lit here at the height of Uisneach, could be seen across the midlands in every direction and fires lit in response on the furthest hills, would light all the way round the coast.

The Hill of Uisneach

This is no theoretical boast as both tradition and archaeology tell of huge ritual fires lit here. There are thick deposits of burnt ground at the fire site which was used from neolithic times until the Iron Age. We have stories about the great Celtic fire festival of Bealtine at the beginning of May, but these fires go much further back into pre-Celtic times to the Tuatha Dé Danann and beyond. In Celtic times the Druids were said to have built two great fires between which all the cattle were driven to ensure their health and well-being for the coming year. A similar practice survived until recent times whereby livestock were driven through water at potent times of the year to protect them from harm of any kind. From the sacred fire at Uisneach, all the fires of Ireland were relit for the coming year.

Symbolically, Uisneach is the centre of Ireland. Energetically, this place is the strongest access point to the being of the whole landscape, whether it be called the 'Earth Mother', the 'goddess' or the 'Cosmic Mother'. There is a well on the southern slope which is held to be the navel of Ireland and the source of twelve rivers. Wells always provide a point of contact between the inner life-blood of the earth and her outer surface where we humans mostly live. It is a hidden well and not easily found and was said to have been lost in the past till Oisín, the poet warrior of the Fianna and son of Fionn mac Cumhaill, went to look for it. He was searching for water for a feast. So as not to be followed while he searched for the hidden well, he walked backwards and found it.

Like all the great centres of Ireland, this hill is held to be the burial site of one of her goddesses, in this case Ériu, for whom Erin was named. She is said to lie beneath the Cat Stone on the south western slope. She embodies the female principle of the landscape and it is from here that the four ancient divisions or provinces extend. In Irish the stone is called 'Ail na Mirenn'. 'Ail na Mírenna' means 'the Rock of Parts' or 'Portions'. Uisneach, being at the centre, is not in any of these four parts but in a middle or fifth province, called 'Midhe' from which the county of Westmeath gets its name.

The Dinnseanchas, the early topographical stories of Ireland, have an account of the naming of Uisneach and Meath. It says that Midhe was the first of the sons of Mil to light a fire on the hill and that it burned for seven years and was the fire from which all the chiefs' fires were lit throughout the country. The Druids, however, said that it was an insult to them to have this fire lit by Midhe. They all came together to take counsel, but Midhe had all their tongues cut out, and he buried the tongues in the earth of Uisneach, and then sat over them. When his mother saw him she exclaimed, "It is Uaisneach (meaning 'proudly' in Irish), you sit up there to-night".

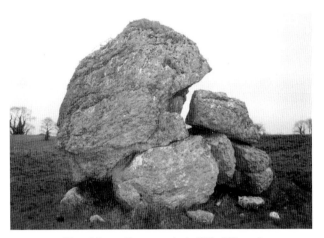

Ail na Mirenn (the cat stone), the Hill of Uisneach

LEINSTER **Westmeath**

Lugh, the hero god of the Tuatha Dé Danann, is said to have come here to save his mother's people from the heavy taxes being exacted by the Formorians. It is from here that he would have ruled over the Tuatha Dé Danann after his victory and it is here that he was supposed to have died.

Uisneach appears to have continued as a centre of power, both energetically and politically uniting the country. The great assemblies here, said to have been initiated by Lugh, dealt with political and fiscal matters before the rituals, races and celebrations began. It is recorded that each provincial king, when attending these assemblies, had to wear 'a hero's ring of red gold' which he left behind on his chair as tribute for the High King. Later High Kings had their seat at Tara.

According to Geoffrey of Monmouth, writing his *History of the Kings of Britain* in the 12th century, Uisneach is said to have been the original site of the great stone circle, Stonehenge, in England. Apparently, when the king, Aurelius Ambrosius, finally defeated the Saxons in England, he collected all the best stone-masons and carpenters in the country to find some fitting memorial for those heroes who had died at the hands of the treacherous Saxon king Hengist. They could come up with nothing worthy enough until Merlin was sent for. Merlin told the king about the 'Giants' Ring' on Mount Killaraus (Uisneach) in Ireland. He told the company that the stones had been brought to Ireland by giants who lived there and had taken the stones from Africa and set them up in a ring in Ireland. In times of illness they ran water over a particular stone into a bath which then had healing properties. Each stone held a different cure.

The band of 15,000 men who went to Ireland led by the king's

brother, Uther Pendragon, quickly overcame the Irish army who seemed to have trouble taking the mission seriously. Surely the stones of Ireland were not worth invading the country for! Too late they realized the English army was deadly serious. After their victory, the English again called on Merlin and he organised the moving of the stones which were taken to Salisbury plain where they can still be seen today.

This is a fascinating story. Geoffery must have understood the importance of Uisneach as well as picking up on some African ancestry in Ireland. He also gives an interesting description of how the stones were used by their builders.

In historical times there is a tradition that St Patrick came here and brought Christianity to this pagan site. His name is often associated with Ireland's most powerful sites, but how far this shows his political astuteness and how far it shows the political astuteness of later Christian writers, is hard to assess. At any rate there are no actual Christian antiquities at Uisneach, though a rectangular platform of stones on the tallest

Money stone, the Hill of Uisneach

summit is known as 'St Patrick's Bed'.

There are stories that the 'Craebh Uisnigh', 'the Sacred Ash of Uisneach', one of the five sacred trees of Ireland, fell when Patrick came here.

Uisneach is not so much a hill as a series of undulations with each rise revealing yet more dips and mounds. Some people say that there's not much to see or that it's hard to find things, but when you follow the lane up into this hill, you get a sense of actually going into the landscape rather that climbing over it. I felt like a very small child in a very big place which bore no relation to the everyday world. I went with an old friend who lived nearby and we still lost our way. The cattle grazing around the pool looked at us with the quiet curiosity of an exotic tribe whose territory we were passing through without knowing their language.

As we climbed the first summit, we came to the earthworks on

the south east side of the hill, called **Rathnew Bivallate Rath**.
The outer bank seems to have been a fortified homestead, possibly
a chieftain's home sometime in the 2nd century AD and an annex
in the west seems to have contained another dwelling.

However, inside the main enclosure, an earlier fosse about 150
feet in diameter was found with an unusual number of pits and
postholes inside and evidence of two massive portals in the east. In
the south there was a large fire site which had been used over
considerable time.

A ramp led from this fire site onto an ancient roadway going
south and traced as far as the Mullingar to Athlone road running
east-west at the foot of the hill. Out of the other side of the
enclosure, another roadway ran north. This earlier enclosure is
thought to be a ritual site perhaps similar to the central enclosure
at Emhain Macha in Armagh.

At Emhain Macha there was also a ritual lake where votive
offerings were found from the Bronze Age. As far as I know, the
pool at Uisneach has not been explored, though it feels like a very
potent place. Above the pool of water on the highest summit is
St Patrick's Bed, already mentioned.

To the west of the ritual enclosure is a low circle of stones,
possibly modern, surrounding an unusual standing stone which
seems to contain fossilized wood. There is a small collection of
coins and offerings on the stone.

To get to the Cat Stone, go back to the road and continue
for half a mile. It's signed through a small gate up the south west
slope of the hill. This is a very venerable stone, split and striated by
time. The splits represent the provinces of Ireland. It sits inside a
circular bank and seems like an external manifestation of the
potency of the hill.

A mile further along the road going west is a crossroad at the
Uisneach Inn. Across the side road from the inn is **St Brigid's
Well**. There is a tradition that it was at Uisneach that she became
a nun, perhaps here at the site now occupied by the ruined church
of Killaire which is opposite the inn. This tradition is probably due
to the strong goddess associations at Uisneach rather than an
actual event in the life of St Brigid.

There is another story that I would like to tell here, though its
link to Uisneach is a bit tenuous. This is the story of **Deirdre and
the Sons of Uisneach**.

Deirdre was the daughter of one of the chiefs of Ulster. Just
before her birth, the king of Ulster, Conchobhar, and all the
chieftains had assembled at his house for a great feast. As she was
born, she gave a loud shriek and the Druid Cathbhadh, who was
present, prophesied that she would be very beautiful but that her

beauty would be the source of much sorrow and death across the land. There were calls for her to be killed at birth to avert the prophesy, but the king overruled them and ordered that she be brought to him at Emhain Macha. She was raised by him far from the eyes of men and when she was old enough, he planned to marry her himself, thinking that this would be enough to prevent Cathbhadh's prophesy from coming true.

However, nothing can truly avert such prophesy and as she grew up, she dreamed of a young man with hair as black as the raven, lips as red as blood and skin white as snow. She fell in love with this dream figure and then one day, in spite of the king's precautions, she met the young man of her dreams. He was called Naoise and he was one of the three sons of Uisneach. She managed to get away from her nurse and meet him and so strong was her passion for him that she forced him to elope with her. He knew who she was and what the consequences might be, but he was powerless to refuse as she put him under a 'geasa' or 'obligation' to her which he could not, with any honour, refuse.

He and his two brothers took her away and were quickly pursued by Conchobhar. So persistent was his pursuit that they had eventually to flee the country in order to escape with their lives. They sailed to Scotland where they lived in safety, though the brothers were very homesick for Ireland.

Because of this longing, it was not difficult for Conchobhar to persuade them that if they returned to Ireland, he would not harm them. All of Ulster was divided over whether or not to support the king's revenge and of course when the sons of Uisneach returned, they were killed. During the ambush much blood was shed and hardly a family in Ulster escaped without loss. Thus the prophesy was fulfilled.

Conchobhar took Deirdre back against her will as a further act of vengeance. She lived with him for a year until the next great assembly at Emhain Macha. Before the assembly, Conchobhar asked her who she hated most, and she said himself and Eoghan Mac Durthacht. So Conchobhar said he would give her to Eoghan as his wife for a year. As she rode to the assembly between the two men, they passed the graves of Naoise and his brothers and she threw herself out of the chariot, dashed her head against a rock, and was killed.

2 Lough Owel

The lake is about 2 miles north of Mullingar. Take the back road past the hospital. After about 1.5 miles, turn left down by the railway line.

Lough Owel has always been considered a magical lake. In limestone areas there is a phenomenon of disappearing lakes, called 'turloughs', where large bodies of water can drain away into subterranean crevices and then reappear, usually seasonally. Though Owel is not a turlough, the story of its origins is in that tradition.

At one time there were two sisters, both giantesses, one living here in Westmeath and the other on the far side of the Shannon, in Roscommon. The sister who lived in Westmeath sent to her sister in Roscommon, asking to borrow her lake and saying that she would return it on Monday. Her sister, being good-natured, immediately granted her request, and winding up her lake in a sheet, she sent it to her sister on the wind. When it arrived, the Westmeath sister unfolded it and spread it just where you see it now. She used the lake as planned, but Monday came and she didn't return it. Her sister sent increasingly angry demands, but the lake stayed where it was as the Westmeath sister decided she liked it too well to part with it. Eventually she told her angry sister that she had meant that she would keep it till Monday after the day of eternity. And the lake, being one of the most beautiful in Ireland, was never returned.

Here on the lakeshore, a Lughnasa assembly was held each year on the 1st Sunday in August. Most Lughnasa festivals were celebrated by excursions up to high places but a small number, mainly in the midlands, were celebrated beside lakes or rivers. These sometimes included immersing livestock in the water and sometimes humans too, to ensure health and well-being for the coming year.

At Lough Owel the main event was a swimming race with horses. The day was called 'Lough Sunday' and, according to accounts of the time, it was as important as Christmas and Easter. The races were dangerous and exciting and as matchmaking would have been an important aspect of the gathering, no doubt winning races took on an extra dimension. According to the *Dublin Penny Journal* in 1835, it was also a time for meeting enemies as it was a good opportunity to settle old scores with people from other areas. There were booths selling food and drink, musicians, dancers and ballad singers and, of course, crowds of people dressed up for a day out.

Before the race, the men lined up on horseback, barefoot and stripped to the waist. At the signal they plunged into the water, the horses often terrified and sometimes bolting. They had to swim out to a small boat, around it, and back to shore. In the event described by the *Penny Journal* , a horse was injured as it turned at the boat and sank, taking its rider with it. His lifeless body was later

recovered. The elements of skill and danger must have added greatly to the excitement as well as to the importance of winning.

Boats are available for hire locally. Enquire nearby. From Frewin Hill you can look out across the water and at Portloman Abbey you can get to the lakeshore.

3 Frewin Hill

Take the R393 west of Mullingar to Ballynacarrigy and turn right after about 2.5 miles. Signed Bunbrosna. After about 3 miles Frewin Hill is on the right.

There is a path to the top as there are now two masts on the hill. However, it is still worth the climb to visit the Bronze Age barrows and look out over Lough Owel.

Frewin Hill

This hill is supposed to have been the home of Eochaidh Aireamh, the Ploughman-King ('Aireamh' means 'Ploughman'). He is one of the three main characters in the story of *The Wooing of Étaín* (see **Ardagh**, LONGFORD). He got the name because he taught Midir how to plough with oxen, using their shoulders for pulling, rather than the old method of having straps around their foreheads.

He is also described in another story as levying a road tax on his people. This meant making them build him a road laid with tree trunks. They so resented this that they attacked and burned his palace on Frewin Hill, killing him as well.

An unfinished wooden road of this type dating to the second century has been found in nearby Longford. It is called 'the Corlea Trackway'.

Portloman Abbey

One mile east of Frewin Hill.
Turn left down to the abbey (about a mile).

The abbey is said to have been founded by St Lommán whom some say was a nephew of St Patrick by his sister. Other accounts say that he was of the race of Conall Gulban. His feast day is on the 7th February.

All that remains of the abbey now is a ruined medieval church with an ancient wall enclosing it. The church has no special features, though there is a finely carved medieval grave slab nearby. The site is on the western shore of the lake and set in open parkland which was once part of the Portloman estate.

Near the abbey enclosure by the lakeside, are a number of Bronze Age barrows, some planted with mature beech trees. It is a good site from which to see Lough Owel. Across the lake is Church Island with another tiny ruined church called 'Temple Loman'.

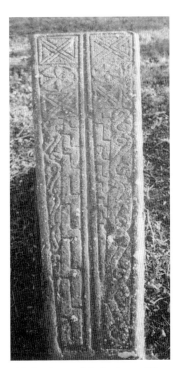

Medieval grave slab, Portloman Abbey

LEINSTER **Westmeath**

Bronze Age barrow, Portloman Abbey

4 Lough Derravaragh

From Mullingar take the R394 towards Castlepollard. As the south eastern tip of the lake comes into view between two hills, Knockbody and Knockeyon, there's a road down to the shore giving access for fishing. From here you can see the length of the lake.

The northern shore has stunted oaks still growing, part of the primeval forest that once covered all the country.

Excavations this century have shown late mesolithic remains around the lake, part of a second mesolithic population in Ireland around 5000 BC, a thousand years after the early settlers at Lough Boora in nearby Offaly.

The hill on the right is Knockeyon, named after St Eyon who built a hermitage on the steep wooded slope above the lake. It was described in 1682 by Sir Henry Piers who had just acquired the estates of the Abbey of Tristernagh by Lough Iron to the north (Description of Westmeath - *Collectanea de Rebus Hibernicus 1786*). He describes St Eyon's chapel, cut out of the cliff, one side being solid rock and already without a roof.

> 'it hath in it a curious purling brook of crystal water, which issuing out of the rock side of the chapel traverseth it, and falling through the opposite side wall, hasteneth down to the waters below.'

Lough Derravaragh

Its construction must have been extraordinarily difficult and, though there are few facts available about St Eyon's life, a local tradition tells that he was being pursued when he arrived here by boat. There is a steep wooded path up to the oratory traditionally climbed on the first Sunday in August. The well had clooties hanging from the branches over it, put there to aid cures. (Clooties

are small pieces of cloth usually placed against the injured or diseased part of the body and then hung near a holy well. As the cloth rots away, the injury, or illness, disappears as well.) After the pilgrimage, people came down from the cliff and passed the remainder of the day in dancing and singing with bagpipes playing and plenty of food and drink stalls. Unfortunately there is no access to the site at present.

Lough Derravaragh is shaped like a bird, perhaps even a swan in flight, and this is the place where the children of Lir are supposed to have spent their first 300 years. It is a lovely but poignant story.

The Children of Lir

Lir was a northern chief married late in life to Niamh, foster-daughter of Bodbh Derg, the chief of Connacht who had his court at Killaloe in Clare. Theirs was a happy marriage with two sets of twins born to Naimh, first a girl and a boy, Fionuala and Aedh, and then two more boys, Fiachra and Conn. Tragically, she died shortly after the birth of the two boys and Lir was broken-hearted, kept alive in the months that followed only by his love for his four children.

Hearing of the tragedy, Bodbh Derg was also grief-stricken. After a time he decided to send Niamh's sister, Aoife, to Lir to marry him and be a mother to the four children. In time Aoife and Lir grew happy and the children were greatly loved by them both and by all the court. They travelled often to Killaloe to the court of their grandfather Bodbh Derg.

The years went by and Aoife bore no children of her own and, though she had loved her sister's children, gradually she came to feel jealous of them. This jealousy grew until it dominated every other feeling and she felt that her husband loved only his children and had no time for her. Finally she began plotting to get rid of them and she told Lir that she was taking them to visit her foster-father, Bodbh Derg. The children were delighted, all except Fionuala who had been warned in a dream that her step-mother wished them harm. However, she said nothing and they set out.

They rested on the shores of Lough Derravaragh and Aoife, unable to persuade any of the servants to harm the children, took them to bathe in the lough. There she struck them with a golden druidical wand and transformed them into four beautiful white swans. Fionuala pleaded with her to change them back and when she saw that it was hopeless, asked her at least to tell them how long the enchantment would last.

Aoife replied that they would spend three hundred years here on Lough Derravaragh, then another three hundred years on the

Sea of Moyle off the coast of Antrim and a further three hundred years on an island off the coast of Mayo. They would remain as swans until a new age dawned in Ireland. They would know the time had come when they heard the sound of bells pealing. In spite of herself Aoife felt sorry for the children and allowed them to keep their human voices and also gave them the power to sing so sweetly that those who heard their music would forget all their troubles and be lulled into a sweet sleep.

Word of Aoife's treachery reached Lir, but he was powerless to undo the enchantment. He visited them often at Derravaragh and their kinsfolk came to play to them and to listen to the wonder of their singing. Then at the end of the 300 years, they flew away. The spell forced them to fly north to the cold and treacherous Sea of Moyle where they would spend the next 300 years. Together they endured the harsh conditions until it was time for them to leave for Inis Glora in the west. Here again they suffered great hardship in the fierce Atlantic storms, but the island gave them shelter and they sang so sweetly, that many other birds were attracted to the island and it became known as 'Inis Gora' or the 'Island of Voices'.

One day Fionuala felt a change around her and knew that the end of the enchantment was near. Patrick had come to Ireland and one day a saint called Caemhoch came to Inis Glora. The children heard a strange sound which at first filled them with fear. Then Fionuala recognised it as the sound that would break their enchantment. It was the sound of a church bell. The four children began to sing and Caemhoch heard them. He went to them, for he had been searching for them for a long time, having been sent to break Aoife's spell. He had two silver chains made. He placed one between Fionuala and Aedh and the other between Fiachra and Conn and they went with him and told him of all that had happened to them over the last nine hundred years.

However, before the spell could be lifted, Deocra, a princess of Munster, on her betrothal to Lairgnen, a chief of Connacht, came to Inis Glora and asked Caemhoch for the singing swans as a wedding gift. The saint refused her, but Lairgnen dragged them away by the silver chains. The spell was lifted, but instead of the children they had been, they showed their great age which was more than nine hundred years. They were immediately old and frail and, as they were dying, Fionuala asked that they be buried together:

> "place Conn at my right hand and Fiachra at my left, and
> Hugh before my face, for there they were wont to be when I
> sheltered them many a winter night upon the seas of Moyle."

Caemhoch buried them as they wished on the island of Inis Glora all together and the tiny graves are there to this day.

5 St Munna's Church

Take the R394 north east of Mullingar and turn right in Crookedwood. It is visible from the road on the right.

The area is called 'Taghmon' which is from 'Teach Munna', meaning 'Munna's house'. Munna is the local name for St Fintan who founded a monastery here in the 6th century. The present medieval church sits inside a circular bank which would originally have enclosed the old monastery.

The 15th century church which stands here today has crenelated battlements and a barrel vaulted roof. The acoustics inside are wonderful. The north and south windows are original and over one of the north windows on the outside is a Sheela-na-Gig taken presumably from an earlier building. It looks as if the lower part of the sculpture has been broken off. Her face is broad with a wide grinning mouth and broad nose. Her eyes are small circular depressions and above them are two more depressions, giving the appearance of another pair of eyes. Her hands are displaying her abdomen rather than her vulva, and there is another small depression lower down the body, perhaps a navel. The head of a bishop can be found over the north door and another very worn head inset into the west wall of the tower house.

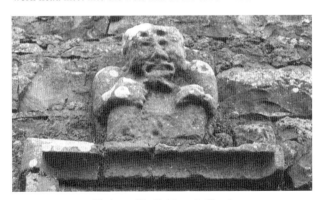

Sheela-na-Gig, St Munna's Church

The tower house is at the west end of the church. It has four storeys and would have provided secure accommodation for the clerics. The second floor has a fireplace and two seats as well as a slop stone or drain. There's a bedroom above with a garderobe or toilet. It is possible to climb up the spiral staircase and out

onto the roof.

The church is empty though not ruined, and a key is needed for the inside. You can get it from a nearby house.

To the south east, overlooking the church, is a lovely ring-fort and possible motte. From here you can see right out to Lough Derravaragh with Knockeyon to the north west.

6 Fore Abbey
Signed east of the R195 between Castlepollard and Oldcastle.

An early monastery was founded here in this quiet valley between two hills by St Féichín in the 7th century. The name 'Fore' comes from 'fuarán' meaning 'a spring' and refers to the magical spring of St Féchín which is just below the old church. Apparently, the water flows underground from Lough Lene to the south and comes up in this valley.

St Féichín is thought to have been born in Sligo around 580 or 590 and, like many of the early saints, he had a name for piety from a very young age. He founded his first monastic community at Cong in Mayo, as well as hermitages on two of Galway's islands, Omey and Ardoileán. He then came to Fore where he attracted a community of 300 monks by the time he died. He died around 665 from 'yellow plague' which must have been rampant in monasteries at the time. St Ciarán of Clonmacnois and St Manchán of Lemanaghan in Offaly both met the same fate.

The foundation here suffered many attacks and is recorded as being burned no less than twelve times between the 8th and 12th centuries. All that remains of this early time is a small stone church. The nave is thought

Fore Abbey with clootie tree in the foreground

to be 11th century with its walls 3 feet thick, antae and trabeate doorway. Local legend maintains that St Féichín himself put the whole doorway in place, including the massive lintel which is inscribed with a Greek cross inside a circle. He is said to have achieved this through the power of prayer and this became, in medieval times, one of the seven wonders of Fore. To the north are some earthworks which may be part of this early monastery.

At the time of the 12th century church reforms, the monastery adopted the Rule of the Canons Regular of St Augustine. They added the chancel around 1200.

Then, at the beginning of the 13th century, a Benedictine Priory was built on low ground to the north of the old foundation by the Norman de Lacy family. It was a dependency of the Abbey of St Taurin in Normandy and was confiscated in 1340 by the English crown when England was at war with France. These are probably the only Benedictine remains in Ireland as this order never really spread here.

The remains include claustral buildings and a 13th century church with some carved stonework with three round-headed windows in the east gable. Fragments of the beautiful arcaded cloister have been re-erected. The towers and fortification are 15th century as were the town fortifications. Fore was at one time an outpost of the Anglo-Norman Pale to the east. To the north east, on higher ground, are the remains of a columbarium or dovecote.

Some eighteen wayside crosses are dotted around the area dating to the 17th century, when pilgrimage was at its most fashionable. A plain stone cross and the socket of another sit on a grass triangle in the village.

At this time Fore gained renown for possessing Seven Wonders. They are enumerated at the site and include 'water from the spring that won't boil' and 'the tree by the spring that won't burn'. These were both common magical properties of the time.

Money tree by St Féchín's spring, Fore Abbey

The tree is a small stunted thorn which has centuries of coins hammered into it as votive offerings - perhaps a modern version of throwing a bronze axe-head into the lake. About 200 yards away is a sacred ash overhanging St Féichín's bath where he lay at night as

part of a prayer vigil. Children were healed by being dipped in the water of this pool.

The town of Fore has all but disappeared, though some of the fortifications remain. The valley is now yellow with irises in Spring and the old priory lands are a sanctuary for wildlife. Ravens nest in the ruined buildings.

7 **Gallagher's Moteens** on Slieveboy Hill

Overlooking Lough Lene, near Fore. Take the R195, the Oldcastle road, east out of Castlepollard and take the second left, about 2 miles out of the town. Stop at the first sharp right-hand bend. The barrows are up on the hill to the left.

There are 4 Bronze Age barrows on this hilltop but there is also a great view out across Lough Lene. To the north east you can also make out the rounded hills of Loughcrew in the distance.

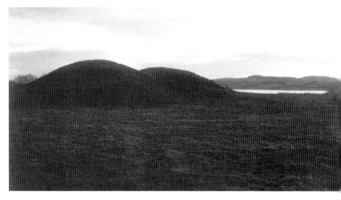

Gallagher's Moteens

8 **Rindoon Hill - Turgesius' Fort**

2 miles outside Castlepollard on the Collinstown road. However, you need to climb it from the north side as it is protected from the south and east sides by rock face. Take the lakeside road (the first left outside Castlepollard) for about 2 miles.

This is a lovely site across fields overlooking Lough Lene. It is said to be the fort of Turgesius, who led a great Viking incursion of 120 longboats inland through the waterways of Ireland in the 9th century. His main residence was at Clonmacnois on the Shannon where his wife is said to have issued pagan oracles from the high altar. After seven years of plundering and destruction of the heartland of Ireland, he was finally captured and drowned

here in Westmeath, though there is dispute as to which lake he was drowned in.

He was lured from his fortress on Rindoon Hill by his fondness for beautiful women and, in particular, for the beautiful daughter of the then king of Westmeath, Malachy. Turgesius demanded the Princess Melcha and Malachy dared not refuse outright. Instead, he hatched a plot whereby the princess went to an island in the lake accompanied supposedly by fifteen young maidens to wait for Turgesius and his warriors. But the king got fifteen of his best young beardless warriors to dress up as women and wait on the island with Princess Melcha for the unsuspecting Turgesius.

He came and a whole day passed in preliminary drinking and merry-making, but as soon as Turgesius made to embrace the young princess, the warriors rose up as one body and took him prisoner. They opened the gates and Malachy's men rushed in, killing all of Turgesius' warriors. A few days later, when they decided Turgesius had thoroughly experienced his defeat, he was thrown into the lake, still bound. And so Ireland was freed from a terrible tyrant.

According to the *Annals of the Four Masters*, this happened at Lough Owel, though there is also a local legend associating the story with Lough Bawn, the white lake, 3 miles east of Fore.

LEINSTER **Westmeath**

LEINSTER **Longford**

County
LONGFORD
PRINCIPAL SITES

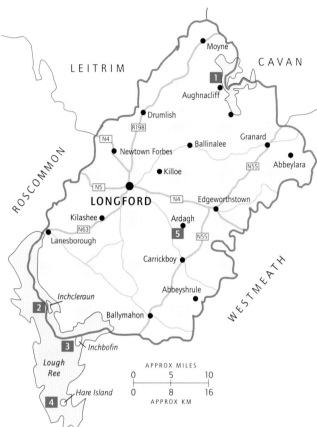

1 Aughnacliff Dolmen

2 Inchcleraun

3 Inchbofin

4 Hare Island

5 Ardagh Hill or Brí Léith
 St Mel's Cathedral
 St Brigid's Well

Block figures in list refer to site locations in map and entries in text.

LONGFORD

LONGFORD LIES BETWEEN THE LAKES of Cavan and Westmeath in the east and the Shannon in the west. It is part of the central plain of Ireland with occasional low ridges and hills to break the skyline. Ardagh is one such hill, included here for its mythological associations and superb view, though unfortunately the hill itself has been damaged by masts.

In the north east of the county where Longford borders Cavan, the 'Black Pig's Dyke', known locally as 'Duncla', runs for six miles as far as Lough Kinale in the east. In places it reaches 16 feet; in other places it has been completely levelled. It is part of a linear earthworks that crossed Ireland in the early Iron Age. It was said to be the work of a giant black sow as she cut a track with her massive tusks on her way to Armagh. The various remains of this earthwork form part of the border between Leinster and Ulster which was possibly the reason for its creation in the Iron Age.

There are two Cistercian abbeys in the county, Abbeylara and Abbeyshrule, both with tall fragmentary ruins, slightly surreal remains which still manage to convey a sense of the space and height of the original. Both are in small villages where the 'feel' or 'aura' of the abbey and its estates still permeates everything and manifests occasionally in archways or bridges or a piece of field wall built with dressed stone.

Abbeylara is signed off to the right on the road from Granard to Ballyjamesduff. Abbeyshrule is 4 miles north east of Ballymahon, signed off the R392 to Mullingar.

1 Aughnacliff Dolmen

Aughnacliff is a small village on the west side of Lough Gowna. From Granard take the Ballinalee road for about 8 miles following signs to Dring and then Aughnacliff. In Aughnacliff, past the church and down the hill, the dolmen is signed on the right. The lane forks but keep right over the hill till you see a stone stairway in the hedge that leads down into the field below.

It is rare to find a dolmen in the midlands and this one is quite spectacular. It is effectively hidden in a gentle hollow protected by trees and hedgerows. It is a tall imposing structure that seems to

balance effortlessly according to some other system than the law of gravity. A thick cap-stone 9 feet long rests on the tip of one huge pillar 6 feet high, the other side held by 2 other stones of about equal size, one on top of the other. The second cap-stone rests on one of the chamber uprights. The 6 foot portal has a small cross inscribed on it.

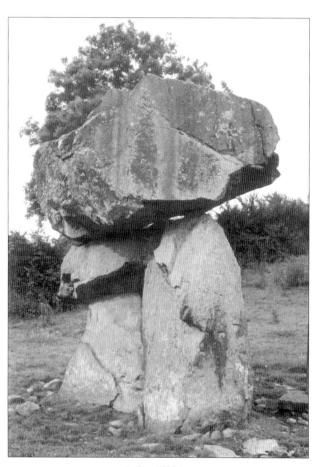

Aughnacliff dolmen

Lough Ree

Lough Ree borders on the three counties of Roscommon,
Westmeath and Longford, though I have included it here
in Longford. It is one of the three great lakes of the river Shannon,
16 miles from north to south.

According to local tradition, there is a drowned city in the Lough and a monastery. An early bishop of Clonmacnois was said to have visited there, but not returned. There are tales of local people who have also gone there, but none have come back. This city is mostly invisible, but occasionally when conditions are right, it can be glimpsed through the water.

There are also a number of islands in the lake with monastic ruins which can be visited by hiring a boat. There are no regular ferries but plenty of boats for hire. Pubs and Post Offices are usually the best places for information about what is available.

There is something very gentle and otherworldly about this lake with its islands uninhabited for hundreds of years. However, the scale and detail of some of these ruined churches suggest that they were once well populated centres of learning and craft. Their position on the Shannon meant that they were on a major route-way for travellers going north or south and possibly far beyond the shores of Ireland to Europe and North Africa. They were also on the border between the provinces of Leinster and Munster and the annals record frequent raids by their own countrymen. As if that was not enough, they were also easy prey for the Vikings on their forays inland before Brian Boru took on the intruders and ousted them from the Shannon regions by the end of the 10th century.

2 Inchcleraun

In the north of Lough Ree (LONGFORD county)

A monastery was founded here by St Díarmaid in the 6th century. It was enclosed by a cashel wall with an unusual Romanesque gateway. The voussoirs from the arch were later re-used in the Teampall Mór (Great Church). Teampall Díarmaid (Díarmaid's Church) is 7 foot by 8 foot inside and has antae extending from the gable walls and a trabeate doorway. It was probably built as a shrine or mortuary house for the founding saint. There are a number of other churches as well: the ruined Teampall na Marbh or the Church of the Dead; the nave and chancel remains of St Mary's Church and the Church of the Women. There are some cross slabs.

Outside the enclosure on higher ground is the medieval belfry

church with a square tower at the west gable and two doors in the north wall. This site was colonised for a time by the Augustinian Canons, but was attacked on a number of occasions in the 11th and 12th centuries by the people of Munster.

On the highest part of the island is **Grianan Meva**, a small cashel named after the legendary queen/goddess Maebh. She is said to have been killed as she bathed in the waters around the island by a piece of hard cheese fired from a sling shot by an Ulsterman from the mainland shore.

This gentle island is probably best visited from the northern shore. The campsite at Knockcroghery on the western side has boats for hire.

3 Inchbofin

Inchbofin is further south and to the east of the lake.
There are boats for hire from Lough Ree House which is on the lake shore. Go west of the N55 at The Pigeons north of Athlone and follow signs.

There was a monastery founded here by St (Mo) Rí-óg (or Ríoch) in the 6th century. He died in 588.

Today there are two small churches on the island enclosed by the remains of a cashel wall. To the south is a nave and chancel church with pointed door in the south wall and round-headed windows in the chancel.

In the north east is another church. This one has a piscina and, opposite it, a Romanesque window north of the altar. A transept and sacristy were added later. There is a carving of a bishop's head on the outside of one of the transept windows.

A 10th century Viking bronze piece was found here, possibly left behind from the Viking raid of 922.

South of Inchbofin is **Inchmore** where St Líobán founded an early monastery. The church ruins are still visible. And further south is Hare Island

4 Hare Island

This is where St Ciarán founded a monastery before moving down the Shannon to Clonmacnois.

South again is Friars' Island which is a small neck of land accessible across a narrow causeway in summer. The Franciscans from Athlone sheltered here in the 17th century and Michael O'Cleirigh, one of the Four Masters who compiled the *Annals*

of that name, worked here for some time transcribing the *Lives of St Ruadhán* (**Lorrha**, TIPPERARY) *and St Ciarán* (**Clonmacnois**, OFFALY).

5 **Ardagh Hill** or Brí Léith
South east of Longford town, the village is signed off the N4 between Edgeworthstown and Longford. Take the road west of the village and down to the R393. Turn left and then right up the hill.

This is Brí Léith, home of the legendary Mídir, a king of the ancient Tuatha Dé Danann. This story was probably written down in the 8th or 9th century and has been recovered in fragments. This can make it seem a little complicated, but its wonderful images and layers of magical symbolism make it well worth retelling.

The Wooing of Etain begins when Mídir was visiting his foster-son Aenghus at his home in Brú na Bóinne (see MEATH). He tried to mediate in a dispute between two young men and in the ensuing commotion, he lost an eye. As compensation he demanded the most beautiful maiden in Ireland.

At this time Ailill, the King of Ulster, had a very beautiful daughter called Étaín Echraidhe. He agreed to let her go with Mídir in exchange for having twelve plains cleared, twelve rivers made and her weight in gold and silver. Aenghus could not do all this himself, but with the help of his father, the Daghdha, it was done and Étaín went home with Mídir to Brí Léith.

Unfortunately for Étaín, Mídir already had one wife who was angry at Étaín's arrival and turned her into a pool of water. As the water evaporated, she turned into a worm and then into a big, purple dragonfly that filled the air with fragrance and sweet music. In this form she was blown away out onto the rocks at sea. After seven long years she came ashore and alighted on the breast of Aenghus. He recognised her at once and put her in a sunlit room made of crystal to keep her safe. All was well until Mídir's wife discovered where she was and blew up another storm which drove Étaín north and onto the rooftop of the house of Étar in Ulster.

As she looked down, she slipped from the rafters and fell into the drink of Étar's wife and was swallowed up. Étar's wife later gave birth to her and she grew up again in Ulster, though over a thousand years had passed since she had lived there before.

Things had changed in the world since her previous incarnation. The Milesians had come to Ireland and the Tuatha Dé Danann had retreated into the fairy mounds to practise their magical arts. At Tara the new high-king, Eochaid Aireamh, (Aireamh means Ploughman) couldn't be accepted by his subjects

LEINSTER **Longford**

until he had a queen. He searched the land until one day he came upon Étaín standing alone, naked, and shining with gold and he fell in love with her.

And so they were married and Étaín went to live with Eochaid at Tara. Time passed and Eochaid's brother, who was also called Ailill, was totally smitten by Étaín and became lovesick. He became so ill that he was almost on his death-bed, though no one knew what was wrong. Then, when Eochaid was away and Étaín was looking after Ailill, he confessed his love to her. She agreed to a love tryst to cure him, but only away from the royal residence.

They decided to meet that night but when the time came, a magical sleep came over Ailill and an impostor took his place. After three nights, she began to realize that he was an impostor and challenged him. He confessed that he was her original husband, Mídir, and that he had put a spell on Ailill to make him lovesick so that this meeting could take place. Being from the faerie world, time had not changed him and he asked Étaín to go away with him. She said she could not without her husband's agreement. Mídir left and Étaín returned to the palace where she found the spell had been lifted from Ailill and he was cured.

Sometime later, on a summer's evening, while Eochaid was up on the palace walls, he looked down and saw a young warrior with long golden hair and wearing a purple cloak. They spoke and Mídir told Eochaid who he was and challenged him to a game of chess which he allowed him to win. He let Eochaid choose a winner's favour and repeated the process so often that Eochaid became complacent. The early prizes were animals, swords and cloaks and later they involved Mídir performing huge tasks for Eochaid, such as the building of a great wooden causeway across the marsh of Móin Lámhraighe.

Having established the free demand of a favour upon winning, Mídir then won a game himself. He asked for a kiss from Étaín as his prize, knowing that he could not be refused. Eochaidh agreed reluctantly to the kiss, but delayed it for a month. Fearing that Mídir would try to abduct his new wife, Eochaid surrounded Tara with warriors. However, Mídir appeared magically in their midst and, clasping Étaín in his arms, he rose with her and flew up through the roof.

In the form of swans they flew to the cairn on top of Slievenamon in Tipperary. When Eochaid's men reached the cairn, the couple had already returned to Brí Léith. With Eochaid threatening to take Bri Léith apart stone by stone, Mídir promised to send Étaín back to Tara so long as Eochaid could recognise her. Eochaid, of course, agreed. But when fifty identical women appeared from the mound, Eochaid chose the wrong woman.

So Étaín stayed with Mídir.

This complex story involves the rival gods Mídir of the Tuatha Dé Danann, and Eochaid Aireamh of the Milesians, fighting for possession of the young fairy maiden, Étaín. Máire Mac Neill, author of *The Festival of Lughnasa*, suggests that Étaín is an Irish Persephone with Mídir as the god of the underworld and Eochaid 'the Ploughman' as the cultivator. From their different realms they fight for possession of the young maiden who will ensure the fertility of the land for the coming year. Appropriately, Mídir, the 'underworld god' wins.

In Ireland the players in this drama are more usually the sun god, Lugh, and the old and stooped Crom Dubh, who appears from the Otherworld at harvest-time and takes Eithne, the corn maiden, back with him into the earth. It is interesting that there is a long tradition of a community outing to the hill here on the first Sunday in August - the festival of Lughnasa. This was mainly a bilberry picking day, but it was also considered to be an opportunity for young couples to get together. The fruit was eaten but some saved and crushed with sugar to make a special wine which was particularly efficacious in the pursuit of romance.

The Christian harvest festival takes on some of the elements of the old Lughnasa, but the meaning of offering the first fruits back to the earth to ensure fertility the following year has been partially lost.

There was a strong tradition among older people of a huge giant who lived in the hill and children were warned not to stray from the adults for there was a 'swallyhole' on top of the hill where they might be pulled in by the giant. This giant was called 'King Midas', an interesting deviation from Mídir, but the inside of the hill was said to be full of passages leading to his great castle at the centre of the hill. This story obviously describes the god of the underworld on the lookout for a modern day Étain or Eithne.

Apparently, there were attempts to open a quarry on the hill in the past. These were abandoned when the workers were pelted with stones and sods. The Otherworld was protecting its hill. Unfortunately, the mast-builders of recent times were not so easily deterred and the hilltop now has three masts on its summit. However, the view on a clear day is magnificent. You can see right across the centre of Ireland to hills so distant that they pale into a hazy horizon.

At **Corlea** or Cor Léith, a long bog road crossing only a few miles from Brí Léith was found some years ago. Over a mile of oak planks were laid to form this roadway in the middle of the 2nd century BC. It was not finished and soon abandoned. Perhaps this was Mídir's road.

LEINSTER **Longford**

There is a visitor centre at Corlea where part of the trackway can be seen. It's signed off the N63 two miles south of Longford town.

St Mel's Cathedral, Ardagh
In the village. Signed.

This little ruined church with antae and lintelled doorway is probably 8th century. The lower part of the walls are built with large stone blocks also typical of that time. Excavations in 1967 revealed traces of an older wooden structure which may be the remains of an earlier church, perhaps even the original one said to have been founded in the 5th century by St Patrick, and left in the care of St Mel as its first bishop. He is also supposed to be buried here. His staff or bachall is preserved in the Diocesan Museum in Longford.

There is a story that Mel lived here with his sister Eiche and rumours circulated about the true nature of their relationship. St Patrick is supposed to have come to look into the rumours and, to prove their innocence, brother and sister each performed a magical act. He caught a salmon in a rain-soaked furrow and she carried coals in her apron without getting burned. In spite of this, Patrick ordered that they live apart to avoid futher scandal and Eiche founded a nunnery on the west side of the hill. Even this late story concerns romantic love. The nunnery on the side of the hill, said to be the oldest in Ireland, has echoes of the fifty maidens from the hill who confused Mídir so that he could not find Étaín.

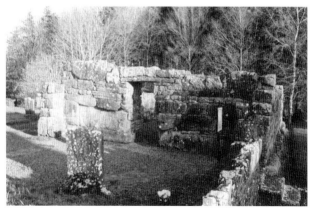

St Mel's Cathedral, Ardagh

St Brigid's Well, Ardagh

Take the road west out of the village past the post office and down the hill. There are old double gates on the left.
Cross into the second field and over a stile on the far right.
Cross another stile on the right in the next field and go through some trees. About 0.5 miles.

This is a circular well with a white thorn tree beside it. It is still visited at the beginning of February, in honour of Brigid. There are strong connections with Eiche's nunnery and a local story about nuns still seen walking between the well and the nunnery, accompanied by a big spotted cow.

LEINSTER **Longford**

LEINSTER **Meath**

County
MEATH
PRINCIPAL SITES

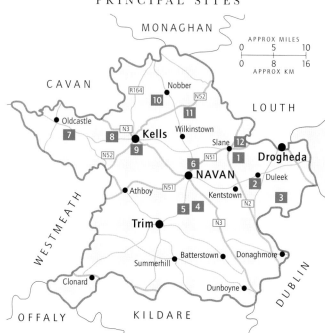

1 **Brú na Bóinne**
 Newgrange passage cairn
 Knowth passage cairn
 Dowth passage cairn

2 **Duleek** priory and crosses

3 **Fourknocks** chambered cairn

4 **The Hill of Tara**

5 **Bective Abbey**

6 **Donaghmore** round tower

7 **Loughcrew** passage cairns or Sliabh na Caillí

8 **Castlekeeran** high crosses
 St Ciaran's Well

9 **Kells**

10 **Cruicetown** church and cross

11 **Killary** high cross

12 **Slane** friary and church

Block figures in list refer to site locations in map and entries in text.

MEATH

MEATH IS A LUSH AND FERTILE COUNTY with wide rivers and gently sloping hills. These hills are barely noticeable among the tall hedgerows and yet command some of the most extensive views across the country. The view from the Hill of Tara, for example, seems to take in the entire country, yet the hill itself does not stand out in the surrounding landscape.

The county is watered by the Boyne river and her tributaries, many of which begin in the lakelands of central Ireland. Swelled by these Midland rivers, the Boyne meanders east to the sea at Drogheda. Along her banks are the great passage cairns of Brú na Bóinne described below. This river personifies one of Ireland's most ancient goddesses, Boand or Bóinn, and carries with her the special waters of her origin. She is said to inhabit a sí or mound at the river's source (see KILDARE). There the well is described as having nine magical hazel trees overhanging it. As the nuts drop into the water, it is imbued with their magical properties. Some stories say that the water can convey the gift of second sight. It is also said that anyone drinking its water in June will become a poet.

The Boyne, as a personification of Bóinn, the White Cow Goddess, is also a reflection of the heavenly river, the Milky Way, which gives this sacred landscape its celestial dimension and enhances its power as a doorway to the Otherworld. ('Boand' is the medieval Irish form of 'Bó Fhinn' which means 'White Cow'. It is pronounced 'Boeen' and commonly written as 'Bóinn'.)

LEINSTER **Meath**

1 **Brú na Bóinne**

Brú na Bóinne lies between the town of Drogheda near the east coast and Slane on the N2 about 6 miles to the west. It is signed from Slane or Drogheda.

The river Boyne meanders in a southern loop before continuing east towards the Irish Sea. The area within this loop contains the sacred neolithic landscape known as 'Brú na Bóinne'. The three passage cairns, Newgrange, Knowth and Dowth are part of this as well as many smaller cairns, henges and standing stones. There is a stone circle around the Newgrange cairn and a cursus to the east of it. From each of the three main cairns, the other two are visible.

The word 'brú' has a number of meanings: it means a 'river bank' and it also means a 'hostel'. Newgrange is described in some of the

stories as 'Aenghus's hostel', meaning 'a place of great hospitality'.

The site is now generally recognised as the culmination of a neolithic culture which probably began in the west near Sligo and gradually moved across the country, creating a seam of major centres from Sligo to Brú na Bóinne. These include Carrowmore and Carrowkeel in Sligo and Loughcrew in Meath. There are some 230 known passage cairns in Ireland but only a few are as monumental as these. And none are as present in our collective psyche.

This comes at a price, however. Since the reconstruction of the Newgrange cairn, and the intense marketing of the site as a tourist attraction, numbers of visitors have increased dramatically. A new visitor centre has been built to cope with these visitors and access to Newgrange is limited to 300 visitors a day! There are no advance bookings for individuals, so it is best to get there early and preferably out of season. It opens at 9.30 am.

The cairns at Loughcrew are only about 30 miles from here. (see below) Tara is about 10 miles south west.

For an in-depth and inspired look at the astronomical alignments and art of these and other passage cairns, Martin Brennan's book, *The Stars and the Stones* is the book to read. Some of his information is included here.

The Mythology

The first power here is the broad accommodating Boyne river with its wide fertile banks, embodiment of the great goddess Bóinn. Her abundant nature is also expressed as the White Cow and in this form she crosses the heavens, sprinkling her milk to form the stars of the Milky Way, celestial mirror of her earthly waters. Her source is the well of wisdom, the mythical Well of Segais, surrounded by hazel trees whose nuts fall in the water creating bubbles of mystic inspiration called 'na bolcca immaiss'.

The earliest stories about Brú na Bóinne involve the Tuatha Dé Danann. It is said variously that Bóinn's first husband was Nuadhu or Elcmar and that he lived at Brú na Bóinne in her gentle embrace. Their Otherworld palace was a magnificent place of feasting and plenty with fruit trees always in fruit and everywhere around them was peace and prosperity.

One day, however, the Daghdha sent Elcmar off on a day's journey so that he could lie with Bóinn himself. Their magical union stopped the sun so that time stood still for nine months until Bóinn had given birth to a son. They called him Aenghus Óg - Aenghus the Young, and sent him to be fostered at Brí Léith. (see LONGFORD) Elcmar returned thinking only a day had passed, but found instead that he had been ousted by the Daghdha and his time as consort to Bóinn was over.

There followed many more years of feasting and plenty. The Daghdha became known as 'the Father of All', 'Eochaidh Ollathair', and he was famed far and wide for his huge cauldron which could never be emptied. It may have been his connection with the Boyne and its magical source that earned him the title 'Ruad Rofhessa', which means 'the Lord of Perfect Knowledge'.

When Aenghus grew up, he returned from his foster family. He asked his father to let him have Brú na Bóinne for a night and a day and the Daghdha agreed to this modest request. But when the day and night were passed, Aenghus didn't leave. He argued that day and night are all there is, and so he stayed, replacing his father.

In this way king followed king, as day follows night and youth replaces age in the affections of the goddess - in this case the river goddess, Bóinn.

Eventually the Tuatha Dé Danann were replaced by the Celts with their new iron technology. However, they remained connected with the landscape and became identified with the Otherworld beings and the goddesses of sovereignty, and the two cultures lived side by side. The story goes that the Tuatha Dé Danann witheld corn and milk, the symbols of fertility, from the newcomers until they made a settlement giving them the underworld or Otherworld as their domain. The Daghdha, father god of the Tuatha Dé Danann, gave each chief a mound or cairn for their tribe and this is how our Tuatha Dé Danann ancestors became the fairy people who live under the hills.

In later stories Newgrange is identified as the 'Síd Broga' or 'Fairy Dwelling' of Cúchulainn's birth. His mother, Dechtire, was visited by a beautiful young man on her wedding night and told that she would bear his son. This man was none other than the god Lugh and Dechtire retired to Brú na Bóinne for nine months with her maidens to await the birth of her son. She named him Setanta, but this was later changed to Cúchulainn when he defeated the great hound of Culainn in Ulster (see ARMAGH). This sounds a little like a re-telling of the earlier story of Aenghus's birth. Far from detracting from the myth, this repetition of a theme reinforces the symbolic role of Brú na Bóinne as a centre of power in the psyche of the people.

Brú na Bóinne is mentioned again at the end of the tragic tale of Diarmuid and Grainne. (see **Tara** below)

These small glimpses into the huge body of mythology surrounding Brú na Bóinne give some idea of the power which it has held in people's collective consciousness for thousands of years. Those connected with it are said to have created the stars and been responsible for the fertility of the land. They also had power over the natural order of night and day. It was a place of light but also,

LEINSTER **Meath**

particularly at Dowth, a place of darkness beyond the ordinary limitations of time and space where even death was no barrier.

If we understand these stories as a way of passing an inner knowledge of our world from generation to generation, then they also create links for us across the sacred landscape. For example, Aenghus was sent from Brú na Bóinne to Brí Léith to be fostered, creating a familial link within the story which is symbolic of an energetic link between the two places in the landscape.

Fertility

The passage cairns at Brú na Bóinne and others throughout Ireland have often been compared to wombs. A womb inside a great mound of earth becomes the womb of the earth goddess. This association with fertility is reinforced by the kind of objects found inside them.

In spite of the obvious importance of these cairns, they were not full of rich objects. These were not tombs where the powerful set off on journeys to another world. The objects found here, oval stones or 'egg stones' and phalluses, were clearly fertility objects possibly empowered by the sun's ray as it entered the inner chamber of the cairn. This womb-like function of the inner chambers of cairns throughout the country is illustrated in mythology by the association of so many of them with a particular goddess.

The presence of hammer pendants, small numbers of beads and carved bone pins are common in many passage cairns and the subject of much speculation. Perhaps pendants were energised inside the chamber and then worn as power objects. Maybe they were worn by young women in rituals to ensure impregnation by the gods.

Perhaps the cremated remains of a dead chieftain were placed in a recess inside the cairn so that the sun's rays penetrating the womb of the goddess could impregnate the bones and allow his spirit to reincarnate.

Newgrange

This cairn is named after the local townland of Newgrange, so-called when the area was incorporated into the abbey lands of the great Cistercian abbey of Mellifont in Louth in the middle of the 12th century. These outlying lands or farms associated with the great abbeys were called 'granges' and Brú na Bóinne was their 'new grange'.

In 1699 Charles Campbell, who owned the land at that time, unearthed the decorated entrance while taking stones from the

mound for use elsewhere. He went inside, the first person to do so for possibly 4000 years. He stopped using it as a quarry and it remained open for 300 years before excavations began in 1962.

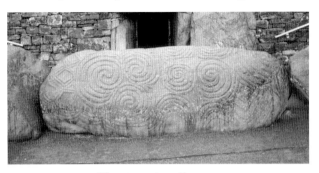

The entrance stone, Newgrange

It has been extensively restored, startlingly so. Its white quartz facade glistens in the sunlight and its crisp lines are hard to reconcile with the usual image of things prehistoric as grey and lichen-covered with soft organic contours.

It was built some 5000 years ago using an estimated 200,000 tons of smooth water-rolled granite stones from Dundalk Bay to make up the cairn as well as white quartz from the Wicklow mountains for the facing. This white quartz glistens as it reflects the sun's rays and it always feels cool to the touch. The granite, on the other hand, absorbs energy from the sun and is warm.

The cairn is surrounded by a circle of large stones, up to 8 feet high which belongs to a later period. Only 12 of a probable 38 stones are still standing. The cairn is not quite in the centre of the stone circle. The stones are furthest away from the cairn entrance: about 60 feet.

The cairn itself is about 50 feet high with a diameter of 280 feet though the passage inside is only 62 feet long. This passage leads to an almost circular chamber with a 20 foot high spiralling

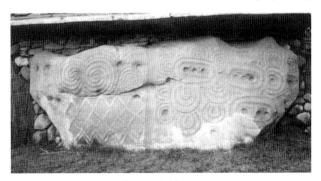

Kerbstone 52, Newgrange

corbelled roof and three recesses, one straight ahead and one on either side, giving it a cruciform shape. The overall shape is symmetrical though each recess is very different. The one in front is quite large but with just one decoration, a triple spiral, which is only visible from inside the recess. This is the recess into which the sun shines directly at midwinter. The recess on the right is highly decorated, especially its roof stone and has 2 basin stones in it, one on top of the other. These are shallow and smooth dish-shaped stones of the type often found in the recesses of passage cairns. They can be up to 3 feet in diameter and often beautifully shaped.

The recess on the left is small. The great differences in size and decoration between the three recesses seems to suggest that each had a function.

The passage is formed by tall orthostats, some of them carved, and carvings have also been found on the back of some of these stones and on the upper surface of some of the roofing stones. These were obviously not intended to be seen. These carvings fulfilled their function without any conscious intervention from humans. Outside, the mound is ringed at its base by a row of stones which form a kerb around it. At least 3 of these are carved on the inside as well.

In front of the entrance is a massive stone carved with multiple spirals and lozenges. A vertical line down the centre of this stone separates the left-hand spirals on the left from the right-hand ones on the right. This line also marks the place where the rising midwinter sun touches the stone. Exactly on the opposite side of the cairn from the entrance and facing north east, is a kerbstone with carvings echoing those on the entrance stone. It has an even more pronounced line down its centre which also forms part of the alignmnent, though not visually touched by the sunbeam.

Above the cairn's entrance there are two lintels and between them there is an opening, known as 'the light box' because it is through here that the beam of sunlight is able to enter the chamber. The passage rises 6.5 feet along its length so that the chamber floor is level with the roof box. At midwinter the sun rises in the south east over the Redmountain, passes just to the left of the standing stone 60 feet from the entrance, crosses the entrance stone and, when the full disc of the sun appears above the horizon, a beam of light enters the chamber just before 9 o'clock and stays in there for 17 minutes.

The dawn sunlight shines into the end chamber for five days around the winter solstice. The stone at the front has five spirals on it - three going anti-clockwise and two clockwise - perhaps representing these days. There is a groove down the middle of the stone coming out of one of the spirals.

From the archaeological record of mounds which were excavated and reburied, it would appear that the sunlight, after

illuminating the chamber of the main Newgrange cairn at dawn, then enters a number of satellite cairns in succession throughout the day until it enters Dowth at sunset. This means that the sunbeam is constantly held within a cairn throughout the shortest day of the year. One of these, called cairn K, has a south facing passage and is penetrated by the sun's rays at mid-day. Cairn T at Loughcrew and the great cairn at Knowth both have satellites with a south facing entrance. (*The Sun and the Stones*)

Newgrange was built around 3000 BC and closed around 2500 BC, though the site remained important even after the blocking stone was in place.

Knowth Passage Cairn

The main cairn at Knowth is the largest of the Boyne Valley group and the largest in Ireland. Given its size, it has surprisingly few mythological associations compared with Newgrange, yet it is thought to have been built about 500 years earlier, around 3000 BC. The mound is associated with Englec, daughter of Elcmar, who was the first husband of Bóinn. Englec was also the lover of Aenghus who was Bóinn's son.

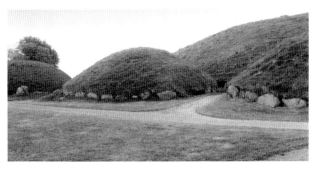

Satellite cairns at Knowth

The mound itself covers about an acre and is surrounded by a cluster of 17 small satellite cairns. At least one of these was already there when the main cairn was built. It was obviously considered important enough to be incorporated into the main cairn. A visit to Knowth does not yet include access to the inside of the main cairn as the east passage is over 100 feet long and very small. The west passage is blocked at present. (see below)

The east passage leads into a corbelled chamber with three recesses similar to Newgrange. There is an exquisitely carved basin stone in one of these. In front of it was found a delicately carved flint ovoid known as the 'mace head' which is now in the National

Museum, Dublin. This passage is illuminated at sunrise at the time of the equinoxes which fall around March 21st and September 21st. At this time the sun rises directly in the east and sets in the west and day and night are of equal length.

The entrance stone outside the west passage is carved with a vertical line similar to the entrance stone at Newgrange. Across on the other side of the cairn, the entrance stone outside the east passage echoes the vertical line on the western stone. Outside the western passage two standing stones cast shadows onto the cairn at sunrise. At the equinoxes the shadow of the taller standing stone touches the vertical line on the entrance stone. The other standing stone is wide, almost circular, and at sunrise its shadow falls on some carvings on the kerbstone to the right of the entrance: a spiral, concentric circles and a series of arcs. Inside the passage the beam of light extends as far as a slight bend to the right near the end of the passage.

White quartz and rolled granite were set into the ground before the entrances here, whereas at Newgrange these two types of stone were incorporated into the mound itself.

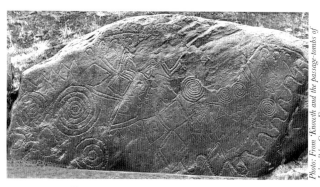

Photo: From 'Knowth and the passage-tombs of Ireland' by George Eogan

Knowth - the lavishly decorated kerbstone 13

There are thought to be about 134 kerbstones encircling the Knowth mound. More than half of these are covered with carvings. Many others have carvings on them. Evening is the best time to see them, when the shadows are long. These form about a third of the 300 decorated stones on the site. The rest are inside the mound.

Knowth seems to have been closed up around 2500 BC. A Bronze Age 'Beaker burial' was set into the cairn about 500 years later and in front of one of the smaller mounds a circle of pits containing votive offerings was found, each with a wooden post beside it. It was used again in the Iron Age and in the early Christian period it was the palace of the kings of North Bregia.

Even the Normans were here using the mound as a motte between the 12th and 14th centuriies. By now the entrances were

completely blocked and probably no one knew they were there. The
Normans had slated roofs on their houses and a stained glass oratory,
but only lived here for about a year before integrating into the
local community and abandoning their fortified accommodation.

An article appeared in *The Sunday Times* newspaper om the
22nd October 2000. The headline read: "**Ancient Tomb is
Wrecked by Experts**". The article told how, after thirty-eight
years of excavations and reconstruction at Knowth, archaeologists
have actually blocked up the entrance to the west passage at
Knowth with concrete. Apparently they felt that as this passage
was not an exact alignment and therefore not important. This
seemed an extraordinary way to treat one of Ireland's greatest
monuments. Two years later the concrete is still in place.

To follow the ongoing concern about current practice in the
care or otherwise of our ancient monuments, click on to:
www.global-vision.org/ireland

Dowth Passage Cairn

At present, Dowth is not open to the public, though you can see it
from the outside. From the N51 going west from Drogheda, take
the first left after the turn for the site of the Battle of the Boyne. It
is on the left just after Dowth castle. It has now been closed for
some years for conservation work but is rumoured to be opening
within the next twelve months.

The cairn shows damage from early 'excavations' and
19th century stone quarrying. It has fallen victim to treasure-
hunters over the years, including the Vikings. The mound is about
275 feet across and nearly 50 feet high.

Like Knowth it has two passages opposite each other: a north
passage about 27 feet long and a shorter south passage about
11 feet long which faces towards Newgrange. The sun rises to
illuminate the Newgrange chamber at the winter solstice and at the
end of the day it enters the south passage of the Dowth cairn at
sunset. Though the passage and chamber are much smaller here
than at Newgrange, the beam of light is much bigger. This
chamber has one recess on the right. The stone forming the right
side of this recess is decorated with circular symbols. Martin
Brennan describes how the beam of light at the winter solstice
sunset hits the back stone inside the main chamber with such
intensity that it illuminates the side stone of the recess which
appears to be angled to catch the light.

The back stone of the main chamber and the stones either side
of it are also decorated. In the days before and after the solstice, the

beam of light at sunset travels across these symbols lighting them in turn. The entrance stone has a large circular hollow which, according to Martin Brennan, marks the position of the setting sun.

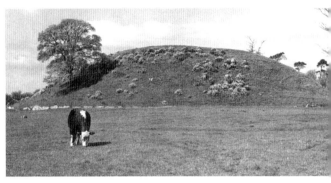

Dowth passage cairn. Photo: from 'Knowth and the passage-tombs of Ireland' by George Eogan

Dowth's alignment with the setting sun at the winter solstice places it at the end of the sun cycle and the beginning of the longest night, the darkest point of the year. Its mythology reflects this. It is said to have been built by the Druid Bresal who wanted to build a tower that would reach to the sky. He engaged the men of Ireland to help him for a day. As this was not enough time, his sister cast a spell to stop the sun setting until the tower was built. However, they committed incest and the spell was broken. The sun set and the tower was never finished. She decided that it would be called 'Dubhaigh' (Dowth) which means 'darkness'.

This is an interesting story which mythologises the association of Dowth with the darkest time of the year and involves a union between brother and sister which goes against the natural order and offends the gods. This is in direct contrast to the sovereignty rite where the king lies with the earth goddess to ensure fertility in the land and prosperity for everyone.

2 Duleek Priory and Crosses

Duleek village is just off the R152, signed 5 miles south of Drogheda.

The name 'Duleek' or 'Damh Laigh' means 'stone church' for it is here that the first stone church in Ireland was reputedly built.

St Patrick founded a monastic settlement here which he left in the care of St Ciarán in the 5th century. It was attacked frequently by Vikings and Irish alike between the 9th and 12th centuries and all that remains of this period is the imprint of a round tower against the square 15th century tower and two high crosses.

Then at the end of the 12th century the Norman baron,

Hugh de Lacy, founded an Augustinian house near here. The priory in Duleek was probably part of that house.

The bodies of Brian Boru and others slain in the Battle of Clontarf in 1014, rested here on their way for burial in Armagh.

Today the site consists of a graveyard and old parish church dedicated to St Ciarán. The ruins of the medieval priory are to the south west and date from the 13th to the 15th century. A tiled plan of the site shows the chronology of the buildings.

There is a much later 17th century altar tomb of the Preston and Plunkett families in the nave. It is beautifully carved with saints on the west end, the crucifixion with angels and St Michael on the east, the instruments of the passion on the north, and family arms on the south.

There is a high cross, thought to be 10th century, just north of the church. It belongs to the Transitional group of crosses such as

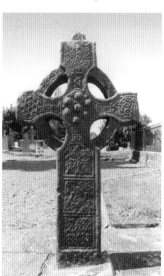

the cross of St Patrick and St Colmcille at Kells and the cross at Termonfeckin (see below). On these crosses, the figure panels are no longer confined to the base, and the 'watch spring' spiral patterns on the sides have been replaced by interlacing, zoomorphic knotwork and fabulous beasts whose lines show a strong Scandinavian influence.

The east face is beautifully decorated with seven bosses spiralling in a circle at its centre, possibly symbolizing the sun and other heavenly bodies. We will

Duleek cross, east face

never know for sure what those who carved these crosses intended, but it is interesting that the centre of the east face, decorated at this time with spirals and circles was, a century later, always carved with another heavenly scene, *Christ in Glory surrounded by angels*.

The west face shows scenes from the New Testament, beginning with *The Nativity* at the base and *The Crucifixion* at the centre. The left arm shows an ecclesiastic with a hooked crosier and the right arm shows another but with a Tau crosier. The Tau cross or crosier shows an Egyptian influence here as well as down the west coast in Clare and Donegal. Above the crucifixion, *The Raven brings Bread to SS Paul and Anthony*.

The north and south sides show winged beasts with a strong Scandinavian influence, possibly representing the four evangelists. There is the head of another cross in the priory.

3 **Fourknocks Chambered Cairn**

Going south from Duleek on the R152, Fourknocks is signed on the left. It is perhaps easier to continue south to the N2 and then turn left into Garristown turning left again and going north for 2 miles to the Four Roads Crossroads. There are a number of hilltop mounds on the Meath - Dublin border. This is perhaps the most impressive. The key is available locally.

The site is well signed and accessed up a grassy path to the side of a field.

The primary cairn and the only one that can be visited has been dated to around 2000 BC, or the late neolithic period. A secondary cairn was dated to about 1500 BC. A third mound found nearby was classified as a Bronze Age barrow.

The site was excavated in the early 1950s. The main cairn was reconstructed with a concrete domed ceiling inside and regrassed on the outside so it retained its pre-excavation appearance. Some corbelling extends a little into the ceiling of the main chamber but could not have made up the whole roof. A central post-hole has given rise to the idea that the main chamber was roofed with timber supports.

The use of concrete to preserve and make safe was common in the 50s and 60s. It can affect the atmosphere by creating a barrier which inhibits the natural flow of energy at a site. Mostly, this practice has been discontinued but there are some notable and controversial exceptions.

Having said that, this is a wonderful place. The passage is 17 feet long and opens north north east. Seefin in Wicklow has the same orientation. It was originally paved. It leads to a large chamber, 18 feet by 21 feet, which takes up most of the inside of the cairn. Where Newgrange is characterized by a long narrow passage leading to a small, though high-ceilinged chamber, Fourknocks has a short passage leading to a large, circular chamber. Both have three recesses off the chamber. There are strong similarities with cairn L at Loughcrew. The cairn was surrounded by a low dry-stone wall rather than kerb stones.

There are twelve stones carved with powerful angular images. Zigzags predominate. There is a particularly well-known image in the chamber near the passage which some people take to represent a head, maybe human or divine. Martin Brennan has commented on the presence of zigzag and diamond motifs here and at Seefin.

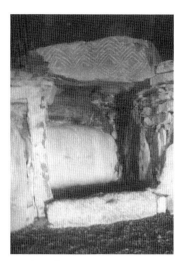

*Central recess with zigzag lintel,
Fourknocks passage cairn*

He suggests that there is a connection between these images and an orientation which may involve moon or star light.

Fragments of human bone, some cremated, were found from over sixty individuals. These were found in the side recesses, but also in the passage itself.

The archaeologists also found stone beads, hammer pendants, bone pins, small chalk balls and a polished stone axe as well as fragments of Carrowkeel pottery. These artefacts were commonly found in passage cairns, but the number of individual humans represented is particularly high.

Five cist burials of inhumed children and two cremations in inverted urns were added much later when the site was re-used, possibly around the time when the Bronze Age barrow was made.

150 yards to the east, the second mound was found to have a passage facing north east, lined with orthostats and roofed with stone slabs, leading into a long rock-cut trench sited at right angles to it. The trench was lined with charcoal and bone fragments and may have been a cremation trench for the ceremonial burning of bones before they were placed elsewhere. (A similar cremation trench was found in **Dooey's Cairn** in ANTRIM.) A number of much later secondary burials were found in this cairn as well.

4 The Hill of Tara

30 miles north west of Dublin, west of the N3, it is signed.

'Tara' or 'Teamhair' means simply an 'eminence' or 'hill'. However, there is a tradition that it contains the burial mound of Tea, ancestor queen and goddess of the Milesians or Celts. 'Teamhair' is said to come from 'Tea Mhúr' meaning 'Tea's ground'.

The Mound of the Hostages

Tea's place is the ancient passage cairn now known as 'the Mound of the Hostages' which sits within the Rath of the Kings. This is the oldest monument on the site, being built around 3000 BC, the time

LEINSTER **Meath**

of the great cairns of Brú na Bóinne.

Most of the sites at Tara were given fanciful names by 19th century antiquarians fired by images of Celtic warrior heroes and great battle feasts. Hostage-taking was a common method of controlling territory in Ireland. Niall of the Nine Hostages, who ruled at Tara at the beginning of the 5th century, was said to have taken one hostage from each of the five provinces of Ireland as well as from the Scots, the Saxons, the Britons and the French.

This cairn is 70 feet in diameter and 9 feet high. Inside it is a short passage, only 13 feet long and divided by low sill stones, into three sections. The passage is oriented to the rising sun on the cross-quarter days, November 8th and February 8th, the beginning of Winter and the beginning of Spring. The sill stone at the entrance is aligned to the horizon so that a beam of light, shaped by the portals and lintel at the entrance, strikes the backstone as soon as the sun appears above the horizon. The backstone is carved with circles and arcs. Other cairns aligned to these two cross quarter days are cairns L and U at Loughcrew and one of the passages at Dowth.

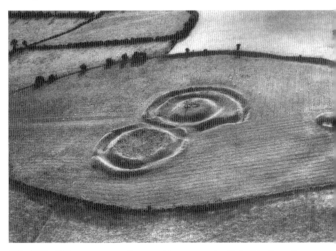

The Hill of Tara Photo: From 'Knowth and the passage-tombs of Ireland' by George Eogan

Two beautiful gold torcs were found here, dating to around 2000 BC. The cairn was used as a sacred mound where bodies were deposited right into the Bronze Age. It was so popular that excavations have revealed over a hundred burials here, the largest number in any one mound.

There is a strong connection between Tara and the festival of Samhain or the coming of winter. This was traditionally a time for the ancestors to bless the living and ensure good fortune for the difficult months ahead.

The Goddess Bóinn

The goddess Bóinn or the White Cow goddess is also present at Tara. There are two wells on the hill, the one on the western slope is called 'the Well of the Calf'. It is in a small triangular field called 'Fodeen'. There was apparently a mound in the same field, called 'the Hill of the Cow'. This has now disappeared, but across the hill on the east slope is the other well, called 'the Well of the White Cow'. It is now also called 'St Patrick's Well'. The waters from the wells flow in opposite directions, east and west, into two rivers which later come together as they join the waters of the Boyne.

The Hill of the Cow was described in the 19th century by the historian, George Petrie, as 40 feet in diameter and 6 feet high. Perhaps it was a passage cairn? It was also called Glas Teamhrach which links it with the Glas or Enchanted Cow of the mythical smith god, Goibnui. This cow gave milk to everyone and was a symbol of generosity and plenty.

The time of the cow is Imbolc, and the beginning of Spring, when the milk begins to flow and the hard winter days are past. This time is also marked by the passage cairn on February 8th. In Christian times Imbolc came to be associated with Brigid, who was, among other things, overseer of all things connected to dairying.

Maebh the Sovereignty Goddess and the Bán Fheis

In the mythological development from Bronze to Iron Age, the magical race of the Tuatha Dé Danann retreated into the sacred places of Ireland where they lived in the Otherworld and became the ancestor deities of the Celts. They embodied the spirit of place and, where kings were inaugurated, they became the goddesses of sovereignty. Tradition demanded that a sacred marriage take place between the new king and the goddess, who held the fertility of the land in her power. He would then rule his people and in return for their loyalty to him, they would enjoy the prosperity and plenty that he had won through union with the goddess. This ritual was called the 'Bán Fheis'.

Nowhere was this ritual more celebrated than at Tara. And there was no sovereignty goddess more powerful or more celebrated than the great Maebh. She is said to have been 'married' to nine successive high kings.

Rath Maebh sits just 0.9 miles south of Tara on the old road that runs east of the hill. It is marked as a henge on the Ordnance Survey map and is on the right side of the road going south, just opposite a turn off on the left. It is a wide circular enclosure, about 750 feet in diameter, with an opening facing towards the summit of Tara. It has been called a ritual enclosure, though little is known

about it. It is a lovely secluded site, rarely visited.

Tara had long been a seat of kings but it was at the beginning of the Iron Age, some time around 500 BC, that Tara became associated with the concept of high king: whoever ruled at Tara, ruled the whole country. This was often in name only and always contested, but Tara became a symbol of royal power and the Bán Fheis or Sacred Marriage became a symbol of harmony between the people and the earth.

At its height, under **Cormac Mac Art** in the 3rd century, Tara was considered a kind of Camelot. Cormac was such a wise and powerful king that calves needed only three months gestation before they were born, every ridge produced a sackful of wheat, the rivers were full of salmon and there were not enough vessels to hold the milk from the cows.

The Royal Seat and Cormac's House

These are two circular earthworks to the south of the Mound of the Hostages. All three are enclosed by a large oval bank with an internal ditch, called **The Rath of the Kings**. The internal ditch marks it as a ritual enclosure rather than a fort, because a defensive ditch needs to be on the outside of the bank. The bank had, originally, a wooden palisade on top.

These sites are associated with the high king, Cormac mac Art, who embodied all that was most valued in the society of the time. As befits a hero, he had a magical beginning. His father, Art, foreseeing his imminent death in battle, impregnated Étáin, the daughter of a Druid in whose house he was staying. He told her that their son would become king and he left her his royal ring and the sword of Cúchulainn which was known as the Sword of Light. Art died in battle and, when the time came to give birth, Étáin travelled to the home of the Druid, Lugna Fer Trí, whom Art had chosen as foster father for his unborn son. Cormac was born, however, before they reached Lugna's house he was abducted by a she-wolf and reared in the forest until he was found much later as a young child by Lugna.

With Lugna he learned the warrior skills of the time as well as the magical arts of the Druids. It was a time of division in Ireland and eventually Lugna told Cormac that he must take his place as high king for only he could unite the country. They went to Tara where Cormac gained acceptance by the people as their new king.

Shortly after their arrival, a judgement had to be made. Some sheep had been grazing in one of the queen's fields and a judgement was required against their owner. The high king judged that the sheep should be forfeited to the queen. Cormac was asked for his opinion. He said that the forfeit was too great. The

queen should get the wool from the sheep, not the sheep, for both the wool and the grass would grow back. His judgement was seen to be the correct one and immediately one side of the house in which the false judgement had been given, fell down the slope. This place can still be seen at the north west corner of the hill. It is called **Clóenfherta**, the Crooked Mound of Tara. After his false judgement, the king lost power and soon the kingship passed to Cormac as it had been foretold.

There are clear parallels between this story and the accounts of the early life of King Arthur of Britain.

The Lia Fail

It was a testing time for kings. The seat at Tara was the greatest prize, though for many of her kings, the title of high king was in name only. The new king had to seek acceptance by the sovereignty goddess. He also had to pass a number of other tests. On the hill there was a stone known as the 'Lia Fail', which was said to have been brought to Ireland by the Tuatha Dé Danann. It was traditionally used for the inaugural ceremony of kings and was relied upon to cry out if the king was indeed the rightful heir. The prospective king also had to drive a chariot between two stones known as **Blocc and Bluigne**. If they accepted him, they would open up before him so that the chariot could go between them.

Long after these rites had been dropped, the high king Brian Boru chose to incorporate it in his inauguration ceremony in the 11th century as a point of tradition. The story goes that a great sound was heard all across the land, proclaiming him the rightful king. The Lia Fail or Stone of Destiny still sits on the hill, though some people argue that the real stone was taken to Scotland where it became the Stone of Scone.

The tradition of the sacred marriage remained strong at Tara well into Christian times. St Patrick is said to have confronted the Druids in the royal palace here and won. Yet, interestingly, he did not build a church here. In fact, little changed at Tara for at least a hundred years.

Diarmuid and Gráinne

The rite of the Bán Fheis symbolized a harmony between the land and its people, but there are also many myths which describe what happened when this natural order broke down.

Sometimes the man raped the goddess. Sometimes the goddess appeared in her hag aspect and the young man rejected her, and sometimes, as in the story of Gráinne and Diarmuid, the man was too old and was rejected by the goddess. This is the story of what happened when the beautiful Gráinne, daughter of Cormac mac

Art, rejected Fionn mac Cumhaill, the great chieftain and leader of the Fianna, choosing instead one of his young soldiers, Diarmuid.

A great betrothal feast was held at Tara for Gráinne and Fionn, but when Fionn arrived and Gráinne saw that he was older even than her father, she was determined not to go through with it. Instead she saw the young Diarmuid in his company with dark hair and cheeks the colour of rowan berries. Immediately she found herself falling in love with him. Quickly she made a plan. She prepared an enchanted drink which she gave to everyone present except Diarmuid and a few of his closest companions. When all the company fell asleep, she told Diarmuid that she loved him and asked him to take her away from Tara. Diarmuid was very afraid of the consequences for Fionn was his leader, but eventually he was persuaded and he and Gráinne left the palace while the company slept.

For seven long years they travelled the country pursued relentlessly by the furious Fionn. Many times he had to fight his old companions, the Fianna, but his love for Gráinne deepened and there was nothing he wouldn't do for her. At times Aenghus, the god of love, came to their rescue, taking Gráinne to safety while Diarmuid fought yet more of Fionn's men. At the end of the seven years, Diarmuid built a house for himself and Gráinne at Kesh Corran in Sligo, as far away from Fionn as possible. For seventeen years they lived happily there and Gráinne gave birth to a daughter and four sons.

Eventually, however, their exile became too painful. Gráinne wanted to see her father again and Diarmuid missed the companionship of the rest of the Fianna. They invited Fionn and the Fianna to their home at Keshcorran. Fionn came and stayed with them for a year, though he found that his jealousy only grew stronger. At the same time he was Diarmuid's guest and custom forbade him to fight his host.

Then one day he learned that there was a prophesy that Diarmuid would be killed eventually by a wild boar. It was for this reason that Diarmuid never hunted the boar on nearby Benbulben. By a magical trick, Fionn lured Diarmuid out onto the hillside at night and left him to face the wild boar alone. Diarmuid fought bravely and managed to kill the boar, but was himself fatally gored.

By this time Gráinne and Fionn had arrived, as well as some of the Fianna, including Fionn's son, Oisín. Oisín asked Fionn to carry water from the well to Diarmuid, for he knew that Fionn had the power to heal him by this act. Reluctantly Fionn carried water twice, but each time he let it slip through his fingers before he reached Diarmuid. The third time he had made up his mind to save him, but

it was too late. By the time he reached Diarmuid, he was dead.

It is said that Gráinne was heart-broken, but she eventually married Fionn to prevent her four sons taking vengeance against him. And Fionn himself was devastated, and tried to take Diarmuid to Brú na Bóinne so that he could communicate with him from the Otherworld.

Cormac's House, Hill of Tara

The decline of Tara is associated eventually with St Ruadhán's curse (see TIPPERARY), near the end of the 6th century. The High King, Diarmuid Mac Cerbhaill, incurred the wrath of the Christian clerics by celebrating once again the Bán Fheis in AD 560. This is often seen as the final conflict between paganism and Christianity. Tara was cursed by St Ruadhán of Lorrha and legend tells us it was abandoned. Diarmuid was killed at the Battle of Cúl Dréimhne. The annals say his death was brought about by the prayers of Colmcille. And so the transition from paganism to Christianity was complete. The words of Thomas Moore's poem best describe the end of the old ways:

> The harp that once through Tara's halls
> The soul of music shed,
> Now hangs as mute on Tara's walls
> As if that soul were fled.

A Final Thought

The hill of Tara is a modest 300 feet high, yet from the summit it is said that 40% of Ireland can be seen. This may have something to do with its long history, but it is also a very magical place. The hill is wide and grassy, yet it seems to expand as you cross it, as if it contains so much history and so much power, that time and space are of little importance.

It would be nice to think that some of this power at least was due to the long history of creative marriage between the earth goddess and the people of Ireland.

I found the following tribute to Cormac mac Art in an excellent book on Tara by Michael Slavin who is sometimes to be found in the little bookshop at Tara:

> "The great sigh which a cow gives when she lies down on the grass at Meath is for the happy days when Cormac, the great king, reigned at Tara."

5 Bective Abbey

The abbey is signed off the R161 about halfway between Navan and Trim to the east of the road.

The abbey ruins sit in lush pasture beside a a magnificent twelve-arched bridge over the wide waters of the Boyne.

At present the abbey is approached through a small spring door set in an old gate by the roadside and then across a field. There are plans afoot for a car-park etc., but for the moment, this lovely site is left undisturbed. A tiled plan inside the building shows the layout and chronology of the site.

Bective Abbey

This abbey was founded in 1147, by Murchad O Maeil-Sheachlainn, King of Meath. It was one of the first daughter houses of the Cistercian abbey of Mellifont in Louth. Mellifont was the first Cistercian foundation in Ireland. It had been founded only five years before and had already grown beyond its own walls. The Cistercian order spread quickly in Ireland. Its strict Benedictine rule seemed to offer a new aesthetic idealism and a freedom from local power and corruption.

The ruins are wonderfully intricate with stairways to climb and arches and vaulted ceilings, great stone fireplaces and tall chimneys. There are some remains of the original 12th century abbey, but most of the building standing today dates from the 15th century when much of the abbey was rebuilt and fortified. The lovely cloisters date from this period and include a fine carving of a figure with a staff. He appears to be wearing monk's robes, though they are somewhat fuller than those allowed by the strict rule of the Cistercian Order. The position of the figure is similar to those at Jerpoint, though much smaller.

Hugh de Lacy's body was buried here but following a dispute, it was taken to St Thomas' in Dublin. After its suppression in 1536, it was transformed into a manor house.

6 Donaghmore Round Tower

1.5 miles north east of Navan on the N51 to Slane. Signed.

Donagh or Domhnach in a place name usually means a connection with St Patrick. He founded churches as he travelled across the country and left each in the care of a bishop newly appointed by himself.

The early church here is said to have been founded by St Patrick and it must have developed into a substantial foundation, for a round tower was added to the monastic buildings in the 12th century. It is complete, having had its conical roof replaced last century. The round arched doorway has

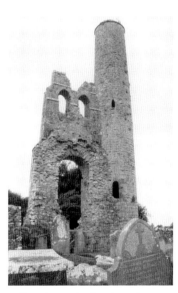

Donaghmore church and round tower

a crucifix carved above it with a head on either side of the arch.

The present 15th century church replaces a Romanesque building which would in turn have replaced earlier monastic buildings. A carved head from the 12th century Romanesque period built into the south wall of the bell tower. The graveyard contains some Early Christian grave slabs. Today this is a quiet and secluded place.

7 Loughcrew Passage Cairns or Sliabh na Caillí

*A key to Cairn T on Carnbane East can be obtained from the
nearby Loughcrew House & Gardens either by calling in person
during opening hours or phoning 049 8541356
(Website: www.loughcrew.com). To visit the cairns on Carnbane
West you need permission from the landowner and the key for
Cairn L is not so readily available.
Contact Brú na Boinne on 041 9880303 to plead your case.*

Sliabh na Caillí is part of a ridge of hills a couple of miles long on the
western border of Co Meath. The hills form a kind of island of high
ground surrounded on one side by the lakes and lowlands of Cavan,
and on the other by the wide expanse of the Boyne valley and its
tributaries. Sliabh ne Caillí sits at the head of this powerful network
of rivers whose banks are home to more sacred architecture than any
other waterway in the land. It is the highest point in Meath, the
middle kingdom.

There are over 30 chambered cairns on this range of hills.
Most are on two peaks, Carnbane East and Carnbane West.
'Carnbane' means the 'white cairn'. A third hill between them, and
slightly to the south, has one ruined cairn on top, cairn M, towards
which a number of cairns on Carnbane West open.

From the car-park, steps lead to a path which spirals up and
round Carnbane East, which is the peak known as 'Sliabh na Caillí'
or the 'Hill of the Hag'. The central and biggest cairn on top of this
hill was known as her cave. This is the same Cailleach or hag
aspect of the triple goddess which we find on Sliabh Gullion in
Armagh and Knockmany in Tyrone. All these hills have stories of
giants and heroes bewitched or bested by fairy women. The fairy
woman is often the last guise of the goddess, relegated to the
Otherworld by the Iron Age Celts.

A later tradition says that the main cairn here is the tomb of
Ollamh Fódhla, the poet-king and law giver, who instituted the
triennial feis at Tara (see below) around 1000 BC.

This central cairn
is also called **Cairn T**
and is the largest as
well as the best pre-
served on this hill. The
key is needed for access
to the interior. It is
encircled by 37 large
kerbstones. On the
north side, one of these
stones is a massive 10

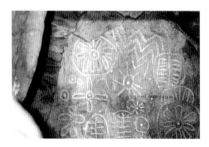

*Interior of Cairn T,
Sliabh na Caillí, Loughcrew*

foot by 6 foot with a recess in the top giving it something of the appearance of a throne or ceremonial seat. It is called 'the Hag's Chair'. 'Carnbane' means 'white cairn' and local tradition holds that Cairn T had a thick layer of white quartz stones inside the kerbs. This

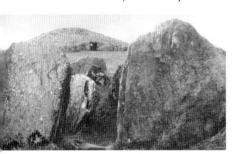

may mean that it was walled with quartz much like Newgrange.

At the entrance to the cairn are intricately decorated portals leading into a narrow passageway crossed by sills. At the end of the passage is a small

Cairn T with Cairn V in foreground, Sliabh na Caillí, Loughcrew

gallery with corbelled roof and chambers on three sides, making a cruciform shape. There are no less than 27 decorated stones inside this cairn, not least of which is the endstone of the back chamber, famously illuminated by the rising sun on the spring and autumn equinoxes. The light moves diagonally across the stone illuminating a succession of images as it does so.

Around Cairn T are a number of smaller cairns with various alignments calculated by Martin Brennan and discussed in his book, *The Stars and the Stones*. To the north west is **Cairn S**, open now to the sky with its entrance facing west and aligning with the sunset on the cross-quarter days - 6th May and 8th August. (Cross-quarter days fall exactly between the solstices and equinoxes.) Its gallery only has two chambers so that the inner structure forms a Y shape.

Cairn U is to the north, with its passage aligned to the other cross-quarter days on November 8th and February 4th.

Cairn V is in front to the east, marking the winter solstice and a stone at **Cairn N**, south west of Cairn T, aligns with the Hill of Fore in Westmeath to mark the Winter Solstice sunset.

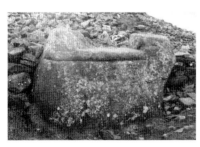

Back to the car-park and following the road back towards the main road there is a gate and stile on the right leading into a huge field with a decorated standing stone just inside the fence. Away across this field the cairns of

The Hag's Chair outside Cairn T, Sliabh na Caillí, Loughcrew

Carnbane West are visible on the hill and to the left on another hill, you can just make out the remains of **Cairn M**.

On Carnbane West **Cairn L** also needs to be unlocked. It is encircled by 42 large kerbstones. Very different from Cairn T, this cairn opening has tall imposing double portals and a short passage

leading to a wide central gallery (see **Fourknocks** above) with what appear to be six chambers. These chambers have tall free-standing portals and two have basin stones inside. Before the last chamber on the right is a tall slender white pillarstone and it is this stone which is illuminated by the rising sun on the November and February cross-quarter days. A shadow is cast by Cairn M on the hill opposite which focuses the light so it only shines on the stone. It feels like, in male/female or yin/yang terms, cairns T and L are two opposites. The narrow passage in cairn T leads to a small womb-like gallery illuminated by the rising sun. In Cairn L there is a wide gallery but it is the tall, phallic pillar stone rather than the gallery which is lit up or activated by the sunlight.

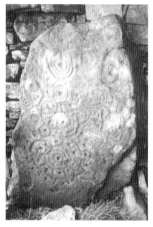

Portal stone, Cairn T,
Sliabh na Caillí, Loughcrew

There are many decorated stones inside Cairn L but nothing visible on the pillar stone. In fact, one of the most intricately decorated stones is in the chamber behind the pillar stone and facing away from the entrance.

West of cairn L, **Cairn H** is a small cairn, 55 feet in diameter (compared to Cairn T's 120 feet) with a long passage-way broken by sills and leading to a gallery with three chambers like Cairn T. Some of the corbelling is still visible, though it is now

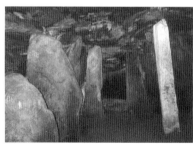

Passage leading into Cairn L with white pillar
stone on the right, Carnbane West, Loughcrew.
(photo: Hannah Meehan)

open to the sky. There are five decorated stones in this cairn and the sill in front of the north chamber has spirals similar to the front sill at Newgrange. This is one of the most beautiful stones on the site.

(margin) LEINSTER **Meath**

This chamber also has a basin stone.

This cairn was excavated in the 19th century and again in 1943 and both times thousands of pieces of cut bone were found with La Tène designs on them, indicating that this cairn was used in the first century AD as a workshop.

There are many other small cairns around L, but to the west is a massive heap of boulders called **Cairn D** with no apparent inner chamber.

Between D and L is a very exposed but lovely **Cairn G** with chambers reclaimed by moss and wild flowers. Nearby is a solitary

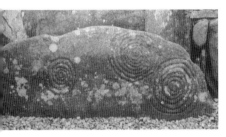

thorn tree and from this point, the fluid outline of the three hills is suddenly reminiscent of the island of Glastonbury in Somerset. Through the estate wall to the east is a magical little copse with a standing stone where it is tempting to linger, but suddenly the sun is going down and it is time to leave.

Sill stone in front of Cairn H,
Carnbane West, Loughcrew

In the National Museum in Dublin are two large and six small stone balls, perfectly round and polished, taken from this site. No-one really knows the purpose of these balls, but their round, smooth shape seems egg-like if we see the passage cairn as the belly of the goddess and the chamber as her womb. Perhaps this 'egg' absorbs the power of regeneration from the penetrating beam of light at a particular time in the cycle of the year.

There are also three large bone pins and nine stone beads on display with other passage cairn goods.

About 2 miles west of **Oldcastle**, in the townland of Fearan-na-gloch (Field of the Stones), are two massive standing stones, called **The Speaking Stones,** which provided the services of oracle from ancient times. At one time there were apparently four stones. They are both around 7 feet tall and quite broad.

They were very effective in curing the consequences of the 'evil eye' and in finding things which had strayed or been stolen and in naming the culprit of any crime. The only rule in consulting them was that they must not be asked the same question more than once. This condition was broken a couple of hundred years ago and the stones have been silent ever since. The smaller of the two stones is blue limestone.

8 Castlekeeran High Crosses

*Take the R163 from Kells to Oldcastle and the Castlekeeran
Crosses are signed on the right about 3 miles out of Kells. It is a
long narrow road, but eventually they are signed on the right,
just before a farmhouse.*

This place is called 'Disert Chiaráin' meaning 'the hermitage of
Ciarán' who was a monk from nearby Kells. He is not connected
to Ciarán of Clonmacnois. The monastery here passed to the
Knights Hospitallers (see **Kilteel**, LOUTH) in the 13th century. It
was dissolved in the 16th century.

There are three high crosses here with strong edge moulding,
but no figure sculpture and only one has interlacing on the arms.
One has bosses at the centre. There is also a base of a fourth cross
said to have been stolen by Colmcille and thrown in the river when
St Ciarán caught him!

St Ciarán's Well

*The well is a short distance beyond the old church site and right
beside the road. It was at one time sheltered by an ancient ash
tree and became famous in the 1840s when the tree was said to
have started to bleed.*

The annual pattern is held here on the first Sunday in August.
For the first hour of this day, after midnight, the water is at its most
potent. Sacred trout are to be seen in the well at this time.

St Ciarán's well

The well area has a number of recesses in the limestone
outcrop where underground water rises to the surface.
The different areas hold different cures. On the left is a round deep
pool reputed to cure toothaches, warts and throat ailments.

(I took some water here for my wart and it was gone in 10 days.) Nearby is the main well for drinking, with a stone chair for curing backs and a long channel where you can bathe your feet while resting on a low metal bench. The place has a strong elemental presence. On the small hill behind is an oratory. The whole area is well kept and accessible to all without resorting to concrete paths.

It was described by William Wilde as 'one of the most beautiful holy wells in Ireland and shaded by a hoary ash tree of surprising size and beauty'. The tree is now gone. Ash trees were often associated with holy wells. The well was produced by a miracle of St Ciarán's.

9 Kells

On the N3 between Navan and Virginia in Cavan.

The name Kells is synonymous with Celtic art and the illuminated manuscript associated with the early Columban monastery here. The *Book of Kells*, an exquisitely illustrated copy of the gospels, may have been written here or it may have come with the monks of Iona who fled here from the Vikings in 807. No doubt there were many others which didn't survive the turbulence of the next few centuries. It is a fabulous celebration of all the art styles of 8th century Ireland and some of Europe as well. The influence of the *Book of Lindisfarne*, from that other great Columban monastery of the time, is also there for those who can see it.

It was stolen in 1007, but quickly recovered although its gold shrine or outer cover was lost. It can now be seen in the library of Trinity College in Dublin.

Kells had long been an important royal seat. By the 6th century it was owned by the High King, Diarmaid mac Fergusso Cerrbheoil, of the Uí Neill. He was a cousin of Colmcille. It is said that these two had many disagreements and to compensate for some action of his against Colmcille, Diarmaid gave him the palace at Kells. It is recorded: "Kells is given without battle to Colmcille, the Tuneful". Colmcille immediately entered the Dún and marked out the site of a new monastery there. The site thus passed into Christian hands and became one of Ireland's most famous Christian centres.

There is no further reference to this foundation until 802 when, according to the *Annals of the Four Masters*, the Church of Colmcille at Kells was destroyed. Just five years later in 807, according to the *Annals of Ulster*, a new foundation was built here for the Columban monks of Iona, forced to flee from there because of the severity of Viking attacks. The core of this old 9th century Columban settlement is now contained within the high walls of the

LEINSTER **Meath**

Protestant churchyard.

For the monks from Iona this was no easy sanctuary. Kells was plundered five times by the Viking settlement in Dublin between 920 and 1017. Various annals record it as being burned no less than fifteen times. Their new stone church was destroyed in 920 and again in 1050; the 'great church' met the same fate and was again replaced. Yet, in spite of all this violence and destruction, Kells remained powerful and wealthy and a centre of artistic expression. The relics of St Colmcille had been transferred here in 877, greatly adding to the wealth and prestige of the settlement.

The round tower still stands in spite of all the destruction, as well as four high crosses, only one of them broken. Just outside the churchyard wall on the north side is St Colmcille's House, a small church or oratory. It has a steeply sloping stone roof with a barrel vaulted ceiling inside, like Cormac's chapel at Cashel in Tipperary or St Mochta's house in Louth. It may have been built to house the relics of the saint in the 9th century or as an oratory where a possible twelve monks might have gathered to pray together. There was a small room above the vaulted ceiling, accessed by a small aperture and presumably a ladder at one time. Originally there was a wooden floor dividing the lower room in two. The entrance to the upper part was high up in the west wall. This has now been blocked and a door at ground level made in the south wall.

On the south side of the churchyard, the round tower provides a landmark for miles around. It rises to a height of 90 feet from street level to the base of its roof and has six storeys with one window on each level, except for the top which has five windows to look out over the five ancient roads leading from the city through the five gates in its walls. Most round towers have four windows in the top storey for the four cardinal points.

In 1076 Murchadh mac Flainn, grandson of the high king, was murdered in the tower where he had sought refuge after making a bid for the kingship of Tara.

THE HIGH CROSSES

The South Cross or Cross of St Patrick and Columba

The carving on this cross is deeply incised and though the cross is very weathered, there is a tremendous sense of fluidity and movement in the figures, as if each scene has just been captured in a snapshot. This is very different from the more monumental style of the other crosses. It was thought to have been carved at the beginning of the 9th century around the time of the arrival of the monks from Iona, but more recent thinking puts it a century later

LEINSTER Meath

because the inscription on the cross mentions both SS Patrick and Colmcille. This makes it likely that the cross was commissioned for the Abbot Máel Brigte mac Tornáin, who came to Kells from Armagh. He was described as 'Coarb of both saints'. He was abbot in Kells from 891 to 927. Interestingly, Dubtach, his successor as Coarb of Colmcille, is probably the DUBT visible on the Cross of Durrow in Offaly.

The body of the cross is carved from one piece of sandstone and stands nearly 11 feet high. The cap-stone is missing.

The east side has mainly Old Testament scenes. From the bottom, you can see *Adam and Eve*, *Cain and Abel*, *The Burning Fiery Furnace*, and *Daniel in the Lions' Den*. Around the head of the cross, the images are mostly from the New Testament: *The Raven bringing food to SS Paul and Anthony in the Desert* on the right arm of the cross, *The Miracle of the Loaves and Fishes* at the top with David with his harp on the left and another figure, maybe Christ, on the right. The left arm is possibly *The Sacrifice of Isaac*. At the centre is a

Detail on the arm of the cross of St Patrick and Colmcille, Kells

circular boss containing seven small circles joined by spirals. This symbol is also found on the Duleek cross (see above) and on the stone pillar at Tibberaghny in Kilkenny. At Tibberaghny the seven circles are all represented as double or triple spirals.

The west side shows the Crucifixion with, at the centre of the cross, *Christ in Triumph*. He is surrounded by *The Four Evangelists* represented by the Lion, the Eagle, the Bull and the Man. This is the only cross which uses these symbols - also used extensively in the Book of Kells.

The sides of the cross are intricately carved, beautifully fluid vine scrolls and knotwork. There are some figure panels. The most common theme appears to be men overcoming beasts, perhaps *David and the Bear* or *Samson and the Lion*. This could symbolize the human spirit overcoming animal passions.

The West or Broken Cross

Only the shaft remains but it stands as high as the south cross. The style is much less fluid than the south cross with a greater emphasis on delineating each panel. The panels on the north and south sides are strongly outlined and each panel decorated with a different type of knotwork, interlacing or spirals. The base is undecorated.

The lower panels on the west face depict Old Testament scenes: *Adam and Eve* and *Noah's Ark*. The upper panels are unclear. The east side has *The Baptism of Christ* at the bottom in which the water is depicted by ribbon-like scrolls (see **Killary** below). Above it is *The Feast of Cana* and again the upper panels are more worn.

In the east is an unfinished cross, most remarkable for its height of about 14 feet. It also shows clearly how the crosses were blocked out before carving.

Baptism of Christ from the east face of the West or Broken Cross, Kells

The Market Cross

Another sandstone cross normally stands in Cross Street in the centre of the town. It is currently away being restored. It has figured panels on all four sides and has much of the fluidity of the south cross. All four sides of the base show animal scenes. The north side has animals, birds and two centaurs.

The spiral motif on the east face of this cross has been relegated to the base of the shaft. Above it in order are: Soldiers Guarding the Tomb (also at **Durrow** and **Clonmacnois**, OFFALY), a possible *Goliath*, and *Adam and Eve* and *Cain and Abel*. The centre of the cross shows *Daniel in the Lions' Den*, an unusual theme for the centre. This would more usually be the place for a spiral motif, or later for *Christ in Triumph*. The west face has a crucifixion at the centre with New Testament scenes on the shaft.

This cross was said to have been erected by Dean Swift after it had lain broken for some time. It was used later that century as a gallows, after the 1798 rebellion.

10 Cruicetown Church and Cross

Just south of Nobber on the R162 turn right after the graveyard, over a level crossing and right again 1.3 miles from the R162. Take the first left and the site is visible on the hillside after 0.7 miles. The white gate is on the right after the castellated stone entrance to the Cruicetown estate.

Access to the site is across a field where the small medieval church sits on top of a hill in the Cruicetown estate. The name 'Cruice' is thought to come from 'the cross of the crusaders', and the Cruice family were said to have come from Devon and been descended from Strongbow's army which came over in 1170. A motte from this time sits on the hill near the church. The family died out in the 19th century.

This small medieval church has a nave and chancel and was built around 1200. There is a very ornate 17th century tomb of the Cruice family dated specifically to the fourth year of the reign of King James II. It has carved figures and at one end the skull and crossbones with bell, book and hourglass, the symbols of mortality.

Cruicetown cross

The site has a lovely gentle feel to it, but perhaps the loveliest thing there is a cross, also 17th century, with a very simple and moving depiction of *Mary and Jesus* on one side. The other side shows a crucifixion in the same naive style.

11 Killary High Cross

On the N52 going from Kells to Ardee, the turn is on the right 2.2 miles after the N2 crosses the R162 road going to Navan and Kingscourt. It is the second road off on the right. The old graveyard is signed a couple of miles down this road on the left.

The name comes from the Irish 'Cill Fhoibhrigh' meaning the 'favoured or influential church'. The old church site is up a lane and on a small hill.

Only part of the shaft remains of this cross with Old Testament scenes on the east, beginning with *Adam and Eve* at the bottom and then *Noah's Ark* in the panel above. The ark looks

rather like a Viking longboat which would have been the local experience of a large ship at that time. On the other side are New Testament scenes including, in the middle panel, a *Baptism of Christ* very similar to that on the Broken Cross at Kells. Both depict the currents of water as rounded scrolls. Near the gate is a gravestone which reads:

> Remember me as you pass by
> As you are now so once was I
> As I am now so shall you be
> Prepare for death and follow me.

12 Slane Friary and Church

Slane lies north of Dublin on the N2 to Derry where the road crosses the N51 between Navan and Drogheda. The Hill of Slane is signed just to the north of the village.

The name of Slane is said to have come from Sláine, a king of the Fir Bolg, who inhabited Ireland before the Tuatha Dé Danann. He is said to have died and been buried here. The large mound erected over his grave is now the Hill of Slane.

Slane is remembered as the place where the great confrontation took place in 433 AD between St Patrick and the High King as St Patrick was making a journey south to Tara, the centre of temporal and spiritual power in Ireland. The story of this confrontation between the old and the new religion has lived on in folk-memory perhaps because it is mirrored in a hundred other such confrontations around the country. St Patrick is credited with seeking out the most powerful places across the land and challenging directly the power of the old gods. Before he moved on, he would convert at least some of the local people and build a small church there.

On this occasion, the High King Laeghaire was about to light the ceremonial fire at Tara on the 25th March. This would have been to mark the spring equinox and it was important that the fire at Tara be the first fire. From this centre all the other fires in the country would spread. Before the fire was lit, Patrick lit a pascal fire on the Hill of Slane in full view of Tara. King Laeghaire rode quickly to Slane and a confrontation took place. As a result, though declining conversion for himself, the king allowed his followers to become Christians if they wished.

At least one person was converted, Erc, later Bishop of Slane. He defied the Druids and followed Patrick. Some sources say that he was actually a Druid himself.

Erc established a Christian foundation here and his remains are believed to lie to the south of the present church ruins. All that remains of his shrine are two gable ends, large rectangular slabs of stone standing upright near the south wall of the church.

This shrine has been held in veneration right into the present century and it was the custom at funerals to carry the coffin three times round the tomb and set it within the gables for a short while before burial.

Little is known about this site beyond records of its being plundered repeatedly, until the building of the Franciscan friary in 1512. Christopher Flemyng, Lord of Slane, discovered two Franciscan friars living in a small hermitage by the river and had the church and college built for them. The most striking feature of the ruins now is a fine west tower with Gothic features and a flight of 68 steps. From the top of the tower you can see for miles. Tara is visible and Brú na Bóinne, as well as the sea beyond. On a clear day you can make out the Sugar Loaf Mountain in Wicklow, Slieve Gullion in Armagh and the Cooley Mountains in Louth.

Gable ends of St Erc's shrine, Slane Friary

LEINSTER **Meath**

Back to earth, the college buildings to the north of the church have the arms of the then king of England, Richard Plantagenet, over the entrance. The outer walls sport occasional carved heads and there is a dragon built into the west wall.

Behind the church, to the west, is a motte encircled by a fosse and now fringed with trees and wild flowers. This would have been the original castle of the Flemyngs who came as part of the Norman invasion in 1169. There was heavy fighting between them and the native Irish, as recorded in the *Annals of the Four Masters*, but they remained and their descendants built their castle on the river bank where the present castle sits today. It is not open to the public, but most years the grounds are used for a huge rock festival, in what is today Ireland's biggest open air venue.

St Erc's hermitage is on castle land. It was recently given to the nation and so will eventually be open to the public.

County
LOUTH
PRINCIPAL SITES

1 Dún Dealgan

2 Brigid's shrine and well
 Faughart Hill

3 Lissachiggel

4 Templetown

5 Carlingford Town
 Dominican Priory

6 Clermont

7 Proleek dolmen

8 Donaghmore souterrain

9 Knockbridge Stone

10 Louth St Mary's Abbey
 St Mochta's house

11 Kildemock jumping church

12 Monasterboice

13 Mellifont

14 Termonfeckin

15 Dromiskin

16 St Colman's Well

Block figures in list refer to site locations in map and entries in text.

LOUTH

THE COUNTY TAKES ITS NAME FROM THE GOD LUGH, the heroic sun god of the Tuatha Dé Danann. Although part of the eastern province of Leinster, the north of the county is linked to Ulster by its mythology and prehistory. From the coming of the Normans in the 12th century, it is strongly linked eastward to the Pale.

Much of its mythological past centers on the Iron Age hero, Cúchulainn, son of Lugh, and the epic of *The Cattle Raid of Cooley*, called in Irish, *Táin Bó Cuailnge* (see p298). The Cooley peninsula, once part of Ulster, is particularly associated with the events of the Táin, its wild and powerful landscape a fitting location for this epic. There are dark forests, rushing waterfalls and wild mountains with names like Raven's Rock and Eagle's Rock and the Black Mountain.

Louth is also by tradition the birthplace of one of Ireland's best loved saints, Brigid, and the area just north of Dundalk is dedicated to her memory. Her festival is Imbolc, the first day of February, also a Celtic fire festival. Brigid has a much older persona as the goddess Brigid, daughter of the Daghdha, father god of the Tuatha Dé Danann (see KILDARE). So Brigid and Cúchulainn share the landscape of this part of Ireland balancing opposites: male and female; wild mountains and gentle pastures.

The south of the county is full of souterrains and castles, legacy of a turbulent history involving Vikings, Normans and the English Crown. The county was divided as the eastern part came under Anglo-Norman control, while the land to the west, both Gaelic and Norman, remained unwilling to submit peacefully to English authority.

Today the ancient hillforts of the Gaelic Kings have all but melted back into the landscape while the Norman castles and fortified houses stand visible for miles.

Here also are the remains of substantial monastic foundations, often devastated by repeated destruction from the 8th century right up until their dissolution in the 16th century. Often built on sacred mounds or places of power, as the more turbulent aspects of their past slowly dissolve, these sites become once again places of power and magic.

Here also can be found the occasional extravaganza such as the tiny Church of Ireland church at Collon. This small church is modelled on the chapel of King's College Cambridge in England.

LEINSTER **Louth**

1 Dún Dealgan

On the outskirts of Dundalk turn left at the first crossroads off the
N53 to Castleblaney.

This site is associated with the legendary Cúchulainn and it is here
that he lived with his wife and where he came before his epic fight
at the ford with Ferdia. There is a standing stone in the field to the
right as you approach the fort. It is also thought to be his burial site.

The present earthworks are Norman, probably built in the last
years of the 12th century. The motte remains high and deep,
preserving its character as a fortress though now softened by trees
and flowers. The bailey walls are also well preserved to a height of
several feet and an 18th century castle sitting within them gives a
good impression of what the fort would have looked like - certainly
in Norman times.

In spite of this later remodelling, Dún Dealgan represents the
energy and character of Cúchulainn and is very much a part of the
character of an area whose softer side is well represented by St
Brigid below.

2 Brigid's Shrine and Well

Take the N1 north of Dundalk for 2.5 miles from the bridge on the
edge of town. The main road turns a little to the right while an
old road goes straight ahead and is signed to Faughart. Follow
this road under the railway bridge and the shrine is signed.

This modern shrine has developed around a small stream and
wooded area where St Brigid is supposed to have worked as a
young girl, tending animals for her father Dufach, a pagan chief.
Her mother, Brocessa, was a Christian.

Like most female saints in these early times, Brigid had to
persuade her father to release her from the restrictions of a suitable
marriage. She did this by plucking out one of her eyes so that she
would no longer be desirable to her suitor. The stones alongside
the stream tell the story of her struggle. The first is the knee stone
with the imprints of her knees where she is supposed to have
prayed for guidance when told by her father that she must marry.
The next stone on the path with a small recess in it is where she
placed the eye she had plucked out. When her future husband
arrived and saw his prospective wife with only one eye, he lashed
out with his whip and the mark is on the eye stone, and the imprint
of his horse's hoof as he rode off is on the next stone.

You can follow the water upstream passing statues and stations
of the cross. In spite of an over-abundance of concrete and plaster,

this remains a sacred place, still and contemplative with a strong nature energy. It is much used and is accessible for large groups visiting together.

Another, less censored version of Brigid's beginnings, tells that Brigid's mother Brocessa was Dufach's slave and she was sent away to Connacht when she was pregnant. Brigid was later reclaimed

by Dufach and came back to work for him. She worked with the cattle and dairying and her generosity created a sense of abundance wherever she went: she churned butter and it multiplied; she gave away food and it reappeared. This magical association with fertility and abundance is in the tradition of the goddess Brigid and her mixed parentage echoes the origins of many Irish heroes from Lugh himself.

St Brigid's water shrine, Faughart

Faughart Hill

Continue past the shrine for almost a mile, keeping right on to the old church site on top of the hill.

This is Faughart Hill, an Iron Age hill-fort and the place where St Brigid was born in 454.

Inside the churchyard is a holy well low on the north east side. Covered by a small beehive hut, there are steep steps going down to the water. It is traditionally visited on the 1st February, St Brigid's Day.

In the graveyard there is also a small cairn with 2 portal stones and the foundations of a circular building with the base of a cross inside. These are all that's left of an earlier Christian foundation.

Faughart fort sits high over the southern end of the Gap of the North, one of the few access routes between Leinster and Ulster, a strategically vital position. Its renown as the birthplace of one of Ireland's most important saints, certainly the saint most associated with generosity and goodness, has always been tempered by its military importance overlooking a border pass.

St Brigid's well, Faughart Hill

There is a grave slab commemorating Edward Bruce who was killed in battle at Faughart on the 14th October 1318. He was sent to Ireland by his brother, Robert the Bruce, to divert the English from Robert's activities on the Scottish border. The stone nearby is traditionally thought to have been used for his decapitation. He is not buried here as apparently his body was quartered, as was the custom of the time, and dispersed throughout the land.

This is also the site of Maebh's treacherous ambush of Cúchulainn. She sent fourteen warriors, who all hurled javelins at him simultaneously. By a mixture of magic and skill, he was untouched and turned on them, killing all fourteen.

3 Lissachiggel Cashel

Take the N1 north from Dundalk across the first roundabout.
After 1.6 miles turn right into Ravensdale. At the T junction in the
village turn right again and 1 mile later turn left up a farm track.
Keep right at the fork and stop at the farm at the top of the lane.
The first part of this walk follows a path through the gate. When
the path disappears, keep the wall on your right and move uphill
beside the stream. At this point you should see the circle ahead
on the hillside.

'Lissachiggel' means 'fort of the rye', hard to imagine now as it sits on a heather-covered hillside in an area that has been covered by blanket bog for over a thousand years. It is huge, slightly oval in shape, measuring about 190 by 155 feet. The stone wall is about 10 feet thick and perhaps 3 feet high in places. Its outer surfaces are dry-stone with coarse clay at the centre. There is one entrance on the south side with evidence of a cobbled floor. There were at least twelve huts inside the enclosure at one time.

It has not been possible to accurately date the site, though it would have been used over a long period of time. It would have

been a prosperous Iron Age farmstead in rich farmland at one time. In more recent years it would have been a booley camp where people stayed for the summer while their animals grazed on the hillside. This annual trip to the high ground in summertime always sounds to me like a lovely adventure, an escape from the drudgery of everyday life. I'm sure the reality was rain and hard work.

Sitting now inside this enclosure on the hillside with a clear sky before me, it seems a perfect place to be still and let my consciousness expand with not so much as a thorn bush to snag it on.

4 Templetown Church and Holy Well

Go east from the N1 north of Dundalk around the Cooley peninsula on the R173 to the five roads cross at Bush. Take the R175 and after 0.9 miles turn right to Templetown beach. Turn right again after 1.1 miles and the well is on the right a mile later.

This well is called locally 'Lady Well', and is dedicated to Mary like the church nearby. The surrounding area has been enclosed and made into a small garden, in spite of the boggy nature of the ground. A statue of Mary sits on a small mound to the west. The gates at either end of the long path have wrought iron arches painted blue and white which help create a sense of entering a special peaceful place. The stones around the well are also painted white.

The 15th of August being Lady Day means this is an especially potent day, when the well water rises and is at its most beneficial for cures.

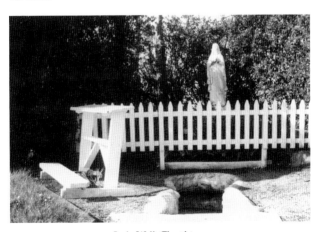

Lady Well, Templetown

Like many other wells, the water here cannot be heated or boiled. A story is told locally about a newly-hired girl from another district who took some water from the well without knowing this. She filled the kettle and put it on to boil. The water remained cold even after she built up the fire and then the people of the house realized where she had taken the water from.

East of the well is a ruined church called 'Kilwirra' or 'Cill Mhuire', meaning 'Mary's church'. The Knights Templars had a preceptory here in the 13th century and the present remains are probably part of this.

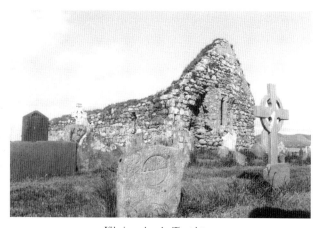

Kilwirra church, Templetown

These Knights were introduced into Ireland by deed of Henry II, probably in the middle of the 12th century, and wore the distinctive white mantle with a red cross. Clontarf was their chief house in Ireland. Most of the preceptories were fortified. Here at the northern extremity of the Pale, their mission would have been to protect the Anglo-Norman lands within the Pale from incursions by a hostile local population.

Political problems led to their possessions being granted to the Knights Hospitallers after 1312, and they were closed down soon afterwards.

The church walls are thick with rubble infill. Two off centre windows in the east and several different windows in the south wall give the impression of a building that has gone through many changes. The arched top of one small window is carved from a single piece of stone. This once busy populated place is now deserted like nearby Whitetown, where only a couple of houses remain from a once substantial town.

5 Carlingford Town

Carlingford is on the north side of the Cooley peninsula and the south side of Carlingford lough.

It is a medieval town of narrow streets, castles and fortifications set between mountain and sea. It grew up in the shadow of King John's Castle, which was built around 1200 by the Norman Hugh de Lacy. It sits on a rocky promontory overlooking the lough, guarding the harbour and controlling all sea traffic north.

Being the most northerly point of the Anglo-Norman Pale, Carlingford was something of a border town and always strongly fortified. It had at one time 32 castellated buildings. The Mint and Taaffe's Castle are 16th century tower houses.

The town was walled in the 16th century and the Tholsel is one of its original fortified entrances. The small upstairs room or Tholsel would have been used for meetings relating to town administration. In the 18th century a recess in the lower wall was also used as the gaol.

Within the 16th century walls of the town, land would have been granted for building and rents or burgage exacted. Space was at a premium with houses filling every available inch, so streets are narrow and there are some odd angles between the walls. Carlingford remained prosperous throughout the 15th and 16th centuries, but went into decline as Newry began to develop. First the ship canal and then the railways defeated this medieval stronghold, and Carlingford became, quite literally, a backwater. Today this means that its medieval character is still very apparent and it has the poignant charm of disused fortifications.

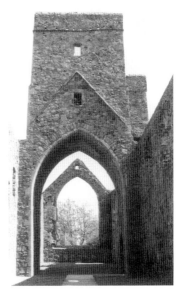

Dominican Priory, Carlingford

The Dominican Priory

The Dominicans came to Carlingford in 1305 to establish a priory

here to work among the poor. Today only the church and part of the east buildings remain, but their size implies a substantial community. This in turn suggests a busy and crowded town nearby. The church is massive and very long. A striking feature is the bell-tower inside the building, dividing the nave and chancel. It has a huge east window - probably the biggest of its time.

After repeated attacks, the buildings were fortified in 1423 and battlements were added to the church walls. The Dissolution of the monasteries came just over a 100 years later in 1539, and the buildings gradually fell into disrepair.

It was used as accommodation for fishermen for a while, and at one point a local clergyman tried to take the bell from the bell-tower for use in the church. They had to remove a lot of the stonework to get to the bell. By the time they had it out, they no longer needed the bell and it was sent to Liverpool where it still remains. Today the ruins sit empty and massive.

THE TÁIN TRAIL

This is a signed walking route you can pick up at any point where you see a sign. It is impossible to miss them in Ravensdale, Omeath or Carlingford. The circuit covers about 25 miles of varying terrain and crosses from Ravensdale over the Black Mountain down to the coast at Omeath and Carlingford and back across the southern slopes of Slieve Foye and down a wooded valley to the road, about a mile south of Ravensdale again. Occasionally it runs along small roads, but mostly it is an off road track.

The air is clear, the birdsong sweet, the mountains timeless and the views fabulous.

It is here more than anywhere that you can sense the power of the landscape and follow if you wish some of the exploits from the epic adventure of the Táin Bó Cúailnge. If you start climbing inland a mile south of Omeath, the trail snakes uphill to a car-park and table map which helps you get oriented.

Táin Bó Cúailnge (The Cattle Raid of Cooley)

The story of the Táin begins with Queen Maebh and her consort Ailill at Crúachain in Connacht in idle conversation as they lie in bed. They were comparing the wealth each of them brought to their union and discovering themselves well matched. They were

equal in everything except that Ailill had a powerful white bull which came originally from one of Maebh's cows but it had transfered to Ailill's herd as it would not be led by a woman. This bull had no equal anywhere in Ireland, except in Ulster, in the Brown Bull of Cooley.

Maebh immediately decided she must have the Ulster bull and sent her messenger to ask for the loan of it for a year. Her request was granted until the owner of the bull overheard the messengers boasting of how they would have taken it anyway. Dáire, the bull's owner, retracted his offer and Maebh did not get her bull.

When she heard that she could not have the bull, she assembled a huge army to march on Ulster and take it by force. She had warriors from all four provinces, including 3000 exiled Ulster men. As they approached Cooley, the Ulster hero, Cúchulainn, sent them warnings not to come any nearer, but each time Maebh pressed on. She had Ferdia, Cúchulainn's foster-brother, in her camp, but Ferdia could not persuade her away from her mission.

Most of the fighting took place at a ford where Cúchulainn chose to take a stand against Maebh and her army. The warriors of Ulster were, at this time, still under a curse and unable to fight (see ARMAGH) so Cúchulainn had to defend the province single-handed. The story tells of warriors sent each day and each night to take on Cúchulainn. Each time they were killed. Eventually Maebh, who had by now a great lust for victory, seduced Ferdia into going to the ford. After three days of fighting, Cúchulainn killed his foster-brother. Cúchulainn himself was badly hurt but, more seriously, he was sick at heart because he had killed his foster-brother whom he loved.

At this point the curse was lifted from the Ulster warriors and a terrible battle ensued, though Cúchulainn was too wounded to join in. Eventually the two great bulls faced each other across the battlefield. In their struggle they moved across the landscape until Ailill's bull was broken on the horns of the brown bull. This happened near Crúachain, and the Ulster bull lurched wounded from there back to Cooley, leaving torn pieces of the white bull along the way. He left his mark on the landscape, tearing up the ground in places, forming earthworks which can still be seen today on the southern border of Ulster. He died before he reached Cooley.

After this terrible battle which ended in triumph for the warriors of Ulster, Maebh and Ailill were reconciled with Cúchulainn and the men of Ulster and the country lived at peace for the next seven years.

This is a story of intrigue, passion and battle-lust. Maebh is a queen, but she is also the red goddess of war, the Morrígan who

incites battle-lust. The red of blood and anger are all around her, even tainting the loyal young warrior, Ferdia. Cúchulainn is the son of the sun god Lugh. The battle is between these two forces and Cúchulainn, the son of the sun god, wins. When the battle is over, they are reconciled and peace is restored as is the way with the gods. Ferdia and the others represent the mortals whose fate is bound up in such dramas.

6 Clermont Cairn

On top of the Black mountain. A road runs to the top.
Turn uphill from the crossroads in the middle of Omeath,
turn right after 0.6 miles and then left at the T junction.
This tiny road goes right over the Black mountain.
You can drive right up to the transmitter on the top.

In spite of the mast, this is a wonderful place. It feels like climbing on the back of a benign dragon. Carlingford Lough and Dundalk Bay both lie below. To the north west is Slieve Gullion in Armagh, and to the north east Slieve Donard in the Mourne mountains in Down. Like Black mountain, they both have a passage cairn on their summit, visible on a clear day.

7 Proleek Dolmen

The Ballymascanlon Hotel is signed from a roundabout on the
Newry Road just north of Dundalk. The dolmen is signed from the
hotel car-park through the property and across the golf course.

This is a lovely dolmen. A huge cap-stone sits poised on the points of three tall stones, two 7 foot matching portals and a slightly shorter backstone. There are no side stones forming a chamber or any evidence of a cairn around it.

There are always a number of small stones balanced on the convex surface of the cap-stone, which is about 13 feet off the ground, as it is believed that if you throw a small pebble up and it stays there, then you will be married within the year.

With its 30 ton cap-stone, it can look a little like a stooped figure weighed down by its load, hence its name - the Giant's Load. It is said locally that it was carried here by the giant, Para Buí Mór Mhac Seóidín. Apparently he is buried nearby.

There is a wedge cairn a little to the south east on the same path. It has a long tapering gallery with a large slab door facing west. It is called 'the grave of Para Buí Mór Mhac Seóidín', who came here to challenge Fionn mac Cumhaill.

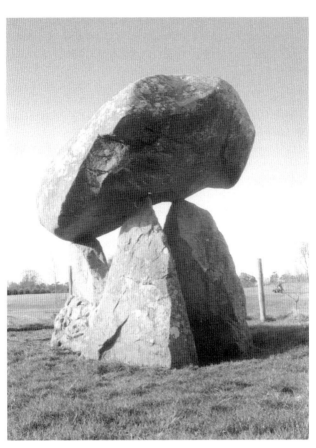

Proleek dolmen

8 Donaghmore Souterrain

About 2.5 miles west of Dundalk. Take the R178 west of Dundalk and turn right at the first crossroads about 1.5 miles outside the town. Take the next turn left and stop at the two cottages on the left after the third bend. The occupant of the first cottage has the keys to the souterrain which is in his back garden and will open the doors for you.

Louth is peppered with souterrains as is much of the east coast, but this one is particularly well preserved and also quite complex. It was found in 1960 when the house beside it was being built. The workmen found a flagstone and under it the entrance to a long and complex souterrain.

It consists of a passage zig-zagging at right angles to the right and then to the left. They are joined by a short upper passage to a

T-shaped passage and end chamber. The average height inside is about 4 feet and average width about 3 feet. The walls are built of dry-stone walling corbelled slightly towards the roof which is made of stone slabs. It is just over 200 feet to the end chamber which is much wider than the rest, measuring about 5.5 feet.

The short upper passage is hard to find. If you didn't know it was there, you would think it was the end of the souterrain, which makes it a very good place to hide. Once into the end chamber, no light or sound leaks either in or out.

9 Knockbridge Stone

The stone sits on high ground in a field exactly one mile east of Knockbridge on the R171 going towards Dundalk.

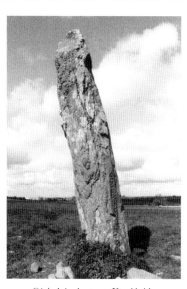

It is here that the mythical hero Cúchulainn finally died, overcome by magic and treachery. Mortally wounded, he bound himself to this pillar stone so that he would die on his feet. It was only when the Morríghan, the three goddesses of battle, took the form of hooded crows and alighted on his shoulders, that his attackers were sure that he was dead and dared to approach his body. A powerful stone.

Cúchulainn's stone, Knockbridge

10 St Mary's Abbey, Louth

On the R171 between Dundalk and Ardee.

This now small village would have been the capital of the kingdom of Oriel until 1233. It is now dominated by the ruins of St Mary's Abbey which is a reminder that Louth was once an important political and religious centre.

Most of the present buildings date to the rebuilding after the abbey was destroyed by fire in 1312. There is an impressive Gothic window in the north wall.

The inside of the abbey has been used as a burial ground for hundreds of years and has now the crowded and dilapidated character of an old city cemetery which seems strangely incongruous in such a rural setting. Across the field is St Mochta's House.

St Mochta's House

The story goes that this small building was built in a night to provide a suitable resting place for St Mochta who founded a monastic settlement here in the 5th or 6th century.

It is also said that St Patrick came here to the townland, now called Ardpatrick or Patrick's hill. Here he founded a monastery and in it looked after twelve lepers. One night he got a message in a dream that he was to go to Armagh and so he placed the lepers and the monastery in the care of his favourite disciple, St Mochta.

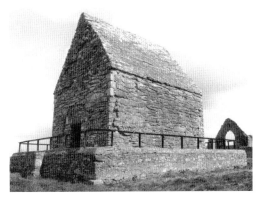

St Mochta's house, Louth

The monastery suffered very badly at the hands of the Vikings in the 9th century and was attacked repeatedly in the 10th and early 12th centuries.

St Mochta's house probably dates from the end of the 12th century and so, of course, he would never have seen it. It is a small rectangular stone house with a narrow arched window in the east, a vaulted ceiling and room upstairs between the ceiling and the tall stone roof. This room is lighted by a small window also in the east and accessed by a tiny narrow circular stairway in one corner of the building.

This type of oratory, with its vaulted ceiling and steep stone roof above it, can also be found in Kells. It is also the basic structure of Cormac's famous chapel on the Rock of Cashel and it is exceptionally strong. At Cashel, the later Gothic cathedral is in

ruins but Cormac's chapel stands intact.

The fairy mound which overlooks the current graveyard was probably at one time a Norman motte and may well have been a hill fort before that.

11 Kildemock Jumping Church
Signed off the R170 just east of Ardee on the way to Dunleer.

St Patrick is supposed to have come here, converted the local population and left them in the care of Diomoc. The site was named Kildemock or church of Diomoc. The wooden church would have eventually been replaced by a stone building.

Some six hundred years later, the site was put under the protection of the new monastery of the Knights Templars at Kilsaran. When the order was suppressed in 1312, its property was turned over to the Order of the Knights Hospitallers of St John.

Excavations in 1953 revealed fragments of stained glass and stone carvings dating to the early 14th century which suggest that the Hospitallers rebuilt the church and what is standing today is from this period. The site fell into disrepair after the Dissolution of monasteries by Henry VIII.

Kildemock Jumping Church

The gable wall at the west end of the church is said to have jumped on the night of Candlemas at the beginning of February 1715. It now sits between 2 and 3 feet inside the wall base still upright (almost). The wall is estimated to be about 40 tons and it is certainly a bizarre sight.

Local lore has it that a man from the parish was working on the building of another church near Ardee. On Sunday, being

anxious to get the job finished, he continued to work without stopping even to pray. As a result, some of the wall he was working on fell on him and he was killed. Being from Kildemock parish, he was buried here and, the church being in ruins for some time, he was buried within the building just by the west gable wall. In the night there was a violent storm and the wall jumped inward so that the dead man would not lie within the church building.

Also inside the building are a bullaun stone and near the south east corner is a beautifully carved fluted piscina with a small plug hole. There are some interesting grave slabs dating from the 17th century.

From the graveyard you can see a low mound 400 yards to the north east. This is called Garrett's Fort where Gearoid Iarla, or the Earl Gerald, and his soldiers lie asleep on horseback with their heads resting on their horses' manes, their hands on their swords. At the entrance to the cave stands a sword. If a man with six fingers should manage to find the cave entrance and have the courage to take the sword, the spell will be broken and Earl Gerald and his knights will awake and ride out to protect Ireland. (see **Lough Gur**, LIMERICK)

12 Monasterboice

The round tower of Monasterboice is a clear landmark to the west of the N1 to Dublin south of Dunleer. It is also well signed, which is good, because the tower appears to move around the hills as you approach.

This is a very beautiful place. The site is encircled by a stone wall. Inside is a profusion of stonework shaded by trees with hardly a space unoccupied and yet it feels calm. It is called Mainister Bhuithe or Monastery of Buithe, after its founder who died around 520. St Buithe is said to have studied in Wales and been a missionary among the Picts before returning to Ireland and founding this monastery on land given to him by the local king. It is likely that this was already a sacred place. Evidence of a Bronze Age burial was found here during excavations. It remained important until the building of the abbey at Mellifont in the 12th century.

The Vikings came here and appear to have occupied the site until they were attacked by Domhnall, King of Tara, in 968.

One of its most learned monks, Flann, died in 1056. He was a Latin master and reputed author of verses on the Tuatha Dé Danann, the Kings of Tara and other historical subjects. Not long after this in 1097, the tower was destroyed by fire and with it the

books and other treasures.

The high crosses here are especially fine. The first cross on your right was once called St Patrick's, but is now known as the 'Cross of Muiredach' because his name is inscribed on the base. Muiredach mac Domhaill was abbot of Monasterboice and his death is recorded in 923. The inscription has been read as: OR DO MUIREDACH LASNDERNAD IN CHROS or 'Pray for Muiredach by Whom the Cross was Made'. This probably makes the cross 10th century.

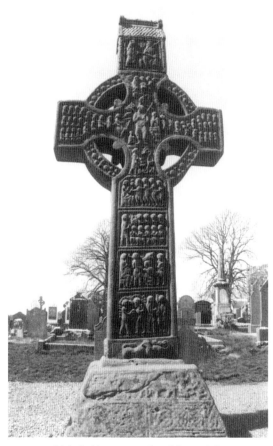

Muiredach's cross, east face, Monasterboice

It stands 17 feet 8 inches high with a separate cap-stone on top carved like a small church or oratory with finials at either end of the roof. The base is carved on each side with patterns and mythical figures. The Old Testament story begins at the bottom of the east side with *Adam and Eve*, and ends with a New Testament subject - *The Adoration of the Magi*, just below the centre of the cross.

Here, extending through both arms, is *Christ at the Last Judgement* with crossed flowering sceptre and cross. The damned are on one side of Christ and the saved on the other. Beneath him, Michael weighs the souls of the dead and Satan tries to thwart him.

On the west side above the base is the arrest of Jesus and above this are scenes leading thematically to the central panel on this side - *The Crucifixion*. Christ is depicted naked and bound and with an angel on each shoulder and below him the soldiers, one with a lance and one with a sponge.

The narrower north and south sides have some scenes from the Crucifixion as well as decorative panels of animal interlace, bosses, scrolls and vines. On the north side is a depiction of *The Hand of God*.

The detail of the figures, their costume and personal ornament, as well as their expressions and gestures, is the work of a genius and this cross certainly marks the high point of this style.

The west cross stands before the round tower. It is much taller (21 feet), allowing for more figure panels, and has a smaller circle. This probably places it a little later than Muiredach's, though it's now much more worn.

The east side, beginning from the bottom, covers more Old Testament stories with *David and a Lion, The Sacrifice of Isaac, The Worship of the Golden Calf, David with the Head of Goliath* and *David being Anointed by Samuel, Goliath defying the armies of Israel*, a scene with a chariot and, just below the centre of the cross, *The Three Men in the Fiery Furnace*.

The image of David killing the lion is interesting as David is depicted as killing the lion with a hurley ball and stick - an interesting contempory touch. A similar image appears on one of the crosses at Kells in Co. Meath. These images are the earliest pictorial evidence for the game of hurley in Ireland.

The north cross head sits inside railings on a modern shaft and has a simple crucifixion scene on the west face and an unusual and intricate pattern of sixteen spirals on the east face. The original shaft lies broken nearby within the railings.

The sundial is here, an unusually ornate granite slab. There is also an early cross-inscribed slab.

The churches seem very plain in contrast to the crosses, but the south building is the older, with parts of it dating to the 9th century when the very first stone churches were built. The north church is the remains of the medieval parish church. The graveyard is still in use.

The round tower is about 110 feet high even without its top, and in spite of the fact that the ground level in the graveyard has been probably raised by burials. It was probably the tallest in the country. It is currently locked and the key is no longer available as it is not considered safe inside at present.

13 Mellifont

Signed east of the N2 between Slane and Ardee.

This site was given to Malachy, Bishop of Armagh, by the King of Oriel, Donnchad Na Cerbhal, so that he could build the first Cistercian monastery in Ireland. Malachy had come into contact with the Cistercian Order when he visited Bernard of Clairvaux in France in 1139. He wanted to join the order himself, but was not allowed to by the Pope who wanted to make him Papal Legate. Instead, he left some of his monks behind to be trained in France, and when he returned to Ireland, he sent more as postulates so that they could form the nucleus of a new monastery here.

Malachy was a politician and a visionary as well as a bishop, and he must have read the mood of the time quite accurately. The religious foundations of Ireland had become increasingly lax, with abbots fathering their own heirs as the monasteries accumulated wealth and used their power to engage in political intrigue. For many young monks, the purity and simplicity of the strict Cistercian Order must have seemed like a breath of fresh air - a return to the spirit of the early Irish saints.

Mellifont was consecrated in 1157 and by 1170, thirteen years later, there were about five hundred Cistercian monks in Ireland. Seven daughter abbeys had been founded and four of Ireland's five provincial kings had become patrons of the order.

Once an abbey had sixty monks, it was advised to make a new foundation. The site, as at Mellifont, had to be 'far from the haunts of men' and the order soon had a reputation for taming wild places and creating sweetness out of hardship, hence the name Mellifont or 'fountain of honey'.

Mellifont was consecrated in 1157 and well endowed. In 1193 St Malachy's relics were brought here from Clairvaux. Shortly after its consecration in 1157, there was a split between the French and Irish monks. The French monks adhered strictly to the Cistercian rule, whereas the Irish were more lax. Eventually the French left and over time the link with the continent decreased, until the abbots had lost almost all contact with the General Chapter in Citeaux. The new Anglo-Norman barons were funding the new monasteries and replacing the French influence with an

English one. When the Order tried to reassert control, they were met with armed resistance at some abbeys. Gradually reforms were imposed, but many of the communities moved away from their initial simplicity to the management of wealthy estates and even, in some cases, to the production of heirs again.

The 15th century carvings at the Cistercian Abbey at Jerpoint, Co Kilkenny, eloquently express the character of much of the order before the Dissolution of 1539. In some ways they had come full circle and become what they had originally come to replace.

After its suppression in 1539, Mellifont became the home of the Moore family. The abbey buildings became a fortified house.

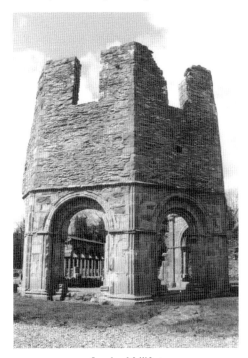

Lavabo, Mellifont

The buildings at Mellifont were laid out in the Cistercian fashion: large cruciform church in the north, chapter-house and domestic buildings in the south and cloister in between. The dormitory was upstairs. (The Cistercians were the first people in Ireland to sleep upstairs.)

The proportions of the church can only be imagined, from the bases of the massive columns, but fragments of tiles in the chapter-house give an idea of the colour. It would have been a truly magnificent place. The site is approached from the north and behind the low ruins of the church, and in total contrast to it,

stands the partially reconstructed Romanesque cloister arcade with its delicate columns and pleasing arches and the octagonal lavabo or washing house with its elegant shape and fine carvings. To the east stands the 14th century vaulted chapter house.

An excellent plan of the site, with alterations and additions clearly marked and dated, sits at the entrance overlooking the site. There is a small visitor centre beside the car-park.

14 Termonfeckin
About 6 miles north east of Drogheda on the R166.

Now a small village, Termonfeckin takes its name from the 7th century St Féichín who is credited with founding a monastery here in 665. He is more famously associated with Cong in Mayo and Fore in Westmeath. Fore Abbey is dated 630. The name 'Termon' means 'a sanctuary'.

The legend here is that he originally chose nearby Castlecoo Hill, but while he was there surveying the site, a raven snatched the chief builder's cap and dropped it where the current Church of Ireland church is situated. This, of course, was the site chosen, and some remains can be seen in the graveyard, near the church door. Most interesting is the high cross with a crucifixion and an angel above it on the east face, and *The Last Judgement*, or *Christ in Majesty*, on the west face. The rest of the panels are covered with delicate interlacing and geometric designs. It dates to the 9th or 10th century and indicates a substantial monastery, though little remains now.

At the foot of the cross is a medieval carved slab with another crucifixion scene and beside it is the base of a small early cross.

Built into the church porch is an early grave slab inscribed: OROIT DO ULTAN ET DO DUBTHACH DO RIGNI IN CAISSEL. 'Pray for Ultán and Dubhtach who made the cashel.'

With the 12th century reorganization of the Church into dioceses, Louth became part of the diocese of Armagh with its centre in Armagh city. As the northern part of the country was beyond English authority, the primates of the time got approval from the English Crown to live within the Pale in Termonfeckin, which they did from 1346 until 1613. St Peter's Church in Drogheda became their pro-cathedral. The primatial residence was attacked and burned by rebels in 1641.

15 Dromiskin

Just 7 miles south of Dundalk to the west of the N1.

St Patrick is said to have founded the first church. It was succeeded in the 7th century by a monastery whose most famous abbot was St Rónán.

The abbey site is in the old graveyard at the east end of the village. The east gable of a small 13th century church marks the site. Nearby are the remains of a round tower somewhat shortened but recapped. It has a round-headed doorway and windows which were added some time in the late 11th to early 12th century.

The top of a high cross is mounted on a modern shaft. On one side four dragons spiral out from a central boss. Their mouths are open, devouring some worm-like creatures. Below is an angel. On the left arm are a huntsman, a hound and a deer and on the right arm there's a headless body being carried on horseback, while a man walks in front holding the head. Exactly the same scene is depicted on the base of the north cross at Ahenny, Tipperary, where it has been suggested that it is the body of Cormac mac Cuilennáin, killed in 908.

On the other side, there is a less deeply carved spiral pattern and fine interlaced lines run to the ends of the cross arms.

There are also dragons on the cross at Killamery in Kilkenny.

At the west end of the village, within the grounds of the Catholic Church, to the left of the school gates, is a bullaun well beside a carved altar stone. It has a history of curing warts.

16 St Colman's Well

Just pass the slipway on the coast road east of Annagassan.
Some remains of concrete benches or steps help you find it.

Sitting between the road and the stony beach is a little fresh water well with a small plaque dedicating it to St Colman with the words: "St Colman pray for us". The water is known as a cure for eye disorders.

From here it is just 1.2 miles round to Salterstown by road from which you can take a small lane down to the old church. This brings you back towards the well. Until this century, a pattern was held here on June 7th, followed by a walk to the churchyard to dress the graves.

LEINSTER **Louth**

LEINSTER **Wicklow**

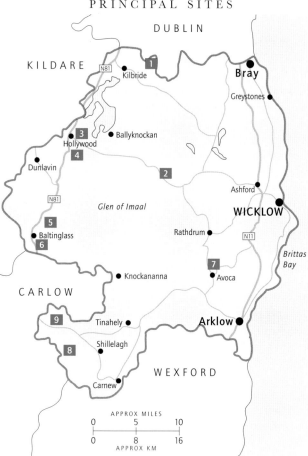

C o u n t y
WICKLOW
P R I N C I P A L S I T E S

DUBLIN

KILDARE

N81

Kilbride

1

Bray

Greystones

Ballyknockan

3
Hollywood
4

Dunlavin

2

Ashford

N81

Glen of Imaal

WICKLOW

5
Baltinglass
6

Rathdrum

N11

Brittas Bay

Knockananna

7
Avoca

CARLOW

9
Tinahely

Arklow

8
Shillelagh

WEXFORD

Carnew

APPROX MILES
0 5 10
0 8 16
APPROX KM

1	**Seefin** passage cairn	**6**	**Baltinglass Abbey**
2	**Glendalough**		**Baltinglass Hill**
	St Kevin's Road	**7**	**Mottee Stone**
3	**The Hollywood Stone**	**8**	**Moylisha**
4	**Church Mountain**		**Aghowle Church**
	Athgreany Piper's Stones	**9**	**Rathgall**
5	**Castleruddery Circle**		
	Brusselstown hill-fort		

Block figures in list refer to site locations in map and entries in text.

WICKLOW

THE COUNTY OF WICKLOW IS DOMINATED BY the granite peaks of the Wicklow mountains which rose to near the earth's surface around 400 million years ago. At the end of the last ice-age, glaciers carved out deep valleys on the east, like Glendalough, and more gentle valleys in the west.

The Wicklow Mountains National Park, just south of Dublin, was established in 1991 and covers about 49,421 acres. It is one of five national parks in Ireland managed by Dúchas, the heritage service. It includes much of the Wicklow mountains as well, and its information office is very useful. The area includes the Glendalough Oakwoods (understorey of holly, mountain ash and hazel) and extensive boglands and mountain areas.

The National Park Information Office, near the upper lake at Glendalough, is open every day in summer and at weekends only in winter. The Wicklow Way is an 80 mile walking route. Many of the hills here are capped with cairns, though few have been excavated. 19th century reports indicate that there were many more stone circles in north west Wicklow.

The first mesolithic peoples lived along the coast of Wicklow, but the hills were settled in neolithic times. There's evidence of a decline in elm and pine around 4000 BC when land was cleared for grazing. This is when the hilltop cairns were built. Most of these were concentrated in the north west, between Baltinglass and Saggart. The two largest today are Seefin and Baltinglass and both have a small number of decorated stones.

Between the granite and highly compressed layers of sedimentary rock there are high concentrations of lead, iron and zinc.

LEINSTER **Wicklow**

1 Seefin Passage Cairn

6 miles east north east of Blessington. From Kilbride go east on the R759 going left at the first crossroads, about 0.5 miles out of the village. After about a mile turn right and then right again at the T junction. Go to the beginning of the forest on the left.

There is a passage cairn on top of this mountain with a passage leading to a chamber with five recesses, making a double cruciform. There are two patterned stones at the entrance to the chamber with concentric diamond shapes on them. There are five lines

carved on one of the roof stones near the entrance. The entrance to the passage is aligned 17 degrees east of north. (see **Baltinglass** below)

The view from here is wonderful. Seefin mountain forms a triangle with Seahan in the north and Seefingan to the west. Both of these hills are also topped with cairns.

2 Glendalough

Take the N81 south, 30 miles out of Dublin and 8 miles north of Rathdrum. It is signed from every direction. A Duchas Site. Admission charged.

There is a Visitor Centre at the site with displays and an audio-visual on early Irish monasticism and the life of St Kevin. The Market Cross, an interesting late 12th century high cross, is now inside the Visitor Centre.

'Glendalough' means 'the Glen of the Two Lakes'. These lakes are in a deep and scenic valley, a place of great natural beauty and seclusion. It was also a place held sacred in Celtic times, where farmers traditionally drove their cattle through the water at Beltaine to keep them healthy for the rest of the year. It must have attracted the young St Kevin who, though of royal blood, came here to live the life of a hermit where the natural world could bring him closer to God.

The story goes that he lived in the hollow of a tree until he was found one day by a farmer who had followed one of his cows to discover why it was giving so much milk. He found the cow by St Kevin's tree, licking Kevin's feet. He took the saint home to clean him up, and from then on Kevin's hermitage attracted others, and a small monastery developed at the upper end of the valley.

There are stories that the lake beside his hermitage had a péist living in it who used to eat pilgrims. A péist is a worm-like creature, usually symbolic of earth energy, perhaps indicating a strong energy line. They were usually 'banished' by early Christian saints, but in Kevin's case it ensured him a measure of seclusion! He never really came to terms with humans.

On the south side of the upper lake are the remains of a small oratory or church called 'Teampull na Skellig'. It stands on a narrow ledge at the foot of the cliff overlooking the lake and has been partly reconstructed. Nearby, to the east, is St Kevin's Bed, a small cave 30 feet up the cliff. These are probably the only remains of St Kevin's early hermitage and, at the top of the valley, they are still the most remote part of the site.

There is another story about St Kevin and a persistent female

admirer who followed him around, eventually even to his bed 30 feet up the cliff. He became so exasperated with her devotion and constant attention, that he pushed her away. She fell into the lake and was drowned. Almost against his will, his piety drew people to him and over his lifetime his hermitage developed into a monastic settlement which continued to grow after his death, around 619. It was to continue growing for the next thousand years. Today, a thousand years of ecclesiastical history are spread out along the valley. It has long been a popular place of pilgrimage, though the annual pattern was banned eventually because it always ended in faction fighting. There are over 30 bullauns scattered down the valley.

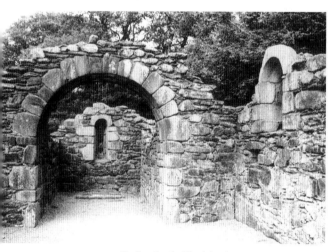

Reefert church, Glendalough

Further down the valley is Reefert church which means the 'Burial Mound of the Kings'. Glendalough became a royal burial site as Leinster rulers chose to be buried beside their famous saint. In turn, the place increased in power and prestige because kings were buried there. At one point it was considered one of the four best burial places in Ireland. It was even enhanced with sanctified earth brought from Rome. Reefert church is a small nave and chancel church with trabeate doorway. Projecting corbels at eaves' height replaces the more common antae. On the cliff above the church are the remains of a beehive hut known as St Kevin's Cell. The cell, unlike Teampull na Skellig and St Kevin's Bed, is quite accessible and a perfect place from which to appreciate the natural beauty of the valley.

Lower down the valley, towards the visitor centre, are a group of monastic buildings from a later phase, from the 10th to the 12th centuries. On the north side is an imposing arched gateway leading into what came to be known as the 'monastic city'. These buildings

include the famous **St Kevin's Kitchen** and the round tower. The 'kitchen' is a small steep-pitched stone roofed oratory with trabeate doorway and a circular tower for its belfry. The stone roof is supported by a semi-circular vault with space above providing an upper storey. (Similar to **St Colmcille's house** in Kells and **St Mochta's house** in LOUTH.)

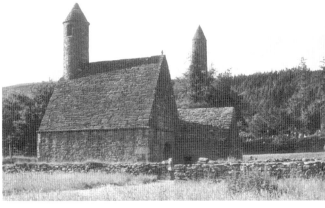

St Kevin's Kitchen and round tower, Glendalough

Nearby is the cathedral with architectural features, indicating different periods from the 10th to the 12th centuries. South west of the tower is St Mary's Church, which is thought to have been a women's church belonging perhaps to a convent outside the monastery walls. These buildings are surrounded by an ancient cemetery with cross slabs and crosses.

A path leads across the river from the cemetery to the Deer Stone. This is one of a number of bullauns in the valley said to have been used by St Kevin to collect deer's milk when the monastery had no cow. Although his problems with people have become part of the folklore, so too has his gentleness and intimate relationship with animals.

Signed east of here is St Kevin's well and east again, a short walk away, is St Saviour's Priory. This was built by St Lórcan O Toole in 1162 for the Augustinians. Unlike other orders such as the Cistercians, the Augustinians liked to live and work in areas where there were already plenty of people.

St Kevin's Road

As the monastery at Glendalough grew, St Kevin needed a new place of retreat. He found it twelve miles away, north west through

the Wicklow Gap, by a village now called Hollywood. Apparently he was passing nearby, when he and his companions found the way blocked by trees. His companions stopped, but he told them to keep walking and when they did so, the trees parted to let them through. Kevin blessed them and put a curse on anyone who would cut them down. This gave the name Holy Wood or, as it is today, Hollywood. Perhaps this reflects a tradition of a sacred grove here?

St Kevin's road runs south of the R756 through the Wicklow Gap. It probably goes north after Ballinagee Bridge by the narrow road along Togher Ridge. ('togher' means 'trackway') There's a cross-inscribed stone on the left about 0.5 miles along this road. The road ends near Hollywood village, on the side of Dragoon Hill at St Kevin's cave. The site is now marked by a modern statue of St Kevin above the cave. There is a prehistoric cairn on top of the hill.

St Kevin's road became a pilgrimage route until medieval times. There are a number of inscribed stones near that path. They may have been earlier standing stones re-consecrated by the early Christians. One at least, the Hollywood Stone, comes from a much earlier time.

LEINSTER **Wicklow**

3 The Hollywood Stone
It was found in Lockstone Upper by the side of the old road 3.5 miles south east of Hollywood.

It is a granite boulder with a magnificent labyrinth carved on one side, possibly dating, according to Estyn Evans, in *Prehistoric & Early Christian Ireland*, to the early Iron Age. It was exhibited in the New York World's Fair in 1964-5 and is now in the National Museum, Dublin.

4 Church Mountain
Just south of Dragoon Hill. From the N81 south of Hollywood, take the first left. There are paths up the hill after about a mile.

Like Dragoon Hill, it is topped by a cairn. It is a wonderful wide-backed hill which makes you feel as if you're on top of the world. A rectangular structure has been built in the cairn and to the north west is a deep rocky cavity with water, the old spring well mentioned by 19th century visitors.

Folklore tells us that these stones were collected to build a church and pave a way from Old Kilcullen in Kildare to Glendalough

over the top of Church Mountain. Old Kilcullen is a very gentle place and so is Glendalough; a line drawn from the valley of Glendalough runs straight to Old Kilcullen. It is possible that this story is a way of marking an energy line between the two places. St Kevin's road weaves its way across such a line.

George Petrie mentions Church Mountain in 1808, when he attends a pilgrimage on what he calls St Lammas Day, on the Sunday before the 1st August. This is obviously a Lammas or Lughnasa assembly.

There is a road between Church Mountain and Dragoon Hill. Between these hills at Dunboyke is a small ruined church dedicated to St Kevin, and to the south west is Athgreany, Wicklow's loveliest stone circle.

Athgreany Piper's Stones

On the N81 south of Hollywood and north of Baltinglass. It is signed. From the road it's a walk of about 200 yds. When the pathway seems to disappear, keep to the right.

The name Athgreany comes from 'Achadh Greine' meaning the 'Field of the Sun'. It is on the north east side of Church Mountain and certainly part of the sacred landscape between Old Kilcullen and Glendalough.

It is 7.5 feet across with fourteen boulders and possibly two missing. Some have fallen, but those standing seem to be of two distinct shapes. They seem to alternate between rectangular flat-topped stones and diamond-shaped ones with slightly pointed tops.

There's a possible outlier down the slope to the north east which may have been upright. It would form an alignment with the circle and midsummer sunrise at a valley point in the hills opposite. A large fairy thorn tree has tumbled within the circle.

Athgreany Piper's Stones

Local legend has it that the circle stones were dancers and the outlier a piper who were turned to stone for dancing on Sunday. Local people also say that fairies play the bagpipes there at midnight (*Stone Circles of Britain and Ireland*). This is not hard to imagine in such a magical place.

5 Castleruddery Stone Circle

4.5 miles north east of Baltinglass on the N81.
Signed on the right and signed again a mile up this road.

This circle sits at the mouth of the Glen of Imail which runs east into the heart of the Wicklow mountains. The Little Slaney river flows down the Glen from its source near the peak of Lugnaquilla. To the south you can see Spinans Hill and the Brusselstown Ring. This is a lovely gentle grassy place with speckled stones surrounded by whitethorn trees.

The circle is made up of about 29 contiguous stones, surrounded by a flat-topped earthen bank which opens to the east. The stone circle inside it is about 100 feet across with two huge recumbent quartz blocks about 4 feet high either side of the entrance. Some of the other stones in the circle are also recumbent. A number of fallen stones mark what would have once been a lined approach. There are strong similarities with Grange Circle, Lough Gur in Limerick.

Aerial photographs have shown an outer ditch some 24 feet beyond the stone circle which possibly provided the soil for the present bank, just outside the stones. There was another bank beyond that with a timber revetment. Soil from this came from yet another ditch beyond it. This outer ditch was 200 feet across, that is, twice the diameter of the inner stone circle.

This is quite strange. We think of stone circles as purely ceremonial. We also think of banks with outer ditches as purely defensive. Yet here we have the two together and their dimensions - inner circle half the diameter of the outer ditch - make them seem to have been constructed as one monument.

To the left of the entrance going into the circle, is a large recumbent stone, pointed at one end with seven small depressions across the pointed end. Maybe this is natural erosion, but it's unusually symmetrical.

The entrance, with its recumbent white quartz portals, remains the site's strongest feature and its greatest enigma. Either side of the entrance they present vertical jambs to walk between, while tapering away to a point at their outer ends. Quartz has always had significance at sacred sites. It reflects light without

LEINSTER **Wicklow**

absorbing it, very different from granite which absorbs and is changed by the sun's rays. It would certainly have been a powerful experience to walk between such portals. And standing between them, looking east to the peak of Lugnaquilla at midsummer sunrise, would be an interesting experience, although the low wide portals and lack of obvious back stone, means that there are no precise markers.

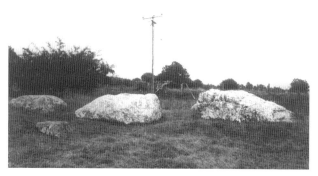

Quartz portals, Castleruddery Circle

Brusselstown Hill-fort

South of Castleruddery stone circle and about 4 miles north of Baltinglass. Go east from the circle, take the first right and then right at the first T junction and left at the second. Follow the road round the western side of the hill and take a left at the crossroads. There's a path up between Spinans Hill and the Brusselstown Ring.

This massive hill-fort complex has an outer rampart which surrounds both hilltops and runs nearly a mile in length from north east to south west. On Spinans Hill there is one big cairn and five smaller ones and inside the Brusselstown Ring there are traces of hut sites. This is the biggest hill-fort complex in the country and the site of a large Bronze Age settlement. These features are now mostly just traces of earthworks, stronger in some places than in others, but the hill itself is worth climbing on a clear day.

The main cairn on Spinans Hill is much earlier, probably neolithic, and part of a complex of cairns on the mountains to the south and east.

Just south of Brusselstown Ring is **Kilranelagh Hill** which is now mostly planted with conifers. However, there are paths through the trees and a number of cairns on the top. On the lower slopes, to the north east, is **Boleycarrigeen Stone Circle,** an embanked circle like the one further north at Castleruddery. It is known locally as the Griddle Stones. On the north west slope is the ruined Kilranelagh church. In the graveyard there are two

standing stones. It is customary to carry coffins between these stones to help the deceased on his or her journey to heaven. There is a similar custom on the Hill of Slane in Meath. The stones are called **The Gates of Heaven**.

6 Baltinglass Abbey

The abbey sits at the north end of the town, just to the east of the river Slaney and Baltinglass hill.

The church is all that remains of this Cistercian abbey which was founded in 1148 by Diarmuid mac Murrough, in what was called the 'Valley of Salvation' or 'Vallis Salutis'. It was a daughter foundation of Mellifont in Louth and founded a number of its own daughter abbeys, the best known being Jerpoint in Kilkenny.

The nave arcade with its pointed arches is probably the most impressive part of the ruins, though the east end has some Romanesque carved capitals.

The narrow tower is medieval and in more recent times, together with the chancel and the east end of the nave, it formed part of a small Church of Ireland church.

Baltinglass Hill

1288 feet up in the Wicklow Mountains. South of Brusselstown on the N81 north of Tullow. This is the south west tip of the Wicklow mountains. This remarkable hill is best climbed from behind the modern graveyard in the town. In 1950 a wooden cross was erected to commemorate the Dogma of the Assumption. Make for the cross when you climb, and then continue diagonally to the right.

At the top of the hill, inside the ruined defences of an Iron Age hill-fort, are the remains of a massive passage cairn about 90 feet across. It is still retained by a double ring of stones. In the north west, overlain by the stones of the inner ring, is the earliest structure, a ruined cruciform chamber of small stones and a long narrow passage. In the south side of the cairn there's a chamber with five recesses defined by low sills. Two of the uprights here have spiral patterns on them.

The most spectacular chamber is on the north side. It was added later and the cairn enlarged to accommodate it. A 12 foot passage leads into a circular chamber about 8 feet across and at the southern end of the chamber there is a huge basin stone, a beautifully cut diamond-shaped block of stone with a smooth concave surface. It is hard to imagine how this stone could have

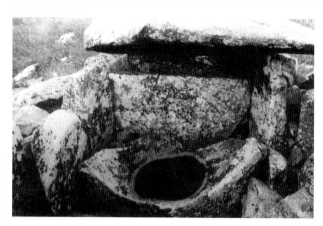

Basin stone, passage cairn on Baltinglass Hill

been brought to the top of the hill, never mind how it was carved so perfectly. The front has been carved with a small ringed cross in recent times.

The earliest passage in this cairn is aligned due north, thus lining up with the pole-star. A vertical line cut on the large basin stone appears to mark this alignment. Star or moon light may have been used here rather than sunlight.

Only two other passage cairns are not aligned to the sun - **Fourknocks** and **Seefin** are 17 degrees east of north. They may also be lit by star or moon light. Martin Brennan points out that there are many zigzags and diamonds in the art at Seefin and Fourknocks. He also points out that Sioux Indian star blankets are covered in similar patterns. (*The Stars and the Stones*)

7 Mottee Stone

It is on top of Cronebane Mountain, signed a mile north of Avoca on the road to Rathdrum.

This massive granite boulder is traditionally said to have been Fionn mac Cumhaill's hurling stone. It sits on top of the hill surrounded by heather and gorse. Another legend says that the iron staples on the side of it were put there so that a local landowner's new wife could climb up and see all his estate.

His estate must have been immense, for you can see Wales from here on a clear day, a reminder of the strong connections between the east coast here and the west coast of Britain.

8 Moylisha

From Shillelagh, which is 10 miles south east of Tullow, take the road to Park Bridge and take the first left just before the bridge. With the river on your left, go about 2 miles and turn left. There's a house on the first bend. The cairn is up the lane through the farmyard. Ask.

This site is called 'Leaba na Saighe' which would mean literally 'the bed of going forward or seeking'.

It's a roofless wedge cairn with thick double walls typical of this type of cairn but with dry-stone infill instead of the more usual endstone. Positioned high up on the north side of Moylisha hill, its entrance faces out over open ground to the north west. The gallery is divided into two chambers.

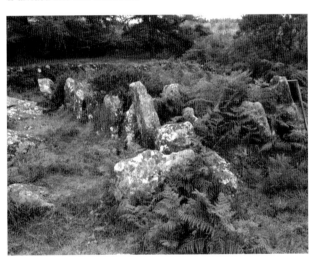

Moylisha wedge cairn

At the front of the chamber on the left side, the double wall has been used to form an extra small cist-like chamber. The same place on the right has a large boulder in it.

A walled enclosure has been built around the cairn in modern times. Wedge cairns were built in the Bronze Age, this one, probably around 1100 BC. It was excavated in 1937 and pieces of coarse pottery, stone discs, and a hammer stone were found as well as two moulds for casting metal spearheads.

Across the valley to the north east in Aghowle Upper, is a hill with two conical peaks. The north one has a cairn on top. The hill is now planted with conifers. If you return to the road and go back to the first T junction and turn left, the cairn is signed up a lane on the right.

LEINSTER **Wicklow**

Aghowle Church and Crosses

From Moylisha return to the first T junction (about 2 miles) and
turn left. Aghowle church is signed on the left after about a mile.

This is the site of the first monastery founded by St Finnian of
Clonard. Its name 'Achadh Abhall' means 'the great field' and it
lies on the western slopes above the broad valley which carries the
Slaney and Barrow rivers southwards.

St Finnian would have been here at the beginning of the
6th century. The present church is early 12th century and has two
small Romanesque windows in the east gable. The outer arch, one
of three, is quite worn on both windows, but some of the carvings
are still visible. Inside, the windows are slightly splayed, and in a
niche below there is a small peace altar with offerings and prayers.

There's also a broken hole stone and a square cut stone basin.
North of the church is a plain ringed cross and bullaun.

It is ironic that the remains here are more substantial than at
Clonard where St Finnian had an international reputation as a
leader and teacher. He is widely thought of as the tutor of the saints
of Ireland, sometimes called 'the Twelve Apostles of Ireland'.
(see WESTMEATH)

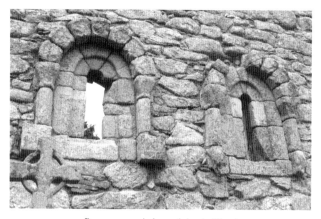

Romanesque windows, Aghowle Church

9 Rathgall

4 miles east of Tullow. Take the R725 east out of Tullow for about
2 miles. It is signed on the left up the old Shillelagh road.

'Rath Geal' means 'Bright Fort'. It sits on high ground facing west
towards Tullow and south across to Moylisha. It was a royal palace
and burial site of the kings of South Leinster. Like most royal forts,
the view is wonderful.

It has three original concentric stone walls variously spaced with outer ditches. You cross the first one as you enter the field. The second one looks, as you approach it, like a bank topped with thorn trees. The stones are more visible as you approach. In the centre is a dry-stone wall enclosure with a wall about 18 feet thick at the base and 150 feet across. It has been dated to medieval times though the whole site is much older.

Excavations revealed signs of bronze metal-working around 700 BC (*Monuments of Ireland*). There are traces of another fort nearby.

View of the lake from St Kevin's cell, Glendalough

County
WEXFORD
PRINCIPAL SITES

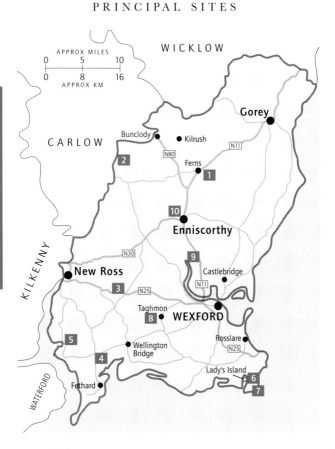

1. **Ferns** monastic site
2. **Caher Roe's Den, Blackstairs Mountain**
3. **Carrickbryne Hill**
4. **Tintern Abbey**
5. **Dunbrody Abbey**
6. **Lady's Island**
7. **St Vogue's** monastic site
8. **St Munnu's Cross**
9. **St David's Well**
10. **St Aidan's Cathedral** Enniscorthy

Block figures in list refer to site locations in map and entries in text.

WEXFORD

WEXFORD IS IN THE SOUTH EAST CORNER OF THE COUNTRY, bounded on two sides by the sea, and in the west by the long Barrow estuary and the broad back of the Blackstairs mountains. The river Slaney, which rises in the Wicklow mountains, meanders across its low plains to the sea in the south east where its languid water deposits silt in the mud flats of Wexford harbour. The name Wexford comes from the Norse 'Waesfjord' and means 'harbour of the mud flats'. In modern times, the silting at the harbour has made it unsuitable for heavy sea traffic, so the ferries bound for Wales and France sail from Rosslare 20 miles south.

Its coastal location has brought mixed fortune to the county. It was an early Viking settlement from the 8th century, and also the landing place of the first Normans in Ireland in 1169, led by Raymond Le Gros. **Baginbun Beach** in the south west was one of the main landing places. Opposite the beach on the other side of Bannow bay is **St Mary's church, Bannow**, all that remains of the first Anglo-Norman town in Ireland, now buried beneath sand. It returned two members to the Irish parliament till the Act of Union, even though all that was left was a ruined church.

Ferrycarrig, north of Wexford city, is thought to be the first Norman stronghold built of sods and branches after the capture of Wexford in 1169 by Robert FitzStephen. They held out against attack from local people, but eventually FitzStephen was tricked into surrender. The site is now included in an Irish National Heritage Park.

1 Ferns Monastic Site, Church and Crosses

At the south tip of the Wickow Hills, the name probably means 'place of the alder trees'.

The early monastery was founded here by St Maedhóg (St Mogue) in the 6th century on land given to him by the King of Leinster. His name, Aedh, prefixed by Mo and ended with og, both affectionate terms, became locally 'Mogue', but in its English diminutive, it becomes 'Aedhin' or 'Aidan'.

It is said that his parents, Sétna and Eithne (she was the daughter of the king of Connacht), wanted a son. They prayed and gave offerings, and eventually the young Aed was born. He was very pious and was educated at St Finnian's school in Clonard. Fellow students included Ciarán of Clonmacnois, Brendan of Clonfert and even Colmcille. From there he went to Wales to study

at Menavia. When he returned, the king of Leinster, Bran Dubh, granted him land at Ferns where he founded his first church. The king, in gratitude for Aed's prayers which had led him to victory in battle, granted him the title Bishop of Leinster.

The site of the 6th century foundation with its circular enclosure can just be seen in the semi-circular wall bounding part of the graveyard.

For some time Ferns was the royal seat of Leinster, and its monastery one of the major religious foundations of south Leinster.

Ferns Cathedral and monastic site

It was on an important route from the coast which brought wealth and power, but this also meant it was frequently raided by the Norse who had settled at Wexford. The monks of Ferns had to be tough. They also had the sacred bones of their founder as protection.

A later poet puts these words into St Maedhóg's mouth:

> I am a fire for burning,
> I am a serpent valiant of victories,
> Sharper than any spear in its wounding
> Are my clerks, and my relics.

In spite of this, Ferns was to be destroyed many times. Proof of its importance comes, in a reference made in 787, to the stone church of Ferns. The first stone churches were just being built in the 8th century and only at important sites. Other stone churches were built at Armagh, Clonmacnois and Kells.

When Diarmuid Mac Murrough was deposed in Leinster, he burned his royal palace and the monastery at Ferns before

retreating into exile. On his return in 1169, with Norman support, he rebuilt Ferns and founded an Augustinian Abbey on the site of the original monastery. The ruins are in the cathedral graveyard, south of the cathedral and include the north wall of the church and a belfry which is a round tower on a square base. Just south of the cathedral is the shaft of a high cross carved with key-patterns which is said to be the site of Diarmuid's grave. There was a local tradition at funerals whereby young men tested their reaching powers around the 'king's monument'.

The 13th century cathedral was built by John St John, the first Anglo-Norman bishop, but after the Reformation in the 16th century, the city and its cathedral were burned again, this time by the O Byrnes of Wicklow, led by Fiach Mac Hugh O Byrne. They were ordered by Queen Elizabeth I to rebuild the cathedral and they did this by patching the chancel and tower. The building was extensively rebuilt in 1817. By the pulpit is a monument to St Edan (Aidan), found in the rebuilding of 1817.

The ruined building east of the cathedral, with its elegant rows of lancet windows, is also 13th century. It is much lower than the cathedral and could not have been part of that building.

Nearby are the remains of a number of high crosses, unfortunately broken, but more proof of the importance of the site here at Ferns. There are some interesting gravestones in the graveyard as some of the carved stones from the old cathedral building were used to mark graves.

Across the road on the way out of the town, is St Mogue's Holy Well. The central arch stone on the well house is from the cathedral. St Moling, who succeeded St Mogue at Ferns, is said to have made the dedication in his honour. His saint's day is 31st January.

Beyond the well is St Peter's Church, north of the roadway, probably built after 1537.

At the top of the town are the remains of the Norman castle of Ferns now in the care of Duchas. Admission charged.

St Mogue's well, Ferns

2 Caher Roe's Den, Blackstairs Mountain

The Den is in the highest pass across the mountains, between the peaks of Blackstairs and Carrigalacken. 800 feet above the pass is a rocky pinnacle, called the 'Sthurra', with a cave in it. The cave is called 'Caher Roe's Den'.

This was a popular assembly site on the last Sunday in August, the festival of Lughnasa, known here as 'Mountain Sunday'. There are a number of sites where Lughnasa was celebrated in Wexford. Of those described by Máire Mac Neill, author of *The Festival of Lughnasa*, this is probably the most important.

People came from both sides of the mountain and the day involved a great deal of rivalry between Wexford and Carlow men, especially in romantic matters.

The first potatoes were dug and eaten at an early dinner before everyone set off up the mountain. Food stalls would be set up on the way. There would be singing, dancing, music and berry picking and perhaps some fighting later on. Rivalry across montain passes was also a feature of gatherings on Mám Eán in Galway or Slieve Bloom, between Laois and Offaly. Or you could sit back after the climb and just enjoy the magnificent view.

Caher Roe is associated with a young 17th century rapparee, a kind of local hero, dispossessed in the plantations, who lived an outlaw's life stealing from the rich to help the poor. However, there's one story told about him where he abducts a young woman at a well and takes her to his den. Her screams draw neighbours who manage to rescue her before she is dragged below. He escapes into the cave.

This story is obviously much older than the 17th century and also out of character with the hero rapparee. He probably echoes a much older figure like the god Crom who, every year, as part of the annual cycle of fertility, abducts the young corn-maiden Eithne and takes her to the underworld (see CAVAN). This is symbolically enacted at harvest-time around the country in traditions associated with the last sheaf of corn and its importance in ensuring next year's crop.

3 Carrickbryne Hill

The Rock of Carrickbryne is just north of the N25, 7 miles east of New Ross.

This was also a hill where people assembled to celebrate Lughnasa in a day out with berry picking and dancing. The date here is the second Sunday in July, earlier than most Lughnasa dates, but it

also starts with a meal of the first dug potatoes or 'first fruits', a strong Lughnasa tradition. In this part of the world, the day was often called Fraughan Sunday, being the local name for the bilberries that were picked. There is a cairn on the hilltop which, tradition has it, was built by each person adding a stone each year.

It is not certain that there is actually an ancient cairn beneath it. It is now called the Old Man of the Rock and, if you stand on top of it, you will not get ill in the coming year.

4 Tintern Abbey

South of New Ross on the road to Fethard. About 4.5 miles north of Fethard.

This was a Cistercian foundation and daughter abbey of Tintern in Monmouthshire, Wales. It was founded by William the Marshal, Earl of Pembroke and son-in-law of Strongbow, in 1200. On his first visit to Ireland as the new Lord of Leinster, he was almost ship-wrecked off the south coast. The story goes that he vowed to found an abbey wherever he should reach safety. He came ashore at Bannow strand and made good his vow by bequeathing land here for the foundation of a Cistercian abbey. As Tintern in Wales was also under his patronage, it became the mother abbey. It was to become one of the wealthiest Cistercian abbeys in Ireland next to St Mary's in Dublin and Mellifont, the first foundation of all.

LEINSTER **Wexford**

Corbel table on the south chancel wall, Tintern Abbey

After the Dissolution in the 16th century, the building was turned into a dwelling and some of the architectural detail covered over. It is currently in the care of Duchas who have been restoring parts of it to its former glory.

The claustral buildings are mostly gone, but the church is monumental evidence of a wealthy patron and, with substantial rebuilding around 1300, it was not subjected to the earlier Cistercian strict exclusion of all sculptures, pictures and stained glass. There are no pictures or glass left now, but some fine sculpture including a corbel table high up on the outside of the north and south walls of the chancel. There are eighteen heads, known as 'grotesque', but actually quite charming and serene. There is only one other corbel table in Ireland, at Grey Abbey in Co Down.

Of the original cruciform church, only the chancel, crossing tower, central aisle of the nave, and the Lady chapel of the south transept, remain.

Most of the stonework detail is carved in Dundry stone which comes from Bristol. The rest of the walls are built with rubble masonry.

As well as building conservation here, nature conservation is important. The Lady chapel has swallows' nests above the carved bosses on its rib vaulting. The abbey is also home to the rare whiskered bat which lives in colonies of twenty to three hundred.

Herb robert, pennywort, and pellitory of the wall, all grow amid the ruins. Hemlock, used in tiny quantities for medicinal purposes, was also found. The nearby estuary is a wintering site for wildfowl.

The drains at Tintern, leading from the latrines near the dormitories, have given some insight into the everyday lives of the 13th century monks. They ate cereals, raspberries, strawberries, apples, figs, blackberries, sloes and hazel nuts. Their meat was beef, mutton, pork and goat as well as oysters, mussels, cockle and whelk. And they ate off fine continental tableware and cooked in locally made pots.

5 Dunbrody Abbey

South of New Ross on the R733 to Campile. Signed 1 mile west south west of Campile.

Dunbrody Abbey was founded in the 1170s by Hervey de Montmorency, uncle of Strongbow. He had granted land to the monks of Bildewas, in Shropshire, on condition that they built an abbey here for the English Cistercians of St Mary's Abbey, in Dublin. A further condition was that there should be a sanctuary in the abbey for criminals. It was completed about 1220 and Hervey made himself its first abbot, though he had not fully adopted Cistercian ways. He remained a soldier at heart and had

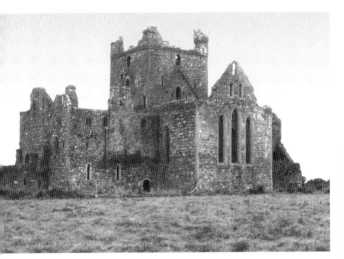

Dunbrody Abbey

a reputation for being bad-tempered. This is perhaps reflected in the bulky embattled appearance of Dunbrody.

The abbey had its share of feuds and battles. In 1355, the abbot and two of his monks were charged with imprisoning Thomas Herlyn, a monk from Tintern abbey, and stealing two of his horses. They were also accused of robbing Thomas de Wiggemore, the abbot of Tintern, and stealing three of his horses.

The abbey buildings, though apparently of poor construction and weak foundations, are remarkably intact. The cruciform church with aisled nave, six transept chapels and a massive central crossing tower, are all standing as well as some of the living quarters, the Chapter House and part of the sacristy. There are three lights in the east window - huge and plain, balanced with two small windows above them and one above that again. The arches of the crossing tower are high and wide, those to the transepts are round and those to the nave and chancel are pointed. The tower was added in the 15th century.

6 Lady's Island

Take the N25 south from Wexford past Rosslare and turn right in Tagoat. It is signed.

This site has a great geographical similarity to Inchydoney in Cork. Lady's Island Lake is a wide inlet like Clonakilty, though here the entrance is almost silted. Here, within the lake, is an island connected by a causeway and, like the tip of Inchydoney, it is dedicated to the virgin. Called Lady's Island, it is visited by

LEINSTER **Wexford**

Holy well, Lady's Island

pilgrims from the 15th August for two weeks. In earlier times the pilgrimage involved walking around the twelve acre island with one foot in the water, or even crawling. Opposite the island is a wide green with car-park and outdoor seating. There's a large statue of Mary painted blue and white. Part of the old 15th century castle has been converted into an altar. Behind the altar you can walk out onto the island where you can see some ecclesiastical remains.

When I was there, it was pilgrimage time, and everywhere was decorated with blue and white bunting. Packed coaches had just left and more were expected that evening. Yet out on the island all was calm. There were migrating water birds feeding across the sand still shiny with water. This is the goddess in her white aspect.

From the car-park, continue on the road for 0.5 miles, keeping left. The well is on the right, down a small grassy path and through the pitch and putt. The **holy well** has a high wall around it painted white with gates and steps down to the water. It's still very much part of the pilgrimage.

7 St Vogue's Monastic Site

0.25 miles north of Carnsore Point. Follow the road south on the east side of Lady's Island Lake past the well. Turn left after 1.8 miles and follow the road round as far as you can go. Keep walking down the track.

East gable, St Vogue's church

This is rough grazing land, flat with huge erratic boulders running out to Carnsore point and the south east tip of the country. Here are the slight remains of an encloure surrounding a small

church built with soft contoured boulders. The east gable is complete with one narrow window with rounded arch and widely splaying sides. It seems a fitting frame through which to look east. The site was overgrown and I couldn't find the well or cross-inscribed boulder.

The early foundation is attributed to St Vogue who may be the same as St Véoc who died at Lanvéoc in Brittany in 585. Excavations at the site found a small wooden structure dating to this time - possibly a shrine.

8 St Munnu's Cross

Going west from Wexford town on the N25, turn left on to the R738 to Taghmon. The cross is in the graveyard in front of the Church of Ireland church.

'Teach Munnu', meaning 'Munnu's house', was a religious foundation begun in the 7th century by St Munnu who was a son of the Druid Tailchán.

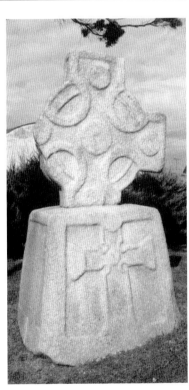

He is recorded as attending the Synod of Magh Ailbhe in about 630 to discuss the date of Easter. He apparently spoke out for the Celtic traditionalists against St Laisrén of Leighlin who wanted Ireland to conform to the European calendar. (*Shell Guide*)

All that survives of the foundation is St Munnu's cross and all that survives of it are the head sitting directly on the base, but it is a very powerful

St Munnu's cross

construction. The head is a ringed cross, not cut through, but outlined with heavy moulding. There are five bosses - one on each arm and one in the centre. The base is plain except for moulded edges and a cross with expanded arms and a central boss on the front.

9 St David's Well

On the N11 halfway between Wexford and Enniscorthy in
Ballinaslaney. Signed down a road to the west.

The well here is beautifully cared for with stone surround and a
painted gate and steps down to the water. There's a small statue of
St David in a recess above.

Nearby is a small house crammed with statues, offerings and
prayers. A pipe brings water into a corner of the house beside a
chair and basin. On a table is a book filled with hand-written
prayers. The dedication to St David is a reminder of the close links
between this part of Ireland and Wales.

St David's well, Ballinaslaney

10 St Aidan's Cathedral, Enniscorthy

This is an early 19th century building at the top of the town, in
Cathedral Street.

There is nothing particularly remarkable about the windows or the
furnishings. However, it has a lovely light energy which may in
part be due to the delicately painted arches and the dark blue
ceiling above white walls.

Well house, St David's well, Ballinaslaney

County
KILKENNY
PRINCIPAL SITES

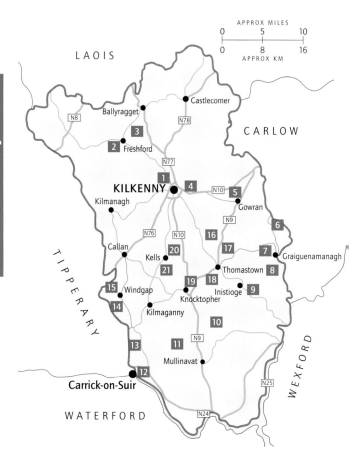

1 **Kilkenny** St Canice's Cathedral
2 **Freshford** church
3 **Rathbeagh Mound**
4 **Freestone Hill** hill-fort and cairn
5 **Gowran** St Mary's Collegiate Church
6 **Ullard** high cross
7 **Graiguenamanagh** abbey and crosses
8 **Brandon Hill**
9 **Cloonamery Church**
10 **Mullennakill** well

11 **Kilmogue** portal dolmen
12 **Tibberaghny** carved pillar
13 **Kilkieran** crosses and well
14 **Knockroe** passage cairn
15 **Killamery Cross**
16 **Tullaherin Church**, round tower and ogham stone
17 **Kilfane Church**
18 **Jerpoint Abbey**
 Newtown Jerpoint
19 **Knocktopher**
20 **Kells Priory**
21 **Kilree** monastic site

Block figures in list refer to site locations in map and entries in text.

LEINSTER **Kilkenny**

KILKENNY

THIS IS A RICH FERTILE COUNTY OF THREE RIVERS. It is bounded on either side by the Suir and the Barrow and cut through by the Nore and they meet at the southern tip of the county. These three rivers are said to be home to the three sovereign goddesses of Ireland, Ériu, Banba and Fodhla. Traditionally these three hold the power of kingship in Ireland, a dynamic that is certainly echoed in Kilkenny's history.

Most of the county fell to Strongbow in the 1170s. He built a motte here in 1172 and later his son-in-law, William the Marshal, built the first stone castle in Kilkenny and with it the power base of an Anglo-Norman presence that held till modern times.

There followed 200 years of integration with the native Irish people while they grew wealthy on the fertile lands of their estates.

The English Crown, afraid of their growing power and autonomy, introduced the **Statutes of Kilkenny** in 1366 to forbid further integration and make intermarriage or cultural mixing of any kind illegal. Kilkenny gradually became the unofficial capital of Ireland outside the Pale and in the 17th century the **Confederation of Kilkenny** was formed. It operated briefly from 1642 to 1648 with its Supreme Council in Kilkenny as an Irish government fighting English control.

They petitioned Pope Innocent X for help and received it in the form of a visit by the Papal Nuncio, Rinuccini, in 1645. He came with a frigate of arms and ammunition, narrowly escaping capture by English ships.

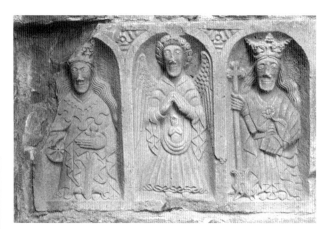

*15th century tomb, St Catherine, St Michael
and St Margaret of Antioch, Jerpoint Abbey*

However, the Confederation did not succeed, and Kilkenny's ecclesiastical treasures suffered the same fate as the rest of the country when the city surrendered to Cromwell in 1650.

The overriding character of the county is medieval and the finest collection of stone carving, particularly 15th and 16th century, is in St Canice's Cathedral in Kilkenny city.

However, in the east along the valley of the Barrow are some of Ireland's most powerful high crosses. They are earlier than the scriptural crosses and are carved with spiralling bosses, ringed circles and other images of light, as well as dark images of devouring dragons and snakes.

There are an increasing number of sites where rock art has been found across Kilkenny and into Carlow. It is thought to date from the neolithic to the Bronze Age.

1 St Canice's Cathedral, Kilkenny
Opens at 9am.

The city of Kilkenny grew around the site of an early monastery founded by St Cainneach. It is now the site of St Canice's Cathedral.

The cathedral has a nave and choir/chancel with two transepts, mainly 13th century, and a 14th century tower. The chancel is probably older. The stonework here is sandstone while the nave is limestone. The blue/grey limestone turns black with wear so that many of the later carvings and effigies seem like black marble. The cathedral is quite dominated by their presence.

The years from about 1480 to 1560 produced some especially

fine figure sculpture in Ireland. Much of this was in the south east and came from the workshop of Patrick O'Tunney and son Rory.

At this time across Europe, in Italy, Michelangelo was painting the Sistine chapel and creating the Pietà for St Peter's in Rome.

There are some 100 memorial and funerary pieces in the cathedral and though some are only fragments, many are intact. The effigies are as characterful and immaculately dressed as if it were only yesterday. The sides of the tombs are lined with the traditional weepers, usually saints, apostles and sometimes Jesus.

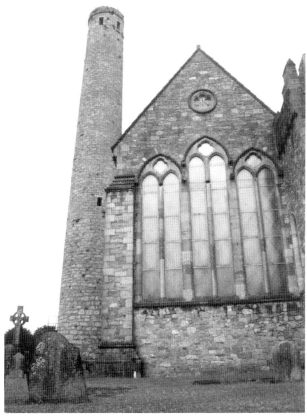

St Canice's Cathedral, Kilkenny

Ironically for weepers, they usually look very happy, even in crucifixion scenes. Probably they are welcoming the newly deceased into heaven.

The Butler family are well represented. They bought Kilkenny castle in 1391 and lived there as Earls of Ormond, loyal to the English crown. The first Duke went into exile with Charles I of England when Cromwell came to power, and returned after the

Restoration. They remained in the castle until Irish independence.

There are two effigies of women, both dressed in costume of the time with horned head-dress. One is of Honorina Grace and dated 1596. Her fingers and thumb are adorned with rings. The other woman is unknown. Her hands are bare, perhaps showing that she had taken holy orders or that she was a widow.

The Trinity Stone sits against the wall in the north transept. It is probably the end panel of a tomb chest. It has an interesting carving of God the Father holding a Tau cross on which his son is crucified. The Holy Spirit is represented as a dove on God's right hand.

The tomb of the notorious bishop, Richard de Ledrede, who died in 1360, is now in the north wall of the chancel. His sandalled feet show his Franciscan origins, though he was later to be better known as a pursuer of heretics. His feet are facing east, not the proper orientation for a cleric. It seems his tomb was moved to the chancel in the 19th century from the other side of the cathedral and, as only the right side of the effigy is well finished, he had to be placed in this undignified position. Perhaps those responsible for the move thought he deserved no better, for in 1324 he pursued one of the town's citizens, Alice Kyteler, attempting to have her tried for witchcraft.

Alice must have had considerable beauty and charisma for, by the time the story begins, she was on her fourth husband, and accused by her step-children of using witchcraft to seduce their fathers and relieve them of their fortunes in favour of her son William.

Bishop Ledrede compiled a list of charges of sacrifice and spells, as well as the very specific act of sweeping the streets of Kilkenny towards her son's door saying:

> "To the house of William, my son,
> Hie all the wealth of Kilkenny town."

Her current husband produced a 'pipe of stick oil' saying that she used it to grease her broomstick (*Old Kilkenny Review 1953*; Alice Kyteler). In Ireland such activities meant trial by the Church on charges of heresy.

Alice managed to use her influence and, no doubt her charms, to prevent her trial and eventually fled the country to escape from the bishop's relentless pursuit. In her place, he tried one of her companions, a woman from Meath by the name of Petronilla. She was burned as a witch in the main street before the people of Kilkenny. She was the first witch ever burned in Ireland.

Alice's son William, who had used his considerable wealth and

influence to thwart the bishop, was given a number of punishments
for his part, including putting lead on the roofs of the chancel and
Lady chapel of the cathedral. Shortly afterwards the roof collapsed.

In 1645 Pope Innocent X sent the Papal Nuncio, Rinucinni, to
the Confederation of Kilkenny having been petitioned for help for
the Catholic cause.

The glass in the great east window at the time was
particularly fine, illustrating scenes from the life of Christ. It had
been commissioned by Bishop de Ledrede in the 14th century.
Rinucinni was so enchanted with the beauty of this window, that
he offered to buy it for £700. Dr Rothe would not agree to sell it
and had, later, to stand by and watch Cromwell's soldiers smash
this beautiful piece of medieval art and bury it.

For a small fee you can climb the round tower just outside the
cathedral.

Also in Kilkenny City

The Franciscan friary is now inside the Guinness brewery,
but Black Friars' church and St John's Priory are both open and
still in use.

The Black Friars' Church or Black Abbey was founded
for the Dominicans around 1226. Its nave is 13th century. New
windows and a tower were added in the 15th century. It has a
lovely medieval alabaster statue of the Trinity. A wooden carving
of St Dominic, once used in procession, is kept in the church.

St John's Priory also dates to the 13th century and was
founded by William Marshal the younger for the Canons Regular
of St Augustine. Only the choir of the original remains.

There are two 3-light windows in the east with carved capitals.
The Lady Chapel in the south was extensively rebuilt in 19th
century with so many windows that it became known as the
Lantern of Ireland.

2 Freshford Church

408 648
South west of Ballyragget on the R694. Signed to Freshford.

St Lachtain founded the first church here in 622. He is best
known for the finely worked silver shrine which was made in the
12th century to hold his arm, preserved as a relic. The shrine is in
the National Museum, Dublin.

An 18th century church has long since replaced earlier buildings,

LEINSTER **Kilkenny**

LEINSTER Kilkenny

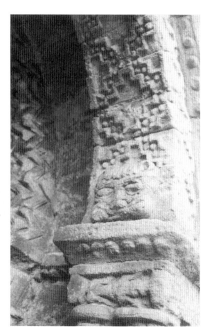

*Step patterns and beading, west doorway,
Freshford Church*

but the west gable has retained a fine 12th century Romanesque doorway in three orders. Either side of the doorway the jambs have unusual niches with carved figures set in them. The niches are rectangular with T-shaped projections above them, perhaps signifying the Tau cross, symbol of truth. The figures inside look like pilgrims. The arch above is decorated with step patterns and beading, echoing the right-angle pattern of the niches. Elsewhere are chevrons and human and animal heads, some quite worn.

It is a very fine doorway and, like so many Romanesque entrances, seems to still hold something of the mystery and magic invoked by its fabulous carvings. A fitting threshold to a sacred place.

Above the doorway is a simple moulded hood and above that an unusual and well preserved rose window with Romanesque chevrons and beading.

3 Rathbeagh Mound

443 671

*3 miles south south west of Ballyragget on the edge of the river
Nore. Take the R693 to Kilkenny from Freshford turning left
almost immediately and left again at the crossroads 2 miles later.
The henge is on the right 0.5 miles further on.*

Tradition has it that this is the burial place of the legendary Éremón or Heremon, one of the sons of Mil. According to the *Annals of the Four Masters*, three of the eight sons of Mil arrived in Ireland. After successfully defeating the Tuatha Dé Danann, two of the brothers fought each other. Heber was killed and Éremón came here and built his palace.

What remains today is an oval henge or platform-type ring-fort on high ground above the west bank of the river Nore. The area around is called the Plain of the Silver Wood. Some people say this refers to the silver shields which the new king made there for his chieftains, others that it is named after the silver birches which grow there. 'Rathbeagh' means 'the fort of the birches'.

4 Freestone Hill - Hill-Fort and Cairn

589 562
5 miles east of Kilkenny in Coolgrange townland. This gentle hill is just north of the N10 going east from Kilkenny city.

It has a lone thorn tree on top and each time I passed, I felt it drawing me back till I gave in and decided to visit it. It belongs to the O'Carroll family who farm the area around it. Their house is by the main road.

The hill is actually ringed by a hill-fort which is not visible till you climb the hill. It has two defensive banks, the outer one enclosing an area about 300 feet by 450 feet and rising 6 feet above the fosse. It was faced with dry-stone walling and also, at one time, with a line of supporting timber posts. Recent excavations found evidence of iron working and occupation till the 4th century AD.

The lone fairy tree at the top sits in the middle in a low cairn some 60 feet in diameter. The cairn is probably Bronze Age, older than the fort. A cist is visible in the centre of it and another ring of stones nearby.

The tree is treated with great respect as befits its fairy status. Apparently it has not grown an inch in the last hundred years.

Fairy thorn, Freestone Hill

5 St Mary's Collegiate Church, Gowran

*About 10 miles east of Kilkenny. Take the N10 east from Kilkenny
and turn right onto the R702 for Gowran. This is now a Duchas
site and admission is charged. The church has recently been
deconsecrated and used to display the fine collection of carved
effigies and tombs from the site.*

The land here was given to Theobald Fitz Walter by Strongbow's
son-in-law, William the Marshal, at the end of the 12th century.
Theobald was an ancestor of the Butler family. The church was
founded a century later by Edmund Butler, Earl of Carrick. It was
the burial place of the 1st and 3rd Earls of Ormond as well as other
members of the Butler family.

It was built with an aisled nave and a long chancel. The
chancel is roofless now but still has some fine decorative detail: the
north doorways, the three-light west window with carved capitals,
the heads on the arch capitals, and the quatrefoil columns of the
arches themselves. A tower was added in the 14th century. This
was later incorporated into the 19th century church.

13th century

There is a 13th century effigy of a priest, called Radoulfus.
Although the figure is in high relief, the style is flat and less
accomplished than many of the other works. Beside him is a tiny
figure holding something by his chest. It is thought this might be a
heart burial.

14th century

There are two flat slabs with the figures of a man and a woman in
flat relief. They are thought to be James le Butler and his wife,
Eleanor de Bohun. They are both wearing long gowns, Eleanor's
being caught at the waist with a kind of realism verging on the
dishevelled. These effigies were probably carved at the same time,
around 1340. However, while James died around this time,
Eleanor remarried and lived for another 20 years and was
probably not buried here at all.

16th century

From the 16th century are two box or altar tombs: one with one
effigy and the other with two. All three are knights with swords and
armour of the period. The single tomb has side panels depicting
apostles on the sides and at the base Christ showing his wounds
and an archbishop and a female saint. These two are probably
Saints Brigid and Thomas of Canterbury (*Irish Medieval Figure
Sculptures 1200 - 1600)*. The double tomb has, on its sides, Butler

shields and symbols of the Passion. The end slab has a crucifixion scene with smiling figures (see **St Canice's**, above). Both tombs are considered to belong to Butler knights.

There is much more. At the moment this site is not open to the public, but is expected to be ready by spring 2002.

6 Ullard High Cross
724 482
Turn left off the R705 3 miles north of Graiguenamanagh.

An early church was founded here on the west bank of the river Barrow by St Fiacre. There is a 12th century nave and chancel Romanesque church here now with 16th century additions to the doorway.

A panel over the window above the doorway shows two people meeting. It may have been part of the original doorway, a panel in the jamb, like at Freshford.

Two worn heads above this doorway are considered to be St Moling and St Fiacre. The chancel was partly blocked in the 16th century and a little of the Romanesque arch can just be seen. Unusually, the church has a vault underneath it to fit the slope of the hill as it falls away to the river.

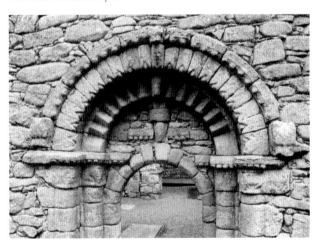

Romanesque arches, west doorway, Ullard

There is now a handball alley attached to the east gable. However, it is built in stone, like the church, to disguise its presence.

At the south east corner is a granite high cross, part of the Barrow group. It is quite worn and part of the shaft has been replaced, but the carvings on the east face are in the same style as

the cross at Moone. The tall base has seven panels of knotwork and interlacing. At the base of the shaft are six Apostles. The rest of the original shaft is missing, but there is a *Crucifixion* at the centre of the cross with *Adam and Eve* below, *David and his Harp*, and *The Sacrifice of Isaac* on the arms. At the top are two figures, one wielding a club. The back of the cross is too worn to identify any of the panels.

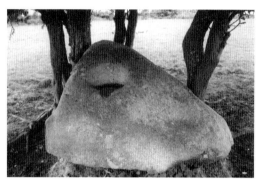

Bullaun stone near well, Ullard

A pilgrimage used to take place to the nearby well. At the north east corner of the church there are steps down to the field. A slight track across the grass marks the way to the well which is deep and clear. Nearby are two bullauns. One is a stunning 3 feet tall, a sculptural pyramid shape with beautifully smooth sides and a deep recess near the top. It sits between two thorn trees.

7 Graiguenamanagh Abbey and Crosses
In the centre of the town.

This abbey, called Duiske, was founded for the Cistercians by William the Marshal in 1207. He brought the monks from Stanley, in Wiltshire, England.

The location is more strategic than wilderness, which is probably a reflection of the interests of its founder. William the Marshal was Strongbow's son-in-law. The abbey is now bound on all sides by the small town of Graiguenamanagh.

The church was cruciform with an aisled nave, transepts with side chapels, a crossing tower and a vaulted chancel - all 13th century. The tower, south aisle, and part of the side chapel to the south have disappeared, as well as part of the north aisle. But it is still one of the best preserved Cistercian abbeys in the country and the largest.

19th century restoration has covered much of the walls and the floor is higher than its original level. However, the modern

baptistery, built onto the south aisle, is at the original level, so the beautiful elaborate 13th century west doorway is preserved.

It was restored in the 1970s and additions made to the Chapter House and domestic buildings. There is a 13th - 14th century effigy of a knight on the north wall of the north aisle.

In the graveyard south of the chancel are two granite crosses from around Ullard.

To the north, is the **Ballyogan Cross**. The crucifixion on the east face looks more like Christ with his arms outstretched in blessing. This

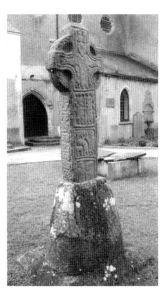

Ballyogan cross, east face, Graiguenamanagh

seems to have been common among the early crosses (see **Carndonagh**, DONEGAL). He is flanked by two small figures and above his head there are two birds or angels. Below, on the shaft of the cross, are *Adam and Eve*, *The Sacrifice of Isaac*, and *David playing the Harp*.

The west face is mostly covered with a pattern of interlocking spirals with a small panel of two figures at the top and another panel of figures at the bottom of the shaft. Like Ullard (above) this cross is part of the Barrow Group.

On the shorter **Aghailta Cross,** the crucifixion shows the figure of Christ in a naive style with arms outstretched in blessing. The arms are long and the hands big, an image that goes back to the earlier sun god, Lugh of the Long Hand, meaning 'all-powerful'. Christ seems to be smiling. The shaft of the cross has two panels of interlacing.

The tow path from here leads to St Mullin's in Carlow.

8 **Brandon Hill**

701 375

Take the R705 west from Graiguenamanagh and turn right for Inishtoge, then left onto the Leinster Way. There's a car-park up this road and a signed track up the mountain. Near the top, follow the spur of the hill up to the cairn.

Both St Mullins and Graiguenamanagh seem to sit within the aura of this hill. And local people are very aware of it. In recent times, the community of Graiguenamanagh placed a cross up here and they hold a mass around it every summer. They also light a beacon at Christmas and Easter.

From here you can see for miles along the Barrow valley with the Blackstairs mountains behind it in the east, and the hills of Kilkenny to the west. South of this summit, across the wooded ridge of Ballinvarry Hill, there is another cairn on Cullentragh.

9 Cloonamery Church

658 354

2.5 miles south east of Inistioge on the east side of the Nore.
Signed off the R700. It is over a mile down this road and then a
walk across two fields.

The church sits on a small ridge within the Nore valley in green and silent fields. It is dedicated to St Bronndán who probably founded the original church on this site.

The oldest part of the building is the lower half of the west wall with antae and trabeate doorway with converging jambs. The stones near the base of the wall and round the entrance are much bigger than elsewhere, and give the doorway a fine, monumental feel.

Cloonamery Church, west gable

Above the doorway is a Maltese cross in relief with lines extending from its base and running down each side of the doorway. At the top of the gable is a bell-cote with room for two bells - the sanctus bell and one to ring out across the valley to call the people to church.

This would originally have been a simple rectangular church. The Romanesque chancel would have been added in the 12th century and the bell-cote and outer room added in the 15th or 16th century. There are three cross slabs inside the church and outside there is a granite bullaun, possibly an early font. There are two beehive hut foundations at the west end of the ridge.

The Annals of the Four Masters records (*Old Kilkenny Review 1956*;

Cloonamery Church) that a mermaid was found by fishermen in the weir, up-river from Cloonamery, near Inishtoge. Inside, in the wall of **Inishtoge** church, is a carving of a mermaid probably taken from the old monastery. Perhaps it was carved to commemorate this event.

St Bronndán is thought by some to be Brendan the Navigator. Interestingly, there is a mermaid carved on the chancel arch of the Romanesque church of Clonfert in Galway which is dedicated to him. There is also a mermaid carving at Kilcooly in Tipperary.

10 Mullennakill Holy Well and Tree

602 313

4.5 miles south of Inistioge and south west of Jerpoint. Go south from Inishtoge about 5 miles to a crossroads. Mullennakill is signed to the right. The well is just beyond the village, on the west bank of the Arrigle river. It is also signed from Thomastown.

'Mullennakill' means 'the church of Moling'. Like many of the early saints, he was said to be of noble birth, a descendant of Cathair Már, a royal prince of Leinster. The story of his birth has strong biblical associations as told by Máire Mac Neill. His father, a wealthy man, seduced his wife's sister. Pregnant and shamed, she ran away, eventually arriving at her native home. It was wintertime and the snow was thick on the ground when, without shelter, she gave birth to her son, Moling. Angels came to guard them and the snow melted around him while a dove appeared to protect him from his mother who had thought to kill him. They lived for seven years under the protection of St Brendan, son of Findlugh, in a place known as 'Brendan's Cave' or 'Uamh Brénainn'.

There are a number of places which claim to be St Moling's birthplace. Mullennakill is one and certainly he built a small church

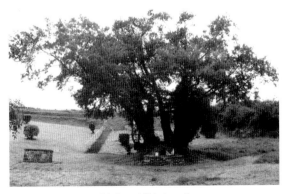

Mullennakill holy well

here in this valley in the 7th century. A venerable oak tree still stands on the site, said to have been planted by St Moling himself.

Nearby, water springs up from a rock crevasse. It is piped to a stone basin, the font from the old church. Apparently St Moling suffered from ulcers and gave the cure for them to the water. The well is called 'Tobar Crann Mo-Ling' or 'the Well at Moling's Tree'.

Beneath the tree is the Altóir, a stone altar where people have placed offerings and statues. The Cistercian monks from Jerpoint Abbey used to come here every year and say mass on the 20th August - the feast of their founder, St Bernard of Clairvaux. This was adopted as St Moling's Day as well and a pattern is still held here.

This is a good example of an early Christian site which is also a nature sanctuary with all the aspects of a sacred site from pagan times: a hill, a well, a stone and a tree.

On the opposite side of the road Tigh Mo-Ling, Moling's House, is signed up the hill. This is the rock shelter or cave where he lived before going to St Mullins. It is also an ancient Lughnasa assembly site where, until the middle of the last century, young people gathered on the hillside on Fraughan Sunday, the second or third Sunday in July, to pick berries and meet each other. Courtship often followed. (*The Festival of Lughnasa*)

St Moling went on to found the monastery of St Mullins to the east in Carlow.

11 Kilmogue Portal Dolmen

503 281

This site is 4 miles east north east of Owning which is signed from the crosses at Kilkieran on the R697. It is on the R698 north east of Carrick-on-Suir. Go through Owning turning left before the pub and go uphill with the church on your left. Keep going for a while and you'll see signs. Also signed from Mullinavat, 5.5 miles away.

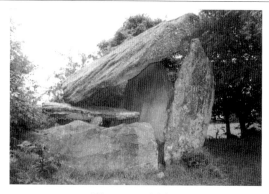

Kilmogue portal dolmen

This dolmen is known locally as 'Leac na Scail' which means 'the stone of the shadow or ghost'.

It is the tallest dolmen in Ireland and spectacular. Its portals are pointed and about 12 foot tall facing north east. The sill between them is nearly as high, blocking the entrance. The steeply pitched cap-stone reaches 15 feet and rests at the back on a second cap-stone laid horizontally across the side stones of the chamber.

It sits in tall hedges in the corner of a field with an earth bank around the front and a small stream to the side.

12 Tibberaghny Carved Pillar

442 215

1.25 miles west south west of Piltown, beside the railway bridge.

This is an early monastic site founded by St Modomhnach in the 6th century. Today there are only the remains of an early chancel and later medieval nave.

Beside it is a carved pillar, which may be part of a cross, though the circular carving on the east face seems like a centre-piece and has definite links with some of the other Kilkenny crosses such as Kilree and Killamery. It is a circular motif formed of six spirals leading into, and forming, a seventh spiral in the middle. This one spirals into three bird heads at the centre. (see **Ahenny Crosses**, TIPPERARY)

The west face has a centaur holding up what appear to be weapons in each hand. There are two animals above it. The north and south sides have two animals each in a style which shows a strong Urnes influence.

Nearby is an early stone trough and south west of the graveyard is a holy well, known as **St Faghtna's Well**.

13 Kilkieran Crosses and Well

422 274

1 mile south east of Ahenny, this is also signed from the Kilkenny road. Kilkieran is just over the border in Kilkenny.

The site, associated with St Kieran, has the remains of three stone high crosses, two like the crosses of Ahenny, and a third tall slender one. Fragments of a fourth cross from this site are on display at Jerpoint. (see below)

The west cross is most like the Ahenny crosses. It has the same basic shape with its heavy base, open circle, angle moulding and rounded conical top. It is patterned with plaitwork around the

LEINSTER **Kilkenny**

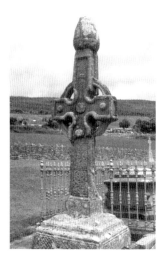
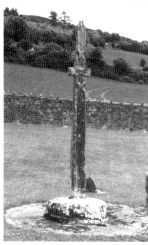

Kilkieran west cross *Kilkieran tall cross*

central bosses and panels of interlacing, frets and spirals on the shaft. There is a procession of eight horsemen on the east side of the base while the other sides are patterned. The north side of the base has two six-pointed stars.

The east cross is the same shape but undecorated except for angle moulding and a central boss.

In 1858 both these crosses were tumbled and broken. They were restored, it is said, by a blind mechanic!

The north cross is very different. It is very tall and slender with tiny arms that look as if they are just tenons from which something bigger has fallen. The angle moulding on the shaft is pinched in above and below the centre of the cross, hinting at the concave arcs that usually compliment a circle. There are faint traces of ornament on the shaft.

In the south east corner of the graveyard is St Kieran's well. The water is clean and clear. Beside it is a bullaun with a headache cure.

14 Knockroe Passage Cairn

409 313

From Windgap on the R698 between Callan and Carrick-on-Suir, go south on the main road and turn right at the crossroads about 2 miles away. Turn left at the next crossroads and right onto a farm lane after 0.6 miles. The cairn is down past the farmhouse.

This site is known locally as the 'Caiseal', meaning 'castle'. When I visited, it seemed to have been only partially excavated, though it did not look as if anyone had been there for a long time.

The remains of a stone cairn about 60 feet in diameter lie open revealing two main chambers. Some kerbstones within the cairn material give the impression that it has spilled out over an area wider than its original kerbing.

The passage facing west has a facade of stones at the entrance. Inside the passage, the chamber is divided into three sections separated by portals and low sills. Each is floored with a large slab. At the entrance to the innermost chamber are two tall portals. One is red sandstone and is illuminated by the midwinter setting sun. Like Newgrange, the floor level of the passage rises as you go in to facilitate the beam of light. (At **Balnuaran**, CLAVA, in north west Scotland, the rear wall has dark red slabs which are also illuminated by the midwinter sun [see *This Sacred Isle*]. At **Loughcrew**, Cairn L has a white pillar which is illuminated by the sun on the November and February cross-quarter days.)

Red portal stone, Knockroe passage cairn

The inside of the chamber is carved with symbols, mainly circles with some cup marks. There are areas of overlapping groups of concentric circles and arcs very much like the carvings in the Boyne Valley cairns and at Loughcrew.

The floor slabs of the outer chambers were covered with a thick layer of cremated bone, some unburnt bone, both human and cattle and some typical passage cairn artefacts such as a mushroom-headed pin, a pendant and a bead. The inner chamber had been disturbed by the roots of a mature ash tree.

The cairn facade around the east entrance was covered, in part at least, with white quartz like the front of Newgrange, and some water-rolled stones were found on the ground in front. This passage leads to a double cruciform chamber. Between these two, in the south west, is a kerbstone with zigzag markings. There is megalithic art on some thirty stones at the site.

The site overlooks the Lingaun valley and there is another

cairn to the south east, also above the river. To the west, from the direction of the midwinter sunset, is the outline of Slievenamon in Tipperary with cairns on the summit and north ridge. They are all part of the same megalithic landscape.

15 Killamery Cross

373 360

The village of Killamery is west of the R698, 10 miles north of Carrick-on-Suir. It is signed from here and from Windygap.
It is about 6 miles north of the Ahenny crosses.

Cill Lamhraidhe is an early Christian site founded in the 6th century by St Goban Fionn.

The cross here is sandstone and dated to the 9th century. It is a wonderful cross and reminds me that the Slievenamon group are my favourite. It is a powerful, and no doubt ancient thing, to see a spiral in the middle of a cross. The crosses themselves are strong and solid and the carving so fluid. (see **Ahenny**, TIPPERARY)

This is a ringed cross with strong moulding, a stepped base and gabled cap-stone. The east face has a squat dragon which dives open-mouthed from the top of the cross preparing to devour four entwined snakes or serpents who rise out of a braided area to encircle the boss at the centre of the cross. The shaft has three square panels, each with a four-petalled motif.

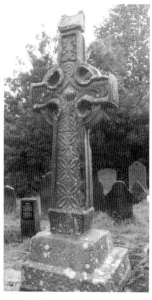

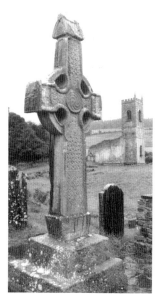

Killamery cross, east face *Killamery cross, west face*

The west face has a double spiral at the centre and below it a crucifixion. Above are two figures, possibly *Adam and Eve*. Left is a hunting scene with dogs pursuing a stag and on the right is a chariot procession. Fine key-patterns and knotwork cover the rest of the west face. The end of the north arm has four small figured scenes. The end of the south arm appears to be *Noah's Ark*.

The faded inscription is thought to read: OR DO MAELSECHNAILL - 'Pray for Mael-sechnaill', high king from 846 to 862.

The cap-stone is traditionally a cure for headaches.

Beside the cross is a cross slab inscribed OR AR ANMIN AEDAEN - 'Pray for the soul of Aidan'. Just south of the cross, down some steps, is a holy well with a carved stone behind it. The stone has a deep recess cut into it just above the well and above that a triangular shape in relief. It seems very old, possibly the gable end of a small reliquary.

North of the 19th century belfry tower is an unusual sandstone grave slab with a double-armed cross surrounded by two lines, one of which runs into the upper arm of the cross. It is enclosed in a further line forming a border except at the base. Conleth Manning (*Old Killarney Review 1982*; Cross slab at Killarney) believes this to be the slab described in the review in 1913 and later lost. It has strong similarities to Aidan's stone.

LEINSTER **Kilkenny**

16 Tullaherin Church, Round Tower and Ogham Stone
591 478
Just north of Kilfane. Take the R703 north of Thomastown and take the first left after the right turn for Kilfane. It is 1.5 miles down this road on the left after the crossroads. It is signed, but not very visible.

The name comes from 'Tulach Chiarain' - 'Ciarán's mound', probably named after St Ciarán of Seir as a pilgrimage used to be held here in honour of him. The six-storey round tower has had its doorway removed and renovations made to the windows in the upper storeys.

The old church with antae has had a medieval chancel added, but both are now in a dangerous condition. This is no new thing. The annals record that the tower was struck by lightning in 1121 causing a stone to fall from it and kill a student in the church. An ogham stone stands supported south of the church.

In spite of the state of the buildings, the place has a nice feel to it. In the graveyard is a tall, rectangular cross base.

17 Kilfane Church and The Cantwell Fada

2 miles north east of Thomastown on the R703. Signed. This site is through a small gate by the gate lodge of the estate and then a short walk down a beautifully cared for grassy lane, overshadowed by mature trees.

It is an early 14th century church dedicated to St Paan with a castellated building beside it - perhaps a sacristy with living quarters above. It was also used for some time as a school.

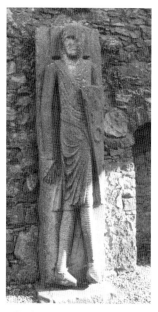

The Cantwell Fada, Kilfane church

The site is famous for the huge stone effigy which now stands upright inside the empty church. The figure is of a knight with crossed legs and dated somewhere between 1250 and 1320. It is thought to be Thomas de Cantwell who was alive in 1319 and probably the founder or rebuilder of this church. Hence the name 'Cantwell Fada'. 'Fada' means 'long' - an allusion to the height of the figure. He is dressed in full chain mail, popular until about 1400, with lifelike detail, and his shield bears the Cantwell arms. It is a fine example of medieval carving.

The church is worth a closer look. The doorways and windows are plain but elegantly cut, and the double sedilia, holy water stoops, and some of the niches in the chancel, show traces of polychrome paint. The spiral staircase in the tower house can be climbed to the top.

18 Jerpoint Abbey

572 402

1.5 miles south west of Thomastown in the Nore Valley. Signed.

This has an excellent small visitor centre with information about other sites in the area. An effigy of a harper and his wife by Rory O'Tunney is on display there.

Jerpoint was established by Donnchadh Mac Giolla Phádraig (Kilpatrick), king of Ossory, for the Cistercians around 1180. Monks

came here from their mother abbey at Baltinglass in Wicklow. Later, as it grew in size, it sent monks to Kilcooly and Kilkenny.

Like Baltinglass, it was placed under the authority of Fountains Abbey in Yorkshire in 1227, in an attempt to prevent the monasteries becoming Gaelicized. However, in 1387 the abbot was fined for breaking one of the Statutes of Kilkenny (see above) by allowing Irishmen to become monks.

For the Cistercians the issues were not just political. The French abbeys remained strictly bound by the rules of the order. In Ireland they were becoming lax. Land ownership and wealthy patronage were endangering the purity of a strict following of the rules of St Benedict. (see **Mellifont**, LOUTH)

And Jerpoint was wealthy. The abbey owned about 14,000 acres. They had forests and farms to administer and at one time their wool output dominated the wool markets of Britain. The old ways of Cistercian austerity had relaxed here. Their benefactors, the Butlers, Earls of Ormond, had acquired Kilkenny castle at the end of the 14th century and there was a close relationship between the abbey and the castle.

Much of the abbey was rebuilt in the 15th century with strong patronage from the Butlers, and the cloisters with their stone portrait gallery date to this time. A stricter adherence to the order might have lost us the very things we value most at Jerpoint.

At its dissolution, the abbey and lands were leased by the Earl of Ormond from the English crown.

Much of the abbey still remains, including the domestic buildings which follow the traditional Cistercian model. There are Romanesque details on the capitals in the nave and a low screen wall between the piers which date them to the 12th century. This wall would have separated the monks from their lay brothers.

But this abbey is famous for its carvings, especially the carved figures around the 15th century cloisters. They show just how far the Cistercians had come from the simple but grand arches of earlier abbeys with their motifs from nature, to this portrait gallery of the

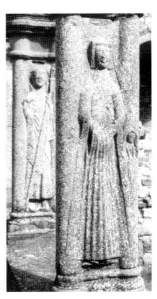

Cloisters, Jerpoint Abbey

LEINSTER **Kilkenny**

rich and famous. There is a strong European influence here with simple figures - geometric rather than naturalistic. The folds of garments and the subjects' hair are reduced to simple patterning.

Subjects include St Christopher, St Anthony, the Bishop of Cork, and the 4th Earl of Ormond and the Countess. They are recognised because of the presence of a tiny monkey, their family talisman since their pet monkey raised the alarm and saved the family from a house fire. Smaller figures appear to represent the sins of gluttony and sloth.

The church itself contains some fine sculptured tombs, many the work of Rory O'Tunney, and some signed by him. There are two altar tombs with effigies of abbots on the north side of the chancel. The one in the east, Felix O Dulany, was the first abbot of Jerpoint to be buried here (in 1202) and so has the first position in the east. His face is rubbed smooth from people touching his eyes for a cure. They both have their heads facing east so that they will rise to face their congregation at the Day of Judgement.

On the other side of the chancel is a simple figure, a young boy in short dress. No one knows who he was or why his effigy was made. He has been named Thomas.

There are two other tombs in the north transept, one is the tomb of the harper and his wife. Their effigies are in the visitor centre. Around the tomb apostles stand as their weepers: *SS Catherine, Michael,* and *Margaret of Antioch. Simon the Zealot,* who was cut in half, is depicted with a saw. Philip is pictured with loaves and fishes and here also are *Bartholemew and Jude.* Note Philip's long fingers, an O'Tunney signature.

Margaret of Antioch is always depicted with a dragon beside her. This is because when she was thrown in prison for her Christian beliefs, a dragon appeared in her cell. She immediately started blessing herself with the sign of the cross. As the dragon began devouring her, the cross expanded and split it in two. She was reborn from out of the dragon and since then she was considered the patron saint of childbirth.

Beneath the tower is the Robert Walsh and Katerine Poher tomb and in the south transept are two knights in armour.

Fragments of frescoes on the north chancel wall show armorial shields. This perhaps shows, more than anything, just how far the monks of Jerpoint had moved from a simple monastic community.

From Jerpoint Abbey, go south on the N9. After 0.5 miles, turn right by a grotto and follow signs to Belmore House. Stop at the house and ask directions to Newtown Jerpoint.

Newtown Jerpoint

568 404

Across the fields is the site of a deserted medieval town and
ruined parish church of St Nicholas.

This was once a large town, but the streets are barely visible now, slight hollows in the grass. The town was abandoned in plague times, but in the graveyard is a damaged 14th century effigy of an ecclesiastic. Local lore has it that the Knights of Jerpoint exhumed and brought back the remains of St Nicholas from the Holy Land at the time of the crusades. He is now said to rest beneath this slab.

Nearby is a circular stone, the base and socket of the town's market cross.

19 Knocktopher

534 372

South west of Jerpoint on the N9.

There is very little left of the medieval church of St David except for the west tower, once the church porch, and a fragment of wall. Inside the tower is the famous 15th century double effigy tomb. The gate is locked to keep it safe but it is still possible to see it - just.

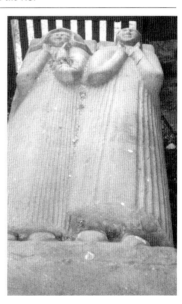

Beside it are two unusual cross slabs. The taller one has a small cross at one end and a border of uneven zigzags on either side. About two-thirds of the way down, a single line spirals out from the

Double effigy tomb, Knocktopher

border. The other smaller slab has a much bolder cross with a tiny circle at the centre and slightly broadened terminals. It too has zigzags either side of the cross. Either side of the top of the cross are two small carvings like tiny crosses with semi-spirals for arms. By the remaining church wall is another tomb, this one dated 1622.

LEINSTER **Kilkenny**

20 Kells Priory

About 10 miles south of Kilkenny on the R697.

This is a strange place. In the 6th century St Ciarán of Seir founded a monastery here on the south side of the river. Then towards the end of the 12th century Strongbow's seneschal of Leinster, Geoffrey de Monte Marisco, erected a motte and bailey here as well as founding an Augustinian Priory. The priory was to house the Canons Regular of Bodmin in Cornwall.

The town which grew up around the motte had a stormy history and the priory was fortified with a high curtain wall and six square towers. It feels more like a fortified medieval city than a priory. It is divided in two by a branch of the river. The church and claustral buildings are in the north court.

Kells Priory

In the north transept there is a stone slab with two heads carved in high relief.

When I visited, restoration work was in progress which unfortunately included the use of weed-killer: particularly unfortunate as quantities of weld (Reseda luteola L) and great mullien (Verbascum thapsus L) had previously been found growing just outside the prior's tower.

Weld is an alkaline loving plant, important to beekeepers and an excellent source of yellow dye. It was also used in treating skin problems.

The flowers of great mullien were used as an infusion to induce sleep and encourage calm. They were used with olive oil in ointment for earaches, bruises and to clean wounds. They were also used for bronchial complaints. Mullien also yields a yellow dye. Its seeds can remain viable for hundreds of years and it is quite possible that these plants formed part of the monks' medicinal herb garden.

A 17th century account says that great mullien sap cures warts and takes wrinkles from the skin. When it is rubbed on the hands and the hands held over water, fish are attracted and can be lifted out of the water. The seed does in fact contain a narcotic which has been used to sedate fish. The seed was also used in the First World War as a painkiller. (*Archaeology of Ireland*; 14.3.53, p13)

21 Kilree Monastic Site, Round Tower and High Cross

497 409

1.5 miles south of Kells. Signed.

This is a lovely circular walled site full of big trees and reminiscent of Monasterboice. It feels like a shrine.

The church was enlarged in the Middle Ages with the addition of a chancel and rounded arch, but it still has antae and a lintelled doorway. In the chancel there is a 17th century tomb with an equal-armed cross on the side, circled with a crown of thorns. It is surrounded with every passion symbol you could possibly think up.

The round tower is almost 100 feet tall, but without its cap.

Across the field is a fine sandstone high cross with carved bosses, spirals and some figure panels - a potent mixture of the old and the new religions.

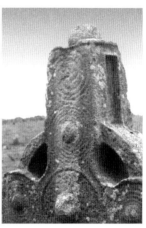

The east face has a central boss surrounded by knotwork enclosed in a moulded ring. This occupies the place later taken by images of the risen Christ as the *Light of the World*. Instead, in this earlier symbolism, we have the sun at the centre surrounded by knotwork symbolising the physical plane and encircled by a ring, symbol of the dawn or return of the light. In Irish 'dawn' is called 'fáinne an lae' meaning the 'ring of day'. This is an image of the Light of the World

Spirals on High Cross, Kīlree

expressed in the old tradition. The rest of this face is covered with key-patterns, spirals and interlacing, except for the arms which have each a very worn figure panel.

The west face has a central boss with four outer bosses around it. The central boss is in the place of the later crucifixion scene. Here the sun is at the centre. The bosses on either side are surrounded by tightly coiled spirals: the left spiral goes clockwise and the right spiral goes anti-clockwise, similar to the spirals either side of the vertical line on the entrance stone at Newgrange in Meath. Jacob Streit, author of *The Sun and the Cross*, suggests that these two spirals represent spring and autumn respectively. The top spiral opens upwards and arcs round into a triple spiral, representing the fertility of summer. Below the centre, the lower boss has no spiral, representing the stillness of winter. In this way he sees the cycle of the year expressed from the left arm of the cross around the four points in a sun-wise direction.

This makes perfect sense. It is a truly beautiful cross.

LEINSTER **Kilkenny**

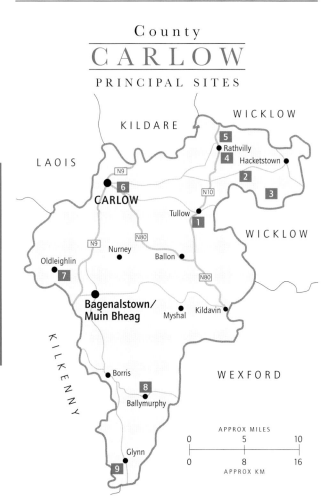

County
CARLOW
PRINCIPAL SITES

LEINSTER Carlow

1 **The Pillar Stones of North Carlow**
 Ardristan
 Aghade

2 **Tankardstown**
 Haroldstown dolmen

3 **Clonmore** monastic site and crosses

4 **The Six Fingers**

5 **Waterstown** monastic site

6 **Brown's Hill** dolmen

7 **Old Leighlin**

8 **Rathgeran** rock art

9 **St Mullins**

Block figures in list refer to site locations in map and entries in text.

CARLOW

CARLOW IS PART OF THE TERRITORY of the goddess Carman, one of the Leinster goddesses. She is still present here in the south east, as the river Garman, although that river has now been renamed the 'Slaney'. The name 'Slaney' comes from the first king of Leinster to rule from here. He is said to have been called 'Sláinge' and was one of the sons of Parthalón, who ruled Leinster from Slane to the south coast, when Ireland was first divided between Parthalón's four sons. The king or rí of Leinster was sometimes known as 'Rí Carmain'. The royal seat of Leinster later moved to Dún Ailline in Kildare.

Along the banks of the Slaney and its tributary, the Dereen, there are a number of grooved pillar stones of a kind found nowhere else in Ireland. There are about eight of them here, around Rathvilly and Tullow. They are made of coarse granite with felspar crystals and they have deep grooves running vertically up the stones. A number have six grooves, but some have five or less. They can be up to 6 foot tall.

The new *Archaeological Survey* suggests that the grooves occur naturally, but it is by no means sure. There is no real understanding of them or how they came to be marked as they are. However, they are also found in Brittany where they are thought to be early Iron Age.

Maybe it is because they are near the village of Rathvilly, which means 'the fort of the sacred tree', but to me they bear a striking similarity to the ancient tree stumps from neolithic times that were swallowed by the encroaching bog. There are other examples of stones symbolizing sacred trees, such as the stone 'tree' at Lough Gur in Limerick. This stone makes a strong link between the symbol of the sacred tree or the 'tree of life' and ceremonial stones such as Turoe. The tradition of the sacred pillar continued into Christian times in the south east of Ireland with some of the finest high crosses in the country.

Though Carlow has few high crosses, it has its own tradition of sacred trees. The Yew of Ross, one of the five sacred trees of Ireland, is supposed to have grown near Old Leighlin, on the river Barrow. It was called the 'Eó Rossa' and is mentioned in the 12th century *Book of Leinster* in a litany recounting the tree's virtues in metaphor.

Carlow town is in the north, and home to one of Ireland's most famous dolmens, Browne's Hill, with a cap-stone estimated to weigh 100 tons.

1 The Pillar Stones of North Carlow

These are made mostly from coarse granite studded with small velspar crystals. Current thinking is that the grooves occur naturally. They are generally smooth and concave with velspar crystals jutting out in them. It is certainly hard to see how they could have been carved this way. However, this could be a result of very slow erosion of the granite leaving the felspar exposed.

Some of the stones are associated with cist burials and pottery sherds. (JRSAI 1939)

Ardristan Grooved Pillar Stone

842 713
Take the N81 south out of Tullow. 2 miles from the town centre, there is a right-angle bend to the left. Turn in to the left onto some waste ground. The stone is in the middle of the next field.

This is possibly the finest of the grooved granite stones in north Carlow. It is roughly square in cross section and stands about 9 feet high. There are six vertical grooves from the top of the stone, stopping about 2 feet 6 inches from the ground. They are concave in cross section, smooth granite hollows with small velspar crystals sticking out from the surface.

There is another standing stone in the next field to the west. It is not grooved.

Ardristan grooved pillar stone

Aghade Holed Stone (Cloghaphile)

847 693
2 miles south of Tullow. 1 mile further down the road from Ardhistan. It is signed. Go into the avenue and the stone is just in on the left, behind the hedge and leaning against it.

'Clochaphoill' means 'holed stone'. This is a large granite slab with a 6 inch circular hole near the top. It's similar in proportion to the Doagh Stone in Antrim which has associations with fertility rites. At Aghade, young babies were passed through the hole to ensure good health.

Tradition has it that Niall of the Nine Hostages tied Eochaidh, son of Énna Cinnselach, to the stone, using a chain through the hole. Eochaidh broke free, killing nine of Niall's men. This may be connected to the uncovering of a great number of skeletons and some urns and cremated bone in 1939 in the ground between the Cloghaphile and the village of Aghade.

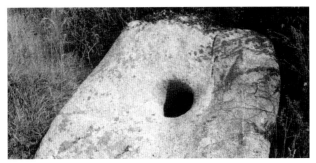

Aghade holed stone (Cloghaphile)

2 Tankardstown

870 772

Go north of Tullow about 2.5 miles and take the Hacketstown road. Turn left at the first crossroads and the stone is in on the left behind the houses.

This stone is about 6 feet high and roughly square in cross section. Its girth is about 5 feet and the grooves are short. They appear to radiate from a centre point on the top of the stone.

Haroldstown Dolmen

902 779

On the south side of the R727 from Carlow to Hacketstown just as it crosses the river Derreen. 4 miles north east of Tullow.

This is a very aesthetically pleasing structure. It has an unusually large chamber 13 feet long and up to 9 feet wide. The portals face north.

Some of the uprights may have been removed during its 19th century time as home to a destitute family. There are two cap-stones, one 12 foot long and resting on a smaller one at the back.

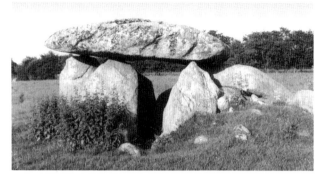

Haroldstown dolmen

3 Clonmore Monastic Site and Crosses

3 miles south of Hacketstown in Clonmore village. It is signed.

'Cluain Mór' means 'the big meadow', in this case 'the Big Meadow of St Maedhog'. This was not the Maedhog of Ferns (see WEXFORD). St Maedhog was of the race of Cathair Mor, a Leinster family.

Many saints were associated with Clonmore and many are said to be buried here. St Finan the Leper is one. He was in charge of the monastery in the middle of the 7th century. It is said of St Finan that when a mother brought him her child who was blind and dumb and afflicted with leprosy, he petitioned God for a cure. God replied that he must be willing to take on the leprosy instead. St Finan agreed and so became St Finan the Leper.

Another saint associated with this monastery was St Onchuo who was an excellent poet from Connacht. He had the idea to travel around Ireland to all the monasteries and holy places and collect relics of the different saints. Towards the end of a successful mission, he arrived at Clonmore and asked Maedhog if he could have some memorial of him. St Maedhog did not know what he could give and so he refused. Immediately one of his fingers

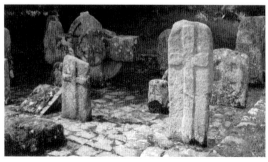

Clonmore crosses

dropped to the ground and Onchuo picked it up for his collection.

Maedhog was then supposed to have said to Onchuo that all the relics which he had collected would belong to Clonmore from then on, and that Onchuo himself would be interred there as well. And so it was.

In a verse from St Moling we hear:

> Dear the two who are at rest
> At the cross with relics in the south,
> Onchuo who loved not a despicable world,
> Finan the Leper, Onchuo a forceful man
> A poet vigorous in quelling tribes.
> At the place where the tree falls
> It is not easy to carry off its top.
>
> (*The Festival of Lughnasa*)

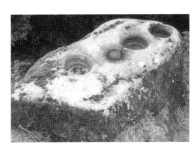

Bullaun, Clonmore monastic site

The list of saints is long and Clonmore came to be known as the Angelic Cemetery because they were all interred there. As if to verify this, there is a large collection of cross-inscribed stones now in the village graveyard which is cut through by the road. Some are simple, some ornate. One is the head of a massive ringed cross with small wheeled crosses at the centre of both faces. There are other slabs with crosses in relief and false relief. There is also a medieval grave slab with a tree of life.

Just west of the graveyard, by the roadside, is a massive granite bullaun with 3 large basins. Across the road is a holy well and garden and beside it is also a large plain wheeled cross.

4 The Six Fingers
912 799
2 miles south east of Rathvilly in Williamstown. Go east of Rathvilly about 5 miles to the first crossroads and turn right at the motte. Keep left at the fork after about a mile and continue 1.3 miles further. The stone is visible in the field on the left.

This is another impressive grooved pillar stone. It is 6¹/₂ feet high with a girth of 13 feet at its widest point and circular in cross

LEINSTER Carlow

section with one flat side facing north. It tapers upwards with five grooves running from about 2 feet off the ground to the top. It has six grooves, like the stone at Ardristan.

There's a local story that it was thrown here from Eagle's Hill, near Hacketstown, by Fionn mac Cumhail. It is supposed to slip down to the river to drink at night. (*Prehistoric and Early Christian Ireland*)

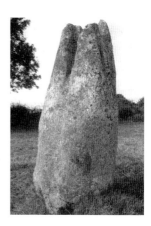

The Six Fingers

5 Waterstown Monastic Site

889 827

1 mile north east of Rathvilly. Go east of Rathvilly about 0.5 miles to the first crossroads and turn left. About 0.5 miles on the left there's a small opening in the hedge with a stile into the field. The site is a small wooded mound in the field.

The remains of a small rectangular structure are just visible, but on top of the mound two crosses have been erected. One is a plain, quite worn ringed cross with deep mouldings. Its base is original. Nearby is a small limestone medieval cross with ring but no projecting arms, set in a granite boulder. On one side is a *Crucifixion* in the Romanesque style. Some pattern can just be seen on the back.

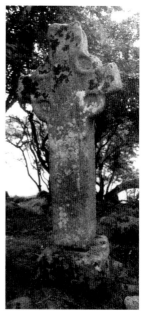

From the mound, continue south west on the other side of the hedge just north of the mound. This path leads across fields and over stiles to St Patrick's well and onto a back lane into Rathvilly. This was the old pilgrims' route.

Across the road from the gap in the hedge sits a bullaun well set in a small wall with a covered arch. There are offerings placed around the bullaun.

Waterstown Cross

6 Browne's Hill Dolmen

Take the R726 east out of Carlow for about 2 miles. It is signed on the right.

Borlase claimed that this was the largest cap-stone in Europe. It is about 20 feet square and 5 feet thick and estimated to weigh about 100 tons. There are three 6 foot uprights and two recumbent stones at the other end. There is no clearly defined chamber, but the portals open east.

It is one of three in the area, described by Borlase at the end of the 19th century, and drawn by Margaret Stokes. He describes another two as being 50 yards north and south of each other. There is now no trace of them.

This is a stunning monument. It is a clear reminder that the cap-stone was more than just a roof. The bigger the cap-stone, the more potent the structure. There seems to be a parallel here between the cap-stone covering this chamber and the cairn material covering the chamber of the passage cairn at Newgrange.

7 Old Leighlin

2 miles west of Leighlinbridge.

The early monastery was founded here by St Gobban who was visited by a host of angels one day while he was preaching. They said that soon a saint would come who would gather together as many servants of God as there were angels. This was St Laisrén (he died in 639), and when he came, St Gobban resigned the monastery to him and retired to Killamery in Kilkenny.

Before the year 630 the pious St Laisrén had attracted a reputed 1500 monks, making Leighlin one of the foremost monastic churches of Leinster. We know this because in 630 there was a synod here to discuss the dating of Easter.

In 625 AD the Council of Nicaea had decreed that the date of Easter was to be standardized throughout the Christian world. The Celtic church were very reluctant to conform. At the synod here, St Laisrén spoke eloquently in favour of the change and was sent as a delegate to Rome. This remained a controversial issue, but eventually the south of England, led by Canterbury, conformed. Ireland and the north of England eventually followed suit in 664, after it was accepted at the Council of Whitby.

From then on, Easter Day was to be the first Sunday after the first full moon following the Spring Equinox. This system is still in place.

In the 12th century, Leighlin became the see of the new diocese of Leighlin and the present cathedral was built. Shortly

LEINSTER **Carlow**

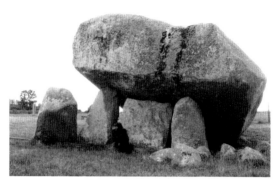

Browne's Hill dolmen

after it was finished, the transepts were added. Only the north one survives. A unique four-seat sedilia with carved heads was set into the south wall.

There is an interesting 16th century altar tomb decorated with ribbing to match that of the crossing vault, and from the early 20th century, there is a beautiful four-light window by Catherine A O'Brien. The cathedral is open from June to August on weekdays from 10 - 5pm.

St Molaise's Well at Old Leighlin

There is a small granite wheeled cross with mouldings on the edges in the modern enclosure of the well. It is dressed with clooties, usually tied to a nearby tree. Behind the well are three new yew trees planted to replace the famous Yew of Ross at Old Leighlin. The Yew of Ross, **Eó Rossa**, one of the five sacred trees of Ireland, is supposed to have grown near here, on the river Barrow.

It is mentioned in the 12th century *Book of Leinster.* The Lives of Molaise and Moling both tell stories of the falling of this tree in the 7th century. It fell during Molaise of Leighlin's lifetime and great care was taken as to what happened to the wood. Molaise

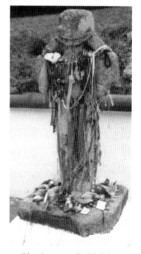

Clootie cross, St Molaise's well, Old Leighlin

shared it out, giving Moling enough for roofing his oratory.

Of the other five trees, **Eó Mugna**, an oak tree, grew near the village of Moone in Kildare. It was so broad, it covered an entire plain,

bearing acorns, apples and hazelnuts and never shedding its leaves.

Bile Uisnig stood on the hill of Uisneach. It is not clear where the other two grew. One was the **Bile Tortan**, an enormous ash associated with a traditional assembly place. Patrick built a church nearby. The fifth tree was the **Craeb Daithi** which was associated with a group of people called 'the Fir Bile' which means 'the Men of the Sacred Tree'.

The 18th April is St Molaise's day, when a service is held at the cathedral, followed by a procession to the well.

8 Rathgeran Rock Art

788 480

Take the R702 east to Ballymurphy. After about a mile, turn right up the hill and park by the lane on the right. Follow the lane as far as it goes. The rock is across rough pasture about 300 yards below the summit to the north west.

It is not easy to find, but well worth it - a journey best made in early spring when the grass is short.

'Rathgeran' means 'the Fort of the Rowan Trees'. The rock is probably an erratic, in other words, it's a natural outcrop. There are many examples of such stones being decorated in prehistory. It's not clear why this particular stone might have been chosen, though some smaller stones on the summit of the hill may be the remains of a hilltop cairn. This would mark it as a sacred hill and the association with rowan trees would certainly re-enforce that.

The rock is covered with eight groups of tightly spaced concentric circles, some of them interlinked. The symbols are similar to much of the carvings from the neolithic passage cairns, including the nearest one at Knockroe in Kilkenny.

9 St Mullins

It is well signed from Glynn village and other points on the R729 between Borris and New Ross.

St Mullins is one of the bigger monastic sites that dot the banks of the river Barrow. It sits on a wooded promontory on its east bank where a tributary joins the main river. The strong presence of Brandon hill is just across the river to the west.

St Moling is thought to have founded the monastery here in the 7th century (see also **Mullennakill**, KILKENNY). We know from the annals that he died in 697 and he is also recorded as a guarantor of the Cáin Adamnán, the law instigated by

Adamnán of Iona for the protection of women, children and clerics from violence.

These few dry facts are amply expanded by folklore and tradition which portray the saint as a great scholar, writer, poet, artist, prophet, teacher and engineer.

He is also remembered in less flattering ways. When he lived as a hermit in Mullenakill, Kilkenny, he was badly afflicted with sores on his legs. The cows belonging to a local widow used to come and lick the sores to help heal them, but this had the effect of making them give less milk. The woman was angry with Moling and he was so offended by her anger that he left Mullennakill and moved to St Mullins some 12 miles east.

Most of the monastic remains are in the graveyard of the Church of Ireland church. The early buildings from St Moling's

St Mullins

time are of course gone, but the Teampall Mór, or big church, probably dates to around 1000 AD. St Moling is said to be buried in the chancel. It is also supposed to be built on the site where Fionn mac Cumhaill camped out while engaged in defending the King of Leinster against unfair tribute demands from the King of Tara. That night Fionn mac Cumhaill was visited by a host of angels who told him of the coming of St Moling four hundred years later. (Moling's birth: see **Mullennakill**, CARLOW)

The tower, of which only the stump remains, would have been built around 1100 AD. Beside the big church is the even bigger 15th century church which was converted for domestic use. It is thought that a staircase connected it at one time to the round tower. Beyond it is a small oratory dedicated to St James.

South east of the churches is a granite cross. Part of the shaft is missing, but the figure of Christ and his disciples and the spiral ornament are typical of the Barrow Valley crosses. Outside the graveyard lies the Fair Green and the dramatic rise of a Norman motte.

Towards the end of his life St Moling was made Bishop of Ferns, but he later resigned so that he could return to St Mullins to

dig a water course to supply water for the monastery and power for the monastic mill. The course runs east of the monastery, beside the Aughavaud river, and into the Barrow to the south. When it was complete, he blessed the work and walked through the stream against the current, followed by the whole community. The practice of wading against the water remained part of the local pilgrimage in honour of the saint. It continued well into medieval times and in the 14th century at the time of the Black Death everyone came: bishops, lords and commoners - thousands of people wading through the water at any one time.

They also came on St Moling's day, 17th June, on 25th July for the feast of St James, and on the Sunday before St James' Day - called Sumaleus Sunday. This is also the time of Lughnasa, a popular time of assembly.

St Moling's Well is across the water from the monastery. If you go north from the churches and right to New Ross, it is signed as you cross the bridge. It is an unusual well with a rectangular stone house through which the water passes before it is accessible. From here people would walk up to the mill-race.

'Teampull na mBó', which means the 'church of the cow' is a small circular enclosure north of St Mullins. It has been used as a children's graveyard in more recent times.

The Book of Moling, now in the Trinity College library, has an interesting line drawing on its final page. There are two concentric circles close together which appear to illustrate the bank or wall of an enclosure. Outside it the four cardinal points are marked. A little to the right of each of them, there are four crosses: one for each of the four evangelists and inside each one are four more crosses for four Old Testament prophets. Matthew is in the south west with Daniel, Mark is in the south east with Jeremiah, Luke is in the north east with Isaiah, and John is in the north west with Ezekiel. Inside the enclosure are four more points, each also marked with a cross. One is Christ with his apostles and the other three are associated with the Holy Spirit, the gifts of the spirit and the angels. This seems like a very important plan which, if understood, would explain a lot about the significance and placing of crosses at monastic sites. Perhaps it forms a link between the old wisdom and the new religion.

Ogham gate-post, St Mullins

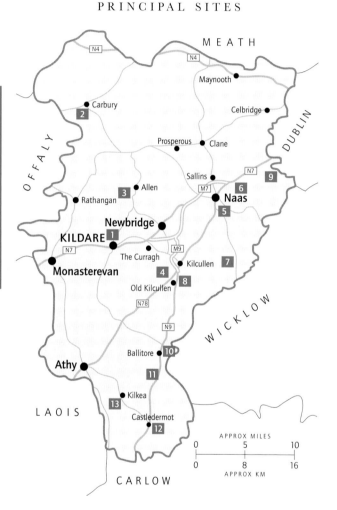

County
KILDARE
PRINCIPAL SITES

LEINSTER **Kildare**

1. **Kildare** - all Kildare sites (see text)
2. **Trinity Well,** source of the river Boyne
3. **Hill of Allen**
4. **Dún Ailline**
5. **Punchestown** The Longstone
6. **Longstone Rath**
7. **Broadleas Commons** The Pipers' Stones
8. **Old Kilcullen**

9 **Kilteel**

10 **Ballitore** Quaker village

11 **Moone** cross and well

12 **Castledermot** crosses

13 **Kilkea Castle** mermaid carving

Block figures in list refer to site locations in map and entries in text.

KILDARE

THE COUNTY NAME 'KILDARE' MEANS 'Church of the Oak', and is named after the monastery founded here by St Brigid. The name and person of Brigid has a long and venerable history going back to pagan times. There are legends of three different goddesses of that name associated with poetry, healing, fertility, smithcraft and fire. They were all daughters of the Daghdha, the father god of the Tuatha Dé Danann. One of his symbols was the cauldron of plenty, and all those connected with him, including Brigid, evoked a sense of bounty and plenty, symbolized by the Daghdha's cauldron. The different personalities of Brigid have been woven together into the saint of today who can be a strong-willed abbess, a generous hostess presiding over a large vat of ale and a compasionate helper of the needy.

The festival of Brigid is Imbolc, the first day of February and a Celtic fire festival. It celebrates the coming of spring and one of its first signs, the lactation of ewes. The goddess Brigid, as befits a daughter of the Daghdha, was reared on the milk of an Otherworld cow. The Christian saint, Brigid, was said to have been made ill by the pagan food of her foster father and so she was fed on milk from a mysterious white cow with red ears. Thus the goddess and the saint merge into one continuous Brigid whose influence is felt all over Ireland, but especially around the county town of Kildare.

The seat of the Kings of Leinster is here at Dún Ailinne. The mystical seer-king Findfile lived here and to the north west is Carbury, the source of the river Boyne, home of the goddess Boand and Nechtain the water god.

In the north east of the county are tall granite standing stones,
unique to this part of Ireland, called needle stones because they are
so slender and pointed at the top. The granite high crosses of the
Barrow Valley seem to continue this tradition, just as Brigid the
goddess becomes Brigid the saint.

KILDARE

BRIGID IS SAID TO HAVE ARRIVED HERE WITH HER NUNS in 480.
Her life before and after coming to Kildare has been coloured by
stories worthy of a saint following in the footsteps of the ancient
goddess. She was already associated with fertility and animals, with
healing and childbirth as well as poetry and the arts. In fact, there
were said to be no less than fifteen saints with the name of Brigid.
It is possible some of them may have succeeded her as abbess of
Kildare.

She became Abbess of a nunnery which some say evolved
from a sanctuary of Druidic priestesses. This sanctuary had a
tradition of perpetual fire tended by twenty priestesses. There are
similarities here with the perpetual fires of Vesta in Rome and
Hestia in Greece. These were also tended by virgins. The tradition
is that after Brigid's death, nineteen women continued tending the
fire, one each night for nineteen nights. Then on the twentieth
night, they would all sleep, having called upon her: "Brigid, keep
your own fire, for the night has fallen to you."

The next morning the fire would still be burning. This fire
continued, though there were attempts made to extinquish it as un-
christian. However, in 1220 the archbishop of Dublin finally had it
put out.

In 1993 the flame was relit by Mary Teresa Cullen, one of the
Brigidine Sisters in Kildare. Since then the sisters have kept the
flame alight at their centre, Solas Bhride.

Brigid's flame is also commemorated in the lighting of a fire on
her feast day at the fire site in the grounds of the cathedral. But the
quiet room where the Brigidine Sisters keep their flame alight all the
time, is a calm and lovely place where it's possible to sit for a while
to contemplate the many aspects of this remarkable goddess-saint.

For many centuries the abbess here ruled over two
communities - one of women - but also one of men, and even
the bishop was subordinate to her. There is a tradition that the
archbishop, moved by an inner guidance, read the order for
consecrating bishops over Brigid, rather than the ritual for veiling
a nun. In fact, such was the authority of the Kildare abbesses, that

they were the subject of a papal legate in 1151 to reduce their power.

Brigid is said to have invited Conleth, a hermit from Old Connell (Kilconnell) near Newbridge, to work with her. Her life is full of stories which show an intelligent, strong-minded and compassionate woman. According to Keating's *History of Ireland*, she died at the age of 87 or possibly 70 years. He suggests her name comes from Breo-shaighead which means an arrow of fire: and she is not inaptly so called, "for she was as a fire lighting with the love of God, ever darting her petitions towards God."

After her death, her fame was so great that the church was lavishly rebuilt in her memory. There's a 7th century account which describes the two tombs containing the bodies of Brigid and Conleth which were decorated with precious metals and gems and sitting one either side of the altar. The altar was adorned with ornaments of gold and silver. Crowns, also of gold and silver, hung above the tombs. A partition stretched right across the east end of the church, decorated and painted with figures and covered with linen hangings.

Brigid, who was said to have used the church vestments to clothe the poor, was probably turning over in her tomb.

LEINSTER Kildare

1 St Brigid's Cathedral

The remains of the High Cross of Kildare stand outside to the north west. It is undecorated.

The present cathedral has been destroyed and rebuilt many times but its basic structure is still early 13th century. Brigid is depicted in the stained glass windows with a flame above her head.

Inside the cathedral there is a 16th century tomb chest of Bishop Walter Wellesley. It came originally from the Great Connell Abbey and was reconstructed in the cathedral in 1971. The slab has a detailled effigy of the bishop with gloved hand raised in blessing. The surrounds are decorated with the Apostles, an Ecce Homo and a Crucifixion. Along its lower edge, almost out of sight, like the medieval imagination, are sprays of foliage, foliage spewers, a

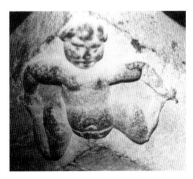

Acrobatic figure from Bishop Wellesley's tomb, Kildare Cathedral

green man, and two grotesque figures. One of these has been called a Sheela-na-Gig though it's more like a large curvaceous nude in acrobatic pose.

The stalls for the choir and chapter are made of oak and carved with acorns and oak leaves to illustrate Cill Dara which means the Church of the Oak.

There are some interesting gargoyles on the outsides of the transepts. Behind the south trancept, is the Wishing Stone. It is said that if you put your arm through and touch your shoulder, your wish will be granted.

The round tower bristles with lichen. It has been given a castellated top but retains its Romanesque doorway with three orders and hood moulding. It has been built with granite up as far as the door and the rest built from brown stone. Perhaps the granite was considered more indestructible in case of attack. You can climb it for a small fee.

St Brigid's Church

This is a remarkable building. It has a lovely light atmosphere which perhaps reflects a different aspect of Brigid than the dark medieval cathedral. The colours here are white, purple, and green.

The door has bronze panels with raised Brigid's crosses and bronze hands for handles. This is the hand of help and hospitality. As the hand of healing and creation, it figures also in a beautifully vivid painting of a hand incorporating three spirals in yellow, green and red.

St Brigid's Well

Just a mile from the town square. Follow signs for the Japanese Gardens and the National Stud, then turn right opposite the entrance to these. It is signed.

St Brigid's Well, Kildare

A stream called Bratog flows into this well at the top of a small garden. The water then flows through the garden beneath an arch and is channelled through two carved stone gargoyles, putting one in mind of two very pendulous breasts. They probably come from the nearby ruined abbey of the Black Knights or Knights of St John, but are known by the name of St Brigid's slippers.

There are seven stones to mark the seven stations in a turas that formerly took three hours to complete. The pattern here was stopped in the 19th century by the parish priest because of faction fighting. Now there are five stones, each representing different aspects of Brigid's life, to provide a focus for contemplation.

At Suncroft village, near the Curragh, is a limestone sculpture of Bríd (Breege) and the children by Anette McCormack. When she went to carve a small cross on Brigid's breast, she found there, in the stone, a fossil in the shape of a crescent moon.

The Black Abbey

The ruins of the Black Abbey are at the entrance to the Japanese Gardens in the grounds of the National Stud. This belonged to the Knights Hospitallers, also called 'the Black Knights'. (see **Kilteel** below)

2 Trinity Well, the Source of the river Boyne

Carbury is signed off the N4 at Innfield about 25 miles west of Dublin. Turn left in the village and stop at the big gates on the right, just by the left turn to Edenderry.

The well is inside the gates of Newberry House where parkland, now cattle pasture, extends either side of the avenue. The well has a stone canopy and is surrounded by a low wall. It is shaded by a large tree. The water is beautifully clear and rises through a sandy bed. It seeps out, creating a marshy area which becomes a slight trickle flowing under a tiny bridge used for traffic up to the house. This is the source of the Boyne and a quiet, gentle place.

The Boyne is closely linked with the goddess Boand or Bó Fhinn, the White Cow Goddess who is part of the earliest Irish mythology. She is said to inhabit a sí or mound here where Newberry house now stands, at the source of the river Boyne. The well is described as having nine hazel trees overhanging it. When the nuts fell into the well, their magical properties went into the water. It was said that anyone drinking its water in June would

become a poet. Board was, among other things, the goddess of poetry. She is mentioned in the ancient Brehon Laws as having her forearm covered in rings to bestow on poets.

In the distant past Carbury used to be known as 'Sidh Neachtain' which means 'the Fairy Mound of Neachtain'. Neachtain is mentioned in the *Annals of the Four Masters* as a Tuatha Dé Danann leader and king of Ireland for one year in 45 AD. He is variously known as Neachtain or Nuadha and also as the magical figure Neachtain, the water god, whose main task was to care for this well and make sure its power was not unleashed in a destructive way. There are a number of versions of the following story:

Neachtain and Board were married but she was never allowed to visit the sacred well with her husband. He and his brothers were the keepers of the well and even its location was kept secret. They made regular visits there and on one occasion, overcome by curiosity, Board followed them. Later she went back by herself and tasted the forbidden water which then rose up and overwhelmed her, flowing out to the sea and forming the sacred waters of the river Boyne, a watery embodiment of her spirit as the goddess Board.

The pattern is still held here on Trinity Sunday, the first Sunday in June. It is one of the few patterns in the country where the secular and carnival aspects still survive. The rosary is recited and then everyone drinks from the well. The priest has the first drink, but the water is handed out by a local family who have the hereditary right to this task.

Afterwards there is a football match and running and jumping competitions. There are stalls selling refreshments and there is dancing in the evening. The usual faction fighting seems to have occurred here, but was apparently stopped by the local clergy.

Tradition has it that once the landlord closed up the well so that local people would not have access to it, but the well came up inside the big house and he was forced to reopen it.

Turn right in the village to Carbury Hill whose mound is Sidh-Neachtain, the fairy mound of Neachtain.

3 Hill of Allen

Go North of Kildare on the R415. About 3 miles north of Milltown, the hill is on the left. There's a layby here with some granite boulders and a path up the hill from the layby.

This hill is associated with one of Ireland's most famous heroic figures, Fionn Mac Cumhail. His name, which means 'fair one', links him closely with the much older Findfile, the mythical Leinster king who was the son of the river goddess Board (see **Dún**

Ailline). There are different stories telling how he got his name. In one, he wrestles and overcomes nine other boys in the water. In another, he falls into the water when he is nine years old and his hair becomes white or fair.

Cynics have suggested that this Celtic hero was brought into being to boost Leinster's struggle against the Uí Néill from the north who had driven them from their homeland in the Boyne Valley. By re-weaving old myths they were re-establishing their sacred right to hold the land which had been peopled by their ancestors.

Fionn received the gift of second sight or knowledge directly from Findfile who appears in the story as an old man fishing on the banks of the Boyne. He was fishing for the famed Salmon of Knowledge. This salmon had eaten the hazel nuts which had fallen into the well at the source of the river (see **Trinity Well**). Whoever ate the salmon would have the gift of second sight. The old man caught the salmon, but left Fionn to mind it while it was cooking, confident that only someone with the name of Fin or Fionn could eat it and gain the knowledge. He had, of course, neglected to ask Fionn his name. Fionn touched it with his thumb to see if it was ready, burnt his thumb and then licked the burn. This was enough. When Findfile returned, he could see what had happened. Fionn grew up to become a hero and leader of the band of warriors, known as the Fianna.

There's a path up the hill through the forest to a 19th century tower on the top. Only half of this historic hill is left and a climb to the top of the tower shows just how close the Roadstone quarry has come to the centre of the hill.

The folly tower was built by Sir Gerald George Aylmer Baronet in 1880 in thankful remembrance of God's mercies, many and great. It is open. A rusty iron door leads to a spiral staircase which gives access to the open top of the tower. The views are stunning. I was told at a house nearby that with a good pair of binoculars on a clear day you can see the people walking down O'Connell Street in Dublin. It certainly feels like you can see forever.

4 **Dún Ailline**

The hill is west of the N78 south of Newbridge. This is a wide expansive hill just across the N78 from the smaller hill at Old Kilcullen. It is impossible not to feel a connection between the two hills from either summit. The N78 follows an ancient roadway.

Dún Ailline is topped by a massive hill enclosure with an almost

circular earth bank up to 15 feet high in places and enclosing an area of about 20 acres. It has an internal ditch, like the site at Emhain Macha in Armagh, implying that the enclosure was not built for defence purposes. The fosse or ditch is up to 6 feet deep in places. Dún Ailline is said to have been the royal seat of the Kings of Leinster and in use since the Bronze Age. However, very little is known about it.

It was excavated between 1968 and 1974 and a succession of wooden Iron Age structures were uncovered. In its last phase the enclosure held a series of concentric palisades with a circular building at the centre. This building was surrounded by large free-standing timbers, possibly up to 13 feet tall, forming a kind of wood-henge inside the pallisades. There are some echoes here of the structure at Emhain Macha, though that was deliberately set on fire. The henge here was simply dismantled at a later date. It was certainly a ritual enclosure, possibly suggesting a grove of sacred trees known in Celtic times as a 'nemed'. A Bronze Age cairn was found on the top of the hill with some evidence of re-use in the Iron Age.

This site is also associated with Findfile, a mythical early king of Leinster. His name means 'fair seer' or 'poet' and he was said to have been born from Boand (see **Trinity Well**) emerging from her out of the water. His father was the rays of the sun. He was subsumed later by the mythical Celtic hero Fionn mac Cumhail. (see **Hill of Allen** above)

5 The Longstone at Punchestown

3 miles south east of Naas on the R410. Turn right at the crossroads. The race-course is well signed. The stone is just north of the race-course on the same side of the road.

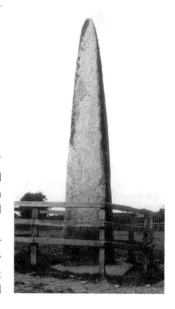

This road forms part of an old route running south west from Dublin and known in medieval times as the Woolpack road.

The longstone is a slender granite stone tapering finely and standing 19.5 feet high. It fell in 1931 and was re-erected

several years later. The full length of the stone was found to be 23 feet and it weighed 9 tons. It stands in a stone-lined socket which had a cist or small stone box to the south west. This was found to be empty but probably dating to the Bronze Age.

The fact that the stone fell suggests that it may have already been disturbed at the base and possibly the contents of the cist removed.

There is another similar stone about 0.5 miles south west of here, on the opposite side of the road, in a field just opposite the entrance to the race-course. Known as **Craddockstown West Pillar Stone**, it is slightly tilted.

6 Longstone Rath at Furness

3 miles east north east of Naas and 1 mile south east of Johnstown. It is in the grounds of Furness House - please ask first. The site is on top of a low wooded ridge on the northwest side of the Wicklow mountains. Interestingly, it is also beside the old Woolpack road mentioned above.

This is a spectacular perfect circle formed by a 10 feet high earth bank and enclosing an area of 190 feet. Unusually, as this is considered to be a ceremonial site or henge, there was a deep fosse, still visible in places, around the outside of the bank. Fosses or ditches are generally on the inside of ceremonial enclosures.

There are two original entrances in the east and west and in the centre there's a slender granite pillar stone some 17.5 feet above ground. Its total height is 21 feet. We know this as it was re-erected in 1912 after excavations at the site. It is very similar in shape and size to the Punchestown stone.

Excavations also showed that the central area of this rath had been a fire site, probably used repeatedly over a long time. It was then covered with a low mound of earth and stones about 2 feet high. The base of the pillar had been set into a stone socket, like the one at Punchestown, and there was a long stone cist or box with no lid about 8 feet long and 3 feet wide extending from the base of the pillar. In the cist were found the cremated remains of 2 adults. With the remains were a polished stone wrist-guard, a flat stone bead and fragments of late neolithic pottery.

Other Needle Stones include the **Longstone Stone**. Turn right at the first crossroads 1.2 miles south of Ballymore Eustace on the R411. Cross one crossroads and the stone is in the grounds of the second house on the right. This townland is called Longstone after the slender granite stone now lying here in the grass. It is broken at the tip and possibly the base as well. There are 3 rough crosses carved on it.

Kilgowan Standing Stone and Circle. This is up on the east side of the N9, 4.5 miles south of Old Kilcullen. It appears to be a small barrow with a pillar stone at the centre.

7 The Pipers' Stones, Broadleas Commons
To the right, 1.5 miles south of Ballymore Eustace on the R411 just before the second crossroads. Visible from the roadside.

This is an almost continuous circle of granite boulders with some quartz and a little sandstone. The stones are asymmetrical boulders, mostly as broad as they are tall.

Ancient rowan and thorn trees grow through the circle and one boulder is split through by the roots of a holly tree.

Stone split by holly tree, the Pipers' Stones, Broadleas Commons

8 Old Kilcullen
The site is south of Kilcullen town on the N9 to Carlow. The old churchyard is up above the road on top of a gently sloping hill with fantastic views.

The early monastery was founded by St Patrick who left St Iserninus here as its first bishop. He died in 469 and one of his successors was St Mac Táil who died in 548. The community here had a very turbulent history with Viking raids recorded in the 10th century and further plunder and burning over the following centuries.

A drawing by the antiquarian, George Petrie, shows a church here with a beautiful Romanesque western doorway with four orders. All trace of it has disappeared this century.

In May, during the 1798 rebellion, there was a battle here between rebels entrenched behind the graveyard wall, and English soldiers led by General Dundas. The round tower with its rounded doorway was badly damaged in the exchange.

There are two granite cross shafts, one with only the panels

outlined and the other, smaller one, carved with some interesting and unusual images. Unfortunately, when it was re-erected on its present base, some of the lower side panels were chiselled away to fit it in the socket. The shaft may not be sitting in its original position.

On the west face from the bottom is a row of human heads. The lower part of the panel has been destroyed. Above this Balaam can be seen riding on his ass which he strikes with a staff. He is on his way to curse the Hebrews and is prevented by the Archangel Michael who stands in front of him with his sword unsheathed. This is an unusual subject, not found on any other high cross in Ireland. Above that, Samson is pulling back the lion's head as he kills it and above that is a riding figure with a dog. The east face has three panels of four apostles each. The south side has three interlace panels.

The north side has David climbing on the lion's back as he struggles to kill it. Above that is an interlace panel and above again is a strange image of a bishop with book, bell, crosier and axe. It is suggested that this is St Mac Táil who was the son of a carpenter, carrying one of his father's tools. His crosier rests on the prostrate body of a man, possibly illustrating a common miracle of the time, the raising of the dead using the saint's crosier. He is also said to have been one of St Patrick's smiths who was skilled in making bells.

This is an interesting and surprisingly well preserved cross shaft and the site also is very special. It has a lovely gentle feel to it in spite of its turbulent history and this is only possible in places where the natural energy of the landscape is very strong.

9 Kilteel

Kilteel village is 4 miles south west of Rathcoole which is on the N7 south west of Dublin.

This tiny village in the foothills of the Wicklow mountains looks right across the plains of Kildare. It sits above the ancient roadway going south west out of Dublin. Little is known about the early monastic settlement here except its name - 'Cell Céli Críst' - which means 'Together in Christ'. However, early in the 13th century, Maurice FitzGerald built a castle here for the Knights Hospitallers of St John of Jerusalem.

The Knights Hospitallers were brought to Ireland by the Anglo-Normans in 1172, about the same time as the Knights Templars. They had three sections: militia, chaplains, and infirmarians originally to protect, heal and minister to pilgrims to Jerusalem. They took vows and lived under a form of Augustinian

rule like other monastic orders but, unlike other orders, they had a military wing and were used by the Anglo-Normans to consolidate English rule along the borders of the Pale and subdue local dissent. They lived in fortified accommodation and operated a kind of feudal system with local landowners providing armed men to the castle or paying fees in lieu. And while they did indeed have hospitals, these were primarily for the care of their own members. By the 14th century some Irish names appear among their members. They were suppressed in 1540, like other monastic orders, and in the case of Kilteel, lease of the preceptory and lands were given to the Alen family.

A 15th century tower house is all that is immediately visible when you approach the village. This is in good condition with five storeys and a round tower on one corner housing the spiral staircase. A key is available nearby.

However, if you look carefully across the fields, there are isolated pieces of stonework here and there among the grazing cattle, fragmentary remains of a once powerful presence. This is one of those places where a small community today lives within the aura or shell of a more powerful and almost tangible past.

A small Romanesque church is visible from the castle and accessible from the road downhill from the village. The church is ruined but inside are the remains of some wonderful stone carvings which are, for me, the main reason for visiting Kilteel.

The pillars of the chancel arch are carved with faces with interlaced beards, embracing figures, acrobats, and a carving of David with Goliath's head on a pole. These are some of the loveliest and least known stone carvings in the county.

10 Ballitore Quaker Village
Just north of Moone is Ballitore, a half deserted village which began as a Quaker settlement. The old meeting-house is now a library and museum.

11 Moone Cross and Well
Moone is signed off the N9 Dublin to Carlow road, about 11 miles south of Kilcullen and 6 miles north of Castledermot. It is just west of the N9

This is the site of an early monastery attributed to St Colmcille in the 6th century. The name 'Moen' or 'Móin Cholmcille' means 'St Columba's Bog'.

In 1835 the high cross was found buried in the ground. It was

re-erected inside the ruined church. The church probably dates to around 1300 and would have been part of a Franciscan friary which was abandoned in 1541. There are fragments of another cross also on display in the church.

The Cross of Moone is a granite cross, part of a group loosely called the Barrow Valley group, all carved in granite. It is thought to be 9th century. People have, mistakenly I think, attributed the simplicity of the images to the hardness of the medium. It is true that the carvings are in low relief and the style is naive, reminiscent of Iron Age figures, such as the Janus figure on Boa Island in Fermanagh. However, it is clear that realism is not being aimed at. Rather, the carvers

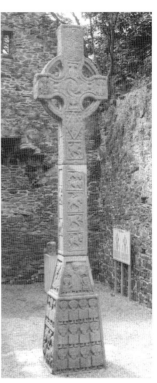

High cross, Moone

seem to be using the power of a much older totemic style to give a different kind of potency to Judaic and Christian images.

Perhaps that is why this cross, more than any other in Ireland, puts me in mind of a totem pole. The style of carving takes us back to an older tradition and contains within it the power of totem conveyed in that tradition. Each image is separate and complete in itself and each fits perfectly within its panel, displaying a perfect sense of space in design. Far from being limited by the material, these carvers have harnessed the power of the stone. Although separated by perhaps a thousand years from the Bronze Age builders of the slender granite pillar stones of North Kildare, they were working in the same tradition.

There is no need to detail every panel here as there are information boards at the site. However, *The Parable of the Loaves and Fishes*, *The Flight into Egypt*, and *The Three Figures in the Burning Fiery Furnace*, all on the south side, are especially fine. *Daniel in the Lions' Den*, at the base of the east face, has seven lions and the Tree between *Adam and Eve* is absolutely laden with fruit. The centre of the west face is carved with the old power symbols of spirals, circles and diamonds, while *Christ in Triumph* is relegated to the top panel

LEINSTER Kildare

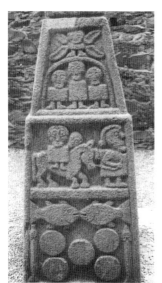

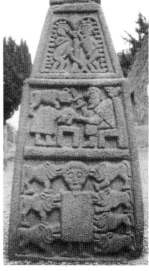

Detail on the south side,
Moone high cross

Detail on the east face,
Moone high cross

of the base. The fabulous beasts which appear on every side, relate to the Slievenamon group (see TIPPERARY), as do the spirals of the west face.

Near the entrance to the church and through the nearby farmyard is **St Patrick's Well**. If you take the small back road on the right as you leave the cross, staying on the west of the river, you will be going south but parallel to the N9. After 1.3 miles from the turn you come to another holy well in a field on the left. The water here is clear and clean and the well is surrounded by a circular stone wall.

One of the five sacred trees of Ireland, **Eó Mugna**, an oak tree, grew near the village of Moone. It was so broad, it covered an entire plain, bearing acorns, apples and hazelnuts. It never shed its leaves. It was named 'Greater of Sister's Sons'. Ninine, the poet, destroyed it, after the king had refused one of his requests.

12 Castledermot Crosses

The crosses are in the graveyard of the Church of Ireland church to the east of the town.

'Dísert Diarmada', or 'Díarmait's Hermitage' was founded in 812 by the Ulster prince Díarmait Ua h-Aedo Róin, a student of Bangor and a member of the Céle Dé. He died in 825. The Céle

Dé movement was attempting to reform what they saw as a corrupt and increasingly secular church. Their members preferred to live as hermits with a simplicity that they associated with the purity and vigour of the earlier monasteries.

The site was plundered by Vikings twice in the 9th century and is mentioned again in the *Annals of the Four Masters* , when the Bishop of Cashel, Cormac Mac Cuilleannáin, was buried here after having his head cut off in battle in 908. The monastery is last mentioned in 1073.

Inside the churchyard gate is a reconstructed Romanesque doorway which would have been part of a now vanished 11th century church. The round tower which was crennelated in medieval times, stands 66 feet tall.

Besides the crosses, there is an early granite cross slab with a hole at the centre of the cross. This is called 'the Swearing Stone', used at one time to seal bargains and swear oaths. There is also a 'hogback' stone, possibly related to those known from Viking Northumbria.

The two crosses are part of the Barrow Valley group. The north cross has interlocking spirals on two sides of its base. The other sides show a fine illustration of *The Loaves and Fishes* and, on the north side, a crouching, bound figure, possibly representing Evil. The east face has *The Crucifixion* in the centre panel with the 12 Apostles around it. Below are two unidentified figures at the bottom, possibly St Diarmait is one, and above that, *The Raven bringing Bread to SS Paul and Anthony*. On the west face from the bottom, the first two figure panels are uncertain. The next shows *Daniel in the Lions' Den* with four lions, rather than the seven at Moone. Then, at the centre of the west face, are *Adam and Eve*, a position usually reserved for the *Christ in Triumph*. Like Moone, the tree between Adam and Eve is

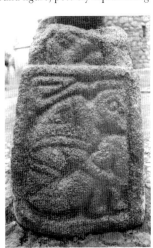

Bound and crouching figure, the base of the north cross, Castledermot

heavily laden with apples. Around the centre of the cross are *David with his Harp*, *The Sacrifice of Isaac*, and a possible *Fall of Simon Magus*.

The south cross is a little taller. Its east face is filled with panels of key-patterns and interlocking spirals. The base is undecorated and the north side of the base is divided into three parts with only one part carved with two wrestling figures. Perhaps the base was

unfinished. The west face is very full, starting with a hunting or herding scene on the base. Next is *Daniel in the Lions' Den* (4 lions), the *Temptation of St Anthony*, *Adam and Eve* with much less fruit on their tree, and *The Raven bringing Bread to SS Paul and Anthony in the Desert*. The centre panel shows *The Crucifixion* surrounded by *David with his Harp*, *The Sacrifice of Isaac*, and above, two panels of three figures.

13 Mermaid Carving, Kilkea Castle

Now Kilkea Castle Hotel, it is 3 miles north west of Castledermot on the R418 to Athy.

This castle was built in the late 12th century by Walter de Riddlesford but later passed to the FitzGeralds who owned it until the 1960s. It was much restored and altered over the centuries and it is now a hotel and golf course.

Lord Walter FitzGerald was a well known antiquarian in the earlier part of the 20th century and he collected pieces of carved stone connected to the family name. There are a number of these still at the castle including the 'Temptation Stone' which shows a man being attacked by ithyphallic beasts.

In the castle grounds there is a small medieval manorial church full of Fitzgerald memorials and a number of carved stone pieces. Among them, on the ground inside the west wall of the church, is a carving of a mermaid in relief on a large limestone slab. It is a stiff carving when compared to Clonfert in Galway, showing a stern mermaid pulling stiffly on her hair. She has a comb in her right hand. There is a serpent with a cat-like head about to bite off her tail.

The style of the carving suggests that it is part of a heraldic shield or tomb carving and it may have been part of the 17th century tomb in the small mortuary chapel dedicated to the two wives of William FitzGerald, Jane Keating and Cisley Geidon.

It measures about 30 inches by 18.

Mermaids remain one of the most enigmatic figures in medieval carving. They were very beautiful and could sing with a sweetness that could not be resisted, but to follow one meant almost certain death. They symbolized something beautiful and terrible at the same time. Physical danger was a symbol for moral danger and closely linked in the medieval mind with Eve, the serpent, and sexuality. (*Archaeology of Ireland*, 1998)

Near the mermaid piece attached to the west wall of the church is a chained monkey with a human face. He is part of the Fitzgerald family crest.

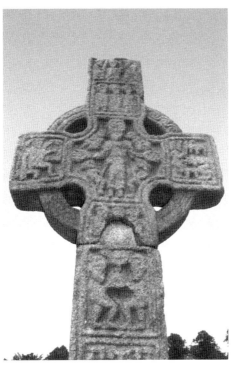

The west face of the south cross, Castledermot

County
LAOIS

PRINCIPAL SITES

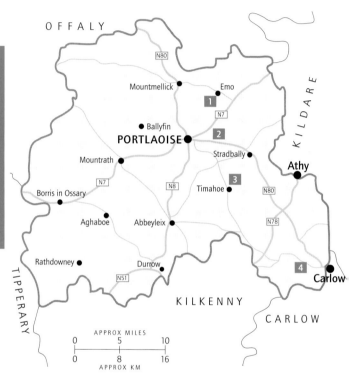

1 **Coolbanagher** St John's Church
2 **The Rock of Dunamase**
3 **Timahoe** monastic site and round tower
4 **Killeshin** early church and monastic site

Block figures in list refer to site locations in map and entries in text.

LAOIS

LAOIS LIES BETWEEN THE SLIEVE BLOOM MOUNTAINS in the west and the river Barrow in the east. The Barrow Valley is best known for its unique style of High Crosses, like at Moone and Castledermot. These date to the 9th and 10th centuries, evidence of strong Christian foundations to the east of the county. The four sites described below lie in the west of this wide valley.

On the other side, the Slieve Bloom mountains remained fiercely Gaelic throughout the medieval period, attacking the Norman strongholds and pushing against the Pale in the east. The limestone hills overlooking the Barrow valley are dotted with ruined megaliths as well as inaccessible caves and old hill-forts hidden among the thorny scrub.

The county of Laois was planted by English settlers in 1556 in an attempt to break the powerful Gaelic chiefs in the area. It was not a success and early in the 17th century the chief tribes of Laois were transplanted to Kerry. The new colonists created new settlements.

Its strong Christian tradition and its turbulent history means that most prehistory in this county has been overlaid, either by monasteries or medieval castles, and these have been razed and plundered down the years as well.

Laois is dotted with sand and gravel ridges, eskers, deposited at the end of the ice-age, often forming the roadways of prehistory. One such road runs from Mountmellick in the north to Portlaoise. Part of a limestone outcrop to the west is the famous Rock of Dunamase, once an Iron Age hill-fort, one of a number across the hills to the south.

LEINSTER **Laois**

1 St John's Church, Coolbanagher.

Turn right at New Inn for Emo on the N7 from Dublin just north of Portlaoise. South of Emo village, it is signed.

Set on the edge of the wooded parkland of Emo Court, this tiny church was built in 1786 in the Neo-Classical style. It is the work of James Gandon, best known as the architect of the Four Courts and the Custom House in Dublin. He was persuaded by the first Earl of Portarlington to design his country seat at Emo and this included this small estate church which is near the monastic site of Aengus the Hermit.

It is palatial in miniature with huge urns recessed in the walls and a lovely sense of clear space in spite of its tiny size. The windows have been reduced to small arcs high up to leave room for the elaborate memorials of the local gentry. There's a small gallery at the back and an elaborately carved 14th/15th century font.

You can ask at the old rectory nearby for the key.

2 The Rock of Dunamase
On the N80 between Stradbally and Portlaoise. Signed.

The Rock of Dunamase is a craggy 150 foot rock topped by the ruined walls of 'Dún Masc', which means the 'fort of the mask or face'. It got its name from one of the O Moore chieftains who built an earlier fort here. His name was Laois Ceannmor, meaning Laois Big Head. This probably refers to his practice of taking the heads of his enemies in battle, rather than to the shape of his head.

The Rock itself is one of the landmarks shown on Ptolemy's map of 140 AD. Today the castle has, to a great extent, faded back into the natural rock so that in places you can hardly tell which is which. The Rock is once more a place of great natural beauty and strength. I found myself looking for evidence of old Lughnasa assemblies or other such ancient rituals, but could find nothing. Then I heard an old story about treasure buried beneath the hill. It is guarded, apparently, by a fierce dog named Bandog, whose massive jaws spew flames when anyone gets too close.

There have been many battles here. The Rock and surrounding lands originally belonged to the O Moores. It was plundered by Vikings in the 9th century and the Abbot of Terryglass and Clonenagh, as well as the deputy Abbot of Kildare, were both killed near the fortress.

Near the end of the 12th century, when Diarmuid MacMurrough, king of Leinster, gave his daughter Aoife in marriage to his new ally, the Norman Strongbow, he gave the Rock and its castle as part of Aoife's dowry. The O Moores regained it in the 15th century and held it till the Plantation of 1556. It was fought over again in the 17th century and finally destroyed by Cromwell in 1650.

3 Timahoe Monastic Site and Round Tower
535 902
7 miles south east of Portlaoise on the R426. Signed.

The name comes from 'Tigh Mochua', meaning 'Mochua's House'.

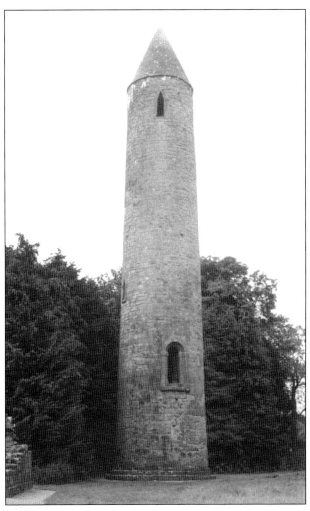

Timahoe round tower

The word 'house' usually means an oratory or small temple founded by or dedicated to a particular saint. St Mochua died in 657.

Today the monastic site is to the side of the small village green and is accessed across a stream. Its most interesting feature is a round tower built of brown sandstone in the Romanesque style of the 12th century. It is very tall at 100 feet and one of the broadest in the country. Its doorway has a rounded arch and two orders with capitals carved with bearded men with elaborately interlaced hair. Similar carvings can be found at Killeshin (see below) and Devenish, Fermanagh, though the double pillars are unique. The window on the third floor is also Romanesque.

The monastery was refounded in medieval times by the O Moores family (**Rock of Dunamase**), and the ruined medieval church probably dates to this time. It was made into a castle after the Dissolution.

The surrounding graveyard has been sensitively cleared by local children, leaving some wild areas for the butterflies. This would surely have pleased Mochua who, it is said, had a marvellous pet fly who walked across the pages of his book, marking his place as he read.

4 Killeshin Early Church and Monastic Site

673 788

Signed off the R430, 3 miles west north west of Carlow at the foot of Sliabh Margy.

A monastery was founded here in the 5th century by St Comghán. It grew to become one of the most important centres in the county. However, the early buildings were destroyed in the 11th century.

The present church dates to the 12th century and includes a beautiful 12th century doorway. The arch is in four orders with a frieze of heads around the capitals, similar in style to Timahoe and Devenish, with beards linked by locks of interlaced hair. There's a wonderful old bearded face on the cap-stone. The doorway has two inscriptions in Irish. One of them reads: 'A Prayer for Diarmit King of Leinster'.

This is all that remains of a once influential monastic school here on the west side of the wide Barrow valley. There was a round tower here but it was demolished in 1703 by a local farmer who thought it unsafe and a danger to his cows. A motte across the fields still guards the now vanished settlement.

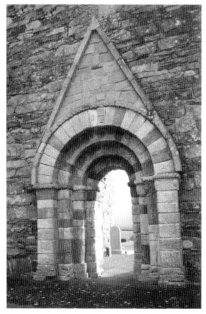

Romanesque doorway, Killeshin old church

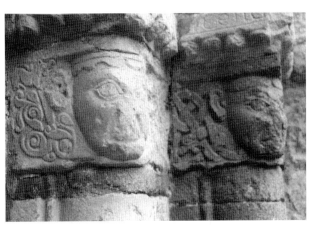

Detail of capitals, doorway, Killeshin old church

County
OFFALY
PRINCIPAL SITES

LEINSTER Offaly

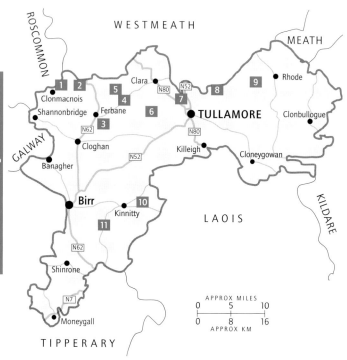

1 **Clonmacnois**
 Clonfinlough Stone

2 **Doon Castle** Sheela-na-Gig

3 **Gallen Priory**

4 **Lemenaghan** St Manchán's church and well

5 **Boher Church** St Manchán's shrine

6 **Rahan** monastic site

7 **Tihilly** church and high cross
 Durrow monastic site with grave slabs,
 high cross and well

8 **Rahugh** well and stone

9 **Croghan** hill cairn

10 **Kinnity** cross

11 **Seir Kieran** or **Saigher Ciarán**

Block figures in list refer to site locations in map and entries in text.

OFFALY

MOST OF THE SITES DESCRIBED BELOW date from early Christian times. The lowlands of Offaly are dotted with early monastic ruins especially along the banks of the river Brosna which runs across the north west of the county. These monasteries have earned it the name 'River of God' or 'Abhainn Dé'. All that remains of most of these are small ivy-covered ruins, but occasionaly there is something really special. At Gallen, on the outskirts of Ferbane, is a wonderful carved slab. There's a fabulous shrine at Boher and a scriptoral cross at Durrow.

And in the west lies the jewel of Offaly, one of Ireland's best known ecclesiastic ruins, the monastic city of Clonmacnois. It sits on the banks of the river Shannon beside a glacial esker which had become one of the ancient roads of Ireland, the Elactar Ria. Across the county the eskers of the midlands held water here in the soft belly of the country, releasing it slowly as lakes which later formed the bogland of the Irish Midlands.

A small tributary called the river Boora runs north into the Brosna. Near its source is Lough Boora where early mesolithic remains were found, probably left there by the earliest inhabitants of the midlands, around 6000 BC.

The county town, Birr, was confiscated from the Irish O Carrolls in 1620 by James I and granted to Sir Laurence Parsons, Earl of Rosse. The 3rd Earl built the Great Telescope in the castle grounds in 1842. It was a 72 inch reflecting telescope, the largest in the world for 70 years, through which he saw the Spiral Nebulae for the first time. Some of the Observatory has been restored though the great Telescope is in the Science Museum in London.

Offaly also lays its own claim to being at the centre of Ireland. The Seffin Stone, near St John's Mall in Birr, is one of the places said to mark the centre of Ireland.

1 Clonmacnois

Clonmacnois is on the east bank of the Shannon river between Athlone and Shannonbridge. It is well signed.

'Cluain Maca Noís' means 'the Meadow of the sons of Nos'. Many early saints chose populated places on good fertile land beside important routes for their monasteries. Clonmacnois was no exception.

It was founded by St Ciarán in the 6th century at the crossing
of the great esker road which ran from east to west across Ireland
and the river Shannon flowing south. This would have been one of
the most important crossroads in the country. Surrounding bog
would have kept travellers to the esker and the river would have
provided transport going north and south and also, of course, to
destinations far beyond the shores of Ireland. Its rapid growth
has usually been attributed to its location, but it is also likely
that it was a powerful place from pagan times. The great stone of
Clonfinlough is just down the road. (see below)

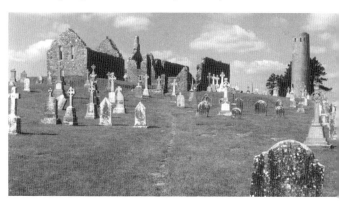

Clonmacnois

Its accessiblity also meant that it was burned and pillaged many
times both by the Irish and by Vikings in its 1000 year history. In
fact it probably suffered more from pillage, burning, plague and
storm than any other place in the country. The site was plundered
by Vikings on 8 separate occasions, but this is put in perspective
when we find recorded 13 fires, 27 Irish raids and 6 Anglo-Norman
attacks. In 1179 the annals record 105 homes were burned.

By 1376 it was in decline and by 1552, just 1000 years after it
was founded, it was finally reduced to a ruin by the English
garrison in Athlone. However, I'm getting ahead of myself.

Ciarán, unlike many of his contemporaries, was not of noble
birth. His father was said to be a craftsman. Some even say he was
a carpenter, but that may be drawing the parallel with Jesus a little
too far. At any rate, Ciarán left home early to pursue a spiritual
life. He spent time with Enda on Inishmore off the coast of Galway,
following the strict monastic discipline of the early church where
life was punctuated by prayer, timed by the monastic sundial and
tolled by the bell. He later spent time studying with St Finnian at
Clonard in Carlow.

He then went to Lough Ree where he founded a monastery on
Hare Island and finally to Clonmacnois around 549, where he is

supposed to have met the young prince Diarmuid who had been exiled by the king. Ciarán apparently prophesied that Diarmuid would become king the next day and, sure enough, King Tual died and Diarmuid was crowned king. He helped Ciarán build the first church at Clonmacnois and promised him a hundred more. However, Ciarán and Diarmuid were both to die of the Yellow Plague before the year was out. Ciarán had been less than a year at Clonmacnois, but the foundation went from strength to strength and became, in spite of all the raids, second only to Armagh.

The legacy of Ciarán is enduring. There's a story that he brought a dun cow with him to Clonmacnois to provide milk for the whole community. Centuries later, in the 12th century, *The Lebor na hUidre*, which translates as *The Book of the Dun Cow*, was compiled at the monastery here. It was the first book in the Irish language and it contained part of the earliest known form of the Táin Bó Cuailnge, the story of the fight between Queen Maebh of Connacht and the warriors of Ulster as she tried to steal the Brown Bull of Cooley. (see LOUTH)

Earlier extant manuscripts from the 8th to the 10th centuries, the time of the scribes, include: *The Annals of Clonmacnois*, *The Annals of Tighernach*, and *The Chronicum Scotorum*.

The high crosses and many of the cross slabs date to this time as well. The crosses are inside the visitor centre now and replicas sit outside in their place. Clonmacnois has some 700 cross slabs, many beautifully patterned with knotwork and interlacing. There are plans for a building where they can all be displayed. At present only a few can be seen in the visitor centre.

The famous crosier of Clonmacnois is in the National Museum, Dublin.

The many churches and other buildings now sit together on the hillside overlooking the river but illustrate well the haphazard placing of the buildings in an early Irish monastery. No buildings remain from St Ciarán's time, of course. The churches, workshops and other domestic buildings which would have been constructed

<div style="float:right; text-align:center; writing-mode:vertical-rl;">LEINSTER **Offaly**</div>

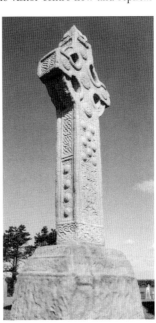

East face and south side of the south cross, Clonmacnois

of wood, have long since disappeared, but one still gets the sense of the vastness of the place.

In the absence of towns, places like Clonmacnois grew in importance and often held the balance of secular power. They had large lay populations and were centres of trade and politics as well as learning, craftsmanship and religion. The balance of power was not always maintained by political means. In 764 there was a battle between Clonmacnois and the Columban foundation of Durrow (see below) over control of various churches. Durrow was beaten and lost 200 men.

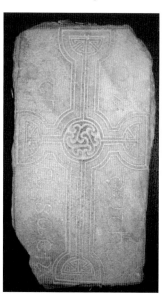

Cross slab, Clonmacnois

The small church of St Ciarán, near the centre of the site, was built in 909. Most of the north, east, and west walls are original. It was an unusually big church for this time and is the oldest dated stone church surviving in Ireland.

In 1111 Clonmacnois became the cathedral church of West Meath. However, it never became affiliated to any of the new continental orders such as the Cistercians or the Franciscans, and by the 14th century its influence began to wane.

This didn't, however, prevent a building boom in the 15th century. Among other things, the new Perpendicular doorway was inserted in the north wall of the cathedral with St Francis, St Patrick and St Dominic above it. A whisper through a recess on the outside can be heard inside - said to have been used by lepers to confess to their priests, so that there was no chance of infection. This doorway was part of the new flowering of stone carving in the 15th century and contemporary with the carvings at **Jerpoint** and **St Canice**'s in KILKENNY.

A tranquil walk through the present graveyard following an old paved path and along a side road, takes you to the **Nuns' Church**. From here the main site is invisible - even the round towers have disappeared. It's a place of seclusion and great natural beauty and the church itself is exquisite. The Romanesque chancel arch has a tiny Sheela-na-gig carved high on the left side - the 7th figure up.

The church here was built by Dearbhforgaill in the 12th century.

She was married to Tigernán Uí Ruairc, King of Breany, when she was abducted, during a raid in 1152, by the then king of Leinster, Diarmuid MacMurrough. It is generally accepted that she was compliant in the affair. *The Annals of Clonmacnois* say that he kept her to satisfy his 'carnal and adulterous lust'. A year later, she was sent back to a humiliated Tigernán. He never forgot the insult and, when the chance arose in 1166, he and his allies drove Diarmuid from Leinster.

This would probably have remained just another internal power struggle had not Diarmuid fled to France where he petitioned Henry II for help to regain his kingdom. Henry, seeing a chance to divert the energy of his land-hungry Welsh barons, gave them leave to join Diarmuid. Some agreed, including the famous Strongbow. In return he was promised Diarmuid's daughter Aoífe in marriage and the right of succession to the kingdom of Leinster.

We will probably never know how all this affected Dearbhforgaill as history has not pursued the human aspect of the story. What we do know is that she was responsible for the building of the Nuns' Church at Clonmacnois in 1167 and that she retired to Mellifont Abbey where she died in 1193 aged 85.

St Ciarán's well is less than half a mile along the road, south of Clonmacnois on the Shannon side.

It is in a field with a small stone surround and beside it a whitethorn tree with no thorns. There are a number of carved stones around the well including a face said to represent St Ciarán.

The 9th of September is St Ciarán's day, now celebrated as the first Sunday in September. The pilgrimage is centred around his church where the earth is considered to have magical properties. Part of the pattern involves kissing the stones at the well.

St Ciarán's well, Clonmacnois

Most people visit Clonmacnois in the summer or in September for St Ciarán's Day. However, I went there recently on a sunny winter's day when the Shannon had flooded much of its low grassy

LEINSTER **Offaly**

banks. The reeds were rust-coloured and in the absence of humans, the silence was broken only by the sound of wading birds calling across the water. Above all, I felt that this is still a very powerful place, in spite of all the destruction during its long history and all the visitors in recent years.

For centuries it was the preferred burial place of kings, an indication of how they viewed its power. This poem was written by the 14th century bard, Angus O Gillan, and translated by T W Rolleston (1847 - 1920):

In a quiet, watered land, a land of roses,
Stands St Kieran's city fair
And the warriors of Erin, in their famous generations
Slumber there.

There beneath the dewy hillside sleep the noblest
Of the Clan of Conn
Each below his stone, his name in branching Ogham
And the sacred knot thereon.

There they laid to rest the seven kings of Tara,
There the sons of Cairbre sleep,
Battle-banners of the Gael that in Kieran's plain of crosses
Now their final hosting keep.

And in Clonmacnoise they laid the men of Teffia,
And right many a lord of Breagh.
Deep the sod above ClanCreide and Clan Conaill,
Kind in hall and fierce in fray.

Many and many a son of Conn, the Hundred-fighter,
In the red earth lies at rest.
Many a blue eye of Clan Colman the turf covers,
Many a swanwhite breast.

Clonfinlough Stone

Just over 2 miles east of Clonmacnois signed off the R444 to Athlone. Park at Clonfinlough Church and take the path beside it.

'Cluain Fionn Loch' means 'Meadow of the bright lake'. This flat slab of carboniferous limestone is about 8 feet by 10 feet and is lying on the side of an esker, currently in rough pasture. Although it's not high up, you can see for miles.

The stone is covered with deeply incised carvings including

foot and hand prints and cups and rings. Some have been converted into crosses and some look like stylised human figures. There are similar pre-celtic carved stones in Iberia. The stone shows signs of still being much visited.

2 Doon Castle Sheela-na-Gig

Doon crossroads is about 7 miles east of Clonmacnois on the R444 where it is crossed by the N62 south of Athlone. The ruined castle is on high ground on the east side of the N62.

There is a well preserved Sheela-na-Gig left of the doorway on the south east corner of the building. The figure appears to have been carved standing though built into the castle on her side. Unusually, her feet both point in the same direction and her hands are placed, one inside, and one outside her thighs. Her genitals and facial features are pronounced and her mouth is open as though speaking.

3 Gallen Priory

Gallen Priory is now a convent housing the Sisters of Cluny. The gate is on the left as you leave Ferbane on the N62 going south to Cloghan. It is on the south bank of the river Brosna.

Gallen is traditionally said to have been founded by St Canoc in the 5th century but nothing of that early period is visible now. It was burned in 820 and later restored by a group of monks from Wales who founded a very successful school here. The reconstructed gables of the 13th century church in front of the convent are set with a number of early grave slabs. They are only a small number of the 200 or so that were found between 1934 and 1935. They date from the 8th to 11th centuries, probably its busiest period. They are ornamented with interlacing, lozenges, wheel-crosses, marigold and plain incised crosses. One is inscribed - OR DO BRALIN (Pray for Bralin).

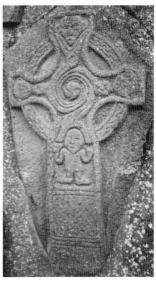

Cross slab, Gallen Priory

There's a particularly stunning slab set into one of the gables. The central Christ-like figure has his head in the jaws of a bird or dragon which spirals into another one with its jaws around another human head at the top of the cross. Either arm of the cross has another head which join to the tails of the animals. Christ is wearing stout boots and has a squat body and face like the Carndonagh Christ in Donegal. His hands are pushing upwards, as though trying to push the dragons off. Their tails form a swastika.

Part of the shaft of an early cross was found under a sacred tree to the east of the site. It has a deer carved on it as well as interlacing and key patterns, and it stands between the gables.

Here also is a bullaun with a 20 inch depression which was found with a lot of iron slag around it, giving the impression it had been used for crushing ore.

4 St Manchán's Church and Well, Lemanaghan
5 miles east of Ferbane on the Ballycumber road.

An early monastery was founded here by St Manchán in the 7th century. We know that his father's name was Indagh and his mother was a holy woman called Mella. We even know that he had two sisters, called Grealla and Greillseach. He died in 665 of the Yellow Plague which also killed Ciarán of Clonmacnois and King Diarmaid who was Ciarán's patron. Diarmuid gave the lands of Lemanaghan to St Manchán for a monastery.

There are a number of stories about St Manchán. Perhaps the best known concerns his cow for, like St Ciarán, Manchán had a very prolific cow whose milk was always freely given and never sold.

One day some jealous farmers from Killmonaghan on the other side of Ballycumber, came and stole her. She managed to leave a trail of marks on the stones with her hooves and tail so that Manchán could follow the thieves, but by the time he caught up with them, she had been killed and was being cooked. He grabbed her limbs from the pot and, by a miracle, she came back to life and lived into old age. The only reminder of her ordeal was a slight limp, as a small piece of her thigh bone was not recovered.

To this day the farmers in Lemonaghan townland will not sell milk. It must always be freely given.

Near the main road are fragments of a Romanesque church and an early grave slab. The site is badly ruined, but many of the carved stones from the doorway have been collected in the old schoolhouse and there are plans to restore the old church. In the graveyard, north of the church, are the remains of St Manchán's house.

East of the church, beyond the graveyard, is the holy well shaded by an ancient ash tree. The tree and ivy-covered wall are covered with small statues and votive offerings.

St Mella's cell, Lemanaghan

Beyond it, linked by an ancient stone causeway, is the 'abbey' which may have been a women's church. It is an enclosure with the remains of a small oratory, said to be St Mella's cell. She is supposed to be St Manchán's mother. Between the well and the abbey is the stone where they met each day without talking.

There is a bullaun near the well and another partially set into the wall which surrounds a tree in the middle of the road outside the graveyard.

5 Boher Catholic Church - St Manchán's Shrine
West of Ballycumber on the road to Athlone. Signed.

St Manchán's shrine is a gabled box of yew covered with finely worked bronze. There are five bronze bosses forming a cross with red and yellow cloisonné enamel on the bosses and on the borders and base. It was made around 1130 and the bronze figures were added later in the 12th century. There were originally fifty of them, but only twelve remain now. There are metal hoops at the corners to carry the shrine in procession. It still contains the bones of St Manchán.

It is thought to have been made in the same workshop, probably at Clonmacnois, as the Cross of Cong which is in the National Museum.

The shrine is one of the few ecclesiastical works of art of the period still in its place of origin. It was kept for a long time in a small thatched church built especially to hold it. This church was burned down and the only thing saved from the fire was the shrine. It was cared for by an old family, the Mooneys of Doon, and

brought to Boher church in 1860 by a family called Bohaly who were direct descendants of Buchail, cow herder of the saint and hereditary keepers of the shrine. It has been used over time for swearing public oaths and

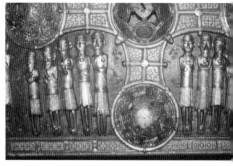

St Manchán's shrine detail, Boher Church

believed by many to have the power to cure.

Behind the shrine is a window of St Manchán by Harry Clarke, with the shrine beneath his feet. Other windows show St Brigid, St Theresa and another female saint.

Parts of St Manchán's crosier, equally delicately worked, have been found in Lemanaghan bog. They are now in the National Museum, Dublin.

6 Rahan Monastic Site

Rahan village is signed 5 miles west of Tullamore. 'Rathain' means 'the Place of Ferns'. A key is available from the Post Office.

St Cárthách or Mo-chuda is associated with the monastery here in the 6th century, before he went to Lismore (see WATERFORD). He is supposed to have been expelled from here at Easter in 636 by King Bláthmac of Tara, possibly for abandoning the traditional Irish dating of Easter. There is no further mention of the site in the annals until it was refounded by Fidhairle Ua Suanaigh around 760. It continued into the 12th century when the present churches were built.

East window with rose window above, Rahan monastic site

The main church is now part of the Church of Ireland parish church which has an 18th century nave connected to the 12th century chancel. From the painted nave you look

through the early Romanesque arch into a small stone vaulted chancel with stone altar and rounded Romanesque east window. The glass in the window is plain and fringed on the outside with ivy, giving the appearance almost of the mouth of a natural cave. The chancel arch is in three orders with carved heads at the capitals of the pillars. Above the east window is an unusual rose window, also in the Romanesque style. (For another, see **Freshford** in KILKENNY.) Both windows are beautifully patterned on the outside.

The altar has a recess at the front which may originally have held relics. Part of one transept can still be seen on the north side of the church.

Across the field to the north east is a well preserved but roofless church with a beautiful Romanesque west doorway. The decoration of the door and the plan of the church suggest an East Mediterranean influence. (*Prehistoric and Early Christian Ireland*) The small windows are finely carved with foliage and one has a horse carved in the hood moulding.

Around the field can be seen earthworks from the original foundation.

LEINSTER **Offaly**

7 Tihilly Church and High Cross

3.5 miles north west of Tullamore, east of the N80, behind a farmhouse. This is also 0.6 miles north of the side road across to the site at Durrow.

Tihilly comes from 'Tigh Theille' or 'Teille's House'. All we know of Teille is that he was the son of Seigín. However, the earliest foundation is credited to St Fintan. St Munnu of Taghmon is then said to have given it to the nun, Cera, who died in 670.

By the late 9th century the monastery was under the Abbot of Castledermot and there is no further mention of it after 936. (*Shell Guide*)

Today you can see the remains of an early stone church on a small mound. Beside it is a weathered but still fine high cross with just visible zoomorphic patterning and fabulous beasts, as well as panels of *Adam and Eve* and *The Crucifixion*. There's a cross slab nearby.

The site is dwarfed by two huge ash trees, one of which is hollowed out like a cave inside.

Durrow Monastic Site with Grave slabs, High Cross and Well

Go 4 miles north of Tullamore on the N52 to Kilbeggan.
The site is in the Durrow Abbey Demesne signed to the left through the wrought iron gates of the estate.

Offaly

LEINSTER

This 6th century site was one of the earliest founded by St Columba around 550 on land given to him by Áed mac Bréanainn, King of Tethba. 'Dairmhagh' means 'Plain of Oaks'. It sits on an esker above the flat plains of north Offaly.

Like Clonmacnois, it was plundered and burned a number of times. Then in the 12th century it was colonised by the Augustinians and eventually, after 1541, it became a parish church which has been used on and off till the last restoration of the building in 1802. West of the now disused Church of Ireland church is the famous 9th/10th Durrow high cross as well as 5 early cross slabs in the tradition of Clonmacnois and a cross frag-ment decorated with interlacing.

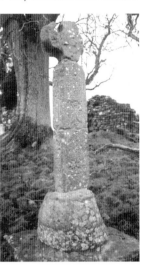

The west face of the high cross has a *Crucifixion*, two Passion Scenes and, on the lowest panel, *Soldiers Guarding the Tomb of Christ*. This is almost identical to the west face of the Cross of the Scriptures at Clonmacnois.

The east face shows *Christ in Glory* with *David and his Harp* on the left, and *David killing the Lion* on the right. The lower panels show *The Sacrifice of Isaac* and *The Last Judgement*.

The north and south sides have groups of two figures. On

Tihilly church and high cross

the north side are *Zacharias and Elizabeth with the Infant John the Baptist*, and at the bottom, possibly *Abraham wrestling with the Angel*. On the south side there is a *Warrior, Cain and Abel* and *Adam and Eve*.

These other sides, though not identical to the Clonmacnois cross, are very similar in style and content. Two of the grave slabs are inscribed, one with:

OR (OIT) DO AIGIDIU - 'Pray for Aigidiu'

and another with:

OR(OIT) DO CHATHALAN - 'Pray for Cathalan'

Along the path north east of the church is St Colmcille's well which is marked by a small cairn of stones. Coins, medals and votive offerings have been left by pilgrims. There is a sign in the words of St Colmcille which reads:

Here angels shall enjoy my sacred cell,

My sloe, my nut, my apple and my well.

It is visited on 9th June.

The Book of Durrow was written in the middle of the 7th century and is the earliest of the great manuscripts still in existence. It is a copy of St Jerome's *Vulgate*.

It marks the beginning of the Golden Age of Irish manuscript art. This art is considered to be strongly influenced by the European La Tène style with its curvilinear, stylized palmettes, tightly coiled spirals and basketry hatching. It also has strong links with the art of North Africa and the patterns woven into the carpets of the Middle East. Pages which are completely covered with knotwork patterns, in Irish manuscripts, are called 'carpet pages'.

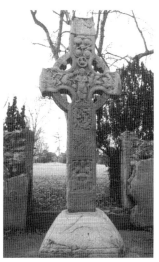

High cross, Durrow Monastic Site

An interesting feature of the book is the interlacing either in the margins or in all-over patterns, using a broad ribbon with a double contoured margin. This broad ribbon interlacing wasn't used for long but it is found on the cross at Carndonagh and on a number of other less known stone crosses in Donegal.

The style of *The Book of Durrow* also links it to the great monasteries of Iona and Lindisfarne which are all connected to Colmcille. It is now in Trinity Library in Dublin. Apparently it was recovered from a farm where it was used by a local farmer who poured water on it as a cure for cattle.

8 **Rahugh Well and Stone**
5 miles north east of Tullamore on the Tyrrelspass Road.
There's a big sign on a farm gate.

This monastery was founded in 537 by St Aodh, who was a contemporary and friend of St Colmcille. 'Aodh' means 'Hugh', hence the place name 'Rahugh' or 'Hugh's Fort'. The monastic enclosure across the field has a small ruined church in it which continued in use as a parish church until 1770.

About 250 yards east of the church is St Hugh's Well, now enclosed with a wall and gate. About 200 yards south west of the churchyard is St Hugh's Stone, lying by the field ditch. It is a huge boulder with a ringed cross carved on it. In the centre of the cross

is a circular depression where you can place the crown of your head while putting your elbow in the smaller hole to the right. This is to effect a cure for headaches.

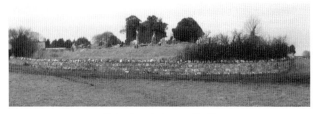

Rahugh ancient monastic site

There was a Cromwellian Anabaptist colony here at one time and the small graveyard has some 17th century gravestones with names, now very worn, such as Abraham, Rebecca and Sarah.

St Áedh is also connected with a hermitage on Slieve League, Donegal. He was also bishop of the area and his crosier is in the National Museum, Dublin .

9 Croghan Hill Cairn

Go south east out of Tyrellspass towards Daingean village about 4 miles. The landscape is very flat except for Croghan Hill which is on the left, about 4 miles out of the town. Turn left just before the hill and left again a mile later, following the lane uphill. St Patrick's well is a mile up this lane.

It is in a walled enclosure with steps down to the water, well maintained with clean, clear water and fresh flowers above it. It is set into a fold in the hillside. St Patrick is supposed to have visited the hill on horseback and the well sprang up where the horses' hooves touched the hillside as he jumped.

Offerings at St Patrick's well, Croghan Hill

Further up the hill is the graveyard and remains of a small abbey which is supposed to be where St Brigid became a nun. It is this association which has given the graveyard a great reputation for sanctity and in the past people came from 20 miles around to be buried here.

Right on top of the hill is a cairn and local lore says that this caps an extinct volcano. Like the hill at Ardagh in Longford, there is considered to be a danger of getting sucked down the hole if you're not careful.

Croghan Hill is mentioned in Spencer's *Faerie Queene*.

10 Kinnity Cross

Take the R440 east out of Birr for 8 miles. Signed.

'Ceann Eitighe' means 'Etech's head' and there are various stories trying to explain why Kinnity got its name. She is said by some to be an Irish princess whose head is buried here.

Kinnity Cross is a sandstone cross with the arms and top missing. It now sits on the terrace in front of Kinnity Castle, also called Castle Bernard. This is a Coillte (forestry) property, 1.25 miles north east of Kinnity.

An inscription on the base indicates that the cross was erected by the High King Maelsechlaill (846 - 862) and probably carved by Colman. It most likely comes from the monastery founded here in 6th/7th century by St Finán Cam (the Crooked), a disciple of St Brendan of Clonfert. The only other traces of that monastery are fragments of a medieval church in the courtyard wall.

On the south face is *The Crucifixion* and a panel that has been interpreted as St Brendan presenting St Finán with a crosier (*Irish High Crosses*). The north face has seven spiraled bosses at the centre, a stylized *Adam and Eve*, and panels of knotwork and intertwined birds and beasts. There is a nine-spiralled panel near the base. The sides have narrow panels of knotwork and interlacing.

1.5 miles north north west of Kinnity, on the north bank of the Camcor in Ballincur, is a fragment of the head of a high cross with a crucifixion on one side. It is possibly from the monastery founded here in the 6th century by St Bárrind.

In the Church of Ireland church is an unusual cross-inscribed stone in the porch. It may have been a ritual stone, later Christianized with crosses. It has stemmed spirals like one of the cross slabs at Inishkea North, in Mayo, as well as snaking lines, simple crosses and a possible human figure.

The church also has some interesting stained glass from the beginning of the century: *The Good Shepherd* by Catherine O Brien, *Martha, Mary Magdalene washing Christ's Feet*, and *The Seven Gifts of the Holy Spirit* by Ethel Rhind.

11 Seir Kieran or Saigher Ciarán

Just north of Clareen. Signed from Roscrea and Birr. About 5.5 miles east south east of Birr.

St Ciarán the Elder founded a monastery here some time before 489 and it remained a seat of bishops until it was made a house of the Canons Regular of St Augustine around 1200. The present Church of Ireland church probably includes some stonework from

the late 12th to early 13th century.

The site, however, is much older. It is thought to have been a sacred place in pagan times, a ritual fire site. It was traditionally the burial place of the kings of Ossory.

Most of the remains of this once great place are now inside the small graveyard of the current church where a small flock of sheep struggle with the long grass.

Here is the stump of a round tower, the base of a high cross with what appears to be a battle scene on one side, fragments of stone wall, some early grave slabs, one inscribed - OR(OIT) DO CHERBALL - 'Pray for Cerball', and a small plain stone cross.

The gateway cuts through the old double ramparts which are part of the boundary of the original 10 acre site. In 917 the king's daughter asked for the grounds to be enclosed to keep the wolves out and, to please her, a wall was built around the whole site. It is thought that some of the wall to the south of the church is part of it. It is a beautiful wall. The soft red stone is crumbling, in places held only by the roots of wild roses and mullien. Navelwort and tiny ferns sprout from the cracks.

The graveyard also contains some interesting gravestones termed 'folk art' with very explicitly carved crucifixes and all the instruments of the Passion clearly represented, though not to scale.

Perhaps the most famous carving from Saigher Cairán is conspicuous by its absence. The Sheela-na-Gig from the east gable of the old church is now in the National Museum, Dublin. The detail is very strong with ribs and breasts clearly defined. She appears to have no hair and she has holes drilled through her abdomen and head. Another hole is placed as though it is being held in her right hand, and another between her feet. Maybe something was placed in them at certain times?

Probably the more potent reminder of St Ciarán's connection to the area is St Ciarán's Stone and Bush. The 'bush' is a whitethorn tree growing quite literally in the roadway 0.5 miles south of Clareen crossroads. The road divides and passes both sides of this tree, heavy with clooties. His stone sits by it.

The holy well has been enlarged and made more accessible but has since fallen into neglect. St Patrick is supposed to have sent Ciarán from Rome to Ireland. He was instructed to carry a bell which would ring out when he had arrived at the right place. This well is that place.

Province of
MUNSTER

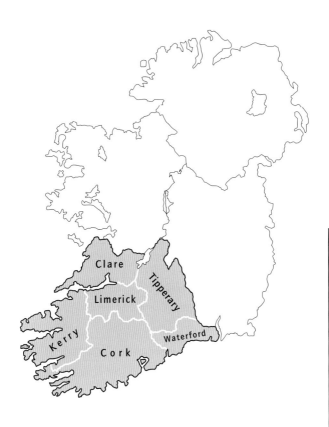

PROVINCE OF MUNSTER

THE PROVINCE OF MUNSTER IS IN THE SOUTH WEST OF IRELAND. In the east is Tipperary, the most fertile county in the whole country. Its lush pasture support herds of dairy and beef cattle and has some of the most magnificent mature trees in the country. The soil gradually thins towards the west until, in the north, it almost disappears in the limestone pavement of Clare. Further south, broad mountain ranges of old red sandstone rise against the skyline and extend long fingers south and west into the Atlantic ocean.

Áine, whose name is loosely translated as 'delight', is probably the best known of the Munster landscape goddesses. She is also called 'radiant', 'bright', 'glowing' and even sometimes 'the goddess of love'. She is associated with the landscape around Lough Gur and Knockainey in Limerick and closely linked in local lore with Grian, the sun goddess whose hill, Cnoc Gráinne, is also in Limerick. Some people argue that they are the same being and others that they are sisters. There are many contradictions between sources, but often it doesn't matter. Áine becomes Anu in Kerry and even Danu, the great matriarch of the Tuatha Dé Danann, the mythical tribe whose arrival from Greece probably heralded the beginning of the Bronze Age in Ireland. They brought with them the skill of working in gold as well as bronze. Much of their gold was ornamented with images of the sun.

The coastal counties of Munster would have provided deep and sheltered inlets for these travellers. And the hills near the coast were rich in metal ores. The landscape of South Munster is dotted with their stone circles, almost a hundred altogether, nearly half the total number of stone circles for the whole country.

Most of the Munster circles align to the setting sun. They are mainly axial which means they have an axial stone, wider than it is tall, lying opposite the two tallest stones. The tall stones are called 'portals' as they seem like the jambs of a doorway.

The axial is so-called because the astronomical alignment has its axis going from the portals through the centre of the circle and the centre of the axial stone.

By Iron Age times the Tuatha Dé Danann and their deities had disappeared into the landscape.

Mór Muman is the ancient landscape goddess associated with the royal site of Cashel in the centre of Munster and it was to her that the ruling tribe, the Eoganacht, came to perform the inauguration ceremony which allowed them to rule in peace and prosperity. A mutual respect allowed for harmonious co-existence.

Further inland the Celtic heroes Fionn and the Fianna hunted

across the hills, sometimes annoying the fairy people and paying dearly for it. However, they sometimes also cared for each other. Fionn is said to have found a fairy harper called Críu (see TIPPERARY) whom he looked after. In return Críu taught the Fianna how to play fairy music. The Munster hills have a strong tradition of such music. On the border between Tipperary and Limerick, the southern slopes of the Glen of Aherlow are called the 'Harps of Clíu'. It is said that you can still hear the Daghdha making music in the breeze.

Many of the holy wells of Munster have ash trees growing by them. There has always been a strong association between the ash and water in Celtic countries. In Ireland and in Wales all oars and coracle slats were made of ash. The ash is associated with the power in water.

Brandon Mountain in Kerry is one of Ireland's sacred mountains. The peninsula around it is covered with oratories, stone crosses and other evidence of a strong Christian presence. However, what comes across most strongly is how much all these sacred places seem to be directed seawards. The steep coastal hills are covered with 'clochans', small stone beehive huts, which seem likely, by their location, to have provided accommodation for pilgrims arriving by sea. We also know that Dingle town was a departure point for pilgrims to Santiago de Compostella in Spain.

It seems that it is only in the last few centuries that Munster has become remote. In earlier times its position on the edge of the ocean made it easily accessible from anywhere on the western seaboard. And the god of the ocean, Manannán Mac Lir, has always been prominent in the province's mythology. Even today on the Beara Peninsula, Cailleach Bearra, the wise woman, who has taken the form of a huge rock, sits waiting for him to return to her.

PROVINCE OF **Munster**

County
LIMERICK
PRINCIPAL SITES

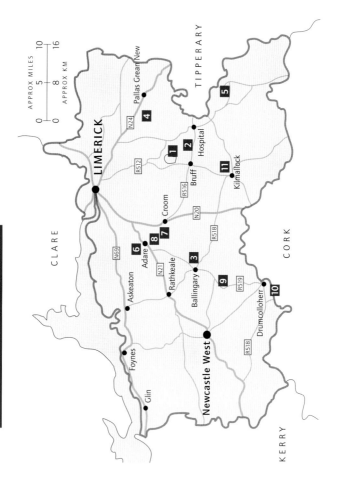

MUNSTER **Limerick**

1 **Lough Gur** and **Knockadoon**

2 **Cnoc Áine**

3 **Cnoc Fírinne** Knockfeerina hilltop cairn

4 **Knockgrean** (Cnoc Gráinne)

5 **Duntryleague** cairns

6 **Adare** Franciscan friary; Augustinian friary

7 **Disert Oenghusa** church and round tower

8 **Dunaman Castle** Sheela-na-Gig

9 **Killeedy** churchyard and St Íde's Well

10 **Tullylease** monastic site with cross slabs

11 **Kilmallock** Dominican priory; Collegiate church

Block figures in list refer to site locations in map and entries in text.

LIMERICK

THE LANDSCAPE OF EAST LIMERICK is right at the heart of Munster, the earthly realm of the sun goddess, Áine or Grian. Called 'Áine' in Limerick, she becomes 'Anu' in Kerry and from an earlier time 'Danu', the mother goddess of the Tuatha Dé Danann who inhabited Ireland in ancient times. Defeated by the Celts, mythology tells us the Tuatha Dé Danann took possession of the Otherworld or underworld places inside the cairns and hills made sacred by an earlier people. From there they became, according to folklore, the fairy people. The mythological goddess Áine became the fairy queen of folklore. Her presence is strongly felt here in Limerick, in place names, legend, and in customs still remembered. She is said to protect herds, crops, the people who care for them, and to have given meadow sweet (airgidín luachra) its scent. Áine is closely linked with the area round Lough Gur but she gives her name to Knockainy, the hill of Áine.

These hills, like the hills across South Tipperary, are the scene of many adventures of the Fianna. Like the knights of King Arthur, they met with challenges at every turn. They hunted for sport and to hone the skills which they needed to right wrongs and fight against impossible odds. Often while out roaming the hills, they would antagonize the fairy people who would take revenge by luring the young warriors into danger. Fionn, their leader, had the power of second sight which he could access by putting his thumb in his mouth. This often saved them, but their courage and loyalty to each other as well as their fighting skills, were what made them heroes.

MUNSTER **Limerick**

Cnoc Áine, Cnoc Grene and Cnoc Firinne are known as the last three fairy strongholds in Munster.

In Christian times in West Limerick, St Íde took on many of the qualities of Áine. She was very maternal and surrounded by women attracted by her piety. She was also known as an educator and numbered many saints among her students, including Brendan the Navigator (see **Clonfert** in GALWAY*). But more than that, she was considered to be the 'Foster Mother of the Irish Saints' and was even traditionally said to have suckled the infant Jesus.

Lough Gur lies about 4m NW of Knockainy near the centre of a wide triangle formed by the 3 fairy hills.

1 Lough Gur and Knockadoon
South of Limerick City on the R512.

It is worth starting at the small visitor centre housed in two reconstructed neolithic houses where you can get a site map to help you find your way around.

It is said that Lough Gur was formed by the goddess Áine who appears here in different forms as mermaid, young woman and hag. As mermaid she rises from her traditional home beneath the sacred waters of the lake, as maiden she empowers the land's human custodians, and as hag she defends her realm.

There was a stone bridge called Cloghaunainey on the Camoge river north of the lake, said to have been built by Áine herself. Unfortunately it was demolished in 1930. A story is told of her meeting by this bridge with the 1st Earl of Desmond, the local landowner. Traditionally it was required of the tribal chief at his inauguration that he seek acceptance of the goddess of the landscape. This was ritualized in a ceremony in Celtic society called a 'feis' which literally means 'to spend the night'. A 'geasa' is a magical prohibition or taboo. When someone is put under a geasa, the penalty for breaking it is usually death.

The story goes like this: the Earl found Áine by the water combing her hair. He crept up on her and took her cloak which immediately put her in his power. She agreed to bear him a son who would be called Géaroid Iarla, but warned him that he must never be surprised by anything the son did. ('Iarla' means 'Earl' but 'iarlais' means 'changeling'.)

The child was born and given to the Earl and grew up

excelling in everything. One evening there was a big gathering at the Earl's castle in Knockainy village. A very accomplished young woman appeared out of nowhere and engaged his son in a contest. She leapt right over the guests and the tables and called him to do the same. He hesitated, but his father, not wanting him to be bested by a woman, persuaded him to show what he could do. However, he

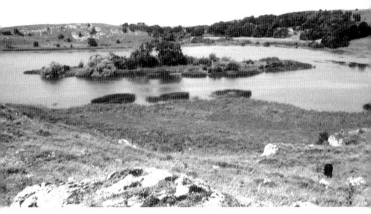

Garrett Island from Knockadoon Hill, Lough Gur

went even further than his father had expected and astonished everyone by jumping into a bottle and out again. His father was so surprised that he broke the geasa put on him before his son's birth. "Now you have forced me to leave you," said the son. And with that he disappeared into the fairy realm.

It is said that he lies sleeping beneath Knockadoon with his knights waiting for the time when they will ride forth and gain freedom for all Ireland. But for the moment he must content himself with riding across the surface of the lake on a milk white horse with silver shoes. According to legend, he must do this once every seven years till the silver shoes are worn away.

Another legend holds that once every seven years the enchanted lake dries up and then the sacred tree at the bottom of the lake can be seen covered with a green cloth. An old woman (Áine as hag) keeps watch from beneath the cloth. She is knitting, recreating the fabric of life. One time a man came riding by just as the lake had disappeared. He snatched the cloth from the tree and rode away. The woman called out and the waters rose, pulling back the cloth and half the horse with it. So Áine continues to protect her realm helped by the waters of the lake (*Mystic Ireland*).

The land around the lake has been inhabited for the last 5000 years. The first neolithic houses to be found in Ireland were

excavated here in the 1930s and the area has provided archaeologists with a wealth of artifacts and information. It is a place where myth, folklore and archaeology seem generally to be in harmony.

It is a magical and very beautiful place where the remains of ancient dwellings, field boundaries, forts, cairns and circles lie half hidden in the bracken and wild flowers, surrounded by grazing cattle and the sound of birdsong.

In the middle of the last century the level of the lake was lowered by drainage and it now forms a semi-circle around the raised headland of Knockadoon in the east. Earlier maps show the hill as an island. At one time it would have had a castle on its summit. When the lake shrunk, over twenty bronze axes, twelve spearheads and other weapons as well as the lovely Lough Gur shield were found. They would have been votive offerings made during the Bronze Age.

Knockadoon itself has evidence of at least seventeen house foundations, some inside circular stone walls. Most date from early neolithic times and appear to have been occupied till the Bronze Age, a period of perhaps 2000 years, as evidenced by the variety of pottery sherds found there. Stone axes from Antrim in Ulster were also found, so this was no isolated community.

The Anglo-Norman Fitzgerald family, later to become the Earls of Desmond, took this land in the 12th century from the Irish Dál gCais clan.(see **Brian Boru,** CLARE) They built two castles here: the Black Castle guarding the south access point to Knockadoon and Bouchier's Castle in the north. Over time the Desmonds became very powerful, finally rebelling against the English crown in the 16th century. They were defeated, the last Earl killed by the English in 1583, and their vast estates and castles confiscated. Munster was subjected to plantation and Lough Gur Castle granted to the Bouchier family.

Bolin Island to the north of Knockadoon and Crock Island in the north east, now part of the mainland, are both crannogs or lake dwellings made by laying down a ring of boulders infilled with earth and brushwood.

Between Crock Island and the visitor centre on Knockfennell are a variety of sites both domestic and ritualistic dating from neolithic to Medieval times - a period of perhaps 4000 years. Here is the Red Cellar Cave where bones of elk and brown bear were found. Caves would have been sacred to the earliest inhabitants and the limestone nature of this place with its caves, swallow holes and even disappearing lakes would have contributed to its mythology and development as a sacred landscape.

The earliest sites to be excavated in 1936 lie east of the car

park on the road to Herbertstown. Access is through a gate and across a field. To the north is a large circular bank around 160 feet in diameter and flanked on both sides by stone slabs. Inside the bank is a ditch and in the centre a smaller stone and earth bank some 45 feet in diameter. The inner ditch suggests a ritual purpose for this monument. South east of this is a small circular earth platform also flanked with stone. Pottery found in this smaller site date it to the late neolithic or early Bronze Age.

The recess in the doorway of Carraig Aille Fort 2, Lough Gur

Returning to the T junction and turning left towards Lough Gur Cross, you will find the two stone forts of Carraig Aille up on the hill to the right just past the shop. Both were excavated in the 1930s. Carraig Aille 1, to the north, was dated to the first millennium AD and Carraig Aille 2 was given an occupation period between the 8th and 11th centuries. Finds from this 2nd fort included a hoard of silver Viking jewellery. Brian Boru is recorded as having fortified sites at Lough Gur against the Vikings at the beginning of the 11th century. The stone walls, though no longer high, have some interesting details preserved. You can see the beginnings of stairways and recesses in the doorways to hold wooden doors.

Turning right at Lough Gur Cross, the road to Holycross passes along the south side of the lake. On the left is a wedge cairn excavated in 1938. It has a long gallery with double walls infilled with rubble. A stone slab near the south west end divided the gallery into two chambers. It is said that when archaeologists removed the bones from this site, every banshee in Ireland could be heard wailing. There is a tradition across the country that when you hear a banshee, it means that someone you know is about to die. 'Bean sí' means 'fairy woman' in Irish.

A little further along the road overlooking the lake is the New Church built by the Desmonds and repaired by the new owner of Bouchier's Castle, the Count de Salis, in 1900.

By the south doorway set in the wall is a glazed picture of the Madonna and Child and a plaque in memory of Thomas Ó Connellan,

a minstrel bard who died at the castle and is buried here in the graveyard.

Turn right at Holycross towards Limerick and soon the great stone circle or Lios at Grange is on your right. It is only a short distance from the lake but cannot be accessed from there. This is one of Ireland's most beautiful stone circles and the high earth bank surrounding it helps maintain the strange otherworldly space inside.

It is made up of a continuous ring of standing stones of varying sizes. Outside, the stones are backed by a bank about 3 feet high. There is no ditch. Trees overhang the bank and shade the long slab-lined cobbled entrance cut through the bank in the north east.

This entrance aligns with sunrise at Lughnasa and Bealtaine - the Cross Quarter Days in May and August. Directly opposite the entrance are two pointed stones which together form a V-shaped depression through which the sun sets at Samhain and Imbolc. These dates, though usually thought of as Celtic festivals, were of course much older points of significance in the annual calendar.

Inside the circle the ground level was raised about 2 feet and quantities of pottery sherds from

Slab lined entrance to the great stone circle at Grange. Note the two pointed stones across the circle from the entrance.

the neolithic and early Bronze Age, which appear to have been ritually broken, were found spread upon the raised floor. This helped date the circle to around 2000 BC - an important ritual site from neolithic times.

A massive stone to the north of the entrance is known as 'Crom Dubh' representing the god of harvest or Lughnasa. Some part at least of the circle's function was associated with harvest-time and Crom Dubh's return to the earth, bent under the weight of the first sheaf of corn, personified by Eithne, the corn maiden.

North of this site are two other stone circles both partly destroyed. The nearest was even bigger than the Lios but has

almost disappeared. East of this is a smaller but more complete one. Both are visible from the Lios.

North east of the Lios is a large standing stone called the Pillar Stone and south east is the great stone known as 'Cloghavilla' (Clogh na bhile) meaning the 'Stone of the Sacred Tree'. It looks like the stump of a giant petrified tree and with its mossy covering, it surely resembles Áine's sacred tree, associated with fertility and renewal, at the bottom of the lake covered with its green cloth.

Some of the sites around Lough Gur are on private land and permission is needed for access.

Barrows on the summit of Cnoc Áine

2 Cnoc Áine

67 36

On the north side of the R516 between Bruff and Hospital. Turn in towards the hill by Knockainy Post Office and follow the road round as far as the school. Like most of Limerick's hills, there is no special path, so just ask.

According to Celtic tradition, this is the sacred hill of the goddess Áine and her place of power. To some people the hill itself is shaped something like a female form with three rings or barrows in her belly. The barrows represent the dwellings of the ancestors of the Munster tribe, the Eóghanachta: Fer Í, Eóghabhal and Eógan. In this particular context Áine is their daughter. To the Celts the cairn on the summit was her palace and the entrance to the Otherworld.

However, the cairn is neolithic and the barrows probably Bronze Age, so this would have been a ceremonial site long before Celtic times. Áine's presence here is most likely a continuation of a much earlier sun deity tradition. By making her their daughter, and the barrows the dwelling places of their ancestors, the Eóghanachta tribe were creating a divine lineage for themselves.

At certain times in the Celtic year, usually the night before the major festivals, the entrance to this Otherworld would open and human lives could be touched for good or ill by spirits or Faerie beings. This could, of course, happen at any time but the eve of a festival such as midsummer was a particularly potent time.

As the inauguration site of the Eóghanacht kings, it was here that they came to be united with the spirit of their kingdom, Áine. While the king lived in harmony with the Otherworld, the kingdom was blessed, but when customs or taboos were broken, everyone suffered.

The following story explains how the king Ailill came to be called 'Ailill Ó-lom' or 'Ailill One Ear'. It has echoes of the inauguration rite described in the story from Lough Gur. Once again the rules are broken by human failing and not without repercussions.

The king was having a problem as, every night when he went to sleep, the grass would disappear. His Druidess, Ferchess, advised him to visit Knockainy the next Samhain Eve. He did as she suggested but fell asleep, lulled by the drowsy sound of cows grazing on the hillside. Waking disorientated in the middle of the night, he saw a beautiful maiden coming from the cairn with her father, Eoghabhal. Forgetting all about why he had come, and overcome with lust, he raped her. She, in her outraged anger, bit off his ear and in so doing, maimed him. This meant that he could no longer, by Celtic tradition, be king (*The Festival of Lughnasa*).

While the king had an obligation to maintain harmony with the Otherworld, the people had responsibilities as well. Until 1879 men used to bring flaming bunches of hay or straw on poles to the summit of Knockainy on Midsummer's Eve. They would carry them clockwise round the three barrows which they called 'the Hills of the Three Ancestors'. Then they would take the brands and run around the cultivated fields and pastures in the area to bring good luck to the animals and crops. It was believed that they were emulating the fairies who also performed this rite under the direction of Áine as she impregnated the land with her solar energy once the humans had gone.

Sometimes people reported seeing her leading the human procession. She was seen on the hill as the 'cailleach' or wise woman and there are many stories of her taking human form. Those who treated her with kindness prospered.

When you climb the hill, the cairn, Áine's sí, is right at the top. The three barrows are a little lower down as you look out towards Knockadoon. There is another cairn nearby in the next field as well as a number of ring forts and a standing stone to the west.

3 Knockfeerina (Cnoc Fírinne) - **Hill-top Cairn**
452 362
2.5 miles west of Ballingarry, south of the Ballingarry Croom road.

A climb up Knockfeerina is still a popular afternoon outing and
there are a number of paths up the hill from the Ballingarry to
Banoge road which runs along the south side of the hill. A popular
path also goes up the north side. Take the R519 N from Ballingarry
towards Adare and go right just a mile out of the town. The second
road on the right, about one mile along, leads to a path up the hill.

Cnoc Fírinne is traditionally known as the 'Hill of Truth'. It is
said to personify Donn Fírinne, the Celtic god of death and
fertility. In folklore he is seen as a giant or the Fairy King. He is
said to live at the bottom of a deep hole in the hillside called 'Poll
na Bruíne' and anyone trying to investigate this entrance to the
Otherworld will not come away unscathed and may even be drawn
in, never to be seen again. There are many cautionary tales to
deter the curious. However, good custodians are rewarded. One
local farmer was granted temporary entrance to Donn's world
under the hill where he met with a brother and sister, both of
whom had died many years before.

Donn is closely associated with weather omens. He is said to
collect the clouds on his hill and hold them there for a while to
warn of approaching rain. Sometimes he is said to be in the clouds
if the weather is particularly bad. He is also said to be flying abroad
when someone dies.

There is a cairn on the top of Knockfeerina called 'Buachaill
Bréige', meaning 'the false or lying boy' and it was the custom, and
indeed the duty, of local people, to carry a stone up the hill to put on
this cairn once a year. The hilltop has traditionally been a popular
Lughnasa assembly site visited at harvest-time, and at this time
freshly picked berries and flowers were strewn around the cairn as
offerings for the hill's fairy inhabitants. On the eves of the festivals of
Bealtaine and Samhain, young girls used to leave gifts high up on the
side of the hill below the western ridge called 'the Strickeen'.

On the north slope of the hill is the Giant's Grave or Fawha's
Grave - a roofless wedge cairn marked 'Megalithic Tomb' on the
map (*The Festival of Lughnasa*).

Like the hills to the east, Knockfeerina is also associated with the
adventures of the Fianna. On the Stricken is a large ring-fort called
'Lios na bhFian' or the 'Fort of the Fianna'. One such adventure is
named after the 'Palace of the Quicken Trees' where the Fianna
become the victims of an act of revenge after being lured to a feast
in an imaginary palace.

A little wary of the invitation, Fionn had left his son Oisín and a

MUNSTER **Limerick**

number of the Fianna behind. And sure enough, while they waited for the food to arrive, the fire began to send out black clouds of evil-smelling smoke. The palace around them disappeared and they found themselves sitting on the hillside and fixed to the ground, unable to rise.

Fionn put his thumb to his mouth, which he did when he wanted to see to the heart of things, and found that the spell that held them had been cast by the three kings of the Island of Torrent. These kings were marching on the palace to kill them and only the blood of these three kings could undo the spell (*Portrait of Limerick*).

When Oisín and the other Fianna came to see if they were alright, Fionn warned them not to come in. He explained what they must do to stop the kings. Eventually the Fianna managed to intercept and then kill the three kings. They took their heads and sprinkled the blood around their companions. Thus the spell was broken.

Issues of revenge and death are common in the Fianna stories. This particular story also illustrates the dark side of Knockfeerina and its reflection in the human psyche. On a lighter note, folk tradition has it that Donn and his followers fought battles on behalf of the countryside. These might take the form of a cross-country hurling match against the fairy people of Knock Áine. The winner would take the best of the potato crop to their side of the county.

4 Knockgrean (Cnoc Gráinne)
75 44
Just south of the N24 from Limerick to Tipperary. In the village of Pallas Green New, turn right to the old village of Pallas Green.

This village is called after the palace of the sun goddess Gráinne. It feels very ancient and part of another world. The hill north west of the village is Cnoc Gráinne or Gráinne's hill. This is the third fairy hill of Munster and home of the goddess and her retinue. The summit is also associated with the Fianna, and called 'Knockseefin' or the 'Hill of Fionn's fairy mound'.

There seems to be no traditional pathway up this hill but there was no problem getting permission to climb through the fields. Although I did not find the same stories associated with this hill, it actually had the gentlest, most magical atmosphere of all three. Definitely a fairy place.

South of Lough Gur and the fairy hills, the mountains run just south of the R515 between Rath Luirc in the west and Tipperary in the east. In the east they become part of the Glen of Aherlow in Tipperary. There are clusters of ring-barrows on their lower slopes at sites from Lissard, north of Duntryleague, to Cush on the slopes of Slievereagh, a striking mountain with peaks capped by ancient cairns.

Around Lissard about twenty barrows were excavated in 1934 and a small amount of cremated bone and charcoal found. One of these had part of an inverted Bronze Age urn near the centre and beside it a decayed wooden trough, possibly a canoe. However, only a few barrows are visible to the naked eye and many have been destroyed by farming.

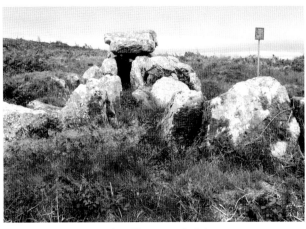

Duntryleague passage cairn. The entrance leads into a narrow passage.

5 Duntryleague Cairns

781 284

About 8 miles south west of Tipperary town near the Tipperary border. It's signed from the village of Galbally at the west end of the Glen of Aherlow. After 1.3 miles, there's space to park by a garden wall and a path leading uphill.

Old graveyard, Adare

MUNSTER Limerick

The path brings you to a saddle between a rise to the west and the summit. Here are the remains of an exposed passage cairn. A long passage leads into an expanded chamber roofed with overlapping flags. The entrance to the chamber is very narrow. The passage opens to the north west, looking out across the plains of East Limerick. Behind the chamber in the distance is the south west tip of the Galtee mountains. There are many kerb and cairn stones still in place near the entrance.

Just before this passage cairn, a path leads off to the right and

the summit of the hill. Here is a mound, now overgrown, containing eight small mounds. Red sandstone dry-stone kerbing is visible in places, but no sign of an entrance. It was excavated but nothing was found except a small piece of iron. Now covered with heather, gorse and bilberries, I was there at midsummer and tasted my first bilberries of the year.

To the south are the Galtee mountains with the Harps of Cliu clearly visible. The Glen of Aherlow fades to palest velvet in the distant east.

6 Adare
On the N21 between Limerick and Rathkeale.

Adare seems to have come into being in the early 13th century as an estate village beside the Norman manor of Geoffrey de Marisco. In more recent times, the village has benefited from patronage by the Quinns, Earls of Dunraven, especially the 3rd Earl, an improving landlord and an authority on early Irish architecture. Adare Manor is now a hotel and golf course.

Franciscan Friary
475 467
Go into the Golf Course and ask permission to visit the friary.

The setting is very beautiful and while the buildings may appear neglected, nature is somehow being assisted so that the walls and walkways are fringed with ferns and wild flowers while the space inside is still quite clear. Founded in 1464 by Thomas, Earl of Kildare, it was dedicated on its opening two years later to St Michael the Archangel. Till the end of the century it was worked on and added to with the refectory, dormitory and infirmary added around 1500. The Earl and

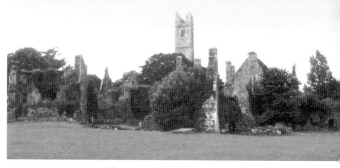

Franciscan Friary, Adare

his wife provided money to put glass in the windows. The cloister to the north has an ornamented west side and there is a fine sedilia in the church. It was restored by the Earl of Dunraven in 1875.

Behind the golf clubhouse are the remains of two small churches. One is dedicated to St Nicholas of Myra. It was the old manor church. In the graveyard are an extraordinary pair of mature beeches which have incorporated a gravestone in their trunks.

Augustinian Friary

468 465
Going east from the village towards Limerick, the friary is on the left hand side.

This friary is now a Church of Ireland church and school. It was built around 1325 as a nave and chancel church with a south aisle. The tower and domestic buildings were added in the 15th century. The small cloisters, also 15th century, are in excellent condition. It is a fine little medieval church with some interesting detail, particularly the west window, the sedilia and the aumbry.

It was re-edified as a Church of Ireland parish church at the beginning of the 19th century, around the same time as Holy Trinity Church, and under the same patronage of the Earls of Dunraven who were also responsible for much of the restoration work here and the massive rebuilding at Holy Trinity.

Outside the building are a number of mature lime trees. These have a lovely sweet smell, making an instant link with the stories of Lorrha and Holy Island in Tipperary and Clare.

7 Disert Oenghusa Church and Round Tower

495 413
Take the Ballingarry road west from Croom, a small town on the N20 between Limerick and Cork. After about 1.5 miles, turn right, signed Rathkeale 14. Disert Oenghusa is signed on the right, down a long lane.

The monastery here was probably founded by Oenghus the Culdee, the great leader of the Céli Dé reform movement, who died in 815. He is also associated with Monaincha, Tipperary. The Céli Dé, or Culdee Movement was an 8th century attempt at monastic reform. The Culdees wanted to recreate in monastic life the purity which they felt was being lost in the face of growing secular concerns. They founded small, isolated hermitages, sometimes called 'dyserts' in remote 'deserted' places.

The present church is 15th to 16th century, though large

MUNSTER **Limerick**

stones low in the wall are probably part of a much older building. The broken lintel in the south wall and the massive stone at the threshold are also much earlier. The tower has no top and stands 65 feet high with pellets and moulding above the round-headed doorway. Human bones were found under the clay floor. The back of the tower seems to be built on solid rock.

8 Dunaman Castle Sheela-na-Gig
473 422

Back on the road from Disert Oenghusa, continue towards Rathkeale. After 1.7 miles, there's a lane on the right down to a farmyard. The castle is a derelict tower house in the farmyard.

The figure sits in the centre of the south wall over the doorway. The style is almost geometric rather than realistic, and very strong. She is framed in a raised band which she fills with her feet reaching the corners. Her ribs are clearly drawn and her hands go behind her legs to touch either side of her vulva from which a drop appears to fall.

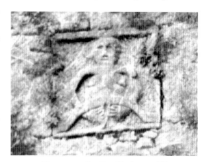

Dunaman Castle, Sheela-na-Gig

9 Killeedy Churchyard and St Íde's Well
271 261

6m south east of Newcastle West and 5.5 miles south west of Ballingarry.

Take the R520 east from Newcastle West and turn right to Killeedy village after about 6 miles.

The slight remains of a church are all that is left of a nunnery founded here by the 'Foster-mother of the Saints', St Íde. According to legend, she suckled Jesus who came to her in the form of an infant. She was born in Waterford and came to Limerick to found her nunnery after enlisting the help of an angel to persuade her father to allow her to follow her vocation. She took only enough land to grow vegetables for herself and her enthusiastic followers, and went on to become a great teacher and healer. Brendan the Navigator was one of her students.

An ivy-covered piscina with a pointed arch gives some idea of

MUNSTER **Limerick**

the delicacy of detail in the building. Though her nunnery was replaced at an early stage by a monastery, she is still revered here. She died sometime between 570 and 577. Her grave is at the junction between the nave and south side of the chancel. It is visited throughout the year and strewn with flowers during the traditional summer pilgrimage.

St Fachtna of Ross Carbery was a disciple.

10 Tullylease Monastic Site with Cross Slabs
358 187
2.5 miles south west of Drumcollier, just over the border in Cork.

Go south out of Drumcollier on the Freemount road and fork right twice, then turn left at the crossroads down into the village. The well and church site are before you come into the village.

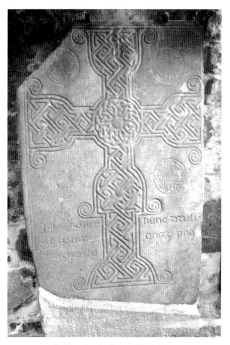

St Berechert's Stone, Tullylease

This monastery was founded by St Berechert in the 7th century. He was one of three sons of a Saxon prince who left England after the Synod of Whitby in 664. There is a well on the right hand side of the road surrounded by a small garden with a little stone house built over it, painted white. The water is clear.

Across the road are the ivy-covered remains of a 12th century

nave and chancel church set on a small hillock on the side of the valley. There are a number of early gravestones attached to the wall including the beautiful St Berechert's Stone.

This was obviously an important artistic centre in the 8th century for this slab is a very early example of celtic ornament on stone and exquisitely cut. It is dated to the 8th century because of its similarity to *The Book of Lindisfarne*.

There is a well dedicated to St Berrihert near Hartnett's Cross at the east end of Macroom. In Tipperary, in the Glen of Aherlow, there is a small enclosed graveyard called St Berrihert's Kyle.

Carving of St Berechert with pilgrims' crosses scratched on it, Tullylease

11 Kilmallock

On the R515 just north of Ardpatrick is to be found one of Limerick's most impressive complexes of medieval church buildings.

Kilmallock is named after St Mo-cheallóg who founded a monastery here in the 7th century. Like Brendan the Navigator, he is also said to have been a pupil of St Íde. The town was founded by the Fitzgerald Earls of Desmond and fortified in the 14th century. It was twice sacked in the 16th century as the Fitzgeralds came into conflict with the English over the suppression of Catholicism. At the beginning of the 17th century the new Earl, James, who had been brought up in England, was rejected as heir by the Desmonds for attending the then Protestant Collegiate Church in Kilmallock. The popular choice was the Súgán Earl, but he was betrayed by his kinsman, the White Knight, Edmund Fitzgibbon.

Traces of the fortifications remain. Most notable is the Blossom Gate, a 16th century replacement so-called from 'Blapat'. 'Bláth' meaning 'flower' in Irish and 'pat' or 'port' meaning 'door' in French.

The four-storey tower house, called St John's Castle, with its wide-arched ground floor, still forms an arch over the Limerick road.

Dominican Priory

609 280
Known locally as the abbey, the priory buildings are just outside
the town walls and accessed from the Limerick road just opposite
the castle. A foot-bridge takes you over the river.

The foundation was probably initiated by Gibbon Fitzgerald, but continued under the patronage of his son Maurice at the end of the 13th century. Maurice was the first White Knight and their tomb was sited near the altar of the church as befits the patrons. The White Knights continued to be buried here until 1608 when Edmund Fitzgibbon, the betrayer of his kinsman, (see above) was buried

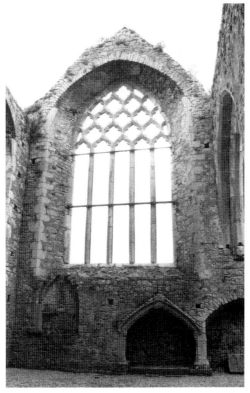

Five light west window, Dominican Priory, Kilmallock

here. It is said that a mark, worn on the tomb by an incessant drip of water, is a sign of his disgrace.

The priory is spacious and elegant with beautiful 13th and 14th century carvings and two exceptionally fine windows: a lovely five-light west window and a beautiful reticulated window in the south trancept. The latter was added in the 15th century when the tower was also built.

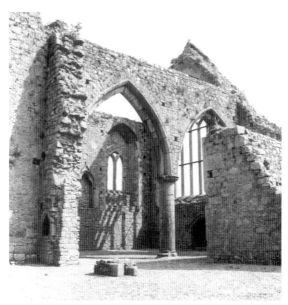

Dominican Priory, Kilmallock

Some Dominicans seem to have remained here after the Dissolution as there is a record of two of them having been executed by the Cromwellians in 1648 (*Monuments of Ireland*).

The Collegiate Church

609 278

Just across the river from the Priory.

This church was built in the 13th century and dedicated to St Peter and St Paul. The south door is original and the remains of a round tower can be seen in the south west corner. It became a Collegiate church in the 15th century and was extensively restructured. The porch, with its richly carved doorway, was added and the nave and transept altered.

The inside of the church feels something like a 'city of the dead' filled as it is with tombs and monuments.

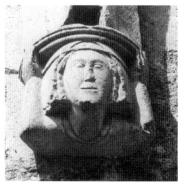

Carved head, Dominican Priory, Kilmallock

MUNSTER Limerick

A number of interesting carved tombs are to be found here, including the Fitzgerald tomb with its skeleton 'Death' holding the grave digger's spade and the body of the dead Earl lying below his foot on an open shroud.

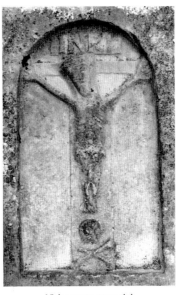

13th century grave slab,
the Collegiate Church, Kilmallock

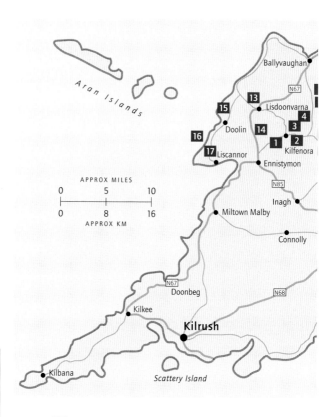

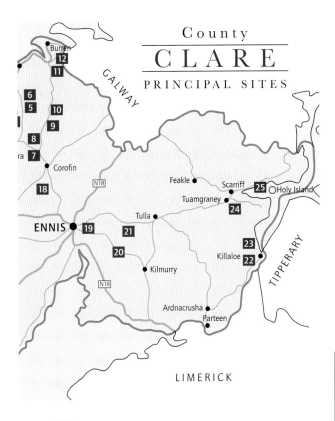

County
CLARE
PRINCIPAL SITES

15 **Teergonean** court cairn

16 **Cliffs of Moher**

17 **Brigid's Well**

18 **Dysert O'Dea** monastic site

19 **Ennis** Friary

20 **Quin** Abbey

21 **Magh Adair**

22 **Killaloe** Cathedral (St Flannan's)
 Kincora and **St Mo-Lúa's Oratory**

23 **Beal Boru**
 Craglea (the grey rock); **Greenanlaghna**

24 **Tuamgraney** St Cronan's Church
 Brian Boru's Oak

25 **Holy Island** or Iniscealtra

Block figures in list refer to site locations in map and entries in text.

CLARE

The abiding image of Clare for me is bright limestone pavement shiny with rain and crammed with purple crane's-bill and yellow bird's foot trefoil, for the limestone holds the day's warmth into the night and hoards moisture in its crevices. Above is blue sky and bright sunshine with the sea as backdrop.

The limestone has been exposed over time leaving the once fertile and well populated hillsides denuded of soil and human inhabitants. All around is evidence of a dynamic prehistoric society. Here is the neolithic Poulnabrone and the hilltop cairns as well as many Bronze Age wedge cairns. Then there are the Iron Age cashels and promontory forts of which there are some 500 recorded in a 100 square mile area. This shows a density of population which was already declining by Christian times.

It could have been simply the readily available fresh building materials which saved these earlier structures from recycling or some deeper reverence for the past which helped to create this multi-layered timescape. Today stone structures from other times dissolve slowly into a landscape that is itself gradually eroding in the Atlantic rain and trickling into underground streams back into the ocean.

The fourth verse of a poem called *Ireland with Emily* by Sir John Betjeman applies here:

> Stony seaboard fair and foreign,
> Stony hills poured over space
> Stony outcrop of the Burren,
> Stones in every fertile place.
> Little fields with boulders dotted.
> Gray stone shoulders saffron spotted.
> Stone walled cabins thatched with reeds,
> Where a stone age people breeds,
> The last of Europe's stone age race.

In the east is the old kingdom of Thomond and home of the famous Brian Boru. He was the younger son of a minor king and rose to hero status as the first Irishman to take on the Vikings. His success at defending his people and the vulnerable monasteries of the eastern plains won him popularity and the kingship of Thomond. He went on to unite the people of Munster behind him and finally to win the title of High King of Ireland. He is perhaps best known for the Battle of Clontarf outside Dublin in 1014 which broke the power of the Vikings in Ireland. He won the battle but

was killed as it finished.

The name 'Boru' or 'Bóromha' means 'tribute', specifically 'cattle tribute' which was owed to him by lesser chieftains in his kingdom. He is credited with introducing the use of surnames into Ireland as his descendants were known as the O Briens: Donal Mór O Brien, for example.

AROUND THE BURREN

1 Kilfenora Cathedral and Crosses
187 941

The tiny **Cathedral** dedicated to St Fachtnan is incorporated at its west gable into the present Church of Ireland church. Though tiny, it still manages to exude a powerful and imposing atmosphere which is not altogether pleasant. However, there are some interesting carvings and a fine east window in the Transitional style. It has three lights with carved capitals and rounded arches similar to O'Heynes Abbey at Kilmacduagh. One capital is carved with a small group of very serious and devout clerics looking down on the congregation. People say that in the 18th century the cathedral had a wooden ceiling painted blue with stars on it covered in gold leaf.

The north wall has a 15th century tomb with a strangely carved bishop. It's not clear whether the carver was just learning his craft or trying unsuccessfully to initiate a new style! It is considered locally to be St Fachtnan. This strange image is all we know about this saint. There's another carving, in a very different style, of a bishop giving

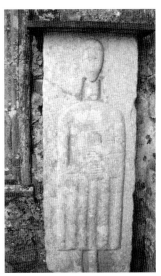

Effigy of bishop inside north door, Kilfenora cathedral

a blessing on the east wall to the left of the window. Kilfenora is, of course, best known for its high crosses which date to the 12th century.

By the entrance to the cathedral is a faintly patterned cross

shaft. West of it, but still in the graveyard, is the Doorty Cross with its bishop holding his hand up in blessing on the east face. Like at Dysert O'Dea, the bishop is mitred and holding a crozier, but here he has been elevated to the centre of the cross, the position formerly reserved for Christ. Below him are two more figures with croziers, presumably also bishops. One is a tau-shaped crozier and the other crooked, which they seem to be thrusting into a beast below them. This image of the Coptic Tau appears again (see **Killinaboy** below) in Clare.

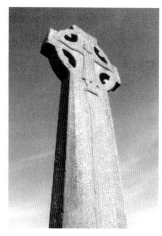

Cross in field, east face, Kilfenora

The east face has a crucifixion on the cross head with the space below filled with animal interlacing in the Urnes or Ringerike style of Scandinavia. Beneath that is a figure, possibly Jesus, riding a donkey over palm branches into Jerusalem. To the north west is another cross with boss and patterning. To the west again, in the next field, is a huge cross with a crucifixion on the east face - the image is rather flat and stylized but imposing - rather like the cathedral itself. The Christ figure appears to be standing on a long thin pole and the space beneath him has finely patterned panels with interlacing and geometrical designs. Unlike most of the western crosses, this one has a pierced ring and longer arms.

Praying clerics, Kilfenora cathedral

2 **Caher Ballykinvarga** (Cathair Bhaile Cinn Mhargaidh)
200 947
1 mile north east of Kilfenora. Take the R476 from Kilfenora to Corrofin. A mile from Kilfenora, turn left by the Co-op Mart. The stone fort is visible 0.6 miles along on the left

'Cathair' means 'castle' and the rest of the name means 'the market town' or 'the town where contracts are sealed'. It is interesting that

the modern Co-op Market is just half a mile away. Ask permission at the nearby farm to visit. There's a track some way in and then it is possible to cross the field to the right.

Caher Ballykinvarga (Cathair Bhaile Cinn Mhargaidh)

This massive old oval cashel is about 150 feet at its widest diameter. The walls are built of great limestone blocks. In places they are up to 12 feet high; in others they have tumbled to half that. Around the cashel are upright pillarstones or chevaux de frise which extend out about 50 feet. The remains of a walled and slightly sunken passageway lead through the protective chevaux de frise to a lintelled doorway in the south south east. This is the only way in. (Chevaux de Frise are stone pillars jutting out of the ground at different angles and set close enough and over a wide enough area so as to be impassable on horseback. They were used as a line of defence by the Friesians instead of cavalry to great effect. There are more around Dun Aenghus on the Aran Islands, off the Galway coast.)

Following the field walls round to the west is **Cill Chaimín** - which means Caimín's church. It is a small circular enclosure with the foundations of an early stone church inside. There are small hut foundations with old grave-slabs or standing stones at the centre. A stone platform beside them is known as 'the monk's bed' (see below).

Tobar Chaimín or Chaimín's Well is in the middle of the field just south. It's a lovely well with clear water. A large stone in the bottom with lichen patterns makes it look very totemic. The well is surrounded by a stone wall. It has a cure for sore eyes but the ritual is complicated. You must visit the well on two consecutive Thursdays and the following Monday. Each time when you pray, you must walk five times around the well (clockwise or deiseal) and repeat the same prayers five times, making twenty-five. When this is done, you must go to Cill Chaimín (above) and lie in

MUNSTER **Clare**

the monk's bed there and pray some more. Hopefully after this you will be cured.

This site may have been regarded as sacred long before St Caimín built his church here. The Christian remains are now so old and weathered that they almost have the look of a prehistoric cairn about them. This place is full of history and the rituals still performed here today clearly illustrate a spiritual connection with our more ancient past - one that we don't always easily acknowledge.

South west of here is the smaller **Cathair Mhionnán**, a raised fort (mionnán means a pinnacle of rock). You can see Noughaval Church in the north east.

3 Noughaval Church

208 967

Continue north from Caher Ballykinvarga for 1.6 miles.
Noughvaval Church is signed on the right.

There are three churches here. The first is still in use and is well worth visiting if you can find someone across the way to open it for you. It is a small church, but they have recently put in a new and stunning stained glass east window. It is an incredible sight when the sun is shining outside. A mass of tiny pieces of bright colour catch the sunlight in a truly transcendent way. It is also such a contrast with the natural beauty of the landscape outside, the gentle green and grey of the land against the light blue sky.

Beside it are the ruins of two earlier churches, one medieval, with a beautifully carved doorway in the Transitional style. (see also **Corcomroe** and **Dysert O'Dea**.) The head of the old Noughaval cross is built onto a stone altar in

Celtic cross, Noughaval churches

the graveyard. Below the graveyard is **St Martin's Well**.

This was famed for the great spreading ash tree above it. An enormous ash tree is still here in a state of semi-collapse and growing through the ancient mossy field wall so that it is hard to distinguish wall from tree. However, it is now so spread over the ground that you cannot get to the well. The ground around it is still

very damp and the undergrowth lush. (Ash tree - see MUNSTER)

It was the custom on St Martin's Day, 11th November, to kill a male animal. It could be anything from a bullock to a cockerel, but the meat was traditionally made into pies which were distributed in the community. The well was also visited on this day.

On a ridge east south east you can just see **Cathair an Chaitín** with its huge limestone blocks. About 140 feet across at its widest diameter, some traces of the fine stairway mentioned by Estyn Evans are still visible. (*Prehistoric & Early Christian Ireland*) It seems to have a narrow entrance in the south south east with several large portals.

There are many cairns and cashels here in the townlands of Ballyganner North and South including a court cairn (very rare this far south) in Ballyganner North.

4 Poulawack Multiple Cist Cairn

233 987

From Noughvaval continue north east for 2.2 miles. You can see the cairn far away high up on the left. Just when you seem to have passed it and the road dips and twists downhill, it's signed by the roadside.

The path up the hill winds its way between limestone slabs, their crevices crammed with flowers. In early summer there is meadow crane's-bill and bird's foot trefoil everywhere. It's a gentle but steady climb. The cairn is a massive 70 feet in diameter and about 8 feet high. It sits high up with wide views across the landscape. When it was excavated, the mound was found to have a circular dry-stone wall inside about 4 feet high with a diameter about half that of the cairn. Inside this wall were 6 cists, 2 of which had 2 compartments. Outside the wall were 2 cists, probably added later. Of the 16 bodies buried there,

Poulawack Multiple cist cairn

MUNSTER Clare

only 2 were cremated and one of these was in one of the later cists. A few items, a scraper, a boar's tusk, a shell and some Bronze Age potsherds were found dating the cairn to the early Bronze Age.

5 Poulnabrone Dolmen

236 004

North of Cathair Chonaill, Poulnabrone is visible on the right going north to Ballyvaughan on the R480. 5 miles south of Ballyvaughan, it is well signed.

Poll means a hole in the ground or a pit and also a dark or mean place. Brón means sorrow. So - a dark, sorrowful place or pit of sorrows.

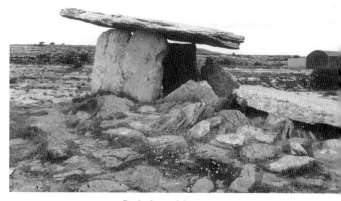

Poulnabrone dolmen

Today it is still a powerful place, though I detected no sorrow and could find no one who knew what its name referred to. This most lovely and most photographed of dolmens receives a steady flow of visitors who seem dwarfed by its hugeness which extends out well beyond the dolmen itself. And so the place maintains a great silence about it like a vast cathedral. It stands on limestone pavement at the centre of a low circular cairn about 30 feet across. The fine limestone slabs lend themselves particularly to a dramatic structure and this one is certainly the finest in Clare.

The 6 foot portals open north north east and are crossed by a low sill-stone. There are 3 side stones on each side and a collapsed endstone. The single slender cap-stone rising at the portal oversails them. It measures 12 by 7 feet. There are 2 possible kerbstones in front. A crack was found in the eastern portal in 1985 and it was replaced.

Poulnabrone is a neolithic dolmen dated to about 2500 BC.

The remains of between 16 and 22 adults and 6 children were found in the chamber and crevices nearby. Most of the adults were under 30 years old. The bodies had been defleshed (a process whereby flesh is removed from the bones) and the bones separated. This process was not uncommon and may have been achieved simply by leaving bodies exposed to the elements.

A later burial of a new-born baby was probably quite recent, reflecting the practice of burying unbaptised babies outside consecrated graveyards, but specifically in ancient sacred sites. Carrowkeel in Sligo and Labercallee in Cork all contain later child burials. A number of artefacts were found in the tomb: a polished stone axe, two stone disc beads, a perforated bone pendant and part of a bone pin as well as two quartz crystals, some flint arrowheads and scrapers and over sixty sherds of coarse pottery.

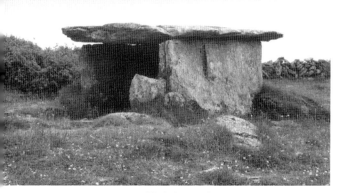

Gleninsheen wedge

6 Gleninsheen Wedge

230 022

'Gleann Insín' means 'little island glen'. Just 1.4 miles north of Poulnabrone travelling towards Ballyvaughan on the R480.

This wedge cairn is beside the road on the right. There's no sign but look out for a small stile. There are reputed to be some 70 wedge cairns in this area. Three are visible from here but Gleninsheen is the best preserved.

Its opening faces east north east with one long sidestone on each side and a single slab forming the roof. There are 2 probable endstones. In places the uprights have been shaped to fit the capstone. Just north north east lies a second wedge with only one sidestone and a displaced cap-stone.

MUNSTER **Clare**

This site is probably most famous for the Gleninsheen Collar, a fabulous gold collar patterned with 6 concentric rings of gold coils. It was found nearby and was dated to the Bronze Age, making it contempary with these wedge cairns. It can now be seen in the National Museum in Dublin.

Just before Aillwee caves there's a rath on the left. A wooden stile leads through to it, although it's not signed. This is a beautiful gem of a place - an earthwork with a ditch and bank outside. Mature trees, mainly beech, are growing from the top of the bank which is almost solid with roots. You'll find it in a hollow between two hills looking out to sea.

7 Killinaboy Crosses and Sheela-na-Gig
272 917
Take the R476 from Corrofin to Kilfenora. Killinaboy Old Church is 2.5 miles from Corrofin on the right-hand side.

The ruined church and round tower stand on a much earlier monastic site dedicated to St Inghean Bhaoth. In Irish this saint's name means 'foolish daughter', but there is no more information about who she was. It has a Cross of Lorainne, a double-armed cross built into the stonework of the west gable. This kind of cross is particularly associated with the Fourth Crusade (1202 - 1204). Such crosses often decorated churches that held a relic of the True Cross. (*Clare, County of Contrasts*)

Over the south door is a rather worn but clearly visible Sheela-na-Gig. Inside the church is a naive crucifix similar to the one at Kilmacduagh (see GALWAY) with a female figure either side of the cross with stylized hoods and crossed hands. Jesus has large hands and wears only a loincloth. The date above is 1644.

At one time a **Tau cross** stood about 1.5 miles from Killinaboy on the left-hand side of the road going to

Sheela-na-Gig over church doorway, Killinaboy

Kilfenora. It is now in the Heritage Centre in Corrofin. It is thought to be 12th century like most of the crosses in the area, but is one of only two Tau crosses in the whole of the country.

MUNSTER Clare

The other is on Tory Island in Donegal. The Clare cross is made of limestone and has a human head carved at the end of each transom. This Tau appears again on the Doorty cross in Kilfenora (above).

The Tau is a Coptic or Egyptian symbol and echoes the shape of the staff used by the Coptic monks for support as they stood during their long hours of prayer. The presence of the Tau in the west of Ireland would seem to imply a familiarity with the Copts. It is known that many of them fled south into the Egyptian desert because they are still there, but it is possible that perhaps some travelled further, ending up on Ireland's west coast. (*Atlantean*)

8 Parknabinnia Wedge Cairn

265 935

Taking the R476 north from Corrofin for 2.5 miles, take the first right after Killinaboy church. This narrow road goes up Roughan hill. The cairn is signed on the left just over a mile up the hill. This is one of many, but it is the most accessible.

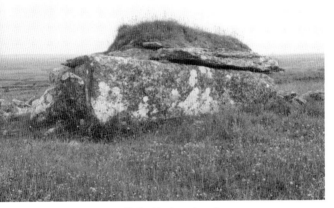

Parknabinnia wedge cairn

MUNSTER **Clare**

The chamber has a neat rectangular endstone but the sides protrude beyond it, seeming to form a second chamber behind the endstone. There are probable cairn stones west and north west and a possible entrance with two portals north north east. Half a mile further up the road on the right, past some houses, are more cairns sited high up with beautiful views over to the east and the soft limestone ridges to the north east. Covered with summer flowers, they look like huge rock gardens.

9 Cahercommaum (Cathair Chomáin)

282 965

Signed 1kilometre down a lane on the right about 1mile north of
Parknabinnia. There is a clear path most of the way. Towards the
end it becomes a track over the hill across limestone pavement.
While this is easy walking on the flat limestone flags while your
goal is visible ahead, it's a different story on the way back unless
you identify some reference points before you go into the fort.

Cahercommaun is a large trivalate or three-walled fort similar to
Dún Aonghusa on Inis Mór. It sits high on the edge of an inland
escarpment on the north side of the wide indented valley of the
Fergus river which separates the Burren area of North Clare from
the rest of the county.

The two smaller outer walls are semi-circular, ending at the
cliff face and a passageway in the east through them, leads into a
central cashel about 100 feet in diameter. The cashel wall, though
quite tumbled in places, is up to 28 feet thick and, here and there,
still 14 feet high. There's a low wall inside the cashel along the cliff
face and wide expansive views to the north and west across
Glasgeivnagh Hill.

The fort is surrounded by good grazing land and associated
with cattle. It is thought to have been built by the king of North
Clare, possibly to collect tribute for the king of Munster at Cashel.
Such tribute would usually have been given in cattle and the two
smaller outer walls of the cashel may have been used to contain
them. They were probably too slight to have been used for defence.
The name 'Comáin' in 'Caithair Chomáin' has a meaning of
'driving' in relation to cattle.

There is a story (*Clare, County of Contrasts*) about a smith called
Lon Mac Loimtha who lived on this hill. He had a magic cow
called Glas Gaibhneach, or the 'smith's grey cow'. He also had
three arms and only one leg. His third arm extended from his
breast and he used it to turn the iron on the anvil as he worked. To
get about, he bounded on his one leg propelled by the elastic power
of his waist and ham. When going further afield, he could be seen
flying over the hills. His boast was that his cow could give milk
enough to fill any vessel and to prove it, he milked the cow over a
sieve allowing the milk to run through and fill up the valley. As the
milk dwindled, it formed seven rivulets which exist today as the
source of seven small streams, a natural feature at the base of the
escarpment below the fort to the north east.

The site was excavated in 1934 by the Harvard Archaeological
Expedition and dated to the 9th century. They found stone
hut foundations. Two of the larger ones had souterrains or

underground passageways. One of these comes out on the cliff face. In the other one they found a silver brooch and a human skull. The brooch is now in the National Museum, Dublin.

There were wooden vessels and iron tools with evidence of iron-working during the castle's two short periods of occupation, both in the 9th century. Some of the tools reflected styles from prehistoric times and the ongoing use of stone axes.

The hills around here are peppered with cashels as well as chambered cairns, wedge cairns and fulachta fia.

10 Temple Cronán (Teampall Chrónáin)
289 000
Continue north to the T junction and turn right into the village of Carron. Teampall Chrónáin is signed down a narrow road on the right just after the village (6.2 miles from the turn at Killinaboy). Park at the stile and follow an almost invisible trackway across the fields till the church comes in sight in a hollow.

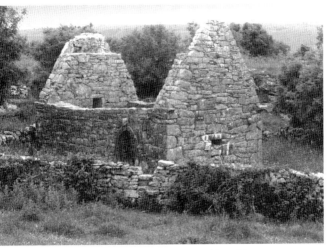

Temple Cronán (Teampall Chrónáin)

This is a beautiful little church with a blocked up lintelled doorway in the west wall replaced in the 15th century by a pointed arch doorway in the north wall. There are carved stones at each corner of the gables jutting out like antae and a number of carved Romanesque heads set into the walls. Behind the church is a stone shrine said to mark the grave of St Cronán to whom the church is dedicated. It is made up of 2 triangular gable ends with 2 slabs roofing the space between. I looked for another shrine in the adjoining field but couldn't find it.

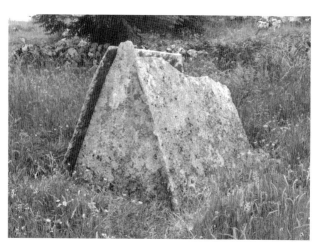

St Cronán's shrine, Temple Cronán

11 Oughtmama Holy Well and Churches (Ucht Máma)

312 082 and 305 078

From Bellharbour go south to the T junction and turn left. This passes the sign for Corcomroe Abbey. A mile along this road there are two lanes on the right, one into a house and the other long lane leads right up the Oughtmama valley into Turlough Hill. It's about a mile walk. 'Ucht' means 'breast' or 'bosom' and 'Mám' means a 'mountain pass'.

As you climb up into the valley, the grey ruins of Corcomroe are visible below. When the valley turns a little to the left, the churches are visible on the right across the fields. At the end of the lane, climb the hillside to the east above a patch of scrub and rushes to the beginning of the limestone escarpment. Spring water trickles out beneath the escarpment at intervals here and tumbles down the valley from this height. The well is under the escarpment near the head of the valley.

An ash tree leans protectively over the well and there's a small thorn tree beside it. Around it is a square dry-stone wall with ferns and flowers sprouting from inside and there are stone steps down to the water. This is a truly lovely place with the gentle contours of the

Oughtmama holy well (Ucht Máma)

grey-blue limestone hills encircling you on three sides and the little churches clustered down in the fertile green valley. Patches of creamy mountain avens shelter between the stones.

On the very top of Turlough Hill is a large cairn. Still on the hill but on a smaller rise to the north east, stands an Early Iron Age hill-fort.

The three churches are all that remain of an early monastic settlement founded by the three Colmáns. One of them was Colman MacDuagh who went on to found Kilmacduagh in Galway.

Mountain avens, Oughtmama

One is a nave and chancel church with a flat-headed doorway and plain Romanesque arch. It has a font in the south west corner carved with two animals with intertwined necks. West of this is a second church with a round-headed doorway and window. Beyond that is a third building with a narrow east window and a doorway in the south. You can approach the churches across the limestone of the upper valley. The alternative is across the fields. Ask permission back at the road.

12 Corcomroe Abbey

295 090

The abbey is signed from Bellharbour on the road east of Ballyvaughan. It is about 1 mile from Bellharbour.

The well at the head of the valley of Oughtmama is a perfect symbol for the great Cistercian Abbey down below which is dedicated to Sancta Maria de Petra Fertili or Mary of the Fertile Rock. This is an apt description of the limestone valley, lush with greenery fed by mountain springs.

Corcomroe was built for the Cistercians at the end of the 12th century with monks coming from Inishlounaght near Clonmel in Tipperary.

Most of the domestic buildings have gone, but much of the church remains. At its centre are three fine arches, one for the chancel and one for each transept. The capitals of these arches are beautifully decorated with symbols of fertility, opium poppy seed, and lily-of-the-valley. There are also human heads. The roof of the choir is rib vaulted and there are three fine lancet windows in the

east. Look out for an interesting carving of a monk on the wall in the choir and a tomb effigy here of Conor na Siudaine O Brien, a patron of the abbey who died in 1267.

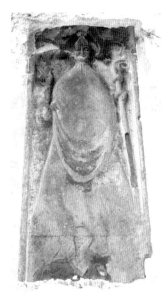

Effigy of a bishop, Corcomroe Abbey

In 1295 jurisdiction here passed from Inishlounaght to Furness in Lancashire during the Mellifont revolt (see **Mellifont**, LOUTH). In spite of the Dissolution in the 16th century, the monks seem to have continued to live here well into the 17th century. Before the west gable is the abbey well with its wide stone surround. Unfortunately, it is choked with weeds.

Wakeman's drawing of the interior of the abbey church in 1857 shows skulls sitting on a piece of wall jutting across beneath the chancel arch. A surprising number of early drawings of abbey ruins around the country show skulls and skeletons lying on altars and propped up in corners. Certainly in plague or famine times when there were not enough people to dig graves for so many, there are reports of bodies being piled up in old ecclesiastical ruins.

Corcomroe was used by Yeats as the setting for his play, *The Dreaming of the Bones*. The play begins:

> Somewhere among great rocks, on the scarce grass,
> Birds cry, then cry their loneliness.
> Even the sunlight can be lonely here,
> Even the hot noon is lonely.

13 Lisdoonvarna

Lisdoonvarna became a popular spa town in the 18th and 19th centuries. The sulphur, chalybeate and magnesium elements in the springs were taken to strengthen the constitutions of 'young and weak females' and others in delicate health. They were also considered beneficial for a variety of arthritic and rheumatic ailments.

The sulphur spring where the Gowlan and Aille waters meet was especially popular in the 19th century. So much so, that when the

MUNSTER **Clare**

local landlord installed a pump house over the spring and locked it against the public, local people blew the gates up in protest. The court case which followed upheld the right of public access.

Today the 19th century pump house is still active and open for bathing and taking the waters. Tel: 065 7074023 for opening times and prices.

14 Kilshanny - St Augustine's Well
137 926

The village is south of Lisdoonvarna on the N67. About 1 mile south of the village, Kilshanny cemetery is signed on the left. The well is down a lane on the far side of the house, just past the graveyard.

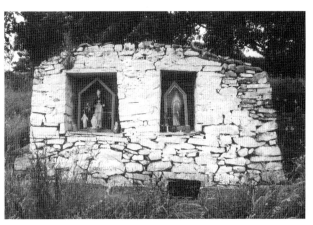

St Augustine's well, Kilshanny

Kilshanny was the site of an Augustinian Foundation but little remains now except a cemetery which is still in use and the holy well.

The well has a tall white-washed dry-stone cover with niches holding statues of Mary and St Augustine. At the front is an opening allowing access to the water. As with most wells in Clare, there's a very old ash tree just beside it. Lovely nature site.

15 Teergonean Court Cairn
068 985

From Doolin north of the Cliffs of Moher, take the R479 north. Less than 0.5 miles later, turn left opposite an inn. Killilagh Church is up here on the left but if you follow the lane right to the end, Teergonean Court is just ahead in a hollow just before the cliff edge.

MUNSTER **Clare**

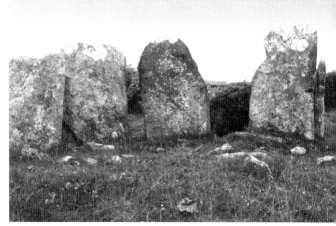

The court, Teergonean court cairn

Two large slabs of limestone form portals with more slabs shaping part of a court on the left side. There are two large chambers. The inner one is collapsed on the right. From just above the court the Cliffs of Moher are visible in the distance.

16 Cliffs of Moher
Signed off the R478 about 2 miles north of Liscannor.

There's a huge car-park to accommodate the numbers of people who want to visit the cliffs. A path has been constructed from the park up to the O'Brien castle which was erected in 1835 as a tea-house. This is a dramatic place where land meets sea. The cliffs are high and gouged by an often wild ocean. Their ledges teem with activity - home to hundreds of nesting seabirds. A magical place at sunset.

17 Brigid's Well
045 900
1 mile north of Liscannor on the R478 on the left hand side of the road.

This is a very potent place of mixed symbols and still much visited both by the curious and by those seeking healing or support. Water flows from the hill underground and drips into a deep stone basin set in the ground. This basin is inside a long cave-like enclosure, its passageway lined with pictures, crutches and other symbols of healing. Candles flicker and ferns sprout in its damp recesses.

It is dark and womb-like and dedicated to Brigid, goddess and saint. Brigid is associated with fecundity and regeneration.

MUNSTER **Clare**

Her festival at Imbolc is the beginning of Spring. Her Christian saint's day is the same time. Uphill from the well are crosses and a walkway linking stations and statues for doing rounds, but it's the well that attracts. The statue of St Brigid is enclosed nearby in a glass shrine. Its associations with fertility are strong.

Entrance to St Brigid's well, Liscannor

This is also a magnet for pilgrims at the opposite point of the year - the fire festival of Lughnasa - and is visited in conjunction with Lahinch nearby, with patterns from the last Sunday in July to the 15th August, the Feast of the Assumption of the Virgin. This has traditionally been a time of overnight vigil.

Many Lughnasa sites are also goddess sites, often mythologised as the burial place of a goddess and represented by a mound or cairn. As the mythology/theology evolved into Celtic times, Lugh appeared as the sun god, seen either as their consort or, in some cases, their child.

A white trout has been seen in this well. Many wells have the tradition of an eel or fish which lives deep in its depths. To see it is to be sure of having one's prayers answered. A trout is especially fortunate as it is associated with the 'salmon of knowledge', symbol of divine wisdom.

MUNSTER Clare

18 Dysert O'Dea Monastic Site

847 282 and 847 284

Signed off to the west of the R476 between Corrofin and Ennis. There is an Archaeology Centre here (Phone: 065 68 37401) with information on the area. I was too early to visit it, but you can go directly to the site by ignoring signs for the Centre.

A little further on, the road runs right by the site. Otherwise stop just outside the Centre gates and follow the path on foot.

This sight used to be called 'Dysert Tola', 'Tola's Hermitage', after the 8th century monk, St Tola, who founded the site. Very little is known about him except that he died between 733 and 737 (*Monuments of Ireland*). The present church is a late medieval

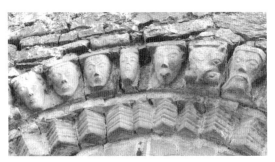

Detail of Romanesque archway, Dysert O'Dea church

reconstruction of an earlier Romanesque building. Fortunately the extravagantly decorated west doorway has been re-used in the south wall. The archway is beautifully carved with geometric designs and fine human and animal heads. You can clearly see a strong Eastern influence in the human faces, brought back from experiences in the crusades and from the Oriental trade routes.

Near the north wall are the remains of a round tower. The high cross is to the east of the church and is one of the later crosses - 12th century, like the Romanesque church and ringless like the other Clare crosses. Like them, it is also very tall and carved from local limestone. It is known as the 'White Cross of Tola'.

The east face shows a stylised crucifixion on the cross head with the figure of a bishop below filling the shaft of the cross. It is probably St Tola, though he is portrayed wearing a mitre and holding a continental type crozier. They are both in high relief, but the bishop is bigger than the Christ figure - a new development - reflecting the enhanced status of bishops after the reforms of the 12th century. His crozier and dress reflect the new continental influences. More importantly perhaps, the proportions also reflect a change in perception of the function of these crosses. They have moved from being power or ritual objects, reflecting biblical and Christian mysteries, to being expressions of the power of the church. They

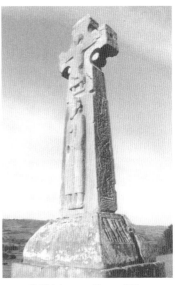

St Tola's cross, Dysert O'Dea

have become monumental or symbolic, rather than totemic.

It is interesting also to note that the realism of earlier times has gone. Christ is wearing medieval dress. There are no other figures such as soldiers or angels. Christ symbolizes, simply, the teaching of the church. Elsewhere on the cross you can see elaborate interlacing and geometric patterns with a strong Scandinavian or Urnes influence - a sometimes unrecognised Viking legacy.

19 Ennis Friary

339 776
Near the bridge over the river Fergus, north east of the town centre.

This friary was built in the middle of the 13th century by one of the O Brien Kings of Thomond for the Franciscan Friars. The magnificent five-light east window which fills the east gable was almost all that survived that turbulent century. In the early 14th century the church was repaired by Turlough O Brien and the east window filled with blue stained glass. It must have been stunning and perhaps more a reflection of the O Brien clan than the Franciscan Order.

By the middle of the 14th century the friary was a flourishing school with over six hundred pupils. The sacristy and refectory were built around this time. Papal Indulgences were granted in 1350 and 1375 bringing more wealth to the friary. The cloister was added about 1400.

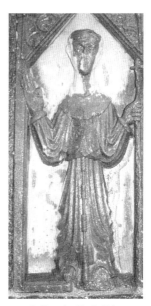

St Francis, Ennis Friary

Today there are many fine 15th century carvings in excellent condition. Some of the tableaux from the MacMahon Tomb seem to have suffered some deliberate destruction but most, etched in hard blue limestone, are barely changed in 500 years. They have been reconstructed with a 19th century canopy in the north side of the chancel. On the south side is a double piscina and beside it a fragment of a Pietà. Pietàs first appear at the beginning of the 14th century. Other carvings to look out for are the the Ecce Homo with a detailed illustration of every aspect of Christ's passion down to the severed ear of the Roman soldier; St Francis with

stigmata, and the carvings of the crossing under the tower. Next to St Canice's in Kilkenny, this is one of the best collections of 15th century stone carving still in place. The last great period when creativity and skill in stonework came together was in the 12th century when the scriptoral crosses were carved.

This is a Dúchas site - admission charged.

20 Quin Abbey

419 746

4 miles east of Ennis on the R469 to Limerick.

In the late 13th century a De Clare castle was built here on the ruins of an earlier church. It was a massive square structure with a tower at each corner. The castle was ransacked by a MacNamara prince and the church rebuilt in the ruins in the middle of the 14th century. However, the castle walls and towers can still be seen in the fabric of the church giving it an unusual solidity. The Franciscans came here in the 15th century.

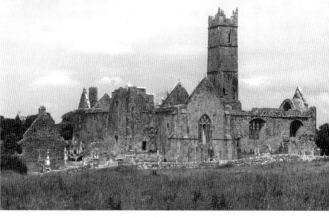

Quin Abbey

There are very well preserved cloisters with a number of interesting masons' marks on the arches and a narrow spiral staircase to climb and look out across the fertile lands of East Clare. In the chancel, the ribbed arch of a tomb niche is finished on one side with a human hand signifying that work in the church had been complete.

The ground inside the buildings is laid with tombstones, some dating from the 15th century. Near the entrance to the church is a blacksmith's stone with all the tools of his trade. In the cloisters is the tombstone of the last friar who lived nearby. He died in 1820.

MUNSTER **Clare**

From a later period, the doorway of the Butler mausoleum has small air-holes through which you can see four coffins, some as much as 100 years old, sitting mouldering in their niches.

Much of interest at this site relates to death and interment, reminding us of the close connection between sacred sites and the deposition of human remains. The megalith builders appear to have recognised and used the close link between death and ritual in their ceremonies.

Today we are much further removed from this understanding in spite of the fact that Christianity is based around the death of Christ. Archaeologists have, until recently, looked at megaliths and seen only tombs. Yet people have instinctively chosen to bury their dead in sacred places. Bronze Age burials are found in neolithic cairns, and Iron Age remains are deposited in Bronze Age barrows. In Christian times, burials will often continue to be made at old cemeteries where the church is in ruins and the population scattered. People want to return to the old sacred sites because they feel instinctively that this is where the souls of the dead will be at peace.

Dúchas site - no admission charged.

21 Magh Adair

442 770

This is signed about 2 miles north of Quin. Pull in by the tiny bridge. There's a small stone stile on the left and the mound is visible across a field. 'Magh Adair' means 'Plain of the Oaks'.

This flat-topped mound with a bank and ditch around it was the inauguration site of the Kings of the Dál gCais and their descendants, the O Brien Kings of Thomond. This is where the famous Brian Boru became leader of the Dál gCais before he went on to become King of the Province of Munster and finally High King of Ireland.

It is beside the oddly named 'Hell River', 'Abhrainn Ifrinn', at this point no more than a stream. There are thorn trees growing on the mound and bank.

It has all the aspects of a sacred hill: water, thorn trees, and across the river a standing stone, once one of a pair and used in the inauguration ceremony. By the time this site was being used for inaugurations, these stones, and the mound as well, would already have been considered ancient and sacred. The stone has a depression on the top which is said to have held water. Local lore tells us that the reddish rock embedded in the stone was used by the king as soap!

MUNSTER **Clare**

When Brian Boru was being inaugurated as High King at Tara, he used the ancient Lia Fáil, the inauguration stone there, as part of the ceremony. It had not been been used for many years but he chose to reinstate the tradition to give authenticity to his claim to the high kingship. Traditionally it would cry out if the king was indeed the rightful heir. The story goes that a great sound was heard all across the land, proclaiming him the rightful high king.

It is recorded that in 982 and again in 1051, when first the High King Malachy and then the king of Connacht wanted to insult the Dál gCais, they cut down the sacred tree at Magh Adair. Another story tells how the High King Flann sat playing chess here for three days to show disrespect to the Kingdom of Thomond.

The site is unusually low for an inauguration mound. More commonly they are on high ground with commanding views across the kingdom, so this place must have been considered very powerful to make up for the fact.

22 Killaloe Cathedral (St Flannan's)

705 728

Killaloe is on the west bank of the Shannon as it leaves Lough Derg. The cathedral is just below the bridge at Killaloe.

The present Church of Ireland cathedral is dedicated to St Flannan, an 8th century prince of the Dál gCais clan. However, it is likely that the first monastery on this site was founded much earlier by St Mo-Lúa and only later dedicated to Flannan in recognition of the Dál gCais' most famous son - Brian Boru. It is certain at least that Killaloe's importance as an ecclesiastical centre owed much to Brian and the O Briens who followed him.

After the reforms of the 12th century it became the See of a Diocese covering the whole of the kingdom of Thomond. The then King of

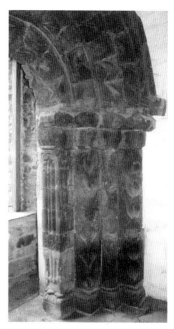

Romanesque west doorway, Killaloe Cathedral

Munster, Donal Mór O'Brien, famous throughout the province for his church building, planned and built a fabulous Romanesque cathedral on this site. It was to be magnificent enough to be the cathedral for the newly formed Diocese of Killaloe - whose bishop was to be his brother Constantin.

Unfortunately Donal Mór's gift at building wonderful churches was matched only by his ability to destroy them, and his new church was burned in 1185 by the King of Connacht in retaliation for a similar raid by Donal into Connacht earlier that same year. In the 13th century, after Donal's death, it was replaced by the present late Transitional building. The lovely Romanesque west doorway was saved and can now be seen in the south wall.

The west doorway of the new building is in the new Gothic style, its capitals beautifully carved with foliage. There are finely carved corbels in the chancel and on capitals throughout the church and an elegant east window, but somehow the most magnificent piece in the new cathedral remains the west doorway from the destroyed church. It is carved from deep purple sandstone and has four orders elaborately carved on arch and pillar with constantly changing patterns of chevrons, lozenges, foliage, animals and human faces.

On a pedestal in the body of the cathedral is a stone with both ogham and runic inscriptions. This is a fragment of a cross shaft requesting a blessing for Thorgrim who carved it and wrote in ogham and runes. A Scandinavian legacy can be clearly seen in many of the high crosses in Clare, especially in the beautiful Urnes style, but this is a unique example of such a bilingual inscription combining Scandinavian and Irish script.

Also in the body of the cathedral is a 12th century high cross presented to the Bishop of Killaloe by the rector of Kilfenora in 1821. It is in the same style as the other Clare crosses. It has a solid ring with short arms and the carved figure of the crucifixion fills the cross head. Spaces around the figure are filled with knotwork and the shaft is decorated with a key pattern.

St Flannan's Oratory

In the grounds of the cathedral is to be found the well-preserved nave of a Romanesque church. The chancel is gone but the stone vaulted roof is in perfect condition. The steep pitched roof is of cut stone and beneath it is a chamber above the vaulting. The style is peculiar to this country and there are other examples in Kells and Glendalough. But perhaps the most famous example is Cormac's Chapel at Cashel, Tipperary.

The Killaloe oratory is Romanesque but ornamented only on the west door.

MUNSTER **Clare**

St Flannan's Well

The well is now in the grounds of the Allied Irish Bank across the street from the cathedral. It is is a deep well with a high dry-stone surround.

Kincora and St Mo-Lúa's Oratory

698 728

In the grounds of the Roman Catholic Church up the main street from the bridge.

The churchyard here is on high ground overlooking the bridge across the Shannon. It occupies part of the site of the old Kincora, royal residence of the Dál gCais kings after Greenanlaghna. (see below)

Kincora remained Brian Boru's preferred place of residence even after he became High King in 1002. He had it enlarged and the fortifications strengthened and for a while it would have been the most splendid palace in Ireland. Its strategic position on a bend in the river just below Lough Derg would have allowed him to keep control of the Shannon and so keep the Vikings and others in check on his home territory, Thomond. After Brian's death in 1014, it went into decline though it continued in use for another hundred years. It was attacked a number of times as dissention grew across the country until it was completely destroyed in 1116. Nothing remains of it now.

Beside the church the remains of St Mo-Lúa's oratory have been erected, brought from Friars' Island in 1929. It would have been a timber-roofed nave with the stone-roofed chancel an addition. Now all that remains is the tiny chancel with its high pitched stone roof.

23 Beal Boru

696 743

About 1 mile north of Killaloe bridge on the R463 to Tuamgraney and Scariff. Signed down a grassy lane on the right.

This is a massive ring-fort with a steep inner bank and faint traces of an outer one. Over eight hundred stone implements have been found in the locality including ten stone axes found inside the fort in 1936.

According to excavations in the 1960s, a ring-fort was built here and occupied around the time of Brian Boru (10th/11th centuries). The foundations of a house were found inside with coins

MUNSTER **Clare**

dated to the 11th century. It was abandoned possibly in 1116 when the *Annals of the Four Masters* report its destruction at the same time as Kincora. A larger structure,which includes the bank and ditch now visible, was built later. Excavations were limited as the owner of the site would not permit the mature beeches and fir trees, planted in the 19th century, to be disturbed.

Entrance to Beal Boru

'Boru' is short for 'Bórumha' meaning 'cattle tribute'. Brian's father and brother both used the name in their title, presumably indicating that they received such tribute. The place itself, Borumha, is first mentioned in 877. It has been said that this was where the Dál gCais kings collected their cattle tribute, but no one really knows how the site was used. It may simply have been named after them. 'Beal' means 'a mouth' or 'an opening'.

Later alterations here may have been a Norman attempt to turn the site into a motte. If so, it was never completed. Today this is a lovely leafy ring-fort with mature beech and fir trees. It has a strong clear energy.

Craglea (the grey rock) and Greenanlaghna

682 750

Going north 1.2 miles past Beal Boru and before the Quay on the right, the Clare Way footpath goes up the hill on the left. It winds around Feenlea Mountain to the left but you can climb straight on and up to the crag, east of the summit.

This crag is traditionally the home of 'Aoibheal', meaning 'the

glowing one' and goddess of this place. It is a powerful nature sanctuary. 'Carrickeevul', meaning 'Aoibheal's Rock', is a 20 feet high projecting rock. She was the goddess protectress of the Dál gCais clan and this was her power place, high above their ancient seat at Greenanlaghna.

The story goes that Aoibheal appeared to Brian on the night before his death at Clontarf in 1014. In her role as 'bean si' or 'banshee', she foretold his death. Towards the end of the battle the next day, when the king's attendants suggested to Brian that he move away from the fighting (he was 73 years old), he said no, he would stay because Aoibheal had already predicted his death.

She is said to have left Craglea when the old woods were cut down. New forests have been planted, so she may have returned.

The fort of Greenanlaghna down below is overgrown and dilapidated, but a special place none the less.

24 St Cronan's Church, Tuamgraney

638 828

Just south of Scariff on the R352 to Ennis. The two small towns of Scariff and Tuamgraney have grown into each other. The church is just out the Killaloe road on the right. Signed East Clare Heritage Centre. The name comes from 'Tuaim Greine' or 'the Mound of Grian', the sun goddess.

In the centre of the village, a natural outcrop of limestone pavement has a magnificent mature lime tree growing in the middle of it. (see **Holy Island**)

The nave of St Cronan's was built in the 10th century with characteristic antae and lintelled or trabeate doorway in the west gable. It was repaired by Brian Boru around 1012. The chancel is a 12th century addition with Transitional features. Its north wall has a Romanesque window carved with chevrons and the windows on the south wall are decorated with fret patterns and spirals.

About 10 years ago the church acquired a beautiful three-light window of the Ascension by AE Child, commissioned in 1906 for the church of Kilfinaghty, Sixmilebridge. St Cronan's may be the oldest church in continual use in Ireland. Certainly it is one of the most interesting. Services are held here once a month. For the rest of the time, it serves as the East Clare Heritage Centre. As such the nave is crammed with an eclectic display of fascinating objects, while the chancel remains clear for worship.

Unfortunately lack of funds in recent years have meant that it is often closed.

Ask Gerard Madden at the pier (see below).

Lime tree, Tuamgraney

Brian Boru's Oak

658 832

From St Cronan's Church follow the road towards Killaloe for 1.5 miles, then turn left into the hospital grounds. Just before the hospital building, take the lane on the right on foot. About 0.5 miles down the lane, you will see the tree is on the right at the very edge of Raheen woods. It is a splendid and venerable oak tree said to have been around 1000 years ago.

25 Holy Island or Iniscealtra

A small island near the west shore of Lough Derg, Iniscealtra takes only a few minutes to get to by boat. The pier is signed off the R352 between Tuamgraney and Mountshannon from where the present boatman, Gerard Madden, ferries people to the island in summer. Most of the information below has been collected by him and published in a small guide book of the island.

MUNSTER **Clare**

We know very little about Holy Island before the first Christian foundation was established here by Colum Mac Cremthainn in the 6th century. However, the story of St Colum's life was written down and this fortunately includes an account of how he first came to the island. He came here at the bidding of an angel and he brought with him a large number of followers. It seems there was already a holy man on the island by the name of Maccriche. This holy man had a sacred tree:

'a tree by the name of Tilia, whose juice distilling filled a vessel
and that liquor had the flavour of honey and the headiness of
wine.' (Acta Sancti Columbae De Tyre Da Glas)

Tilia is the Latin name for the lime or linden tree. It is not a
native of Ireland though it can grow here, especially on the warm
limestone pavement. Its blossom is sweet and the delicate flavour
of its honey well known. This is all we know of Maccriche except
that the same angel who called Colum to the island is also supposed
to have asked him to leave.

St Colum is closely associated with Terryglass to the east of
Lough Derg in Tipperary. This is near the ancient monastic site of
Lorrha. Lorrha also has a tradition of a magical tree: a small leafed
lime which so nourished the monks, it created a kind of paradise
where they needed to do no work. (see **Lorrha**, TIPPERARY for the
full story) St Colum was followed by St Caimin who had such a
reputation for sanctity that he drew many others to the island. He
is supposed to have been present at the Synod of Druimceat in 573.
During his time as abbot, the monastery developed as a centre of
learning. Part of a manuscript called the *Psalter of Caimin* has
survived from this time. It contains 16 verses of the 119th psalm
and is now in the Franciscan Monastery at Killiney, Dublin.

Doubtless many other books were destroyed. The *Annals of
Innisfallen* record destruction of books, shrines and relics during a
Viking raid here in 922. Things improved when Brian Boru came
to power. He defended the monasteries, brought back manuscripts
that had been taken abroad for safety, and repaired and built new
churches. He is credited with building St Caimin's church and he
must have had a special relationship with the island as his brother,
Marcan, was abbot here till his death in 1009.

In later times the monks were strict observers of the rule of St
Benedict, but turbulent times came again with power struggles
among the O Brien's and later with the Dissolution of the
monasteries in the 16th century. The churches on the island lost
their roofs and were no longer used.

AROUND THE ISLAND

From the landing place today, a short walk across the island will
take you to a complex of earthworks and stone buildings which
represents 1000 years of ecclesiastical activity. The bullauns, however,
are probably much older.

The Saints' Graveyard has a unique collection of graveslabs
dating between the 6th and 12th centuries. Nearby is **St Caimin's**

Church. The west end or nave is the oldest church on the island. Its 10th century lintelled doorway was replaced by a 12th century Romanesque arch with 4 orders but the antae at the corners of the building are still there. The present doorway has been rebuilt and is decorated with zig zags, chevrons and an outer order of human heads. There are tiny heads at the top of the square columns. The chancel in the east with its Romanesque arch is also 12th century.

Inside the church are some interesting inscribed crosses including the beautiful Cross of Cathasach with its intricate knotwork traceries on the north wall of the nave. An interesting panel on the lower right side of the cross shows a four-legged animal with a human leg hanging from its mouth.

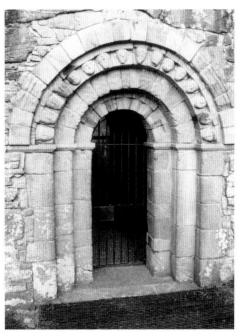

St Caimin's doorway, Iniscealtra

There are three other churches. One is called the **Church of the Wounded Men**, probably a reference to the O'Grady family motto... 'wounded but not defeated...'. Over to the right is the ornate **St Brigid's** with its Romanesque doorway in a walled compound with decorated archway. Furthest away and most recent, **St Mary's**, possibly 13th or 14th century, was in use as a parish church until the reformation. South of St Mary's near the water's edge is the **Bargaining Stone**, sometimes called 'the Kissing Stone' and in use till recently to put the seal on agreements

of any kind. East of the church, also towards the water's edge, is the **Holy Well** with its high wall surround. Unfortunately it has been neglected of late, particularly so, as it is said, that if you can see your reflection in the water, your sins will be forgiven.

Holy Island has been a popular pilgrimage site since Medieval times. In the early 17th century plenary indulgences were granted to pilgrims here. However, by the mid 19th century it was banned by the local priest as a strenuous pilgrimage was followed by an equally excessive indulgence in alcohol, fornication and fighting.

On a gentler note, there is a special place on the highest spot, right in the middle of the island, called St Michael's Garden. This is a small earthwork enclosure reputed to have healing properties. It has been used as a children's burial ground so, although its name associates it with the angels, it is a place unconsecrated by the church but known from ancient times as a holy or gentle place.

A short detour east of the landing stage also lets you experience something of the timeless purity of the island as the water laps gently on the stones. The white waterlilies and pink bistort against the dark water is nature at its visual best and reminds us that beauty is a very powerful thing. And the moorhens cluck among the reeds, oblivious.

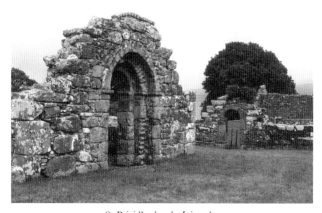

St Brigid's church, Iniscealtra

MUNSTER **Clare**

County
TIPPERARY
PRINCIPAL SITES

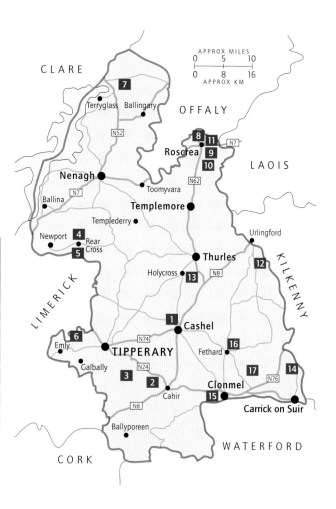

CLARE

7

Terryglass Ballingary

OFFALY

APPROX MILES
0 5 10
0 8 16
APPROX KM

N52

8 **11**
Roscrea **9**
 10

N7

LAOIS

Nenagh

Toomyvara

N62

Ballina

N7

Templemore

Templederry

Urlingford

Newport **4** Rear
 5 Cross

Thurles

12

Holycross **13** N8

KILKENNY

1 Cashel

LIMERICK

6

Emly

TIPPERARY

N74

Fethard **16**

17 N76 **14**

Galbally

3 N24

2

Cahir

Clonmel
15

Carrick on Suir

N8

Ballyporeen

WATERFORD

CORK

MUNSTER **Tipperary**

1 **The Rock of Cashel**
 Hore Abbey

2 **Peakaun or Kilpeacan** monastic site

3 **Kilberrihert or St Berrihert's Kyle**
 The Glen of Aherlow

4 **Baurnadomeeny** wedge and multiple cist cairn
 The Silvermines

5 **Shanballyedmond** single court cairn

6 **Longstone Rath**

7 **Lorrha Monastery**

8 **Roscrea and Sean Ross** ecclesiastical remains
 Roscrea monastic site

9 **Monaincha**

10 **Timoney Hills**

11 **Ballaghmore Castle** Sheela-na-Gig

12 **Kilcooly Abbey**

13 **Holy Cross Abbey**

14 **Ahenny** high crosses

15 **Clonmel** St Patrick's Well

16 **Fethard's** Sheela-na-Gigs

17 **Slievenamon** round cairn

Block figures in list refer to site locations in map and entries in text.

TIPPERARY

MUNSTER **Tipperary**

TIPPERARY IS THE MOST FERTILE COUNTY IN IRELAND. At its centre is a flat limestone plain known as the Golden Vale which provides lush pasture for herds of dairy and beef cattle. These pastures also support some of the most magnificent mature trees in the country.

In the centre of this rich land is the Rock of Cashel, sacred to the goddess Mór Muman, the sovereignty goddess of the south, and royal palace of the kings of Munster since the 4th century. The twelve mountains in the north west are associated with the goddess Ébhlenn. They are known as the Silvermines and have been a rich source of metals since Bronze Age times. Their foothills are dotted with megaliths.

In the south east lies Sliabh na mBan, 'the hill of the women', one of the many hills where Fionn mac Cumhaill passed his days hunting with the Fianna. Fionn mac Cumhaill is the hero of one of the four ancient cycles of Irish literature, the *Fenian Cycle*.

According to various traditions he is a god, a giant, a king and a leader of the Fianna, that mythical band of warriors who hunted across the hills of Ireland, having adventures and righting wrongs. Fionn is especially associated with the 'Salmon of Knowledge' from which he received the wisdom of a seer. In his later years he is also the king who hunted the lovers, Diarmuid and Grainne across the country, finally luring Diarmuid to his death. This act of vengeance lost him the support of his people and the Fianna, and led to his downfall.

These hills and the Galtee mountains in the south west are fairy places. They are often disturbed by the wild hunts of the Fianna and use their magical arts for revenge.

The hills also have a tradition of fairy music. This story comes from the *Book of Lismore*:

Caoilte, Fionn's nephew, is talking about his uncle. He tells how Fionn was walking one day on Slievenamon when a dwarf appeared from a sí or fairy hill and began playing sweet music on his harp. He was called 'Little Criú of Sliabh na mBan' and from that moment, he never left Fionn's side. He had a perfect memory for reciting stories and he taught Fionn's musicians to play fairy music. The Fianna wanted to do something for him in return and so they found him a wife. Her name was Blathnait and she was gifted with seeing the future and would warn the Fianna of danger.

The two little people, as well as Fionn's deer hounds, Bran and Sceolan, were counted the three blessings of the Fianna. So Fionn took good care of them and whenever the weather was bad, he kept Little Criú and Blathnait under his mantle.

<div style="writing-mode: vertical">**MUNSTER Tipperary**</div>

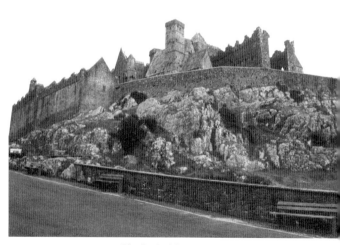

The Rock of Cashel

1 The Rock of Cashel

Cashel is a small town with a great rock at its centre. The massive outcrop of limestone rises to 200 feet, dominating the town and the fertile plains beyond. No less than twelve roads converge at this point where today a cluster of ecclesiastical buildings crowd inside an encircling wall.

The Rock became the seat of the Eóghanacht clan early in the 5th century. They built a fortress here and their influence spread unchallenged across Munster till the 10th century. Cashel was the political power centre of the southern half of the country as well as the place where the kingship was endorsed and empowered by the land itself.

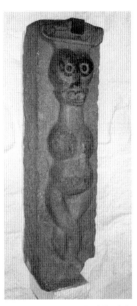

Female figure, Rock of Cashel

Brian Boru took the Rock, as it was called, in 964 and, soon after, the title of King of Munster. However, he remained with his traditional seat of power in Clare.

Later in 1101 Brian's descendant, Muirchertach O Brien, handed Cashel over to the Church. It was to become the see of one of the four new archbishoprics of Ireland along with Armagh, Dublin and Tuam, making it the ecclesiastical capital of Munster as well as its political power base.

Vicars' Choral

Today you enter the walls of the rock through the gateway by the hall of the Vicars' Choral. This 15th century building has been restored and re-furnished except for one room where pieces of carved stone are displayed.

St Patrick's Cross is in here. Over 7 feet high and made from local sandstone, it has stone supports on either side. There is a figure in high relief, the full length of the cross, on each side. One side shows Christ crucified wearing a long robe. On the other side is a bishop, probably St Patrick, standing on an animal's head. It is similar in style to the Roscrea and Monaincha crosses.

The base sits over a mirror so that you can see that it has a deep recess in it. This stone is believed to be much older than the rest of the cross - and is probably the sacred stone through which

the right of kingship was passed at the Eóganachta inaugurations. Urnes-style interlace can be seen on the east side of the base. This would date to the same time as the cross. Also in this room, is an unusual carving of a female figure. She looks like a fertility goddess with legs entwined, accentuated breast and belly, strong thick neck and no arms. Her facial features are exaggerated.

Cormac's Chapel

Cormac's Chapel was built between 1127 and 1135 by Cormac MacCarthy - King of Desmond.

It is exquisitely and lavishly decorated in the Romanesque style. Much is made of a European influence yet its steep stone roof and inner stone vault, built in the traditional Irish style, has proved its most valuable feature as it has protected the inside of the building, making it the best preserved Romanesque interior in the country.

It has also proved more lasting than its 13th century Gothic replacement nearby.

The intricate carvings are made possible by the use of local sandstone which was carried twelve miles to this site by human chain. A particularly interesting carving can be seen on the tympana over the north doorway - of a centaur wearing a helmet and killing a lion with a bow and arrow. The wide arches are carved with human heads showing fantastic features and expressions - even the teeth are remarkable.

Where frescoes and patterns have survived, the strong medieval colours, especially the vermillion and lapis lazulae, are as clear as ever. They were coated with limewash to hide them from sight after the Reformation.

At one time all the arcading on the side walls, the capitals, columns and carvings, would have been covered with frescoes or picked out with the same strong colours.The tomb inside the doorway with its Urnes style carving is contemporary with the church.

The Cathedral and Tower House

In 1169 Cormac's chapel was already too small and a bigger cathedral was built between it and the round tower. It took 65 years to build and can scarcely have been consecrated before it was replaced by an even bigger one built over the lifetimes of three successive archbishops in the 13th century.

This is a large cruciform church with a tower over the crossing and built of limestone, like the rock itself. The nave was shortened by the encumbent archbishop to provide room for a tower house residence for himself. Its Gothic arches, lancet windows and high rib vaulting give the cathedral an air of elegance and there are some beautifully carved figures on the 15th century tombs in the

MUNSTER **Tipperary**

north transept. In a wall niche in the south transept you can see traces of suns and stars in the old plaster.

It was burned twice, the second time by the infamous Earl of Inchiquin in 1647 on behalf of the Parliamentarians. The irony is that he was an O Brien, a descendant of Muirchertach O Brien, who had given the Rock to the church in the first place.

A well preserved round tower 92 feet high and probably early 12th century, completes the catalogue of buildings on the remarkable Rock. So much packed into such a tiny, but very powerful space.

Hore Abbey

Less than half a mile west of the Rock, Hore Abbey was the last Cistercian abbey to be built in Ireland. It was founded in 1272. There's a gate into the field from Dundrum road.

2 Peakaun or Kilpeacan Monastic Site

Off the N24 between Cahir and Tipperary in the townland of Toureen. About 3.5 miles from Cahir, take a left turn signed Cooleen House and go down the lane on the left. Cross the railway on foot and the church is signed further along the lane. This takes you to the north east foot of the Galtee Mountains in the beautiful Glen of Aherlow.

This ancient monastic site is in a small valley cut into the side of the mountain by a tiny stream which flows now to the right of the lane. The site was chosen by the hermit Béagán or Beccanus. He was an anchorite known for his austere practices which included standing every day with his arms outstretched against a stone cross while chanting the psalter.

It's just possible to make out an ancient bank to the left of the lane. This probably marks the boundary wall to the west and south west of the old monastery.

On the right, through a field gate covered with rambling roses, are the ruins of a small church. It has a simple west door but its windows in the east and south walls are in the Romanesque style. These windows are a later addition.

Pieces of a cross called 'the great east cross' sit in front of the little church. It was cut in sections as it was made of a grey/green micaceous sandstone which is very flaky and hard to dress. It has an unusual tapering shaft and appears to have the same crutched form as St Patrick's cross in Cashel. It may even have been the prototype.

Around the pieces of this cross are about thirty early cross-slabs. A number of these are inscribed, including one which has the

MUNSTER **Tipperary**

Pieces of the great east cross, Kilpeacan monastic site

poignant inscription 'Finán Puer' or 'Finán the boy'.

There are some simply carved ringed crosses here which may be as early as the 7th century.

A little further up the lane is Béagán's cell - a low circular wall about the size of a beehive hut with a triple bullaun with one stone inside. Traditionally there were stones in two of the hollows. One was a cursing stone and the other was a 'butter stone' which could be placed in the churn to help with butter making.

A little further up into the tiny valley is a holy well in a grove of mature trees. It is shaded and cool here with a strong sense almost of being inside the hill or at least at the

Béagán's cell and triple bullaun, Kilpeacan. The smallest recess still has its stone inside.

doorway. The water is clear and dark from deep in the hillside. There's a bullaun nearby. Its stone, now gone, used to be thrown into the well to activate its powers.

3 Kilberrihert or St Berrihert's Kyle

Go back to the minor road, turn left and continue for 4 miles to the crossroads. Turn left. There is a wooden field gate a little way down on the left. The kyle is across 2 fields in a grove of mature oaks.

Like Peakaun, it is to be found at the foot of the Galtee mountains on the south slope of the Glen of Aherlow. It is marked 'well' on the old maps. The well is east of the kyle but I couldn't find it.

Berrihert or Berechert is supposed to have been one of three sons of a Saxon prince who left England after the Synod of Whitby in 664. He is also associated with Tullylease in Cork.

The word 'kyle' is used in this part of the country to mean a children's graveyard. The writings of St Augustine in the 5th century taught that we are born in sin and therefore, until a baby is baptised into a state of grace, he or she should not be buried in consecrated ground. Others who had probably not been absolved of their sins before death were also outcast in this way, such as suicides, murderers and their victims, the mentally ill, shipwrecked sailors and paupers. However, by far the most burials in these places would be still-born or newly-born infants.

Kilberrihert wooded sanctuary

A site was usually chosen apart from the settlement, on the boundary between townlands, or the north side of a church. Often it was near an ancient or holy place. Many of these places have become wild and overgrown, but they exist in almost every parish and few are forgotten. They are usually marked as 'cillíns' meaning 'little churches'. This practice was only stopped in the last generation.

Here the old monastic site of St Berrihert has been used as the local kyle. Some time towards the end of the last century, an oval enclosure about 30 by 15 feet was built out of stone to surround the graveyard. The walls are topped by about fifty cross slabs from the earlier monastery. It is in the middle of a small wood and the wall has been built to either side of one oak tree. A second oak and a number of holly trees are growing out of it. Steps have been made into the enclosure like the stepped sides of a cashel.

The cross slabs are mostly small and very varied from plain to quite ornate. Many are in high relief with circular recesses in the

inner corners. Some are plaited with beading and other detail. An altar in the east is made of a huge bullaun with a rounded stone in its recess. Behind it is the head of a red sandstone cross. The centre is described as a six-pointed star within a circle, but it is much more like the marigold image found on other early Christian sites. Jacob and the angel are on the left arm. The right arm and top are too worn to interpret.

Altar with marigold cross and bullaun, Kilberrihert

Small offerings on the altar show that this sanctuary is still visited.

The Glen of Aherlow

On the Tipperary/ Limerick border, the north face of the Galtee Mountains forms the southern slopes of the beautiful Glen of Aherlow.

This north face is called the 'Harps of Clíu'. Fifteen mountain streams gouge channels down its slopes. The five in the east meet in a coombe called Lyre and are separated by Glenageehy, 'the windy glen', from the western 'harp' of 10 gulleys.

'Cliach of the Harps', after whom these streams are named, was a mythical harper of the Tuatha Dé Danann.

In another story, the Daghdha, the father god of the Tuatha Dé Danann, comes from the síd or cairn to harp the seasons into being. His finger breezes play across the gully strings and the falling water contributes to the melody.

Below in the glen are two lovely sites, both early Christian but enhanced beyond measure by their natural surroundings.

4 Baurnadomeeny Wedge and Multiple Cist Cairn

Leave the village following the sign. Keep right at the fork. On the right hand side of the road is a fine tall pillar stone - Cloghfadda - meaning 'the long stone'. Apparently it was originally one of a pair and was probably linked to the wedge cairn up on the hill to the right. The cairn can be reached through the gate by the big stone.

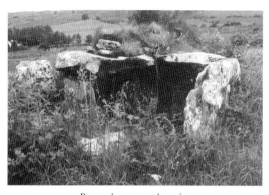

Baurnadomeeny wedge cairn

The wedge runs north east to south west with the antechamber opening to the south west. They are separated by a septal stone. The upright to the north of this dividing stone is heavily scored with horizontal lines on the inside. The antechamber opens to face a gap between two peaks in the Slieve Felim Mountains and the main chamber behind it backs towards the gentle slope of Mother Mountain. The inner walls of the chambers support an overlapping slab roof. At the back of the main chamber, the last cap-stone has a deep groove in its underside. Below it the endstone has a semi-circle cut away in its upper side, thus forming a circular opening between them. A number of the cairn stones have cup or pock marks.

A cist in the antechamber was found to contain cremated bone and some neolithic pottery sherds. There were another 4 cremations in the antechamber and another 16

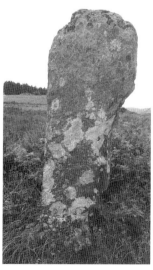

Cloghfadda (the long stone), originally one of a pair below Baurnadomeeny wedge cairn.

in small pits and cists around the cairn. Some may be secondary
but there were no grave goods to date them. All this was covered
by a roughly circular cairn with a retaining kerb 50 feet in diameter
(*Prehistoric & Early Christian Ireland*).

The Silvermines

*A range of small rocky mountains across the north west of
Tipperary, their old name was Dhá Sliabh Déag Ébhlinne or the
Twelve Mountains of Ébhlenn (Evelyn).*

Ébhleen was a mythological figure, married to a king of
Cashel. She fell in love with her stepson and eloped with him.

Right in the heart of these mountains is a small peak called
Máthair-Shliabh or **Mother Mountain** which has a cairn of
stones on top called 'the Terrot'. Those climbing the mountain
would carry a stone from the bottom to add to this cairn. The cairn
was said to cover the grave of a young man who refused to go to
mass one Sunday and went hunting instead. Although it was June
- June 29th to be exact - he was caught in a snow-storm and his
body later found at the spot now marked by the Terrot.

There was a traditional outing up the mountain here until the
1920s. It involved the usual Lughnasa activities of berry-picking,
singing and dancing, though the date was 29th June. The monks of
Kilcommon were said to have started it but it is more likely that
they changed the date from Lughnasa to the earlier date which is
the Feast of SS Peter and Paul (*The Festival of Lughnasa*).

These mountains have, since prehistoric times, been a rich
source of silver, lead and zinc, hence their name, the Silvermines.

The lower slopes, particularly north of the R503, are dotted
with megalithic remains, particularly wedge cairns, which are
associated with the Bronze Age.

Rear Cross is a small town at the foot of the mountains on the
R503 about halfway between Limerick and Thurles. One of the
most remarkable of these megaliths is signed north from the village.
It is called 'Leaba Dhairmada's Ghráinne' meaning 'Diarmaid and
Grainne's bed'. (see story).

5 Shanballyedmond Single Court Cairn
Signed from Rear Cross going south, there is a car-park by the road.

This court cairn is on the east side of the Slievefelim mountains. It
is unusual to find a court cairn this far south. Court cairns belong
to the neolithic period so Shanballyedmond was built and in use

perhaps 1500 years before the wedges nearby. It was an ancient monument when the cist mentioned below was deposited there.

The structure is made of large but thin slabs of limestone, making a narrow, funnel-shaped court which is tall and imposing. It faces north east and opens into a 2 chambered gallery. A line of stones, originally linked by dry-stone walling, surrounds the chambers at a distance of 10 feet and further out again there is an oval of 34 post holes demarcating the cairn. These would have held timber posts around the edge of the cairn - different from the more usual kerbstones.

Under the paved forecourt were found leaf-shaped flint arrowheads and neolithic pottery sherds (*Prehistoric & Early Christian Ireland*). The inner chamber had been used for fire and the cremated remains of a youth were found there. At a later date a cist (Bronze Age) had been placed in the chamber, and disturbed cremation deposits and neolithic pottery sherds were found scattered in the chambers and throughout the cairn.

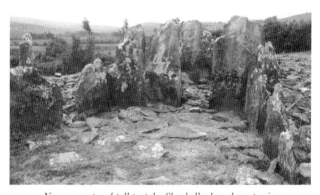

Narrow court and tall portals, Shanballyedmond court cairn

6 Longstone Rath

At Úlla on the N24 about 10 miles north of Tipperary, take the road for Cullen. Go straight through the village and about a mile later, turn right. A mile further on, as the road climbs uphill, the rath (small circular earthwork) is up above the road (not visible above the high bank) on the left just before a right turn.

It is a low hill with a large low cairn in the middle of it surrounded by a bank with an internal fosse. This marks it as a ceremonial rather than defensive site. Inside is a 10 foot pillar stone standing at an angle. It must have been an inauguration or assembly site. The view is fantastic - over to Duntryleague and the Galtees beyond.

Nearby, between here and the village of Cullen, is Cullen Bog - a votive or offering site - probably once a wide pool. In the

18th century many gold and bronze artefacts were found here. They are thought to have been deposited during the Bronze Age when such practices were common.

7 Lorrha Monastery
Signed 4 miles west of Portumna on the R489 to Birr.

The monastery at Lorrha, founded by St Ruadhán in the 6th century, became one of Munster's most famous Christian communities. This was due, in part, to the tradition of the Tree of St Ruadhán at Lorrha which was reputed to give enough food to sustain all the monks at the monastery and visitors as well. Its fame continued into medieval times and made it a popular place of pilgrimage.

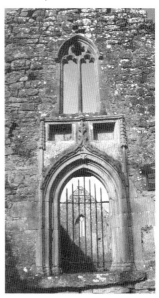

South doorway, the old church, Lorrha monastery

The Church of Ireland church at the east end of the village is on the site of St Ruadhán's monastery. In the churchyard are the shafts of two high crosses in the Ahenny style (see below). One base shows a procession of horses.

The current church is built into the shell of the older church. It has a beautiful stained glass window by Michael Healy, called 'The Holy Women at the Tomb of Christ', made by him in 1918.

The nave of the old church has an interesting south doorway, part 13th century and part 15th century. The famous Stowe missal came from this monastery. Its shrine or cover is in the National Museum, Dublin.

The Cursing of Tara
Next to his tree of plenty, St Ruadhán is most famous for the power of his curse.

Like blessing, cursing was not a new concept in Ireland. Cursing stones at pagan sites were turned sun-wise for good and reversed for ill. The saints with their Christian powers could bless with the right hand and curse with the left. Their ability

(side margin) MUNSTER **Tipperary**

to curse as powerfully as to bless was seen as a measure of their closeness to God.

Geraldus Cambrensis wrote that the Irish saints, like the Welsh, are more vindictive than saints of other countries. Ruadhán was no exception.

The other figure in this story is the High King Diarmuid Mac Cerbhaill.

Diarmuid is remembered best as the last high king to take part in the ancient Feis of Tara. The feis was a pagan ceremony to ensure that the new high king was accepted by the goddess of the kingdom, in this case Maebh. His continued reliance on pagan rituals made him a target for the wrath of a number of saints, ever-conscious of the effect on their newly converted flock.

On this occasion St Ruadhán had given santuary in his church to a man who had killed a corrupt tax collector in the high king's employ. The king was determined to bring the man to justice and, disregarding the sanctuary, he took the man prisoner.

Ruadhán was furious at this violation.

He assembled his monks together with St Brendan of Birr and his monks and they rang their bells against the king and they sang curses and vengeance against him. Twelve kings' sons who were with Diarmuid died, but Diarmuid was unmoved. Ruadhán brought them back to life and then he and Diarmuid engaged in a cursing contest which the saint eventually won. The high king returned the prisoner to Ruadhán's sanctuary.

On another occasion Ruadhán went to Tara and fasted against the king. As in all the stories of the time, the saint won and the king acquiesced, but not before Ruadhán had cursed both Tara and the king.

There are several stories about Diarmuid being cursed by saints, including one about St Ciarán of Clonmacnois. These demonstrate Christian disapproval at Diarmaid's continuing pagan habits, especially his celebration of the Feis Teamhrach.

The last Feis at Tara was in 560.

Ruadhán died around 584 and although Tara continued as the seat of the High Kings a little longer, he is nevertheless given symbolic credit for its destruction.

Just outside the churchyard is the ruined church of the Augustinian priory. It has a lovely Perpendicular doorway but this has unfortunately been incorporated into a handball alley.

At the other end of the village of Lorrha is the ruined church of the Dominican friary founded in 1269 by Walter de Burgo. It is now in the grounds of the Roman Catholic church.

MUNSTER **Tipperary**

8 Roscrea and Sean Ross Ecclesiastical Sites
Roscrea lies at the very northern tip of the county.

St Crónán of Éile founded two monasteries here at Ros Cré which means 'a clay or earth promontory'. The first site was named 'Sean Ross' meaning 'the old promontory'.

Sean Ross old church

St Crónán is said to have founded his first monastery here on this secluded mound only to find that the travellers, whom he was dedicated to feed and shelter, couldn't find the place as it was too far off the main road. So he moved and founded a second monastery at Roscrea by the side of the Slighe Dhála, one of the five great roads of ancient Ireland, linking Tara with north Kerry.

The **Sean Ross** site is now in the grounds of St Anne's Convent on the outskirts of Roscrea. It's signed from the Dublin Road. In the convent grounds the final fork to the left brings you to a small medieval church on raised ground to the right. It is 15th and 16th century and nothing remains of Sean Ross' earlier history.

There is a slight batter to the walls which have ashlar blocks used for the quoins. The church is cruciform, the nave and chancel being 15th century and the transepts added later. There are some beautifully carved details on the windows, though access to the inside is difficult as it is quite overgrown. Nevertheless, it is still a lovely site and the presence of the convent means it may well have been in continual use as a place of spiritual focus since St Crónán first came here in the 7th century.

MUNSTER **Tipperary**

Roscrea Monastic Site

St Crónán moved to this site to be near the road and, ironically, the site is now too close to the main Dublin road on the east side of town.

Far from secluded, this monastery was plundered by Vikings at least three times. There was a great annual fair here, called 'the Aonach', which made tempting plunder. On one occasion, called 'the Battle of Roscrea', the Vikings were driven back by the monks, traders and townspeople when they tried to attack the fair.

The Book of Dimma is the foundation's oldest surviving relic. It is an 8th century pocket-sized illustrated copy of the gospels, and is now in the library of Trinity College, Dublin.

At the beginning of the 12th century the synod of Rath Breasail reorganised the monasteries into dioceses, making Roscrea a part of Killaloe. This loss of independence was keenly felt in Roscrea, where they were allowed to retain their bishops for their lifetimes. Thereafter they went under the authority of the Bishops of Killaloe. It has been remarked that most of what remains of the foundation today can be dated to this time - the Romanesque church, the round tower and the silver book shrine for the *Book of Dimma*. It must have been a last flourish when independence was threatened. Roscrea became part of the diocese of Killaloe in 1161.

The west gable of the 12th century Romanesque church is all that

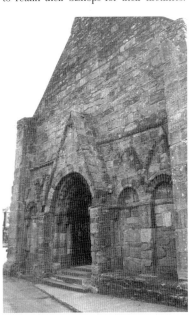

Romanesque gable, Roscrea monastic site

remains and it now forms the archway into the grounds of the Church of Ireland church. The doorway has three orders with square pillars and carved heads on the middle arch. The other arches are decorated with chevrons, ribbon and bead moulding. There's a small gable protruding above the archway, echoed by smaller gables on the arcades on either side.

Although very worn, it is unreconstructed and therefore particularly pleasing to the eye.

St Crónán's Cross or Shrine

This is the 12th century cross usually to be found at the edge of the Church of Ireland graveyard, but it is being cleaned at the moment. One side of the cross head depicts the Crucifixion with Christ wearing a long robe; the other shows a figure presumed to be St Crónán. The shaft is thought to depict Figures at the Foot of the Cross on one side and Adam and Eve on the other. There is also some animal interlacing in the Urnes (Scandinavian) style.

Round Tower

Across the road are the 60 foot remains of the round tower. There is a one-mast sailing ship and an axe carved on the inside of the east window. The tower was reduced to its present height after a rebel shot a sentry in the barracks from the top of it in 1798.

Franciscan Friary and the Roscrea Pillar

The belfry, which is all that's left of the 15th century Franciscan friary, now provides the archway entrance to the Roman Catholic church. The friary was under the patronage of the O'Carroll family until it was dissolved in 1579. Some carved fragments have been cemented to the belfry walls.

This pillar was near the main door of the Roman Catholic Church but has been removed to Kilkenny by Duchas for restoration. It is a square-based pillar just over 3 feet high and carved on three sides, the fourth having been hollowed out to form a water trough in more recent times. One side has two panels, the lower one with 12 bosses and above it, what has been described as an elephant. Another side has serpent-like creatures intertwined and above them a four-legged beast struggling with a serpent. The third side has a circular patterned cross head with a standing horse above it.

9 Monaincha

Signed from the first roundabout on the Dublin Road on the outskirts of Roscrea.

Monaincha was originally one of two small islands in Lough Cré. The surrounding land was drained in the 18th century so the 'island' can now be reached on foot.

Before this it could only be reached by boat. It was used as a retreat by both St Crónán and St Canice of Aghaboe in the 7th century. They must have been attracted by the gentle nature of the place. It may well have been a sacred place in pagan times. Certainly it still feels like a sanctuary.

The Culdee or Céle Dé reformers came to the island around

the 8th century, possibly as a breakaway group from the foundation in Roscrea. The site was dedicated to the Virgin - the only female, human or animal, they allowed to have any association with the island. Then late in the 13th century, Augustinian Canons came and built the fine Romanesque church that is still here today.

When Giraldus Cambrensis was on his tour of Ireland around this time, he tells a story about Monaincha as a magical place where no one can die. He calls it 'Insula Viventium' and the story travelled with him to Europe and back to Ireland again where it was recorded in the *Book of Ballymote* as the 31st wonder of the world. Because of this, it became an important pilgrimage site in medieval times, although the Augustinians moved to Sean Ross (see above) by 1485 and the priory was dissolved in 1568.

The Pope was still granting pilgrims plenary indulgences in 1607 to come here at the height of its popularity and in 1611 there were reported to be 15,000 gathered on this site (*Roscrea & District Monuments & Antiquities*). Since 1975 a local pilgrimage has been revived here.

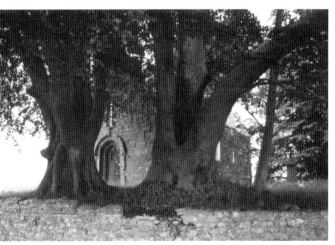

Monaincha

Earthworks, perhaps defining the island, are just visible as you approach the site. The 12th century Romanesque church at the east end is on a small circle of high ground raised by centuries of burials.

The soft red sandstone arches of the west doorway and the chancel are exquisite. There are 3 orders of squared pillars on the west doorway decorated with chevrons and leafy vine scrolls. The arch is patterned with rosettes and flowers. The inclined jambs and style of decoration mark it as late Romanesque (HG Leask 1955 94/95).

The chancel arch has plain cylindrical pillars with scalloped capitals, and chevrons and foliage on its arches. The south window in the chancel and the south east one in the nave are probably original.

The vaulted sacristy is thought to be 15th or early 16th century. Its upper storey is accessed by a stairway on the left of the doorway.

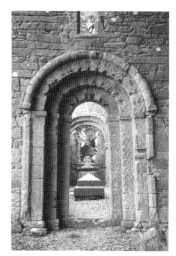

The cross has been re-erected by the west door of the church - the 8th/9th century base with its carved horsemen on one side now has a concrete shaft supporting what is probably a 12th century cross head. One side shows Christ clothed in long robes and the other side has interlacing. It is badly weathered.

Romanesque doorway, Monaincha

10 Timoney Hills

5 miles south east of Roscrea. There's a small road signed to Errill off the N7 from Limerick to Dublin as it skirts Roscrea on the south east. It forks after about 3 miles, keep right and then left past the church and left again. The stones are signed up a lane on the right.

You can see many of the stones from this lane, though there are reputed to be around 300. Except for one circle, recorded in 1937 as being 200 feet across and made up of 16 stones, they seem to be quite haphazard. Half of these 16 stones have since gone (*Roscrea & District Monuments & Antiquities*).

Estyn Evans, archaeologist and author of *Prehistoric & Early Christian Ireland*, thought they might be Bronze Age but was not sure about them. They are

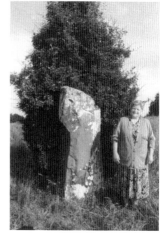

Standing stone, Timoney Hills

possibly the remains of some kind of 18th or 19th century folly, but there exists no record of them being put there.

Equally, there are no stories or local legends which you would expect for ancient stones. It is a mystery.

11 Ballaghmore Castle Sheela-na-Gig
This is well signed on the N7 4.5 miles west of Roscrea.

The castle is privately owned but open to the public. A very jaunty Sheela-na-Gig can be seen high up on the front wall on a quoin stone.

12 Kilcooly Abbey
4 miles south of Urlingford. Take the R689 south out of Urlingford.
At the six road cross, keep straight (actually the 2nd on the left).
1 mile later, keep right on a sharp bend. It is signed on the right.
Drive into the estate to the small church on the right.

The abbey is down a lane behind it. This is a beautiful location in wide parkland, now pasture.

Kilcooly was founded about 1182 by Donal Mór O Brien, King of Thomond. It was colonized from the Cistercians of Jerpoint, its mother abbey, in 1184. Its Cistercian name was 'the monastery of Arvi Campo', 'the Field of Corn', a typical Cistercian allusion to the fertility of the land.

The abbey was built around 1200 and dedicated to the Virgin Mary and St Benedict. As at Holy Cross and Jerpoint, Kilcooly is an example of the final stage of Cistercian architecture, more monumental than spiritual.

The abbey was attacked and burned in 1445 and its abbot, Philip O'Brothe, went to England in search of food and clothing for his monks. By 1450 he was back and the work of rebuilding the abbey got underway.

The delicate east window dates from this time as well as the vaulting in the chancel and transepts, the upstairs rooms and the central tower. Much of the interesting carving is also 15th century.

The sedilia of the abbot, with its perpendicular canopy, deep mouldings and foliage ornament, is especially fine. The prior's is also fine, though less ornate .

However, the most interesting and unique feature of the abbey is the sculpted stone screen between the south transept and the sacristy. The carvings are oddly proportioned and not of a piece with the symmetry of the arch. They put me in mind of a kind of stone sampler.

Above the arch is a crucifixion and beside it St Christopher

MUNSTER **Tipperary**

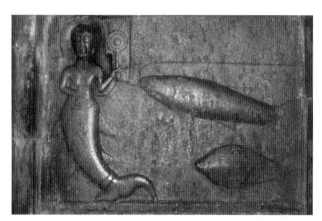

Mermaid and fishes, Kilcooly Abbey

crossing the stream. To the right of the archway is an abbot with large ears and an unusual angel above him wielding a strange kind of horn or club. Stranger still, below the abbot is a mermaid with comb and mirror. Her left hand holds the mirror but has the index finger extended as if pointing to the left. Beside her are two large fish, carved with biological accuracy. The mermaid is black and shiny, the result of a long tradition of being rubbed as a talisman.

There are a number of sculptured tombs and tombstones dated to the 15th and 16th centuries, including a Butler tomb near the altar with an effigy of a knight on top and a panel of apostles and bishops as 'weepers' on the side. Much of the 16th century work is by Rory O Tunney whose father Patrick may be responsible for some of the earlier work.

An interesting mason's mark can be found on the doorway to the cloisters.

13 Holy Cross Abbey

On the R660 to Cashel, 4.25 miles south west of Thurles, just where the road bends to cross the river Suir.

The abbey was founded in the 12th century for the Order of Tiron but passed to the Cistercians by the end of the century. It was colonised from Monasternenagh in Limerick, itself a daughter abbey of Mellifont in Meath. Donal Mór O Brien, King of Thomond and founder of many abbeys and cathedrals, was one of its patrons.

Holy Cross, as its name implies, has had in its possession, probably since the 12th century, a relic of the True Cross. Some say that it was brought here by Donal Mór O Brien and others that it was the gift of a grateful mother whose murdered son was found by one of the monks. Whatever the truth of these stories, this relic

MUNSTER **Tipperary**

gave the abbey the status of an important pilgrimage site. Gifts and donations from these pilgrims made it a wealthy and powerful place known throughout medieval Europe. After the 17th century the relic disappeared from the abbey, but was returned some time later by the Ursuline Sisters in Blackrock in Cork, when it came into their possession. It is still in the abbey in the O Fogarty tomb-niche in the north wall of the chancel, but another relic of the True Cross, this one authenticated by Rome in the 1970s, is on display inside a special reliquary in the north chapel of the north transept.

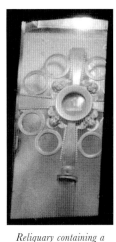

Reliquary containing a relic of the True Cross, Holy Cross Abbey

The abbey was extensively rebuilt in the 15th century when it came under the patronage of the Norman Earl of Ormonde, James Butler. Many of its most interesting details come from that time. These include the 15th century windows and the triple sedilia with canopy; a hunting scene mural in the north transept; a 15th century shrine between the chapels in the south transept and the Transitional doorway to the cloisters. There are beautifully carved leaf patterns and animals in the chancel.

The church follows the Cistercian cruciform lay-out with two east chapels in each transept and a nave and choir with aisles on both sides. The tower rises from the centre of that cruciform or 'crossing' with arches open in each direction. They have a number of mason's marks which have been rubbed black over the centuries as talismans. One of the arches has an unusual high relief carving of an owl in flight. The night stairs still lead from the south transept up to the sleeping quarters as they would have done since the 12th century, to allow the monks to come straight down from their beds for their 2 am devotions.

Through the foresight of its abbot, William Dwyer, it

The night stairs, Holy Cross

MUNSTER **Tipperary**

escaped the initial suppression of the monasteries. In 1534 he resigned his office to a layman so that the abbey became technically a provostry rather than a Cistercian Abbey. Holy Cross continued as a place of pilgrimage with monks maintaining some presence either in or near the abbey. By the end of the 17th century, however, plunder and persecution had taken its toll and the buildings fell into disuse.

The abbey church was restored in 1975 and work done on the cloisters and some of the other buildings. Today it is once again in use as a parish church and as a place of pilgrimage.

The painted walls, stained glass and furnishings, although modern, give a good idea of how it might have looked in its heyday to the medieval pilgrims visiting the relic of the True Cross in the 15th or 16th century.

14 High Crosses - Ahenny

422 274

5 miles north of Carrick-on-Suir, they are signed from the Kilkenny road, the R697.

MUNSTER **Tipperary**

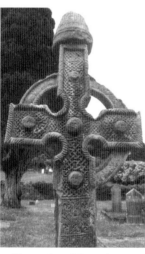
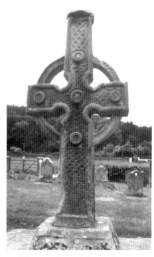

The east face of the north cross, Ahenny

The east face of the south cross, Ahenny

This is the ancient monastic site of Kilclispen in a small fertile valley running north into the Slievenamon hills.

Two of Ireland's finest high crosses are to be found here in the small enclosed graveyard. They are dated to the 8th/9th century and are part of a group of crosses in a similar style called the **Slievenamon group**. Others include Kilkeeran, Kilree and

Kilamery in Kilkenny and Lorrha in Tipperary.

The bases of these Slievenamon crosses are heavy, stepped, and often carved with narrative scenes depicting groups of animals and humans, nature or hunting, processions and battles. Some depict the scriptoral scenes of the later crosses.The bodies are often richly decorated with abstract ornament - spirals, fret and interlace patterns.

Derek Bryce, in his book called *Symbolism of the Celtic Cross*, attaches a symbolic significance to the different patterns: the plaitwork, like that around the bosses on the east face of the north cross, represents the great cosmic loom. The knotwork, for example, at the centre of the south cross, represents the ties which bind the soul to the world and the rayed spirals on both crosses represent the still point at the centre of life. This is an interesting idea, but what strikes me most about the Ahenny crosses in particular, is how North African they look.

Sometimes they are plain with only angle moulding and perhaps a central boss. That boss has been likened to the practical boss found in metalwork, a kind of rivet head perhaps. Yet, surrounded by concentric circles, rayed spirals and swastikas, it becomes a sun-symbol and, enclosed in a spiral of serpents' bodies, it becomes the earth: spirit and matter, light and dark - universal symbols. And surely it is a small imaginative leap from the sun motifs to *Christ as son of God* or *Christ as the Light of the World*?

Seen in this way, the crosses become potent symbols of the earth and the heavens, a kind of Axis Mundi or magical pillar of the world. And perhaps it is in this capacity that they can give us our best insights into their ancient predecessor - the standing stone.

The figures on the bases of the Ahenny crosses are as follows:

The North cross base

The north face shows a procession with chariot. On the south face there is a funeral procession. An ecclesiatic with a ringed processional cross is walking in front of a horse bearing a headless body which is being attacked by ravens. A man behind him is carrying the head face-on.

Some say it is the corpse of Cormac Mac Cuilennáin, bishop-king of Munster killed at the battle of Bealach Mughna (Ballaghmoon), Kildare in 908 AD.

The east face shows *The Lord of the Animals* or *Adam naming the animals* and the west face perhaps *The raised Christ with six Apostles*. Local tradition makes it seven bishops.

The South cross base

The north face is carved with hunting scenes and the south shows *The Fall of man* on the left. The east face has *Daniel in the Lions' Den*.

MUNSTER **Tipperary**

There is the base of a third cross which was stolen about 1800. It is said to have been subsequently lost in a shipwreck.

These crosses were carved in turbulent times. It was the age of Viking raids as well as feuds between the Irish themselves and often between the monasteries. The art of illuminating manuscripts did not survive this time. Indeed, very few of the manuscripts were to survive. Metalwork and enamelling declined as well, but somehow the stone carvers flourished and developed their art over the next centuries.

Kilkieran Crosses and Well are just 1 mile south east of Ahenny and also signed from the Kilkenny road. (see KILKENNY)

15 St Patrick's Well, Clonmel

Leave Clonmel on the N24 to Limerick. At the Cahir roundabout turn left and immediately right. At the first crossroads turn right and the well is signed on the left.

St Patrick's well, Clonmel

Water gently bubbles from the ground here across a wide area creating a shallow lake enclosed by a low wall. The effect is magic. Beside it are the ruins of a small church, mainly 17th century, but with Romanesque fragments incorporated. The head of a ringed cross can be seen in the middle of the water. A gentle place.

16 Fethard's Sheela-na-Gigs

Fethard is a small town surrounded by the remains of its 14th century walls. The four towers are still there and one of the gates.

There is a Sheela-na-Gig built into the old wall near the river and visible from the medieval bridge on the south side of the town. Her face looks grim, she has very prominent ribs and widely spread thighs with hands meeting beneath them at her vulva.

Another **Sheela-na-Gig** is built into a wall near the east end of the church of the Augustinian Friary, next to the parochial house. The friary was founded at the beginning of the 14th century and is at the east end of the town.

This Sheela-na-Gig has thin straight legs and appears to be standing with one hand

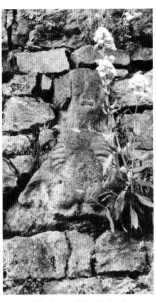

Sheela-na-Gig, Fethard

resting on her abdomen. Her ribs are well defined and though her facial features are small and fine, she has huge different-shaped ears.

17 Slievenamon Round Cairn

299 308

From the church continue uphill, take a sharp turn left and eventually right into the village. Follow signs for Slievenamon Drive and then signs for the summit. A good well-worn path leads up to the top. Allow about an hour to get there. The cairn is almost at the summit and is 9 feet high with a 90 foot diameter.

MUNSTER **Tipperary**

There are numerous mythological associations with this hill where the Fianna spent time hunting deer. They often angered the Tuatha Dé Danann, the fairy people who lived there. When the Tuatha Dé Danann took revenge, it was usually in the form of a woman.

One version of how Fionn got the gift of second sight comes from here. It goes like this:

One day Fionn was out hunting near Sliabh na mBan. He was standing by a spring when a beautiful woman approached, filled a silver drinking cup and left without a word. Fionn followed her in

secret till she reached a door in the hillside. The door opened and she went in with Fionn close behind her. However, the door began to close, leaving him on the outside with his thumb caught between the door and doorpost. He managed to pull it free and put it into his mouth to ease the pain.

From that day onward he only had to put his thumb in his mouth to have knowledge of distant or future events.

Kilcash Old Church is on the south slope of Slievenamon signed from the N76 Clonmel to Kilkenny road. It is a small Romanesque building made from warm red sandstone incorporating the steep gable of a much older building. There is a very worn but lovely Romanesque doorway in the north wall.

In the graveyard is a tombstone dated 1750. It is carved in the 'folk art' style with a sampler display of Passion symbols.

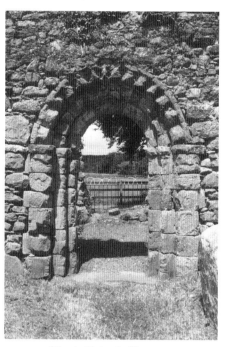

Kilcash old church, Slievenamon

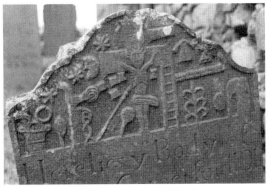

Folk art on grave slab, Kilcash

County
WATERFORD
PRINCIPAL SITES

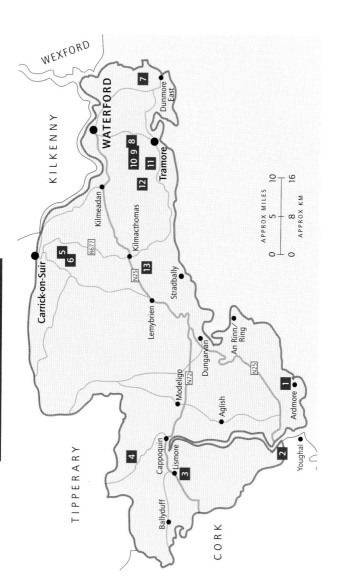

MUNSTER **Waterford**

1 **Ardmore** round tower and St Declan's Oratory
2 **Molana** Abbey
3 **Lismore**
4 **Mount Melleray** Cistercian monastery
5 **Tobarchuain** dolmen and holy well
6 **Mothel** Abbey
7 **Harristown**
8 **Carriglong**
9 **Knockeen**
10 **Gaulstown** dolmen
11 **Matthewstown** passage cairn
12 **Ballynageeragh** dolmen
13 **Drumlohan** - the Ogham Cave

Block figures in list refer to site locations in map and entries in text.

WATERFORD

WATERFORD COUNTY IS ON THE SOUTH COAST. Its eastern tip connects with its sister counties of Kilkenny and Wexford at the meeting of the three great rivers, the Barrow, the Nore and the Suir. (see KILKENNY) In fact the Suir and her tributaries flow along almost the whole of the county's long northern border and the deep mouth of the Blackwater in the west completes her watery borders.

Waterford has a fine collection of megaliths in the east around the town of Tramore, as well as some of the country's most important ecclesiastical sites.

In the north west is the beautiful cathedral of Lismore. In the nearby castle a bishop's crozier and ancient manuscript were found hidden in the thick walls.

In this manuscript, called the *Book of Lismore*, there are stories written as conversation between St Patrick and two of the Fianna, Oisín and Coilte Mac Ronáin. They are called the *Discourses of the Elders*, in Irish - *Agallamh na Seanórach*.

Oisín has returned from Tir na nOg and met up with his friend and cousin, Coilte. They have both been given the gift of longevity so that they can travel around the country with St Patrick on his missionary journeys and pass on the history and topography of every place they visit. The heroes also question Patrick about

MUNSTER **Waterford**

Christianity as he presents the Christian God and they respond from the perspective of their dead hero, Fionn.

Written in the 11th or 12th centuries, the author is critical of Christian dogma as expressed by St Patrick, who often appears arrogant and unbending. It is an interesting insight into the conflict between Roman dogma and the mindset of the Irish monks of the time.

When Oisín hears from Patrick that Fionn will have been consigned to hell as a non-Christian, he replies that Fionn must be more just than God for should he ever find anyone a prisoner in such a place, he would feel honour bound to rescue him.

In the south west Ardmore is thought to be the first monastic settlement in Ireland where St Declan, guided by his magical stone, came ashore for the first time.

1 Ardmore Round Tower and St Declan's Oratory
5 miles east of Youghal. Well signed from the N25.

St Declan founded the first monastery on this site which was established before the time of St Patrick, so he is sometimes looked on as the father of Christianity in Ireland. He later became Bishop of Munster.

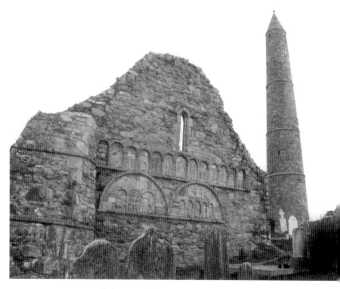

Ardmore gable and round tower

The site includes a ruined medieval cathedral with unique Romanesque carvings on the outside of the west gable, a 12th century round tower, and a small oratory which used to contain the remains of St Declan himself before the medieval enthusiasm for relic collecting.

The cathedral was rebuilt a number of times and you can see the alterations in the stonework of the present walls. What remains today is a 12th century nave and chancel building, very small by today's cathedral standards, but adorned on the outside with a fabulous display of Romanesque high relief carvings of biblical scenes set in a series of arcades. It is most likely that its builder, Máel-Ettrim Ó Duibherathra, was attempting to create a building worthy enough to be the 'cathedra' or seat of the new diocesan bishop. And it seems to have worked as he became a bishop himself shortly after it was finished.

There are two ogham stones now placed inside the church. One has two inscriptions which read:

LUGUDECCAS MAQI.....COI NETA-SEGAMONAS and DOLATI BIGA ISGOB. This stone commemorates Lugaid, son or grandson of Nia-Segmon. The other stone reads: "AMADU", meaning 'the loved one'. (*Monuments of Ireland*)

St Declan's tomb or oratory is nearby, very old but much restored. Inside is a pit which probably once contained the saint's body.

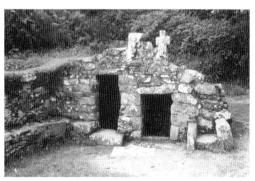

St Declan's well, Ardmore

MUNSTER **Waterford**

Ardmore has perhaps the finest of all Ireland's round towers. It is also one of the latest. It is tall (95 feet) and elegant with string courses stepping in the tower's circumference slightly as it rises, and marking the level of each floor. Its ashlar blocks are not only cut to the curve of the tower, but cut also to gradually taper to the top. It is thought to have been built at the end of the 12th century, around the same time as the cathedral.

St Declan's Well is on the east side of the town, high on the

cliffs above Ardmore Bay and accessed by a path from the town. It has a stone-built front with two chambers for access to the water and a small stone seat. There are two medieval crosses set above the chambers. The water is clear. Just past it to the east are the remains of a small church. An aumbry can be found in the east wall and a small finial on a pier beside it. Some stones of the pier are marked with crosses during the pattern which is held on St Declan's Day, the 24th July.

Nearby, on the beach, is an erratic boulder, called 'St Declan's stone'. It is said to have brought the saint's bell from Wales. Some say it brought St Declan himself. It is reputed to have healing powers.

All these antiquities are included in the pattern.

2 Molana Abbey

3.5 miles north west of Youghal. From the N25 north of Youghal, turn left onto the R634, signed Tallow. After 2.5 miles turn right at Lombards Puh A mile later, turn sharp right and the car-park for the abbey is on the left. You need to walk back down the road to the entrance to Ballynatray House. Go through the main gates and follow the avenue round till a path leads off to the causeway to Dairinis.

Here on this small island is the 6th century monastery founded by St Maelanfaidh (Molana). It was an anchorite settlement, a cell of nearby Lismore of which he was an abbot.

One of its abbots in the 8th century was a leader of the reform movement, the Céle Dé. And Rubin Mac Connaidh, co-author of the 8th century *Collectio Hibernensis*, was a monk here. He was described at his death in 725 as 'the scribe of Munster' and the *Collectio* influenced Church rules and teaching both here and in Europe for hundreds of years. Much later, in the 12th century Molana became an Abbey for the Canons Regular of St Augustine. These were secular clergy who placed themselves under the Rule of St Augustine of Hippo. Their communities were less strict than monasteries.

Raymond le Gros is supposed to have become a patron and been buried in the Chapter Room in 1186 (*Shell Guide*). Raymond, a young Norman knight, led some of the first Normans into Ireland, in advance of Strongbow, landing at Baginbun in Wexford in 1169.

This is a very gentle place and Molana seems to have been a gentle man for there's a story told in which he is greatly moved by the sight of a small bird weeping. He swears to fast till he finds the cause of the bird's distress. Eventually an angel comes to him and

tells him that the bird is lamenting the death of Mo-Lua, son of Oche, because he never harmed any creature.

The island and causeway sit among reeds in the estuarine mud of the tidal waters of the river Blackwater. In keeping with its origins, it is a sanctuary for wildlife, especially water birds.

The remains of the old abbey almost fill the island. The buildings are old purple sandstone, soft and crumbling and currently fenced for safety though you can still see them from the path.

On the east side of the cloisters is a nave and chancel church with 10 lancet windows and a chapter house. There are also some claustral buildings, kitchen, refectory and a two-storey building, probably the prior's house.

3 Lismore

Lismore sits at a crossing point between the river Blackwater as it flows south to Youghal Bay and the high pass over the Knockmealdown mountains to the powerful Rock of Cashel.

An early church was founded here, possibly by St Mochuda in the 6th century.

St Carthage arrived in 636 and is associated with a double monastery. Lismore, meaning the 'great fort', was raided many times by Vikings, being so accessible at the top of the river estuary. But still it grew in prosperity and importance and became a strong centre of the Céle Dé movement of the 8th and 9th centuries. By the 11th century we hear that a stone church was built. There are some fragments preserved in the west wall of the cathedral today.

Lismore cathedral

At one time Lismore was said to have 20 churches. Later, it was involved in the reforms of the 12th century and must have been quite prominent as it became a diocesan see in 1120, when

MUNSTER **Waterford**

the first cathedral was built. It is still the centre of the diocese of Lismore today though most of the 20 churches have gone.

The present town is small and beautifully sited in the Blackwater valley at the foot of the Knockmealdown mountains. Its ancient walls and tree-lined paths give it a kind of quiet grandeur.

The present cathedral is modest and approached by a cobbled avenue lined with ancient limes. The inside is simple, mainly 17th century with its chancel arch and south transept windows a remnant from the original cathedral.

On the right as you come in, you can see a Pre-Raphaelite window by Burne Jones, the only one in the country. Also to be seen is a beautifully carved 16th century tomb of the Mac Graths. Its panels include St Carthage with the saints and apostles as well as a Crucifixion and an Ecce Homo. Above all this the ceiling is delicately painted in a way that seems to lift the spirit and make this one of the loveliest cathedrals in the country.

Lismore castle above the river Blackwater, has a 12th century Romanesque church gateway. It stands on the site of an earlier castle built by King John in 1185 and had changed hands many times till the present owners, the Dukes of Devonshire, acquired it. The 6th Duke, following some medievalist's dream, remodelled it with turrets and battlements, using stone from his ancestral home at Chatsworth in Derbyshire.

The Book of Lismore and the Lismore crozier were found in the walls of Lismore castle in 1814.

4 Mount Melleray Cistercian Monastery

High on the south slopes of the Knockmealdown mountains about 6 miles north of Cappoquin. Take the R669 from Cappoquin to Clogheen. It is signed.

This monastery is fairly new. It was founded by Irish monks expelled from France in 1822 and is still in use as a Cistercian community. There is accommodation for retreat.

Outside is a small room with five ogham stones from Kilgrovan Cemetery.

The view down the valley is spectacular and below the monastery on the road from Cappoquin, is Mount Melleray Shrine. The shrine is in a steep wooded valley below the Cistercian monastery. It is a beautiful nature site with a spring running from the rocky valley wall into a small river, a tributary of the Blackwater. A statue of the Immaculate Conception was placed here in 1982. A few years later, the statue was seen to move. Then the image of the Virgin detached itself from the statue and walked

down the hill. Over a number of days, from August 16th to 24th, she was heard giving a message of peace to the people of Ireland. Since then the grove has become a popular site for pilgrimage and every August there are organised services.

Mount Melleray shrine

MUNSTER Waterford

Unfortunately an ugly roofed structure has been erected for pilgrims and much of the natural beauty of the valley destroyed.

5 Tobarchuain Dolmen

412180

Take the R677 south from Carrick-on-Suir to Dungarvan turning right at the five road cross. Continue south on this road and bear right at the three road cross. After about 0.5 miles there's a dolmen visible across a meadow to the right.

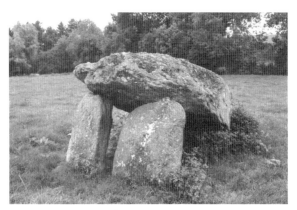

Tobarchuain dolmen

Tobarchuain Holy Well

413 179

Just beyond the dolmen as the road climbs the valley.
There is access from the road.

This is a lovely clear stone-lined well with the water rising from the base of a mature ash to fill the small well before flowing down to the nearby stream and under a bridge. A small grassy slope is maintained with the well and is bounded by its water on two sides.

Tobarchuain holy well

Above the well is a statue of St Cuan who was apparently the second abbot of Mothel. Below is written in Irish: "the site was visited for a pattern in the 19th century from 9th to 11th July".

6 Mothel Abbey

397 164

South of Carrick on Suir. 1.3 miles south of Tobarchuain
continuing on the same road and keeping left at the T junction.

Mothel was an Augustinian Abbey founded by the Power family on the site of an early monastery credited to St Cuan or St Breoghan. Suppressed in 1537, it is now quiet and mostly deserted by all but some noisy rooks nesting in the tall trees nearby.

There are a few medieval fragments but the best feature at the

site is a tomb by Roricus O'Comayn. It is quite worn but most of the figures can be deciphered: *Christ with Orb and Sceptre, Virgin and Child, Monk, St Michael with Scales, Saints Peter and Paul, Saints James and John of Jerusalem, John the Baptist* and *Thomas of Canterbury, St Margaret of Antioch with Dragon, St Catherine of Alexandria with the Wheel.* (*Monuments of Ireland*)

Just past the abbey at the entrance gates to a house, is a pillar stone with a cross carved on it.

Tramore Group of Passage Cairns

In the area around the seaside town of Tramore, 7 miles south south west of Waterford, there is a distinctive group of passage cairns.

They have a passage which widens gradually to form a gallery in the middle of the cairn rather than the more usual narrow passage leading to a separate gallery. There are five of these in east Waterford and they are similar in type to those found in Brittany, the Scilly Isles and Cornwall. Two have been excavated - Carriglong and Harristown. They are listed below as well as Matthewstown, which is a little different again. The area also has a number of very fine dolmens. These are similar, though a little smaller, to Kilmogue dolmen in Kilkenny, just 15 miles north of Waterford city.

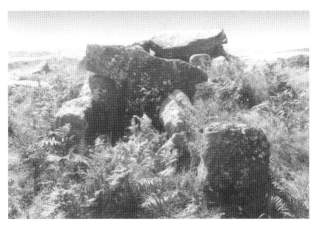

Harristown passage cairn

7 Harristown Passage Cairn

From the R685 east of Tramore continue through Leperstown to the third crossroads where five roads meet. Turn left for about a mile with Knockadirragh hill on your right. The cairn is on the

MUNSTER **Waterford**

summit at the south eastern end. Take the lane up to the mast
and keep going.

This is one of a small number of passage cairns found this far south. It shows clearly the unusual passage which widens towards the middle into a central chamber. The passage and chamber are 22 feet long and the chamber is 4.5 feet wide. The passage is lined with thick granite blocks which increase in size to the back of the chamber. Two slabs of an original slab roof and most of the kerbstones are still in place. The entrance faces north east and has a low sill though there are no strongly defined portal stones.

A perforated polished stone axe pendant was found with cremated bone in the chamber. It is dated to the late neolithic. Estyn Evans suggests that the pendant points to close contacts with Brittany and the Scilly Isles. (*Prehistoric & Early Christian Ireland*)

The cairn was used later for Bronze Age depositions and a food vessel, cordonned urns and a pygmy cup were found in secondary cairns in the mound. One of the urns held a stone bead and a thin bronze blade.

8 Carriglong Passage Cairn
591 050
3 miles north of Tramore. Take the R675 north from Tramore
about 1.5 miles and take the first left at Perry's Bridge across the
disused railway. Turn right and then left at the T junction and
stop at the garden centre. The passage cairn is up the hill across
from the garden centre. Best visited in spring.

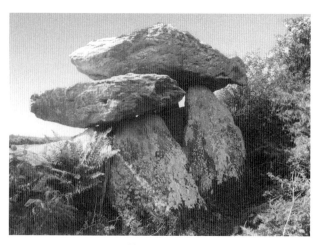

Knockeen dolmen

This is another V-shaped passage cairn slightly smaller than Harristown. Its entrance also faces north east and, like Harristown, there are no pronounced portals. The passage gradually widens and the stones increase in height till they form a chamber about 6 feet wide. It is in a cairn with 21 kerbstones still in place. Excavated in 1939, some cremated bone was found as well as pottery sherds.

9 Knockeen Dolmen

576 065

About 4 miles south south west of Waterford and 2.5 miles north of Tramore. Take the R682 from Tramore to Waterford and turn right at the first crossroads. After about 2 miles, it is signed where another road joins from the left. Just past here across a field on the left, the dolmen is just visible. Check in the house opposite for access.

Sitting in the corner of a disused burial ground called 'Kilburrin', it is partly incorporated into the low stone wall. It faces towards an unusual-looking rocky eminence, probably Knockeen which means a small hill.

The dolmen's portals are 9 feet high, one pointed and the other flat topped. Like several other dolmens in the area it has two cap-stones. The main one is about 12 feet by 7 feet and rests on the portals and a smaller cap-stone and covers the rectangular chamber. The septal slab or door stone is almost as high as the portals, so closing the entrance. The overall height of the dolmen is about 12 feet.

MUNSTER Waterford

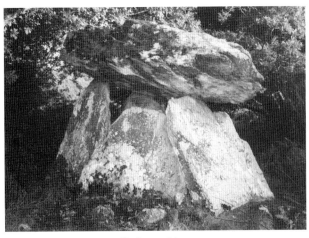

Gaulstown dolmen

10 Gaulstown Dolmen

540 063

5.5 miles south west of Waterford and 2 miles west of Knockeen.
Signed off the R682 about half-way between Waterford and Tramore.

This is a very fine dolmen with well matched east facing portals.
Like Knockeen, one is tapered and the other flat-topped and it has
a door slab in place. One large cap-stone some 14 feet long sits
balanced on the portals and four other uprights forming a tall chamber.

11 Matthewstown Passage Cairn

529 039

1.5 miles north of Fennor church.

Go west from Fennor church and take the first right. After 1 mile,
turn right up an avenue past houses to a T junction and bear left.
The cairn is through a field gate on the left at the top of the hill. It
is visible from the road.

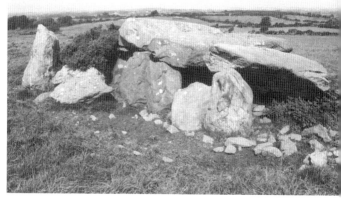

Matthewstown passage cairn.
The single upright on the left is part of the facade.

This is another example of a V-shaped passage cairn. It faces
east, though only the west end of the passage survives, made up of
five stones on each side. There are three large slab stones covering
the chamber. In the north east there is some sign of a double wall
and one upright which looks like part of a facade. Some kerbstones
still remain but no mound.

12 Ballynageeragh Dolmen

495 030

About 5 miles west of Tramore. Go west from Tramore on the R675 through Fennor and turn left and left again into Dunhill village. Keep left past the school for 0.5 miles and turn right down a lane to a farm. The dolmen is in a field just past the farmhouse.

This is a fine big double-capped dolmen similar to Knockeen. It faces south west and has a neatly fitting door or septal stone. Unfortunately it has been reconstructed on a cement base. There are 4 uprights and 2 cap-stones.

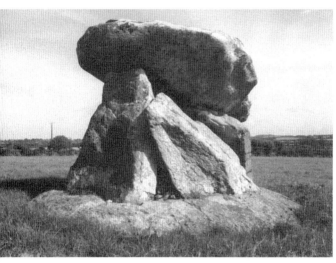

Ballynageeragh dolmen

13 The Ogham Cave of Drumlohan

367 013

2 miles north of Stradbally. Take the N25 towards Cork from Kilmacthomas turning left for Stradbally after about 1.5 miles. After 2.5 miles there's a lane into the right. Where the lane stops, walk through the woods, across a stile and into a field. The site is across the field to the right, inside a wooden fence.

In the enclosure of Drumlohan early church site, there was a souterrain with 10 ogham stones. It was called locally 'the ogham cave'. They have now been re-erected above ground. Having spent so long in the souterrain, they are well preserved and are the best group of oghams in the county.

There are a number of other sites where ogham stones can be seen in this area. These are probably all early monastic sites. They include:

Toberkillea

377 980

North east of Stradbally, past the Post Office on the left, after about 0.3 miles, there are 2 ogham stones down the valley south of the road in Ballinvooney.

Island Ringfort

356 958

2 miles south west of Stradbally. Take the main road south of the village. After almost 2 miles, turn left. At the end of this road a track leads east to the site. There is an enclosure with stone revetment which is probably the site of an early monastery, though nothing is known about it. Inside the enclosure are a bullaun and a fallen ogham stone.

Garranmillon

353 042

North of the N25, 3 miles from Kilmacthomas and 9 miles north north east of Dungarvan. There are 2 ogham stones in rough pasture near the ancient church site.

Kilcomeragh

336 057

Yet another stone can be found less than 0.5 miles south south west of Kilcomeragh Crossroads, just off the R676 about 14 miles south of Carrick-on-Suir and 2 miles north of Lemybrien. Just north of the minor road.

AND FURTHER NORTH:

St Seskinan's Church and Ogham Stones, Knockboy

216 047

7 miles north of Ballymacmague Crossroads, which is 3 miles north west of Dungarvan on the R672 to Clonmel. After 6 miles, Knockboy is signed on the right. The church is signed down a lane a mile later.

St Seskinan's church is high up on the west side of the Colligan river valley with the Monavullagh mountain range in the east. What remains of the building is now ivy-covered but the ogham stones are clearly visible. One is used as a lintel over the north doorway and another forms the lintel of the lower window in the

west gable. A third one stands upright in the south west corner of the building. A fourth is mentioned but I couldn't find it.

Ogham stone at the Ogham Cave of Drumlohan

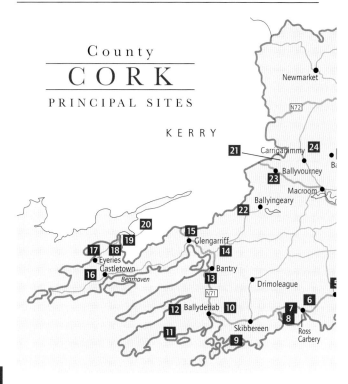

County
CORK
PRINCIPAL SITES

MUNSTER Cork

1. **Youghal** St Mary's Collegiate Church
2. **Rostellan** dolmen
3. **Timoleague** Abbey
4. **Inchy Doney**
5. **Templebryan** monastic site and stone circle
6. **Callaheenacladdig** - Hag of the Sea
 Ahaglaslin (Callaheenacladdig) cairn
 Bonhonagh circle
7. **Reanscreena** circle
8. **Drombeg** stone circle
9. **Lough Inne** eye well
 Ballymacrown killeen and cross
10. **Skeagh Hill-top** cairn
11. **Altar**
12. **Dunbeacon** circle
13. **Kilnaruane** cross pillar
14. **Kealkil**
15. **Garranes** ancient church site and multiple bullaun
16. **Derrintaggart West** circle
17. **Faunkill or Ballycrovane** stone
 Cailleach Beara and **Kilcatherine** old church

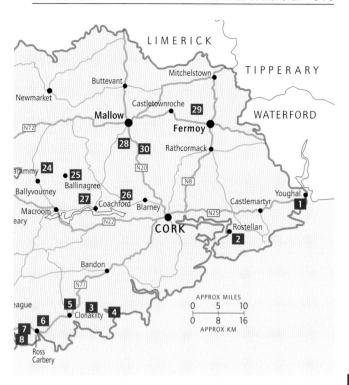

MUNSTER Cork

18 **Ardgroom** outward stone circle
19 **Cashelkeelty** circles
20 **Drombohilly** circle
 Uragh circle
21 **The Paps of Anu**
22 **Gougane Barra** (Finbarr's Cleft)
23 **Ballyvourney** monastic site
 St Gobnait's Stone
 St Abbán's Grave and Well
24 **Knockraheen** circle
 Glantane East circle and cairn
 Glanane North West wedge and circle
 Knocknakilla Complex
25 **Rylane** circle
 Carrigagulla stone circle
26 **St Laichteen's Well**
27 **St Ólann's Cap** well and stone
28 **Carraig Chlíodhna**
29 **Labbacalee** Hag's Bed
30 **Island** wedge cairn

Block figures in list refer to site locations in map and entries in text.

CORK

CORK IS IRELAND'S LARGEST COUNTY and forms about half of her southern coastline. It is crossed from west to east by three rivers, the Blackwater, the Lee and the Bandon.

Between the Lee and the Blackwater runs a ridge of mountains whose lower slopes are dotted with stone circles, cairns and rows, the remnants of a strong and flourishing Bronze Age population. There are many more along the south coast and out into Cork's westerly reaches, Mizen Head and the Beara Peninsula.

Cork has been doubly blessed. The wide gentle rivers have created fertile valleys and the mineral rich hills have provided another kind of wealth, attracting people to settle here since the first metal workers arrived on Irish soil.

The universal belief among ancient peoples that the sun goes into the earth each night makes the west, the place where the sun disappears, a mysterious place. It was thought also to be the place where the souls of the dead go. This is sometimes expressed as an island in the west or in the Beara Peninsula as 'Tech Duinn' - 'the house of Donn, the dark one'. Bull Rock on the Beara Peninsula, with its black rock portals, was thought to be the entrance to this house through which souls passed to the other world.

Beara is also home to the Cailleach Bhéarra, the Hag Goddess whose name is linked to 'Boí' meaning 'cow'. She has a strong presence in the west and in contrast to the dark Donn, she evokes light. She is the goddess of sovereignty, creator of land and responsible for making many of the rocks and islands off South West Ireland and Scotland. As protector of animals, she has keen eyesight so she can see her cattle at a great distance. In Connacht and the North Midlands she is associated with harvest.

She is said to have lived through seven periods of youth and had seven husbands. Now, on the Beara Peninsula, she sits as a stone waiting for her consort, Manannán mac Lir, to return.

The three colours of the triple goddess are black, white and red. Red is symbolized by 'Crobh Dearg' which means 'the Red Claw', 'the Crow Goddess', in the mountains to the north.

The Paps of Anu are included here as part of a trilogy of goddesses although they are actually part of Kerry. For similar reasons Tullylease is included with Limerick.

The river Lee and its sister river, the Sullane, run like a fertile seam across the county from west to east. It is here that the early saints chose to build their churches re-dedicating sacred hills and wells and carving crosses on the stones. In some cases the gods and goddesses themselves have reappeared in a new guise.

Gougane Barra and Ballyvourney are both strong pilgrimage sites, now Christian but unmistakeably pagan in origin. In the more populous east, the early monasteries were replaced by large medieval abbeys, such as the Franciscan Timoleague on the south coast.

You will see that I have used Jack Roberts' booklet, *The Stone Circles of Cork & Kerry: An Astronomical Guide*, for information about the orientation of the stone circles included here in Cork and in Kerry. There are many, many more in his booklet which comes with a map and diagrams - it is very useful and I encourage any traveller in Ireland to buy it.

1 St Mary's Collegiate Church, Youghal

This church was built at the beginning of the 13th century possibly replacing an earlier one burned in 1192. This is a nave and chancel church with north and south transepts. It has suffered from 19th century restorers who plastered over some of the original features, but this is now being removed to reveal the original fabric of the building.

A fascinating old church, it is full of interesting historical and architectural detail. Richard Boyle, Earl of Cork had a breath-takingly lavish tomb made by Edmund Tingham in Jacobean Baroque style for himself, his wife, his mother and nine of his children. Richly painted, it shows him lounging as if at a picnic. Perhaps this is how he imagined himself contemplating the beauty of heaven. It can be found in the south transept which he purchased as a private mortuary. He now shares it with some interesting gravestones including an unusual one of Richard Paris depicted with a bird.

Around the same time Boyle restored the tomb of the church's 13th century founders, commissioning effigies of them in 17th century costume. This is also in the south transept.

In the chancel is a double piscina for washing the communion vessels. The left one is used for washing the vessels before they've been used. The water from this drains away to the outside. The right-hand piscina is used to wash the vessels after use and the residue from this, which includes consecrated wine, is channelled into the foundations of the building. There is a small slit between them where a finger can be passed to make a wish or add power to a prayer.

Like many busy ports, Youghal suffered badly from the plague. On the hill behind the church, in the graveyard wall above

MUNSTER **Cork**

the west door, is a recess where the north and south walls of the town meet. This was where the pest coffin was kept and used over and over again for carrying plague victims to their graves. Apparently it was used about 200 times between April 1683 and April 1684, mostly for plague victims.

Behind this recess was the death house where paupers' bodies were tipped from the pest coffins. They were limed and their bones left to accumulate in the building. In 1851 it was apparently full to overflowing. When it was finally cleared, the bones were all buried in a common grave in the churchyard. At one time the old Fever Hospital had a door opening into the graveyard for ease of burial.

2 Rostellan Dolmen

882 672

7 miles south of Middleton and 5 miles east of Cobh on the south side of a narrow creek on Cork Harbour.

Almost covered by the sea at high tide, this shaggy seaweed encrusted dolmen is 6 feet tall with uprights slotted into the limestone pavement below in the water.

3 Timoleague Abbey

473 435

6.5 miles from Clonakilty. Signed north of Clonakilty on the N71.

Timoleague takes its name from Tigh Mo-Laga or house of St Mo-Laga after an early monastic foundation by that saint. He was a disciple of St David of Wales. (St Mo-Laga is also associated with Labba-molaga, 5 miles north west of Mitchelstown.)

The abbey sits at the head of a wide inlet. It was founded in 1312 for the Franciscans. They returned again after the Dissolution, but were burned out with the rest of the town in 1642 by the soldiers of the

Timoleague Abbey

English crown. The rambling claustral buildings and church are full of interesting details in spite of their Franciscan simplicity.

MUNSTER **Cork**

The Catholic church at the other end of the town has one of Harry Clarke's last windows - in three lights over the west doorway. The interior of the Church of Ireland is covered in mosaics.

4 Inchy Doney
Signed south of Clonakilty.

Inchy Doney is almost an island within the wide womb-like circle of Clonakilty harbour. Its southern tip is a tiny point called the Virgin Mary's Point which lies between two beaches and just within the circular sweep of the harbour. This is a powerful spot with a clear light energy, strong in spite of the enormous hotel nearby.

Interestingly, there is an almost identical land and water formation in South East Wexford also dedicated to the Virgin, called 'Lady's Island'. The Wexford site has for many years been an important centre of Catholic pilgrimage. The topography here is very female and, coupled with its dedication to Mary, makes it likely that it was at one time a goddess sanctuary.

5 Templebryan Monastic Site and Stone Circle
486 438
1.5 miles north of Clonakilty. Go north of Clonakilty on the N71 and turn left to Shannonvale (0.7 miles). Turn left at the crossroads and the circle is by the roadside, just visible over the ditch on the right.

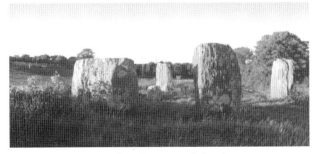

Templebryan stone circle

There are only 4 stones upright of an original 9 but there seem to be far more. They are all tall, up to 6 feet, and have bevelled tops.

This is a strong circle with a white quartzite pillar in the centre. I was told this was the 'sun stone' which gives Clonakilty (Clocha na Coillte) its name. There are two interesting bits of information here, though they've been confused. While 'cloch' means 'stone',

MUNSTER **Cork**

'coillte' actually means something more like 'purifying' or 'emasculating'. This could well be a folk memory of a ceremonial function. At the same time, calling the quartz pillar a 'sun-stone' must also refer to its function in the circle. The axial stone here is 210 degrees from north (*The Stone Circles of Cork and Kerry*).

Up the lane behind the farmhouse just before the circle, is Templebryan monastic enclosure on an east-facing pasture slope. The collapsed state of the enclosing wall gives it the feeling more of a cairn. Inside is a small ruined church and beside it a tall slender pillar stone with a bullaun. The hollow in this stone holds water which is reputed to be a cure for warts. These so-called wart wells are a common feature in bullauns throughout the country. The pillar stone is 11 feet tall with a cross inscribed on its west face and traces of an ogham inscription beside it.

This feels like a very ancient place - much older than the visible remains.

6 **Callaheenacladdig** Hag of the Sea
Ahaglaslin (Callaheenacladdig) **Wedge Cairn**
Further west along the south coast just before Ross Carbery.
This compact wedge cairn looks much like a dolmen and is visible from the N71, 1.5 miles east of Ross Carbery just 0.5 miles east of the big garage.

It sits high up on a grassy ledge below a steep rock face. Not easy to reach, however, as the land in between is boggy. It has the double walls and wedge shape of a wedge cairn, though it faces east and has a large tilted cap-stone - characteristics more usually associated with dolmens. Its local name, Callaheenacladdig, links it with other sites connected to the goddess Clíodhna in Cork.

Clíodhna has strong associations with Rosscarbery Bay. Sometimes the tides rushing into the sea caves of the bay make a kind of melancholy roar called 'Cleena's Wave' or 'Tonn Chlíodhna' - one of the three magic waves of mythology.

Clíodhna was a goddess of the old world, famed even among other goddesses for being exceptionally beautiful. She lived in a place called 'the Land of Promise' or 'Tír Tairnigiri', the home of Manannán mac Lir, the Lord of the Ocean. One day she caught sight of Ciabhan, a young mortal with long curling golden hair. She fell in love with him and they left Tír Tairnigiri together. They arrived exhausted on the shore of Cork at Glandore. Ciabhan went hunting for food while Clíodhna rested, but while he was gone, she was lulled to sleep by the music of Manannán who then sent a great wave which swept her into the sea and back to him. Ciabhan was left heart-broken.

Bohonagh Circle

308 368

2 miles east of Ross Carbery. 2 miles from Ross Carbery on the N71 to Clonakilty. Turn left back up a farm lane at Newmills Crossroads.

This is a beautiful circle on a hilltop 1mile from the coast. The sea is just visible in a fold in the hills.

It is a 13-stone circle with the stones getting smaller from tall 8 feet radial portals to its axial stone. This axial stone is oriented west, giving the circle an alignment with the equinox sunsets. (*The Stone Circles of Cork and Kerry*)

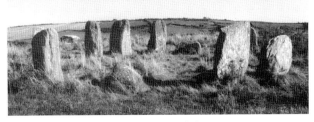

Bohonagh stone circle

The site was excavated in 1959 and a shallow rock-cut pit was found in the middle of the circle with fragments of cremated bone inside. The circle appeared to have been stripped of turf before the bone was deposited.

South east of the circle is a boulder dolmen with cupmarked cap-stone on low sandstone and quartz supports. Near it is a displaced stone with 7 cup marks. South of the circle, post-holes of a rectangular structure were excavated

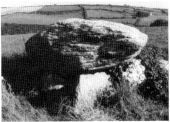

Bohonagh boulder dolmen

creating parallels with Dromberg circle just 3 miles away. Both circles are 30 feet in diameter.

7 Reanascreena Circle

265 410

Inland from Ross Carbery, Reenascreana village is well signed. Go west from the village, then left at the crossroads. Take the first lane on the right and ask at the farm.

Reanascreena means 'the ring of the shrine'.

There are 13 stones in this circle, all still there with the axial at 258 degrees from north. This could be a lunar alignment. (*The Stone Circles of Cork and Kerry*)

The circle is surrounded by a shallow fosse or ditch which is, in turn, surrounded by a low earth bank or henge. The site was partially excavated in the 60s. Peat had grown over the original floor which was found to be heavily eroded from use. To combat this, stones had been brought in to build up the floor and support the orthostats. A pit was found in the centre. It was filled with earth. Another pit to one side was lined with a paste of charcoal and cremated bone. Four pits in the bank near the portals were filled with stones.

8 Drombeg Stone Circle
247 352
Signed off the N71 east of Skibbereen, near the village of Glandore.

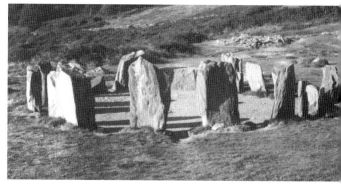

View through the portals to the axial stone, Drombeg stone circle

Drombeg means a little ridge and the circle sits on the edge of a stone terrace looking out to sea, visible between a fold in the hills about a mile away.

This stone circle is locally known as 'the Druid's Altar' or 'Ring' and originally had 17 stones encircling an area about 30 feet across. The gaps have been filled by smaller boulders set in the original sockets, so the circle feels complete. The portals are tall, about 6.5 feet, and the stones decline in height from this down to the axial stone in the south west. This stone is about 7 feet long with two cup marks on its top side, one of them ringed. It is held in place with stone wedges, possibly so that it can be adjusted over time. The top angles down slightly into the circle. One of the portals is flat topped, the other pointed.

The site was excavated in 1957 and '58, the first circle in the area to be closely examined. Before the circle was constructed, the area was levelled artificially and built up on the south side. Once constructed, the circle was paved with small flat stones and the area kept clear.

Two pits were found near the centre, one with the cremated remains of a youth, together with a plain broken pot. Other pits contained pottery sherds and small stones. Dating of the human remains seems to place it quite late in the 1st century BC, in other words, Iron Age, though the circle is much more likely to be earlier.

The axial stone is almost in line with the midwinter sunset. For 3 days over the winter solstice at sunset, the sun disappears behind a hill on the horizon and then reappears lower down in a fold in the hills as it continues its journey down and to the right. The circle is briefly and dramatically illuminated. This only happens over these 3 days, allowing very accurate pinpointing of the exact time of the solstice. (*The Stone Circles of Cork and Kerry*)

West of the circle are the foundations of two conjoined Iron Age huts, one with a roasting oven. These are linked by a narrow path to an oval enclosure surrounded by piles of burnt stones and containing a cooking place or fulacht fia. There's a flag-lined cooking pit, a hearth for heating the stones and a well to fill the pit with water. A drain carries the overflow from the well away from the cooking area. It was still in use in the 5th century AD.

This is a rare chance to see one of these sites uncovered.

9 Lough Inne Eye Well

Take the Baltimore road from Skibbereen and follow signs for Lough Inne or Hyne. Just as you reach the lake, park in the small car-park on the right and follow the path into the woods. Follow the path over the small stream on stepping stones and onto a lane. Up the lane a short distance and the well is visible back in the woods on your left. A 10 minute walk. The well is surrounded by a semi-circular dry-stone wall covered with moss and ferns. The water is clear and clean.

Lough Inne Eye well

Ballymacrown Cillín and Cross

1.75 miles east north east of Baltimore. Leaving Baltimore on the R595 going east, turn right just outside the village as the road turns sharply left. Keep left at the fork and right after 1.4 miles. The cillín, or children's burial ground, is beside the first two-storey farmhouse up this road on the left.

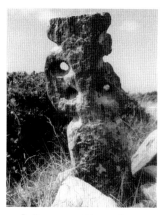

Ballymacrown killeen and cross

This is an enclosure with bank and ditch on rough ground. Inside are a number of small cairns of stones, one with a pillar. A slight inner enclosure has a very old worn celtic cross nearby.

10 Skeagh Hill-top Cairn

072 365

3.5 miles north west of Skibbereen. Turn right at Meen Bridge in Aghadown. About 2 miles along turn right at a crossroads. About 1 mile up this road there's a forestry lane in on the right.

This is a large hilltop cairn some 10 feet high in forestry land. Access is clear, a short walk along a forestry lane, but the view and with it the sense of place, is obscured by trees. Also the associated ring-barrows can no longer be seen. However, the cairn itself still sparkles and is ringed with bilberries, heather and whins, with a top-knot of bilberries filling a collapsed chamber in the centre.

11 Altar

858 303

On the east side of Toormore Bay on the Mizen Peninsula. Take the R592 west from Skull about 8.5 miles. Just after the road turns sharply right as it meets the sea, there's a small car-park on the left with access to the site.

This wedge cairn is unusual in that its walls are made of single slabs. However, it opens to the south west like most other wedges. Its entrance faces across the bay to a small pointed hill in the distance.

MUNSTER Cork

It has two roof-slabs and an interesting endstone with a corner cut away (see **Labacallee** below). Estyn Evans described it as open at both ends and with one cap-stone displaced, so it must have been rebuilt in recent years.

This site seems to have been used throughout prehistory. Cremated bone was found from the late neolithic; shallow pits were dug in the late Bronze Age, and a pit containing shells and fishbones, including whale bones was found dating to the end of the Iron Age. Finally it was used in the 18th century as a mass rock. In penal times (16th to 19th century) the celebration of mass was outlawed by the English Crown. Mass was celebrated in private homes or secluded sacred sites such as prehistoric cairns.

There is said to be a well across the road associated with the site.

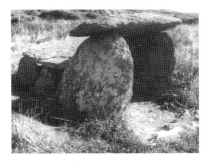

Altar wedge cairn

12 Dunbeacon Circle

On the north side of the Mizen Peninsula, 8.5 miles south south west of Bantry. Take the R591 2 miles west of Durras and take the 3rd turn on the left uphill for 0.5 miles.

The circle is across farmland right of the road, opposite a large pair of standing stones just beyond an avenue of trees on the left. The stone pair are called 'the Standing Stones of Coolcoulaghta'.

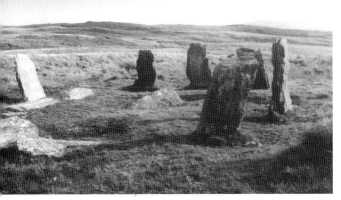

Dunbeacon circle

MUNSTER **Cork**

Only 6 stones are still standing of this 11-stone circle and most of them are oddly angled. The fallen stones are still lying where they fell and there's a large stone lying in the centre, possibly a fallen upright. Like Bohonagh and Drombeg, the sea is visible through a fold in the hills. Despite its ruined state, this circle has a strong, clear atmosphere about it and is well worth a visit.

13 Kilnaruane Cross Pillar

985 475

1 mile south west of Bantry. Signed to the left off the N71, it is about 1 mile west of Bantry.

This low hill on the outskirts of the town is thought to be the site of the now disappeared Kilnaruane church. All that remain are a 7 foot carved pillar and bullauns in an old fenced enclosure.

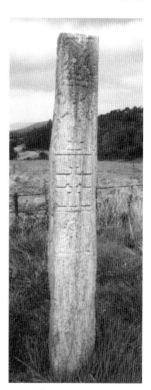

However, the pillar is very unusual. One side is carved with stepped pattern, cross and interlacing and a figure with hands raised in prayer or blessing. Two other figures are thought to represent SS Paul and Anthony in the desert.

The other side has an interesting carving running lengthways depicting a large boat with four sailors rowing and another in the back steering with a large rudder. There are crosses around the boat, perhaps a talisman for a safe voyage or the symbol of a holy mission? Before the boat are four animals which seem to be upside down. The boat

Kilnaruane cross pillar

image is singularly unsuited to the shape of the pillar and the boat itself appears to be travelling heavenward. Is it possible that this is an illustration of the arrival of Cesair in her ark-like boat complete with animals to start a new life? Cesair was the granddaughter of Noah and first inhabitant of Ireland.

Indentations at the top of the pillar show that there was more: possibly arms and an upper portion forming a tall and slender cross.

14 Kealkil

054 556

6 miles north north east of Bantry. Go north of Bantry on the N71, turn inland on the R584 to Kealkil. Go uphill by The Brown Pub. The site is through a field gate on the left at a right hand bend.

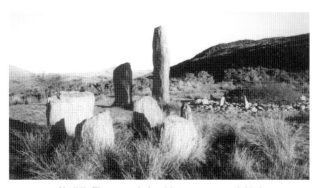

Kealkil. Five-stone circle with two-stone row behind and radial cairn to the right. (photo: Bernard Bosonnet)

A magical site. There is a small 5-stone circle here with all the stones, including the axial, about 4 feet high. The axial stone is 5.5 feet long and opposite it the portals are distinctly shaped - one flat-topped and the other shaped to a soft point. This circle was excavated in the 1930s and crossed timber sleepers were found in the centre, presumably once holding a stone.

Two huge standing stones, one broken, the other still 12 feet high, stand in the north east, and south of these is a perfect example of a radial cairn with 18 radial uprights in a cairn of smaller stones.

This site has a light clear energy and the axial stone feels very powerful. I was taken there by friends, almost at dusk, and certainly the time was especially potent and possibly the company as well. It has become quite noticeable as I revisit sites that the energy is quite different at different times.

As at many of the other circles round the Cork coast, the sea is visible through a small fold in the hills.

15 Garranes Ancient Church Site and Multiple Bullaun

Signed 'Burial Ground' on the right, about 3 miles north of Glengarriff on the N71 to Kenmare. It is up a side road called 'the Priest's Leap Pass'.

Garranes church was dedicated to St Fachtna, founder and patron

MUNSTER **Cork**

of Ross and its first bishop.

In the grounds is a multiple bullaun complete with stones, known locally as 'the Legend Stone'. Its stones were traditionally turned as part of the turas or pattern on St Fachtna's Day, August 14th, but the tradition is probably much older.

(see **St Brigid's Stone**, CAVAN)

16 Derrintaggart West Circle
Signed off the R572 at the west end of Castletown Bearhaven

A multiple stone circle which, in spite of some fallen stones, has a good strong energy about it. It has a large axial stone with stones on either side gradually increasing in size to one remaining tall portal.

The axial stone is 270 degrees from north, giving it an alignment to the setting sun at the Spring and Autumn Equinoxes.

Beyond the circle is a fulacht fia, cooking site, called 'Cooking Place of the Hunters'. (see **Drombeg**)

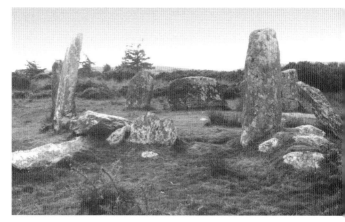

*View through the portals (one broken) to the axial stone,
Derrintaggart West circle*

17 Faunkill or Ballycrovane Stone
657 529
North of Eyeries at the eastmost inlet of Coulagh Bay.
Take the coast road north from Eyeries, or leave the R571 south
of Ardgroom towards Kilcatherine Point. This massive stone is
visible from the road but there is access signed if you continue
east to Ballycrovane Harbour.

MUNSTER Cork

It is very impressive at 17 feet high and probably much older than its ogham inscription which reads: MAQI-DECCEDDAS AVI TURANIAS - 'Of the son of Deich descendant of Torainn'. Estyn Evans notes the bad placing of the upper letter, concluding that it must have been carved in situ.

This is the largest ogham stone in the country.

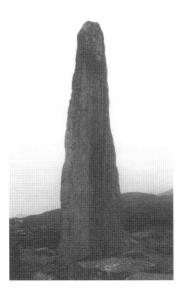

Faunkill or Ballycrovane Stone

Cailleach Beara and Kilcatherine Old Church

The stone is signed on the coast road east of Kilcatherine Point. The church is a little further, on the other side of the road.

This is the Goddess Cailleach Beara turned to stone and said to be waiting for her consort, the God of the Sea, Manannán mac Lir. It has a powerful kind of a shape with its striations full of tiny offerings of flowers, jewels and ribbons.

Further on is a ruined church dedicated to Caitighern who is supposed to be represented by a strange carved head with elongated neck over the doorway. Everything here, including the old medieval church and plain cross, is worn and wind-blasted like the landscape around it.

The Cailleach Beara

These sites seem closely related and both have a similar energy. Ancient, like old bleached bones, I would associate their energy with the hag aspect of the goddess - wise woman energy.

18 Ardgroom Outward Stone Circle

East of Ardgroom. Signed from the R571 inland. Follow the lane to some farm gates and the circle is visible on the right.

One of a number of circles in the area, this seems to have been an 11-stone circle with an outlier nearby. A couple of the stones have fallen. It is on slightly raised ground overlooking Ardgroom Harbour. The axial stone is oriented 182 degrees from north, in other words, almost due south. (*The Stone Circles of Cork and Kerry*)

These next sites are in Kerry but are included here as part of the Beara Peninsula.

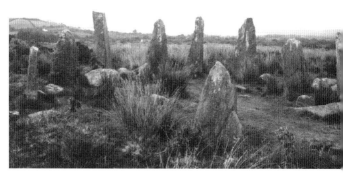

Ardgroom Outward stone circle

19 Cashelkeelty Circles

On the Old Green Road between Ardgroom and Lauragh. You can walk this road from either end or you can access it from the main road about 5 miles from Lauragh. A tiny path leads over a wall and through the woods by a waterfall and out onto the track. Signed as 'the Beara Way', just before it is a parking area for forestry vehicles.

Once you clear the woods, turn right and up to the highest point on the path. It is a wonderful location at the top of the pass with the sea in front and to the right, the valley falling away behind and rocky hillside to the left.

The first circle is a small 5-stone one with a cap-stone in the centre at ground level. The site was excavated in 1981 and cremated adult remains found in a pit under this stone. Just behind the circle to the south is a 3-stone alignment. The nearest is rounded and broad, about 8 feet tall, the next an angular rectangle about half as tall, and the last rounded and smaller again. They seem to be lined east-west with the circle. The excavations also suggest that they may be

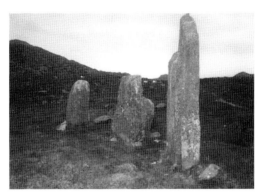

Three-stone arc, Cashelkeelty circles

as much as 200 years older than the circle. This would emphasise the importance of place over time and evolving practice.

A little further west but within sight are 3 stones declining in height and forming an arc, part of a multiple stone circle.

20 Drombohilly Circle
Signed down a lane into the valley on the Beara Way.

There are 9 stones standing of this multiple stone circle on the north side of Knockanoughanish Hill. The stones are widely spaced, forming a large circle some 35 feet across. This is a lovely site, though it is not clear how it is aligned.

Uragh Circle
Inchiquin Park and the Uragh Circle are signed on the right.
Access to the circle is through the park.

The circle is in a beautiful spot on a small hill between two lakes and accessed by a bridge. It is a tiny 5-stone circle with a large alignment stone.

St Latiaran - The Three Sisters
In the north west of the county on the Kerry border there's a ridge called the Derrynasaggart Mountains. It is here that the famous Paps of Anu are found - the two peaks looking more like breasts than mountains.

A well here, by the mountain pass, is known as the City Well or 'Cahercrovdarrig' - 'Crobh Dearg's castle'. The name means 'the Red Claw' and she is usually thought of as female. The site is

associated with a May Eve gathering when cattle were driven to the water to keep them safe from disease for the rest of the year.

About 16 miles north east is the village of Cullen, just north of the N72 on the west bank of the Owentaraglin river.

Cullen is home to St Latiaran. Here is an old graveyard with her well and beside it a white-thorn tree said to have been planted by her. Nearby is the famous 'Curtsey Stone', a large heart-shaped stone where women traditionally curtsied during the pattern on St Latiaran's Day. Her pattern day is 25th July, Lughnasa, or the first day of harvest. People would come to the graveyard to perform the turas and drink from the well before dancing and games began in the village. Travellers came with stalls selling fruit and sweets.

Latiaran was said to be one of three sisters. One tradition held that the others were called 'Lasair', meaning 'Flame' and 'Inghean Bhuidhe', meaning 'Yellow-haired daughter'. They both left Cullen and are associated with parishes nearby, though none are as well-known as Latiaran.

Another tradition has Crobh Dearg and Gobnait (see below) as her two sisters. It is interesting that Gobnait is remembered in February, Crobh Dearg in May and Latiaran at the end of July - covering three of the Celtic festivals.

An earlier tradition mentions three goddesses here as Anu, Badhbh and Macha. Whatever we make of the mixture of names and stories, the tradition of three women remains. One story says that they each disappeared and the three wells sprang up in their place, at Cullen, Cahercrovdarrig and Ballyvourney.

Another story tells of how Latiaran used to go from her cell every morning to get a fresh ember from the smith for her fire. One morning he commented on her beautiful feet and in a moment of vanity, she looked down and the ember burned through her apron. She cursed him and sank into the ground at the spot now marked by the heart-shaped Curtsey Stone. (*The Festival of Lughnasa*)

21 The Paps of Anu

Just east of the Paps, the peak of Caherbarnagh rises to 2259 feet. There was a local tradition of a berry-picking outing with games and competitions here on the Sunday nearest July 25th. This would have been an old Lughnasa festival though it came to be known as St Latiaran's Sunday. About 10 miles north at St Latiaran's well in Cullen there was a pattern on the same day. (The Festival of Lughnasa)

22 Gougane Barra (Finbarr's Cleft)

Signed south of Macroom on the R584, 4.5 miles past Ballingeary.
The site has been a forest park since 1966.

The Lee Valley is strongly associated with the early life of St Finbarr. His father's land was outside Macroom and it was here at Macloneigh that he founded his first church. He is the Patrick of Munster bringing Christianity to the south west and, like Patrick, he is depicted with crozier and mitre, a patriarchal and political figure in church history. He is officially remembered as the founder of Cork city and its first bishop, but he is probably most popularly associated with his hermitage and oratory here at Gougane Barra, the source of the river Lee.

His pattern replaces the old midsummer gathering here at this very powerful nature site at the source of the river. In times past, cattle were driven through the water here to ensure their health and well-being for the coming year. The island, which is joined by a causeway, had a wooden pole erected at the centre where votive rags and spaneels of cattle were hung. Part of the lake was enclosed and treated as a holy well for bathing. This was often the only bathing of the year and was considered to ensure good health for the whole year. Unlike at other times, there was no danger of drowning during the midsummer bathing.

23 Ballyvourney Monastic Site

8.5 miles west north west of Macroom off the N22 to Killarney.
Signed on the left in Ballyvourney. Follow the road over the bridge
and up to the Church of Ireland church.

This is the other great pilgrimage site of the Lee Valley and one of the most visited in the county. It is interesting that the saint being venerated here is female, for female saints often replace a goddess tradition.

St Gobnait is most revered in this part of Cork although she was born in County Clare. She is supposed to have fled from Clare and taken refuge on the Aran islands where she encountered an angel who instructed her to go on a journey. The angel told her that when she came upon nine white deer, that would be the place of her resurrection. She duly travelled across the south of Ireland building churches as she went. When she got to County Cork, she found three white deer near Clondrohid. She followed them to Ballymakeera where she saw six more deer. Eventually, at Ballyvourney, she found nine white deer together and this is where she stayed, founding a religious community for women.

MUNSTER **Cork**

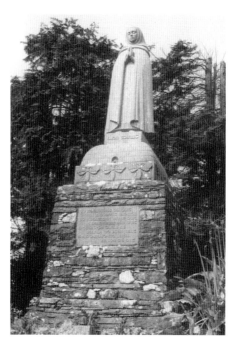

St Gobnait, Ballyvourney monastic site

She is famous for her care of the sick and one famous story tells how she kept the plague out of Ballyvourney by designating it consecrated ground.

She is also known as the patron of bees and famous for her relationship with them. Her name, 'Gobnait', is the equivalent of the Hebrew name 'Deborah' which means 'Honey Bee'. The properties of honey in the treatment of illness and healing of wounds would have been well known in the 6th century. Bees had long been important in Irish society. So much so, that there were special bee laws, called the 'Bech Bretha'. In prehistoric times the soul was thought to leave the body as an insect, either a bee or a butterfly.

St Gobnait's well and clootie tree, Ballyvourney

Her well is clearly marked with a wrought iron archway. Trees form a dark cave-like approach and the tree beside

the well is hung with personal tokens. A special stand is covered with rosary beads and there are taps and mugs to take the water. Even in bright sunshine the well area is dark and cool.

A stile leads from here into the churchyard. Beside the present church an older ruin holds paintings of the Stations of the Cross and grave-slabs scratched with crosses by pilgrims doing the rounds. In the church is a human mask voussoir from a Romanesque arch and the story is that it is a carving of one of the masons of thechurch who stole his fellow worker's tools. His face was carved in stone to remind everyone of his crime.

Over one of the church windows is a tiny Sheela-na-Gig carved into an oval recess in the lintel. Her hands rest gently on her abdomen or genitals and she appears to be standing. She is touched as part of the turas around the church and thought by some to be St Gobnait. Outside the south east corner of the church is the Priest's Grave.

Pilgrims' crosses, St Gobnait's grave

A very worn 13th century wooden figure of St Gobnait is kept by the parish priest and taken out on the saint's day which is 11th February and Whit Sunday. Some people still use 'Tomhas Ghobnatan' - a length of woollen thread or ribbon which is measured against the statue and used for healing.

Across the road from the church is the site of a 6th/7th century nunnery founded by St Gobnait. It is said that she came into Munster from Galway looking for a herd of 9 white deer which would show her where to build her church. She found them in Ballyvourney, built her church and a convent of nuns grew around it.

Another story tells of a robber who arrived in the area and tried to erect a pagan shrine here. Gobnait threw her bowl which demolished it. The bowl is now attached to the west wall of the church and a tradition has grown up of touching it with a personal item for healing.

There is another station here called 'Tigh Ghobnatan' which translates as 'Gobnait's House', but probably means her 'church'. Nearby is a statue of St Gobnait put up in 1950. She stands on a beehive surrounded by bees. Inside the churchyard is her grave, a small mound with 3 bullauns. Crosses have also been scratched here by pilgrims. The turas involves going around each of these places in turn.

St Gobnait's Stone

0.5 miles north east of Ballyvourney Church.

An early cross pillar known as St Gobnait's Stone. Both faces have a Maltese cross inscribed inside a double circle. On one side the circle is surmounted by a figure with a crozier. It was found at the site of a dried-up well nearby.

St Abbán's Grave and Well

0.75 miles east of St Gobnait's well.

St Abbán is credited with giving St Gobnait the site for her nunnery. His grave is actually a small cairn with a cist or stone-lined recess inside. Nearby is a bullaun and around it three ogham stones. Pilgrims come here also as part of the pattern.

24 Knockraheen Circle

305 801

On the south slopes of the Boggeragh mountains. Take the second road on the left in Carriganimmy just south of the post office. It is signed.

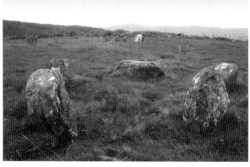

Knockraheen five-stone circle. View through the portals to the axial stone and quartz boulder beyond.

MUNSTER Cork

This 5-stone circle with an axial stone at 240 degrees from north, gives it an alignment to sunset at Imbolc and Samhain. (*The Stone Circles of Cork and Kerry*)

Its portals and axial stone are also aligned with a 2-stone row some 30 feet away. The nearer of the two stones is rectangular and compact. Behind it and clearly visible from the circle is the second stone, a large bulbous white quartz boulder. Nearby is a ruined cairn with 3 radial stones still in place.

Glantane East Circle and Cairn

293 827

This is one of a group of Bronze Age sites on the west slopes of the Boggeragh Mountains. Go north from Carriganimmy on the R582. It is signed to the right - up the old Millstreet, Macroom road.

Signed up a lane to the east on the west slope of Musherabeg, walk to a fine 11-stone circle with its axial stone aligned 192 degrees from north. (*The Stone Circles of Cork and Kerry*)

Glanane North West Wedge Cairn and Circle

283 840

North of Carriganimmy on the old road to Millstreet.
About 0.5 miles past the lane to Glantane East, Glantane wedge is visible in a field to the left. In the next field is another circle.

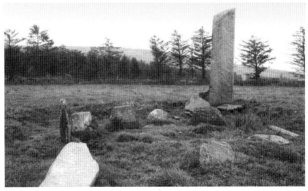

Glanane North West. Arc of low stones with 12 foot pillar behind.
There is a second pillar fallen in the foreground.

An arc of 5 low stones still mark what appears to be an inner circle with one 12 foot stone standing just outside. It seems to form an arc with two other stones which could be part of an outer circle.

MUNSTER Cork

Another tall stone has fallen on the other side. The two 'circles' are enclosed in a shallow ditch - possibly a henge as at Reanascreena.

Knocknakilla Complex

306 853
North of Carriganimmy on the old road to Millstreet. 9 miles north of Macroom. 1.5 miles beyond Glanane.

High up on the side of Musheramore and the highest site of the group, it is a partly fallen stone circle with 2 tall pillar stones, one of them fallen. Nearby is a low radial cairn.

The circle seems to have two portals still upright, one side-stone upright and the axial stone fallen. Behind the axial stands one of the 14 foot tall stones with the other lying in front of it. The axial stone is aligned 200 degrees from north. Nearby is a small radial cairn with a strong outer stone ring.

25 Rylane Circle

439 813
About 1 mile west of Rylane on the east side of the Boggeragh mountains. From Rylane Post Office go west, keep left at the fork and the circle is visible across a field on the left.

This is a small compact 5-stone circle with axial stone aligned to the Winter Solstice sunset. It is oriented 220 degrees from north (*The Stone Circles of Cork and Kerry*). A pillar stone can be found 2 fields east of the circle.

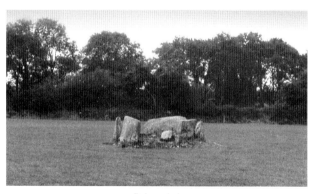

Rylane circle

MUNSTER Cork

Carrigagulla Stone Circle

Go west from Rylane Cross for 2 miles and turn left.

Go over the bridge and it is signed up a lane behind a big farmhouse. Or you can go east from Ballynagree Village (north of Macroom), about 1 mile to the sign. Walk up over the hill and down to the first gate on the right after the forestry trees begin on the left. It is visible down in the fields to the right.

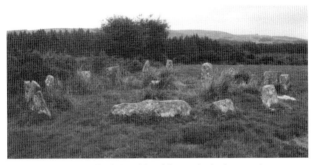

Carrigagulla circle with axial stone in the foreground

A very gentle magical place, this is a lovely, almost complete circle originally with 17 stones and one in the middle. Two stones are missing. The axial stone is 245 degrees from north giving the circle a possible alignment with the setting sun at Imbolc and Samhain. (*The Stone Circles of Cork and Kerry*)

Continue north about a quarter of a mile to another small 5 stone circle. Only the portals and axial stone remain

26 St Laichteen's Well

1.5 miles south east of Donaghmore.

St Laichtín founded a monastery here early in the 7th century. His well is visited at midsummer as well as the following Sunday and the 26th June which is St Laichteen's day. This probably means that this is also a traditional site for midsummer gathering. It is quite likely that the date for St Laichtín's day was chosen to support the tradition.

There is an exquisite 12th century shrine from here, now in the National Museum, Dublin. It is a finely worked silver arm, containing a relic of St Laichtín, putting one in mind of the arm made for the High King Nuadha by Dian Cécht, healer of the Tuatha Dé Danann. There was a great revival of interest in relics in the 12th century and pilgrims were encouraged to visit them.

St Laichtín is also credited with founding a monastic

settlement at **Clahina, Kilnamartyra**. His well here is also still visited. This well is actually two oval depressions in the rock and linked by a narrow fissure. They are not true wells as they are not fed by any spring. Strangely, the water in each is a different colour. Knowledge of their exact location had been lost for some time until they were found again in the middle of the 19th century. A woman dreamed of their exact location, the turf was cleared and they were found.

27 St Ólann's Cap, Well and Stone

440 782

Aghabulloge old Church is 4.25 miles north west of Coachford in Coolineagh on the north side of the valley. Take the Macroom road from Coachford. Aghabulloge is signed on the right. The well is on the Rylane road by the roadside.

This foundation is attributed to St Ólann who taught St Finn Bárr of Cork. South east of the ruined church in the graveyard is an ogham stone with a small quartzite cap-stone on top, called 'St Ólan's Cap'. Up until 1831 the Caipín (little cap) was made up of 2 stones and used to cure female ills and also to bind oaths. Its blatantly phallic appearance eventually prompted the local priest to take off the cap-stones. Apparently they were immediately replaced by the existing ones which have proved just as potent.

Further north, beyond the graveyard, is St Ólann's Stone - a boulder with the imprint of his feet.

St Ólann's Well is 440 yards north north east on the Rylane road. It is covered by a small clochán or beehive hut which in turn has been covered by ivy. A small thorn tree is growing out the top. An ogham stone beside it was found in the foundations of the old mill at Mullenroe and put here in 1851. The turas includes the Caipín, Stone and Well on St Ólann's Day - 5th September.

St Ólann's Cap

MUSTER Cork

28 Carraig Chlíodhna
In Carrigcleenamore, 7.5 miles south south west of Mallow.

This great rock slab is traditionally the door to the Otherworld, seat of the Goddess Clíodhna. It is known as 'Cleena's rock'.

Unfortunately it now sits stranded high up in a quarry. The owners have obviously been constrained to preserve it, but its plight illustrates only too well how a monument is affected by the destruction of its place. This stone still has a strong presence about it but its place has been literally eroded away, and with it, its 'spirit of place', which was symbolized as "the door to the Otherworld". A painful sight.

Carraig Chlíodhna

29 Labbacalee - Hag's Bed
774 020
Just over a mile south east of Glanworth village which is on the R512 north west of Fermoy. It is signed.

This is the largest wedge cairn in Ireland and associated with the Cailli or Hag Goddess, in Cork 'the Cailleach Beara'. 'Leaba Cailli' means 'the Hag's Bed'. The stones here are huge and have a strong, gentle atmosphere about them, rather like the energy you can get from a very old tree.

The two chambers have triple, instead of the usual double walls and there are still three massive cap-stones in place. The slab dividing the chambers has an upper corner cut away, forming a kind of porthole as at **Altar** above.

There are interesting parallels with the later early Christian shrines where holes allowed contact between pilgrims and the relics inside.

At the east or thin end of the wedge are 3 vertical slabs at right

Labbacalee or the hag's bed. The kerbstones which would have
surrounded the cairn are in the foreground.

angles to the endstone and at the front or west end are uprights
forming a kind of enclosure or antechamber separated from the
main chamber by a door slab. These are both unusual features.

The east chamber was found to contain the bones of a woman.
Her skull had been placed separately in the large west chamber
with the remains of a man and a child. With her were cremated the
bones of pig, ox and sheep as well as a small pin made of bone.

At a higher level, in other words from a later period, the
remains of at least five other people were found from later times
with neolithic pottery sherds. Some had been cremated.

A cist burial with food vessel sherds was found in front of the
enclosure as well as a number of other later burials, including
much later child burials. These last follow the relatively modern
tradition of burying unbaptized children at ancient sacred sites.

Carrowkeel in Sligo and Poulnabrone in Clare also contain
much later child burials.

Perhaps the name of the site reflects a folk-memory of a female
presence in the cairn.

30 Island Wedge Cairn

603 908.

5.5 miles south south east of Mallow on the south west side of
the Nagles Mountains. 5.5 miles south of Mallow on the N20, turn
right into Burnfoot. 0.6 miles past the school is a farm entrance
with blue gateposts and a long avenue. Ask at the farm.

This is a lovely location on sloping pasture above a stream. It is a
good example of a wedge cairn with thin limestone slabs forming
double walls around a U-shaped gallery. The gallery is undivided
and faces south west. Some of the roof slabs are still in place and

there is some infill of small stones between the walls and marking out the shape of a round cairn which would have covered the whole structure.

It was excavated in 1957. About 3 feet from the outer gallery wall were found kerbstones ending at the front in a flat facade. In front of the entrance, sockets were found for a curved front kerb which would have held the cairn stones in place. These would finally have closed the entrance.

Near the back of the gallery, a deep circular pit was found with a small amount of cremated human bone.

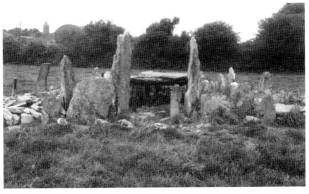

Island wedge cairn

County
KERRY
PRINCIPAL SITES

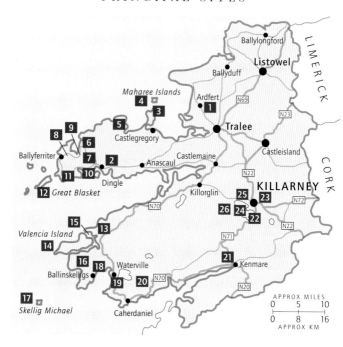

1 **Ardfert** cathedral, churches
 Tobar na Molt

2 **Dingle**

3 **Kilshannig** cross pillar

4 *Maharee Islands* and **Illauntannig** old monastic
 enclosure

5 **Brandon Mt**

6 **Cosán na Naomh** and **Kilmalkedar** monastic site

7 **Reenconnell** burial ground and cross
 Kilfountain Church Site, cross slab and ogham
 Teampull Geal - Ballymorereagh stone oratory

8 **Reask** pillar

9 **Gallarus Oratory**

10 **Coláiste Íde** ogham stones

11 **Dunbeg Fort**
 Fahan and **Glenfahan** beehive settlements

12 *The Blasket Islands*
 Inishtooskert oratory, crosses and beehive huts
 Inishvickillane oratory, cell and cross
13 Leacanbuaile Fort
14 *Valencia Island*
15 Beginish
 Church Island
16 St Buonia's Well
17 *Skellig Michael*
18 Ballinskelligs monastery
19 Eightercua
 Loher alpha/omega stone
20 Staigue Fort
21 Kenmare stone circle
22 Muckross friary
23 Lissyviggeen stone circle
24 Inisfallen Abbey
25 Aghadoe church
26 Dunloe stones

Block figures in list refer to site locations in map and entries in text.

MUNSTER **Kerry**

KERRY

ACCORDING TO *THE BOOK OF INVASIONS*, the first people to inhabit Ireland were of the family of Noah. Three ships set sail to escape the flood and made their way westward through the Mediterranean and northward up the coast of Spain to Ireland. They already had knowledge of this island where they thought they would be safe as it was uninhabited and therefore would not be included in the destruction of the flood.

However, only one ship arrived safely. In it were Cesair, granddaughter of Noah, with fifty of her women and three men: Bith, her father, Ladra, the ship's pilot, and Fionntán. They came ashore on the Dingle Peninsula here in Kerry.

The story goes that they divided the women between the three men but Bith and Ladra soon died, leaving Fionntán with responsibility for all the women. He fled (see CLARE) and Cesair died soon after of a broken heart and all the women with her.

Fionntán is said to have lived on for 5500 years, changing shape over time. He lived as a salmon, then an eagle and a hawk and witnessed the events of history so that they could later be

written down by historians writing such works as *The Book of Invasions*.

This mythological event may seem fanciful, but it illustrates a connection that has always been recognised between this part of Ireland and the countries which fringe the Mediterranean Sea.

The famous playwright John Millington Synge has been quoted as saying of Kerry:

> One wonders in this place, why anyone is left in Dublin, or London, or Paris, where it would be better, one would think, to live in a tent or hut, with this magnificent sea and sky, and to breathe this wonderful air which is like wine in one's teeth.

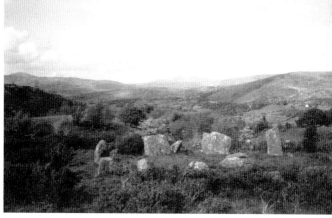

Gurteen stone circle, Co. Kerry (photo: Jamie George)

The sites included here are all fairly accessible. Much of Kerry is not. As I travelled round the county, I realized that what I really needed was to abandon the car and walk along the Kerry Way, following the old green roads south of the Macgillycuddy Reeks. This is where you find rocks with prehistoric carvings and standing stones, intricately ornate cross-pillars and old church sites from a time when such places were not considered remote.

MUNSTER **Kerry**

1 Ardfert Cathedral, Churches

786 212

About 5 miles north west of Tralee on the R551. 'Ard Ferta Brénnain' or 'the Height of the Burial Mounds of St Brendan' is the full name of this place. This 'Brendan' lived in the 6th century and was of the family of Altraige of North Kerry. He became known as 'Brendan the Navigator'.

There has been a religious foundation here since the 6th century but virtually all traces are gone, replaced by a strong medieval community from at least the 11th century. The first mention of a stone church here

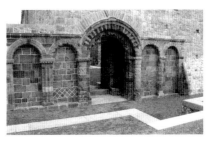

Reconstructed doorway and blind arcade, Ardfert cathedral

was in 1046, at a time when these were still rare enough to merit a mention in the annals.

A new cathedral was built in the 12th century, probably at the time of Ardfert's elevation to the status of Diocesan See, during the new church reforms. The beautiful Romanesque doorway and blind arcade now in the west gable date from this time as well as the little church just north west of the cathedral called 'Temple na Hoe'. This means 'the Church of the Virgin'. The Romanesque detail is exquisite, especially the patterned bosses and flowers around the small window in the south wall.

The main body of the present cathedral is 13th century, but if you look closely at the lower part of the north wall, you can see some of the large stones characteristic of 11th century building. They are part of the original stone church.

The lovely high lancet windows are 13th century. There were a number of 15th century additions: the south transept, the battlements, and a new roof. Another church beyond the Temple na Hoe was also built at this time.

This was an important and busy place in medieval times. When the site was excavated, over 2000 burials were found. One body, thought to be that of a bishop, was wearing a ring depicting the Roman goddess Minerva. Another had an ornate pilgrim's badge from Santiago de Compostella in Spain.

Although Ardfert may now seem 'off the beaten track', it would have been well placed at a time when sea travel was easier than by land with Spain and the Mediterranean just a sea voyage away.

MUNSTER **Kerry**

Tobar na Molt (Well of the Wethers)

818 204

Go south from the cathedral on the R551 and take the first left before the petrol station (still in the town). Follow this road about two miles to a T junction and turn left. The well is signed on a field gate on the right.

Some say that the 'wethers' was the fee exacted by the bishop for baptising St Brendan. Another story tells how three wethers saved a local priest who was being chased across the fields by bloodhounds. They jumped out from beside the well and the hounds chased them, leaving the priest free to escape to safety. (A wether is a castrated ram.)

Well and well house, Tober na Molt

A track leads across two fields to the well. It is a beautiful sheltered site with mature trees and enclosed with an oval hedge. The well is wide and deep with steps down to it. Nearby is a small house with seats where people have left offerings. On the other side of the well is a small mound called St Íte's grave. She is supposed to be of the same North Kerry family as St Brendan. Her church at Kilmeedy is only about 35 miles east of here, in Limerick.

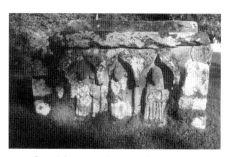

Carved figures on the altar, Tobar na Molt

Beside it is a stone altar with three carved figures on the front. They look like three weepers from a 15th or 16th century tomb, probably from the cathedral. Here they are considered to be St Colmcille, St Brendan and St Íte. Their heads are rubbed smooth from being touched by pilgrims and they have crosses scraped on them, also as part of the rounds or turas. There are instructions in the little house as to the order in which it should be done.

2 Dingle

In medieval times Dingle harbour was the departure point for pilgrims to the grave of St James at Santiago de Compostella in

Spain. The present Church of Ireland church in Main Street is dedicated to St James and the first church on this site was said to have been built by the Spanish.

Now the deep sheltered harbour is home to a dolphin called Fergie and people come from far and wide to connect with this creature who seems to be a willing contact between them and the healing underwater world of the dolphin.

One of Ireland's sacred mountains, Brandon Mountain, named after the saint of seafarers, St Brendan, is on the the Dingle Peninsula.

3 Kilshannig Cross Pillar

625 195

5 miles north of Castlegregory, on a neck of land jutting out from the north coast of the Dingle Peninsula. Follow the road as far as it goes out along Scraggane Bay. Fork right for Kilshannig.

Kilshannig is a tiny dilapidated village at the end of the road with a small graveyard and ruined church on high ground above the sea. 'Kilshannig' means 'St Senan's church'. In the graveyard is a cross pillar with a fine incised cross with expanded terminals and a double spiral at its base, similar to those at Kilfountain, Kilmalkedar and Reask.

Kilshannig cross pillar

MUNSTER **Kerry**

4 Maharee Islands and Illauntannig Old Monastic Enclosure

624 213

From Kilshannig graveyard the Maharee islands are visible away to the north, flat pancake shapes like the smooth boulder clay glacial islands of Clew Bay, rather than the rough sea-scoured rocky islands around this coast. 'Machaire' means 'a plain'. To get there, ask at Fahanmore harbour which you can see to the west.

St Senan founded a monastery here and 'Illauntannig' means 'St Senan's Island'. There are two small stone oratories inside a

massive stone enclosure, one with inclining jambs and herringbone masonry in the south wall. The other has a cross over the door formed of rounded white stones in the masonry. There are also three beehive huts and three leachtaí or stone slabs.

A stone cross 6 feet high stands near one of the leacht. It is said that a poor man who had killed someone stayed here at the foot of this cross for two days and nights without food, until a priest came and persuaded him to leave it. (see *JRSAI 1897*, p.291)

5 Brandon Mt
North west tip of the Dingle Peninsula.

This holy mountain is the second highest peak in Ireland. At 3127 feet, its summit is often shrouded in Atlantic mist, but from the top on a clear day it's easy to imagine how St Brendan was inspired to sail west. We are told in the *Book of Lismore* that he climbed alone to the mountain top and prayed for three days. Then he fell asleep and an angel came to him in a dream and promised to guide him to a beautiful island. He came down from the mountain and left almost immediately, probably from Brandon Bay.

At the place where he had his dream, a small oratory was built. Nearby are some mounds, the foundations of beehive cells and beside them is St Brendan's Well.

Brandon mountain used to be called 'Sliabh Daghda' or 'the mountain of the Daghdha', the father god of the Tuatha Dé Danann. It has been considered sacred for a long time. The mythological Brendan is descended from these earlier gods. According to tradition his father was called Fionnlugh - an interesting amalgam of heroes. Lugh was the young heroic god of the Tuatha Dé Danann and Fionn was the mythical hero of the Gaels. While the historical Brendan had his roots in North Kerry, the heroic Brendan had a much loftier lineage.

There is a strange legend here concerning a pillar stone called 'Leac na nDrom', 'the Stone of the Back'. It was in the time of Fionn when there was an invasion of 'Black Men' or 'Fir Ghorma'. He managed to defeat them and built a great fire on the shore to burn their bodies. However, the heat from the fire was so great that he had to back away from it. He had to back away so far that he ended up at this stone on the top of the mountain. (*The Festival of Lughnasa*)

According to Máire Mac Neill, author of *The Festival of Lughnasa*, the pilgrimage to the summit of Brandon Mountain replaced an old Lughnasa assembly, a harvest outing which involved climbing the mountain and then going down into the village of Cloghane on

Brandon Bay for a festival that involved games, competition and courtship, feasting on mutton pies, singing and dancing. It was also the day for trying the new potatoes, a traditional Lughnasa event. This festival was the biggest on the Dingle peninsula and took place on Crom Dubh's Sunday, the last Sunday in July.

In Christian times the practice was continued. It was now said to celebrate the conversion of the old harvest god, Crom Dubh, to Christianity. It was very popular in medieval times but had all but died out in the 19th century. In 1868 the Bishop of Kerry tried to revive interest in the event by organising a mass on the mountain top on June 29th. This day is now also associated with the mountain as well as St Brendan's Day which is the 16th May.

Around Ballynavenooragh and Ballinknockane

On the NW side of the mountain where it slopes down to the sea, the hillside is dotted with clochans or beehive huts. Maybe they offered shelter to pilgrims who had travelled from far off. No doubt they came by sea directly from Europe and even possibly North Africa.

There were probably many more on the East side where the village of Cloghane (Clochan) grew up.

To the West, the rest of the Dingle Peninsula is full of monastic remains, settlements, some small, some big which grew up in the shadow of the holy mountain. Best known is probably the Gallarus Oratory and the Reask Pillar. While these are the best examples from an architectural and artistic point of view, there are others which are a little more remote and therefore, perhaps, still carry a more powerful sense of their original function.

6 Cosán na Naomh and Kilmalkedar Monastic Site.
403 062
5 miles north west of Dingle. Signed on the R559 west of Dingle, it is on the main road about one mile past the turn for Gallarus.

This is the site of a 7th century monastery founded by St Maolcathair, said to be of royal blood of the tribe of Fiachra. It is also the starting point of 'Cosán na Naomh', 'the Way of the Saints', which takes you right to the top of Brandon Mountain along the old pilgrims path. Follow the lane up past the churches.

The oldest building on this site is the collapsed St Brendan's Oratory, built like the one at Gallarus. Near it is a flat stone with three large depressions, called 'the Keeler's Stone'.

The main church has a 12th century nave and later chancel. The nave has a well-preserved Romanesque round-headed

doorway decorated with zigzags and beading. A head is carved on the central stone and above it a blank tympanum. Either side of the doorway are antae with animal head decorations.The gables are high pitched and one has a finial intact. Some of the original barrel-vaulted roof is still visible.

Inside the church is a cross-inscribed stone and another stone with Latin letters called 'the Alphabet Stone'.

The ogham stone outside the church is

Sundial, Kilmalkedar monastic site

inscribed: ANM MAILE-INBIR MACI BROCANN - 'The name of Mael Inbir son of Brocán'. (*Monuments of Ireland*)

In the graveyard is a fine sundial with a hole for the gnomon and double lines radiating from it. For some reason the diagonal on the right has a triple line. Nearby is a large unfinished stone cross.

7 Reenconnell Burial Ground and Cross

426 062

From Dingle take the small back road due north for 3 miles and turn right at the crossroads. Stop at the first boreen on the left. Go through the deserted farmyard and across two fields. The cross is visible from the farmyard.

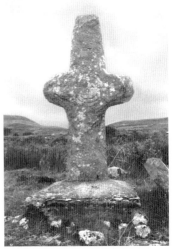
Reenconnell Cross

'Rinn Chonaill' means 'Conal's Point' - a lovely site on a slight ridge at the head of the Milltown river valley. It is called an old burial ground, but the cross and a patch of stoney ground are all that remain at

this site. The cross is huge, carved from one block of stone, simply patterned with an incised cross and circle. An impressive sight, sitting on raised ground facing down the valley.

Kilfountain Church Site, Cross Slab and Ogham

422 031

2 miles north west of Dingle. Go west out of Dingle and turn right towards Gallarus. After 1.2 miles, stop at a farm gate. Follow the lane on foot to the stone outhouse and then cross the field behind it to the left.

'Cill Fhiontain' means 'Fintan's Church'. Surrounded by open hills to the west of the Milltown river, this site is about 1.5 miles south of Reenconnell in the same valley.

This ruined circular stone enclosure with a tiny oratory inside is strangely similar to a circular cairn with a passage and chamber. An interesting comparison.

Within the enclosure is a patterned cross pillar, more slender and less ornate than Reask, but in a similar style. On the west face is a cross inscribed in a circle with extended spirals below. Below this, according to Estyn Evans, is a dedication to St Fintan. The inscription is now difficult to see. Down the side of the stone is an ogham inscription. A bullaun stone stands beside it.

Pillar stone and bullaun,
Kilfountain church site

Teampull Geal - Ballymorereagh Stone Oratory

405 027

South east of Gallarus. From the farm gate to Kilfountain, continue north for 1 mile and turn left. After about 0.5 miles there's a lane on the right. Follow it to the top and then cross the next field diagonally to the left.

The oratory sits high up on a north facing slope above Dingle Bay. It is incomplete with a trabeate doorway with inclining jambs. One finial is reset on the west gable. There's a cross pillar inside and

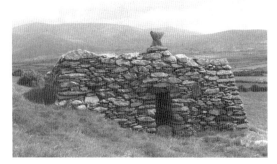

Teampull Geal - Ballymorereagh stone oratory

a niche in the north wall. In front of the doorway is an ogham stone.

8 Reask Pillar

367 044
Signed off the main road just east of Ballyferriter.
'Riasc' means 'a marsh'.

The cross pillars are inside the old monastic enclosure with partially rebuilt clochans or beehive huts and the ruins of a small oratory. Some of the clochans are joined together. These buildings are probably 8th or 9th century. However, from an earlier period, buried deeper, some fragments of amphorae were found with other domestic debris. These are pottery jars from the eastern Mediterranean area and dated to the 5th or 6th century.

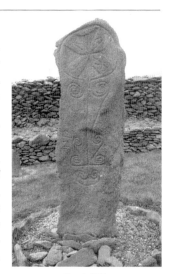

Reask Pillar

It is possible that the equal-armed cross on the Reask pillar is evidence of eastern Mediterranean, perhaps Greek, influence.

The pillar is about 6 foot tall. The pattern seems to follow the uneven facets of the stone. At the top is an equal-armed cross with expanded terminals inside a circle. The circle opens at the bottom into a pattern of extended spirals which have been compared with the La Tène style of Celtic art.

There's something about the main circle at the top and the

placing of the spirals which reminds me of the crucifixion slabs from the islands of Dunvillaun and Inishkea, off the Mullet in Mayo. They are in a kind of naive style with spiral designs on the shoulders and hips. Perhaps the spirals on this pillar at Reask are symbolically placed to represent the figure of Christ? The letters DNE are carved to the side - short for Domine.

Two small cross pillars were found and erected nearby. One of them has an unusual bird motif.

9 Gallarus Oratory

394 048

5 miles north west of Dingle. Leave Dingle going west. Gallarus is signed just out of town on the R559 on the right. There's a small visitor centre or you can choose just to visit the oratory from the Pilgrims' Way.

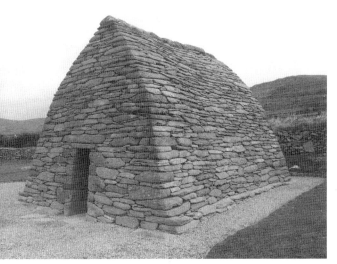

Gallarus Oratory

This is one of the most famous buildings in Ireland and it therefore has many visitors. Thankfully, the small visitor centre is some distance away so there are no modern buildings around it. Set back against the hillside, it has fields on either side.

It is built of large cut stones neatly fitted together with walls angled from the base to a corbelled roof whose gable ends also lean inward in a curved batter. The corbelled stones slope slightly down towards the outside to help rain run off. The doorway at the west gable end is lintelled with sloping jambs.

MUNSTER **Kerry**

On the inside over the lintel are two holed stones to support a wooden door. The east gable has a small round-headed window splayed on the inside. Although mortar was in use from the 8th century, there is none used in this type of oratory. This doesn't necessarily make it earlier, but it does make it difficult to date with any accuracy. This style of oratory is peculiar to Kerry in the south west. The remains at Kilmalkedar and Teampall Geal are nearby examples, though they are both partly ruined. However, their small size and their ratio of length to breadth as 1.5:1 are characteristic of most early Irish churches. The lintelled doorway and inclined jambs are also common throughout the country. Corbelling, of course, was in use from neolithic times in structures such as Newgrange.

10 Coláiste Íde Ogham Stones
421 997
Follow the R559 west of Dingle and turn left at the end of the harbour following signs for Coláiste Íde.

There is an interesting collection of ogham stones in the college driveway. Some of these are the more unusual 'cigar-shaped' oghams. These usually lie horizontally and have their sharp edges rounded.

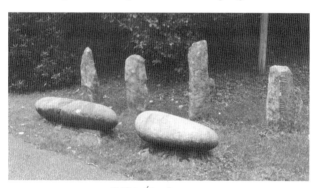

Coláiste Íde ogham stones

11 Dunbeg Fort
352 972
9 miles west of Dingle, this is signed from the R559 and is visible from the road.

This is an Iron Age promontory fort on a small V-shaped headland about 2 miles west of Ventry. 'Dunbeg' means 'Little Fort'.

A thick dry-stone wall about 150 foot long, cuts the headland off from the rest of the peninsula. Both ends are eroded where the

sea has reclaimed part of the cliff.

There are four bank and fosse defences on the landward side of the wall. The entrance passage is about 20 foot long and roofed with large lintel stones. There are sentry chambers in the walls on either side. Inside the fort are the remains of a large circular building with a square interior. In front is a souterrain or tunnel now covered with a flag-stone.

Fahan and Glenfahan Beehive Settlements

About 1 mile west of Dunbeg on the north side of the road.

For several miles the steep slopes of Mount Eagle on the north side of the road are dotted with clochans or beehives. Some, like Caher Murphy and Caher Martin, are enclosed in cashel walls. Others sit alone.

The extreme south west of the peninsula has a tight concentration of clochans and other stone remains. When RAS Macalister was surveying the area at the end of the 19th century, he recorded 414 clochans. This area was dubbed the 'City of Fahan'. Most are round, though some are D-shaped, being built against the rock. Others are shaped like Gallarus. A few have up to four chambers, some have souterrains and others are conjoined, so that a number together form the one structure.

It has been suggested that the population was at its height here between the 6th and 10th centuries (*Prehistoric and Early Christian Ireland*). No doubt they provided shelter for the pilgrim travellers who would have come ashore here on their way to the holy Brandon Mountain.

Another suggestion is that some of the hollows inside the walls are early stone bee skeps (*Pagan, Celtic Britain*). Tradition has it that the first domestic bees were introduced into Ireland by St Gobnait (see CORK). They became very important and even had their own laws - the Bech Bretha. In prehistoric times the soul was thought to leave the body as an insect, either a bee or a butterfly.

The tradition of clochan building has not entirely died out here. Some are still being built as farm buildings. Access to them is clearly signed and generally involves paying a small fee at the nearest house.

MUNSTER **Kerry**

12 The Blasket Islands

There are six islands in this group, though the Great Blasket is by far the biggest . It is a long finger of land just 2 miles west of Slea Head and looks as if it has been torn from the end of the Dingle peninsula by the relentless pounding of the ocean. The

other islands are mere fragments discarded by the way. Boats go to Great Blasket every half hour from Dunquin in the summer. For ferry enquiries phone 066 915 4864 or 0782316131.

The Great Blasket was bought by the Congested Districts Board in 1906. This organisation was set up by the government to help those living in isolated rural places. They bought land from the big estates and gave it to the tenant farmers and organised materials and markets to encourage traditional industries like fishing, farming and weaving. The island land was redistributed and five new houses built. In spite of this, the village on Great Blasket was evacuated finally in 1954 when government policy favoured relocating islanders on the mainland. People realized too late what was being destroyed.

However, Great Blasket was home to a disproportionate number of writers, like Tomás Ó Crohan and Peig Sayers who wrote about their lives there at the turn of the twentieth century when the delicate fabric of the island community was still intact.

Tomás Ó Crohan, in his *Island Cross-Talk: Pages from a Diary*, describes the vulnerability of a landscape and its people in a winter storm of 1921:

MUNSTER **Kerry**

> The blast of the great gale is driving the waves high over all that lies within their reach. The rocks jutting out of the sea are smothered by the fury of the white surf bursting over them. The grass that yesterday was green is withered today. The very skin of the people is changing with the bad weather. The sheep on the hillside are blown from their pastures and are trying to push their way in the door to us. The fish that all summer disported itself and basked in the sun near the surface of the water has vanished in the storm. The young woman, trim as a swan on the lake for the rest of the year, brings in her bucket of water; with the comb snatched from the back of her head by the wind, her hair trailing into her mouth, her clothes spattered with mud, the water half spilt, she is as ill-humoured as someone who is out of tobacco.

> Of the old people, whose bones were so smooth and supple all summer in the warmth of the sun, this one has cramp in his leg, that one's arm is paining him and another is dozing by the fire with an eye being kept on him for fear he might fall in.

> There is great healing in fine weather, and great harm follows the bad.

Two of the smaller islands have remains of early monastic settlements on them. They are:

Inishtooskert: Oratory, Crosses and Beehive huts

'Inishtooskert' means 'Northern Island'. This one is shaped like a small butterfly and lies about 5 miles north of Great Blasket.

Unpopulated, it was once home to a small community of monks. The ruins of their church are still here as well as their beehive huts, one almost perfect, and three stone crosses.

Inishvickillane: Oratory, Cell and Cross

About 4 miles south west of Great Blasket lies Inishvickillane, the most southerly of these islands.

A ruined oratory, beehive cell and an early Christian settlement are all that remain.

13 Leacanbuaile Fort

446 808

Cross the bridge over the Valencia river in Cahersiveen and turn left at the first crossroads about 0.5 miles out of the town. Just over 1 mile along this road is a small car-park.

From the fort you can see right out over the harbour, across Beginish Island to Valencia and out to sea. On every other side are hills - an excellent site for a fort.

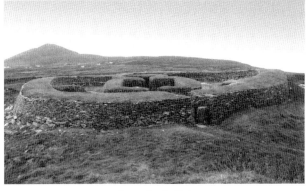

Leacanbuaile Fort

The walls are 10 feet thick and reconstructed up to 4 feet. Inside, a number of house sites have been built up to give an idea of how such a fort might have been used. There are remains of a circular house

in the west with a later square building in the middle and a covered drain leading out of the enclosure. The entrance is in the east and would probably have been a covered passageway, like at Staigue. To the south east and just a short walk away is another fort at Cahergall.

14 Valencia Island

The name 'Bheil Inse' means 'the island at the river mouth', but its older name, 'Dhaibhre', means an 'oak grove'. Valencia forms the north west tip of the Iveragh peninsula and looks as if mere accident has snapped it off from the north bank of the river Ferta. 'Feartha' means 'miracles'. It also means a 'mound' or a 'tumulus'.

A ferry crosses to Knightstown from Reenard Point, west of Cahersiveen, but there is also a road bridge from the harbour at Portmagee. There's a small heritage centre at Knightstown.

This is a very ancient place. In recent years footprints were found across rock on the far side of the island and dated to 385 million years old. They were thought to be the tracks of a tetrapod, the first creatures to venture onto land from water. This is only one of four places in the world where such footprints have been found. At that time Valencia would have been just south of the equator and the prints made in the mud would have been on an alluvial flood plain which then became fossilised over millions of years. In more modern times the slate quarries of Valencia provided the slates for the roof of the House of Commons in Westminster.

A circle of road runs around the island with small roads branching off to the seashore. In the north west a road leads down to Beennakryraka Head. It peters out into a track which goes towards the headland. There are 3 stone crosses and a well to the right, dedicated to St Brendan, the patron saint of seafarers.

About 2 miles further east on the main road is a small ruined enclosure with the remains of an oratory and clochan. Another can be found north of Chapeltown on the side of Kilbeg mountain.

15 Beginish

Off the east end of Valencia Island is Beginish which means 'small island'.

You can still see the old field systems here and the remains of eight stone houses, remnants of a small rural community. Two of the houses have been dated to the 12th century. One had an ancient stone with a runic inscription on it in use as a lintel. It is now in the Museum of University College, Cork.

MUNSTER Kerry

Church Island

430 786

This island is a tiny speck between Beginish and the mainland,
accessible on foot from there at very low tides.

There is an oratory here and the remains of some stone
buildings. A cross-inscribed stone from here with a later ogham
inscription is now in the Museum in Cork.

Perhaps the most interesting discovery at this site is a tiny cloth
fragment just 1 inch square which was found during the
excavations of 1955. It has been traced to the Mediterranean and
could have come either from Rome or North Africa, yet another
reminder of how widely travelled were many of the early Christian
monks of the west coast.

16 St Buonia's Well

400 695

Killabuonia. 4.5 miles north west of Ballinskelligs on the road
from Ballinskelligs to Rathkieran on the right hand side.

This site is on the steep south facing slope of Knocknaskeereighta
mountain, looking out over St Finan's Bay and beyond to
the Skelligs.

St Buonia or Beoanigh is supposed to have been a sister of
St Patrick. The monastic enclosure is on three stone terraces
following the contour of the hill. There are grave slabs and the
remains of clochans and an oratory.

At the south west corner on the lowest terrace is St Buonia's
well. It is surrounded by a low cairn of pebbles which have been
brought here by pilgrims. Beside it is an 18th century grave slab
scored with crosses as part of the turas or rounds.

Nearby is a stone shrine, called 'the Priest's Shrine', similar to
Teampall Chrónáin in Clare. It is a relic shrine and would usually
have held the bones of the saint who founded the monastery. Stone
slabs form the gables and two rectangular slabs complete the roof.
One of the gables is missing and the other has a circular hole cut
out near the base so that pilgrims could leave votive offerings
inside. There is a cross inscribed above the hole. Beside it is a cross-
inscribed stone pillar.

Traditionally the well was visited on Friday, Saturday or
Sunday. Scratching a cross on the pillar was part of the turas.
(*Archaeological Survey of South Kerry*)

About 1 mile south west in Rathkieran are the ruins of
Killemlagh Church, marking another monastic site said to have

MUNSTER **Kerry**

been founded by St Fíonán Lobhar, after whom St Finan's Bay is named.

17 Skellig Michael

8 miles west of Ballinskelligs Bay off the tip of the Iveragh Peninsula. Boats leave from Ballinskelligs and Portmagee, but only in clement weather. Sean Feehan has two boats (one covered) leaving from Ballinaskelligs daily at 11am. Phone 066 947 9182

There are many remote monastic settlements on the rocky islands off the West of Ireland, but this is the most remote. It is impossible to visit this island and remain unmoved by the sheer power of it, so remote and so high up as to make you wonder if the monks who lived here felt themselves half-way to heaven just by being here. Did the view every morning fill them with elation and joy and a sense of the presence of God or were they driven mad by the night cry of the shearwaters and the constant physical discomfort of living on a remote rock?

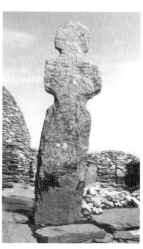

Like other rocky eminences, this one is dedicated to St Michael - the saint of uncompromising truth symbolized by a sword, but also the saint who carries the souls of the just to heaven. Definitely a fitting dedication.

Little is known about the origins of this settlement. Local lore associates it with the Kerry saint, St Finian, but more recent explorations of our Atlantean connections with the Mediterranean and North Africa, suggest a

Stone cross, Skellig Michael

more exotic origin. In a series produced for television in the 1980s, Bob Quinn suggested that the first monks could have been Copts fleeing persecution in the 6th century from both the Roman and Byzantine world.

The Skelligs are mentioned in the *Annals* , later recording the deaths of abbots and Viking raids. Sometimes the two came together as in this entry in the *Annals of Innisfallen* for the year 823:

> "Skellig was plundered by the heathen and Etgal was carried off and he died of hunger on their hands."

However, the monks endured and legend has it that 150 years later in 993, the Viking Olav Trygvasson was baptised by a Skellig hermit. Olav later became king of Norway and his son Olav II her patron saint. They even built a new church in the 12th century, bringing stone from the mainland. The site was finally abandoned in the 13th century and the monks moved to the monastery of Ballinskelligs on the mainland.

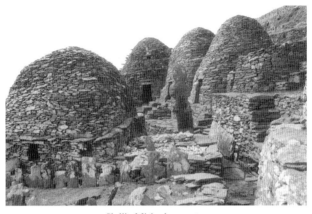

Skellig Michael monastery

Even today Skellig Michael is often inaccessible and pilgrims have to jump ashore from bobbing boats onto the landing stage. The cluster of tiny stone beehives and terraces are reached by a dizzying climb up some 600 slate steps to over 700 feet above sea level.

There are six beehive huts and two small oratories. The site was well chosen for, in spite of its awesome position, it is quite sheltered and south facing. The huts appear round outside, but inside they are rectangular with walls curving inward as they rise to form a corbelled roof. They are surprisingly spacious and with storage niches in the walls and sleeping platforms overhead, they would have made very practical living quarters.

The oratories are larger and are shaped like upturned boats, not unlike the one at Gallarus. They all have narrow lintelled doorways with sloping jambs. Around the buildings there are low walls to retain soil and create paths with even a small graveyard which has more the appearance of a raised vegetable bed if it weren't for the cross-inscribed grave slabs. Two tall crosses stand in the main enclosure roughened by time and the elements.

The monks carved water basins out of the rock to collect fresh water. They must have lived on fish, shellfish and seal meat as well as birds' eggs in season and what little herbs and vegetables they could manage to grow. They may have kept some sheep and goats

MUNSTER **Kerry**

and excavations in the 1970s uncovered evidence of iron-working. Perhaps they traded puffin feathers on the mainland?

As if this place was not remote enough, there is a spot even higher up on the south peak, called 'the Needle's Eye', which was a famous destination for pilgrims in medieval times. It is virtually inaccessible today, unless you are a skilled rock climber, but there are ledges here built over a thousand years ago with a tiny oratory and more rock basins for collecting rain water. This pilgrimage to the south peak continued long after the monks left in the 13th century.

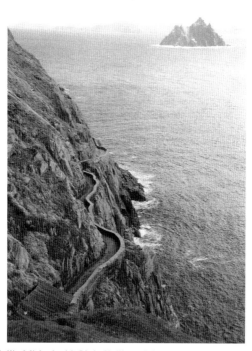

Skellig Michael with Little Skellig and the mainland in the distance

There were 2 lighthouses here at one time with two families in each. Children were raised here and occasionally buried as well - there are two small gravestones in the monks' graveyard. The lighthouse people constructed a road at the beginning of the 19th century which now makes access to the main settlement a little easier.

The smaller rock, before Skellig Michael, is called 'Little Skellig' and is home to a teeming 23,000 pairs of gannets. The shearwaters, storm-petrels, puffins and other inhabitants of Skellig Michael winter as far afield as Africa and South America -

reminders, if we need them, that the world, seen from Skellig Michael, has its own unique perspective.

18 Ballinskelligs Monastery

434 650

On the north side of Ballinskelligs Bay, north east of the town. By the seashore, it is visible on the right from the road to Waterville.

Ballinskelligs monastery

Founded for the monks who came from Skellig Michael in the 12th/13th century, there are two churches here dating to the 15th century. One has a cloister attached and a large hall on the other side.

Just beyond the monastery, on the shoreline at Dungeagan, is St Michael's Well. There was a pattern day here on the 29th September.

19 Eightercua

512 646

On a ridge above the road about 1 mile south east of Waterville.

Visible from the road and accessed through a small gap in the ditch, there is a small ruined church just inside the ditch on low ground and behind it, up on the hill, there are 4 big stones up to 10 feet high and forming an east west alignment for 30'. There are traces of an enclosure or the base of a cairn around them.

Local tradition says it is the burial place of Amhairghin, the first of the Milesians to come ashore in Ireland. He seduced the goddess Ériu, of the Tuatha Dé Danann, with his famous words which broke the power of the Tuatha Dé Danann's spells. Amhairghin sang the words:

MUNSTER **Kerry**

I am the wind on the sea;
I am the wave of the sea;
I am the bull of seven battles;
I am the eagle on the rock;
I am a flash from the sun;
I am the most beautiful of plants;
I am a strong wild boar;
I am a salmon in the water;
I am a lake in the plain;
I am the word of knowledge;
I am the head of the spear in battle;
I am the god that puts fire in the head;
Who spreads the light in the gathering on the hills?
Who can tell the ages of the moon?
Who can tell the place where the sun rests?
— *Lady Gregory's Complete Irish Mythology*

Eightercua stone row

From here you can see across Lough Currane where there is an especially high concentration of standing stones on the north shore. To the west is the wide sweep of Ballinskelligs Bay.

In the Lough itself is a tiny island called **Church Island** which was the site of a 6th century foundation by St Finian. Here also are the ruins of a 12th century church with a Romanesque doorway with four orders. An interesting stone built into the wall of the church depicts a man playing a stringed instrument. Unusually, it isn't a harp.

To the east is a small stone house called St Finian's cell and to the west, traces of some oblong buildings.

There are 8 cross slabs on the island and 2 have old Irish inscriptions:

A blessing on the soul of Anmchadh.

A blessing on the soul of Gilleinchomded O'Buicne.

– Monuments of Ireland

Loher Alpha/Omega Stone

509 616

About 2 miles south from Eightercua stone row, down from the road on the right.

Here is a stone enclosure with the remains of an oratory, a clochan, a stone altar, graveyard, and three cross-inscribed slabs.

One of these slabs has a smooth west face with a finely cut Roman cross on it with expanded terminals. Beneath the cross arms are the symbols alpha and omega. These symbols are common on Coptic metal altar crosses and this stone provides yet another link between this part of the world and the early Christians from Egypt and the Mediterranean. The stone is known locally as 'an leac chaol' which means 'the thin stone'.

20 Staigue Fort

610 633

Signed north of the N70 between Sneem and Waterville.

A small road winds for several miles into the hills before the fort appears. It sits on a small rise, its stone walls almost invisible against a backdrop of rugged hills. In front, the landscape falls away to the coast.

MUNSTER **Kerry**

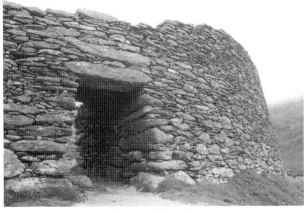

Entrance, Staigue fort

This is one of Ireland's biggest and best ring forts with walls up to 18 feet high and 13 feet thick, enclosing an area 90 feet in diameter.

Access to the interior is through a passageway 6 feet high with massive double lintels. The converging jambs are reminiscent of early church architecture and, particularly given the location, of the clochans on nearby Skellig Michael. Inside, the walls are climbed using a series of crossing stairways which run up to the ramparts. Inside the wall there are two small oval rooms with corbelled roofs.

The fort is surrounded by a large bank and ditch, still clearly visible on the north side. Such earthworks also surround the Grianán of Aileach, in Donegal. These forts were built without mortar, using skills developed since neolithic times. The thick walls, with tightly fitting stones and a slight batter, provide all the strength and stability needed to withstand both enemy attack and centuries of wind and rain.

In the past, different people have been credited with its construction. Here and elsewhere such forts have been said to be the work of the Danes. In Kerry, with its Atlantean connections, some have credited the Phoenicians with Staigue's construction. However, locally it is said that its builders were a small people who came in search of metal ores in the hills of the south west. This would date it to possibly the Bronze Age. But it is most likely to be Iron Age and built as a royal site, a fortified palace for a wealthy chieftain. It is unlikely that we will ever know for sure.

21 Kenmare Stone Circle

This circle is in the town of Kenmare, signed from the town square.

I have included this circle because it is probably the largest in the south west and it has an impressive boulder dolmen with a huge cap-stone in the centre of the circle. However, it has been domesticated and turned into a feature garden and to me it's like seeing an elephant in a tutu. I'd rather not.

It is made of 15 large boulders and situated at the head of the Kenmare river estuary looking out over the Caha mountains and the north coast of the Beara Peninsula.

Beara Peninsula

Uragh, Drumbohilly, and Cashelkeelty Circles are on the Beara Peninsula and included in that section with Cork.

22 Muckross Friary

975 870

The car-park and entrance to the abbey is opposite Muckross
House Hotel on the N71 going south from Killarney.

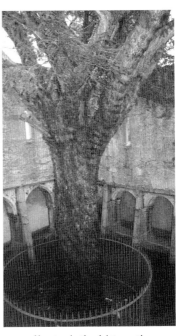

Yew tree in the cloister garth,
Muckross Friary

This was a 15th century Franciscan foundation with a south transept added around 1500. The wide tower was also added later and is unique in Franciscan architecture. Otherwise the buildings are compact and modest in the Franciscan tradition. They are exceptionally well preserved with safe stairways giving access to the upper storey of the claustral buildings.

The really remarkable feature, however, is a massive yew tree, planted many years ago, in the middle of the small cloister garth. The cloisters have remained unchanged, but the tree has grown and now fills the entire space. It has probably been here since the time of the monks and has thankfully not been disturbed. This is a truly venerable tree and a wonder to see.

23 Lissyviggeen Stone Circle

998 906

Take the N22 E out of Killarney. After about 2.5m turn left for
Lissyviggen. The circle is accessed from the green lane on the left.

This is a small but lovely circle with seven uprights, surrounded by a bank. There are two large stones outside the bank.

The local story is that the outliers (outside stones) are the parents and the seven stones in the circle are seven children. The family were turned to stone for dancing.

MUNSTER **Kerry**

24 Inisfallen Abbey

934 894

In Lough Leane. Opposite the cathedral in Killarney town are the gates of the old Kenmare (Knockree) Estate. A walk through the grounds brings you to Lough Leane and the 14th century tower house, called Ross Castle.

These grounds are an exquisite combination of woodland and water with the highest mountain range in the country, the Magillycuddy Reeks, as backdrop. From the castle you can enquire about a boat to Inisfallen. The official tour on the lake doesn't stop at the island, but there are other unofficial guides who will oblige. There are some thirty islands in this lake but Inisfallen is the largest.

The monastery founded here in the 7th century developed into a great centre of learning and is said to have numbered the High King Brian Boru as one of its students. (see CLARE) It is certainly true that one of Ireland's most famous healers and friend of the High King, the monk Maelsuthain O'Carroll, was attached to this monastery.

Around 1215 the *Annals of Inisfallen* were written here, providing an important historical reference for early Irish history. They are now in the Bodleian Library in Oxford.

The west end of the old abbey church dates probably from the 11th century and has antae and a trabeate doorway in the style of the early stone churches. The site was adopted by the Augustinians in the 12th century. The east end and the domestic buildings in the north are later - 13th century. By the shore is a beautiful 12th century Romanesque oratory with an ornate west doorway carved with animal heads.

The Inisfallen crozier is in the National Museum in Dublin.

25 Aghadoe Church and Round Tower

935 927

Not far north west of Killarney. Take the N22 north and follow signs for Aghadoe Hotel.

This site was founded by St Finian the Leper in the 7th century. It is on high ground overlooking Lough Leane and the fine parklands of Muckross. The ruined abbey on the tiny island of Inishfallen is visible below, though often the lake is hung with mist. St Finian is credited with the first foundation here.

The church has a beautiful Romanesque doorway with three orders in the west gable - the west end is the oldest and was finished in 1158. The pillars are squared with chevron and key patterns on

the outer two. The east window, 13th century, has a carved head and a four-petal knot at the intersection.

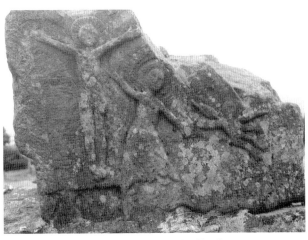

Crucifixion stone, Aghadoe Church

There is an ogham stone on top of the south wall. Also on the south wall is an interesting carved stone with a crucifixion scene in a naive style. The female mourner at the foot of the cross has one arm extended towards Christ and the other towards a flying angel on her other side.

26 Dunloe Stones

878 910

Take the N72 north out of Killarney and turn left at the sign for 'The Gap of Dunloe'.

Turn right and right again by Dunloe Castle Hotel. The stones have been relocated in an enclosure on the right hand side of the road.

Seven of these stones came from the souterrain at Coolmagort, discovered in the 19th century. They are very well preserved, thanks to their long stay underground. The prostrate slab is from Kilbonane churchyard nearby.

MUNSTER **Kerry**

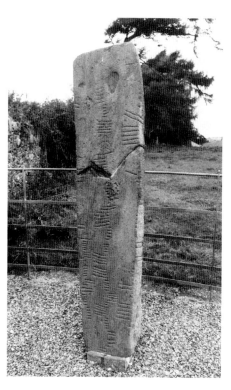

Ogham stone, Dunloe

MUNSTER **Kerry**

Province of
CONNACHT

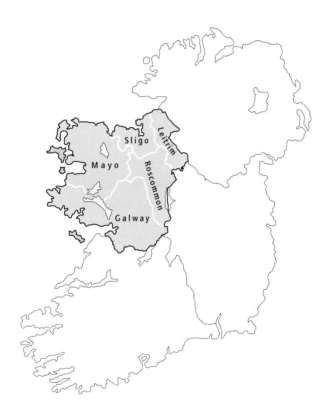

Sligo

Leitrim

Mayo

Roscommon

Galway

PROVINCE OF CONNACHT

CONNACHT IS THE WESTERN PROVINCE. It is bounded by the river Shannon in the east and the Atlantic ocean in the west. It is divided from north to south by a chain of lakes: Loughs Conn, Mask, and Corrib, which run from Killala Bay on the north coast right down to Galway Bay. They mark a natural division between the gentle plains in the east and the rugged mountains and lakes which drop to a fragmented coastline pounded by Atlantic breakers in the west.

Today this west coast seems wild and remote. This is one of its attractions though it was not always so. Its deep sheltered bays at Galway, Clew and Sligo attracted ships from as far away as Africa and the Middle East. The Tuatha Dé Danann are supposed to have arrived first in Connacht. They came from Northern Europe in flying ships, hidden in a mystic cloud, until they touched the soil of Ireland with their feet. It was on the plain of Cong, by the north shores of Lough Corrib in Mayo, that they fought the Firbolg for possession of the land.

We also know now that the people of the great cairns were here in Connacht before they were in the Boyne Valley. One of their most prominent cairns is on top of Knocknarea in Sligo. Its fame is due partly to its association with Maebh, goddess and queen, whose presence in the Connacht landscape is still felt, especially around Knocknarea in Sligo, and Crúachain in Roscommon.

Her mythology tells of a powerful and passionate woman who crossed and re-crossed the country in pursuit of her bloody aims. She reappears in Meath as sovereignty goddess at Tara. It is interesting that these sites from Sligo to Meath follow the same diagonal energy line across the country as many of the major passage cairns. Myth often has a way of mirroring and preserving a hidden reality. If Maebh personifies a ley line between Sligo and Meath, then it must have a very fiery energy.

The other great, larger than life, Connacht figure, is Grace O'Malley, known to all as the Pirate Queen, Granuaile. She was an only child, daughter of Dubhdara O'Malley, one of the few Gaelic chiefs at that time not to have submitted to the English.

In 1588 Richard Bingham was made Governor of Connacht in an attempt by the new English Queen, Elizabeth I, to extend her power right to the west coast of Ireland.

His violent and overbearing methods brought him into direct conflict with the Gaelic chieftains, and particularly with Granuaile, who sailed twice to London to petition the queen to intervene.

The second time she was 63 years old. She seems to have been successful, a remarkable feat, considering her reputation as a pirate and her rejection of English rule. Granuaile's visits to London raised rather than lowered her prestige among her people. The enemy was not England, but individuals who threatened the wealth and survival of others. Nationalism was yet to come. Political expediency was all important and Granuaile had lots of that. She was brave. She protected and avenged her followers, had great physical endurance and an indomitable spirit: all the old virtues of a Gaelic chief, and she was treated as such.

However, time was running out for her and eventually all her lands were laid waste. So she went to sea again. She looted and plundered up and down the west coast as far as the Isle of Barra in Scotland. By this time she was aged about 66. She and Elizabeth died in the same year, 1603.

Crúachain in Roscommon is the royal site of Connacht. The province is crossed from east to west by an ancient roadway which runs between Crúachain and the holy mountain, Cruachan Aigle, now known as Croagh Patrick.

<div align="center">

County

ROSCOMMON

PRINCIPAL SITES

</div>

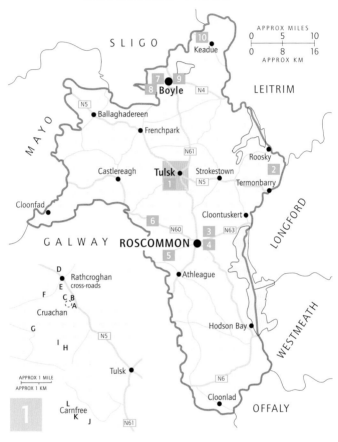

1 **Crúachain** - see area detail above for site locations **A - L**

 A Rathcroghan Mound
 B Misgaun Meva
 C Milleen Meva
 D Rathmore
 E Rathbeg
 F Rath na dTarbh
 G Oweynagat
 H Daithí's Mound
 I Reilig na Rí
 J Chloch Fhada na gCarn
 K Dúmha Selga
 L Cnoc na Dála or Carnfree inauguration mound

2 **Tobar Barry**
3 **St Brigid's Well**
4 **Rahara** Sheela-na-Gig
5 **Fuerty** old church
 Castlestrange Stone
6 **Oran** St Patrick's Holy Well
7 **Drumanone** dolmen
8 **St Attracta's Well**
9 **Boyle Abbey**
10 **St Lassair's Well**

Block figures in list refer to site locations in map and entries in text.

ROSCOMMON

THE RIVERS SHANNON AND SUCK form much of the boundary of Roscommon, running as they do one each side of the county to meet at its southern tip. Its border with Sligo in the north is a chain of lakes. In the centre of the county sits Crúachain, Royal Seat of the Kings of Connacht and of its most famous Queen, Maebh. It sits in the middle of the great limestone Plain of Crúachain which slopes north east to the Shannon. This is cattle country and the source of royal wealth and power in Connacht.

The passionate presence of the goddess in her red aspect at Crúachain is balanced by the gentler presence of the holy wells: St Brigid's, St Attracta's, St Lassair's and St Barry's. At St Attracta's and St Lassair's, 'serpent's eggs' still sit beside the water to encourage fertility.

1 Crúachain

A complex of ancient monuments about 3 miles north west of Tulsk village. Toberry crossroads on the N5 is used as a reference point for directions.

Crúachain is the sacred heart of Connacht. The principal site, the Mound or Rath of Crúachain, sits in a wide fertile plain which is dotted with some 60 raths, barrows, standing stones, cairns and enclosures, the monuments of a ritual landscape which has been in use for thousands of years. Its mythology is layered through time and, like the sites themselves, the earlier layers are more elusive

and harder to find. However, these few early mythic fragments lend a colour and character to the landscape here which you can still experience, if you are lucky.

I spent a couple of magical summer evenings here when the air was still and the shadows long. The strong light of the midsummer sunset exaggerated each mound and bank and cast a pink glow across the landscape. The sun is an important part of the vitality of this landscape and this is reflected in its earliest mythology.

Keating (*History of Ireland*) tells us that Crúachain is named after the goddess Crochen Croderg.

> Raith Cruachan from Crochain Croidhearg,
> Who sped great wrath upon the plain.

Other sources tell us that Crochen Croderg was born of the sun goddess Étain and dropped from her apron as she passed over the western lands on her daily journey across the heavens. When she fell, she went into the ground through an opening or cave, called 'Oweynagat'. This is held to be the entrance to her dwelling or sidh and the light of the rising sun at midsummer would have shone into her cave which faced east. Her name, Croderg, means blood-red, the colour of the setting sun, but also the symbolic colour of birth and death. This time of day symbolises the death of the light as well as the dark power of hidden fertility and gestation before new birth. Crochen Croderg is the goddess in her red aspect.

Her daughter, Maebh, is also associated with the colour red, and with this site. According to Keating, Rathcroghan was built by Maebh's father, Eochaid Fidleach (*History of Ireland*). She later gave the government of it to her mother, Crochen Croderg.

Later, in the Iron Age, it was one of the great Royal Sites of Celtic Ireland along with Tara, Emhain Macha and Dún Ailinne, and one of the great assembly places of Ireland where games, horse riding and feasting accompanied seasonal rituals. In the Iron Age epic, the *Táin Bó Cúailnge*, Maebh is Queen of Connacht and her palace is the mound of Rathcroghan. She lived here with her husband Ailill in a splendid residence, wealthy and extensive. From here, their quarrel over who had brought most wealth to their union, initiated a war between Ulster and Connacht that devastated both kingdoms. (see LOUTH) It ended in the symbolic fight between Finnbennach and Donn Cúailnge, the White Bull of Connacht and the Brown Bull of Cooley. This fight between the two bulls also took place here at Crúachain in the Rath of the Bulls. (see below)

The 13th century Connacht king, Cathal Crovdearg O'Connor,

kept the name of the Connacht goddess as part of his own.

There are over 60 scheduled monuments here, although many have been reduced to little more than undulations in the wide green fields. Still others are visible only from the air and we will never know how many have entirely disappeared. The sites described below have survived the centuries, retaining something of the aura of their past. They are as fine as any at Tara or Emhain Macha. Most of them got their names from the antiquarian, John O'Donovan, who visited Rathcroghan in 1837 while working for the Ordnance Survey.

There is a small visitor centre in Tulsk, called Crúachain Aí, which has recent archaeological information including interesting data on the recent geophysical survey of Rathcroghan. Some of the myths are also illustrated. Guides are available. To contact the centre, phone: 071 96 39268 or email: cruachanai@esatclear.ie

A Rathcroghan Mound

0.5 miles south south east of the crossroads, west of the road.
Visible and signed from the road, there is a car-park.

This is a wide, circular, drum-shaped mound about 10 feet high with a small ring barrow just visible on top. It sits at the centre of this wide ceremonial landscape, unexcavated and enigmatic, maybe a passage cairn, maybe not. Its ceremonial importance is not in doubt, however.

Recent geophysics have shown up to five concentric circles on the site, all man-made, showing that the site was altered and rebuilt many times over thousands of years. It has also shown a vast enclosure, about 400 yards across, encircling all five inner structures.

120 yards north north east of Rath Crúachain is (B) **Misgaun Meva**, meaning 'Maebh's lump', a fallen sandstone pillar. In keeping with all things associated with Maebh, the sandstone is red. About 50 yards west of this is (C) **Milleen Meva**, a low circular stony mound, about 23 feet across, with a fallen block of limestone nearby.

The nearest ring-fort visible is just in front of a copse of trees directly south of the mound, between the 2nd and 3rd field walls. Oweynagat is behind the row of conifers.

The field fence south of Rathcroghan follows the line of an ancient roadway which is said to run all the way to Croagh Patrick, the sacred mountain in the west, in Mayo. Parts of this road have been uncovered near Ballintubber Abbey in Mayo, where it formed part of a later pilgrims' road from the abbey to Croagh Patrick.

CONNACHT **Roscommon**

D Rathmore

Signed and visible by the roadside opposite the school. About 0.2 miles west north west of the crossroads going towards Bellanagare on the N5.

This impressive mound is at the west end of the site. 'Rathmore' means 'the Big Fort'. The area enclosed inside this 'fort' is unusually small, only about 100 feet across, but it is high. It is a natural mound with a flat top. A deep ditch has been dug around it and the earth used to form a bank or enclosure around the flat area at the top of the mound. There is an entrance in the east where a break in the bank opens onto a causeway across the ditch.

E Rathbeg

From Rathmore, continue towards Tulsk on the N5 and take the first right at Toberrory crossroads. Signed by the roadside on the left.

This is another dramatic rath, although smaller than Rathmore. 'Rathbeg' means the 'Little Fort'.

F Rath na dTarbh

From the crossroads continue past Rathbeg. After 0.4 miles, Rath na dTarbh is on the right.

'Rath na dTarbh' means the 'Fort of the Bulls'. This lovely enclosure is said to be the site where the two bulls from the *Táin Bó Cúailnge* finally confronted each other. Before the battle was won, Maebh had the brown bull of Ulster, Donn Cúailnge, taken to Connacht. There he met the white bull of Connacht, Finn Bennech, and the noise and the violence of their meeting stopped the battle. Night fell and the two bulls left Crúachain and ran right around the country. In the morning, Donn Cúailnge appeared with Finn Bennech on his massive horns. He shattered the white bull's body, dropping it as he went back towards his home, but the strain had destroyed him, and he fell down dead before reaching Ulster.

In Thomas Kinsella's translation of the *Táin*, there is a description of the origins of these two bulls. They were originally two pig keepers, one from Munster and the other from Connacht, who had entered into such rivalry that their pigs were suffering and both were dismissed. They spent the next two years as birds of prey together. Some of that time was at Crúachain. Those who heard

them complained that they had done nothing but squabble in all that time. After this they separated for two years, each living under water as water creatures. They then became locked in deadly battle, first as stags, then warriors, phantoms and dragons, dropping finally from the air as maggots, one into the drinking water of the cattle at Crúachain and the other into the water at Cúailnge. They were swallowed by a cow in each place and each cow gave birth to one of the bulls.

William Wilde, author of *Irish Popular Superstitions*, describes taking his children to a festival at Crúachain where cattle were bled and the blood mixed with oatmeal and scallions. This was then cooked and eaten outdoors. He describes the mound at Crúachain as being red with blood. This may have been a healthy early summer boost to the diet of people waiting for the first crops, as well as a purge for the cattle. It may also have its roots in ritual: perhaps an ancient kingship rite from Iron Age times when Crúachain was the inauguration site for the kings of Connacht?

This is a fine enclosure, about 280 feet across, with a slightly raised mound inside. There are a number of breaks in the bank. The outer ditch is only noticeable in places as it is mostly filled in. The edge of the enclosure touches the roadside in the east.

G Oweynagat

From the crossroads, go about 0.3 miles beyond Rath na dTarbh and take the narrow road on the left. At the end of the road, just past the last house, there is a small gate on the right. Oweynagat is to the left going under the road and sits in the bank of a circular earthwork which has been cut through by the road.

'Oweynagat' means 'Cave of the Cats'. It is mentioned in *The Book of Leinster* as being one of the 'Three Caves of Ireland'. The others are at Howth, outside Dublin, and at Dunmore, in Kilkenny. These are entrances to the Otherworld where humans can be abducted into the fairy realms, or where, particularly at the end of the Celtic year at Samhain, beings from the Otherworld come out of the cave and are visible to humans. Sometimes they may take the form of cats or other animals or birds. Like the caves at Kesh in Sligo, Oweynagat is associated with the Morrigan who is the goddess of war.

One of these 'beings' is the 'new year maiden' who emerges from Maebh's sidh through the mouth of the cave each Samhain.

She is Crochen Croderg, the daughter of the sun goddess and a powerful aspect of the annual cycle of the seasons as the earth responds to the movement of the sun throughout the year. She is

Entrance to the cave, Oweynagat

also the fairy woman in the disturbing story of Nera, Ailill's
servant, who went down into the cave at Samhain and married
a fairy woman. While there, he had a vision of the destruction
of Crúachain by the beings of the Otherworld. His fairy wife
explained that it was a vision of what would happen next Samhain.
Nera returned to the world and warned Ailill of what would
happen. So Ailill and his soldiers rode against the fairy world and
destroyed the sidh before Samhain.

The folk traditions of Samhain or Halloween involve dressing
up as a way of hiding from the spirits, and making a lot of noise to
frighten them. There is also a belief that if you are kind and
generous, you will not be hurt by these Otherworld beings.

Oweynagat is a natural fissure, about 120 feet deep into the
limestone. In the past, a new entrance was made facing south. The
passage of this entrance is roofed with lintels, two of which bear
oghams which date this alteration to the cave to the early Christian
period.

According to Samuel Ferguson, in an article for the Royal
Irish Academy in 1864, one of the stones reads: FRAICC MAQI
MEDFFI - '(Stone) of Fraech, son of Medb'. (see **Carnfree** below)
This stone was most probably standing somewhere nearby long
before it was incorporated into the cave. It may also have been
standing long before it was inscribed, and certainly the story of
Fraech is much older than ogham script. (see below)

Today you can slide down through the entrance. A few feet
later, a right angle bend to the left takes you into the cave proper.
It is this original part of the cave which may in the past have been
lit by the midsummer sun at sunrise.

H Daithí's Mound

*Go towards Tulsk from Toberrory crossroads and pass Rath
Croghan on the right. 0.5 miles further on, turn right. After 0.4
miles, there is a small unmarked stile from where you can cross the
fields to the mound.*

Dailhí's Mound is a partly artificial mound inside the remains of a rath or enclosure. In the centre of the small mound is a red sandstone pillar, known as 'Coirthe Dearg', the 'Red Pillar stone'. It is broad at the base and about 6 feet high. Nothing was found in the mound, but the enclosure had some charcoal underneath it which was dated to about 200 BC. This would make it an Iron Age site, though the stone may be a re-used Bronze Age pillar stone.

It is said to mark the grave of Daithí, the last pagan king of Ireland. Daithí was a nephew of Niall of the Nine Hostages. He died at the beginning of the 5th century, around 445 AD, when he was struck by lightning while on a raid with his soldiers at a place called 'Sliabh na hAlpa'. ('Alpa' may mean 'Alba' or 'Scotland')

Reilig na Rí

Further west across the fields from Daithí's mound. 0.5 miles south of Rath Croghan.

Its name means 'Graveyard of the Kings'. The 19th century Ordnance Survey workers thought that this was where the kings of Ireland had been buried, though excavations at the time did not find any human remains. But the tradition of burial at sacred and important places has been strong in Ireland for a long time and early Christian writers often included extravagant accounts of cemeteries with very little factual basis. *The Book of the Dun Cow*, which was written probably in the 9th or 10th century at Clonmacnois says:

> Fifty mounds I assert are in the Assembly-place of Cruachu
> Fifty keen truly honorable men are beneath each of
> these mounds.

> The three heathen cemeteries
> The cemetery of Tailtu for chosing
> The cemetery of ever-pure Cruachu,
> and the cemetery of the Bruig.

The 'ever-pure Cruachu' is of course the goddess Crochen Croderg, and the three cemeteries are the three mounds of Telltown, Crúachain and Brú na Bóinne.

According to George Petrie, who was working for the Ordnance Survey, there was a stone circular enclosure within which, "are small circular mounds, which, when examined, are found to cover rude sepulchral chambers, formed of stone, without cement of any kind, and containing unburnt bones".

CONNACHT **Roscommon**

This circular enclosure is nearly 350 feet in diameter. Its bank has become part of the later medieval field system. Inside this bank are the remains of an eroded ring-fort about 200 feet across. In 1872 Sir Samuel Ferguson uncovered part of a souterrain which had some animal bones inside.

Carnfree

From Tulsk take the N61 south towards Roscommon. About a mile out of the town, take a sharp right turn. Turn left after 0.2 miles and continue up the hill for 0.9 miles. Park by the roadside. These sites lie along the ridge running parallel to the road to your left.

J Chloch Fhada na gCarn

In the first field on the left.

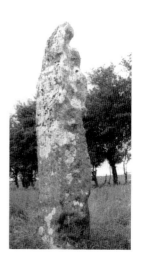

'Chloch Fhada na gCarn' means the 'long stone of Carn'. It is a tall pillar stone with a square base, about 1.5 feet across and about 12 feet tall. Weathering and striations give it a kind of totem-pole appearance. East of it, in the same field, is another fallen pillar stone, heavily eroded and broken in two.

Chloch Fhada na gCarn, Carnfree

K Dúmha Selga

About 0.2 miles further along the road, this mound is up on top of the ridge.

This site is mentioned in *The Annals of the Four Masters*, where it is called, 'the Mound of the Hunt'. It is a perfectly circular cone shape: a Bronze Age barrow about 70 feet across.

Cnoc na Dála is visible to the west. Carnfree is on the highest point of Carns Hill, south of Tulsk. Carnfree is 'Carn Fraoich' or 'the burial mound of Fraoic', whose name was on the ogham stone at Oweynagat.

L Cnoc na Dála or Carnfree Inauguration Mound

This stone cairn sits prominently on the hilltop with views right across the landscape.

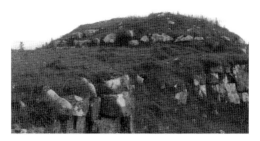

Cnoc na Dála or Carnfree inauguration mound

Cnoc na Dála means the 'Hill of the Assemblies' and Carnfree or Carn Fraích means the 'Cairn of Fraech'. Historically it is the inauguration site of the O'Connor kings. The last one was Charles O'Connor of Ballintuber who was inaugurated in 1641. This is the highest point on the ridge.

It is also reputed to be the burial site of Fraech from the *Táin Bó Fraich*.

Fraech's mother was Bébinn, a sister of Bóinne, (see **Brú na Bóinne**, MEATH) and Fraech was the most handsome young man in all of Ireland and Scotland. Maebh and Ailill's daughter, Finnabair, had fallen in love with him just from listening to the stories. Hearing this, and knowing of her beauty, Fraech came to Crúachain with his men and stayed at the royal palace where they were made very welcome.

Fraech went to meet Finnabair at the river and she gave him her thumb ring, a present from her father. She told him to speak to Ailill, which he did, but Ailill demanded a very high price for his daughter which included all of Fraech's wealth, even the magical red-eared cows which he had from his mother Bébinn. Fraech could not accept. Later, when he was swimming in the river, Ailill, afraid that they might elope together, stole Finnabair's ring from Fraech's belt and threw it into the water. Luckily, Fraech saw it just as it was swallowed by a salmon, and he caught the salmon and hid it in the river bank.

Ailill then asked him to pick some magical rowan berries that grew near a dragon's lair ('péist' in Irish meaning 'worm') in the hope that the dragon would eat him. However, Finnabair helped Fraech, and the dragon was killed, though Fraech was badly wounded. He was taken into the Otherworld through Oweynagat by fifty maidens dressed in red and green. Here he was revived and then taken back to Crúachain.

Ailill and Maebh held a feast for him. At the feast Ailill demanded to see the thumb ring, thinking this would expose the couple as neither of them would be able to produce it, but Fraech had retrieved the salmon and cooked it for the feast. When the ring was recovered, Finnabair and Fraech were betrothed and Fraech brought his herd of magical cows to Crúachain. He was later killed, fighting Cúchulainn in the *Táin Bó Cúailnge*. (*The Oxford Dictionary of Celtic Mythology*)

The mound is small, about 40 feet across and nearly 5 feet high. It is faced with coursed stone. The top is roughly grassed with a small raised area to one side. The Proclamation Stone, which had the impression of two feet on it, is no longer there.

The views from here are spectacular even though the hill is only about 400 feet high.

2 Tobar Barry

Take the N5 east from Strokestown to Longford. It is nearly 9 miles to Termonbarry where you turn left. Just over 3 miles later, it is signed on the right. Go past the cemetery and on down to the end of the lane.

According to local lore, there was a Great Serpent who lived on the nearby hill, Slieve Badhan. It held the local people in thrall until St Barry came. He challenged it and chased it towards Lough Lagan where it plunged in and disappeared forever.

Tobar Barry

Before it disappeared, the saint thrust at it with his staff, and at the spot where his knee hit the ground, a well sprung up. He blessed it.

This is a lovely clean clear well with a high wall surround. Inside is a small garden and a statue of St Barry. Some clooties or rags have been pushed between the stones in the wall.

3 St Brigid's Well

5 miles north east of Roscommon in the grounds of Holywell House. Take a small road, called The Walk, east out of Roscommon to the village of Ballyleague about 2.5 miles away. Turn left at the T junction, then right just over a mile later. Pull up at the first 2-storey house and ask if you can visit the well. It is across two fields in front of their house.

This land once belonged to the old Holywell estate. Holywell house itself has completely disappeared, although the land around it has retained that distinctive parkland feel. The Gunnings lived here, and in the 18th century the famous Gunning sisters are said to have owed their beautiful complexions to the water from the well.

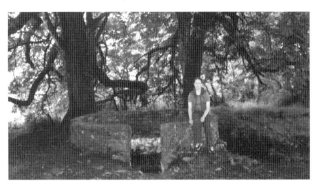

St Brigid's well

Amanda Gavigan, who helped me to find the well, had a slightly different version. According to local children, the Gunnings were two very ugly sisters. They were transformed into beautiful women by water from the well.

The well is clear and clean, not too deep and has a circular stone wall around it. It is in the shade of a circle of mature beech trees.

4 Rahara Sheela-na-Gig
The Rahara Sheela-na-Gig is in the County Museum in the old Presbyterian church, Roscommon.

It comes from the old graveyard at Rahara where it was found face down in the earth. Being protected from the elements, the carving is very clear. It is a strange figure: her body is beautifully proportioned with explicit genitals, pendulous breasts and a belly button, yet her face is like a grotesque mask. She has a massive nose with accentuated nostrils and no mouth and a strange plait across her forehead, hanging down either side of her head.

5 Fuerty Old Church
4 miles west south west of Roscommon. It is signed Fuerty.

This ancient site is reputed to have been founded by Patrick and passed to Justus, who baptised and tutored St Ciarán. It was closely associated with Clonmacnois.

There are two grave slabs built into the doorway of the old church. One has a fish motif on it. Carvings of fish are rare in the Celtic Church, although the symbolism of the fish was already very strong in pre-Christian times as the symbol of wisdom. The inscription on the stone translates: 'A prayer for the soul of Aidacán'. This may be Aeducán, a táinaiste-abbot of Clonmacnois who died in 865 AD.

The Castlestrange Stone

Take the R366 out of Roscommon through Fuerty.
The entrance to Castlestrange House is on the left, about
6 miles from Roscommon.

Castlestrange House is at the top of the hill, a huge derelict mansion. The grounds around it are used as pasture for cattle. The stone is halfway up the driveway.

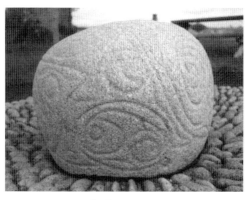

Castlestrange stone

This is a lovely asymmetrical egg-shaped granite stone, about 2 feet high. Like the Turoe stone, it is decorated with curvilinear ornamentation of the La Tène period, full of powerful symbols of the time. It is one of three stones in Ireland, the others being the Turoe stone in Galway, and the Killycluggin stone in Cavan County Museum, in Ballyjamesduff.

6 St Patrick's Holy Well, Oran

About 7.5 miles from Roscommon on the N60 to Castlebar, this well
is on the left just before Oran graveyard and ruined round tower.

Oran, in Irish 'Uarán', means 'a spring' or 'a fountain' and the spring here is visited on Garland Sunday. This is the time of Lughnasa, implying that this was a sacred place and the site of a

Lughnasa Assembly before the well was dedicated to St Patrick. In Christian times, it is said that St Patrick rested at the bush here and blessed the spring. The mark of his knee can be seen on a stone. The pilgrimage today can be made on Garland Sunday or on three successive Sundays.

The pilgrimage or turas begins at St Patrick's bush where seven pebbles are lifted. The well is circled seven times, and each time the pilgrim passes the bush, a stone is dropped. The pilgrim finishes by kneeling in St Patrick's knee print. Some water can be taken home, as well as a piece of the fern which grows beside the well, as this brings a blessing into the house. Pilgrims tie a ribbon to the bush as they leave.

The well is inside a square of stone walling with the water pouring through one side and through some stone chambers. It is clean and clear. A huge statue of St Patrick towers above the water.

The tower stump and remains of a small church on the opposite side of the road were once part of an early monastery that included the well.

7 Drumanone Dolmen

Take the R294 west out of Boyle to Tobercurry and fork left at the sign for Gorteen. Just over a mile later the road goes under the railway bridge. Park on the right by the lane and walk up it and across the railway line. The dolmen is in the field on the left.

This is an impressive dolmen, although it is not at all well known. It is in a prominent position on raised ground with some evidence of a mound or cairn to the south west. The portals are nearly 8 feet tall and face north east. There is a sill between them and the cap-stone rests on this and one portal. The side stones are quite small and converge towards the back. There is no endstone.

Excavations revealed an amount of charcoal with burnt and unburnt bone fragments and a small polished stone axe-head. Unusually, the sill's depth below the soil was found to be the same as the portals, making it immoveable.

There is a local story that in the 18th century a miller removed one of the uprights, causing the present slope of the cap-stone. It is not clear how he suffered as a result.

8 St Attracta's Well

Continue on the R294 and take a left turn to Monasteraden. Through the village on the road to Ballaghdereen, the well is on the right by the roadside.

CONNACHT **Roscommon**

St Attracta was a contemporary of St Patrick. The daughter of an Ulster chieftain, she rejected the suitor her father had chosen for her. Instead, she left her father's house in secret and came to Boyle in search of Patrick. He told her to dedicate her life to hospitality and charity towards all. After some time as a nun, and eventually abbess of Killaraght near Boyle, she built a hostel at Boyle dedicated to Hospitality and Charity at the point where seven roads meet.

Patrick came to visit her new hostel to say mass and bless it. However, during the ceremony, Attracta realized there was no paten. She knelt in prayer and a gold disc materialized, descending above her. Patrick took it and found it marked with the sign of the cross. Some say this is how the Celtic Cross came about.

St Attracta's well

There is no trace of St Attracta's hostel, but the much later Cistercian foundation still stands where the main roads cross, on the edge of the town of Boyle.

She is remembered in the small village of Monasteraden with a well dedicated to her, just southwest of the village. Her well has a natural bullaun, also called 'the serpent's egg', to hold the water. The rest of the water flows in a channel to the side into a covered area. It is backed by a wall with a crucifix carved in a primitive style.

Above this, on the top of the wall, are more 'serpent's eggs', hinting at a much older usage of this well. The eggs have been cemented in a row along the top of the wall. They are associated with fertility, the custom being to handle them or take one into one's house to encourage pregnancy.

9 Boyle Abbey

This Cistercian Abbey was founded in 1161 as a daughter house of

Mellifont, though it was not consecrated until 1218, work on the building having been interrupted by the Norman invasion. It was, in fact, burned in 1202. Its style is mainly Romanesque with some transition to Gothic as in the north arcade.

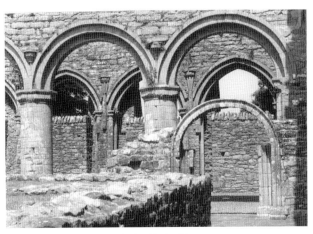

Arches, Boyle abbey

It is a massive and imposing place, yet surprisingly gentle. Its huge pillars are like ancient trees and the whole place seems dedicated to the power and beauty of nature. Its carved capitals are the work of a master craftsman whose subjects include mythical beasts, foliage and fruits and biblical scenes. He is known as the Ballintubber carver, possibly part of a 12th century school of carvers. The same quality and style of carving can be seen at Ballintubber, Castlebar, Ballinrobe and Cong. It is thought, however, that Boyle was completed first.

The Cistercians sought architectural simplicity, but their abbeys were the largest and most complex buildings in Ireland to date. They exude a great sense of strength, perhaps reflecting their occupants' sense of place in their physical and spiritual world.

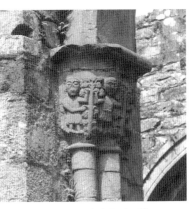

Carving on capital, Boyle abbey

It numbered all the wealthiest families in the west among its patrons and they were all represented among its abbots and monks. After the Dissolution

CONNACHT **Roscommon**

in the 17th and 18th centuries, it was used as a military garrison.
Duchas site - Admission charged. Open April to October.

10 St Lassair's Well

From Boyle take the N4 towards Carrick-on-Shannon, turning left
for Keadue. At the T junction turn left towards Lough Meelagh.
The well is across the road from the tiny abbey ruins of Kilronan.

The water from Lassair's well runs through a tiny garden and into
Lough Meelagh. On the right there is a grove of trees and a hollow
stone. The stone, which is called 'the Cleansing Stone', is used for
washing feet.

There was a sacred tree or 'bile' here, an ash tree famous for
its healing power and studded with coins, rosaries and pins. Sadly
it has died and all that remains is a stump. A stone table supports
a large round egg stone which is believed to promote fertility.
A long-standing cure for back problems involves crawling under
the table.

St Lassair was the daughter of St Ronan and St Ailbhe, two
other local saints. The hollow basin stone here is also called
St Ronan's font. This was a sacred site before Christianity. It is

St Lassair's well

remembered in folklore as a Lughnasa site, where people came to
celebrate the beginning of harvest at the beginning of August. The
presence of serpents' egg stones as fertility aids may even go back
to neolithic times.

CONNACHT **Roscommon**

Altar and egg stone, St Lassair's well

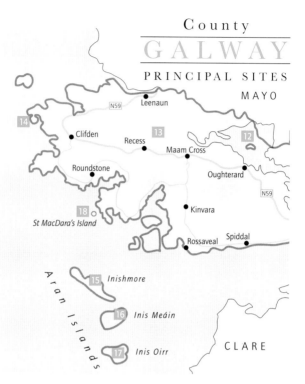

County
GALWAY
PRINCIPAL SITES

1 **Knockmaa**

2 **Tuam** St Mary's Cathedral and high crosses

3 **Knockmoy Abbey** (Chnoc Muaidhe)

4 **Clontuskert** Augustinian priory

5 **Clonfert Cathedral**

6 **Turoe Stone**

7 **St Brendan's** Roman Catholic Cathedral, Loughrea

8 **Kilmacduagh** Cathedral and round tower

9 **Annaghdown** churches and priory

10 **Ross Errilly Friary**

11 **Moyne** graveyard

12 **Inchagoill** monastic site

13 **Mám Ean**

14 *Omey Island*

THE ARAN ISLANDS

15 *Inishmore*

16 *Inis Meáin*

17 *Inis Oirr*

18 *St MacDara's Island*

Block figures in list refer to site locations in map and entries in text.

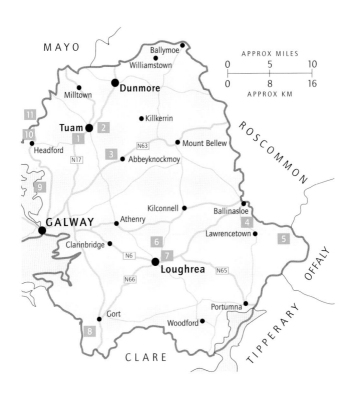

GALWAY

TRAVELLING THROUGH GALWAY THIS SUMMER, I saw a sign to Coole Park, once the home of Lady Gregory and immortalised in the poetry of W B Yeats. Lady Gregory was an Anglo-Irish playwright and founding member, with Douglas Hyde, of the Gaelic League in 1899.

Her vision and energy inspired the founding of the Abbey Theatre in Dublin and encouraged a new generation of Irish literature. Yeats was a frequent visitor, and thought Coole Park the most beautiful place on earth.

In the walled garden there is a famous autograph tree where he and others of his time carved their names: George Bernard Shaw was there, Sean O'Casey, and Augustus John. I had often seen photographs of the carvings on its trunk and I wanted to see it.

What I found took me completely by surprise. This is a mature copper beech with broad boughs spreading a canopy of delicate copper leaves almost to the ground. I walked underneath this canopy into the dappled sunshine and an atmosphere so clear and

CONNACHT **Galway**

Autograph tree, Coole Park

sweet, it almost took my breath away. I felt I was in the presence of
an angel.

Coole Park is in the fertile east of the county, an area bounded
by lakes and rivers, with the ruins of great medieval monasteries and
towns with names synonymous with battles, such as Athenry and
Aughrim. In the west, beyond Lough Corrib, the landscape fragments
into a lacework of rock and water, forming a network of tiny lakes
in the landscape and a mass of small islands beyond its shore.

Galway City was a medieval port. The tradition holds that
Christopher Columbus prayed here, in the Church of St Nicholas
of Myra, before setting sail across the Atlantic. In the 16th century,
six hundred Spanish trading ships could be at anchor at the same
time in the bay.

Galway is also home to Brendan the Navigator whose foundation
at Clonfert has the most elaborately carved Romanesque doorway
in Ireland.

1 Knockmaa

*5 miles west of Tuam on the R333 to Headford. Turn left up a
long drive past the old tower house and park by the old school.*

Knockmaa possibly means 'Maebh's hill'. This is Maebh, Queen of
Connacht and old world goddess of the Tuatha Dé Danann. Most
of the great hilltop cairns in Ireland are linked in mythology to
goddesses, sometimes known as queens in the early mythology.

According to local tradition, the Princess Cesair was also
buried on Knockmaa with one of the great cairns marking the
place. She is the earliest inhabitant of Ireland, according to the

CONNACHT **Galway**

mythological history, the *Leabhar Gabhála Éireann* or *Book of Invasions*.

It was written in the 12th century and tells the story of the ancient inhabitants of Ireland. The first group to arrive, according to this source, was brought here by Cesair. She was the daughter of Bith, Noah's son, and was warned by Noah of the impending flood. She set sail with her father, fifty maidens, and two other men, Ladra, the ship's pilot, and Fionntán. They travelled with two other ships which foundered on the way, so Cesair and her companions came ashore without them at Corca Dhuibhne, which is the Dingle Peninsula.

As the story goes, the men divided responsibility for the 50 women between them, but unfortunately Ladra and Bith died, leaving only Fionntán. Awed by such huge responsibility, he fled.

Cesair died of a broken heart and her maidens did not long survive her. And so the first people to come to Ireland died out except for the magical bard, Fionntán, who lived on for 5500 years as a salmon, an eagle, and a hawk, and witnessed the events of history so he could pass them on.

You can follow the circular path clockwise up through the woods, leaving it at its highest point to climb the last stretch through the ancient beeches. This brings you to a gap in an old boundary wall which leads, on a summer's day, out of the dark woods onto bright, warm limestone pavement and the strangest dry-stone construction you ever saw - Finvarra's castle. This is actually a Victorian folly - a massive neolithic cairn of bleached limestone rebuilt into a fairy castle. A square tower-like structure is surrounded by two concentric walls, the whole softened into an organic state of collapse. Tiny steps in the wall of the castle seem made for fairy feet.

In folklore, Finvarra is King of the Connacht fairies, and it is said that they fought here against the Ulster fairies over whether Ulster or Connacht should be blessed with good crops. This

Knockmaa cairn

folklore echoes the older mythology whereby the goddess of the sacred hill has the power to grant or withhold fertility.

There are the remains of four cairns across this ridge, running roughly east west, and they are more or less accessible. The most easterly is the largest - about 70 feet in diameter and 15 feet high.

CONNACHT Galway

However, distances are deceptive and so are the pathways. The tiny alpine flowers are seductive, but the wind-burnt fairy thorns cut deep when you try to cross them.

Cairns are also to be found on the summits of the adjoining hills: Knocknacarrigeen (Hill of the Little Rocks) to the east, and Cave to the west. To the north, in Carrowbeg North on sloping grassland, there are two Bronze Age barrows, excavated in the 1930s. Cremated bone and a flint knife were found in one and, in the other, cremated bone and a small bronze knife. This barrow also had secondary skeletal burials in the rock-cut fosse which surrounded the barrow.

2 Tuam - St Mary's Cathedral and High Crosses
On the Galway road, Tuam. Open daily in summer.

The O'Connors were the Gaelic rulers of medieval Connacht. They made Tuam their seat in 1049 and ruled from here for almost 200 years. Turlough O'Connor was High King of Ireland from 1111 to 1156. This was the time of the great 12th century reforms in Ireland, when the centralised diocesan system was introduced. Tuam became a diocesan see and the new cathedral was built here. The chancel arch and chancel with east window are all that remain of the original Romanesque building. Its nave was destroyed by fire in 1767.

It is probably the most beautiful arch of its kind in the country; it is certainly the widest. The proportions are exquisite, 22.5 feet across and 16 feet high, and it stands arched in perfect balance without a keystone. The warm red sandstone is richly carved with six orders or columns on either side with Celtic interlacing in bold relief, showing the strong Scandinavian or Urnes influence which is so typical of the 12th century. The capitals are also carved with interlaced designs and stylized human heads.

In the 14th century a new church was built in the east. It is now behind the chancel, visible through the east window, and used as the Synod Hall. The rest of the cathedral to the west is 19th century Gothic Revival. It stands in the centre of the present Church of Ireland cathedral.

There is a tall cross here in the cathedral made up of slabs from at least two separate crosses. It is called the market cross and was once in the centre of the town, equidistant between the two cathedrals, so that neither would feel more or less favoured. It was erected in 1874 after George Petrie found the base in the car-park. Since then, it has been restored by Duchas and re-erected here in St Mary's. There is more interlacing with zoomorphic figures in

the Urnes style on this cross shaft. Figures can also be seen at the ends of the arms and on the base. A 12th century cross shaft is on display here.

Both crosses are sandstone and both say: "Pray for Turlough O'Conor". The shaft also asks us to pray for the craftsman, Giolla-Críost O'Toole, and for the successor of Jarlath, Áedh O'Hession. Jarlath was the early Christian saint who dedicated the first Christian foundation in Tuam.

The base of the Market Cross adds: "Pray for O Hession by whom it was made on its east face and on its west face, a prayer for Áedh O Hession, for the abbot..."

Excavations in 1986 in the graveyard here uncovered the burial of a male, approximately 45 years old, wearing on his hip the scallop shell of a pilgrim to Santiago de Compostella in north west Spain. Fragments of another shell were found with a second burial.

Santiago de Compostella was a major pilgrimage site for Western European Christians in the Middle Ages (11th to 16th century), being by tradition the burial place of St James the Apostle. Many Irish pilgrims travelled to Bordeaux on the ships involved in the wine trade, and from there joined the European pilgrims trekking on foot through the Pyrenees. *The Annals of Ulster* and *The Annals of Loch Cé* both mention such pilgrims.

While this burial is the only first hand evidence of them in this country, some 300 such shell burials have been recorded in Europe.

3 **Knockmoy Abbey** (Chnoc Muaidhe)
South east of Tuam - on the N63 between Galway and Mountbellew.

This abbey was founded by the Cistercians from Boyle Abbey in Roscommon and dedicated to the Blessed Virgin Mary in 1189/90 by the then King of Connacht, Cathal Crovdearg O'Connor. It subsequently had a very chequered history.

It was sacked in 1200 and in 1228. Then, in 1240, the abbot was censured for having had his hair washed by a woman. At the time of the Dissolution in 1542, the abbot, Hugh O'Kelly, surrendered the abbey to Henry VIII. In a clever political move, he then renounced the Pope, so that he was technically no longer an abbot. He was then given the abbey and its lands for life, in exchange for supplying soldiers and horses for the English Crown in Connacht.

There are medieval line paintings or frescoes on the north wall

CONNACHT **Galway**

of the chancel. They show the Archangel Michael with the scales which he used to weigh the souls of the dead, to see if they were light enough for heaven. Beside him is the figure of Christ with his hand raised in a blessing. Next, there are archers pointing their bows at St Sebastion who is being martyred for his faith.

Above this are three dead kings with the inscription: "We have been as you are, you shall be as we are". The message is directed at another three kings who are out hawking, enjoying being alive.

The chancel itself is rib-vaulted and has beautifully carved stonework on its capitals and on the east window. The scale is huge and the ornamentation expressive of later, more decorative Cistercian architecture.

There are more frescoes in the small Cistercian abbey, founded in the 13th century as a cell of Knockmoy, on Clare Island, off the coast of Mayo. Restoration of the paintings is under way at both sites. The chancel is closed while restoration work is carried out.

4 Clontuskert Augustinian Priory
5 miles south of Ballinasloe on the R357.

The Augustinians built a priory here in the 13th century on the site of an earlier monastery. It prospered and became very wealthy by the end of the century, but gradually succumbed to corruption, and in 1443 the Pope took it under his protection.

It had been destroyed by fire in 1413 and 10 year indulgences were being granted to all who contributed to its repair. This resulted in a number of building projects, including a wonderful Perpendicular west doorway in 1471, carved with figures of the saints in the style of the north doorway of the cathedral at Clonmacnois, in Offaly. The saints here are the Archangel Michael with scales for weighing souls, John the Baptist, Catherine of Alexandria, and St Augustine standing on a serpent.

Either side of the doorway are some wonderful carvings,

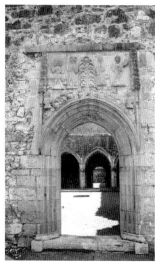

Perpendicular west doorway, Clontuskert Priory

a kind of stone sampler with isolated images of different proportions, similar to the carvings on the stone screen in the south transept of **Kilcooly Abbey**, in TIPPERARY.

At the right side of the doorway are: a mermaid holding a mirror inside an eight pointed star, two stags with entwined heads, a fabulous bird with a long tail, a dog biting its tail. On the other side are: a triple rose with fifteen, then ten, then one central petal; two horses facing each other, a pelican pecking its breast to give blood to its young. Other 15th century additions include the stone rood screen with its mason's mark - JOHES, the cloister arcade and the lovely east window.

It is an impressive ruin, across fields in the green valley of the river Suck. East of the ruins is a circular earthwork in the field.

5 Clonfert Cathedral

13 miles south east of Ballinasloe. Take the N6, Galway road, south east of Ballinasloe and fork left onto the R355 to Portumna. It is signed to the left, just before the village of Laurencetown.

The early church here was founded by St Brendan the Navigator in 563. His fame throughout Ireland, Britain and Europe, comes from the 8th century story, The Navigation of St Brendan. It tells of his seven year voyage across the Atlantic with thirty companions in a small hide boat, searching for a land revealed to him by angels in a dream. (see **Brandon** mountain, KERRY)

Their allegorical journey took them to the Paradise of Birds, which was an island inhabited by fallen angels. They also met a massive whale which they took to be an island. The whale allowed them to celebrate Easter on his back. Finally they reached the land promised by the angels, where they filled their boat with jewels and fruit before returning home.

In 1976 an American professor, Tim Severin, crossed the Atlantic in a small hide boat, and found islands along the way which might have been the fabulous places described by St Brendan. If his findings were accurate, then St Brendan reached America nearly a thousand years before Christopher Columbus. Perhaps St Brendan's voyage was the inspiration for Columbus' trip and even for some of the others on board his 15th century crossing of the Atlantic, for he is believed to have called here in the 15th century on his way to America. Apparently, Spanish records show that it was a gentleman farmer from Clonfert parish who was the first man ashore from Columbus' ship, when it landed in America.

Although St Brendan died at Annaghdown, (see below)

his remains were brought back to Clonfert. The elaborate Romanesque doorway of this tiny cathedral is a 12th century attempt to provide a magical portal to his tomb. Ornamentation of doorways was especially significant at this time, reflecting perhaps an understanding of the esoteric importance of the entrance to a sacred place.

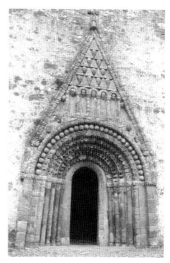

Doorway, Clonfert Cathedral

The 12th century doorway was inserted into a much older gable with antae and inclining door jambs. The innermost order, which is limestone, was added in the 15th century, to 'correct' this incline. It is carved with floral ornament and the figures of two ecclesiastics.

The outer six orders or archways are magnificent, with each set of pillars carved with different patterns: finely incised chevron, fleur-de-lis, angular and curvilinear designs. Their capitals display scroll patterns, animal interlacing in the Scandinavian Urnes style, and animal heads and masks which look

Happy Mermaid on the Chancel Arch of Clonfert Cathedral

like oriental dragons. The arches are carved with bosses, palmettes and geometric patterns in high relief, made especially dramatic by the shadows cast by strong sunlight.

Above the arch a moulded gable reaches heavenwards, as if elevating the consciousness of anyone who walks beneath it. Ten stylized heads are set in the apex of this gable, each different and some with forked or plaited beards, common to Romanesque carving. Below them, beneath five arches of a blind arcade, are five more heads. These seem to be contemporary faces, each a careful portrait of a living individual.

CONNACHT Galway

Inside the church there is a wonderfully voluptuous mermaid, as well as a dragon and some angels carved on the chancel arch. The body of the mermaid is worn smooth by human hands.

6 Turoe Stone

630223
Take the R350 about 3 miles north of Loughrea to the village of Bullaun. It is well signed from there.

The stone was originally taken from Feerwore Rath at Kiltullagh, a few miles from its present location, in the grounds of Turoe House. Three small standing stones on the north side of the rath, now levelled, are thought to mark the place where it came from. Feerwore Rath was dated to the end of the prehistoric period and the stone is thought to date from the same time - anytime between 300 BC and the 1st century AD. Finds from the site included glass beads, worked flint, bronze pins and also some iron objects.

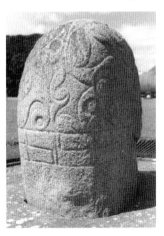
Turoe Stone

It is a domed granite boulder nearly 4 feet high. Most of the stone is decorated by pocking or removing stone, so that an intricate and graceful curvilinear pattern of spirals, circles, trumpets and triskeles are set out in relief across the domed surface. The pattern is linked to the La Tène period. The triskele is a triple image, an emblem of fertility and also possibly a solar symbol. Below this there is a Greek step pattern in a band around the lower area. The base is plain.

Little is known about its function though a less well known stone of similar proportions and similarly patterned was found at Killycluggin in Cavan. It was said to represent the dark underworld god Crom Cruach and apparently stood, decorated with finely beaten gold, just outside a stone circle in Killycluggan until it was destroyed by St Patrick who took a sledge hammer to it to break the power of Crom Cruach. The Turoe stone can certainly be classed as a ritual stone in the manner of inauguration or initiation stones which are capable of transferring power in ceremony.

Another fine example is at Castlestrange just across the border in Roscommon. Other examples can be found in Brittany and in

the Rhine, though the Turoe stone is said to be the finest in Europe.

There are similarities with the phallus stones found at one time in West Britain. (Apparently one still exists at **Clackmannan**, east of Stirling.) There are even parallels with the more modern market crosses found in Britain, and described by Derek Bryce as tall pillars with ornamental spheres on top. These are partly phallus or world symbol of fertility, partly symbol of the heavens or the sun.

7 St Brendan's Roman Catholic Cathedral, Loughrea
On the N6 about halfway between Ballinasloe and Galway.

Loughrea is the cathedral town of the Roman Catholic Diocese of Clonfert. Its cathedral, dedicated to St Brendan, is a celebration of Irish sacred art of the first half of the 20th century. Even if you have never looked at a stained glass window before, this is not to be missed.

The Queen of Heaven, window by Michael Healy, St Brendan's Cathedral, Loughrea

St Brigid, window by Evie Hone, St Brendan's Cathedral, Loughrea

The first time I came to Loughrea, the cathedral was crammed with people attending the funeral of a much loved teaching nun. I sat in a deserted cafe and waited. After everyone had left, I went inside. The huge throng of people and their prayers had left a palpable presence in the cathedral and it felt wonderful. It still smelled of incense and the evening sunshine poured through the

most beautiful collection of stained glass I have ever seen.

The development of the art of stained glass in this country began when Edward Martyn of Tullira Castle, near Ardahan, commissioned some windows in the early 1900s, insisting that the work be done in Ireland and not in England as had been the custom. These commissions took AE Child from London to Dublin, where he became teacher of stained glass in the Dublin Metropolitan School of Art.

Near Tullira Castle and just south of Ardrahan on the N18, the modern **Laban Church** has a number of these early windows, commissioned by Edward Martyn and created by A E Child.

Martyn's commissions also helped the founding of the Túr Gloine (Glass Tower) Studio by Sarah Purser, where many of the other artists represented here in St Brendan's, worked together.

The artists represented here in St Brendan's include: AE Child, Sarah Purser, Hubert McGoldrick, Michael Healy, Evie Hone and Patrick Pye. Though less well known, this very particular sacred art form had a revival and a flowering in the first half of the 20th century, like the illuminated manuscripts of the early monasteries or the 12th century high crosses.

Michael Healy has three triple light windows on the south side of the cathedral. The Queen of Heaven, Christ Ascending and Christ in Judgement, are all powerful subjects. He breaks down colour into tiny liquid drops which seem the perfect medium to illustrate angelic beings. The face of each mortal is sensitively painted so that every single one has character and individuality.

In contrast, Evie Hone's St Brigid, made in 1942, seems dark and earthy.

AE Child, Michael Healy and Sarah Purser produced three windows in 1904, representing the Baptism of Christ, St Simeon and St Ita respectively. They are all different, yet all delicate and full of light.

8 Kilmacduagh Cathedral and Round Tower
About 3 miles south west of Gort on the R460 to Corrofin. Signed.

'Kilmacduagh' means 'the church of the son of the black man'. Colmán Mac Duagh is renowned as the most saintly of Irish saints. The King of Connacht is said to have tried to kill Colmán's mother, his kinswoman, because he was jealous of the prophesies surrounding the unborn Colmán. He sent two men who tied a huge stone about her neck and cast her into the river Kiltart. However, the stone floated and towed her to the river bank and safety. The young Colmán was born in secret and brought up in

CONNACHT Galway

the Keelhilla Hermitage, where his saintly qualities endeared him to everyone.

The stone which saved Colmán's mother can be seen today, with the rope marks still on it. It forms part of the inside windowsill of the old church at **Kiltartan**, beside the Kiltart river. (just off the N18 north of **Gort**)

When the old king died, his successor Gúaire Aidhne, discovered Colmán, his kinsman, in the hermitage. Some say he was so impressed by his goodness that he offered him a site for a monastery. Some say it was also to atone for his father's brutal actions. However, there is another story.

It was coming to the end of Lent and Colmán and his fellow monks in the hermitage were running out of food and becoming weak with hunger. The monks were worried about how they were going to find food for Easter. But Colmán assured them that God would provide if they only had faith. That Easter Sunday, just as King Gúaire and his household were sitting down to their Easter feast, the dishes rose up from the table and flew, with the food still on them, out of the window. Astonished, Gúaire and his men chased after them on horseback, but soon they found their horses stuck to the ground and themselves to the horses' backs. When they finally were freed, they rode on to the hermitage and were just in time to see Colmán and his monks wiping the plates clean and praising God for providing so amply for their needs. Gúaire was so impressed, he offered his kinsman land for his monastery.

Whichever way it happened, Colmán accepted the king's offer, but decided to leave the choice of place to God. When his girdle fell to the ground one day as he travelled through a great wood, he took it as a sign that this was the place chosen by God. He founded his monastery there around 632 AD.

It was a wise choice, between two lakes and beside a natural causeway used by travellers coming up from the coast. It became one of Connacht's greatest monasteries.

Its location also made it vulnerable to Viking raids, particularly frequent in the 10th century. In 920 AD the then lord of the territory, Maol mac Duach, was killed by Vikings. Brian Boru contributed to the restoration of the monastery after one such raid.

In the 12th century, Kilmacduagh was made a Diocesan See, as part of the restructuring of the Irish church and a cathedral was built here.

The Cathedral and O'Shaughnessy Chapel are the first buildings on the left as you approach from Gort. The cathedral nave is mainly 13th century but includes part of a much earlier church wall with a trabeate doorway in the west gable. You can see

some of the massive stone blocks at ground level here, typical of the earliest stone churches. This doorway would have been replaced in the 15th century by the fine new one in the south wall.

The rest of the cathedral: transepts, west window and new chancel, were probably added at the same time in the 15th century.

There is a simple crucifixion scene carved above the O'Shaughnessy tomb in the family chapel. They were patrons of the cathedral and therefore allowed a tomb within its walls.

Also in the cathedral north transept are two carved slabs, originally part of an earlier reredos (wall or screen behind the altar). The one on the right shows St Colmán as Bishop with an inscription which translates: "St Colmán, Patron of the entire Diocese of Kilmacduagh". This is most likely 13th century and carved for the new cathedral.

The slab on the left is a crucifixion scene with strange naive peg-shaped figures representing Our Lady and St John either side of the cross. Its inscription translates: "Our Lord. Holy Mary. INRI. Have mercy on us Lord. Have mercy on us. Let Thy mercy O Lord be upon us".

Beside the cathedral is the **Round Tower**, most likely 11th or 12th century. It is famous firstly for its tilt. It leans 2 feet off the perpendicular, but it is also, at 112 feet, the highest in Ireland.

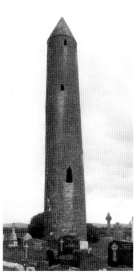

The legendary Goban Saor is credited with being the architect of Ireland's round towers, if only because no one can really understand how so many of them have remained standing for close on a thousand years. They have very shallow foundations, with only the downward thrust of their slightly tapering walls to give them stability. This makes the Kilmacduagh tower particularly miraculous, though some restoration work was carried

Round Tower, Kilmacduagh

out in the 19th century, when a crack was discovered running almost right to the top. The bell from the tower is said to lie at the bottom of a nearby lake.

North of the cathedral lies **Teampall Eoin Baiste,** or the Church of John the Baptist. Like the cathedral, its walls contain some early stonework.

CONNACHT Galway

Beyond this are the imposing ruins of the fortified **Glebe House**, once the bishop's residence, as well as a seminary for educating priests. It has an upstairs oriel, a projecting corner balcony with a window from which the bishop blessed the pilgrims on the 29th October, St Colmán's Day. This is also, of course, Samhain, which makes it likely that this is an ancient sacred site.

Across the field lies **O'Heynes Abbey**, built by the O'Heynes for the Augustinian Canons in the early 13th century. They remained here until 1584.

This was most probably the site of the original monastery of St Colmán. The chancel arch is gone, but the pillars have beautifully carved capitals. These pillars and the two delicate lancet east windows with their rounded Romanesque arches are reminiscent of Kilfenora and Corcomroe. The quoins, or dressed corner stones, are elegantly tapered and have carved bases, also in the Romanesque style. Some fragments of the domestic buildings can still be seen through the cloisters.

Nearby is 'Leaba Mic Duagh' or 'Colmán's bed', supposed site of his tomb. People with bad backs come to lie on this stone to get relief.

Colmán's girdle remained in the care of the O'Shaughnessys and the O'Heynes who used it as, among other things, a talisman in battle. The Battle of the Boyne in 1690 was the last time it was seen on Irish soil.

A part of St Colmán's crosier is in the National Museum in Dublin.

9 Annaghdown Churches and Priory

12 miles north of Galway City on the road to Headford. Signed on the left.

In the 16th century St Brendan founded a convent here, on the shore of Lough Corrib, for his sister, St Brigga or Brigid. Local tradition says that she nursed him here when he was dying.

At the south end of the graveyard is a 15th century cathedral with a 12th century window and doorway. Other 12th century fragments inside have come either from the priory or from an earlier church on the site.

North of the cathedral are the featureless ruins of an earlier church, dated to the 11th or 12th century. Any earlier buildings would have been made of wood. Just west of the graveyard, on the way to the pier, are the remains of a 12th century priory built for the Arroasian nuns. This is a lovely old ruin built with large blocks

of dressed stone softened with age. There is a delicate Romanesque north window in the chancel and some Romanesque carvings, part of a chancel arch, in the south west corner, near the road. This is probably where the cathedral got its 12th century doorway and window.

10 **Ross Errilly Friary** - Ros Oirialaigh
Signed from the crossroads in Headford on the N84 north of Galway and east of Lough Corrib.

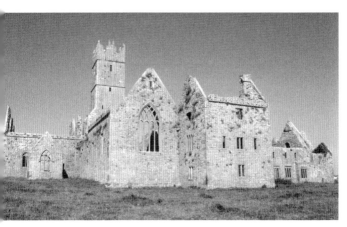

Ross Errilly Friary

Founded around 1351 by Sir Raymond de Burgo for the Franciscans, this became one of their largest foundations in Ireland. It is one of the most westerly of Galway's medieval monastic foundations. It was greatly enlarged in 1498 and most of the extant buildings date from the late 15th century. There is a nave and chancel church with a double south transept and two cloisters to the north. The domestic buildings include a kitchen with a stone fish tank and huge oven.

The friary was taken by the Cromwellians in 1656, but returned eight years later and, despite the fact that the monks were expelled a total of seven times, it has remained the best preserved Franciscan friary in the country. It was finally abandoned in 1753.

It is a lovely warren of a place, substantial yet modest in its proportions. The church windows are tall and slender, while those of the living quarters are modest but still pleasing to the eye. Situated by the Black river, it looks out across the plains of east Galway.

There are two earth banks running south either side of the entrance and some signs of an outer curved bank to the west.

CONNACHT Galway

Franciscans

Unlike the Cistercians, the Franciscans mixed freely and worked with the local community. In Europe they would have lived and worked in the towns among the people, but in Ireland, where there were few towns, they found themselves adapting to more rural locations. Many came from the local community and were Irish speaking. They were often felt to be more in touch with the ethos and spiritual needs of rural Ireland, than some of the other continental orders. Their grey habits and even their buildings reflected a kind of modesty in the world and before God.

After the initial boom in continental religious establishments in Ireland in the 12th and 13th centuries, no new abbeys were founded in Ireland after 1349. Yet over the next 200 years there were over 80 friaries of mendicant orders built, and 36 of these were Franciscan. (Of the others, 29 were Dominican and 16 Augustinian)

Friars or mendicants live on alms or donations freely given. They own nothing, unlike the often wealthy abbeys.

11 Moyne Graveyard

*(This is in MAYO, though included here as it is near **Ross Errilly**.)*
It is 2 miles south of Glencorrib on the Headford road.
The site is signed down a lane on the left.

A small, fairly featureless rectangular church sits in the middle of a huge circular enclosure, now a graveyard. North west of the church building are two standing stones, between which there is a tradition of placing coffins before burial. This tradition also exists at Slane in Meath and provides a possible link between today's rituals and ancient practices at the prehistoric megaliths.

Standing stones, Moyne Graveyard

12 Inchagoill Monastic Site

*This is one of the larger of the islands of Lough Corrib and,
though uninhabited, is accessed by a regular ferry service from
Lislaughera Quay , south west of the village of Cong.*

'Inchagoill' means 'the island of the foreigners', though little else is
known of the island's history. It is well stocked with re-introduced
native species, and is now a haven for wildlife. A path leads
through lush woods to a secluded monastic site.

The older church is a plain
rectangular building with an added
chancel. The doorway is lintelled.
The graveyard round the church
was in use until the 1920s. It was a
fairly common practice in Ireland to
continue using island graveyards
after the island had been abandoned
for the mainland.

*Luguaedon stone, Inchagoill
monastic site*

Near the church door is a pillar
inscribed: LIE LUGUAEDON
MACCI MENUEH which translates
as 'The stone of Luguaedon, son
of Menueh'. This is the oldest
surviving Irish inscription using
Latin characters rather than ogham.
Local people say that it is shaped like
a rudder because Luguaedon was
a sailor. However, it is probably a
pre-Christian standing stone with
a piece broken off. Perhaps this
already ancient stone was then inscribed? There are a number of
small equal armed crosses carved on it. The stone is Silurian
sandstone and very hard.

An old track leads from this ruin to a later Romanesque nave
and chancel church with a fine rounded chancel arch and tiny
rounded east window. However, it is the west doorway with its arch
of oriental looking carved heads, and its beautifully carved capitals,
that give the building its incongruously exotic appearance in
the middle of the forest. The soft sandstone is heavily pitted, but
somehow this does not make it any less exquisite.

Inside the church is an elaborately carved early cross slab in
the style of St Berrihert's cross at Tullylease in Limerick, and many
of the cross slabs at Clonmacnois in Offaly.

13 Mám Ean

It is signed off the N59 between Oughterard and Clifden, about 8 miles west of Maam Cross. The road goes up 2.2 miles to a small car-park. Follow the track up into the gap between the mountains.

'Mám' means 'a mountain pass' and 'ean' is 'a bird'. The climb takes under an hour and is spectacular, especially on a summer's evening when the sun is setting through the pass. A stony track runs right up between two peaks in the Maamturk mountains which separate Connemara in the south west, from Joyce country to the north east.

From Mám Ean looking north

At the top of the pass, about 1200 feet above sea level, is a holy well, now dedicated to St Patrick. Tradition says that St Patrick climbed the pass from the north and looked out across Connemara, blessing the land before turning back. He spent the night in a shallow cave here beside the well, now called St Patrick's bed.

People have long gathered here at the well from both sides of the mountain on the last Sunday in July, which is known as Mám Ean Sunday, or Domhnach (Sunday) Chrom Dubh. This is, of course, an old Lughnasa assembly traditionally celebrating the First Fruits or harvest, and honouring Crom Dubh, the dark god who returns to the Otherworld with the First Fruits to ensure the earth's fertility for the coming year. As at most Lughnasa assemblies, an early dinner of the first potatoes of the season was eaten before the climb.

The more recent assembly involved a mass by the well, attended by people from both sides of the hill. This was followed by music and dancing as well as the inevitable faction fighting. Men from either side of the pass fought each other with shillelahs, swinging at each other and each other's weapons.

This so-called 'faction fighting' is often cited as the reason for many of these old gatherings being abandoned. However, Máire MacNeill refers to these fights as 'cudgel contests', implying that they may be part of an older ritual enacted between the young men of neighbouring districts. She describes how, at Mám Ean, there seemed to be no hard feelings and everyone went home at sunset.

Mám Ean

The Christian pilgrimage has been revived in recent years. A statue of Patrick as a young boy now looks down over the pass, and stone circles and standing stones below are now incorporated into a modern pattern. Stone pillars stand as Stations of the Cross following the track through the pass. The Celtic Tiger has been this way.

However, the powerful symbolism of the mountain pass as the gateway between two worlds is as strong as ever. It is high enough and wild enough here to withstand the changes in human fortunes below.

14 Omey Island

Take the N59 north of Clifden. After 3 miles, take a left turn to Claddaghduff. About 5 miles later, take the lane on the left down to the shore.

A monastery was founded here by St Féichín of Cong (MAYO) in the 7th century. Tradition has it that the last pagans in Ireland were here when he arrived.

Near the north shore, in a hollow in the sand dunes, is a small ruined medieval church, called Templefeheen. St Féichín's well is in an inlet in the west.

At low tide you can walk across to the island (like **Iniskeen** in DONEGAL) and there is time to walk right round it before the tide comes in, especially if you go when the moon is full. Cross the sand at the markers and follow the road around to the left until it runs

out. There is a track to the right across the sand towards a small lake. Just before you reach the lake, cross to the left to the seashore and follow it around the inlet.

St Féichín's Well, Omey Island

St Féichín's well is just above the rocky shore with a long, dry-stone walled entrance from the sea to the well. The extra-high tide at the full moon rises up into the well through this entrance. On top of the enclosure are round stones, called serpent's eggs, placed here by women as part of a fertility ritual.

Go back to the path by the lake and follow it around to Templefeheen. The church is in a hollow in the sand-hills. The east gable is intact with a small flat-topped window with splayed sides. The stones are a lovely warm pink and the sand dunes speckled with tiny flowers: biting stone-crop, sea milkwort and bog pimpernel.

You can continue round the island by the shore. This journey or turas, which encircles the island, takes about two hours.

High Island and **Friar Island** are seen to the north west. Both have the remains of monastic cells.

THE ARAN ISLANDS

The Aran Islands continue the limestone plateau of the Burren. And yet they are completely different. Nothing quite compares with the feeling of approaching an island by sea. The symbology of the island is lived out in the practicalities of getting there, taking time to cross the water.

Driving to the ferry from Galway to Rossaveal, the stone walls get gradually bigger and the fields get smaller, as if to prepare you for the islands themselves. The boat takes just over half an hour. You need to check schedules with the office, as they change with the seasons.

- Island Ferries sail from Rossaveal, about 30 minutes by car, west of Galway city. They provide a bus link f rom Galway.
 Phone: 091 572050. Evenings: 091 572273.
- Doolin Ferries operates out of Doolin in Clare from April to September.
 Phone: 065 70 74455. Evenings: 065 70 74189.

Both ferries run to all three islands.

Going into the west has long been associated in Celtic mythology with entrance to the Otherworld. From a mainland perspective, the islands off the west coast often shroud themselves in mist and become invisible.

The west coast is also associated with the lost civilisation of Atlantis, from which echoes of a powerful and magnificent past can be heard from time to time. There are suggestions of a cataclysm which separated the islands and perhaps all of Ireland, from that great land-mass. Some say that the great forts on the island belong to this time - why else would the massively fortified Dun Aenghus have been built on the west coast?

Until the 16th century the mythical island of Hy Brasil, the Island of the Blessed, was still marked on maps, and some people claim still to see an island off the seaward cliffs of Inishmore, when the light is just right.

15 Inishmore

Inishmore is the largest of the islands and the most visited.

First impressions in April are of strong evening sunlight glinting off stone. The cracks and pockets in the limestone pavement are stuffed with primroses and oxlips and flowering juniper and thorn, bent tight against the rock. All this in tiny fields with high stone walls and grassy lanes between. As well as all this beauty, the island is covered

Oxlips, Aran Islands

with shrines, holy wells, temples and forts - potent places that defy the narrow boundaries of contemporary belief.

And stone is so plentiful, there is no need to dismantle the old to build the new, so everything remains. The landscape is marked at every turn by its stories and histories. Here are some of these places. There are many more.

For a compact and comprehensive guide to the islands, get Dara Ó Maoildhia's *Pocket Guide to Árainn: Legends in the Landscape.* (Pub: Aisling Árainn,1998.)

For a much more detailed read, try *Stones of Aran: Labyrinth.* by Tim Robinson. (Penguin: London, 1997 Vols 1 & 2.)

Both are available on the island.

CONNACHT Galway

Stone walls, Aran Islands

There are seven great forts on the islands. Four of them are on Inishmore. Their origins remain a mystery. It seems that the more that is discovered, the more questions arise. Restoration work was carried out in the 19th century, during the Celtic Revival (1870 - 1900), and today's historians lament some of the reconstruction. The effect, however, is quite stunning, which was probably the object at the time.

Their names date to this time of reconstruction. Local people were not familiar with the name Dún Aonghusa, for example, until well into the 20th century. To the Celtic Revivalists, Aenghus was the King of the Firbolg and a Celtic sun/son god and Dun Aenghus an appropriately magnificent setting for him.

The Book of Invasions tells us that the Firbolg were driven west into Connacht and the western islands by the Tuatha Dé Danann. The Firbolg became a kind of dark people, living on the borders of the mainstream, as pirates and outlaws. Sometimes they are depicted as being one-eyed or one-legged. However, in these western islands, their association with such magnificent forts suggests that they are thought of rather differently.

Dún Dubhchathair, The Black Fort

A mile from Cill Rónáin where the ferries dock, on the way to Cill Éinne, turn right at the disused electricity station - a grey building under the hill. Turn right again at the top of the hill and follow the road out to the cliffs. Where the road ends, turn left and the fort is in front of you.

The landscape from here to the fort is extraordinary. The limestone pavement is divided by stone walls into strip fields which run right over the edge of the cliff. For the most part, these fields contain no earth, only limestone pavement. Many of the walls are made with massive stones and are over 6 feet tall. There are half tumbled animal shelters that could be prehistoric and the limestone is black and seems to absorb all sound. Here and there, there are gaps in the walls, which make it possible to cross the landscape.

The fort walls are huge and terraced on three levels across the

neck of a promontory undercut by the sea. Inside are clocháns, small circular beehive huts, though there is no fresh water supply. Outside are 'chevaux de frise', a defensive band of spiked stone pillars set at an angle into the ground.

It is 3.5 miles further south on the same coast as Dun Aenghus, and may be much older. A formidable place.

Dun Aenghus

It is a short walk uphill from Kilmurvey with a small visitor centre.
Phone: 099 61008. Admission charged.

This is the best known and most visited of the forts. It has been described as one of the most magnificent prehistoric monuments of western Europe. Three concentric, semi-circular walls, each ending at the cliff edge, create an impenetrable barrier facing inland. They are dry-stoned and terraced on the inside. The innermost wall is massive: nearly 20 foot thick and 15 feet high. Between the second and third walls is a formidable band of 'chevaux de frise', up to 5 feet high in places. This is a wide ring of stone pillars driven into the ground at different angles to prevent a straightforward approach to the cashel walls. (There are also 'chevaux de frise' at **Cathair Bhaile Cinn Mhargaidh** in CLARE.)

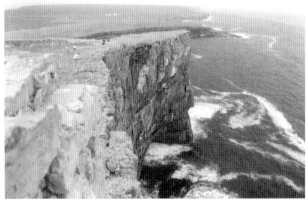

Cliffs from Dun Aenghus

The inner fort is accessed through a deep, arched entrance. Once inside, you are effectively cut off from the rest of the island, but exposed on a cliff edge to the endless expanse of the Atlantic Ocean 300 feet below. The pounding of the waves against the sheer cliff dominates everything inside this inner cashel.

Recent excavations in the western part of the inner enclosure have revealed a number of hut sites, one of the best preserved

CONNACHT Galway

being circular, with a paved floor and stone hearth, with a stone trough nearby. A sample of bone from the area was dated to the beginning of the Iron Age. Outside this inner enclosure, the remains of a crude hut were found which seems to have been inhabited around 900 BC, towards the end of the Bronze Age. Moulds for casting bronze have been found. This is an interesting discovery as it shows settlement perhaps even before much of the fort was built. Occupation continued into the Iron Age and probably for at least another 1000 years. Some objects from the site may date to as late as 9th century AD.

Dún Eochla and Dún Eoghanachta

Dún Eochla is signed off the main road from Kilronan to Kilmurvey and sits high up beside the old lighthouse.
Dún Eoghanachta is visible to the south up on the hill above the village of Eoghanachta or Onaght in the west of the island. It is signed on the left.

Eochla was thought to be one of Aenghus's brothers.

This is a snug almost circular fort about 91 by 75 feet with an inner cashel with steps in the wall. There is a walkway round the top. An outer wall gives even more protection. After Dun Aenghus, it feels safe here and it is lovely to climb inside and sit encircled by

Steps and terraces inside Dun Eochla, Inishmore

thick stone walls. The lighthouse nearby is a small folk museum.

The Eoghanacht were kings of Cashel and ruled most of Munster or the southern half of Ireland till the 10th century. They are said to have finally driven the Firbolg from the islands. Eoghanachta is a univalate stone fort with three rectangular clocháns inside.

Christian Times
The island's father saint is **St Enda**. He was born a prince of Oriel in the north east of Ireland, and converted to Christianity while helping his sister Fanchea set up a religious foundation in Killany, Monaghan.

He travelled widely and was involved in many religious foundations, but he would have seen the Aran Islands as a special prize, with its powerful and wealthy fortresses, and its stories of the Otherworld in the west. For him it would have been a chance to take the new faith right to the edge of the known world and beyond, even to the Celtic Otherworld.

His other sister was married to the powerful King of Cashel, and with her help, he gained permission to go to the island of Aran Mór and set up a monastery there.

He travelled to Inishmore around 485 AD with 150 monks where they founded ten monasteries. A dispute over Enda's controlling all these houses was settled by a fast and the vision of an angel appearing with a copy of the gospels and a cloak for Enda, symbolising power over all the houses and authority to teach the gospels.

He had many students, such as Ciarán of Clonmacnois. There is also evidence that Colmcille stayed here for a while, though Enda apparently was not keen on having such a charismatic rival. The mark of Colmcille's ribs can be seen on the shore below Killeanny where they came to blows. Things also came to a head with St Breacán and this event was marked in the landscape, until the tarring of the road covered the prints of St Breacán's hooves.

Enda was one of the great patriarchs of Irish monasticism.

Teachlach Éinne (the household of Enda)

Go south from Kilronan past Killeany and the airstrip on the left.
It is in the graveyard on the left. Signed.

The tiny church here is built on the site of Enda's grave, a common practice in the early Celtic church, and perhaps following a much older tradition of the great megalith builders. Local people will tell you that there are no less than 113 saints buried in this area.

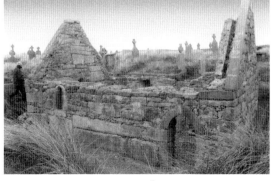

Teachlach Éinne

The east end of the church, with its massive facing stones and antae, date to the 10th/11th century; the rest may be as late as the 17th century. There is a stone altar and a number of reassembled pieces of a carved cross, as well as some granite bullauns. One of the cross pieces shows a horse and rider.

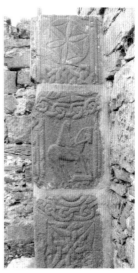

Nearby is the grave of a more modern icon, Tiger King, an islander who played the lead in Robert O'Flaherty's 1934 classic documentary, *Man of Aran*. (Robert O'Flaherty went on to make *Nanouk of the North*, a documentary about the life of the Innuit.)

Cross shaft, Teachlach Éinne

Teampall Bheanáin (Benan's Church)

Back into Killeany, turn left at the signpost by the stone house, then right by the thatched house onto a lane.

Up this lane is **Tobar na mBráthar** - the Well of the Brothers. The Franciscan Brothers came to Aran in the early 16th century and remained till Cromwell arrived in the 1690s. Little is left of their buildings as they were recycled by Cromwell's soldiers for their fort, Caisleán Aircin, down near the pier.

On up the track is **Dabhach Éinne** or Enda's barrel. It is a covered well and stone altar. When Enda first came to the island, the local chief demanded some sign of his powers. He took a barrel

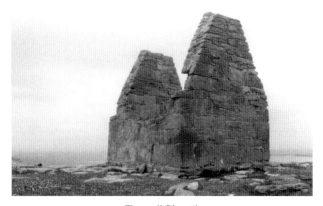

Teampall Bheanáin

of corn and put it afloat near Corcomroe in Clare, and it sailed straight to Aran, leaving a track of calm water in its wake. Corban, the chief and one of the old Firbolg, was very impressed and Enda was permitted to stay. The barrel was buried here.

Between the two wells is **Cosán na nAingeal**, the footpath of the angels. This is a green path following the contour of the hill and a lovely gentle place where Colmcille is said to have walked each day and talked with the angels.

And finally the climb up to **Teampall Bheanáin** on top of the hill. The views are worth the climb. Another tiny building, only 7 foot wide inside, it probably dates to the 11th century. From here St Benan went on to succeed St Patrick in Armagh. The church is unusual in that it lies north east to south west, instead of east/west.

There are traces of monastic buildings around the church, a priest's house perhaps, clochans, and the base of a round tower.

Teampall Chiaráin

From Kilronan take the main road west to the next village, Mainistir. Teampall Chiaráin is signed on the right.

This is a lovely gentle place with a sacred well, standing stones and a grove of trees. It is now dedicated to one of Ireland's most gentle of saints, St Ciarán, who spent seven years studying here under Enda, before leaving to found Clonmacnois. It was here that he dreamed he saw a huge tree growing in the centre of Ireland. Its fruits were being carried by birds all over the country. Enda was to interpret the dream for him. He said that the tree was his life's work: a very important monastery that would spiritually nourish the whole country. Enda was sorry to see him leave and reflected that many of the island's angels left with him.

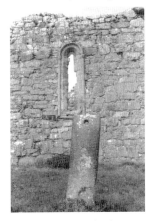

Teampall Chiaráin

Ciarán died at the age of thirty-three from plague, just seven months after founding the monastery at Clonmacnois. Teampall Chiaráin continued in use long after St Ciarán left. The oldest dateable part of the church, the west door, is 8th century while the newest part, the north door, was added in the 16th century when monasticism was being suppressed.

There is an ancient stone by the west gable, inscribed in

CONNACHT Galway

Christian times, probably in the 8th century, with an elaborate cross. There is also a stone sundial with a hole for a gnomon in it. It has been used in recent times as a contract stone. (A contract stone is a special stone where people make contracts or agreements that are then considered binding.) While charting the sun's passage through the sky was important to neolithic peoples, the early Christians used its passage as a discipline to mirror their activities and devotions throughout the day.

With your back to the east gable, you can see two more stones also cross-inscribed and both with embryonic cross arms and a small capped top. They are accessible over stiles.

The 9th of September is St Ciarán's day and turas are performed around this site.

An Ceathrar Álainn
Translated locally as 'The Four Comely Ones'.

Signed from the main road up a lane and over a stile. Follow the track across the first field and over the next stile. The small medieval church is visible from here.

There are four grave slabs at the gable end behind a low wall, supposed to belong to St Conal, St Berchan, St Fursey and St Brendan of Birr. However, this is a much older site. From the gable wall looking west, there are two standing stones - the furthermost one being a massive 11 feet high. And matching the four saints, are four ancient wells.

Near their graves, by an opening in the field wall, is the first one, called the **Well of the Saints**, from Synge's play of that name. Modern pilgrims go around the well and church seven times sun-wise, with seven small stones, saying prayers each time. They finish by drinking from the well. Pattern day here is the 15th August, right at the end of Lughnasa.

To visit the other wells, go back across the track, and leaving the monastery wall, cross the field and go over the stile. Then turn left onto the track. Just as the track turns right, there is an **eye well** to your left off the track. Past this, continuing towards the road, cross another stile and turn right. At the base of the wall, a few yards from the stile, is a bullaun which is the **Third Well**. The **Fourth Well** is used as the village well and is back out on the lane, further up the hill on the left. It is a typical island well with water dripping down an overhanging rock into a pool beneath.

Up over the brow of the hill, with Dun Aenghus in the distance, a **dolmen** is visible through the fields to the left, above the standing stones of An Ceathrar Álainn, a reminder of just how ancient the sacred site below actually is.

CONNACHT Galway

Na Seacht Teampaill - The Seven Churches

At the north west end of the island, signed off the main road in the tiny village of Onaght, is the site of The Seven Churches.

Only two were actually churches - the others were domestic buildings, though time has blurred the distinction. It is an interesting site even though neither church is particularly memorable.

Teampall Bhreacáin is the larger of the two, with **St Breacán's grave** slab lying in a small enclosure nearby. This shrine was an important place of pilgrimage in times past, St Breacán being associated with a number of other foundations across the country.

It was St Breacán who challenged Enda to divide the island and share his power. Breacán was also from a royal family and by all accounts as strong-willed as Enda, and not averse to a little trickery. Enda agreed that they should go, one to each end of the island, and start walking at dawn. The line would be drawn where they met. Enda secretly planned a head start by sleeping on high ground for an earlier sunrise. Breacán, however, took things a little further and went by horse. The all-seeing Enda knew what he was doing and cast a spell, rooting his horse to the spot. The hoof marks were visible until the roads were tarred in the 1880s. A plaque now commemorates the spot between Fearann-a-Choirce and Kilmurvey beach.

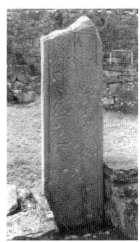

Near the saint's grave is **Leaba an Spioraid Naoimh**, or the Bed of the Holy Spirit. Used as a prayer station, it is a raised stone area with the shaft of a finely carved high cross on it. One side is covered with panels of knotwork and interlacing, and the other has part of a Crucifixion on it.

East of the other church are four inscribed pillar stones. One reads: TOMAS AP and another: VII ROMANI. The latter, meaning 'Seven Romans', may refer to seven monks or pilgrims from Rome or they may be monks who followed the Roman, rather than the Celtic

Cross shaft, Leaba an Spioraid Naoimh

monastic calendar and practices. (see **Council of Whitby**)

The **north cross** is a field away. It was originally a massive 13 feet high and carved from a single piece of limestone. It is beautifully decorated with interlacing. The **south cross**, with its

CONNACHT Galway

crucifixion scene, is lying flat on a ledge above the monastery, surrounded by a wall. To get there, cross a stile near the VII ROMANI stone and turn right at the top of the hill. Near it is a holy well: a natural bullaun with a stone cover.

16 Inis Meáin

Inis Meáin, or the 'middle island' is the least visited of the Aran Islands. It is greener than Inis Mór, with brambles and ferns growing from the walls which are a soft brown colour.

This was the island chosen by John Millington Synge at the end of the 19th century for his total immersion in rural Irish culture. He stayed for four summers and his book, *The Aran Islands*, gives a great insight into life here over a hundred years ago. His play, *Riders to the Sea*, is set here.

Dún Chonchúir

This is a very dramatic setting on high ground in the centre of the island, surrounded by a patchwork of field walls.

Conor, for whom this fort is named, was said to be another brother of Aenghus. This fort is oval with its wall about 18 feet high and nearly as wide: bigger than the inner wall of Dun Aenghus. The wall is terraced on the inside with steps connecting the terraces. It was partially reconstructed in the 19th century. There are some clochans inside which may be later than the walls, though there have been no excavations.

Another smaller fort, **Dún Fearbhaí**, is east of here.

Séipeal Eoin agus Naomh Mhuire gan Smál

The name translates as 'The Chapel of St John and Mary Immaculate'. This small island church, built in 1939, has stained glass by Harry Clarke.

17 Inis Oirr

This is the smallest of the islands. The north is dominated by the ruins of a 15th century tower house which sits on top of a steep hill inside one of the island's forts, Dún Formna.

The medieval tower house belonged to the O'Briens, descendants of the High King, Brian Boru, who died at the beginning of the 11th century. They remained the ruling family in Clare. From Inis Oirr they controlled Galway Bay and the merchants of Galway agreed to pay them twelve tons of wine annually to fund a small navy to keep the Bay free of pirates.

Teampall Chaomháin is a 10th century church dedicated to St Kevin, the patron saint of the island. It has had to be excavated out of the sand dunes. This Kevin is said to be a brother of St Kevin of Glendalough in Wicklow.

Cill Ghobnait is a small 11th/12th century church now in ruins. It is associated with St Gobnait (see CORK) who was said to have been the only woman allowed on the island in early Christian times. She is still held in high regard.

18 St MacDara's Island

721 299

1.5 miles off Mace Head, near Carna. Access from Mace by private arrangement. 'Mace' comes from the Irish 'Más', meaning 'buttock' or 'thigh', an allusion to the shape of the headland.

The island is also called 'Crúanacára', which is hard to translate but 'hill of the beloved saint' might do. It shows how people felt about St MacDara, who was also known as 'son of the fox'. He is considered the patron saint of Connemara's seafarers, and sailors dip their sails in respect as they pass the island.

He founded a hermitage here in the 6th century. At some time, probably around the 8th or 9th century, the present stone oratory was built to replace a wooden one. The roof is steep and projects over the gable ends to rest on the antae in the manner of a wooden building. It is said that the early stone churches were built like wooden ones. It is likely, however, that the builders of temples were copying a style they considered important for a sacred structure and not just, as is sometimes implied, that they had not evolved a style for building in stone. It is used, after all, in the painting of King Solomon's Temple in the *Book of Kells*. It is also used for the tops of the high crosses at Monasterboice and Durrow.

The walls are built with massive stones at the base in the manner of the early churches, and the gable had a carved butterfly finial which has fallen. It has a trabeate doorway and small east window.

There is also a holy well and several cross slabs here and the saint's bed. The traditional pilgrimage days are the 16th July and the 25th September. A mass is now said here on the 1st August as well.

In the summer these patterns are followed by boatraces, as Connemara people come with their boats to have them blessed, but also to race afterwards.

CONNACHT **Galway**

County
MAYO
PRINCIPAL SITES

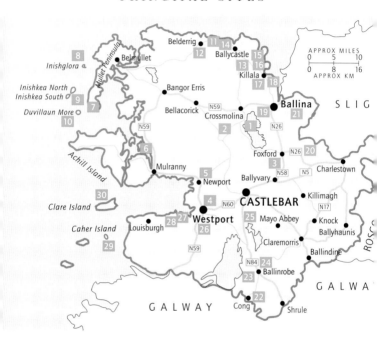

APPROX MILES
0 5 10
0 8 16
APPROX KM

1 **Errew Abbey**
2 **Tristia** - St Patrick's Well
3 **Strade Friary**
4 **Westport**
5 **Newport** catholic church
6 **Drumgollagh** court cairn
 Achill Island
7 **Fallmore** church and well
8 *Inishglora*
9 *Inishkea North*
 Inishkea South
10 *Dunvillaun More* - monastic site and cross pillar
11 **Ceide Fields**
 Behy court cairn
12 **Beldberg Farm**
13 **Ballybeg** court cairn

Block figures in list refer to site locations in map and entries in text.

MAYO

I FIRST ARRIVED IN NORTH MAYO when the wind was stripping autumn from the countryside and rain and cattle between them were creating sticky brown mud around field gates. This county is rich in prehistory, much of it scattered across the fields of the north and definitely more accessible in dry weather. On my next visit, the following summer, I discovered just how many sites there were.

There are nearly 80 court cairns, about a quarter of those found in the entire country. Many of these are found in the area around Bunatrahir Bay, near Ballycastle. There is also a distinctive Mayo-type court cairn which has a cruciform chamber, like the centre of Newgrange, for example, or the transepts in a cathedral.

One of these, at Behy, is within the Ceide Fields complex.

The Ceide Fields are high up on the north Mayo coast. The area is best known in recent times for the discovery of 5000 year old field systems which have revolutionised our thinking about neolithic activity in Ireland.

A chain of lakes runs down the centre of the county, through fertile farmland dotted with deserted monasteries.

In the west, the land lies exposed to the elements - subject to the extreme mood swings of sun and rain, deeply fragmented into an archipelago of islands. Many of these islands were inhabited in earlier times by monks who felt that their remote elemental nature brought them closer to god.

THE NORTH

1 Errew Abbey

Two miles outside Crossmolina on the R315 to Castlebar, it is signed on the left. A further 2 miles on, this road comes to an end and a track crosses the fields to the abbey, at the tip of the peninsula jutting out into the lake.

The church is a solid and fairly plain long rectangular building, probably dating to the 13th century. Attached are some 14th century domestic buildings belonging to the Augustinians. Their best feature is a section of closed cloister with small trefoil windows and a barrel vault ceiling.

You can climb a small staircase to the first floor and look out on the peaceful waters of Lough Conn on three sides, with Nephin mountain west south west. Cattle drink at the lakeside much as they might have done 500 years earlier.

Nearby to the north you can see **Templenagalliaghdoo,** which means Church of the Black Nun, a small rectangular oratory probably on the site of the 6th century foundation of Tighernan. A small annex on the north side may have enclosed a well or the grave of the founder.

2 Tristia - St Patrick's Well
074 087

From Castlebar take the R311 west. Branch right onto the R312 north, then right again on the R316 to Crossmolina. The road passes between the Nephin and Tristia mountains. The white wall of a small altar is just visible a little way up the mountain on the left and access is via a forestry lane. You can drive up.

CONNACHT **Mayo**

St Patrick is supposed to have passed this way en route from Croagh Patrick.

There are two wells here, small deep holes with stone slabs in front, in a patch of cut grass. The one nearest the whitewashed dry-stone altar, is St Patrick's. Mass is said here on Garland Sunday, an old Lughnasa tradition reinstated about 20 years ago. The well is associated with family reconciliations, baptisms, eye cures and healing in general.

3 Strade Friary

From the N5 between Castlebar and Charlestown, turn north onto the N58 towards Foxford. Strade Friary is on the right, about 2 miles along, beside the new Michael Davitt museum.

This was the site of a Franciscan friary in the 13th century. Six fine lancet windows in the north wall of the chancel date from this time, but the rest is most likely 15th century, when the friary was transferred to the Dominicans and restored.

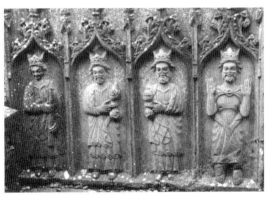

15th century tomb, north wall, Strade Friary

The tomb by the north wall is 15th century and carved with happy, smiling figures, ironically known as 'weepers for the deceased', in this case, the O'Jordan family. The figures are of saints and bishops as well as one of a smiling Christ displaying his wounds. There is another carved tomb under the east window with a Pietà and kneeling figures.

Some medieval stone coffin lids can also be seen here. They portray a stylized Tree of Life as cross, but otherwise they are less ornate than Northern ones. (see **Newtownards**, DOWN)

Michael Davitt was born in Strade in the middle of the 19th century. He and Charles Stewart Parnell set up the National Land League to try to protect tenant farmers and their families from

15th century tomb beneath east window, Strade Friary

unfair rent increases and evictions. This led to the Land War of 1879 to 1882, which gave the farmers some protection in law.

4 Westport

Two miles east of Westport, off the N5, is one of Ireland's most famous 'Sían' (sheean) or fairy mounds.

It was from this hill that Daniel O'Connell gave one of his famous addresses to the people of Ireland in the turbulent 19th century, calling for revolutionary changes to English law in Ireland. His aims were revolutionary, the emancipation of Catholics, but he is famous for the strength and passion of his oratory, persuading people to achieve change through constitutional means.

His use of the great outdoors to include everyone in the pursuit of justice was in keeping with the old Gaelic tradition of conducting such affairs 'under the eye of the sun'. His popularity and fame, of course, is also due to the unparalleled success of his methods.

The plantation landlords, with their imposing court houses, were seen to dispense a different kind of 'justice', which might not hold up under such conditions.

5 Newport Catholic Church

8 miles north of Westport on the road to Achill.

In 1926, when this church was being built, the then priest, Fr Michael McDonald, wanted an especially fabulous east window for their new church. Apparently he sold his life insurance for £800 to pay for it. This was one of Harry Clarke's last windows. He was consumptive and died in 1931 in a Swiss sanatorium.

Examples of Harry Clarke's stained glass windows can be

found in every corner of Ireland. His influences seem unusual in someone whose art was essentially sacred. He admired Gustave Moreau and the decadent poets of the end of the century, like Baudelaire and Huysman. His own art seemed to touch on just that combination of the macabre and the beautiful, making his windows still touch our imagination.

The centre panel here shows the Last Judgement. If you look closely, one of the lost souls beneath Christ's feet has got Harry Clarke's face.

His best known work is in Loughrea cathedral in Galway.

6 Drumgollagh Court Cairn

797 049

This cairn sits on a low ridge surrounded by bog and sea inlets with a view west across to Slievemore on Achill. It is a dramatic and beautiful location.

The gallery runs south east to north west with a short antechamber in the east. Imposing portals, 6 feet tall, lead into the next chamber which is separated from a further back chamber by another pair of tall portals. This second pair of portals have a septal slab between them which is as tall as they are, effectively blocking the back chamber. One of the first portals is pointed and the other square, giving the impression that they each had a different function when one passed between them. Unlike some of the other structures in Mayo, this one has a large endstone in place.

The gallery was roofed with sods in recent times and used as a shed, but this has been removed.

Achill Island

At 50 square miles, this is Ireland's largest island, although it has been connected by a causeway to the mainland since 1887.

'Acaill' means 'eagle' and *The Book of Fermoy* tells of a dialogue between the historian Fintán and the legendary eagle of the island:

> It is old thou art, O bird of Eachaill,
> Tell me the cause of your adventures;
> I possess, without denial,
> The gift of speaking in the bird language.

Two eagles, the white-tailed sea eagle and the golden eagle, used to breed here in the 19th century. Sadly, both are now gone.

CONNACHT **Mayo**

It was a fitting place for eagles, dominated by mountains of ancient Pre-Cambrian quartzites and schists, with deep corries scooped out by glaciers. Cone-shaped Slievemore in the north is the highest, but Croaghaun mountain to the west is possibly more dramatic, with its sheared cliff face and glacial lakes. South of Croaghaun, basking sharks, known locally as sun-fish, appear in spring in Keem Bay.

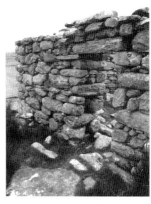

Deserted village, Achill Island

The painter, Paul Henry, spent many years here painting the island and its people. His paintings were considered over-dramatic by the Dublin critics at the time, but a few years later, in the 1920s, with the struggle for independence and national identity, people saw in them their cultural roots and an expression of the soul of Ireland.

The infamous **Achill Mission** was centred at Dugort, on the east slope of Slievemore. It was founded by a Church of Ireland clergyman, the Rev. Edward Nangle. The main building is now a hotel. The mission provided schools, jobs and housing on the island at a time when island life was very bleak, and the Rev Nangle himself fund-raised in England to collect money for famine relief for the island in the 1840s. However, that tricky combination of economic and social opportunity, linked to religious conversion, meant that the mission was always beset by enemies, not least of which was the Catholic Church. By the end of the century it had run its course.

On the mountain's south slope, about 100 ruined stone houses are all that is left of the **Deserted Village**. Most of the houses follow a single street, now grassed over, but lined with round granite slabs and pillars that would have made fine comfortable places to lean and sit on a summer's evening. The houses run along the 200 foot contour of the hill, single storeyed cottages with well cut corner stones and solid, south facing gables. It is a poignant place with its worn door-steps and small wall niches inside to hold lamps or other possessions. The island's history is strangely silent concerning its abandonment.

Following the path east from here, still at about 200 feet, are a number of megaliths. Most are pretty well ruined. Nearest, in the townland of **Keel East**, is a court cairn with an almost circular court facing south. The gallery is about 20 feet long and the outline of the cairn 30 feet by 60 feet.

To the east and higher up is another cairn with a smaller court facing north. The gallery here is divided into 3 chambers and a massive cap-stone is still in place at the end of the gallery.

At 54 degrees north and 10 degrees west, Achill has the longest evening daylight in Europe. This increases that magical time - a west coast sunset. It is said that the enchanted island of Hy Brasil is seen off the west coast of Achill every seven years. Some say it is just a reflection in the western evening sky.

Belmullet Peninsula

This long ragged neck of land is almost an island, joined as it is to the mainland at one brief point. In fact it is almost several islands, so narrow is it in places. It has neither hills nor trees to deflect the elements. The sun shines here with a special intensity, and the sand on its west coast is so white, that the islands beyond could seem a kind of mirage.

7 Fallmore Church and Well

622 184

Fallmore is at the southern tip of the Mullet Peninsula. Just before it, on the road from Blacksod, is an exquisite modern sculpture of a spiral of standing stones. It stands against the sky on a bare hillside where even the heather can barely flourish. The stones seem translucent in the evening light, reflecting the blues, whites and pinks of a stormy evening sky.

The church and well here are dedicated to St Deirbhile, a 6th century saint who was said to be so beautiful that she had to pluck out her eyes so that no man would desire her and she could dedicate her life to God. This seems to have been a common tactic among female saints at this time. It is certainly unthinkable in Irish story-telling to have a young heroine who was anything other than very beautiful.

And this is a very beautiful site. It is a small rounded hill supported by dry-stone kerbing and looking south to Achill and Slievemore, and west to the islands off the peninsula.

St Deirbhile's grave is a small enclosure with a cross slab beside the little church. The contours of the little church are soft and the light is clear and seems to reflect off the rounded granite stones. The doorway has an unusual rounded, asymmetrical lintel, carved with knotwork and border. Interlacing is still visible on the thick door jambs as well. The jamb has also been scratched with a cross, a common pilgrimage practice in modern times. The pilgrim makes the sign of the cross on a particular spot using a small stone.

There are three small granite crosses nearby.

CONNACHT Mayo

Dabhach Daerbhle

This is St Deirbhile's well. The bright blue and white canopy is visible across the sand dunes to the north. It has a cure for eye problems.

This is an unusual name for Deirbhile's well for it also means a vat or cauldron, which is a universal symbol of the goddess, signifying nurture and abundance. In Christian times it became associated with St Brigid.

St Deirbhile's day is 15th August, when an annual pilgrimage or pattern was held. It was stopped by the parish priest who disapproved of such pagan practices, but it has since been revived.

8 Inishglora

Inishglora lies about 2 miles off Cross Point on the Mullet Peninsula. Though small, it is the largest of these islands.
There is no regular access, but you can phone Inniskea Charters: Michael or Carmel Lavelle: 097 85669.

The monastery here was founded after St Brendan the Navigator visited the island on the start of his famous voyage. The monastery continued in use into medieval times.

Today there are two churches inside a circular wall or cashel. One is dedicated to St Brendan. Outside the wall is the women's church or nunnery. There are also three beehive huts and a holy well. In the graveyard there are some cross slabs and pillar stones. It is said that bodies buried here, never decay.

This island is where the Children of Lír spent their last 300 years of exile as swans. It was said that their voices melted the hearts of all who heard them sing and may have given the island its name as 'glórtha', meaning 'voices'. It was a haven of sorts after the wild storms of the Sea of Moyle, and they were befriended by St Mochaomhóg who baptised them when they changed back into human form just before they died.

I met a man whose family came from the island. He told me that in his grandparents' time the islanders used to look after four small graves near the shore, thinking them to be the graves of the Children of Lír.

In 1927 a sudden storm at sea claimed the lives of ten islanders. The last inhabitants left for the mainland in 1934.

9 Inishkea North

About 2 miles off the tip of the Mullet Peninsula. For access here and for Inniskea South, check with Inniskea Charters as above.

Traditionally, the standing stone at Dun Fiachrach, on the western tip, was a favourite resting place of the Children of Lír.

The Crucifixion Slab

There is a monastic site on the island with a small church and a number of cross slabs, including one very unusual one. It is just over 4 feet tall with a crucifixion incised on the west face. The cross is wide with slightly broadened tips.

Christ's head is flattened on top, wide across the temples, and with strong almond-shaped eyes. Lines forming arched brows continue down the centre of the face to outline a strong nose. His arms are short and his hands fine. A line spirals out from each hip. These spirals on Christ's body are also found on a crucifixion slab on Duvillaun More. (see below) A small figure stands either side of the cross, one below each arm. One holds a sword and the other a sponge. Above the cross arms on each side, there is a small equal-armed cross formed with a double line.

The Naomhog

This name means a female saint and is pronounced 'neewoge'. She is a small stone figure held on Inishkea, and considered to have power over the weather. She was used in times past to invoke favourable winds.

Then, one day, a pirate came and took everything from the island, burning houses as he went, but the house where the Naomhog was, didn't burn. The islanders blamed the figure and took her out and broke her against a rock. After this, her power lessened, but she was still carried around the island as protection against sudden storms. She was kept in a blind window in a different house each year and dressed anew in homespun.

Some time ago, a new parish priest came to the island and thinking to end this practice, he took the figure and threw her in the sea. He died soon after and the island fell on hard times. People said that there had been no hunger or misfortune on the island before that time. The head was rescued and is still kept in a homespun bag, but no one knows of its exact location today.

Another interesting find on the island was a quantity of **Purpura lapillus** sea-shells, commonly known as Dog whelk and harvested for its purple dye. Excavations in the 1950s uncovered a workshop for its manufacture. It was thought to have been in use around 800 AD. It may have been attached to the monastery here, to make purple dye for manuscript illuminations, but it could mean that the island had Mediterranean connections as the Phoenicians travelled widely to procure this dye.

Inishkea South

On the western shore of the island is a church dedicated to St Deirbhile. Nearby is a cross pillar and a cross slab with a cross pattern similar to Reask, Kilfountain and other pillars in Kerry. Here also is a well dedicated to St Deirbhile. (see **Faulmore**)

10 Dunvillaun More - Monastic Site and Cross Pillar
581 161
This island is 3 miles off the tip of the Mullet Peninsula, 2.5 miles south east of Inishkea South.

There is a cashel-like enclosure here divided by a wall. The foundations of an oratory lie on the east side with a large stone box or cist, called 'the Saint's Tomb'. At the head of it is a striking cross pillar with strong connections to the one on Inishkea North (see above). There are a number of clochans west of the cashel.

The pillar is nearly 6 feet tall and 2 feet wide with a crucifixion on its west side. The Christ figure is simply incised: a long torso with short arms and wide angular hands. His legs are small and thin, shapely, with both feet pointing to his left. His circular head has a nimbus around it and behind him the cross is outlined to fit the shape of his body.

His hips are each marked with a spiral, the outer line running up his body to form the outline of his torso. Smaller spirals form the breasts and continue up to form the armpits and underside of his arms. These spirals also appear on the crucifixion slab on Inishkea North. (see above)

Small figures either side of the crucifixion represent the soldiers, one with sponge and the other with sword. On the other side is a cross formed with arcs, like the Maltese cross of the crusades.

This very unusual image is naive and quite beautiful. Peter Harbison points out that the position of the figures either side of the cross is reversed from the norm in Ireland (*Figures from the Past*). Stephaton, who holds the sponge up to Christ, is normally placed on his right. This is also true of the Inishkea cross. He suggests an Italian influence.

The spirals on the breast and hips reminded me of the cross pillars at Kilfountain, Kilmalkedar and Reask in Kerry, as well as the one here on Inishkea South, with their stylized crosses elaborated with spirals. These crosses are peculiar to the west coast, so it is quite possible that they have been influenced from abroad.

CONNACHT **Mayo**

11 Ceide Fields

Signed from Ballina. Go west out on the R314. The site sits high above the Atlantic on the north Mayo coast. Run by Duchas. Admission charged.

The visitor centre is primarily concerned with the archaeology of this area, where stone field walls, found beneath the bog, follow the contours of the hills in a coherent pattern over 4 square miles. This evidence of a huge and well organised farming community here 5000 years ago is a rare and special glimpse into neolithic society. Around the visitor centre, you can see areas where these walls have been exposed.

There is also a very interesting geological account of the area, going back 350 million years, when apparently the climate here was tropical. Fossils from this period can be seen all along the north Mayo and Sligo coast, and in Belderg harbour you can see rocks crumpled and crushed by colliding continents millions of years ago.

Behy Court Cairn

050 405

Get directions from the visitor centre.

'Behy' means 'birch land' - a reference perhaps to an earlier time, before the bog and before intensive neolithic agriculture. This cairn stands on the hillside beside the visitor centre. Like the ancient field walls, it is buried beneath a deep blanket of bog. Part of the cairn has been cut away so that it is possible to go down into the chamber.

From its oval court with dry-stone walls opening to the east, you climb down into the first chamber. A shallow sill and jambs lead into a second chamber measuring 10 feet by 6 feet. This has side chambers roofed by corbels resting on lintels, forming a kind of cruciform gallery, like a passage cairn. This unusual feature is unique to Mayo. The side chambers are called transepts like the side chapels in a cathedral.

The west end of the long covering cairn appears to have been convex in shape and, like the side walls, it had been revetted with dry-stone walling up to a height of 4 feet.

When it was excavated in 1963-4, sherds of neolithic pottery were found in the paved floor of both main chambers, with charcoal also in the inner chamber. Pottery was also found beneath the cobbled floor of the court, as well as a small polished axe, two flint lance points and chert scrapers. The inner chamber had been used to house a poteen still in recent years.

CONNACHT **Mayo**

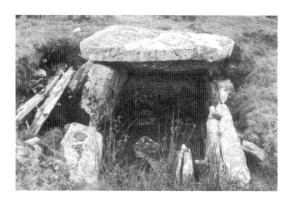

Behy court cairn

12 Belderg Neolithic Farm Site

From the Ceide Fields go west through Belderg and turn right. Signed.

This is a poignant outline of a neolithic farmstead with house walls and hearth and other features indicated with stone markers. An information sheet is available from the Ceide Fields Visitor Centre.

13 Ballybeg Court Cairn

137 320

Go south on the R315 from Ballycastle to Crossmolina and after about 5 miles, turn left for Kilcon. Take the first left and follow this windy road about a mile to a T junction. Turn right and then left up to some houses. Keep right and stop at the end house. The cairn is in a field behind the house. Ask. It sits on level pasture on a flat ridge south of Seefin Hill.

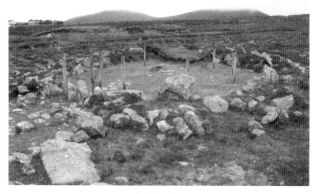

Belderg farm

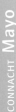

CONNACHT **Mayo**

It is a huge structure and unusual in that it has an outer and inner court. The stones are broad and flat and none are over 3 feet high. There is a court to the east. From this outer court, an entrance made up of 2 matching blocks on each side, leads into a central circular court. This inner court is almost complete with 17 stones. Well-matched jambs lead into a long gallery in the west. Some stones on either side of this may be side chambers.

14 Doonfeeny Cross Pillar
085 398
2 miles north west of Ballycastle overlooking the sea. It is visible from the R314. Turn up a narrow road on the left to the cemetery.

The church is not very interesting, but the pillar is square and a massive 18 feet high. Two simple crosses near the base have been added to Christianise it. On the lower cross are bird's head designs. There is a small enclosure around the pillar which may be a rath or killeen.

Doonfeeny cross pillar

15 Rathlacken Court Cairn
166 388
From Ballycastle take the road signed Rathlacken. After 0.7 miles turn right at the crossroads. About 2.5 miles later, fork left and the site is visible down a side road to the left after 1.5 miles.

This is a beautiful 3-chambered court cairn made of softly contoured stone bleached white by the bog. It has a full court made of a mix of dry-stone walling and large orthostats. It sits at the highest point of rounded Creevagh Head, looking east to Knocknarea in Sligo and north east across Donegal Bay to the Slieve League cliffs in Donegal.

St Cuimín's Well and Sundial
On Kilcummin Head on the north west side of Killala Bay. From Carrowmore crossroads south of Lacken strand, go west, then take a left. Keep straight on for 4 miles until you come to Church

Village. Go past the pier, and on the left Kilcummin graveyard
slopes down to the sea. In it are the ruins of St Cuimín's church,
his well, and a sundial.

St Cuimín is the local saint who is said to have been washed
ashore here in a wooden box as a tiny infant. A local man named
Maughan spotted the child when he saw one of his cows licking the
wooden box, and he took him home to his wife. Her family name

was Loughney and they
fostered the young Cuimín.

One day, years later,
Maughan sent the boy to
keep the birds away from
his newly planted corn.
He was surprised and
a bit cross when Cuimín
returned almost immed-
iately. He asked him why
he was not in the field,
and Cuimín replied that
he had sent all the birds
into the church so the
corn would be safe. From
then on his powers became

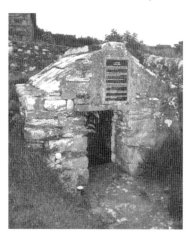

St Cuimín's Well

well known. In Lacken church, near Rathlacken village by the
strand, there is a stained glass window over the north door showing
St Cuimín calling the birds into the church.

The well is believed to have healing properties and a pattern or
pilgrimage took place here on Domhnach Chrom Dubh, or the last
Sunday in July. Up to five patterns were held here at one time. A
modern altar has been built near the site now and a mass is held
here annually, still on Crom Dubh's Sunday, now renamed
Garland Sunday. Crom Dubh is the old god of the harvest who
abducts the maiden or 'first fruit' below into the underworld, to
ensure fertility for the following year. It is also the beginning of
Lughnasa, the festival of Lugh. The well area is still used for a
pattern which involves prayers and walking sun-wise around the
well and nearby mound. Instructions are by the well which is
enclosed in a small stone house.

There is a hollow, north of the church, traditionally held to be
St Cuimín's grave - the earth is good for cures but must be lifted by
a Maughan or a Loughney. People keep it in their houses for
protection or even in their cars to stay safe on the roads.

To the west of St Cuimín's grave is the head of a sundial with
a hole for the gnomon and incised rayed lines. One of the rayed

lines has a forked end.

Leac Cuimín, a cursing stone said to have been left by St Cuimín, was also in the care of the Maughans and the Loughneys. If anyone wanted to redress a wrong, they would first fast for 15 days against the person they felt a grievance towards, and then approach the keeper of the stone. The keeper would turn it anti-clockwise thus bringing down a curse, most likely killing the person it was directed at. However, if the curse was unjust, it would come back on the instigator. It is said that a friend of one of its victims came and broke the stone. It was tied together with thongs for some time, but eventually, some say, Dean Lyons of Ballina Cathedral had the fragments built into the altar there out of harm's way. Others say it has been built into the wall of Killala cathedral.

16 Rathfran Priory

4 miles north west of Killala. Going north past Rathfranpark wedge cairn, turn right at the crossroads down to the cemetery and the old Dominican Priory of Rathfran.

It was founded in 1274 and the church remains are mostly from this time. The church has a fine triple lancet east window and a small stone crucifixion panel over the west door. Some changes were made in the 15th century. In 1438 indulgences were exchanged for donations to build the refectory and bell-tower. The nave was also reconstructed at this time and a south aisle added.

In 1577 it was granted to Thomas Dexter, but like most ecclesiastical buildings in the area, it was burned by Richard Bingham. Only the foundations of the cloisters remain. Some friars remained in the area until the 18th century.

Half a mile further on this road a lane on the left takes you up to the brow of the hill and a very ruined stone circle which appears to be the kerbing of an old cairn. You can see for miles in all directions from here.

Rathfranpark Wedge Cairn

184 333
Signed by the roadside about 0.5 miles north north east of Carbad More on the road from Palmerston Bridge to Lacken Bay.

It overlooks the Palmerston river estuary to the south east, with the Ox mountains beyond in Sligo. Nephin mountain and the Nephin Beg range are prominent to the south south west.

The chamber is oriented east west, about 9 feet long with

double walls. The outer wall is made of massive slabs set end to end, and is about 3 feet beyond the inner wall. The entrance is in the west and has low jambs set against the inside of the chamber. The other end of the chamber has been piled with stones from a nearby circle.

Carbad Mor Court Cairn

181 326

North west of Killala. Take the R314 from Killala towards Ballycastle turning right after Palmerston Bridge at the sign to Kilcummin. Go past Templemary school on the right, then after the sharp left bend, there is a farm track on the left just as the abbey ruins come into view on the right. The court is about 100 yards down the lane.

This is a dual-court cairn with an almost circular court at each end. The end of one of the courts has been cut off by the lane. The axis runs south west to north east.

The south west court has 10 stones still in situ. Those forming the portals into the gallery are about 3 feet tall. The gallery has two chambers. This pattern is repeated at the other end.

The stones are boulder-shaped and low to the ground which gives this court, and others in the area, a less dramatic appearance than its counterparts in other places where perhaps limestone slabs create a more sculptural effect. Nevertheless, it is well worth a visit. Nephin mountain is prominent west south west, with the Nephin Beg range beyond.

17 Killala Round Tower

In Killala town opposite the cathedral.

The tower is 84 feet high with a rounded doorway and is all that remains of an early monastery founded by St Patrick in the 5th century and left in the care of St Muireadhach, its first bishop.

Across the road, the 17th century Church of Ireland cathedral is on the site of an earlier medieval church. It has a medieval font and a complete set of box pews where the more important local families could sit in relative privacy during services. There is a collapsed souterrain in the graveyard.

CONNACHT *Mayo*

18 Moyne Friary

This is a Franciscan Friary just a mile north of Rosserk (see below), this one housing monks of the Strict Observance. It is accessed down a lane by some farm buildings and across fields. It overlooks Killala Bay.

The church here is much more monumental than Rosserk below, much bigger but with little ornamentation, in keeping with the stricter order. Great round pillars separate the south aisle from the nave and a huge bell-tower sits over the crossing. This was added later. The hole for the bell rope is still visible. There is some graffiti of 16th century ships in the plaster of the west nave and on the respond of the aisle arcade. The cloisters and domestic buildings are in a good state of repair. The stairs are intact and the refectory has a stream flowing underneath.

This friary was destroyed by Richard Bingham in 1590, but some of the friars remained. The last one died around 1800.

Rosserk Friary

Rosserk is signed on the right 3.5 miles from Ballina on the R314 to Killala. It is a further 3 miles from the main road on the west shore of Killala Bay. Well signed.

It was founded in 1441 for the Franciscans of the Third Order by the Joyce family. The Third Order of Franciscans was established for lay people and so is less strict than the other Orders. Although no new abbeys were founded in Ireland after 1349, the number of friaries continued to grow. 36 Franciscan friaries were established over the next 200 years. While the popularity of the rich abbeys was in decline, the mendicant orders continued to grow.

The buildings are very well preserved in spite of having been burned down by Sir Richard Bingham in 1590. They are modest and simple, though the church has a finely carved west doorway, east window and window in the south transept. There are angels carved on the piscina as well as a strange little carving of Killala round tower. The domestic buildings are vaulted, with the refectory, kitchen and dormitory upstairs.

19 Ballina Dolmen

On a small hill near the railway station, overlooking the town of Ballina. It is right beside the road and signed from the N59 going south.

This dramatic dolmen is known locally as 'the Dolmen of the Four Maols'. The local story explaining its name tells of four foster-brothers named Maol who murdered their master who was a bishop. The murdered man's brother sought revenge and the four murderers were hanged and buried here at this dolmen. The word 'maol' most commonly means 'bare' or 'bald' but it also can mean 'a servant' or 'devotee'.

It is an impressive dolmen, almost 5 feet high, with 3 uprights supporting a cap-stone. A fourth stone lies nearby.

20 Cartronmacmanus Court Cairn
360 074
*This cairn is south of the Ox mountains in the foothills and east north east of Foxford, overlooking the valley of the river Moy. About 5 miles west of **Tobercurry** (SLIGO) on the R249, turn left to Aclare (2.5 miles) and then to Kilmacteige. Go straight through the village and continue south west for 3 miles. Turn right, then left and left again. The cairn is behind houses at the end of this road.*

This is a beautiful location and the cairn a magical place, though in a somewhat ruined state. There are 11 stones forming a broad shallow court with portals about 4 feet high leading into the first chamber. These portals are square-topped and the tallest in the structure. The gallery runs east west and is divided into two parts, each with a side chamber to the north.

21 Carrowcrum Wedge Cairn
315 161
Carrowcrum is south west of Bunnyconnellan about 4 miles east of Ballina, near the north east tip of Mayo. The Ox mountains are a strong presence in the south east. Turn right about 1.8 miles west of Bunnyconnellan off the R294 to Ballina. Turn left after 1.5 miles and the cairn is by the roadside on the left.

This cairn is known as Diarmuid and Grainne's bed, though it has more the appearance of a fairy house. In fact, it is a well-preserved wedge cairn with some of the facade still present.

Its chamber is short, oriented north east to south west and enclosed in a U-shaped cairn. The cairn has been built up with field stones, but some of the outer wall stones can be seen poking through. The chamber is wider and higher at the front, in keeping with the usual wedge shape. It has been partly reconstructed.

THE SOUTH

22 Cong Abbey

Between Loughs Corrib and Mask, west of the N84, 28 miles north of Galway.

The first monastery here was founded in the 6th century by St Féichín on a small island crammed into a narrow inlet at the north end of Lough Corrib. St Féichín is best known for his later foundation at Fore in Westmeath. In the 12th century this foundation was replaced by the High King Turlough O'Conor who built a house for the Augustinian Canons Regular around 1120. Most of the remains today are 13th century and the ruined abbey is now surrounded by the village of Cong.

One stone, at the south east end of the village, is a relic of an even earlier time. Leac na bPoll is a prehistoric bullaun stone with five hollows, (see **St Brigid's stone**, CAVAN) probably as old as the cairns and circles outside the village and part of the same ritual landscape.

The element of water is strong here, particularly around the abbey, and the island exudes fertility. We know that hollows, lakes and springs had sacred significance, particularly in Bronze Age times. These people deposited offerings of their most precious possessions of bronze and gold in their sacred waters and saw the smile of their gods in the ensuing fertility of these places. This

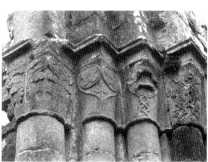

Foliage detail on capitals, Cong Abbey

lakeland area around Loughs Corrib and Mask has an abundance of such sites, evidence of a thriving culture here even before Celtic or Iron Age times. But first the abbey.

This is a beautiful place and it does not really matter that much of the Romanesque and Transitional detail of the doorways and windows has been replaced into a slightly later building. The 12th century building was destroyed in 1203 and rebuilt quite quickly. Most of the building is therefore early 13th century. There was much restoration in the late 19th century with geometric, leaf, and flower motifs, reflecting the strong elemental nature of the site.

The entrance to the abbey is through a beautiful Romanesque

CONNACHT **Mayo**

doorway in the north wall of the chancel. There is another very fine doorway, this time Transitional, leading from the chapter house into the cloisters, as well as some exquisitely decorated windows. The cloister has also been reconstructed and completed with some 19th century carving on some of its capitals.

Follow the pathway from the cloisters westward through an arch and left to the seclusion of the fish house. Here among the trees is the feeling of a water shrine, despite the mundane function of the building. It is a small stone house built over the river from which the monks hung a net with a line attached to a bell in the kitchen. When a fish was caught, the bell would ring.

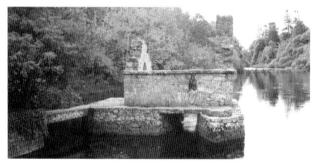

Fish house, Cong Abbey

The Roman Catholic Church nearby, despite its ugly exterior, has a beautiful Harry Clarke stained glass window which is well worth making a detour to see.

THE FIRST BATTLE OF MAIGH TUIREADH

This battle is said to have taken place on the plain of Cong just north of the town. The area is full of interesting sites, although sceptics say that the siting of the battle here was a transparent attempt to explain the presence of these sites, which were thought to be prehistoric graves. William Wilde, father of Oscar Wilde, made the original connection between this landscape and the legendary battle between the Firbolg and the Tuatha Dé Danann.

According to legend, they were both descendants of Nemhedh and had fled Ireland after their failed uprising against the severe taxes imposed by the earlier inhabitants, the Fomorians. Some fled north and some south. The southerners later returned from Greece as the Firbolg. They introduced the system of five provinces and were responsible for the socio-political order of the time. Perhaps

they were the original cairn builders. Their fifth province was at Uisneach, the navel of Ireland, and they are credited with introducing the concept of kingship and giving it sacred qualities.

The northerners returned later as the Tuatha Dé Danann. They brought with them new skills in magic and the Druidic arts. They also brought the Lia Fáil (see **Tara**), the Sword of Nuadha, the Spear of Lugh and the Cauldron of the Daghdha, from which no one would go unsatisfied.

The Tuatha Dé Danann came from the air in a cloud of invisibility, only taking form when they touched the mountain of Slieve Anierin in Leitrim. From there they travelled to Cong and some say it was here that they fought the Firbolg for possession of Ireland.

Some of the sites below are associated with this legend.

Cregotia or Toberbioge Cairn

About 2 miles west of Cong on the Clonbur road, pull in on the left by a forestry entrance on a right-angle bend. Follow the track into the forest on foot, taking the first path on the left. As the path narrows, look out for a worn track up the small limestone escarpment on the right.

The cairn stands on a limestone outcrop, the remains of cairn stones partly covering a deep chamber in the middle and parts of other possible chambers to the side.

It is in a small clearing in the woods, surrounded by ash saplings, holly and ivy. The stones are a mass of wild flowers - scabious, St John's wort and wood sage.

Cregotia cairn

Ballymacgibbon Cairn

Take the R346 from Cong to Cross and the cairn is signed on the left a couple of miles outside Cong. Access is up a lane and across a stone stile.

This is a massive cairn of stones, about 100 feet in diameter and about 25 feet high. It is partially ringed by thorn and ash trees which make it almost invisible until you are right beside it. There is a powerful sense of water here, similar to the cairn at Heapstown in Sligo. A small circular stone tower has been erected on top of the cairn. A wooded ring-fort is visible below the cairn across the road to the south.

CONNACHT **Mayo**

Glebe Stone Circles

About 1 mile from Ballymacgibbon Cairn. Take the Cross road back towards Cong and turn right towards Ballinrobe. One of the circles is signed on the right.

Glebe Stone Circles

This circle sits on sloping ground surrounded by mature trees. In fact there are 4 circles in the area with mention of a fifth when they were first discovered in the 17th century. The others are on private ground.

23 Eochy's Cairn

Go south from Ballinrobe on the R334 for about 5 miles and turn right at the crossroads. Take the first right and stop at the first right hand turn and follow the track on foot. The cairn is visible ahead.

This is also called Cairn Daithí. It is associated with the Battle of Maigh Tuireadh in which King Eochy or Daithí was killed.

This round cairn sits 22 feet high on a low hill overlooking Lough Mask to the west and beyond it to the impressive mountain ranges of Connacht. To the east, the plains of Galway stretch as far as the eye can see. With a diameter of over 150 feet, it is probably the largest cairn in Connacht and may contain a passage and chambers.

There is a very clear fosse or earthwork encircling the cairn, strongest in the west. This was probably constructed much later. There are outlying standing stones in the south west and east north east.

Inishmaine Abbey

Turn right off the R334 just south of Ballinrobe and keep on for several miles till the abbey is signed on the right. This last stretch of road takes you along the shore of Lough Mask where the grass is cropped tight by grazing cattle and geese, and dotted with erratic boulders. Finally the road dwindles into limestone pavement and then disappears as you reach the abbey and the lake shore.

The original monastery was founded here by St Cormac in the 7th century, then in the 12th/13th century, the monks became

Canons Regular of St Augustine.

There is a small church here now in the Transitional style of that time, with a fine double light window. The ends of the window mouldings are decorated with mythical beasts and the chancel arch has capitals carved with foliage and animals in the style of Cong. It has a trabeate door in the north wall which may have come from an earlier church. The transepts date to the 13th/14th century and there is a small 15th century gatehouse nearby. This is a tranquil place, with water from the lake lapping gently around slabs of limestone pavement which tilt into the water. Everywhere birds stand quietly watching for fish.

Some distance along the shore is an interesting sweat house with two doors. It is a long but delightful walk in a landscape that has seen very little change for centuries.

24 Ballinrobe Catholic Church

There are 9 stained glass windows by Harry Clarke here, all dated to 1926. Many of Mayo's saints are here: SS Fursey and Féichín, Colman and Brendan, Gormgall and Ciaran, Enda and Jarlath. Patrick, Brigid and Colmcille are also here, as well as scenes from the early life of Christ. (*Shell Guide*)

FROM BALLINTUBBER TO CROAGH PATRICK

25 Ballintubber Abbey
Just east of the N84, about 11 miles south of Castlebar. Signed.

An Augustinian abbey was founded here in 1216 by the King of Connacht, Cathal Crovdearg O'Connor, on the site of an earlier foundation. In 1216 its position on the pilgrims' path to the holy mountain of Croagh Patrick would have given it an important place in the medieval religious calendar. To the west of the church are the remains of a bathhouse and hostel where early pilgrims walking the old path would bathe their feet and rest on their journey.

In spite of fire damage in 1265, and destruction at the hands of Cromwell's forces in 1653, the abbey has remained in continual use right up to the present time. In fact the present restoration work was only completed in 1966. The effect is simple and magnificent at the same time, giving some sense of how a large

CONNACHT **Mayo**

medieval church would have looked and felt in medieval times.

The late Romanesque carving on the windows and capitals is very delicate and attributed to a group of masons, called the Ballintubber stone-carvers, who worked between the 12th and 13th centuries. The capitals at Boyle Abbey are also attributed to them. Other interesting features are the 15th century west doorway, the chapter house doorway (similar to Cong style) and the tomb of Tiobód na Long Burke, Granuile's son who died in 1629.

The grounds have unfortunately been turned into a kind of spiritual theme park in an uneasy mixture of kitsch and concrete.

The pilgrims' path from here to Croagh Patrick has been reopened and anyone can make the 15 mile journey. It is known as 'Tóchar Phádraig', meaning 'Patrick's Way'. The 12 foot wide roadway, now reduced to a small path, has 113 stiles and many sacred sites along the way. Some cannot practically be reached any other way. It is asked that you get a note from the abbey before you set out, as this is part of the agreement made with local landowners who have allowed access to their fields.

Of course Croagh Patrick's status as a holy mountain is much older than Christianity. Anyone travelling in the area who has suddenly seen it come into view, can be in no doubt that it has always been a powerful presence in our landscape. Local tradition has it that the pilgrim path links the sacred mountain with Crúachain, in Roscommon, the royal site of Connacht. It is likely that ritual journeys were made along this route from at least Bronze Age times as evidenced by, for example, the standing stones at Lankill and Lanmore. The Boheh stone is also on this route.

26 The Boheh Stone

It is about 5 miles from Croagh Patrick. To get there by road, take the N59 south from Westport for about 6 miles to Liscarney crossroads and post office. Turn left just before the Post Office and then right for 0.3 miles. The stone is in a farmyard on the right. There are old concrete sheds nearby.

It is old and rugged, an asymmetrical heap of small stones and one huge one. In 1873 it was described as being in a field. Now it is between a house and some farm sheds.

Many of the surfaces are inscribed. There are cup marks, single incised circles and double or triple incised concentric circles. Some are surrounded by broader half and quarter circles and some of these have straight lines extending out from them. It is not clear whether or not the stone was moved here, or raised up on the smaller stones, or whether it was found and carved in situ. Whatever the

case, when you stand on the Boheh stone at certain times in the year, the setting sun appears to roll down the right hand side of the mountain 5 miles away.

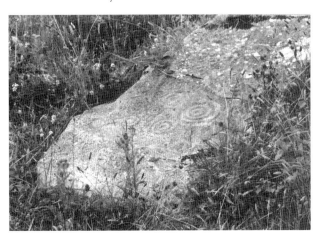

Boheh Stone

This phenomenon was first noticed by Gerry Bracken, from the Mayo Historical Society, following repeated visits to the stone. In April 1991 he described how, over a 20 minute period, the setting sun followed the slope of Croagh Patrick as it went down. He concluded that what he was seeing would have been seen in prehistoric times from this same stone, giving it special significance which resulted in the inscriptions which we can still see today. (*GG Bracken & PA Wayman WHS 1992.12*)

The dates when this phenomenon occurs are the 18th April and the 24th August. Together with the winter solstice, they divide the year into thirds. They could also be linked to times for sowing and harvest.

27 Murrisk Friary
To the north of the R335 Louisbourg Westport road.

This small Augustinian Friary was founded by Tadhg O'Malley in 1457. It is the starting off point for the ascent of Croagh Patrick in modern times.

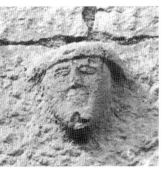

Head, Murrisk Friary

CONNACHT **Mayo**

Killadangan Stone (Kildun Pillar Stone)

1 mile east of Murrisk beside the R335 is a pillar stone and 4 stone row. There is also an enclosure which may be part of a circle.

28 Croagh Patrick

My first view of Croagh Patrick was travelling south from Ballina to Castlebar on the R312. The road runs between Nephin mountain and the Nephin Beg range and it was almost dark with the evening sun behind the mountains. Then the landscape opened out all the way to the coast and I came to Beltra Lough. Suddenly, it was bright and warm and the clear cone of Croagh Patrick appeared shining across the lake.

It is made of hard Pre-Cambrian quartzite, like many of the west's mountains, and the cone shape is also familiar: Errigal in Donegal, Slievemore on Achill or Nephin in Mayo, for example. Their hard crystalline structure absorbs and refracts light and other unseen energies. Their circular shape also allows them to radiate. The properties of white quartzite were recognised by the megalith builders in prehistory who used it in their cairns and circles, and still today the remnants of this practice continues, where special stones are whitewashed annually.

While it is possible to dismiss Croagh Patrick's magnificence as an aesthetically pleasing bit of geology, it has a long history of much more.

It has been associated beyond living memory with Lugh, the god of light and Lughnasa at the end of July, the time of the first fruits of harvest. It is also associated with Crom Cruach, the dark figure associated with the underworld and to whom the last harvest sheaf is given. He takes it underground in the form of the corn maiden, and the seed is sown to ensure fertility for the coming year. Lugh and Crom are part of the same cycle.

The later Christian association of darkness with evil has

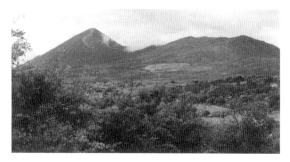

Croagh Patrick from Boheh

turned Crom Cruach into a fearful figure and St Patrick has replaced Lugh as the symbol of light.

As at all Lughnasa sites, the holy mountain was climbed and the cycle of fertility celebrated at the end of July. It used to be the last Friday of the month, which was Crom's day, but today's pilgrimage is on the following Sunday.

Peter Dawkins suggests that the original route up the mountain is along the spine, a longer walk, but by a route that energises, rather than exhausts (*The Landscape Temple of Ireland*). This makes a lot of sense as it also follows the line which runs in a slight arc between Crúachain in Roscommon, through Croagh Patrick, and on to Caher Island to the west. It also illustrates the change in emphasis from a pagan festival to a medieval Christian pilgrimage.

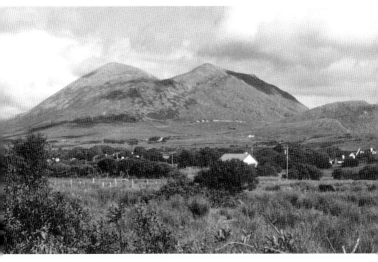

Croagh Patrick from the north

Early writings say that Patrick came here to fast for 40 days and nights to win some concessions from God. One of these was that he should be allowed to judge the Irish people at the Last Judgement. Apparently, God conceded on this point. While he was fasting, he was attacked by demons in the form of birds. He had a sacred bell, given to him by St Brigid, so he rang it, but the demons remained. He then threw the bell at them and they all fled except one - the Caoranach. Some call her the devil's mother, to others she is one of the three aspects of the goddess, and to others still, she is seen as the serpent, symbol of paganism.

Nearby in Galway there is a mountain, called the Devil's Mother, where she is said to have rested. In Lough Derg, Donegal, her petrified serpent's body forms islands in the lake.

658 PROVINCE OF CONNACHT *Sacred Ireland*

In true Celtic style Patrick becomes, over the centuries, associated with sacred and royal places, with magical feats according to the tradition of a Celtic god. He defeats the triple goddess in her darkest form, as Caoranach, and usurps the sun god Lugh. Over in Cavan, he destroys the power of the dark Crom.

The reek can be climbed anytime, but on St Patrick's day and Garland Sunday, huge crowds climb and services are held at the summit. There are also special stations or places where prayers can be recited and the stations perambulated, always sun-wise or deiseal and, at this site, 7 or 15 times.

Excavations have uncovered a large asymmetrical enclosure at the top of the reek, and inside Teampall Phádraig, an oratory of similar construction to that at Gallarus, Kerry, has been found.

It is interesting that this same construction is found at both pilgrimage sites on the coast. Peter Harbison puts Croagh Patrick, Sliabh League, Donegal and Mt Brandon, near Gallarus, Kerry, together as three pilgrimage sites accessed by sea. This type of oratory he sees as shelter for pilgrims. It is possible they were signed by cross-inscribed pillar stones visible from the sea.

Continuing the way...

Tradition links the mountain with **Kilgeever Church and Well** and with **Caher Island**. Between these two lie a two stone row at **Cloonlaur**, by Sruhir strand, north west of Killadoon village.

Kilgeever is signed just past the camp site on the south side of the R335, about 2 miles east of Louisburgh. The holy well here is called 'Tobar na Rí', which means 'the Well of the King'.

From Louisburgh take the R335 south for 5 miles to Cregganbaun. Turn right. **Srahwee Wedge Cairn** is less than a mile along on the right just before a right turn. It is visible from the road. Considered locally as a holy well, it is a well-defined tapering wedge-shape with a typical double wall. It is made of limestone slab with one large cap-stone. The door stone is in place in the west north west. There is some evidence of a cairn.

Continue past Srahwee into **Killeen.** In the churchyard here there is a marigold stone and cross slab.

Go through Killeen to the next crossroads and turn left. **Cloonlaur Stones** are down a lane about 0.5 miles along on the right. This two stone row seems to line up with Croagh Patrick in the east and Caher Island to the west.

29 Caher Island

5 miles south west of Roonah Quay, 3 miles from Louisburg.
Caher Island is less than a mile long, running south east to
north west and has no pier. The landing place is at Portatemple.

Its full name is Cathair na Naomh, 'the City or Seat of the Saint',
and a little south east of the monastic enclosure is Bothar na
Naomh, or 'the Saint's Road', which is said to cross the seabed and
connect with Croagh Patrick. Caher Island is supposed to be the
last station on the pilgrims' road to the holy mountain. This seems
to be a way of saying that the energy line doesn't stop, as the
pilgrims do, at the mountain.

A small monastery sits in a hollow to the west of the
landing place within the fragmented remains of a dry-stone wall
enclosure. Inside is a dry-stone oratory, renovated in the 14th or
15th century. East of it is Leaba Phádraig, Patrick's Bed, a carved
slab and headstone, credited with miraculous healing powers and
said to cure epilepsy, if occupied overnight. Other stone slabs and
leachtaí (platforms) mark pilgrim stations.

It is claimed that the soil of Caher, as well as stones from the
top of Croagh Patrick, will keep rats away. However, misfortune
will follow anyone who removes anything from the island.

Caher has been uninhabited for more than a century.

30 Clare Island

Far out in Clew Bay, it is reached by mail-boat from Roonah Quay,
3 miles from Louisburgh. It takes 15 minutes. For details phone
098 28288/25212 or 0868515003. They also have a small boat
which can be chartered for individual trips in the Clew Bay area.

Clare Island formed part of the territories of the O'Malley family,
made famous by their pirate daughter, Gráinne Ni Mháille, known
as Granuaile.

The ruined 15th century castle near the harbour belonged to
her father, and it was here that she returned with a substantial
following from her piratical exploits after the death of her first
husband. Her notoriety as pirate queen spread from here.

The castle was renovated in the early 19th century as a coast-
guard building. What irony!

About 1.5 miles south west are the ruins of a small abbey,
founded in the 13th century as a cell of the Cistercians of
Knockmoy, in Galway. The present building is 15th century and in
the chancel you can still see traces of medieval frescoes of animal
and human forms on the ceiling and the east wall.

The remains of Granuaile are supposed to be interred in the O'Malley tomb here. A memorial in the chancel reads: TERRA MARIQ POTENS O'MALLEY -

O'Malley, Powerful on Land and Sea.

There is a dwelling tower over the chancel.

Granuaile

Granuaile was the most famous of the O'Malley clan - chieftain, pirate and politician, negotiator with queens and princes, and a fierce upholder of Gaelic life. She was born about 1530, an only child, daughter of Dubhdara O'Malley, one of the few Gaelic chiefs at that time not to have submitted to the English. Her mother, Margaret, was heir to much land in her own right.

Although she is remembered for her piratical exploits, she was also a politician and when Richard Bingham turned to violence to enforce English rule, she sailed to London to see Queen Elizabeth I for herself. An audience was granted in September 1593. According to some sources, Queen Elizabeth offered her the title of countess, but she refused, saying she had no need of such titles as they were already equals.

One of her ancestors, Muirisc, though less well known, and living some time about the 6th century, was a Bronze Age matriarch of similar strength of character to Granuaile, but she lived before the great change in women's status that came about with medieval Christianity. The ensuing patriarchy did much to end the tradition of strong warrior women in Ireland. By the time of Granuaile, women's roles were strictly limited in society to childbearing and good works and moving more or less within the orbit of their husbands' world.

The Brehon Laws were gradually replaced by Roman Salic Law and the Christian attitude to women as secondary humans who threaten the spirituality of men by offering temptation, gradually crept its way through Irish society.

Before this, men had often taken their mother's name, as Conor Mac Nessa, for example. The warrior hero, Cúchulainn, was trained in battle skills by the female warrior Scathach. Granuaile had ancestral precedents for her power on land, but not at sea. Until Granuaile, the sea had always been a male domain.

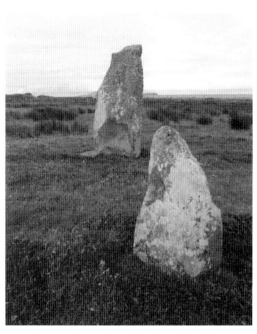

Stone row linking Croagh Patrick to Clare Island

County
SLIGO
PRINCIPAL SITES

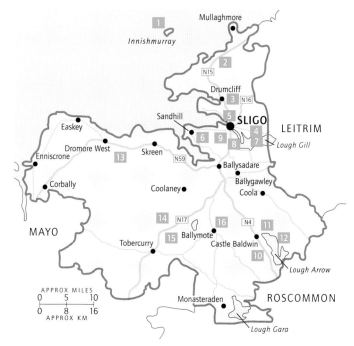

1 **Inishmurray** monastic settlement

2 **Creevykeel** court cairn

3 **Drumcliff** high cross

4 **Magheraghanrush** court cairn

5 **Sligo Abbey**

6 **Knocknarea** and **Maebh's Cairn**

7 **The Lake Isle of Innisfree**

8 **Tobernalt** well

9 **Carrowmore**

10 **Carrowkeel**
 Kesh Corran
 Cormac's Well or **Kingstone Well**

11 **Heapstown** cairn

12 **Carrickglass Dolmen** or **The Labby Rock**
 Barroe North round cairn (See Lewey)
 Lough Na Súil (The Lake of the Eye)
 Moytirra East court cairn
 The Eglone

Block figures in list refer to site locations in map and entries in text.

SLIGO

SLIGO IS IN THE NORTH WEST. Its name comes from the Irish 'Sligeach', which means the 'Shelly Place'. All of the county was, in ancient times, under the sea, so that even high up in the mountains, shells are still found in abundance. Sometimes you can find rocks in the hills which are full of petrified coral and black rock full of small white stars which look like the night sky.

Mesolithic remains that may be over 8000 years old, have been found at Carrowmore. Some archaeologists accept a date around 4000 BC for some of these structures, which is still about 1000 years before Brú na Bóinne, or Newgrange. This means that Brú na Bóinne was not the first passage cairn in Ireland, a fact that is fairly universally accepted now. It also suggests that this megalithic culture developed across Ireland and may even be indigenous, rather than arriving complete from outside. Perhaps Ireland's mesolithic people had a much more organised society than we imagine, one in which they constructed the first great cairns as symbols of the great Earth Goddess. Perhaps the passages expressed in the physical plane their understanding of the cycle of conception and birth: the sun or moonlight impregnating the womb inside the great belly of the cairn.

It is possible that these were the Firbolg. Bolg means 'belly' which is one of the universal symbols of the goddess. Fir means 'men'. It is conceivable that these were the 'people of the goddess', one of the earliest societies in Ireland, and possibly the first successful one. This could explain why the big cairns are all associated with a particular goddess.

We do not know where these people came from, though the possibilities have widened dramatically in recent decades. North Africa, the Middle East, the Basque Country? Who knows? Wherever they came from, Sligo Bay provided a gateway into Ireland.

CONNACHT **Sligo**

1 Inishmurray Monastic Settlement

Accessed by boat in good weather by private arrangement.
Phone either Mullaghmore Village - 071 91 66124 or
Rosses Point - 071 91 42391.

This small sandstone ridge, about 4 miles out in Donegal Bay, became an island around 9000 years ago, when surrounding land was submerged by rising water levels at the end of the last ice-age.

It is a remarkable place, with a purity of atmosphere that seems to make time stand still. There are some slight megalithic remains, but little early mythology. Yet it has a rich spiritual past with links connecting it to Devenish Island and Iona in Scotland through the activities of two of Ireland's most colourful saints, St Molaise and St Colmcille. It is thought by Michael Poynder to be on a major ley line that crosses Ireland from Newgrange in Meath.

On the island are the ruins of an early monastery, said to have been founded in the 6th century by St Molaise, who is more famously associated with Devenish Island in Fermanagh. He was visited by St Colmcille after the battle of Cúl Dreimhne, when he came to receive judgement from St Molaise. (see DONEGAL) The story goes that Colmcille came to the water's edge and, finding no boat to take him across to the island, he spread his cloak on the water and a dry path opened before him.

Molaise's judgement was to exile him to a point from which he could no longer see the hills of Ireland. Colmcille spent some time here, in preparation for his journey, and then sailed north. The first land from which no sight of Ireland could be seen was the island of Iona, and this is where he stayed.

Inishmurray was raided by Vikings in 807 AD. There is no other mention of it in the annals. Oral tradition suggests that the monks left the island at the end of the 12th century and the monastery was not colonised by any of the new European Orders. In this way it escaped the dogma of Medieval Christianity and, while it may not have developed as a monastic settlement, it continued to serve the spiritual needs of the islanders until their final evacuation in 1948. The island had no church or priest, only the ancient site which provided the focus for their prayers and religious observances. These observances probably owe as much to Celtic as to Christian tradition. The remains inside the cashel were used as praying stations.

Most of the monastic buildings are enclosed by a stone cashel, which was divided into three separate areas. There are three churches: Teampall na bhFear, or the Church of the men, Teampall na Teine, or the Church of the fire, and Molaise's

House. The Church of the Fire is called 'the monastery kitchen', but there was a tradition, while the islanders still lived on the island, that if all the fires on the island went out, they could be rekindled from a turf placed on the hearth here. There is also some mention of a perpetual fire here and a story about someone who desecrated the hearth and was consumed by fire. Their bones now rest in an alcove in the church.

Teach Molaise, or Molaise's House, is a tiny oratory with trabeate doorway and steep stone roof. His altar and his bed are here, and a wooden statue dated probably to the 12th century was taken from here, and is now in the National Museum. Its depleted state is in part due to the islanders' habit of chipping off bits to send to relatives abroad in times of trouble. Early this century a curate from Grange stopped this practice by blessing religious medals and touching them to the statue, so that they could be sent from the island instead.

There are also two beehive huts. One is large, with a corbelled roof and a stone bench along one wall inside. It is called 'the Wake of the Virgin', though there is no clear explanation for its name. The other is called 'the Lenten Retreat'. This one has two rooms and an upper storey above one of them.

Just outside the cashel is a sweat house near a deep covered well and nearby is Teampall na mBan, or the Church of the Women. This division of men and women in separate churches is quite common in early Christian sites and presumably precedes the concept of single sex Christian communities, which are still with us today.

Near the Women's Church is a hole stone with a cross inscribed on it. This stone and another, near Teampall na mBan, were visited and prayers said by pregnant women for a safe delivery. The stones are called 'Praying Stones', and the person would kneel with their thumbs on the front and their fingers pushed into recesses in the side, so they could grasp the pillar. This also made it easier for a heavily pregnant woman to rise from the stone. It is said that no-one on the island ever died in childbirth. Near the Church of the Men is another pillar, similar in size, but without hole or carving.

There are three altars inside the enclosure, one with about 50 round stones sitting on top. These are the Speckled, or Cursing Stones (Clocha Breaca), now Christianised with simple incised crosses. There was a tradition on the island that if a curse was wanted against someone, the Big Station (see below) had to be done in reverse, that is, not sun-wise, but anti-clockwise, and the stones turned anti-clockwise while making the curse. If, however, the curse was unjust, it would rebound on the perpetrator.

CONNACHT **Sligo**

This practice is not unlike that described in the story of Cormac mac Art's conversion to Christianity. It is said that the priests of Crom Cruach, when they heard of it, cursed him daily in their mystic ring, turning the stones.

A number of these stones have been taken from the island to the National Museum for safe keeping. An appointment is needed to see them.

The Big Station

There was a traditional pilgrimage around the island which was called the 'Big Station'. It was performed at least once a year on the 15th August, the Feast of the Assumption. People from the mainland used to come and join the islanders in this 'turas' (journey) around the shore of the island, stopping at inscribed stones, stone altars and relics which marked 16 different stations or stopping places. These would be walked around twice while prayers were recited.

The Big Station involved fasting from the previous midnight and walking barefoot, beginning with rounds and prayers inside the cashel. Pilgrims then walked three times around the cashel walls, before setting off to visit each station in turn, going sun-wise around the island.

The first station is south east of the cashel at the shore near the landing stage, Port an Churaigh. It is a stone altar, called the Altar of Colmcille, or in Irish, 'Leachta Cholmcille'. A little further to the west and still south of the road is Roilig Ódhráin, meaning 'Oran's Cemetery'. This was the next station. It came to be used as a burial ground for unbaptised children, though it was probably once the graveyard for the islanders. Later, men were buried in the cashel and women in Teampall na mBan.

Still going west, Mary's Altar is the next stop at Clashymore Harbour and then the ruined hermit's cell, called Trahaun Ó Riain, over on the eastern shore. Continuing sun-wise round the shore, the Great Cross is a small cross inscribed on an altar, then Hugh's Cell, and Tobar na Córach, the Well of the Fair Weather, on the north coast.

In an emergency in bad weather, water from this well would calm the ocean.

Leachta Phádraig, a memorial altar to St Patrick, is right at the east end of the island on the cliff edge, and not to be confused with the stone piles for drying seaweed. The last two stations, called simply the Big Station of the Trinity and the Small Station of the Trinity, are in front of the houses just before the Altar of Colmcille again.

The Big Station would then finish at Teampall na mBan.

Lesser stations associated with the monastic enclosure were performed more frequently by the islanders.

The *Soiscéal Molaise*, or *Gospel of Molaise*, and his statue are in the National Museum, Dublin. His bell and crosier are in private ownership in England.

2 Creevykeel Court Cairn
To the left of the N17, 8 miles south of Ballyshannon.
Signed with small car-park.

This is a fine example of a court cairn, with a full circular court set within a wedge-shaped cairn, which would have been about 230 feet long. A passage in the east leads from the wide end of the cairn into a cobbled court, which measures about 50 feet by 30 feet. Opposite this passage, across the court, is the gallery which has a fine pair of portals with a lintel on the top at its entrance. More portals and a sill mark a division of the gallery into two chambers.

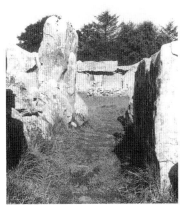

Creevykeel court cairn. View through the entrance to the court with the gallery portals visible at the other side.

Shallow pits were found in the gallery in the west end of the cairn during the excavation in 1935. They contained four cremated burials. Other items were also found: polished axe-heads, a stone bead, some flint arrowheads and neolithic pottery. Most interesting of all was the discovery of two clay balls of a type which is more usually associated with passage cairns. Other court cairns in Connacht, such as Behy in Mayo, have side chambers forming the same kind of cruciform shape as many of the passage cairns like Newgrange in Meath.

Three single chambers open directly into the sides of the cairn at the west end. They appear to have been part of the original structure.

This is a lovely court cairn, partially and sensitively reconstructed so that its complex nature can be appreciated.

To the left of the car-park is a narrow path leading to a small well with clear clean water. The surround is whitewashed with a little gate in front.

CONNACHT **Sligo**

3 Drumcliff High Cross

Going south on the N15, there is a ruined round tower on the right. Down a lane to the left is Drumcliff Church, where Yeats' grandfather was vicar from 1811 to 1846.

Yeats died in France in 1939. Four months before he died, he wrote a poem describing this place as his chosen resting place where he would be buried with a simple limestone gravestone. As he requested, his grave is simple and the stone carved with the words:

> Cast a cold eye
> On life, on death,
> Horseman, pass by!

He was originally buried in the south of France where he used to spend the winter, but in deference to his final wishes, his remains were brought back here in 1948. To the north east of the graveyard, under the trees, the presence of 'bare Ben Bulben's head' is intense, not entirely benevolent, but very powerful in a wild kind of way. It is easy to see why Yeats was so affected by this mountain.

In the graveyard by the car-park is a highly ornamented high cross dating probably to the 10th century. This, together with the tower, are all that remain of the monastery founded here by St Colmcille in the 6th century. The cross has ornate beaded moulding around scriptural panels. On the east face from the base: *Adam and Eve* are either side of a tree whose roots and branches form intricate knot patterns above and below, while the tree itself has a very life-like serpent wound round its trunk. Above this is a lion-like figure in high relief with other old testament scenes and *Christ in Glory* at the centre of the cross. The west face has an interlace panel at the bottom, with *The Presentation at the Temple* above it, and above that, another exotic animal in high relief. As usual, the centre of the west face shows the Crucifixion.

The sides are ornamented with interlacing and mythical beasts in high relief. They also have two unusual square mortise holes, one on each side, about a third of the way up the cross.

4 Magheraghanrush Court Cairn

Approaching Sligo town from the north, turn left towards Enniskillen and Dromahair on the R286. After 0.5 miles veer left to Calry. About 0.5 miles past Calry, the Giant's Grave and Deerpark is signed to the right. From the car-park, walk up the path on the left and then turn right up a track signed 'Stone Circle'. This is a 20 minute walk.

CONNACHT Sligo

Here we have a beautiful limestone court cairn with a huge oval central court, about 50 feet long. The limestone slabs are pocked and pitted and hoary with lichen and other flora. The entrance

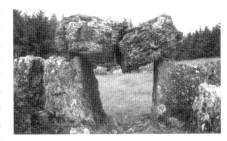

Magheraghanrush court cairn. Broken lintel looking out onto the court.

to the court is in the south. Two galleries open off the east end and one opens west. The galleries in the east appear to have three chambers while that in the west has only two. Some of the long cairn, which would have covered this temple, is still visible, extending in length about 150 feet and with a width of about 60 feet.

Unburned human and animal bones have been found at the site but no artefacts.

A **cashel, wedge cairn and souterrain** can be found in a field lower down to the south.

5 Sligo Abbey

In the centre of the town. The abbey is under the care of Duchas. Admission charged.

The remains of the abbey, which is actually the Dominican Friary of the Holy Cross, are quite substantial, in spite of its stormy past. It was burned in 1414, destroyed by the English in 1595, and destroyed again by the Parliamentarians in 1641.

Parts of the 13th century nave and chancel have survived and there is an unusual 15th century sculptured altar, as well as part of the rood screen and some well-preserved cloisters. In the refectory upstairs you can still see the reader's desk where a monk would have read to the rest of the community while they ate.

The O Craian tomb in the north wall of the nave is early 16th century. Nine canopied niches on the front of the chest frame nine figures. In the centre are Mary, and Christ being Crucified. On either side from the left are: Saints Dominic and Catherine, another saint, Saints John, Michael, Peter, and a bishop.

On the ground near the cloisters is a grave slab in memory of a young man called James. The stone was erected by his mother. Some time later, all other details by which he might be identified have been carefully chiselled away. Presumably he or his family lost favour with the friary.

CONNACHT **Sligo**

Erased grave slab, Sligo Abbey

The small visitor centre has copies of Charlotte Thornley's diary. She was the mother of Bram Stoker, who wrote the Dracula stories, and they lived in Sligo during the cholera epidemic of 1832. She describes the desperate conditions in the town as the living struggled to bury the dead. Apparently coffins and bodies were carried into the disused abbey and left piled high on the altar, the only available consecrated ground in the town. In 1848 a town cemetery was opened and burials were no longer allowed in the abbey. Townspeople took to burying their dead in the abbey at night so that they could be with other family members.

6 Knocknarea and Maebh's Cairn

Take the R292 west of Sligo, signed to Strandhill and turn left at the crossroads 3 miles out of the town. Turn right at the second crossroads and the car-park is signed on the right, less than a mile along this road. The car-park is on the south eastern slope of the hill.

The striking profile of Knocknarea is visible for miles in any direction and from its summit, five different counties can be seen, as well as miles of ocean far beyond the confines of Sligo Bay.

On top of the hill and visible from all five counties, is Maebh's Cairn. It is about 35 feet high and 200 feet across and is said to hold upwards of 40,000 tons of loose stones. Here in Connacht, Maebh is the warrior queen. In Celtic myth her palace was at Crúachain, in Roscommon, where she lived with her husband Ailill. She is best known for her part in one of Ireland's most famous sagas - *The Cattle Raid of Cooley* or *Táin Bó Cúailnge* (see LOUTH) which begins and ends at Crúachain.

Folklore tells us that Maebh's remains are buried in an inner chamber in the cairn. Indeed, it is said that she has still not forgiven Ulster for not letting her have the Brown Bull, and so she is not lying at rest inside the cairn, but standing, spear in hand with her best warriors, facing Ulster and just waiting for an auspicious

moment. These myths give us clues to a deeper reality. Although the cairn is associated with Maebh, it was never meant to be her tomb. According to a much older tradition, she is the goddess of this place and very much alive in the fertility of the land, the red of the sunset, and the rising moon.

The myths and folklore illustrate just how powerful this site was to those who lived within its aura thousands of years ago, and the importance of its place in the sacred landscape of which it is a part. The cairn is probably 6000 years old, with a passage and chambers inside, like the other Sligo cairns. In fact it is considered to be the main cairn for the Carrowkeel complex south east of here, in the Bricklieve Mountains. Most of the cairns there have their entrances facing Maebh's cairn on Knocknarea.

The mythical Maebh is strongly associated with the colour red, which fits well with her passionate role as inebriator and seducer of kings. Moreover, the setting sun reddens the waters below her cairn. In contrast, the great sidh at Brú na Bóinne in Meath is associated with Bóinn, the White Cow, and is situated in the east of the country, connected to the rising sun and the colour white.

Martin Byrne, who lives in the area, has been observing astronomical alignments here for a number of years. He has noticed that the lunar standstill is an important time at Knocknarea. The Moon's cycle takes 18.6 years to complete as it moves from its most northerly to its most southerly positions. At its most southerly rising position, which last happened in the summer of 1987, the moon, when viewed from Maebh's cairn, rose over the Carrowkeel sites in the Bricklieve Mountains. If the inner passage in Maebh's cairn was open, maybe the moon, at its most southerly point, would shine inside it.

Conversely, this should mean that near the winter solstice in 2006, as the Moon sets behind Knocknarea, it will illuminate the chambers of four of the Carrowkeel Cairns. And perhaps the Irish meaning of Knocknarea is actually 'the Hill of the Moon'. (see Martin Byrne's website: **www.carrowkeel.com**)

It seems that the top of Knocknarea was inhabited over a 1000 years after the cairn was built, around 2300 BC, still in neolithic times. Archaeologists have found some hut enclosures, with worked flint, north east of Maebh's cairn. There are a number of such hilltop habitation sites dating to this period, when the weather was several degrees warmer and dryer than at present. They were all abandoned when the climate deteriorated and, denuded of their forest cover, most of these hilltops became smothered in blanket bog.

South east of Sligo town is Cairn Hill, where there are two large unexcavated cairns. It is due east of Knocknarea. The west cairn on Cairn Hill, visible from Knocknarea, is said to be the

resting place of the Daghdha, chief of the Tuatha Dé Danann and father god of the Celts. According to this tradition, Maebh is his consort, and together they have a daughter called Fionndeabhar. Further east is Lough Gill.

According to Martin Byrne, at the equinoxes, if you stand on Maebh's cairn, the sun rises over Lough Gill to the east. The dawn light reflects off the water, creating a sea of brightness. Lough Gill means the 'Lake of Brightness'. Conversely, when the sun sets at the equinoxes you can stand on the western cairn at Cairn Hill, just west of Lough Gill, and watch the sun setting over Knocknarea.

Cairn Hill is accessed by a path from the car-park at Cairn Hill Forest Park, in Sligo town.

The People of the Hill

This is a story, given to me by Michael Roberts, who has been collecting local stories in the Sligo area. It gives another version of the origins of the landscape around Sligo town, and especially the beautiful **Lough Gill**. This story links the lough with the holy well, **Tober an Ailt**, and the cairns on **Cairn Hill**.

Gealla was the daughter of Aodh Múr, the local chief. She was greatly admired for her beauty and gentle nature. ('geal' means 'brightness and purity' in Irish). She was popular with the people of the village and many of the local chiefs wanted to marry her, though she was in love with Oghamra, a young scholar who lived on the hill on the other side of the lake.

But there was a problem. Romera was a soldier, hardened by battle and wise in the ways of the world. He was arrogant and insensitive and wanted to marry Gealla to enhance his standing among the chiefs of the region. He spoke to her father and asked for her hand. Aodh Múr was reluctant to even consider him, but protocol demanded that he should put it to Gealla. When Gealla was consulted, she refused to consider the proposal at all because of her love for Oghamra. This made Romera very angry and jealous. He was not a patient man, but he waited for his opportunity.

One day, while Oghamra was hiking in the hills to the south of the village, he heard someone singing in the distance. It was Gealla. He followed her voice, pushing his way through the hazel wood until he could see her near the cliff. She didn't notice him, but went on collecting herbs and singing with the birds. Then she noticed Oghamra and stopped singing. They looked at each other.

Usually Gealla was accompanied by her attendants, but for the moment they had wandered away in search of myrtle that grew in the area. He felt a little shy and hesitated to start a conversation. She laughed at his shyness and he smiled.

Just then Romera appeared, sword in hand, in a jealous rage.

He had planned to talk to Gealla alone to try to persuade her to marry him, but now his plans were thwarted. He charged like a wild boar in a blind, black rage, and a moment later Oghamra lay mortally wounded at her feet. She knelt down, holding his head in her lap and sobbing, as his life slipped away. Romera, realising what he had done, ran away into the valley and there he fell on his sword and put an end to his own life.

Some days later, Gealla was found lying across her lover's body. She had died of grief and her tears had flowed over the cliff and formed a pool among the stones at its foot. The tears of the handmaidens who found her joined hers, and they filled the valley, until a lake was formed.

Filled with grief, her father covered her body with her favourite flowers and herbs and let it float down the stream of her tears and out onto the lake. In time, the birds came to nest on this small, floating island, to sing to Gealla as they had when she was alive, and they hatched their eggs in her keeping. They brought her gifts of grasses and twigs and, in time, the island took hold in the lake. It is now called Innisfree.

With the passing of the years, the island became as beautiful as the young woman who had gathered flowers and herbs at the cliff that bright spring morning.

The lake, Lough Gill, flooded the village of Sligo, and the people moved further downstream to where the river runs into the sea.

Oghamra and Romera were carried to the top of the nearby hill and were covered with stones, monuments to the sadness and foolishness of this world. This is now called Cairn Hill.

People still visit the well at the cliff, Tober an Ailt, to consider Gealla, Oghamra, and Romera, and how they met their sad fate. (see below)

7 The Lake Isle of Innisfree

From Kilerry continue to the end of the road and you come to a cul de sac by the south shore of Lough Gill. The Lake Isle of Innisfree, made famous by the poet W B Yeats, is just off the shore of the lake.

I will arise and go now, and go to Innisfree,
And a small cabin build there, of clay and wattles made:
Nine bean-rows will I have there, a hive for the honey bee,
And live alone in the bee-loud glade.

And I shall have some peace there, for peace comes
 dropping slow,

CONNACHT **Sligo**

Dropping from the veils of the morning to where the
cricket sings;
There midnight's all a glimmer, and noon a purple glow,
And evening full of the linnet's wings.

I will arise and go now, for always night and day
I hear lake water lapping with low sounds by the shore;
While I stand on the roadway, or on the pavements grey,
I hear it in the deep heart's core.

On an autumn evening in warm sunlight, with the wooded
lake shores just changing colour, you can walk out along the long
slender pier into the lake and surround yourself with water clear as
glass, the silence broken only by the cry of a heron as it lifts off the
shore. You can see across the lake to Parkes Castle.

8 Tobernalt Well

708331
Just east of Sligo town by Lough Gill. Signed to the left on the N4
leaving Sligo. Follow the road for several miles down to the lake. It
is signed again on the right and there is a car-park.

I arrived here one Sunday evening in October to find a constant
stream of people visiting this well. They were still coming when I
left and the light was fading. Dusk is, of course, the most magical
time of day, but I imagine most of these people were coming here
in the evening after work. There is a tradition that the well contains
a sacred trout. It was apparently caught by a traveller and prepared
for cooking, when it leapt from his hands and returned to the well.

The site is accessed through a gap in a stone wall and well-kept
paths lead through an exquisitely wooded garden where the stream
flows from the well. You have now entered a kind of sacred grove.
Ahead, on the wooded hillside, is a Christian altar complete with
banks of flickering candles, while left and right paths lead off to
other altars all similarly illuminated. The effect is enchanting - a
perfect blend of natural and Christian magic.

There is a healing stone near the centre of the grove, just
below the well itself. It has a depression at one end where you can
rest your back for a cure for back pain. On top of the stone are four
indentations, said to have been left by St Patrick's fingers. If you rest
your fingers there, some of the saint's power is transferred to you.

Special prayers are said here on Garland Sunday, the last
Sunday in July. Garland Sunday is linked to the festival of Lughnasa.
While I was there, I met Padraig Scanlon, who has visited this

site every day since he received a
cure here in 1983. He visits with
a mobile shrine dedicated to
St Philomena who has been the
focus of many miracles here.

This hillside with its stone,
sacred trees and well, is a sacred
site: a place where people have
always come to bring a little
divine energy into their lives.

Portable shrine, Tobernalt Well

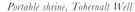

9 Carrowmore

2 miles west south west of Sligo town. Signed from the town.

It is worth starting at the small visitor centre (closed in the winter
months), where you can get a plan and even a guide for the part
of the site covered
by the centre.

Carrowmore
is the largest mega-
lithic complex in
Ireland. It covers
an area of more
than 1.5 square
miles, dotted with
circles of boulders,
large and small,

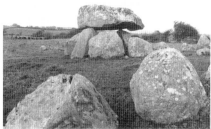

Dolmen, Carrowmore

most of which have at their centre a dolmen or stone chamber of
some kind. These are thought to be early passage cairns which
were part of a megalithic culture culminating in the great cairns of
Brú na Bóinne in Meath.

Radio-carbon dates here have been very controversial. The
Swedish archaeologist, Professor Goran Burenholt, who has done
a lot of work here since the 1970s, has suggested that one of the
structures at Carrowmore, called 52A, may be as old as 5400 BC.
This would make it at least 2000 years older than Newgrange and
put it in the mesolithic, rather than the neolithic age.

There are some 30 passage cairns here and at least another
25 which have been destroyed since 1800. Each one is known by
the number assigned to it by the historian, George Petrie, in his
report for the Ordnance Survey in 1837.

Carrowmore is on a low-lying gravel ridge and ringed by

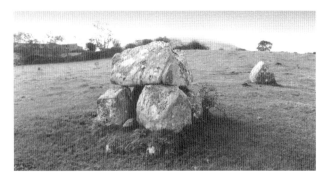

Carrowmore with Knocknarea in the background

mountains so that it forms a kind of bowl. Knocknarea, with Maebh's Cairn on top, lies to the north west, yet it does not provide the main orientation for the chambers here at Carrowmore.

The structures form a kind of oval, empty in the centre, and with an opening to the north with sites 7 and 13 on either side of a possible entrance. The centre of the oval may have been a point of assembly or ritual, with sites 7 and 13 functioning as a doorway. Many of the structures have been classified as passage cairns often on account of the artefacts found in association with them. These include cremated human bone, pins with mushroom-shaped heads made of antler or bone, small balls of bone or chalk, worked flint and chert and Carrowkeel pottery.

In some cases only a dolmen remains, or a dolmen ringed by boulders, or a ring of boulders with nothing inside. It is argued that some of the circles may be transitional forms between the heavy kerbs of cairns and true free-standing stone circles. Some have been excavated - many have not. And many have disappeared, falling victim to treasure seekers or quarry men.

Where it is possible to identify portal stones, most of the chambers seem to open towards one large cairn in their midst. It is known locally as 'Listoghill' or the 'Giant's Grave', and to archaeologists as '51'. This is the largest structure in the complex and the only one so far which was definitely covered by a cairn of small stones. The remains of seven skeletons were found in this cairn. The bones had been scratched and marked, leading to speculation that they had been defleshed or cleaned before they were deposited. A large amount of charcoal was found here, leading to the idea that it may have been a fire site having a ritual focus for the wider area. On the other hand, the smaller structures may simply have opened onto the central area.

There are 3 stone circles east south east of Listoghill. These include site 27 - a wide boulder circle with a passage in the centre which opens into 3 chambers - the only one of its kind here,

but very common at the other three major passage cairn sites across Ireland. There are also sites across the road from the visitor centre, to the north north west. They include site 4 which has at its centre perhaps the smallest dolmen in Ireland, and site 7, an exquisite dolmen sitting on a small ridge surrounded by a boulder circle. Site 55 was excavated and found to be intact at its lower levels. Two beautiful stone pendant beads were found in it.

East of Carrowmore, in Cloverhill, there is a single passage cairn with 3 decorated stones. One other stone was built into the school wall and is now in the Sligo museum. And recently, at Listoghill, a carving has been found of concentric rings, semi-circles and circles.

Some finds from Carrowmore are on display at the National Museum, Dublin. These include 3 bone pins, a rock crystal pendant and a decorated bone fragment.

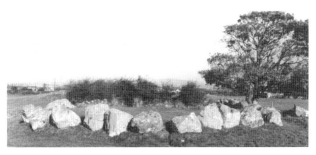

Stone circle, Carrowmore

These early dates for passage cairns at Carrowmore are interesting for all kinds of reasons. They remind us that our neat categories, like mesolithic and neolithic, are far from complete. If people in mesolithic times were building megaliths, then they must have been living in large enough groups and producing enough food to be able to build on this scale. Yet this predates the beginning of farming in Britain, and even western Europe, by hundreds of years. However, cultures to the east of the Mediterranean were farming at this time and the old stories tell us that the Firbolg came from there. Food for thought...

Sligo county was relatively undeveloped until recent years and so her prehistoric past is better preserved than some. Even so, at Carrowmore, which has the largest group of passage cairns and probably the oldest in Ireland, half of these monuments have been destroyed since 1800. Much of this is due to quarrying. However, the main cairn at Carrowmore has fallen victim to another threat. It is being reconstructed by our heritage service. Apparently, they were unable to rebuild the central chamber in the way it had stood for thousands of years. It has been set in concrete. Our ancient monuments were safer before the birth of the Celtic Tiger.

CONNACHT **Sligo**

10 Carrowkeel

*The cairns are signed on the right in Castlebaldwin, about
15 miles south of Sligo, on the N4 from Collooney. Follow the
signs and park at the top of the hill after the sheep gate.
It is possible to drive further up if you need to.*

This is a spectacular and exhilarating place. The local name for
these cairns is 'the Pinnacles'. They are high in the Bricklieve
Mountains on ridges of carboniferous limestone which run north
west to south east. There are 14 cairns up on these ridges and on
the northern slope of the most easterly ridge, there is a cluster of
hut circles, known as Doonaveeragh neolithic village. They are
thought to have been built sometime between 3000 and 2000 BC.
The site remained in use until about 1500 BC.

Carrowkeel was excavated
in 1911. The excavations took
twelve and a half days, ludicrous
even by the standards of the
time. Worse still, dynamite was
involved. They assigned a letter
to each cairn, however, and
these letters are still used today
to help identify the individual
cairns. A number of bone pins,
stone beads, pendants and balls
were found in the cairn, as well as
a kind of coarse round-bottomed
pottery associated with passage
cairns in other parts of the

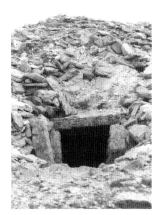

Cairn entrance, Carrowkeel

country, but called Carrowkeel ware, after this site.

The cairns are built of limestone with chambers inside
constructed of limestone slabs. Some have corbelled roofs. They
range in size from 25 to 100 feet in diameter and some are up to
20 feet high. Inside, each is different. The chambers in G and K
have three recesses forming the classic cruciform chamber.

Cairn G has a light-box above its doorway that works like the
light-box at Newgrange. The sun at sunset enters the cairn through
this box for a month either side of the summer solstice. It also lets
in the light of the setting moon for a month either side of the winter
solstice. According to Martin Byrne, the cairn opens towards the
most northerly point of the setting moon. The moon reaches this
point every 18.6 years.

From Cairn K at Samhain and Imbolc, the sun can be seen
going down behind Croagh Patrick, the sacred mountain 75 miles
away to the south west in Mayo. At the back of the right-hand

recess in Cairn K, there is a stone, known as Croagh Patrick Stone, because it looks like the mountain in outline. According to Martin, this alignment extends back to Moytura, on the other side of Lough Arrow, to the north east.

Cairn entrance, Carrowkeel

Cairn F has 5 recesses and B and O have just a simple undifferentiated chamber.

Cairn E is different. It is long, about 120 feet long and about 8 feet high. At the south end there seems to be a court, yet there is no passage from it leading into the cairn. Instead, the way is blocked by a massive 12 foot slab. There is a passage from the north end leading into the cairn and a possible side chamber in the east. This cairn is unique, seeming to be part court and part passage cairn.

Carrowkeel was used in Christian times as a sacred place for the burial of unbaptised children.

There is a powerful energy running through these hills. It seems to run along the lines formed by the hill themselves. The most noticeable height nearby is Kesh Corran to the west.

Kesh Corran

This mountain dominates the R295 from Boyle in Roscommon to Ballymote in Sligo. It is also called 'the Hog of Corran'. ('Céis' means 'a young pig'). Take the N4, then N17 south of Sligo towards Galway and turn left onto the R293 to Ballymote. Take the Boyle road. As the caves come into view, a minor road to the right takes you to within a field of the hill. Ask for access.

This hill, and especially the caves high up on its steep west slope, are associated with many different myths and stories. They are invariably violent and sometimes tragic and this is reflected in the atmosphere here. Certainly I felt a presence here in the caves: not good or bad, but very powerful and to be respected. I reached the caves first and went inside, but did not stay long. There was a pool of sticky mud on the ground in the big cave which held onto my boot with such determination, that I felt I should leave while I could.

I climbed to the top of the hill which was much higher than I had thought. The sense outside the hill was very different from the

CONNACHT **Sligo**

cave inside. However, as I crossed the rough ground, I felt as though at any minute I might fall down a hidden hole in the ground and end up inside the mountain - not a pleasant thought.

When I reached the top, it was all worth it. The sun was going down and it lit the small lakes, giving them a solidity that seemed more real than the soft quilted green of the fields. From the cairn the view was stunning: the Ox mountains, Knocknarea, Ben Bulben and Carrowkeel. It felt like I was above them all. The cairns on Carrowkeel seemed to glow with a faint purple light and the whole mountain had a white glow to it.

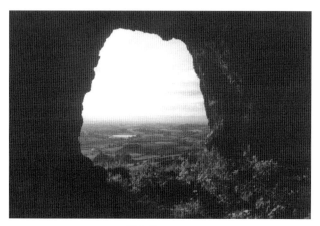

Kesh Corran cave

Kesh Corran is also known as 'Sídh ar Crúachain'. The caves are considered to be an entrance to the Otherworld and the place where the goddess, known as the Morrigan, emerges to do battle. This story tells of the Morrigan in her triple aspect, as fierce protector of her domain.

One day Fionn mac Cumhaill is said to have been hunting in the hills here with the rest of the Fianna and their dogs and making a huge commotion, killing deer, boar, hares and badgers. But these were Sidh or fairy hills and the domain of Conaran, son of Imidd of the Tuatha Dé Danann. Angry at the intrusion, he instructed his three daughters to go up to the mouth of one of the caves where they sat down to wind wool, using branches from a nearby holly tree. When Fionn and his companion Conan arrived, they saw three old hags winding hanks of yarn. As they passed the enchanted thread, they became weak and trembling and were easily overpowered and tied up in the cave. Each time more of the hunting party arrived, they suffered the same fate until the three women believed they had taken them all. They came with their swords to kill them, but decided to check that there were no

more and went outside. There they met Goll, son of Morna, the Flame of Battle, the last of the hunting party. The three hags fought a fierce battle with him, although he eventually managed to kill two of them. The third hag offered to restore his companions in exchange for her life and took him into the hill where they were tied. She released them from their bonds and from the enchantment, and they returned home safely.

It is said that Diarmuid and Gráinne came here to live when they finally gave up moving to a different place every night to escape Fionn's anger. The land around Kesh belonged to her father. It was here that they were finally happy, but it was also from this hill that Diarmuid heard in his sleep the cry of the hounds that lured him outside to his death on Ben Bulben.

In the long meadow, at the foot of the mountain, Lughnasa was traditionally celebrated on the last Sunday of July, which is also known as Crom Dubh's Sunday.

Cormac's Well or Kingstone Well

717101
A mile away from Kesh in Cross.

This is reputed to be the spot where Cormac Mac Art was born as his mother Étáin travelled to the home of the Druid Lugna who had been chosen to foster her unborn son. The king's stone is where he left the imprint of his head whilst being born.

The story of his birth and how he came to be high king of Ireland is told in the chapter on **Meath**, province of LEINSTER. His reign brought peace and plenty. His young warriors, the Fianna, travelled the land righting wrongs, a kind of Irish Knights of the Round Table. Analogies were drawn between Tara and Camelot.

He is also credited with formulating the Brehon Laws which formed the basis of Irish society for centuries. The following story illustrates his fitness for this task.

The young king accepted a magical sleep-inducing bough from a warrior who later turned out to be Manannán mac Lir. In exchange, the warrior demanded that the king give up his wife to him. Cormac refused and followed the warrior until he found himself in a great castle. Here the warrior revealed himself and gave Cormac a golden cup which would split into three if it heard an untruth. Only three truths could make it whole again. This association of Cormac with a golden chalice further adds to his image as an Irish King Arthur.

AROUND LOUGH ARROW

The deep clear waters of Lough Arrow are bounded on the south by the Curlew Mountains and in the east by the Moytirra Hills. East of the hills lies the Plain of Maigh Tuireadh, meaning 'the Plain of the Pillars', a reference to all the standing stones and megalithic structures here.

Some people suggest that the story of the battle of Moytura is just an attempt to explain so many megaliths at a time when they were all thought to mark grave sites. It was felt that some momentous battle must have taken place to account for them. However, there is almost always some allegory or hidden insight in the old stories and they should never be lightly explained away or dismissed.

Tradition holds that the Second Battle of Moytura was fought on this high plain, between the Túatha Dé Danann and an older, more ancient people, the Formorans. Lugh of the Long Arm led the Túatha Dé Danann to victory over their opponents and oppressors, the Formorians, and killed their leader who was also his grandfather, Balor of the Evil Eye.

11 Heapstown Cairn

Just over 3 miles south east of Riverstown and just north of Heapstown crossroads and the Bo & Arrow Pub. Pull in by the green and white gateway and follow the yellow arrows for the Historical Trail, called 'Slí Stairiúil'.

This massive cairn has been plundered by builders in the past, but it retains its magnificence still, and has an awesome presence. It is partially ringed by huge limestone kerbs, now covered with moss and encircled by sweet chestnut trees. The stones of the cairn are laced with creeping plants and wild flowers. The site has never been excavated and probably contains a passage and chamber, like those nearby at Carrowkeel.

Legend marks this as the site of the healing well where Dian Cécht, a healer among the Tuatha Dé Danann, brought the wounded and dead every evening during the Second Battle of Moytura. Each person who was dipped in this well became fully healed and ready to go into battle again the next day. Their enemies, the Formorians, realised the importance of the well and, led by Octriallach, they captured it and each warrior threw a stone into it to block it up. The stones formed this great cairn.

The tradition of a magical well beneath the cairn is interesting, as it is one of the few stories about a cairn that refers to water flowing beneath it. There is a strong connection between underground water and power points.

12 Carrickglass Dolmen or The Labby Rock

*From the Heapstown crossroads, follow signs for Cromlech Lodge
which is a modern hotel. From the hotel car-park, you can follow
the yellow signs on foot up to the dolmen.*

The name 'Labby' comes from the story of Diarmuid and Gráinne,
whereby megaliths were thought to be the beds of the two lovers as
they moved around the country, never staying more than one night
in each place, in case Fionn caught up with them. 'Leaba' means
'bed' in Irish.

The dolmen sits in a hollow at the edge of a pine wood where
its enormous cap-stone dwarfs its tiny supports. Its surface is
seamed and pitted and sprouting a variety of vegetation, from
heather to ferns, which gives it a homely and generous air.

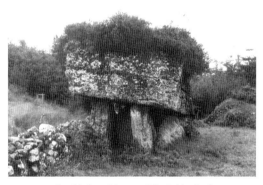

Carrickglass dolmen or The Labby Rock

The cap-stone covers a rectangular chamber which is closed
by a door slab on the inside of the portals, so that the portals are
not part of the chamber. Unusually, the cap-stone is resting on the
door slab, which means the slab must have been part of the original
structure and not put there later to close the chamber.

Cremated bone was found in the chamber in the 19th century.

Barroe North Round Cairn (Seelewey)

*If you keep following the yellow signs from the Labby Rock, you will
get here. It has, in fact, been visible on top of the next ridge as you
came down towards the Labby Rock. Alternatively, leave the Cromlech
Lodge and turn left. Take the next left (less than 0.5 miles) and after
0.6 miles, you come to the point where the yellow walking signs cross
the road. Park and follow signs to the right up to the cairn.*

It stands on a ridge 745 feet high which runs south east into
the two townlands of Moytura. Local lore says that this is the site

of the Second Battle of Moytura, and legend tells that this is where Lugh was placed to oversee the battle, surrounded by his own warriors to keep him safe. The Tuatha Dé Danann knew that without him they could not hope to defeat the Formorians. This may explain its local name 'Suí Lugh', pronounced See Lugh or Seelewey, which means 'Lugh's position or seat'.

Lugh is the Celtic sun god, so perhaps this tradition illustrates an astronomical alignment with the sun. From here the summer solstice sun sets behind Knocknarea, and on the winter solstice, if you stand on top of Knocknarea, the sun rises over Moytura and Shee Lugh. From this height Carrowkeel is also visible.

The cairn itself is 100 feet in diameter and was privately excavated, but no results published.

Lough Na Súil (The Lake of the Eye)

Follow this road to the end and you come to the lake on your right. Turn right at the T junction and again at the crossroad and this brings you around three sides of the lake.

This is the place where Lugh put out Balor's Eye. As the battle dragged on, Lugh finally came down from the hill to confront his grandfather and to fulfil the prophesy that Balor would be killed by one of his own descendants. (see **Tory Island**, DONEGAL) Balor had a single eye which could kill with a glance. This eye was huge and, when required, needed to be propped open by a number of his men. Lugh came up to him and cast a slingshot towards the eye with such force, that it was driven through to the back of his head, which had the effect of killing many of his own warriors. The eye then fell to the ground, where it burned a great hole and disappeared. The hole filled with water and a lake was formed on the spot.

At intervals the water vanishes for a few days, leaving a crater with a large, deep hole at the bottom. This is supposed to happen every 100 years. It happened in 1833 and again in 1933. Then it happened in 1965 and again in 1985. So maybe 2005 will be next?

Moytirra East Court Cairn

815141

Going south east along the road north of Lough Arrow, turn left back along the history trail. There is a small gate on the right just after a yellow bungalow.

The shallow court faces north north east and there is an interesting double entrance into the gallery which appears to be

divided into four chambers. The double entrance suggests perhaps a ritual purpose in separating the two activities of going in and out.

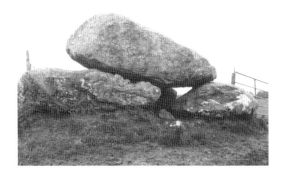

Aconry Boulder dolmen

The Eglone

On the corner opposite the Hollywood community centre.

This massive limestone upright is 18 feet high and 7.5 feet by 11.5 feet wide. This is a very imposing stone which would certainly have demanded explanation in times past.

13 St Patrick's Well, Dromard

571292

From the N59, about 8.5 miles east of Dromore West, turn right at the sign for Dromard Roman Catholic Church, at the Fiddler's Elbow Public House. Follow this road for 1.8 miles and then follow signs for the well and cemetery. Just past the cemetery is a field gate with whitewashed pillars and wall. The well is in here.

This is said to be the oldest well in Connacht. There is a local tradition that water from from this well was taken to consecrate all the holy wells in Ireland.

Outside the enclosure is the first well and inside are two others. There is also an altar and statues of St Patrick and St Brigid, as well as St Brigid's Stone. All is well looked after, with flower beds, the water clean and the paths clear.

Instructions are given for the pattern at the well which is still performed. A particular number of prayers are said at different points around the site and the site itself walked around in a clockwise direction. Then the feet are washed at the outside well before stepping into the round well inside the enclosure. Three sips of water are finally taken from the smaller well in the enclosure.

CONNACHT **Sligo**

14 Knocknashee

556190

From Lavagh village take the Coolaney Road north east and pass
2 roads off to the right. The next house on the left is Scully's and
the hill is easily climbed from the side of their house.

This is a huge limestone plateau, called 'the Hill of the Fairies'. It is similar in shape and geology to Knocknarea and just as spectacular. It is topped with a massive contour hill-fort enclosing 53 acres overlooking the plains of north Connacht.

In the east of the enclosure are about 30 circular stone hut sites dating to the end of the Bronze Age. They are enclosed by rock-cut ditches. There are 2 large cairns north east and north west and between them a circular stone platform.

The sheer scale of the place alerts the senses and from its summit you feel a natural connection with the other cairn-topped hills - Knocknarea, Carrowkeel and Kesh Corran. On a clear day Croagh Patrick is visible to the south.

15 Aconry Boulder Dolmen

576140

Go back to Lavagh and turn left crossing the N17 at a staggered
crossroads. Follow this road for 1.7 miles, the boulder dolmen is
visible on the left just below a farmhouse. Access is from the
farm lane.

The dolmen is incorporated into a boundary fence but not suffering because of it. It has a large round cap-stone resting on 3 boulders. Unlike other dolmens, these boulders are horizontal rather than upright, to form a chamber.

This is a fine example of a boulder dolmen and unusual this far north. Most of them, about 70, are in Cork and Kerry. They are normally associated with Bronze Age stone circles and rows and seem to occur near copper deposits where you might expect Bronze Age people to settle.

Some cover deposits of human remains. This one has not been excavated.

16 Rathdooney Beg Barrows - Neolithic to Iron Age

Heading north east from Ballymote, go past the schools and take
the first left. The site is about 1.5 miles along this road on the left.
One of the barrows is visible on the ridge above the road and the
farm gate has a sign on it.

There are 3 mounds here on top of a drumlin ridge with panoramic views through 180 degrees. Knocknarea lies to the north, Carrowkeel in the Bricklieves is south south west and the large cairn on the summit of Kesh Corran is to the south.

The largest barrow, a beautiful compact cone, 20 feet high with ridged sides, is enclosed by a wide fosse surrounded by a bank. The fosse is now mostly filled in but was originally about 7 feet deep. Excavations reveal that it started filling up in the early neolithic period, around 3300 BC, when pollen samples suggest that the area was mainly grassland with some cereal cultivation. Excavations also revealed stone kerbing but as the actual mound was not touched, it remains speculation as to whether or not it contains a passage. When a bank encloses a ditch, rather than the other way round, this is usually considered to be a ceremonial site. A bank with ditch outside is usually considered to be for defence.

North of this is a much smaller barrow of similar proportions. It is surrounded by a fosse and bank. Attached to its west side is a saucer barrow enclosed by a crescent-shaped ditch and external bank. These 2 structures have been dated to the Iron Age with the saucer barrow being a later addition. It is not unusual to find Iron Age sites attached to earlier structures from, say, the Bronze Age.

By the time these two barrows were being built, the soil was becoming waterlogged and acidic and conditions would have been just right for the development of blanket bog.

A section of this small conical barrow was excavated with interesting results. A fire was burned on the ground, maybe involving cremation but maybe not. The burnt sods were then placed, burnt side up, to form a low mound about 6 feet in diameter and 2.5 feet high. The barrow was then piled up with material from the surrounding ditch. Fragments of human skull, unburned but with scratch marks, were found near the base of the mound. It is not known what lies beneath the burnt sods.

Inside the saucer barrow were two small pits containing charcoal and, in one, a small amount of crushed cremated bone (dated to around 100 BC). In the other, there were a few bone fragments. In the base of the ditch to the west was a third deposit of charcoal and cremated bone with 11 iron objects, including nails and a handle which appear to have once been part of a wooden box.

On the road back to Ballymote and right by the roadside are two more barrows at 663174 and 664172. On the other side of the road, in Carrigans Upper, are also barrows, ancient field walls, enclosures and cliff edge forts.

County
LEITRIM
PRINCIPAL SITES

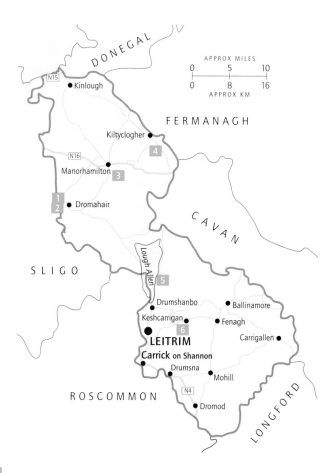

1 **Creevelea Abbey**
2 **Kilerry** churchyard - The Straining Threads
3 **Tullyskeherny** megalith
4 **Corracloona** court
5 **St Hugh's Well** and **Sweat House**
6 **Sí Beag** or **Sheebeg**

Block figures in list refer to site locations in map and entries in text.

LEITRIM

COUNTY LEITRIM STRETCHES FOR FIFTY MILES from Donegal Bay in the north west to the Longford border in the midlands. This long narrow county is cut in the middle by the waters of Lough Allen, the first great lake on the river Shannon. It is named after Aillfhion, the spirit of the lake who is known for her vengeful nature and capable of raising a storm in minutes, should she feel slighted or aggrieved. Perhaps she is the same creature who has appeared a number of times in recent years with a massive head and several undulations of her serpent-like body breaking through the surface of the water.

Ail Fhionn also means 'Fionn's Stone'. It can still be seen in the townland of Barnameenagh, on the western slope of Slieve Anierin, which is on the eastern side of the lake. Fionn mac Cumhaill is said to have hurled this stone from the far shore to this point near the top of Slieve Anierin. There are indentations in the side of the stone where Fionn is said to have gripped it. If you put your hands in the same place, the stone will give you strength.

Slieve Anierin, or Sliabh an Iarainn, is the mountain where the Túatha Dé Danann, the Tribe of the Goddess Danu, first arrived in Ireland. They came from the air in a cloud of invisibility, only taking form when they touched this mountain. From here they went to Lough Corrib in Galway where they fought the Firbolg for possession of Ireland. (see MAYO)

Near the northern border with Ulster is one of the best preserved bits of the Black Pig's Dyke. A discontinuous fosse, about eight feet wide, crosses the road between Kiltyclogher and Rossinver and curves along the border for about six miles. In places it has been cut through rock. This is thought to be part of a massive Iron Age defensive earthwork between Ulster and Connacht.

The megaliths at Corracloona and Tullyskeherny are dramatic, both in location and form. There are many other less well known sites in this area.

1 Creevelea Abbey (Leitrim)

Just west of Dromahair on the R288, the abbey is signed on the left just past the railway line. Access is by foot over the bridge, along the river bank, and up the rise to the abbey.

Founded in 1508 by Owen and Margaret O'Rourke, Creevelea was the last Franciscan friary to be built in Ireland before the Dissolution.

It was accidentally burned in 1536 and then destroyed by the

notorious Richard Bingham in 1590. He used it as a stable for his soldiers' horses and, though it was used again by the friars and repaired in 1642, Cromwell's men closed it down again. Later the friars rented it once more, re-roofing the church with thatch and possibly converting the tower into living quarters. They left finally by the end of the 17th century.

The nave, choir, tower and south transept of the church are still standing and so are the refectory and kitchens around the cloisters to the north. One of the cloister pillars in the middle of the north side has some interesting carvings on it. The higher one shows St Francis with stigmata and an inscription crossing his body. Below this he is shown preaching from a pulpit with birds in a nearby tree. On the east side of the cloisters are three rooms, and beyond them a corridor leads outside.

The entire inside of the buildings still function as a graveyard, from the smallest room to the main body of the church. All is beautifully kept with flowers, wreaths, ornaments and memorabilia, putting one in mind of a walled garden. The raised ground level, from centuries of burials, has made the doorways and arches so small that they seem to have become more ornamental than functional and the whole area feels like a beautiful walled sanctuary.

2 Kilerry Churchyard - The Straining Threads
776306
Going south from Dromahair, turn right onto the R287 to Sligo just 0.5 miles out of the town. 2.4 miles later, at a double crossroads, turn right and right again following the sign for Innisfree. The church is 0.8 miles down this road on the left.

The Straining Threads

In the graveyard of Kilerry church there are a number of small round boulders clustered around a taller stone (perhaps 2 feet tall) which has a number of laces and bands wrapped around it. These are the Straining Threads. They are replaced by a local family who

has responsibility for this cure. No one else can do this.

If you take a band from this stone and apply it to a sprained limb, it is said to cure the sprain. Hence the name, the Straining Threads. The cure is not confined to humans and has been used to cure animals as well, particularly horses.

The boulders are ancient cursing stones which would have been turned long ago when a curse was made against someone. As at other sites, an unjust curse would rebound on the one who sent it.

3 Tullyskeherny Megalith

899370

Just outside Manorhamilton on the N16 to Blacklion. Take the first right turn off the N16 following signs for the Leitrim Way walking route till you get to the top of the hill. (1.3 miles) Continue on the Leitrim Way as it follows a field track. The stones are beside the track, on the left after a sharp bend.

This site has been classified as a two-segmented gallery grave and two court cairns, one with six chambers.

Tullyskeherny hill is about 600 feet high, dipping right at the summit to form a kind of shallow recess. From the rim of the hill you can see right down into the valley and the town of Manorhamilton below. From inside the recess, where the megalith is, the view is

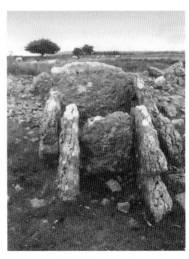

Tullyskeherney cairn

quite different. It is completely cut off from the valley and town and there is no longer any point of reference to the immediate world down below. All you can see is the rim of the hill and beyond this, a ring of mountain tops in the distance. This seems to lend an Otherworld character to the place.

The first structure appears to be a massive long cairn running east west for about 90 feet. It is about 30 feet wide, with eight or more chambers sited down its length, opening alternately on either side of the cairn. The slabs forming the chambers are pitted limestone, gnarled and sculpted by the elements.

CONNACHT **Leitrim**

Fairy thorn and sheep, Tullyskeherny

Just west of this is another cairn with a large chamber formed by 7 huge slabs of limestone.

There is a very powerful feeling up here of being in another world. The valley below has disappeared and the porous limestone hill seems to absorb everything except the music of the tiny song birds singing in the thorn trees scattered among the ruined cairns.

If you continue along this track, you come to a cashel on your right, with walls up to 3 feet high and 4 feet thick. Further on, there are another two cashels also on the right and a cairn, called the Giant's Grave. It has a rectangular chamber formed by 9 limestone slabs.

A further cairn in Tawnymanus to the west, also called the Giant's Grave, is inaccessible.

4 Corracloona Court Cairn

From Kiltyclogher go south east on the R281 for 2 miles. Corracloona is on the right, about 150 yards before the old Corracloona School. It is signed as Feart Chonaill Flaith, or Prince Connell's grave, and is accessed over a small wooden stile onto rough pasture.

This is an impressive cairn. It has one large cube-shaped chamber measuring about 6 foot in each direction. The chamber entrance faces south west and is closed by a great square door slab. A rectangular doorway, big enough to duck through, has been cut in it. This doorway is an unusual feature and has been called a kennel entrance to distinguish it from the more common 'porthole' openings of other sites. 'Portholes' are cut away at the top of door slabs. The word 'kennel' was probably more appropriate when the ground level was much higher and the doorway seemed only about a foot tall.

The entrance is further sealed by dry-stone walling on the

outside which is kept in place with another even larger slab.

The court is partly made up of dry-stone walling and is 11 feet deep and 16 feet wide across the entrance. The remains of a long cairn can be seen, some 60 feet long, with dry-stone kerbing which includes some large kerb-stones at intervals.

This unusual court cairn was excavated in the 1950s, but no report was published.

Down the small side

Doorway, Corracloona court cairn

road just opposite Corracloona, you can see another bit of the **Black Pig's Dyke** - possibly the best bit. After about half a mile, the road dips down into a deep wide channel which is just visible across the landscape.

5 St Hugh's Well and Sweat House

Take the Dowra road (R207) north out of Drumshanbo.
At 4.1 miles, just after crossing the Stoney river, there is a small road up to the right following the Leitrim Way. Some way up there is a sharp right turn. The well and sweat house are through the gate on the left. Follow the path down to the left over the bridge and through another gate on the left to reach the well.

This well is dedicated to a sixth century saint, St Beoighe, or Beo-Aodh, which means possibly, 'Lively Hugh'. This is a cool and shady place with a deep pool of water which is strong and rich in iron.

Go back to the first gate and follow

St Hugh's Well

the tarred path down to the right and across a small bridge to the left. Here is a sweat house built into the bank by the stream. It is a

lovely gentle place of running water, ferns and mossy stones. A large fire was lit inside this small stone house till it was heated through. The fire was then raked out and a layer of rushes laid on the floor. Water sprinkled on the rushes created a steamy atmosphere where one or two people could sit to gain relief from a range of aches and ills. They could then bathe in the nearby stream

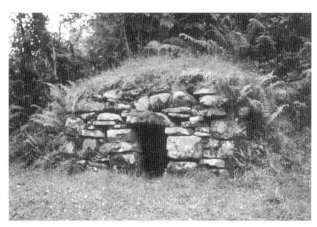

St Hugh's Sweat House

6 Sí Beag or Sheebeg

Just outside Keshcarrigan on the R209 Carrick road, turn left onto a narrow road signed Sheebeg. Keep left at the fork and continue to the top of the hill where there is a sign and stile to the cairn.

'Sí Beag' means 'the Little Fairy Mound', and when you stand on top of this grassy mound, 'Sí Mór', which means 'The Big Fairy Mound', is visible away to the south. This is reputed to be the grave mound of Fionn mac Cumhaill and Gráinne. When Diarmuid and Gráinne eventually stopped running from Fionn, they settled at the caves of Kesh Corran in Sligo where they lived until Diarmuid's death. He was lured by Fionn to Benbulben where he was gored by a wild boar. Grainne returned with Fionn to his home and a year later she threw herself from his chariot and died. She was buried on Sí Beag and later he was placed beside her.

This grassy mound was excavated and two skeletons were found in it, lying side by side.

BIBLIOGRAPHY

Guides: General

Evans, Estyn *Prehistoric & Early Christian Ireland: A Guide.*
Batsford, London. 1966.

Harbison, Peter *Guide to National & Historic Monuments of Ireland.*
Gill & Macmillan, Dublin. 1992.

Killanin, Lord & Duignan, Michael V *The Shell Guide to Ireland.*
Gill & Macmillan, Dublin. 1989.

McNally, Kenneth *The Islands of Ireland.* Batsford.

Muir, Richard *The Shell Guide to Reading the Celtic Landscape.*
Michael Joseph, London. 1985.

Office of Public Works *Heritage: A Visitor's Guide.*
Government Publications, Dublin. 1990.

Guides: Local

Cumann Staire is Seanchais Chloich Cheann Fhaola *Tory Island.
Cloich Cheann Fhaola. Bloody Foreland: A Scenic Drive Through Historic
Northwest Donegal.* Údaras na Gaeltachta. 1992.

Fox, Robin *Tory Islanders: The People of the Celtic Fringe.*
Cambridge University Press. 1978.

Gillespie, Christy *St Colmcille. Gartan to Iona: A Life's Journey.*
Nicholson & Bass, Belfast. 1997.

Heraughty, Patrick *Inishmurray: Ancient Monastic Island.*
The O'Brien Press, Dublin. 1982.

Herity, Michael *Donegal History & Society. Early Christian Decorated Slabs in
Donegal.* Geography Publications, Dublin. 1995.

Herity, Michael *Gleanncholmcille: A Guide to 5,000 years of History in Stone.*
Na Clocha Breaca, Dublin. 1998.

Herity, Michael *Rathcroghan and Carnfree.* Na Clocha Breaca, Dublin. 1988.

MacMahon, Bryan, Tr. *Peig: The Autobiography of Peig Sayers of the Great
Blasket Island.* The Talbot Press, Dublin. 1974.

Marshall, J D C *Forgotten Places of the North Coast.* Clegnagh Publishing,
Armoy, Co Antrim. 1987/1991.

Ó Maoildhia, Dara *Pocket Guide to Árainn: Legends in the Landscape.*
Aisling Árainn. 1998.

Robinson, Tim *Stones of Aran: Labyrinth.*
Penguin, London. 1997 (First published 1995)

Slavin, Michael *The Book of Tara.* Wolfhound Press, Dublin. 1996.

Synge, J M *The Aran Islands.*

Myth & History

Chambers, Anne *Granuaile: The Life & Times Of Grace O'Malley
1530 - 1603.* Wolfhound Press, Dublin. 1998.

Gregory, Lady *Gods & Fighting Men.*
Colin Smythe Ltd. Gerrards Cross, 1904.

Gregory, Lady *Lady Gregory's Complete Irish Mythology*. Reprint by
 Chancellor Press, London. 1994 of two books originally published
 by John Murray, London. 1902 and 1904.

Keating, Geoffrey *History of Ireland*.
 Irish Texts Society, London. 1902 - 1914.

Kinsella, Thomas, Tr. *The Tain*. Oxford University Press, Oxford. 1969.

MacCana, Proinsias *Celtic Mythology*. Hamlyn, London. 1970.

Mackillop, James *Dictionary of Celtic Mythology*.
 Oxford University Press, Oxford. 1998.

Monmouth, Geoffrey of *The History of the Kings of England*.
 Penguin, London. 1966 (written c.1136)

Moody T W, & Martin, F X, Eds.*The Course of Irish History*.
 The Mercier Press, Cork & Dublin. Revised 1994.

Neeson, Eoin*The First Book of Irish Myths & Legends*.
 The Mercier Press, Dublin.

Neeson, Eoin *The Second Book of Irish Myths & Legends*.
 The Mercier Press, Dublin. 1966.

O'Rahilly, T F *Early Irish History & Mythology*.
 Dublin Institute for Advanced Studies, Dublin. 1971.

Powell, T G E *The Celts*. Thames & Hudson, London. 1958/1980.

Ross, Anne *Pagan Celtic Britain*.
 Routledge and Kegan Paul, London. 1967.

Beliefs, Folklore & Tradition

Bryce, Derek *Symbolism of the Celtic Cross*. Llanerch Enterprises. 1989.

Danaher, Kevin *The Year in Ireland: Irish Calendar Customs*.
 The Mercier Press, Cork & Dublin. 1972.

Green, Miranda *The Gods of the Celts*. Sutton Publishing, Surrey. 1986.

Jestice, Phyllis G *Encyclopedia of Irish Spirituality*.
 ABC-CLIO, California. 2000.

Low, Mary *Celtic Christianity & Nature: Early Irish & Hebridean Traditions*.
 The Blackstaff Press. 1996.

MacNeill, Máire *The Festival of Lughnasa*.
 Oxford University Press, London. 1962.

Merry, Eleanor *The Flaming Door*. New Knowledge Books. 1936/1962.

Ó hÓgáin, Dáithí *The Sacred Isle: Belief & Religion in Pre-Christian Ireland*.
 Collins Press, Cork. 1999.

Streit, Jakob *Sun and Cross: The Development from Megalithic Culture to Early
 Christianity in Ireland*. Floris Books, Edinburgh. 1977/1984.

Yeats, W B *Irish Fairy & Folk Tales*. Barnes & Noble Books, USA. 1993.

Yeats, W B *The Celtic Twilight: Myth, Fantasy & Folklore*.
 Prism Press, Dorset. 1893/1990.

Sacred Landscape

Brennan, Martin *The Stars and the Stones: Ancient Art and Astronomy in
 Ireland*. Thames & Hudson, London. 1983.

Dames, Michael *Mythic Ireland*. Thames & Hudson, London. 1992.

Michell, John *At the Centre of the World. Polar Symbolism Discovered in Celtic,
 Norse & Other Ritualized Landscapes*. Thames & Hudson, London. 1994.

Pennick, Nigel *Celtic Sacred Landscapes.* Thames & Hudson, London. 1996.

Poynder, Michael *Pi In The Sky: A Revelation of the Ancient Wisdom Tradition.* Ryder, London. 1992.

Swan, James A, Ed. *The Power of Place: Sacred Ground in Natural & Human Environments.* Gateway Books, Bath. 1993.

Christian Period

de Paor, Liam *St Patrick's World.* Four Courts Press, Dublin. 1993.

de Paor, Máire & Liam *Early Christian Ireland.* Thames & Hudson, London. 1958.

Gwynn, A & Hadcock, R N *Medieval Religious Houses: Ireland.* Longman Group Ltd, London. 1970.

Hughes, Kathleen & Hamlin, Ann *The Modern Traveller to the Early Irish Church.* Four Courts Press, Dublin. 1997.

Manning, Conleth *Early Irish Monasteries.* Country House, Dublin. 1995.

Marsden, John. *The Illustrated Columcille: The Life of St Columba.* Macmillan, London. 1991.

McMahon, Joanne & Roberts, Jack *The Sheela-na-Gigs of Ireland and Britain: The Divine Hag of the Christian Celts - An Illustrated Guide.* Mercier Press, Cork. 2001.

Richardson, Hilary & Scarry, John *An Introduction to Irish High Crosses.* Mercier Press, Cork & Dublin. 1990.

Rynne, Etienne, Ed. *Figures From the Past: Studies in Figurative Art in Christian Ireland.* Glendane Press & RSAI. 1987.

Archaeology

Burl, Aubrey *A Guide to the Stone Circles of Britain, Ireland and Brittany.* Yale University Press, New Haven & London. 1995.

de Valéra, Ruaidhrí & Ó Nualláin, Séan *Survey of the Megalithic Tombs of Ireland.* The Stationery Office, Dublin. 1964.

Donnelly, Colm J *Living Places: Archaeology, Continuity and Change at Historic Monuments in Northern Ireland.* Queens University, Belfast. 1997.

Flanagan, Laurence *Ancient Ireland: Life Before the Celts.* Gill & Macmillan, Dublin. 1998.

Harbison, Peter *Pre-Christian Ireland: From the First Settlers to the Early Celts.* Thames & Hudson, London. 1988.

Hickey, Helen *Images of Stone.* Fermanagh District Council & Arts Council of N Ireland. 1976/1985.

Mallory, J P & McNeill, T E *The Archaeology of Ulster: From Colonization to Plantation.* Queens University, Belfast. 1991/1995.

McNally, Kenneth *Standing Stones & Other Monuments of Early Ireland.* Appletree Press, Belfast. 1984.

Ó Ríordáin, Séan P *Antiquities of the Irish Countryside.* Fifth Ed. Routledge, London. 1942/1991.

INDEX

Page numbers in **bold** refer to numbered and featured sites.
Page numbers in *italics* refer to map pages and their site listings.
County and Province names in **Bold.**